ERWIN PANOFSKY

RENAISSANCE AND RENASCENCES

IN WESTERN ART

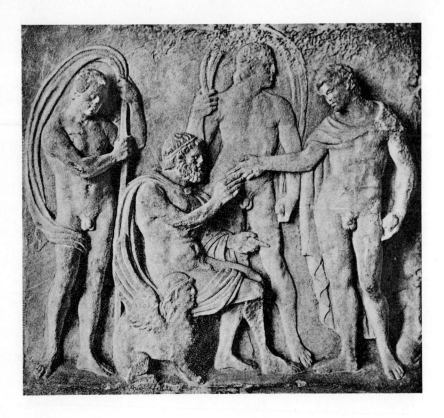

RENAISSANCE
AND RENASCENCES
IN WESTERN ART

By ERWIN PANOFSKY

Icon Editions
Harper & Row, Publishers
New York, Evanston, San Francisco, London

D. M.

D. S. GOTTESMAN

EXPIANDIS

First HARPER TORCHBOOK edition published 1969.
First ICON edition published 1972.

STANDARD BOOK NUMBER: 06-430026-9

EDITOR'S PREFACE

As will be seen from the Author's Preface, this book is based on some of Professor Erwin Panofsky's lectures and seminars during a week in the summer of 1952 at Gripsholm Castle which houses the Swedish National Portrait Gallery. The texts have been revised and considerably amplified. The occasion developed into a symposium in which teachers and graduate students from all the universities and major museums of Sweden participated. The Institute of Art History of the University of Uppsala was responsible for the arrangements, but the symposium as well as this publication was made possible by the generous financial assistance of the Gottesmann Foundation.

As an inter-academic affair taking place outside Uppsala—although in surroundings that to our students of the history of art have become a kind of *Akademia*—this symposium was unique in the series of Gottesmann lectures. It has, accordingly, been considered appropriate to include the publication both in this series and in the *Figura* series, published by the Institute of Art History of the University of Uppsala.

The first-mentioned series has now been concluded, and this provides an admirable opportunity to recall the circumstances of its origin.

In November, 1947, D. S. Gottesmann sent a letter to the Swedish Consul General in New York, from which the following passages are quoted: "For quite some time I have felt that the acts of mercy on the part of the Swedish people and the Swedish Government during the war and since the conclusion of hostilities have not been fully recognized. While words of appreciation have been expressed from time to time, I have felt very strongly that these expressions of appreciation and gratitude should have taken a more concrete form."

On December 2nd, 1947, this letter was followed by a deed of gift to the University of Uppsala. The sum of $50,000 was donated "for the purpose of enabling the University to arrange for a series of lectures by world-renowned persons, irrespective of nationality, in the field of the humanities". The donation served as an expression of gratitude for certain Swedish initiatives, especially on the part of the late King Gustav V, in organizing aid to the Jews of the nazi-dominated countries

in their truly painful predicament. But it also shows one man's faith in humanistic research and its necessity to the survival of civilization. This is very clearly borne out by the following words of D. S. Gottesmann: "The administration of human affairs has fallen behind our technological advances, with the result that the physical and moral self-destruction of the human race is in the air. It is not to science that we must turn for guidance but to the humanities—to the several fields of learning having to do with the social and moral fibres of our people. We must develop the ethical, cultural and philosophical values and learn from history and literature. In that way we can build up the liberalism and understanding that is so necessary to win the race against the weapons of man's own creation."

This is not the place to comment upon the work now presented to the public. The editors wish only to express their conviction that to an eminent degree it corresponds to the purpose of the Gottesmann Foundation—to demonstrate the function of the Humanities in our Western civilization, exemplified in one of the most brilliant cultural achievements of mankind.

Gregor Paulsson

CONTENTS

ILLUSTRATIONS

AUTHOR'S PREFACE

THE LITTLE VOLUME here submitted to the public requires more than the usual measure of explanation and apology.

When the University of Uppsala did me the honor of appointing me as Gottesman Lecturer in 1952 and generously proposed that the lectures be given during the month of August so as to facilitate the participation of as many Swedish colleagues, old and young, as possible, I sought to find a topic which might be of interest to them regardless of their special field of study. I therefore suggested "The Renaissance Problem in the History of Art", and this suggestion was accepted even though it could be foreseen that it would result in considerable duplication.

The subjects of Lectures Nos. 1 and 2—both dealing with the question as to whether there was such a thing as the Renaissance and, if so, in what manner it differed from the mediaeval revivals often referred to by the same name (pp. 1–113 of this volume)— and Lecture No. 10—discussing the relation of art and science in the fifteenth and sixteenth centuries—had already been treated, in a preliminary way, in two previous essays; but since these essays had appeared, unimplemented by footnotes, in fairly inaccessible places,* it was not thought improper to repeat and republish them in revised form. The content of the third lecture, concerned with Italian Trecento painting and its impact on the rest of Europe (pp. 114–161 of this volume), was to be coextensive, to a degree, with that of some chapters in a book scheduled for publication in the following year;** but since, in this case, the treatment in the book would be more circumstantial and oriented toward a different goal, the repetition of several passages, in part verbatim, was not considered intolerable.

Thus the lectures were delivered, as proposed, in the ideal setting of Gripsholm Castle, and the ensuing discussions—occasionally attended by the inquisitive inhabit-

* "Renaissance and Renascences", *Kenyon Review*, VI, 1944, pp. 201–236; "Artist, Scientist, Genius: Notes on the 'Renaissance-Dämmerung'", *The Renaissance, A Symposium, The Metropolitan Museum of Art, Feb. 8-10, 1952*, New York, pp. 77–93.

** *Early Netherlandish Painting; Its Origins and Character*, Cambridge (Mass.), 1953, Introduction and Chapters I–III, V, VI.

ants of the deer park, agreeably interrupted by social gatherings and excursions, and terminated by a gala performance in the delightful circular theater of Gustavus III— will always live in my memory as an experience that can be described only by the phrase "Et in Arcadia ego". But when I tried to fulfill my obligation of submitting the lectures for publication, I realized that I had a tiger by the tail or—to use the even more telling simile of Emperor Tiberius—"a wolf by the ears".

To bring the first and second lectures up to date—and, as far as possible, up to standard—proved to be more difficult and time-consuming than had been anticipated. To revise the third turned out to be an almost superhuman task because the literature on Italian Trecento art, vast though it is, seems to have paid comparatively little attention to the period's attitude toward the Antique. And what made the process of revision demoralizing as well as laborious was the fact that practically no week went by without giving birth to some new contribution which demanded attention. No man can read, within a given time, all that a hundred others can write, and in the end I came to see that, as regards the Renaissance Question, it has become impossible to be either comprehensive or original: not only all the wrong but even all the right things seem to have been said. What could be attempted was, at best, to reduce an immense panorama to a small, rough outline drawing whose only claim to merit rests on the fact that it has its focus in the point of view of one observer; and, on the other hand, to enter some minute details into the accurate ordinance maps devised by others.

In short, after more than five years no more than the first half of the series, comprising Lectures Nos. 1–4, was as "fit to print" as I could hope to make it: I found myself confronted with the choice of either postponing the publication of the whole for another five years or of asking for permission to publish the first half as a separate volume. In view of the insecurity of human affairs (and because the partial payment of an outstanding debt is better than no payment at all) I decided in favor of the second alternative— a choice which may seem justified in view of the fact that these first four lectures, mainly devoted as they are to the antecedents of the High Renaissance, may claim a certain unity. My thanks go to Dr. Carl Nordenfalk for having acted as my advocate; to Professor Gregor Paulsson for having recommended my proposal to the authorities of Uppsala University; and to the University itself—particularly to its former Vice-Chancellor, Professor Åke Holmbäck—for having agreed to accept a fragment which comes both too early and too late.

To the two first-named friends and to the other participants in the Gripsholm symposium I am further indebted for innumerable stimulating suggestions as well as for help in more practical matters. To other friends and colleagues I am similarly obliged. Suffice it to mention J. Adhémar, K. Bauch, H. Bober, A. Châtelet, H. F. Cherniss, C. O. Cunningham, M. Davies, L. D. Ettlinger, L. Grodecki, W. S. Heckscher,

H. W. Janson, E. H. Kantorowicz, G. Kubler, K. Lehmann, M. Meiss, E. Meyer, the late T. E. Mommsen (whose studies on Petrarch have done more to shape my own views than any other single influence), M. Muraro, F. Nordström, R. Offner, J. Porcher, U. Procacci, C. Seymour, J. R. Spencer, H. Swarzenski, H. van de Waal, J. Walker, K. Weitzmann, H. Wentzel, and F. Wormald, as well as Mesdames M. T. d'Alverny, A. de Egry, E. Frankfort, E. L. Lucas, M. Scherer, and D. B. Thompson. The diagrams reproduced in Text Ills. 1, 4–7, and 9 were drawn by Mr. Zane Anderson. My special gratitude is due, as in the case of several previous publications, to my former research assistant, Mrs. W. F. King, whose patience has been more severely tried by the preparation of this volume than on previous occasions, as well as to her successor, Miss R. Sanossian. And I am forever beholden to Dr. Allan Ellenius of Uppsala University who shouldered the thankless tasks of seeing the proof through the press and preparing the Index.

PRINCETON, N. J., December 1957

E. P.

PREFACE TO THE SECOND EDITION

For technical as well as personal reasons the second edition of *Renaissance and Renascences* differs from the first only by the correction of all-too-numerous errors, typographical and otherwise, and by the addition, on p. 172, of Gentile da Fabriano to the little list of pioneers in what may be called the "proto-archaeological" study of classical art; my sin of omission was brought home to me by the appearance of B. Degenhart's and A. Schmitt's excellent article, "Gentile da Fabriano in Rom und die Anfänge des Antikenstudiums," *Münchner Jahrbuch der bildenden Kunst*, XI, 1960, p. 59 ff.

Apart from the flaws detected by myself, corrections were suggested first, by P. O. Kristeller's review in *Art Bulletin*, XLIV, 1962, p. 65 ff.; and, second, by personal communications from Professors Creighton Gilbert, Millard Meiss, G. N. P. Orsini, and, above all, Richard G. Salomon; to these helpful critics I wish to express my heartfelt gratitude.

So much has been published about the "Renaissance problem" after the completion of the original Bibliography in 1957 that no concerted effort could be made to bring it up to date. I should like to jot down, however, the titles of a few publications (in addition to the article on Gentile da Fabriano already cited) which I found particularly helpful and/or stimulating regardless of whether or not I agree with their respective authors on all points.

PREFACE

A. BOOKS

C. Beutler, *Bildwerke zwischen Antike und Mittelalter*, Düsseldorf, 1964.

E. W. Budnar, *Cyriacus of Ancona in Athens (Latomus*, LIII), Brussels-Berchem, 1960.

A. Chastel, *Art et humanisme au temps de Laurent le Magnifique*, second ed., Paris, 1960.

A. Chastel and R. Klein, *L'Europe de l'Humanisme et de la Renaissance; L'Age de l'Humanisme*, Brussels, 1963 (English translation, entitled *The Age of Humanism* and omitting the name of the co-author, New York, 1964).

W. Köhler, *Die Karolingischen Miniaturen*, III: *Die Gruppe des Wiener Krönungsevangeliars, Metzer Handschriften*, Berlin, 1960.

D. J. A. Ross, *Alexander Historiatus: A Guide to Mediaeval Illustrated Alexander Literature*, London, 1963.

F. Saxl, *Lectures* (particularly "Jacopo Bellini and Mantegna as Antiquarians," I, p. 151 ff., and "Illustrated Mediaeval Encyclopaedias," I, p. 228 ff.), London, 1957.

E. Wind, *Pagan Mysteries in the Renaissance*, New Haven, 1958.

B. ARTICLES

J. Engels, "Berchoriana I: Notice bibliographique sur Pierre Bersuire," *Vivarium*, II, 1964, p. 62 ff.

K. Heitmann, "Typen der Deformierung antiker Mythen im Mittelalter am Beispiel der Orpheussage," *Romanistisches Jahrbuch*, XIV, 1963, p. 45 ff.

O. Raggio, "The Myth of Prometheus, Its Survival and Metamorphosis up to the Eighteenth Century," *Journal of the Warburg and Courtauld Institutes*, XXI, 1958, p. 44 ff.

W. Sauerländer, "Art antique et sculpture autour de 1200," *Art de France*, I, 1961, p. 47 ff.

M. R. Shapiro, "Donatello's *Genietto*," *Art Bulletin*, XLV, 1963, p. 135 ff.

C. Trinkaus, "A Humanist's Image of Humanism: The Inaugural Orations of Bartolommeo della Fonte" (containing the earliest known illustration of the *Calumny of Apelles*), *Studies in the Renaissance*, VII [1960], p. 90 ff.

It may also be mentioned that the following publications listed in the original Bibliography are now available in "paperback editions" which contain corrections and amplifications:

M. Meiss, *Painting in Florence and Siena after the Black Death*, New York, 1964.

E. Panofsky, *Studies in Iconology*, New York, 1962.

—— "Artist, Scientist, Genius: Notes on the 'Renaissance-Dämmerung,'" in *The Renaissance, Six Essays by Wallace K. Ferguson et al.*, New York, 1962, p. 121 ff.*

This new edition of *Renaissance and Renascences* increases the debt of gratitude which I owe to my kind and patient editor, Dr. Allan Ellenius of Uppsala University.

Princeton, October 1964

E. P.

* [A German reprint of my *Idea*, containing references to some publications not as yet mentioned in the Italian translation of 1952, appeared at Berlin in 1960; an Italian translation of my *Meaning in the Visual Arts*, entitled *Il significato nelle arti visive* and provided with much better illustrations, was published at Turin in 1962; and my article "Die Perspektive als symbolische Form," supplemented by some other essays and, more importantly, by an exellent summary of the "question of perspective" by Marisa Dalai (pp. 118–141) is also available in Italian: *La Prospettiva come "forma simbolica" e altri scritti*, G. D. Neri, ed., Milan, 1961. For a still more recent contribution to this subject, see P. H. von Blanckenhagen and C. Alexander, "The Paintings of Boscotrecase," *Mitteilungen des deutschen archäologischen Instituts*, Röm. Abtlg., VI. *Ergänzungsheft*, 1962, p. 30, Note 37.]

CHAPTER I

"Renaissance"—Self-Definition or Self-Deception?

I

Mᴏᴅᴇʀɴ sᴄʜᴏʟᴀʀsʜɪᴘ has become increasingly skeptical of periodization, that is to say, of the division of history in general, and individual historical processes in particular, into what the *Oxford Dictionary* defines as "distinguishable portions".[1]

On the one hand, there are those who hold that "human nature tends to remain much the same in all times",[2] so that a search for essential and definable differences between succeeding generations or groups of generations would be futile on principle. On the other, there are those who hold that human nature changes so unremittingly and, at the same time, so individually, that no attempt can and should be made to reduce such differences to a common denominator. According to this view, they are due "not so much to a general spirit of the age but rather to an individual's solution of ... problems". "What we call 'periods' are simply the names of the influential innovations which have occurred constantly in ... history", and it would therefore be more reasonable to name periods of history after individuals ("the Age of Beethoven") than to attempt their definition and characterization in general terms.[3]

The first, or monistic, argument can be dismissed for the simple reason that, if it were true, everything would be possible everywhere at every moment, which would make the writing of history ("a written narrative constituting a continuous methodical record, *in order of time*, of important events")[4] impossible by definition. The second, or

[1] *The Oxford Dictionary, s.v.* "innovation".

[2] L. Thorndike, "Renaissance or Prenaissance", *Journal of the History of Ideas*, IV, 1943, p. 65 ff., particularly p. 74.

[3] G. Boas, "Historical Periods", *Journal of Aesthetics and Art Criticism*, XI, 1953, p. 248 ff., particularly pp. 253–254. The ellipses in my quotations stand, in the first sentence, for "aesthetic" before "problems"; in the second, for "the" before, and "of art" after, "history". But since the article, though pri-

marily addressing itself to aestheticians and art critics, discusses historical method in general, these two omissions would seem to be justified. A most instructive survey of the extraordinarily numerous systems of periodization proposed in the course of the centuries is found in J. N. J. van der Pot, *De Periodisering der geschiedenis; Een Overzicht der theorieën*, The Hague, 1951.

[4] *The Oxford Dictionary, s.v.* "history".

atomistic, argument—reducing "periods" to the "names of influential innovations", and the "names of influential innovations" to the achievements of "individuals"—confronts us with the question how the historian may be able to determine whether and when an innovation, let alone an influential one, has taken place.

An innovation—the "alteration of what is established"[1]—necessarily presupposes that which is established (whether we call it a tradition, a convention, a style, or a mode of thought) as a constant in relation to which the innovation is a variable. In order to decide whether or not an "individual's solution" represents an "innovation" we must accept the existence of this constant and attempt to define its direction. In order to decide whether or not the innovation is "influential" we must attempt to decide whether or not the direction of the constant has changed in response to the variable. And the trouble is that both the original direction of the constant and its subsequent deflection by an innovation—not difficult to detect as long as our interests do not reach farther than, as Aristotle would say, "the voice of a herald can be heard"—may take place within territorial and chronological boundaries limited only by the observability of cultural interaction (so that a history of Europe in the age of Louis XIV, though not a history of Europe in the age of the Crusades, would legitimately include what happened in America "at the same time").

If we are concerned with the history of book printing in Augsburg at the time of Emperor Maximilian, we shall find it easy to set down the invention of detachable flourishes as an "influential innovation" attributable to Jost de Negker—though even this very specific statement presupposes some investigation of the general state of affairs in Augsburg book printing before as well as after Jost de Negker's appearance on the local scene. And if we are concerned with the history of German music from *ca.* 1800 to *ca.* 1830, we may well decide to call this period the "Age of Beethoven"[2]—though, in order to justify this decision, we must be able to show that the works not only of Haydn, Mozart and Gluck but also of many other German composers now nearly forgotten have so many significant features in common that they may be considered as manifestations of an "established style"; that Beethoven introduced significant features absent from this established style; and that precisely these innovations came to be emulated by a majority of such composers as had occasion to become familiar with his works.

If, on the other hand, we are concerned with the history of Italian painting in the first quarter of the sixteenth century, we shall find it very hard to designate this period by proper names. Even were we to limit ourselves to the three great centers of Florence, Rome and Venice, Leonardo da Vinci, Raphael, Michelangelo, Giorgione, and Titian

[1] *Ibidem, s.v.* "innovation". [2] Boas, *op. cit.*, p. 254.

would have legitimate claims to recognition as godfathers, and we should have to contrast them with so many predecessors and followers—and, again, to point out so many characteristics in which the innovators differ from the predecessors but agree with the followers—that we might find it more convenient (and, given the existence of such marginal yet indispensable figures as Andrea del Sarto, Rosso Fiorentino, Pontormo, Sebastiano del Piombo, Dosso Dossi, or Correggio, more appropriate) to resort to generic terms and to distinguish between an "Early Renaissance" and a "High Renaissance" phase of Italian painting. And if we are concerned with the history of Western European art (or literature, or music, or religion) in its entirety, we cannot help widening—or, rather, lengthening—these generic terms into such notions as "Mycenean", "Hellenistic", "Carolingian", "Gothic"—and, ultimately, "classical", "mediaeval", "Renaissance", and "modern".

Needless to say, such "megaperiods"—as they may be called in contradistinction to the shorter ones—must not be erected into "explanatory principles"[1] or even hypostatized into quasi-metaphysical entities. Their characterization must be carefully qualified according to time and place and must be constantly redefined according to the progress of scholarship. We shall probably never agree—and, in fact, should not even try to agree in a number of cases—as to precisely when and where one period or "megaperiod" stopped and another started. In history as well as in physics time is a function of space,[2] and the very definition of a period as a phase marked by a "change of direction" implies continuity as well as dissociation. We should, moreover, not forget

[1] *Ibidem,* especially p. 248f. In this respect I completely agree with Professor Boas: he is both witty and right in maintaining that to explain what took place in the Colonial or Revolutionary periods of American history by a Colonial or Revolutionary "spirit" would be tantamount to the assertion that the behavior of a given person during his childhood, his youth and his maturity can be explained by the fact that "a spirit" of babyhood, youth and maturity "becomes incorporated" in the various phases of his activity. There is, however, a difference between the statement "cats are distinguished from dogs by embodying the spirit of cathood as opposed to that of doghood" and the statement "cats are distinguished from dogs by a combination of characteristics (such as the possession of retractable claws and only four upper and three lower molars, the inability to swim, the tendency to form attachments to localities rather than persons) which, in the aggregate, describe the genus Felis as opposed to the genus Canis". Should someone decide, for the sake of convenience, to designate the sum total of such characteristics as "cathood" and "doghood", he would do violence to the English language but not to method.

[2] For the world of history as a "spatio-temporal structure", where chronological systems are valid only within the framework of a given territory (this "territory", however, to be taken as a specific cultural environment rather than as a purely geographic area definable in terms of degrees of longitude and latitude) and where determinable temporal relations between two or more phenomena exist only in so far as a cultural interaction can be shown to take place between these phenomena, see E. Panofsky, "Ueber die Reihenfolge der vier Meister von Reims" (Appendix), *Jahrbuch für Kunstwissenschaft*, II, 1927, p. 77 ff.; *idem*, "The History of Art as a Humanistic Discipline", *The Meaning of the Humanities*, T. M. Greene, ed., Princeton, 1940, p. 89 ff., particularly p. 97 f. (now reprinted in *Meaning in the Visual Arts*, New York, 1955, p. 1 ff.. particularly p. 7 f.).

that such a change of direction may come about, not only through the impact of one revolutionary achievement which may transform certain aspects of cultural activity as suddenly and thoroughly as did, for example, the Copernican system in astronomy or the theory of relativity in physics but also through the cumulative and, therefore, gradual effect of such numerous and comparatively minor, yet influential, modifications as determined, for example, the evolution of the Gothic cathedral from Saint-Denis and Sens to Amiens. A change of direction may even result from negative rather than positive innovations: just as more and more people may accept and develop an idea or device previously unknown, so may more and more people cease to develop and ultimately abandon an idea or device previously familiar; one may cite, for example, the gradual disappearance of the Greek language, the drama and the perspective representation of space from the Western scene after the downfall of the Roman Empire, the gradual disappearance of the devil from the art of the seventeenth and eighteenth centuries, or the gradual disappearance of burin engraving from that of the nineteenth.

In spite of all this, however, a period—and this applies to "megaperiods" as well as to the shorter ones—may be said to possess a "physiognomy" no less definite, though no less difficult to describe in satisfactory manner, than a human individual. There can be legitimate disagreement as to when a human individual comes into being (at the moment of conception? with the first heartbeat? with the severance of the umbilical cord?); when he comes to an end (with the last breath? with the last pulse? with the cessation of metabolism? with the complete decomposition of the body?); when he begins to be a boy rather than an infant, an adult rather than a boy, an old man rather than an adult; how many of his characteristics he may owe to his father, his mother, his grandparents, or any of his ancestors. Yet, when we meet him at a given moment within a given group, we shall not fail to distinguish him from his companions; to put him down as young or old or middle-aged, tall or short, intelligent or stupid, jovial or saturnine; and ultimately to form an impression of his total and unique personality.[1]

[1] The above paragraphs had been written before the publication of P. O. Kristeller's valuable book *The Classics and Renaissance Thought*, published for Oberlin College by the Harvard University Press, Cambridge, Mass., 1955. I am happy to note that Kristeller's general view of the Renaissance, as set forth on p. 3f. of his book, agrees with mine not only as far as the chronological limits of the period are concerned but also in the view "that the so-called Renaissance period has a distinctive physiognomy of its own, and that the inability of historians to find a simple and satisfactory definition for it does not entitle us to doubt its existence; otherwise, by the same token, we should have to question the existence of the Middle Ages, or of the eighteenth century". See also below, p. 8.

II

THE chief target of what may be called, by way of returning a compliment, the "deperiodizers" is the Renaissance—which bears a French designation in English as well as in the Germanic languages because it was in France that the meaning of the word *renaissance* changed from the limited but unspecific (the revival of something at any given time) to the specific but comprehensive (the revival of everything in the particular period supposed to usher in the modern age).[1]

This period was confidently defined, as late as 1933, as "the great revival of arts and letters, under the influence of classical models, which began in Italy in the fourteenth century and continued during the fifteenth and sixteenth".[2] But there is no denying that it is particularly vulnerable to what may be called the "objection of indeterminacy" ("historians neither agree on what its essential character was nor even on when it began to show itself and when it stopped");[3] and during the last forty or fifty years the "Renaissance problem" has become one of the most hotly debated issues in modern historiography.[4]

[1] According to Huizinga ("Das Problem der Renaissance", *Wege der Kulturgeschichte*, Munich, 1930, p. 89 ff., particularly p. 101), the word "Renaissance" in this specific yet comprehensive sense seems to occur for the first time in Balzac's *Le Bal de Sceau* of 1829, where it serves to characterize the conversation of a charmingly spoilt *contessina* of nineteen: "Elle raisonnait facilement sur la peinture italienne ou flamande, sur le moyen-âge ou la renaissance". It would seem, then, that the term had gained currency in the intellectual circles and polite society of Paris some twenty-five years before it was sanctioned, so to speak, by Jules Michelet's *La Renaissance* of 1855, and some thirty years before it appeared on the title page of Jacob Burckhardt's *Die Kultur der Renaissance in Italien* of 1860.

[2] *The Oxford Dictionary*, s.v. "Renaissance". According to this source, the phrase "the period of the Renaissance" occurs in Ford's *Handbook of Spain*, 1845, and the phrase "the Renaissance period" in Ruskin's *Stones of Venice*, 1851. Only five years before Ford, however, Trollope still felt it necessary to add a somewhat apologetic explanation: "the style of the renaissance, as the French choose to call it" (*Summer in Brittany*, 1840).

[3] Boas, *op. cit.*, p. 249.

[4] It is therefore impossible to give an approximate idea of even the most recent and general discussions of the Renaissance problem. Suffice it, for the time being, to list, in addition to Huizinga's admirable article cited above, the following books and articles where further bibliographical references may be found: W. K. Ferguson, *The Renaissance in Historical Thought; Five Centuries of Interpretation*, Cambridge (Mass.), 1948 (cf. *idem*, "The Interpretation of the Renaissance, Suggestions for a Synthesis", *Journal of the History of Ideas*, XII, 1951, p. 483 ff.); H. Baeyens, *Begrip en probleem van de Renaissance; Bijdrage tot de geschiedenis van hun onstaan en tot hun kunsthistorische omschrijving*, Louvain, 1952 (cf. the interesting review by H. Baron in *Historische Zeitschrift*, CLXXXII, 1956, p. 115 ff.); "Symposium 'Tradition and Innovation in Fifteenth-Century Italy' ", *Journal of the History of Ideas*, IV, 1943, pp. 1–74 (with contributions by H. Baron, D. B. Durand, E. Cassirer, P. O. Kristeller, L. Thorndike, etc.); A. Renaudet, "Autour d'une Définition de l'humanisme", *Bibliothèque d'Humanisme et Renaissance*, VI, 1945, p. 7 ff.; *The Renaissance; A Symposium, February 8–10, 1952*, The Metropolitan Museum of Art, New York, 1952 (with contributions by R. H. Bainton, L. Bradner, W. K. Ferguson, R. S. López, E. Panofsky, G. Sarton); M. de Filippis, "The Renaissance Problem Again", *Italica*, XX, 1943, p. 65 ff.; K. M. Setton, "Some Recent Views of the Italian Renaissance", *Canadian Historical Association, Report of Annual Meeting*, Toronto, 1947, p. 5 ff.; H. S. Lucas, "The Renaissance, A Review of Some

5

It is no longer necessary to dwell on what may be called a "Renaissance Romanticism in reverse": that twentieth-century reaction against the glorification of the Renaissance which, based on nationalistic or religious prejudice, deplored the intrusion of Mediterranean *Diesseitigkeit* upon "Nordic" or Christian transcendentalism in much the same way as the humanists of old had deplored the overthrow of Greek and Roman culture by ecclesiastical bigotry or "Gothic" barbarism, and which occasionally extended its hostility to classical antiquity itself.[1] Nor shall we waste any time on those ludicrous racial theories which acclaim the work of Dante, Raphael and Michelangelo as a triumph of the German blood and spirit.[2] Suffice it to acknowledge the fact, established by many decades of serious and fruitful research, that the Renaissance was linked to the Middle Ages by a thousand ties; that the heritage of classical antiquity, even though the threads of tradition had become very thin at times, had never been lost beyond recuperation; and that there had been vigorous minor revivals before the "great

Views", *Catholic Historical Review*, XXXV, 1950, p. 377ff.; "Symposium 'Ursprünge und Anfänge der Renaissance'", *Kunstchronik*, VII, pp. 113–147; E. Garin, *Medioevo e rinascimento*, Bari, 1954, especially pp. 91–107; P. Renucci, *L'Aventure de l'humanisme européen au Moyen-Age (IV^e–XIV^e siècle)*, Paris, 1953 (with useful bibliography on pp. 197–231). P. O. Kristeller's extremely important studies concerning the Renaissance problem, published from 1936 to 1950 and recently printed together under the title *Studies in Renaissance Thought and Letters*, reached me too late to be referred to hereafter; but the new volume deserves to be mentioned not only because of its intrinsic value but also because of the excellent bibliography appended on pp. 591–628. Neither was I able to consider B. L. Ullman's *Studies in the Italian Renaissance*, Rome, 1955, the first chapter of which deals with the "Renaissance, the word and the underlying concept". For further references, cf. also the following note and p. 9, Note 1.

[1] For the nationalistic point of view in "Renaissance Romanticism in reverse", see, for example, J. Nordström, *Moyen-Age et Renaissance*, Paris, 1933; C. Neumann, "Ende des Mittelalters? Die Legende der Ablösung des Mittelalters durch die Renaissance", *Deutsche Vierteljahrsschrift für Literaturwissenschaft und Geistesgeschichte*, XII, 1934, p. 124ff.; W. Worringer, *Abstraktion und Einfühlung*, Munich, 1908; *idem*, *Formprobleme der Gotik*, Munich, 1910 (their and related views discussed by Ferguson, *The Renaissance*). To be added, as a characteristic curiosity, K. Scheffler, *Der Geist der Gotik*, Leipzig, 1925, which, on the strength of "by their fruits shall ye know

them", makes St. Peter's and, in the last analysis, the Pantheon, responsible for the Neo-Renaissance of the Victorian, Edwardian and Wilhelminian eras (without, however, blaming the results of the contemporary Gothic and Romanesque revivals on the Cathedrals of Speyer or Reims). For the Neo-Catholic point of view (likewise discussed by Ferguson), see, for example, J. Maritain, *Religion and Culture*, Essays in Order, London, 1931, No. 1, and *idem*, *True Humanism*, New York, 1938; C. Dawson, *Christianity and the New Age*, Essays in Order, London, 1931, No. 3. Even a scholar to whom the humanities owe so tremendous a debt of gratitude as E. Gilson comes dangerously close to Maritain's essentially anti-historical position when he writes: "La différence entre la Renaissance et le moyen âge n'est pas une différence par excès, mais par défaut. La Renaissance, telle qu'on nous la décrit, n'est pas le moyen âge plus l'homme, mais le moyen âge moins Dieu, et la tragédie, c'est qu'en perdant Dieu la Renaissance allait perdre l'homme lui-même". (*Les Idées et les lettres*, Paris, 1932, p. 192; English translation in Ferguson, p. 382). For a discussion of the common denominator between the Catholic and Protestant objections to the Renaissance, see H. Weisinger, "The Attack on the Renaissance in Theology Today", *Studies in the Renaissance* (Publications of the Renaissance Society of America), II, 1955, p. 176ff.

[2] For representatives of this trend (particularly H. S. Chamberlain and L. Woltmann), see Ferguson, *The Renaissance*, pp. 323ff.

revival" culminating in the Medicean age. It has been questioned whether the role of Italy in this "great revival" was really as important as claimed by the Italians themselves, and the contribution of the North has been stressed and analyzed not only with respect to sculpture and painting but also with respect to music and poetry. It has been debated whether the Renaissance includes or excludes the fourteenth century in Italy and the fifteenth in the Northern countries; and whether the seventeenth should be interpreted as its continuation or rather (as I am inclined to believe) as the beginning of a new, fourth era of history.

Of late, however, the discussion has taken a new turn. There is a growing tendency, not so much to revise as to eliminate the concept of the Renaissance—to contest not only its uniqueness but its very existence. "Whatever qualifications a larger survey might compel one to make", we read in the context of an excellent argument vitiated only by the silent assumption that "mediaeval" and "Christian" are necessarily the same—"they would not alter the main conclusion that the classical humanism of the Renaissance was fundamentally medieval and fundamentally Christian".[1] "This period [the Renaissance] is *only* the most famous and brilliant example of a cultural rebirth which coincides with and runs parallel to a revival of classical culture; but today it no longer needs to be proved that there has been a permanent tendency of revival throughout the last millennia of Western civilization".[2] "This much we must grant—the great Renaissance was not so unique or so decisive as has been supposed; the contrast of culture was not necessarily so sharp as it seemed to the humanists and their modern followers, while within the Middle Ages there were intellectual revivals ... which partook of the same character as the better-known movement of the fifteenth century".[3] And, finally: "There is no dividing line between 'medieval' and 'Renaissance' culture".[4]

We are confronted, then, with two preliminary questions which must be answered before we can attempt to discuss the questions of "where", "when" and "how". First, was there such a thing as a Renaissance which started in Italy in the first half of the

[1] D. Bush, *The Renaissance and English Humanism*, Toronto, 1939, p. 68.

[2] W. Jäger, *Humanism and Theology* (The Aquinas Lecture, 1943), Milwaukee, 1943, p. 23. In spite of his emphasis on the "only", the author is too good an historian to overlook the fact that the "rhythmical movement of the intellectual history of Europe" (p. 25) which produced a series of classical revivals throughout the postclassical era did not exclude a difference in principle between, for example, Erasmus' *philosophia Christi*—or, for that matter, Ficino's *theologia Platonica*—and Thomas Aquinas' *sacra doctrina*,

even though the humanists of the thirteenth century "would be astonished to see how 'mediaeval' they appear to us".

[3] C. H. Haskins, *The Renaissance of the Twelfth Century*, Cambridge (Mass.), 1927, p. 5. For a radicalization of Haskins' view to the point of considering the "Renaissance of the twelfth century" as the one and only one, see J. Boulenger, "Le vrai Siècle de la Renaissance", *Humanisme et Renaissance*, I, 1934, p. 9 ff.

[4] Thorndike, *op. cit.*, p. 70.

fourteenth century, extended its classicizing tendencies to the visual arts in the fifteenth, and subsequently left its imprint upon all cultural activities in the rest of Europe? Second, if the existence of such a Renaissance can be proved, what distinguishes it from those waves of revival which, as has been granted, occurred during the "Middle Ages"? Do all these revivals differ from one another only in scale or also in structure? In other words, is it still justifiable to single out the Renaissance with a capital *R* as a unique phenomenon in comparison with which the various mediaeval revivals would represent as many "renascences" with a small *r*?

III

Curiously enough, even those who refuse to recognize the Renaissance as a period *sui generis* and *sui iuris* tend to accept it as such wherever an occasion arises to disparage it (much as a government may vilify or threaten a regime to which it has refused recognition): "The Middle Ages loved variety; the Renaissance, uniformity".[1]

In extolling what they admire at the expense of what they have shown not to exist, the authors of statements like this unwittingly pay tribute to the very period the historicity of which they deny, and to the very humanists whose "disconcerting and annoying" ambitions[2] they strive to refute. In compelling the Renaissance-denying mediaevalists, like the rest of us, to speak and think of "their" period as the "Middle Ages", the Renaissance may be said to have taken its revenge on them: it is only on the assumption of an interval between a past supposed to have been submerged and a present supposed to have rescued this past from submersion, that such terms as *media aetas* or *medium aevum* could come into being.[3] And in addition to defining and naming what it believed to have left behind, this present conferred a style and title, so to speak, not only upon what it claimed to have achieved (*renaissance* in Pierre Belon's French, *rinascita* in Vasari's Italian, *Wiedererwachsung* in Dürer's German)[4] but also, and perhaps even more surprisingly, upon what it claimed to have restored: the world of the Antique, not designated (so far as I am aware) by a collective noun before, came to be known as *antiquitas, sancta vetustas, sacra vetustas,* even *sacrosancta vetustas.*[5]

[1] *Ibidem,* p. 71.

[2] W. J. Ong, "Renaissance Ideas and the American Catholic Mind", *Thought,* XXIX, 1954, p. 327ff.; the phrase referred to, p. 329.

[3] For the first occurrences of the terms *media tempora, media tempestas, media aetas* and, finally, *medium aevum* (about the middle of the fifteenth century), see G. S. Gordon, *Medium Aevum and the Middle Ages* (Society for Pure English, Tract No. XIX), Oxford, 1925; and, above all, P. Lehmann, "Mittelalter und

Küchenlatein", *Historische Zeitschrift,* CXXXVII, 1928, p. 197ff.

[4] For these occurrences, see below, pp. 17, 30, 38.

[5] For *antiquitas* in this specific sense, see especially the inscriptions left in the Roman catacombs by the "Sodalitas litteratorum sancti Victoris et sociorum" under Sixtus IV: VNANIMES ANTIQVITATIS AMATORES and VNANIMES PERSCRVTATO-RES ANTIQVITATIS (referred to in L. Pastor, *The History of the Popes from the Close of the Middle Ages,*

This memorable process of self-realization ("realization" in the double sense of "becoming aware" and "becoming real") has been described so often and so well that it would seem superfluous to summarize it once more were it not for the fact that the art historian, for whose benefit these notes are written, has a special stake in the matter. While the Renaissance produced his ancestors, the artistically-minded humanists and the humanistically-minded artists of the fourteenth, fifteenth and sixteenth centuries, these ancestors of his took an important part in shaping the concept of the Renaissance itself. And the specific significance and nature of their contribution deserves a brief re-examination.[1]

IV, F. A. Antrobus, ed., London, 1910, p. 63 f., and instructively commented upon in W. S. Heckscher, *Sixtus IIII Aeneas insignes statuas romano populo restituendas censuit* [inaugural address, Utrecht University], The Hague, 1955, p. 24 f.); cf. also M. F. Ferrarini, *Antiquitatis sacrarium*, Reggio Emilia, Bib. Com., MS. Regg. C398 (D. Fava, *Tesori delle Biblioteche d'Italia*, Emilia-Romagna, Milan, 1932, p. 380). For *sancta vetustas*, see, e.g., Fra Giocondo's letter to Lorenzo Medici quoted, e.g., in E. Garin, *Il Rinascimento italiano*, Milan, 1941, p. 51 ff. For *sacrosancta vetustas*, see, e.g., the title of Petrus Apianus' well-known *Inscriptiones sacrosanctae vetustatis*, Ingolstadt, 1534. Five years before, the biographer of Philip of Burgundy, Bishop of Utrecht, Gerard Geldenhauer of Nimwegen, referred to the very relics of classical antiquity as "sacred": "Nihil magis eum [Philip of Burgundy] Romae delectabat, quam *sacra illa vetustatis monumenta*, quae per clarissimum pictorem Ioanem Gossardum Malbodium depingenda sibi curavit" (Gerardus Noviomagus, *Vita clarissimi principis Philippi a Burgundia*, Strasbourg, 1529, frequently adduced in discussions of Jan Gossart, e.g., E. W. Weisz, *Jan Gossart gen. Mabuse*, Parchim, 1913, p. 4).

[1] Here again only a small selection (in addition to the titles mentioned p. 5, Note 4) can be given: L. Varga, *Das Schlagwort vom finsteren Mittelalter*, Vienna and Leipzig, 1932; G. Falco, *La Polemica sul Medio Evo*, I, Turin, 1933; G. Toffanin, *Storia dell'umanesimo*, 2nd ed., Naples, 1952 [English translation: *History of Humanism*, New York, 1955]; F. Simone, "La Coscienza della Rinascita negli humanisti", *La Rinascita*, II, 1939, p. 838 ff. (hereafter cited as "Simone I"); III, 1940, p. 163 ff. (hereafter cited as "Simone II"); *idem*, "La Coscienza della Rinascita negli scrittori francesi della prima metà del Cinquecento", *La Rinascita*, VI, 1943, p. 143 ff. (hereafter cited as "Simone III"); W. K. Ferguson, "Humanist Views of the Renaissance", *American Historical Review*, XLV, 1939, p. 5 ff.; T. E. Mommsen, "Petrarch's Concept of the Dark Ages", *Speculum*, XVII, 1942, p. 226 ff.; H. Weisinger, "The Self-Awareness of the Renaissance as a Criterion of the Renaissance", *Papers of the Michigan Academy of Science, Arts and Literature*, XIX, 1944, p. 661 ff.; *idem*, "The Renaissance Theory of the Reaction against the Middle Ages as a Cause of the Renaissance", *Speculum*, XX, 1945, p. 461 ff.; *idem*, "Ideas of History during the Renaissance"; *Journal of the History of Ideas*, VI, 1945, p. 415 ff.; *idem*, "Renaissance Theories of the Revival of the Fine Arts", *Italica*, XX, 1943, p. 163 ff.

For the subject of the last-named article, see, particularly, the still fundamental contributions of Julius von Schlosser: "Lorenzo Ghibertis Denkwürdigkeiten, Prolegomena zu einer künftigen Ausgabe", *Jahrbuch der K. K. Zentralkommission für Kunst- und historische Denkmalpflege*, IV, 1910, especially pp. 1–7 ff. (also published in book form, Vienna, 1910); *idem*, *Lorenzo Ghibertis Denkwürdigkeiten*, Berlin, 1912; *idem*, *Die Kunstliteratur*, Vienna, 1924 (revised Italian translation, *La Letteratura artistica*, Florence, 1935), pp. 83–183; *idem*, "Zur Geschichte der Kunsthistoriographie; Gotik", *Präludien*, Berlin, 1927, p. 270 ff. Further: J. Huizinga, "Renaissance und Realismus", *Wege der Kulturgeschichte*, Munich, 1930, p. 140 ff. Also: R. Krautheimer, "Die Anfänge der Kunstgeschichtsschreibung in Italien", *Repertorium für Kunstwissenschaft*, L, 1929, p. 49 ff.; A. Haseloff, "Begriff und Wesen der Renaissancekunst", *Mitteilungen des kunsthistorischen Institutes in Florenz*, II, 1931, p. 373 ff.; R. Kaufmann, *Der Renaissancebegriff in der deutschen Kunstgeschichtsschreibung*, Winterthur, 1932; H. Kauffmann, "Ueber 'rinascere', 'Rinascita', und einige Stilmerkmale der Quattrocentobaukunst", *Concordia Decennalis, Deutsche Italienforschungen*, Cologne, 1941, p. 123 ff.; W. Paatz, "Renaissance oder Renovatio", *Beiträge zur Kunst des Mittelalters (Vorträge der ersten*

As everyone knows, and as was recognized by his very contemporaries, the basic idea of a "revival under the influence of classical models" was conceived and formulated by Petrarch. Moved "beyond words" by the impression of the ruins of Rome and acutely aware of the contrast between a past the grandeur of which shone from the remnants of its art and literature as well as from the living memory of its institutions and a "deplorable" present that filled him with sorrow, indignation and contempt, he evolved a novel version of history. Where all the Christian thinkers before him had thought of it as a continuous development, beginning with the creation of the world and leading up to the writer's own lifetime, he saw it sharply divided into two periods, the classical and the "recent", the former comprising the *historiae antiquae*, the latter the *historiae novae*. And where his forerunners had conceived of that continuous development as a steady progress from heathen darkness to the light that was Christ (whether His birth was held to mark the last of Daniel's "Four Monarchies", or the last of the "Six Ages" corresponding to the six days of Creation, or the last of the "Three Eras", the first before the Law, the second under the Law, the third under Grace), Petrarch interpreted the period in which the "name of Christ began to be celebrated in Rome and to be adored by the Roman emperors" as the beginning of a "dark" age of decay and obscuration, and the preceding period—for him simply the period of royal, republican and imperial Rome—as an age of glory and light. He had been born too soon, he felt, to see the new day which he felt was dawning; "for you, however", he addresses his famous poem, the *Africa*, composed in 1338, one year after his first visit to Rome, "for you, if you should long outlive me, as my soul hopes and wishes, there is perhaps a better age in store; this slumber of forgetfulness will not last forever. After the darkness has been dispelled, our grandsons will be able to walk back into the pure radiance of the past".[1]

Petrarch was too good a Christian not to realize, at certain moments at least, that this conception of classical antiquity as an age of "pure radiance" and of the era beginning with the conversion of Constantine as an age of gloomy ignorance amounted to a complete reversal of accepted values. But he was too deeply convinced of the fact that "history was nothing but the praise of Rome" to abandon his vision. And in transferring to the state of intellectual culture precisely those terms which the theo-

deutschen Kunsthistorikertagung auf Schloss Brühl, 1948), Berlin, 1950, p. 16 ff.; idem, *Die Kunst der Renaissance in Italien*, Stuttgart, 1953, pp. 11–20; E. van den Grinten, *Inquiries into the History of Art-Historical Writing*, Venlo, n.d. [1953], pp. 18–39; A. Chastel, *Marsile Ficin et l'art*, Geneva and Lille, 1954, especially p. 180 ff.
[1] Petrarch, *Africa*, IX, line 453 ff., reprinted in

Mommsen's "Petrarch's Concept of the Dark Ages", on which our discussion of Petrarch is based, p. 240:

"At tibi fortassis, si—quod mens sperat et optat—
Es post me victura diu, meliora supersunt
Secula: non omnes veniet Letheus in annos
Iste sopor! Poterunt discussis forte tenebris
Ad purum priscumque iubar remeare nepotes".

logians, the Church Fathers and Holy Writ itself had applied to the state of the soul (*lux* and *sol* as opposed to *nox* and *tenebrae*, "wakefulness" as opposed to "slumber", "seeing" as opposed to "blindness"), and then maintaining that the Roman pagans had been in the light whereas the Christians had walked in darkness, he revolutionized the interpretation of history no less radically than Copernicus, two hundred years later, was to revolutionize the interpretation of the physical universe.

Petrarch looked upon culture in general, and classical culture in particular, through the eyes of the patriot, the scholar and the poet. Even the ruins of Rome failed to evoke in him what we would call an "aesthetic" response. In spite of his personal admiration for the great painters of his time, he may be said, not too unjustly, to have conceived of the new era for which he hoped largely in terms of a political regeneration and, above all, of "a purification of Latin diction and grammar, a revival of Greek and a return from medieval compilers, commentators and originators to the old classical texts".[1]

This narrow definition of the Renaissance did not, however, prevail among Petrarch's heirs and successors. By 1500 the concept of the great revival had come to include nearly all fields of cultural endeavor; and this broadening of its significance set in, under Petrarch's own eyes, with the inclusion of the visual arts, beginning with painting.

The notion, condensed in Horace's *ut pictura poesis*, that an analogy, even a natural affinity, exists between poetry and painting[2] is very old and had been kept in the public mind by the recurrent debate about the admissibility or non-admissibility of sacred images. At the beginning of the Trecento, however, this notion was concretized and, as it were, charged with topical significance by Dante's famous lines about the transitoriness of human fame. These lines, it will be remembered, are spoken by an illuminator, Oderisi of Gubbio, whom the poet encounters in the first circle of Purgatory, where the souls are purged of pride. When Dante greets Oderisi as "the glory" of his home town and his profession, the latter—frankly admitting that he would not have been so modest during his lifetime—declines the compliment with the remark that another illuminator, Franco of Bologna, was better than he had been and then goes on to say:

> "O vain renown of human enterprise,
> Not lasting longer than the green on trees
> Unless succeeded by an uncouth age!
> In painting Cimabue thought to hold
> The field; now Giotto is acclaimed by all
> So that he has obscured the former's fame.

[1] Thorndike, *op. cit.*, p. 68.
[2] See the brilliant article by R. W. Lee, "*Ut Pictura* *Poesis*: The Humanistic Theory of Painting", *Art Bulletin*, XXII, 1940, p. 197 ff.

Thus has one Guido taken from the other
The prize of language; and there may be born
One who will chase them both from where they nest".[1]

In paralleling the relation between two well-known poets, a formerly famous but now outmoded older Guido (presumably Guido Guinicelli) and a now famous younger Guido (presumably Guido Cavalcanti), with the relation between two well-known painters, Cimabue and Giotto, this passage lent both authority and actuality to the old idea that poetry and painting are sister arts. And in evoking, in this context, the specter of an "uncouth age" (*etati grosse*), it was apt to suggest an oscillation between refined and crude, productive and unproductive, phases of cultural history; such, at least, was the interpretation of Oderisi's remarks provided by Benvenuto da Imola: "If, in the course of time there had been several Virgils, writing equally well about the same or similar subjects, his fame would not have maintained its exalted position for so many centuries".[2]

For a reader conversant with Petrarch's concept of history it was almost inevitable to equate the period of stagnation or decay, implied but naturally not as yet specified in Oderisi's speech, with Petrarch's *tenebrae* and thus to acclaim Giotto, mentioned by name as the supplanter of Cimabue, as the reformer of painting after the "dark ages". To take this step—not contemplated by Petrarch himself, whose personal sympathies would seem to have belonged to the "transcendentalist" Simone Martini rather than Giotto[3]—was left to Giovanni Boccaccio, Petrarch's devoted disciple and, at the same time, a professional interpreter of Dante. "The genius of Giotto", Boccaccio says, "was of such excellence that there was nothing [produced] by nature, the mother and operator of all things, in the course of the perpetual revolution of the heavens, which he did not depict by means of stylus, pen or brush with such truthfulness that the result seemed to be not so much similar to one of her works as a work of her own. Wherefore the human sense of sight was often deceived by his works and took for real what was

[1] Dante, *Purgatorio*, XI, verses 91–99:

"O vana gloria delle umane posse,
 Com' poco verde in sulla cima dura,
 Se non è giunta dall'etati grosse!
Credette Cimabue nella pintura
 Tener lo campo, ed ora ha Giotto il grido,
 Sì che la fama di colui oscura.
Così ha tolto l'uno all'altro Guido
 La gloria della lingua; e forse è nato
 Chi l'uno e l'altro caccerà di nido".

[2] *Benevenuti de Rambaldis de Imola Comentum super Dantis Aldigherij Comoediam*, J. P. Lacaita, ed., Florence, 1887, Vol. III, p. 312: "quia si coniungeretur subtilibus, non duraret; verbi gratia, si fuissent plures

tempore Virgilii, qui scripsissent de eadem materia vel simili eo, vel aeque bene, fama eius non durasset jam per tot secula in alto apice". Benvenuto's *Commentary*, already referring to Petrarch and Boccaccio, was written about 1376, not (as is occasionally asserted) as early as about 1350.

[3] See Petrarch's famous lines in Sonnet LVII:

"Ma certo il mio Simon fù in paradiso,
Onde questa gentil Donna si parte;
Ivi la vide e la ridusse in carte
Per far fede quaggiù del suo bel viso".

For Petrarch's observations on Giotto, see below, p. 13, Note 2.

only painted. Thus he restored to light this art which for many centuries had been buried under the errors of some (*alcuni*) who painted in order to please the eyes of the ignorant rather than satisfy the intelligence of the experts, and he may rightly be called one of the lights in the glory of Florence".[1]

Here, then, Giotto is represented not only as a man whose fame had obscured that of an older confrère but as the man who had brought the art of painting back from its grave after so many centuries; and this he is said to have achieved by dint of a radical naturalism—so radical that it not only deceived the eyes of many trained observers but also shocked the taste of the general public. Boccaccio's very praise implies that Giotto was criticized by the "ignorant" among his contemporaries; and from other sources we may infer that he was criticized by the sophisticated among a younger generation.[2]

Thus the same Boccaccio who made it axiomatic that his "famous teacher", Petrarch, had "reinstated Apollo in his ancient sanctuary", had "reinvested the muses, soiled by rusticity, with their ancient beauty", and had "rededicated to the Romans the

[1] Boccaccio, *Decameron*, VI, 5: "[Giotto] ebbe uno ingegno di tanta eccellenzia, che ni una cosa dà la natura, madre di tutte le cose et operatrice, col continuo girar de' cieli, che egli con lo stile e con la penna o col pennello non dipignesse si simile a quella, che non simile, anzi più tosto [*generata* or *prodotta*] dessa paresse, in tanto che molte volte nelle cose da lui fatte si truova che il visivo senso degli uomini vi prese errore, quello credendo esser vero che era dipinto. E per cio, avendo egli quella arte ritornata in luce, che molti secoli sotto gli error d'alcuni, che più a dilettar gli occhi degl'ignoranti che a compiacere allo 'ntelletto de savj dipignendo, era stata sepulta, meritamente una delle luci della fiorentina gloria dir si puote ..."

[2] The criticism implied by Boccaccio is echoed in Petrarch's last will and testament, dated 1370, where he bequeathes to his princely patron, Francesco da Carrara, a *Madonna* by Giotto, "cuius pulchritudinem ignorantes non intelligunt, magistri autem artis stupent" (*Opera*, Basel, 1581, p. 117; see now *Petrarch's Testament*, T. E. Mommsen, tr. and ed., Ithaca, N. Y., 1957, pp. 22 ff., 78 f.). Benvenuto da Imola, *loc. cit.*, qualifies Boccaccio's praise, which he quotes verbatim, by adding that Giotto "adhuc tenet campum, quia nondum venit alius eo subtilior, cum tamen fecerit aliquando magnos errores in picturis suis, ut audivi a magnis ingeniis" (cf. M. Meiss, *Painting in Florence and Siena after the Black Death*, Princeton, 1951, p. 4 ff.). A new wave of admiration for Giotto, however, can be observed, characteristi-

cally, in Padua, the scene of Altichiero's activity in the last quarter of the fourteenth century. In a letter of 1396, brought to my attention by the late Theodor Mommsen, Pier Paolo Vergerio expresses himself as follows: "Fatendum est igitur, quod etatis nostre pictores, qui, cum ceterorum claras imagines sedulo spectent, solius tamen Ioti exemplaria sequuntur" (*Epistolario di Pier Paolo Vergerio*, L. Smith, ed., Rome, 1934, p. 177). Further references of Petrarch to Giotto (for which I am also indebted to Theodor Mommsen) are found in Petrarch's *Itinerarium Syriacum* (*Opera*, I, p. 560), where he refers to him as "conterraneus olim meus pictor, nostri aevi princeps", and in a letter of 1342–43 (*Le Familiari*, V. Rossi, ed., Rome, 1934, II, p. 39), where he quotes Giotto as a modern parallel to several ancient sculptors and painters distinguished by genius but not by good looks: "Atque ut a veteribus ad nova, ab externis ad nostra transgrediar, duos ego novi pictores egregios nec formosos: Iottum, Florentinum quidem, cuius inter modernos fama ingens est, et Simonem Senensem". Giotto's ugliness was proverbial; it is emphasized in Boccaccio's novel (see above, Note 1) as well as in the Dante commentary by Stefano Talice da Ricaldone (V. Promis and C. Negroni, eds., 2nd ed., Milan, 1888, Vol. II, p. 144: "Et fuit iste Giottus turpissimus homo, & turpiores filios habebat") and was referred to by Vasari in a particularly remarkable context (see below, p. 20).

13

Capitol not venerated for a thousand years",[1] established the doctrine that Giotto—like Socrates a great man in spite of his extraordinary ugliness[2]—had revived the dead and "buried" art of painting. This doctrine, too, was unanimously accepted. The beginning of Politian's epitaph on Giotto still reads like an abridged translation of Boccaccio's praise ("Ille ego sum per quem pictura extincta revixit"),[3] and Giotto's reputation as the great reformer of painting spread abroad so far and so fast that a German Benedictine of the early sixteenth century, summarizing the history of painting for the benefit of a nun engaged in book illumination, could credit a "Master Zetus" (obviously a corruption of "Zotus", in turn due to a misreading of Joctus or Jottus) with having "restored the art of painting to the dignity of the ancients".[4]

The only detail that had to be entered into the picture drawn by Boccaccio was the figure of Cimabue in its relation to that of Giotto. For Boccaccio, Cimabue did not exist, and the earlier Dante commentators restricted his role to that suggested by the basic text: he was a good painter, unluckily surpassed by a better one, who either gracefully acquiesced in his fate and even befriended the rising young genius, or arrogantly discarded every work which had met with criticism.[5] But in the wider perspective of a later generation, looking upon Giotto as an ancestor rather than a father, the distance between him and Cimabue seemed to diminish: instead of being dismissed as an artist obscured—or, with Boccaccio, entirely obliterated—by a great innovator, Cimabue came to be thought of as a precursor, paving the way for the great innovator's achievement: "Johannes, surnamed Cimabue", says Filippo Villani, writing just about 1400, "was the first who by his art and genius (arte et ingenio) began to call back to verisimilitude the antiquated art of painting that, owing to the painters' ignorance, had become dissolute and wayward, as it were, and had childishly strayed from reality... After him,

[1] Boccaccio, Lettere edite ed inedite, F. Corazzini, ed., Florence, 1877, p. 189 ff. (see "Simone I", p. 848); a translation is found in J. B. Ross and M. M. McLaughlin, Portable Renaissance Reader, New York, 1953, p. 123 ff.

[2] See p. 13, Note 2.

[3] See F. A. Gragg, Latin Writings of the Italian Humanists, New York, etc., 1927, p. 207. Another line of Politian's epitaph is interesting because of the use of the word modulus for "design" or "model":

"Mirares turrem egregio sacro aere sonantem;
Haec quoque de modulo crevit ad astra meo".

[4] Johannes Butzbach, Libellus de praeclaris picturae professoribus, ca. 1505; cf. Schlosser, Die Kunstliteratur, p. 180 ff.

[5] For the former interpretation (culminating in the famous story, first told by Ghiberti, of how the little Giotto, sitting on the ground and drawing a sheep upon a slate, was "discovered" and taken under his wing by Cimabue), see, e.g., Commento alla Divina Commedia d'Anonimo Fiorentino del secolo XIV, Pietro Fanfani, ed., Bologna, 1868, Vol. II, p. 187 (cf. E. Kris and O. Kurz, Die Legende vom Künstler, Vienna, 1934, p. 33 ff.); for the latter, L'Ottimo Commento della Divina Commedia, Testo inedito d'un contemporaneo di Dante citato dagli Accademici della Crusca, Pisa, 1828, II, p. 188: "Fu Cimabue ... sì arrogante, e sì sdegnoso, che se per alcuno gli fosse a sua opera posto alcuno difetto, o egli da sè l'avesse veduto (chè, come accade alcuna volta, l'artifice pecca per difetto della materia in ch'adopera, o per mancamento che è nello strumento, con che lavora), immantenente quella cosa disertava, fosse cara quanto si volesse". See also J. Schlosser, "Zur Geschichte der Kunsthistoriographie; Die florentinische Künstleranekdote", Präludien, p. 248 ff.

with the road to new things already paved, Giotto—not only comparable to the classical painters in fame but even superior to them in art and genius—restored painting to its pristine dignity and great renown".[1] Thus Cimabue was transferred to a penumbral region between the night of the "dark ages" and the new day said to have dawned with Giotto; and there he remained—after a futile attempt to relegate him to the realm of mere legend—ever after, an embarrassment to Vasari and a problem to the art historians of our day.[2]

To claim that it was Boccaccio who, in applying Petrarch's theory of history to Dante's reference to Giotto, revitalized the notion that painting developed *pari passu* with literature and thereby extended the concept of the great revival from the realm of the spoken and written word to that of visual experience might seem extravagant. But it is hardly an accident that Aeneas Sylvius Piccolomini, when stating this very notion *expressis verbis* nearly a century later, still did so by exploiting Boccaccio's parallel between the latter's "famous teacher", Petrarch, and Giotto: "These arts [eloquence and painting]", he says, "love one another with mutual affection. A mental gift (*ingenium*), and not a low but a high or supreme one, is required by eloquence as well

[1] Filippo Villani, *De origine civitatis Florentiae et eiusdem famosis civibus* is still most easily accessible in J. von Schlosser, *Quellenbuch zur Kunstgeschichte des abendländischen Mittelalters (Quellenschriften für Kunstgeschichte,* New Ser., VII), Vienna, 1896, p. 370 ff.; cf. *idem,* "Zur Geschichte der Kunsthistoriographie; Filippo Villanis Kapitel über die Kunst in Florenz", *Präludien,* p. 261 ff. For an Italian translation by Giammaria Mazzucchelli, see Weisinger, "Renaissance Theories of the Revival of the Fine Arts", p. 163: "Inter quos primus *Johannes,* cui cognomento Cimabue nomen fuit, antiquatam picturam et a nature similitudine pictorum inscicia pueriliter discrepantem cepit ad nature similitudinem quasi lascivam et vagantem longius arte et ingenio revocare. Constat siquidem ante hunc *Grecam Latinamque* picturam per multa secula sub crasse [in]peritie ministerio iacuisse, ut plane ostendunt figure et ymagines que in tabulis atque parietibus cernuntur sanctorum ecclesias adornare.

Post hunc stracta [should read *strata*] iam in novibus [should read *novis*] via *Giottus,* non solum illustris fame decore antiquis pictoribus conparandus sed arte et ingenio preferendus, in pristinam dignitatem nomenque maximum picturam restituit". Christoforo Landino, commenting on the famous Dante passage about 1480 (*Dante con l'espositione di Christoforo Landino et di Alessandro Vellutello,* in the Venice edition of 1564, p. 203 v.), writes in a similar vein: "Cimabue, costui essendo la pittura in oscurità,

la ridusse in buona fama. Giotto diuenne maggiore, piu nobil maestro di Cimabue". The Preface of Landino's Dante commentary includes a general and very important discussion of the development of painting and sculpture in Florence (cf. Schlosser, *Die Kunstliteratur,* p. 92; Krautheimer, "Die Anfänge der Kunstgeschichtsschreibung in Italien") which has recently been reprinted and commented upon by O. Morisani, "Art Historians and Art Critics, III; Christoforo Landino", *Burlington Magazine,* XCV, 1953, p. 267 ff. A French translation is found in Chastel, *op. cit.,* p. 193 ff. For a kind of continuation of Villani's list of artists, see P. Murray, "Art Historians and Art Critics, IV; *XIV Uomini Singhularii in Firenze*", *Burlington Magazine,* XCIX, 1957, p. 330 ff., announcing the author's forthcoming monograph on "early Italian sources".

[2] For Cimabue's controversial place in earlier historiography, cf., apart from Schlosser, *Die Kunstliteratur,* p. 39 f., E. Benkard, *Das literarische Porträt des Giovanni Cimabue,* Munich, 1917; E. Panofsky, "Das erste Blatt aus dem 'Libro' Giorgio Vasaris; Eine Studie über die Beurteilung der Gotik in der italienischen Renaissance mit einem Exkurs über zwei Fassadenprojekte Domenico Beccafumis", *Städel-Jahrbuch,* VI, 1930, p. 25 ff. (English translation in *Meaning in the Visual Arts,* p. 169 ff.). For his appreciation in more recent literature, see R. Oertel, *Die Frühzeit der italienischen Malerei,* Stuttgart, 1953, pp. 44–54.

as painting. Wonderful to tell, as long as eloquence flourished, painting flourished, as can be learned from the times of Demosthenes and Cicero. When the former revived, the latter also raised its head. Pictures produced two hundred years ago were not refined, as we can see, by any art; what was written at that time is [equally] crude, inept, unpolished. After Petrarch, letters re-emerged; after Giotto, the hands of the painters were raised once more. Now we can see that both these arts have reached perfection".[1]

Lorenzo Valla, extending the analogy from painting to sculpture and architecture and thereby completing the triad still known to us as the "fine arts",[2] welcomed this triad if not into the sanctuary at least at the threshold of the temple of the *artes liberales:* "I do not know why the arts most closely approaching the liberal arts—painting, sculpture in stone and bronze, and architecture—had been in so long and so deep a decline and almost died out together with literature itself; nor why they have come to be aroused and come to life again in this age; nor why there is now such a rich harvest both of good artists and good writers".[3]

[1] Aeneas Sylvius Piccolomini, *Opera*, Basel, 1571, p. 646, No. CXIX, reprinted in Garin, *Il Rinascimento italiano*, p. 94: "Amant se artes hae [eloquentia et pictura] ad invicem. Ingenium pictura expetit, ingenium eloquentia cupit non vulgare, sed altum et summum. Mirabile dictu est, dum viguit eloquentia, viguit pictura, sicut Demosthenis et Ciceronis tempora docent. Postquam cecidit facundia, iacuit et pictura. Cum illa revixit, haec quoque caput extulit. Videmus picturas ducentorum annorum nulla prorsus arte politas. Scripta illius aetatis rudia erant, inepta, incompta. Post Petrarcham emerserunt litterae; post Iotum surrexere pictorum manus; utramque ad summam iam videmus artem pervenisse". For a more critical attitude toward Petrarch, see T. E. Mommsen, "Rudolf Agricola's Life of Petrarch", *Traditio*, VIII, 1952, p. 367 ff.

[2] Cf. below, p. 18 ff. For the problem in general, see P. O. Kristeller, "The Modern System of the Arts", *Journal of the History of Ideas*, XII, 1951, p. 496 ff.; XIII, 1952, p. 17 ff.

[3] Lorenzo Valla, *Elegantiae linguae latinae* (written between 1435 and 1444), Preface, in the Lyons edition of 1548, p. 9 (cf. Weisinger, "Renaissance Theories of the Revival of the Fine Arts", p. 164; Ferguson, *The Renaissance*, p. 28): "[Nescio] cur illae artes quae proximae ad liberales accedunt, Pingendi, Scalpendi, Fingendi, Architectandi, aut tandiu tantoque opere degenerauerint, ac pene cum litteris ipsi demortuae fuerint, aut hoc tempore excitentur,

ac reuiuiscant ..." (how popular the notion of this parallelism had become in Italy by the middle of the fifteenth century is also evident from the Filarete passage quoted below, p. 22). It should be noted that Valla recognizes the visual arts as approximations to the *artes liberales* but does not as yet admit them to their number as had been the ambition of their practitioners from the beginning of the century (cf., apart from the well-known passage of Cennino Cennini, Filippo Villani, *loc. cit.*: "Many believe, and not unreasonably, that painters are not inferior with respect to gifts [*ingenium*] to those on whom the rank of master is conferred by the *artes liberales*, since the latter apprehend the preceptes of their art, transmitted in writing, by study and learning while the former obtain what they know in their art only from their high gifts and their tenacious memory"). This tolerant yet somewhat snobbish point of view remained prevalent among humanists for a very long time. Giglio Gregorio Giraldi, quoted in Weisinger, *ibidem*, p. 164 f., expresses himself as follows: "Videtis enim nostram hanc aetatem non senio languidam atque defectam, ut ingrati quidam deflent, cum in omni poetica et dicendi arte viros excellentes protulisse tum in reliquis bonis artibus; nam, ut liberales mittam, res militaris, architectonica, pictura, sculptura, reliquae nostro hoc tempore ita florent vigentque, ut non modo aemulari antiquitatem dici possint nostri opifices, sed etiam multa antiquis intenta effingere et conformare ..."

Vespasiano da Bisticci and Marsilio Ficino—the latter adding grammar and music to eloquence and the fine arts—hailed the revival of culture in a similar vein. Even Erasmus of Rotterdam, though normally interested only in that which can be expressed by words rather than that which speaks to the eye, rejoiced, in a letter written about 1489, in the new flowering of sculpture in metal and stone, painting, architecture, and all kinds of craftsmanship as a concomitant to that of "eloquence".[1] In the end, the territory whose conquest was glorified in the humanistic paeans of triumph came to include the natural sciences in addition to the "humanities" and the arts. "All the good disciplines have been welcomed home from exile by the special grace of the gods", wrote Rabelais in 1532 with special reference to medicine.[2] Pierre de Ramée (Petrus Ramus) rejoiced in the fact that doctors could now read Galen and Hippocrates rather than the Arabs, and the philosophers Aristotle and Plato rather than the Scotists and the followers of Petrus Hispanus.[3] Pierre Belon, principally a naturalist though keenly interested in classical antiquity, extolled the "eureuse et desirable renaissance" of "toutes especes de bonnes disciplines".[4] And a German mathematician, Johannes

[1] For Vespasiano da Bisticci ("In painting, sculpture and architecture we find art on its highest level"), see Weisinger, *ibidem*, p. 165, Note 1; for Ficino, Ferguson, *ibidem*, p. 28; for Erasmus (Letter to Cornelius Gerard, probably written in June, 1489), "Simone I", p. 857; Ferguson, *ibidem*, p. 43; Weisinger, *ibidem*, p. 164: "At nunc, si vltra tercentum aut ducentos annos caelaturas, picturas, sculpturas, aedificia, fabricas et omnium denique officiorum monimenta inspicias, puto et admiraberis et ridebis nimiam artificum rusticitatem, cum nostro rursus aeuo nihil sit artis quod non opificum effinxerit industria. Haud aliter quoque priscis saeculis cum omnium artium, tum praecipue eloquentiae studia apprime floruisse constat ..." Ferguson is certainly right in assuming that this particular reference to the "fine arts" was inspired by Valla. It is significant that in a letter written some thirty years later (addressed to Boniface Amerbach and dated August 31, 1518, *Opus Epistolarum Des. Erasmi Roterodami*, P. S. Allen, ed., III, Oxford, 1913, p. 383 ff.) Erasmus limits the efflorescence of studies "buried for so many centuries" to grammar, eloquence, medicine and law, looking at the latter two disciplines from the point of view of style rather than content, and omits the visual arts altogether. In fact, I am inclined to believe that the very date which he assigns to the inception of this efflorescence in his letter to Gerard ("plus minus octoginta" before the time of his writing, that is to say, about 1439) was prompted by his admiration for Lorenzo Valla, whose *Elegantiarum Latinae linguae libri IV* was composed between 1435 and 1444, while his exposure of the "Constantinian Donation", one of the early triumphs of classical philology, was published in 1440.

[2] Rabelais, Letter to André Tiraqueau: "In hoc tanta saeculi nostri luce, quo disciplinas meliores singulari quodam deorum munere postliminio receptas videmus ... ("Simone II", p. 170f.).

[3] See Thorndike, *op. cit.*, p. 68.

[4] Pierre Belon, Dedicatory Epistle of *Observation de plusieurs singularitez et choses memorables, trouvées en Grece, Asie, Iudée, Egypte, Arabe, & autres pays estranges*, Paris, 1553 (here quoted after Thorndike, *op. cit.*, p. 68): "De la est ensuivy que les esprits des hommes qui auparavant estoyent comme endormis et detenuz assopiz en un profond sommeil d'ancienne ignorance ont commencé à s'eveiller et sortir des tenebres ou si long temps estoyent demeurez ensueliz et en sortant ont iecté hors et tiré en evidence toutes especes de bonnes disciplines lesquelles à leur tant eureuse et desirable renaissance, tout ainsi que les nouvelles plantes apres saison de l'hyver reprennent leur vigeur à la chaleur du Soleil et sont consolées de la doulceur du printemps". Of other publications by Pierre Belon (1517–1564) there may be mentioned *De aquatilibus ...*; *De arboribus coniferis, resiniferis ...* (both Paris, 1553); *Histoire de la nature des estranges poissons marins* (Paris, 1551).

Werner, voiced his delight in the new ideas and problems—particularly the conic sections—which had "recently migrated from Greece to the Latin geometricians of our age".[1]

IV

THIS gradual expansion of the humanistic universe from literature to painting, from painting to the other arts, and from the other arts to the natural sciences produced a significant shift in the original interpretation of the process variously designated as "revival", "restoration", "reawakening", "resurrection", or "rebirth".

When Petrarch exclaimed, "Who doubts that Rome could rise up again were she only to know herself",[2] and, in a more general way, hoped that the future would be able to "walk back into the pure radiance of the past", he indubitably conceived of this new efflorescence as a return to classical—in his opinion, Roman—antiquity. This point of view prevailed, by and large, among all those whose attention was focused on the "revival" of literature and learning, philosophical thought and political ideas. Such dedicated humanists as Niccolo Niccoli or Leonardo Bruni went so far as to look down on all vernacular poetry, including the sacred Dante and the even more sacred Petrarch—though we must not forget that their very extremism served to make others all the more keenly aware of the possibilities inherent in their native tongues.[3] Vernacular poetry reached a new height not so much in spite as because of the fact that it was challenged by Neo-Latin classicism, and an overly vigorous reaction against this challenge produced a kind of nationalistic purism in even the most ardent admirers of classicial antiquity. It was in a translation of Hesiod that Antoine de Baïf flaunted that queer phonetic spelling intended to emphasize the independence of the French language and rendered the name Pandora ("gift of all") as "Toutedon"; it was in direct contact with Apollonius and Sporus that Dürer concocted such names as "Eier-linie" (egg line) for ellipse, "Brennlinie" (burning line) for parabola, "Muschellinie" (shell line) and "Spinnenlinie" (spider line) for conchoid and epicycloid.

Those, however, who focused their attention upon the visual arts—beginning, as we must never forget, with painting—could not at first acclaim the great revival as a return to classical sources. Boccaccio could say that Giotto had "brought the art of painting back from its grave", and Filippo Villani—explicitly comparing his account

[1] Johannes Werner, *Libellus super viginti duobus elementis conicis*, Nuremberg, 1522, Preface.

[2] Petrarch, *Le Familiari*, ed. cit., II, p. 58; quoted in Mommsen, "Petrarch's Concept of the Dark Ages", p. 232.

[3] For the earlier stages of this process, see H. Baron, *The Crisis of the Early Italian Renaissance*, Princeton,

1955, I, Chaps. 13–15. For its opposite aspects, the infusion of a modern and personal feeling into the traditional vocabulary and syntax of neo-Latin poetry, see L. Spitzer, "The Problem of Latin Renaissance Poetry", *Studies in the Renaissance* (Publications of the Renaissance Society of America), II, 1955, p. 118 ff.

of Florentine painters with what the classical authors had to say about Zeuxis and Polyclitus, Apelles and Phidias, not to mention Prometheus—could boldly assert that Giotto was superior rather than equal to the painters of ancient Greece and Rome. But neither Boccaccio nor Villani was in a position to maintain that Giotto—or, for that matter, any other painter known to them—had formed his style in imitation or emulation of classical prototypes. What Giotto—and, to a lesser extent, Cimabue— could be credited with was only a reformation of painting *ad naturae similitudinem*.

The inclusion of painting in the theory of revival thus resulted—and this, it seems to me, is rather an important point—in a kind of bifurcation or dichotomy within what may be called the Petrarchian system of history. To Petrach's principal theme, "*back to the classics*", Boccaccio and Villani (followed by many other writers on painting, such, for example, as Bartolommeo Fazio or Michele Savonarola)[1] opposed, as a counterpoint, the theme, "*back to nature*"; and the interweaving of these two themes was to play a decisive role in humanistic thought, not only with reference to the relation between the visual arts and literature, but also, as time went on, with reference to the relation among the visual arts themselves. For, if the second theme (rediscovery of nature) was introduced in connection with the revival of painting at the beginning of the fourteenth century, the first theme (rediscovery of the Antique) was vigorously reaffirmed in connection with the revival of sculpture—and, even more so, architecture —at the beginning of the fifteenth.[2] Where Giotto had been praised as a naturalist, Donatello was represented both as a peer and as an imitator of the ancients: according to Christoforo Landino, writing about 1480, he was not only an artist distinguished by the variety, vivacity and apt arrangement of his compositions, by his command of space and his ability to impart motion to all his figures but also a *grande imitatore degli antichi*.[3] And what struck the observers as "imitation" in sculpture struck them as a renewal, even (quite literally) a "re-formation", in architecture.

"I, too, used to like modern [*scil.*, Gothic] buildings", says Antonio Filarete, a practitioner of architecture as well as sculpture, in his treatise on architecture composed between 1460 and 1464; "but when I began to appreciate (*gustare*) classical ones, I came to be disgusted with the former ... Having heard that the people of Florence had

[1] Bartolommeo Fazio, *De viris illustribus*, composed *ca.* 1456; see Schlosser, *Die Kunstliteratur*, p. 95 ff. M. Savonarola, *De laudibus Patavii*; see Schlosser, *ibidem*, pp. 94 f., 103.

[2] For the reappreciation of classical architecture and sculpture in Petrarch's circle as a prelude to their actual "revival", and for the art-historical background of this reappreciation, see below, p. 208 f.

[3] Landino, *ed. cit.*, p. 253 ff. The passage referring to Donatello reads as follows: "Donato sculptore da

essere connumerato fra gli antichi, mirabile in compositione et in varietà, prompto et con grande vivacità o nell'ordine o nel situare le figure, le quali tutte appaiono in moto. Fu grande imitatore degli antichi et di prospectiva intese assai". Landino's characterizations were literally quoted in the "Libro" of Antonio Billi, composed between 1516 and 1525, which was one of the sources used by Vasari (see C. Frey, *Il Libro di Antonio Billi*, Berlin, 1892, p. 38 ff.).

started to build in this classical manner (*a questi modi antichi*), I decided to get hold of one of those that were mentioned to me; and when I associated with them, they woke me up in such a way that now I could not produce the smallest thing in any manner but the classical".[1] And: "I seem to see, my lord, [in the new structures built according to the *modi antichi*] those noble edifices that existed in Rome in classical times and those that, we read, existed in Egypt; I appear to be reborn when I see these noble edifices, and they seem still [*ancora*] beautiful to me".[2]

That the people of Florence had "started to build in the classical manner" was, needless to say, due to the influence of one man who, while considered a second Giotto on account of his genius, his universality and his unprepossessing appearance,[3] was praised for having done for architecture what Petrarch had done for literature: Filippo Brunelleschi. He had, in Filarete's words, "resuscitated that classical way of building" (*questo modo antico dell'edificare*) which should be universally adopted in place of the *usanza moderna;* and Filarete's statement is echoed, with redoubled force, by Brunelleschi's enthusiastic biographer, Antonio Manetti, according to whom his hero had "renewed and brought to light that style of building which is called Roman and classical" (*alla Romana et alla antica*) whereas "before him all the buildings were German and are called modern".[4]

[1] *Antonio Averlino Filaretes Traktat über die Baukunst*, W. von Oettingen, ed. (*Quellenschriften für Kunstgeschichte*, New Ser., III), Vienna, 1890, IX, p. 291: "Ancora a me soleuano piacere questi moderni; ma poi, ch'io commenciai a gustare questi antichi, mi sono venuti in odio quelli moderni ... et ancora udendo dire che a Firenze si husano d'edificare a questi modi antichi, io determinai di auere uno di quegli i quali fussino nominati. Si chè, praticando con loro, m'anno suegliato in modo, che al presente io non sarei fare una minima cosa che non la facessi al modo anticho". It may be an accident—but, if so, a noteworthy one—that Jean Lemaire de Belges in his *Plainte du Desiré*, written in 1504, designates the Northern artists of the fifteenth century as "des esprits recents, et nouuelets" while reserving the term "modernes" to three Italians (Leonardo da Vinci, Giovanni Bellini and Perugino) and two contemporary Northerners already influenced by Quattrocento art (Jean Hey and Jean de Paris); see *Oeuvres de Jean Lemaire de Belges*, J. Stecher, ed., III, Louvain, 1885, p. 162.
[2] *Ibidem*, XIII, p. 428: "Signiore, a me pare uedere di quegli degni hedificij ch'erano a Roma antichamente e di quegli che si leggie che in Egipto erano; mi pare rinascere a uedere questi così degni hedificij, et a me ancora paiono begli" (it should be noted that, while the buildings of the Egyptians are mentioned, those of the Greeks are not). I am grateful to Mr. John R. Spencer for having checked the wording of this important text the crucial passage of which is occasionally reprinted with a not unimportant deviation ("rinascere *e* uedere" instead of "rinascere *a* uedere"). Professors Creighton Gilbert and G. N. P. Orsini have convinced me that my objections to the translation in E. G. Holt, *Literary Sources of Art History*, Princeton, 1947, p. 151, are without foundation. My thanks go to Professors Gilbert and Orsini, and my apologies to Mrs. Holt.
[3] *Le Opere di Giorgio Vasari*, G. Milanesi, ed., Florence, 1878–1906, II, p. 327f., with special reference to Boccaccio's novel referred to above, p. 13.
[4] For Filarete's statement, see Filarete, *op. cit.*, VIII, p. 272; for Manetti's, see C. Frey, *Le Vite di Filippo Brunelleschi scultore e architetto fiorentino*, Berlin, 1887, p. 61: "Da che naque, come si rinnuouò questo modo de muramenti, che si dicono alla Romana et alla antica ..., e chi di nuouo la recò a lucie; che prima erano tutti Tedeschi e diciensi moderni". Manetti's biography (for a modern edition, see E. Toesca, ed., *Antonio Manetti, Vita di Filippo di Ser Brunellesco*, Florence, 1927) was probably composed between 1482 and 1488, that is to say, at about the same time as Landino's survey which, unfortunately, does not include architects and mentions Brunelleschi

As soon, then, as the "revival" of the three visual arts could be perceived as a coherent picture, the historiographers agreed that the complementary motives of this "revival", return to nature and return to classical antiquity, had become effective at different times and, more important, with different potency according to media: that the return to nature had played a maximum role in painting; that the return to classical antiquity had played a maximum role in architecture; and that a balance between these two extremes had been struck by sculpture. We have already heard what Manetti had to say of Brunelleschi and what Landino had to say of Donatello. Of Masaccio, however, the same Landino, making no mention of the Antique at all, says only that he was "an excellent imitator of nature, of great importance in a general way, good in composition, pure without ornament, wholly devoting himself to the observation of reality and the relief of the figures, and as proficient a perspectivist as any of his contemporaries".[1] Three generations later, Vasari still echoes this trichotomy in stating, in one and the same paragraph, that Brunelleschi had rediscovered the measurements and proportions of the ancients; that the works of Donatello were a match for theirs; and that Masaccio—again considered without any reference to classical art—excelled in "a novel manner of coloring, foreshortening, natural postures, and much more expressive emotions of the soul as well as gestures of the body".[2]

V

It was, perhaps, because both the novelty and the classical implications of the new style were so much more conspicuous in architecture than in the representational arts[3]— and, above all, because the physical presence of the Roman buildings, reduced to ruins by the events of the past yet transmitting the spirit of this past to the present, so vividly demonstrated the idea of decay and revival—that the writers concerned with architecture were more inclined to develop their experience into a complete "Geschichtskonstruktion" than were the writers concerned with painting and sculpture.

The first known account of this "Geschichtskonstruktion", to which we still pay homage when we speak of the "Gothic style" (a term originally restricted to architecture

only in so far as he, although an architect, was also a competent painter and sculptor and a specialist in perspective, of which he is said to have been the "rediscoverer or inventor (*ritrovatore o inventore*)".

[1] Landino, *ed. cit.*, p. 253 ff.: "Fu Masaccio optimo imitatore di natura, di gran rilievo universale, buono compositore et puro senza ornato, perche solo si decte all'imitatione del vero et al rilievo delle figure; fu certo buono et prospectivo quanto altro di quegli tempi".

[2] See Vasari's preface of the second part, *op. cit.*, II, p. 103 ff. Even in the biography of Donatello (II, p. 397 f.), Vasari does not go farther than to credit his hero with "cercare l'ignudo delle figure, come ei tentava di scoprire la bellezza degli antichi, stata nascosa già cotanti anni". For Masaccio, cf. also the passages in his biography, II, p. 288.

[3] Cf. Kauffmann, *op. cit.*, p. 127 ff.

and architectural ornament[1] but now extended to all the fine arts),[2] is found in the treatise, just mentioned, of Filarete; but the very sketchiness and awkwardness of its presentation bear witness to the fact that the author is merely attempting to summarize what had become accepted opinion at his time: "As letters declined in Italy, that is to say, as people became gross in their speech and in their [use of] Latin and general coarseness ensued (so that it is not until fifty or perhaps sixty years ago that minds came to be resubtilized and awakened) ..., so did this art [of architecture] and stayed this way, as a result of the ruinous invasions of Italy and of the wars of those barbarians who ravished and subjugated her several times". It came to pass, he goes on to say, that Italy was swamped with "customs and traditions from north of the Alps, imported not by real architects but by painters, stonemasons and, particularly, gold-smiths who practiced what they liked and understood"—so that (a rather shrewd remark) big buildings "came to be fashioned in the likeness of tabernacles and censers". And "this manner or mode was taken over from the people beyond the Alps (tramontani), that is to say, the Germans and the French".[3]

[1] The *Oxford Dictionary* still defines "Gothic" in this restricted sense.

[2] As late as 1842 the eminent German art historian Franz Kugler (*Handbuch der Kunstgeschichte*, Stuttgart, 1842, p. 516, Note) was so reluctant to extend the adjective *gothisch* beyond the limits of architecture and architectural ornament that he decided to replace it by *germanisch*, explicitly justifying this decision by the need for "a word capable of being applied to the representational arts as well as to architecture" ("um Architektur und bildende Kunst mit demselben Worte bezeichnen zu können"). When Giovanni Baglione applies such expressions as "antico-Gotico" or "anticomoderno-Gotico" to sculpture and painting (E. S. de Beer, "Gothic: Origin and Diffusion of the Term; The Idea of Style in Architecture", *Journal of the Warburg and Courtauld Institutes*, XI, 1948, p. 143 ff., particularly p. 153) he obviously uses them not as designations of a specific period but in the general sense of "neither classical nor modern but mediaeval and therefore antiquated", just as his French contemporary, J. Doublet, does in his *Histoire de l'Abbaye de S. Denys en France*, Paris, 1625, p. 241, when he describes a supposedly Carolingian portrait as "une petite figure en bas-relief d'un goust fort gothique". In fact, the same Baglione quotes almost verbatim Vasari's notorious characterization of Gothic architecture (cf. the passages quoted in Panofsky, "Das erste Blatt ..." [*Meaning in the Visual Arts*, pp. 177, Note 15, and 187, Note 34]): "un altro ordine, che Gotico o Tedesco si nomina, è

piuttosto disordine"; his only contribution was the addition of the adjective *Gotico* to Vasari's *Tedesco*, which was just becoming fashionable in Italy. For good historical and geographical reasons it was in France rather than in Italy that humanists tended to concentrate their invectives against barbarism in general, and the barbarous Middle Ages in particular, on the Goths whereas the Italians preferred to couple them with other *nazioni barbare e straniere* (such as Vandals, Huns, Lombards, Germans, and the French themselves) and tended to lump all these together under the heading *tramontani*. Thus the adjectives *goticus* and *gothique* were used in France at a much earlier time than in Italy. As early as 1496, more than thirty years before Rabelais' Letter to Tiraqueau (quoted by de Beer, p. 144, and referred to above, p. 17, Note 2), Lefèvre d'Etaples (Faber Stapulensis) writes in his *Artificiales Introductiones*: "A gotica enim illa dudum latinorum litteris illata plaga, bonae litterae omnes nescio quod goticum passae sunt" ("Simone III", p. 121); and in 1524, Budé in his *Introductiones in Pandectas* asks: "Quae est igitur in sermonibus perversitas ut, cum tantam atque elegantem utendi fruendique iuris supellectilem habeant ... sordida ... supellectili hac gotica et barbara uti malent" ("Simone III", p. 134).

[3] Filarete, *op. cit.*, XIII, p. 428f.: "Come le lettere mancorono in Ytalia, cioè che s'ingrossorono nel dire e nel latino, è uenne una grossezza, che se non fusse da cinquanta o forse da sessanta anni in qua, che si sono asottigliati et isuegliati gl'ingegni ... e

This theory was elaborated by the following generations. Manetti—as Brunelleschi's biographer conceivably reflecting the master's own observations—not only pays careful attention to the phase between the downfall of the Roman Empire and the advent of his hero (a phase coolly ignored by Leone Battista Alberti)[1] but also recognizes that a preliminary revival of Roman architecture had taken place in the so-called "Tuscan proto-Renaissance" which he ascribes to none other than Charlemagne (thus dating most of its monuments several centuries too early but evincing a keen perception of stylistic criteria and intuiting, as it were, what later scholarship was to define as the Carolingian *renovatio*): "after the expulsion of the barbarian tribes, Goths, Huns, Vandals, and, finally, Lombards", the great restorer of the Empire employed architects from Rome, "not very expert for want of practice yet able to build after the fashion of the structures among which they had been born"; but since his dynasty did not last very long and was supplanted by German rulers, the style of the barbarous invaders came to predominate again and lasted "down to our century, up to the time of Filippo". Manetti also pointed out that the generally accepted superiority of Roman over Greek architecture was not so much due to the inherent gifts of the Roman race as to political and economic factors, the shift in power and wealth from Greece to Rome causing the architects "to go where the power and wealth were" and there to advance their art "more wonderfully than in Greece".[2]

The next important step was taken, some thirty years later, in the famous letter to Leo X variously attributed to Bramante, Baldassare Peruzzi and Baldassare Castiglione and probably resulting from a collaboration between the last-named and Raphael.[3]

così è stata questa arte; che per le ruine d'Italia, che sono state, e per le guerre di questi barbari, che più uolte l'anno disolata e sogiogata. Poi è accaduto, che pure oltramonti è uenuto molte usanze e loro riti. Et uenuto poi, quando per Ytalia s'è voluto fare alcuno hedificio, sono ricorsi quegli, che anno voluto far fare, a orefici e dipintori, e questi muratori, i quali, benchè appartenga in parte al loro exercitio, pure è molta differentia. E che anno dato quegli modi, che anno saputo e che è paruto a loro, seconeo i loro lauori moderni. Gli orefici fanno loro a quella somilitudine e forma de' tabernacoli e de' turibili da dare incenso ... E questo huso e modo anno auuto, come ò detto, da' tramontani, cioè da Todeschi e da Francesi".

[1] Manetti (Frey, *Le Vite di Filippo Brunelleschi*, p. 81 f.); for Alberti (*De architectura*, VI, 3), see particularly Krautheimer, "Die Anfänge der Kunstgeschichtsschreibung in Italien".

[2] Manetti, *ed. cit.*, p. 78 ff.: "E perche la disciendenzia di Carlo Magnio si distese in pochi gradi di sucie-

zione, e lo inperio uenne poi nelle mani de Tedeschi, per la magiore parto el modo, che era ritornato pel mezo di Carlo, si rismarrì, e ripresono uiogre e modi Tedeschi; equali durarono insino al secholo nostro al tenpo di Filippo" (p. 82). For the "Tuscan Proto-Renaissance" ascribed to Charlemagne by Manetti (and, after him, by Vasari, *ed. cit.*, I, p. 235 f.), see below, pp. 40 and 55 ff. Manetti's account of the shift from Greece to Rome (p. 81) reads as follows: "E perche gli architetti uanno e sono tirati ne luoghi, doue sono e tesori e principasi, e doue se [s'è] atto a spendere, col regnio di Grecia si trasferì l'architettura ... onde in Roma fiorirono e maestri piu marauigliosamente che in Grecia come piu marauigliosamente s'acrebbe el principato e le sperienze".

[3] See Schlosser, *Die Kunstliteratur*, p. 175 ff., and the still very useful survey in L. Pastor, *op. cit.*, VIII, R. F. Kerr, ed., London, 1908, p. 244 ff. The letter, which exists in two slightly different redactions, is still most easily accessible in J. Vogel, *Bramante und Raffael (Kunstwissenschaftliche Studien*, IV, Leipzig,

Here Filarete's and Manetti's views are crystallized into a definite archaeological classification;[1] and, more important, a first genetic account of the "Gothic" style is attempted by a bold reinterpretation of what the classical writers had conjectured about the beginnings of architecture at the very dawn of human civilization. According to Vitruvius, primaeval man had constructed shelters by "putting up unsquared timbers and interweaving them with branches (*furcis erectis et virgulis interpositis*)".[2] In replacing Vitruvius' primaeval man with invading barbarians and substituting "living trees, their branches bent and joined on top" for Vitruvius' "unsquared timbers interwoven with branches", the author or authors of the letter to Leo X furnished a plausible explanation for the most amazing and most controversial feature of the Gothic style, the pointed arch, which they considered as inferior to the semicircular arch not only from an aesthetic but also from a technical point of view; and this explanation, had they but known it, was to give rise to those comparisons of Gothic piers with "trees of God" and avenues of trees with "Gothic naves" which were to spread like an epidemic in the age of Romanticism.[3]

Speculation on the history of the representational arts, particularly painting, proceeded, in a somewhat less elaborate and systematic manner, so as to dovetail with that on the history of architecture: where architecture was held to have been destroyed by the vandalism of savage conquerors, sculpture and painting were held to have been stifled by the iconoclastic zeal of the Christian Church.

Boccaccio, we recall, had blamed the unhappy state of pre-Trecento painting on

1910), p. 103 ff., and V. Golzio, *Raffaello, nei documenti e nelle testimonianze dei contemporanei e nella letteratura del suo secolo*, Pontificia Accademia Artistica dei Virtuosi al Pantheon, Vatican City, 1936. Portions of the text are reprinted (after the first redaction, published in 1733, in the *Opera* of Baldassare Castiglione) in de Beer, *op. cit.*, p. 146 ff.; a fairly complete German translation is found in E. Guhl, *Künstlerbriefe*, 2nd ed., A. Rosenberg, ed., Berlin, 1880, I, p. 99 ff., and an English one in E. G. Holt, *A Documentary History of Art*, I, Garden City, N. Y., 1957, p. 289 ff.

[1] "The first kind [of buildings] dates from the time before Rome was ruined and laid waste by the Goths and other barbarians; the second from the reign of the Goths and a hundred years thereafter; the third from then up to our own day ... the more recent buildings are easily recognizable not only by their newness but also by the fact that they show a style neither so beautiful as do those from the times of the Emperors nor so crude as that from the time of the Goths" The phrase "a hundred years there-

after" (*e ancora cento anni d'appoi*) would seem to indicate an indefinite period of considerable length (as we say, "This will take a hundred times longer") rather than just one century.

[2] Vitruvius, *De architectura*, II, 1, 3. Renaissance illustrations based upon this theory are found in Vitruvius editions, Filarete manuscripts, and in an interesting picture by Piero di Cosimo (Figs. 138, 139), for which see below, p. 179 ff., and E. Panofsky, *Studies in Iconology*, New York, 1939, p. 44 ff., Figs. 18–23, with some further bibliography.

[3] I cannot resist the temptation to quote a dialogue between two young Prussian noblemen, a captain of Life Guards and a civil servant, which occurs while they are riding through an avenue of stately old chestnut trees: "'Das ist ja wie ein Kirchenschiff', sagte Rex ... 'Finden Sie nicht auch, Czako?'— 'Wenn Sie wollen, ja. Aber Pardon, Rex, ich finde die Wendung etwas trivial für einen Ministerialassessor'" (Theodor Fontane, *Der Stechlin*, first published 1898, Chap. II).

the errors of an unspecified group of incompetents, *alcuni*. In Villani's account these *alcuni* are, more specifically yet more comprehensively, identified as the practitioners of a "Greek and Latin painting that for many centuries lay prostrate in the service of gross ineptitude".[1] But this distinction between Greek and Latin painters—apparently referring, on the one hand, to artists actually hailing from Byzantium and, on the other, to natives of Italy working in the Byzantine manner—was soon abandoned in favor of a collective designation denoting their "antiquated" style regardless of their nationality: *maniera greca*. Cennino Cennini, writing at about the same time as Filippo Villani, says of Giotto that he "had retranslated the art of painting from Greek into Latin and [thereby] made it modern";[2] and in Lorenzo Ghiberti's *Commentarii*, composed about the middle of the fifteenth century, *maniera greca* is used as a generally accepted, distinctly disparaging term.

It is in these *Commentarii* that we find the first explicit statement of what may be called the theory of internal suppression as opposed to the theory of external devastation: "At the time of Emperor Constantine and Pope Sylvester the Christian faith gained ascendancy. Idolatry being violently persecuted, all the statues and pictures, adorned with so much nobility as well as ancient and perfect dignity, were dismembered and mutilated; and together with these statues and pictures there perished the books and the treatises as well as the [theoretical] drawings and rules which had provided guidance for that great, outstanding and gentle art ... Since art was finished, the sanctuaries remained bare (*bianchi*) for about six hundred years. Then the Greeks made a very feeble beginning in the art of painting and practiced it with great clumsiness: they were as rude and clumsy in this age as the ancient [Greeks] had been competent in theirs".[3]

At first glance this sharp (and, in a way, entirely logical) distinction between barbaric destructiveness and iconoclastic bigotry, the former wreaking havoc on architecture, the latter crushing the representational arts, seems only to disclose a lack of liaison between the minds concerned with these two fields of artistic activity. But we soon realize that the two theories have one important feature in common: in speaking of the

[1] See above, p. 15, Note 1.

[2] *Cennino d'Andrea Cennini da Colle di Val d'Elsa, Il Libro dell'Arte*, II, D. V. Thompson, Jr., ed., New Haven, 1933, p. 2: "Il quale [Giotto] rimutò l'arte del dipingere di Grecho in latino, e ridusse al moderno".

[3] J. von Schlosser, *Lorenzo Ghibertis Denkwürdigkeiten*, I, p. 35 ff.: "Adunche al tempo di Constantino imperadore et di Silvestro papa sormontò su la fede christiana. Ebbe la ydolatria grandissima persecutione in modo tale, tutte le statue et le picture fuoron disfatte et lacerate di tanta nobilità et anticha et perfetta dignità et così si consumaron colle statue et picture et uilumi et comentarij et liniamenti et regole [che] dauano amaestramento a tanta et egregia et gentile arte ... Finita che fu l'arte stettero et templi bianchi circa d'anni 600. Cominciorono i Greci debilissimamente l'arte della pictura et con molta roçezza produssero in essa; tanto quanto gl'antichi furon periti, tanto erano in questa età grossi et roçi". A new edition of Ghiberti's *Commentarii* has been made by O. Morisani, Naples, 1947.

"violent persecution of idolatry", Ghiberti attributes the decay of sculpture and painting to a disruption of the classical tradition even more deliberately destructive than that which had led to the decay of architecture—an act of man rather than an act of God—and thereby implies that this disruption could be redressed, as it were, by an equally deliberate return to the Antique. Himself a fervent admirer and collector of ancient sculpture,[1] he clearly invites his fellow artists to look for guidance not only to nature but also to what remained of classical art. And in deploring the loss of "volumes and commentaries" in the same breath as the destruction or mutilation of "statues and pictures", he just as clearly invites them to extend their studies to what remained of classical literature.

This message was developed into a formal doctrine by Ghiberti's more articulate contemporaries and followers, first and foremost by Leone Battista Alberti. In his *Treatise on Painting*, written about 1435, Alberti advises the painter to turn to the humanist for secular (viz., classical) subject matter, offering as an example the story of the Calumny of Apelles as told by Lucian and thereby demonstrating the pictorial usefulness of a Greek author practically unknown to the Middle Ages as well as stressing the dignity of the painter.[2] Alberti also adapted, however tentatively, to the painter's profession the categories of classical rhetoric: invention, disposition (changed to *circonscriptione* and *compositione*, and about one hundred years later replaced by *disegno*), and elocution (changed to *receptione de lume*, and about one hundred years later replaced by *colorito*).[3] And, most important, he introduced—or rather reintroduced—into the theory of the representational arts what was to become the central concept of Renaissance aesthetics, the hoary principle of *convenienza* or *concinnitas*, perhaps best rendered by the word "harmony": "[The painter] must take pains, above all, that all the parts agree with each other; and they will do so if in quantity, in function, in kind, in color, and in all other respects they harmonize (*corresponderanno*) into one beauty".[4]

[1] See especially J. Schlosser, "Ueber einige Antiken Ghibertis", *Jahrbuch der kunsthistorischen Sammlungen des Allerhöchsten Kaiserhauses*, XXIV, 1904, p. 125 ff., and Krautheimer, "Die Anfänge der Kunstgeschichtsschreibung in Italien".

[2] Leon Battista Alberti, *Kleinere kunsttheoretische Schriften*, H. Janitschek, ed. (*Quellenschriften für Kunstgeschichte*, XI, Vienna, 1877), p. 144 ff.; in the most recent version, *Leon Battista Alberti, Della Pittura*, L. Mallè, ed., Florence, 1950, p. 104 f.; in the English translation (*Leon Battista Alberti, On Painting*, J. R. Spencer, tr., New Haven, 1956), p. 90 f. For the Latin version, see R. Altrocchi, "The Calumny of Apelles in the Literature of the Quattrocento", *Publications of the Modern Language Association of America*, XXXVI, 1921, p. 454 ff. For the way in which Renaissance artists acted upon Alberti's suggestion, see R. Förster, "Die Verleumdung des Apelles in der Renaissance", *Jahrbuch der königlich preussischen Kunstsammlungen*, VII, 1887, pp. 29 ff., 89 ff., and G. A. Giglioli, "La Calumnia di Apelle", *Rassegna d'arte*, VII, 1920, p. 173 ff. Alberti's rendering of the story differs significantly from both the Greek original and the translation of Lucian by Guarino Guarini (1408); see Panofsky, *Studies in Iconology*, p. 158 f.

[3] Alberti, *ibidem*, Janitschek ed., p. 98 ff.; Mallè ed., p. 81 ff.; Spencer tr., p. 67 ff. For an interpretation of Alberti's categories, see Lee, *op. cit.*, pp. 211, 264 f.

[4] Alberti, *ibidem*, Janitschek ed., p. 111; Mallè ed., p. 88; Spencer tr., p. 72.

This doctrine, reiterated *ad infinitum* by Alberti's followers (among them, to cite only the most famous, Leonardo and Dürer), opposed to the older postulate of verisimilitude that of aesthetic selection and—at least as far as the "harmony in quantity", that is to say, proportion, is concerned—mathematical rationalization. That the skin of a negro is dark throughout is a matter of common, everyday experience; but who is to judge of the "harmonious" relation between, say, the length of the foot, the width of the chest and the thickness of the wrist without combining empirical observation with archaeological research and exact mathematics? To aid the artist in this respect was what Alberti set out to do in his second treatise on art, *De statua*.[1] And while his method of determining and recording human proportions was, and even remained for some time, unique, his interest in the subject as such was shared by all his contemporaries and even retroactively imputed to the great masters of the past.

Where Boccaccio and Villani had praised Giotto exclusively for verisimilitude, Ghiberti extols him, in addition, for having attained that blend of grace and dignity which the Italians call *gentilezza*; for having rediscovered not only a practice but also a theory (*doctrina*) that had been buried for six hundred years; and—most important—for always having observed the "right proportions" (*non uscendo delle misure*). Landino—transferring to the "teacher" what Ghiberti had claimed for the "pupil" and even more explicitly invoking the spirit of classical antiquity—asserts that Cimabue was the first to rediscover, in addition to the *lineamenti naturali*, that "*vera proportione* which the Greeks call symmetry".[2] And even a non-Florentine poet of *ca.* 1440, eulogizing a non-Florentine painter, adds to the values of "naturalness", "art", "air", "design", "style", and "perspective" that of *mesura* (proportion).[3]

In all these fifteenth-century sources, then, we see the function of painting, hitherto confined to a reproductive imitation of reality, extended to the rational organization of form—this rational organization dominated by those "just proportions" the secret

[1] Alberti, *De statua*, Janitschek ed., p. 199 ff.

[2] Ghiberti, *loc. cit.*: "Arecò [Giotto] l'arte naturale e'lla gentilleza con essa, non uscendo delle misure". For Landino, see above, p. 15, Note 1.

[3] Sonnet by Agnolo Gelli on Pisanello, dated 1442:

> "Arte, mesura, aere et desegno,
> Manera, prospectiva et naturale
> Gli ha dato el celo per mirabil dono."

(published in A. Venturi, *Le Vite de' più eccellenti pittori, scultori, e architetti, scritte da M. Giorgio Vasari, I, Gentile da Fabriano e il Pisanello*, Florence, 1896, p. 49). As published, the text says also that "il dolce Pisano" was greater than Cimabue, "Gretto", and Gentile da Fabriano; the second member of this triad is generally identified with Allegretto Nuzi. However, the combination of Cimabue with Giotto was so common at the time, and a favorable comparison with the latter so much more telling than one with Allegretto Nuzi, that a corruption of "Giotto" into "Gretto" may be suspected. Another problem posed by Gelli's sonnet is the significance of *aere*. Taken to mean something like atmosphere, the term would be somewhat anachronistic and, if so interpreted, would appear more natural in combination with *prospectiva* than with *desegno*. I am inclined to interpret it, as in our "airs", as referring to the postures, gestures and general deportment of Pisanello's figures.

of which was held to have been revealed in the lost "doctrine of the ancients".[1] And in the same decades the function of architecture, hitherto confined to the purposeful assemblage of structural materials, was extended to a re-creative imitation of nature—this re-creative imitation dominated by the same "just proportions".

"If I am not mistaken", says the same Alberti who had introduced the principle of *convenienza* into the criticism of the representational arts and had transformed the theory of human proportions from a method *por legerement ovrer* into what may be called aesthetic anthropometry,[2] "the architect has borrowed from the painter [that is to say, from one who, by definition, "imitates nature"] his epistyles, capitals, columns, pediments, and other similar things".[3] And: "The Greeks, trying to outdo the rich Asian and Egyptian buildings in genius and quality, distinguished between the good and the less good and *resorted to nature*, following her intentions instead of mixing incongruous things, *observed how the male and female* [principles] *produce a better third* and studied design and perspective".[4] Manetti assures us that Brunelleschi achieved what he did not only by rediscovering the classical orders but also because, "endowed with a good mental eye (*buono occhio mentale*) as well", he had familiarized himself with "sculpture, dimensions, proportions, and anatomy".[5] And the letter to Leo X explicitly states what in the meantime had become common knowledge as a result of Vitruvian studies, that those famous classical orders represented an architectural transformation and glorification of the human body: "the Romans had columns calculated after the dimensions of man and woman".

This statement, manifestly based on Vitruvius' derivation of the Doric, Ionic and Corinthian columns from the proportions of a man, a full-grown woman and a slender virgin,[6] expresses the fundamental fact that classical as opposed to mediaeval architecture is—if I may use these terrifying expressions—catanthropic rather than epanthropic: dimensioned in analogy to the relative proportions of the human body, not scaled with reference to the absolute size of the human body.[7]

[1] The loss of this doctrine is constantly deplored by Dürer; see particularly K. Lange and F. Fuhse, *Albrecht Dürers schriftlicher Nachlass*, Halle, 1893, pp. 207, line 7 ff.; 288, 10 ff.; 295, 16 ff.; 298, 5 ff.

[2] See E. Panofsky, "Die Entwicklung der Proportionslehre als Abbild der Stilentwicklung", *Monatshefte für Kunstwissenschaft*, XIV, 1921, p. 188 ff. (English translation in *Meaning in the Visual Arts*, New York, 1955, p. 55 ff.).

[3] Alberti, *On Painting*, Janitschek ed., p. 91; Mallè ed., p. 77; Spencer tr., p. 64: "Presse l'architetto, se io non erro, pure dal pittore li architravi, le base, i chapitelli, le colonne, frontispicii et simili tutte altre cose; et con regola et arte del pictore tutti i fabri, i

scultori, ogni bottega et ogni arte si regge". For the interpretation of this passage, see Kauffmann, *op. cit.*, p. 127. As Janitschek, p. 233, convincingly points out, Alberti, the universal artist, here takes issue with Vitruvius (*De architectura*, I, 1, 1), who—like the mediaeval scholastics—claims that all the other arts hold an ancillary position in relation to architecture.

[4] Alberti, *De architectura*, VI, 3.

[5] Manetti (Frey, *Le Vite di Filippo Brunelleschi*, p. 73).

[6] Vitruvius, *De architectura*, IV, 1, 1–12.

[7] See C. Neumann, "Die Wahl des Platzes für Michelangelos David in Florenz im Jahr 1504; Zur Geschichte des Masstabproblems", *Repertorium für Kunstwissenschaft*, XXXVIII, 1916, p. 1 ff.

In a Gothic cathedral the doors are just large enough to admit a procession with its banners. The capitals—if there are any—rarely exceed the moderate height of the bases while the height of the pillars or shafts may be increased or diminished regardless of width. And none of the statues is appreciably over lifesized (when Thomas Gray, the author of the "Elegy Written in a Country Churchyard", visited Amiens Cathedral, he had nothing to say about it except that it was "beset with thousands of *small* statues").

In a classical temple—and, consequently, in a Renaissance church—the bases, the shafts and the capitals of the columns are proportioned, more or less, according to the relation between the foot, the body and the head of a normal human being.[1] And it is precisely the absence of such an analogy between architectural and human proportions that caused the Renaissance theorists to accuse mediaeval architecture of having "no proportion at all".[2] The doors of St. Peter's rise to about twelve meters and the cherubs supporting the holy-water basins to nearly four. As a result, the visitor is permitted, as it were, to expand his own ideal stature in accordance with the actual size of the building and for this very reason often fails to be impressed by its objective dimensions, however gigantic they may be (St. Peter's has been described, only half facetiously, as "small but neat"); whereas a Gothic cathedral of much lesser dimensions forces us to remain conscious of our actual stature in contrast with the size of the building. Mediaeval architecture preaches Christian humility; classical and Renaissance architecture proclaims the dignity of man.

VI

WHAT all this amounts to is that the old question, "when the men of the Renaissance gloried in the revival or rebirth of art and culture, did they conceive of this revival or rebirth as a spontaneous resurgence of culture as such (comparable to the awakening of nature in the spring) or as a deliberate revitalization of classical culture in particular"?[3] cannot be answered without historical and systematic qualifications.

For Petrarch, we might say, this alternative would have been meaningless. It came into being only when, with Boccaccio, the revival of literature began to be paralleled with that of painting and sculpture, and it was sharpened when, early in the fifteenth

[1] This conflict between the Gothic and the classicizing interpretation of architectural proportions came into the open as early as about 1400 in the notorious quarrel between the French and Italian architects of Milan Cathedral, the former claiming that the height of the pier capitals should not exceed that of the bases, the latter asserting that—since the word *capitellum* derives from *caput*—the capitals should be as much higher than the bases as the human head is in relation to the foot. See J. S. Ackerman, "'Ars Sine Scientia Nihil Est'; Gothic Theory of Architecture at the Cathedral of Milan", *Art Bulletin*, XXXI, 1949, p. 84 ff., particularly p. 98.

[2] See above, p. 19 ff.

[3] See particularly Kauffmann, *op. cit.*

century, a maximum of classical influence became apparent in architecture whereas a minimum of classical influence and a maximum of naturalism seemed to be evident in Massaciesque painting. Soon afterwards, however, the gap between the various spheres of cultural activity, and thereby the gap between the two injunctions, "back to nature" and "back to the classics", began to close itself—the concept of proportion linking the representational arts to architecture (and, we may add, architecture to music),[1] the concepts of invention, composition and illumination linking the representational arts to literature.

Thus the stage was set for a general, if temporary, reconciliation: for an interpretation of history which saw the barbarous destruction and the ecclesiastical suppression of classical values as two aspects of one and the same calamity, to be relieved by one and the same remedy;[2] and for an aesthetic theory—not seriously opposed until the very end of the Renaissance and strengthened rather than weakened by this opposition ever after—which resolved the dichotomy between "return to nature" and "return to the Antique" by the thesis that classical art itself, in manifesting what *natura naturans* had intended but *natura naturata* had failed to perform, represented the highest and "truest" form of naturalism. "The Antique", says Goethe, "is part of nature and, indeed, when it moves us, of natural nature".[3]

When Dürer, writing about 1523, discusses that *Wiedererwachsung* which he, an honest man, credits to the Italians, and the inception of which he dates back to the approximate time of Giotto's maturity (or, alternatively, the approximate time of Brunelleschi's birth[4]), he applies, characteristically, the expression "art" partly to the practice of painting (*die Kunst der Malerei*) and partly to the theory of human proportions (*die Kunst, die Menschen zu messen*); but in both cases he leaves no doubt that that

[1] See R. Wittkower, *Architectural Principles in the Age of Humanism*, 2nd ed., London, 1952, particularly p. 90 ff.

[2] It is interesting to note that Vasari, in the preface of the third part (cf. below, p. 32), speaks of the providential discovery of such famous classical works as the *Laocoön*, the *Torso Belvedere*, etc., as "causing" the disappearance of the imperfections still present in the style of the Quattrocento.

[3] Goethe, *Maximen und Reflexionen*, M. Hecker, ed., 1907 (*Schriften der Goethegesellschaft*, Vol. XXI), p. 229; cf. E. Panofsky, "Dürers Stellung zur Antike", *Jahrbuch für Kunstgeschichte*, I, 1921/22, p. 43 ff. (English translation in *Meaning in the Visual Arts*, p. 236 ff., particularly p. 265 ff.).

[4] The actual term *Wiedererwachsung* was used by Dürer only once, in a draft for the preface of his *Four Books on Human Proportions*, dated 1523, where the

"itzige Wiedererwachsung" is said to have taken its inception "one and a half centuries" ago (that is to say, about 1375) and after an interruption of "a thousand years" (Lange and Fuhse, *op. cit.*, p. 344, lines 6–19). The historical view expressed in this statement, however, recurs repeatedly in his writings and is set down, with the same dates, in two other drafts for the same preface (Lange and Fuhse, pp. 259, lines 16–22; 338, line 25; 339, line 2). The printed preface of the *Treatise on Geometry*, published in 1525, differs from these passages only in that the beginning of the revival is pushed back "two hundred years ago" (that is to say, *ca.* 1325) while the estimate of the fallow interval remains unaltered; and here the Italians are explicitly credited with having "brought to light the art that was hidden" (Lange and Fuhse, p. 181, lines 23–28; cf. also *ibidem*, p. 254, line 19f.).

which had been "brought to light after having been lost for a thousand years" had been mastered and "held in honor" by the "Greeks and Romans", and that it had "perished with the downfall of Rome".[1] For Dürer, then, the distinction between "revival of art" and "revival of classical art" had ceased to be an alternative. And the same applies, on a new level of historical and systematic awareness, to that great co-ordinator—or, if you like, conflationist—Giorgio Vasari.

The first explicitly to affirm the consanguinity of the three fine arts as "the daughters of one father, Design",[2] the first to treat them in one volume where all his predecessors had dealt, or proposed to deal, with architecture, sculpture and painting in separate treatises, and the first to represent the outrages of the barbarians and the "perfervid zeal of the new Christian religion" as the joint causes of one catastrophe rather than as two unrelated disasters,[3] Vasari saw the "rebirth of art" as a total phenomenon which he christened with a collective noun, *la rinascita*.[4] From the vantage point of 1550 he looked back upon the "progress of this rebirth (*il progresso della sua rinascita*)" as an evolution unfolding itself in three phases (*età*), each corresponding to a stage of human life and starting, roughly, with the beginning of a new century. The first phase, comparable to infancy, was ushered in by Cimabue and Giotto in painting, by Arnolfo di Cambio in architecture and by the Pisani in sculpture; the second, comparable to adolescence, received its imprint from Masaccio, Brunelleschi and Donatello; and the third, comparable to maturity, began with Leonardo da Vinci and culminated in that model of the *uomo universale*, Michelangelo.[5] Vasari thus divided his *Lives* into three parts, and in the general preface of this triad (*Proemio delle Vite*) as well as in the individual prefaces placed at the head of each part he attempted to define the stages of the whole *rinascita*.

The general preface leaves no doubt that, in Vasari's opinion, the new efflorescence of art was due to a return to classical antiquity: "the geniuses who came afterward [viz., after Cimabue], well able to distinguish the good from the bad and abandoning the old style, reverted to the imitation of classical art with all their skill and wit".[6] In

[1] This is the passage, Lange and Fuhse, p. 181, lines 23–28, referred to in the preceding Note. See also *ibidem*, p. 338, line 27f.: "Denn do Rom geschwächt ward, so gingen diese Kunst alle mit unter".

[2] Vasari, *ed. cit.*, I, p. 168 and *passim*; cf. Panofsky, "Das erste Blatt ..." (*Meaning in the Visual Arts*, p. 214f.). While the "father" of the three fine arts is always identified as *Disegno*, their "mother" is alternately named *Invenzione* (II, p. 11) or *Natura* (VII, p. 183).

[3] Vasari, "Preface of the Lives", *ed. cit.*, I, p. 230 ff.

[4] In a general sense this significant term is first used in the general preface, *ibidem*, I, p. 243, while the

preface of the second part (II, p. 99) applies it, more specifically, to sculpture: "La quale [scultura] in quella prima età della sua rinascita ebbe assai di buono". For the religious implications of the terms *rinascita* and *renaissance*, see below, p. 38.

[5] For Vasari's *Geschichtskonstruktion*, see again Panofsky, "Das erste Blatt ..." (*Meaning in the Visual Arts*, p. 215 ff.), with further literature.

[6] Vasari, *ed. cit.*, I, p. 242: "Gli ingegni che vennero poi, conoscendo assai bene il buono dal cattivo, ed abbandonando le maniere vecchie, ritornarono ad imitare le antiche con tutta l'industria ed ingegno loro".

the preface of the first part, dealing with the Trecento, however, classical influence is not mentioned at all, and Giotto is interpreted as a naturalist to such an extent that he of all people is credited with having introduced the famous "eye-deceiving insect" into postclassical art (according to Vasari, he adorned the nose of a figure just finished by his "teacher", Cimabue, with a fly which the old gentleman repeatedly tried to brush away). In the preface of the second part, devoted to the Quattrocento, Vasari makes the characteristic distinction, already commented upon, between the roles of Brunelleschi, the rediscoverer of ancient architecture, Donatello, the rival of the ancient sculptors, and Masaccio, whose style he never seems to associate with ancient art at all. It is only in the preface of the third part, describing the climactic phase of the *terza età*, that full and comprehensive credit is given to the influence of the Antique.

Summarizing the entire development once more, Vasari here demonstrates the gradual realization of five artistic requirements or principles (*aggiunti*): rule, order, measure, design, and "manner" (the last-named principle amounting to something like an intuitive synthesis by means of which the artist distils from individual experiences a "type" of beauty all his own). In all these respects Giotto and "all the artists of the first phase" are found wanting although they had "become aware of the basic principles (*principj di tutte queste difficoltà*)" and made some progress in lifelikeness, coloring and composition. The masters of the second phase made tremendous advances; they failed, however, to attain that combination of precision, grace and freedom which, for Vasari, represents perfection: their works, however meritorious, had something "dry" about them and fell short of classical standards in details even where "the whole of the figure already agreed with the Antique" ("wir wollen dem Naturalisten sein Vergnügen lassen", wrote Heinrich Wölfflin in 1898 of such an offending detail in Piero di Cosimo's *Mars and Venus*).

"Those, however, who came after them", Vasari continues, "saw rise from the earth certain classical works mentioned by Pliny among the most famous, the *Laocoön*, the *Hercules*, the powerful *Torso of the Belvedere*, the *Venus*, the *Cleopatra*, the *Apollo* and numberless others; and these, in their softness and precision (*dolcezza e asprezza*), their contours full-fleshed and observed from the greatest beauties of real life, their postures not contorted throughout yet moving in certain parts with a most graceful grace (*graziosissima grazia*), caused the disappearance (*furono cagione di levar via*) of that dry, rude and cutting manner" which, "by too much study", had come to prevail in the masters of the second half of the Quattrocento, from Piero della Francesca and Castagno down to Botticelli, Mantegna and Signorelli. Their "errors" were dispelled by Leonardo da Vinci, who, "in addition to the vivacity and boldness of his design, and in addition to his ability to imitate, in the most subtle manner, all the minutiae of nature ... truly imparted movement and breath to his figures by dint of good principles (*la buona*

regola), better order, just measure, perfect design, and divine gracefulness". And so, after the contributions of Giorgione, Raphael, Andrea del Sarto, Correggio, and others, a final climax was reached in the "divine Michelangelo Buonarroti: "ruling supreme" in all the three arts, he surpassed not only his immediate forerunners, who "had already vanquished nature in a manner of speaking (*costoro che hanno quasi che vinto già la natura*)", but also those who had "so gloriously surpassed her without any doubt (*che si lodatamente fuor d'ogni dubbio la superarono*)", namely, the classical masters themselves.[1]

This summary, needless to say, is fraught with inconsistencies for which Vasari has been severely reprimanded. Two of his "principles", "rule" and "order", appear to have been transferred to sculpture and painting from architecture. And in his attempt to demonstrate a gradual and, if one may say so, self-propelling evolution in the direction of ever greater verisimilitude yet to do justice to the importance of such sensational discoveries as those of the *Laocoön* or the *Apollo Belvedere*, Vasari gets to a point where he, and his readers, find it next to impossible to distinguish between what this evolution owed to an increasing familiarity with nature and what it owed to an increasing familiarity with the Antique.

From what has been said, however, it will be evident that these very inconsistencies were almost inevitable at a moment when the originally divergent development of two forms of artistic practice (architecture and the representational arts) had reached a point of convergence, and when two originally disparate historical concepts (return to nature and return to the Antique) had come to coalesce. And in one respect at least Vasari did serve the cause of clarification: he systematized the terminology.

Terms referring to temporal relations are by their very nature indeterminate. Taken by themselves, the words *antiquus* and *antico* only denote "something old" or "of the past" but not necessarily something "antique" in contradistinction to a definite "something else" that was to follow. Taken by themselves, the words *modernus* (apparently coined by Cassiodorus) and *moderno* only denote something "recent" or "of the present" but not necessarily something "modern" in contradistinction to a definite "something else" that had occurred before. Cennino Cennini, we remember, asserted that Giotto had made the art of painting "modern". Filarete and Manetti, however, referred to the old buildings erected by transalpine architects (the style of which we would call Gothic) as *moderni* while calling buildings in the new "Renaissance" style *antichi* or *alla romana et alla antica;*[2] and this use of *moderno* persisted so stubbornly that Vignola

[1] *Ibidem*, IV, p. 8 ff.

[2] See above, p. 20, Notes 1 and 4. Similarly, Lorenzo Ghiberti refers to the *clipeus* on the back of his "Cassa di Zan Zanobi", exhibiting an incised inscription in beautiful Roman capitals, as an "epitaphyo intaglato di lettere *antiche*" (Schlosser, *Lorenzo Ghibertis Denkwürdigkeiten*, I, p. 48).

could still apply it to the Gothic portions of the much-debated façade of San Petronio in Bologna, and the majority of non-Italian writers of the fifteenth and sixteenth centuries, particularly in Spain, employed it to distinguish the contemporary, still essentially Late Gothic, tradition from the imported, purely Italianate, High Renaissance style.[1] Conversely, one of Vignola's Bolognese confrères could employ the word *vecchio* (then used in Rome and Florence as a synonym for "old-fashioned" or "out-of-date", and therefore as an antonym to *antico*) in the sense of "classical",[2] while a Bolognese academician of even later date could use the then generally sacrosanct expression "gli Antichi" to designate the "dry and stiff" painters active before the advent of the High Renaissance.[3]

In short, there reigned at the time of Vasari an utter confusion aggravated by the fact that the same Greeks who had lent their name to the deplorable *maniera greca* had once originated that classical style which was to culminate in the art of the Romans.

Fully aware of this confusion and explicitly declaring his intention to help his readers to a better understanding of the difference between *vecchio* and *antico*, Vasari devised a somewhat cumbersome but quite consistent terminology. The term *maniera vecchia* ("the old-fashioned style"), he explains, should be applied only to the style of the *Greci vecchi e non antichi* ("the Greeks that belonged to the past but not to antiquity"); it is thus the equivalent of what we call Byzantine or Byzantinizing. The term *maniera antica*[4] ("antique style"), however, should be restricted to *la buona maniera greca antica*[5] ("the good, antique-Greek style"); it is thus the equivalent of what we call classical.

What corresponds to the *maniera greca* of painting in architecture is, needless to say, the *maniera tedesca* (it should be noted that neither Vasari nor any other sixteenth-century author, least of all in Italy, ever uses the adjective *gotico*), which, therefore, can also be designated as *vecchia*. And in order to differentiate the art of his own age from both the "antiquated" style of the Middle Ages and the "classical" style of antiquity, Vasari proposes to apply to it the very term which had thus far been reserved for the art of the Middle Ages: the term *moderno*. In Vasari's terminology, therefore, this word no longer denotes a style opposed to the "buona maniera greca antica",

[1] As far as the Italian usage of the word *moderno* is concerned, see Panofsky, "Das erste Blatt ..." (*Meaning in the Visual Arts*, p. 196 ff.). Its use in Spanish and French sixteenth-century sources was discussed in a lecture by Professor George Kubler which, it is to be hoped, will become accessible in print. For the time being, Professor Kubler was kind enough to indicate to me that the best Spanish sources are Juan de Arfe, *Varia comensuración*, Seville, 1585, the chapter minutes of Salamanca Cathedral digested in F. Chueca, *La Catedral nueva de Salamanca*,

1951 (*Acta Salmaticiencie IV*), especially the discussions of 1588, and Alonso de Vandelvira's manuscript *Libro de traças de piedras* (in the University Library at Madrid), where "modern" vaults are defined as having ribs and pointed arches.

[2] Panofsky, *ibidem* (*Meaning in the Visual Arts*, p. 198, Note 68).

[3] *Ibidem* (*Meaning in the Visual Arts*, p. 196, Note 59).

[4] Vasari, *ed. cit.*, I, p. 242.

[5] *Ibidem*, I, p. 249.

it denotes, instead, the "buona maniera greca antica" *revived* in contradistinction to the "buona maniera greca antica" *itself*. Frequently qualified by such epithets as "good" or "glorious" (*buona maniera moderna, il moderno si glorioso*),[1] the term "moderno" thus becomes, in a general way, synonymous with the style of the "Renaissance" as opposed to that of the Middle Ages; and in a narrower sense it may even be restricted to the "High Renaissance" of the Cinquecento (*terza età*) as opposed to the two earlier stages of the *rinascita*. In the preface of the second part, for example, Vasari credits Masaccio with having "brought to light that modern manner (*quella maniera moderna*) which then and up to our own day was practiced by all our artists"; but in the preface of the third part he praises Leonardo da Vinci for having "laid the foundations of that third style which we have decided to call modern" (*dando principio a quella terza maniera che noi vogliamo chiamare la moderna*).

This bold reversal of contemporary usage was understandably slow in being accepted; occasionally, where the context left no room for doubt, Vasari himself relapsed into the earlier habit of using the word *moderno* in the sense of "no-longer-classical" (viz., "mediaeval") instead of in the sense of "no-longer-mediaeval" (viz., "of the present").[2] And as time went on, the beginning of this "present" was naturally subject to successive futher postponements: today, a "Museum of Modern Art" is generally understood to contain nothing antedating, say, the latter half of the nineteenth century, and a good case might be made for restricting the term "modern" to that "fourth period of history", essentially distinguished from the Renaissance, which began about 1600 and seems to be drawing to a close right now.[3] All these more recent modifications, however, presuppose a tripartite system of periodization which places the first major dividing line in the annals of Western Europe between antiquity and the Middle Ages, and the second between the Middle Ages and what Vasari and his contemporaries proposed to call the "modern" era.

[1] *Ibidem*, IV, p. 8.

[2] In the "Life of Cimabue" (*ibidem*, I, p. 249), Vasari opposes the *buona maniera greca antica* to the *goffa maniera moderna di quei tempi*; but here the qualifications *goffa* and *di quei tempi* leave no doubt that he exceptionally retains the earlier usage, equating *moderno* with "mediaeval". As a rule he was fairly consistent in applying the word *moderno* only to the style of the Renaissance, and more particularly, to its "third phase". In his autobiography, for example, he tells how he changed the Gothic vaults of an old-fashioned refectory at Naples by replacing *tutta quella vecchiaia e goffezza di sesti* with *ricchi partimenti di maniera moderna* (VII, p. 674).

[3] See D. P. Lockwood, "It Is Time to Recognize a New 'Modern Age'", *Journal of the History of Ideas*, IV, 1943, p. 63 ff. Cf. also below, p. 182.

VII

FROM the fourteenth through the sixteenth century, then, and from one end of Europe to the other, the men of the Renaissance were convinced that the period in which they lived was a "new age" as sharply different from the mediaeval past as the mediaeval past had been from classical antiquity and marked by a concerted effort to revive the culture of the latter. The only question is whether they were right or wrong.

In view of the fact that long before Petrarch, especially in the ninth and twelfth centuries, a good many scholars had an ear for Latin verse, knew something of Platonic philosophy and even collated and corrected classical manuscripts, it has been stated that the humanists of the Renaissance attempted to "sell" their scholarship as something new only because "the so-called novelty of their wares enhanced their value in the eyes of some"; and that such variations as can be detected between them and their mediaeval predecessors were "rather in quantity than in quality": "There is, at one time or another, a difference in the amount of work done in each of the activities, a difference in the number of the persons engaged ... In short, the Renaissance which opens in the fourteenth century is set apart from the others not intrinsically but only measurably".[1] However, whether the poets and scholars of the Carolingian era really did the same thing as Petrarch and Lorenzo Valla, whether the "Platonism" of the twelfth century is really the same as Marsilio Ficino's or Pico della Mirandola's, is precisely what has to be proved. And to say that two forms of humanism differed only in "quantity" is almost tantamount to saying that the Crusades differed from earlier expeditions to the Holy Land only by the greater number of participants and more extensive propaganda.

In history, concerned as it is with human affairs, the effect of a thousand men's doings is not equivalent to the effect of one man's doings multiplied by the factor 1000. And, even more important, it is not only what men do that counts but also what they think, feel and believe: subjective emotions and convictions are no more separable from objective actions or achievements than "quality" is from "quantity". The Mohammedan's belief in the mission of the Prophet, the Christian's belief in the Gospels as expounded by the Fathers, the contemporary American's belief in free enterprise, science and education—all these beliefs determine, or at least contribute to the determination of, the realities of Mohammedan, Christian and contemporary American civilization, regardless of whether the things believed in can be proved to be "true".

"A girl of eighteen", it has been said, "dressed up in the clothes which her grandmother wore when a girl of eighteen, may look more like her grandmother as she was

[1] A. C. Krey, "History and the Humanists", *The Meaning of the Humanities*, T. M. Greene, ed., pp. 43 ff., 50 f.

then than her grandmother herself looks now; but she will not feel or act as her grand-mother did half a century ago".[1] However, if this girl adopts her grandmother's clothes for good and wears them all the time in the conviction that they are more becoming and appropriate than those she used to wear before, she will find it impossible not to adapt her movements, her manners, her speech, and her susceptibilities to her remodeled appearance. She will undergo an inner metamorphosis which, while not transforming her into a duplicate of her grandmother (which no one has claimed to be true of the Renaissance in relation to classical antiquity), will make her "feel and act" quite differ-ently from the way she did as long as she believed in slacks and polo coats: her change of costume will indicate— and, later on, serve to perpetuate—a change of heart.

The Renaissance man's sense of "metamorphosis", however, was more than even a change of heart: it may be described as an experience intellectual and emotional in content but almost religious in character. That the antitheses between "darkness" and "light", "slumber" and "awakening", "blindness" and "seeing" which, we remember, served to distinguish the "new age" from the mediaeval past were borrowed from the Bible and the Fathers has already been mentioned; and no less obvious are the religious origin and connotations of such words as *revivere, reviviscere* and, most particularly, *renasci*.[2] Suffice it to quote a passage from the Gospel of St. John: "nisi prius renascitur denuo, non potest videre regnum Dei" ("except a man be born again, he cannot see the kingdom of God"),[3] the *locus classicus* for what William James described as the experi-ence of the "twice-born" man.

These borrowings, it seems to me, should not be interpreted as implying a lack of either originality or sincerity: the greatest masters have resorted to appropriation, even quotation, as an intensive device. To express the anguish of the Lord breaking down under the Cross, Dürer repeated the pose of Orpheus killed by the Maenads; to lend supreme confidence to the *Dona nobis pacem* and supreme solemnity to the *Gratias agimus tibi*, Bach appropriated the theme of both these fugues from St. Gregory; to create the proper atmosphere for the finale of the *Magic Flute*, Mozart transformed an

[1] Thorndike, *op. cit.*, p. 66.

[2] For a collection of passages relevant to both the term *renasci* and the *lux-tenebrae* antithesis, see, in addition to Konrad Burdach's fundamental "Sinn und Ur-sprung der Worte Renaissance und Reformation" (*Sitzungsberichte der Akademie der Wissenschaften in Berlin, phil.-hist. Klasse,* 1910, p. 655 ff.), Simone, *opp. citt.,* particularly "Simone I", p. 850 ff., and "Simone II", p. 170 ff.

[3] John 3:3; see also John 3:5: "Nisi quis renascitur ex aqua et Spiritu Sancto, non potest introire in regnum Dei". St. Augustine, *Quaestiones Veteris et Novi Testamenti,* 115, even uses the noun *renascibilitas*

as an equivalent for *regeneratio baptismalis.* There are, needless to say, numerous cases in which the verb *renasci* is used in a purely secular sense as in Judges 16:22 ("Capilli eius [Samsonis] renasci coeperant") or in Horace, *Ars poetica,* 70 f. ("Multa renascentur quae iam cecidere ... vocabula"). An intermediary position between the religious and the secular usage would seem to be held by references to the sun, who "de Oriente renascens gyrat per meridiem" (Eccle. 1:5), or to the phoenix, who is said "corpore de patrio ... renasci" (Ovid, *Metamorphoses,* XV, 402).

old chorale ("Herr Gott, vom Himmel sieh darein") into the *cantus firmus* "Der, welcher wandelt diese Strasse voll Beschwerde", employing in its orchestral accompaniment a haunting violin figure borrowed from the aria "Blute nur" in Bach's *Passion according to St. Matthew.* When the men of the Renaissance, instead of describing the new flowering of art and letters as a mere *renovatio*,[1] resorted to the religious similes of rebirth, illumination and awakening,[2] they may be presumed to have acted under a similar impulse: they experienced a sense of regeneration too radical and intense to be expressed in any other language than that of Scripture.[3]

Thus the very self-awareness of the Renaissance would have to be accepted as an objective and distinctive "innovation"[4] even if it could be shown to have been a kind of self-deception. Such, however, is not the case. It must be admitted that the Renaissance, like a rebellious youth revolting against his parents and looking for support to his grandparents, was apt to deny, or to forget, what it did owe, after all, to its progenitor, the Middle Ages. To assess the amount of this indebtedness is the bounden duty of the historian. But after this assessment has been made, the balance, I believe, is still in favor of the defendant; in fact, some of his unacknowledged debts have turned out to be compensated for by unclaimed assets.

It is perhaps no accident that the factuality of the Italian Renaissance has been most vigorously questioned by those who are not obliged to take a professional interest in the aesthetic aspects of civilization—historians of economic and social developments, political and religious situations and, most particularly, natural science[5]—but only exceptionally by students of literature, and hardly ever by historians of art.

[1] See below, p. 43 ff.

[2] See the Filarete passage quoted above, p. 20, Note 2. It should be noted that the term *suegliare* has no less definite religious connotations than the term *rinascere* or the light-and-darkness simile; see, for example, Romans 13:11, 12, or the well-known hymn: "Surge, surge, vigila".

[3] Characteristically, the term *renasci* and its vernacular derivatives, more heavily fraught with religious implications than their numerous parallels, seem to have been employed by the Northerners—for whom the Renaissance movement, imported from abroad, was more of a "revelation" producing conversions and filling the souls of the converts with a kind of missionary zeal—even before they became popular in Italy. Here they were, so far as I know, not used until the middle of the fifteenth century. In France, however, *renasci* occurs, not long after Petrarch's death, in the writings of one of his ardent disciples, Nicolas de Clamanges (or Clémanges), born 1355 (see "Simone I", p. 850; A. Coville, *Gontier et Pierre*

Col et l'humanisme en France au temps de Charles VI, Paris, 1934, particularly pp. 99 ff., 140 ff.). In the sixteenth century the verb *renaître* occurs, e.g., in Du Bellay and Amyot (Simone, *ibidem*, p. 860; cf. J. Plattard, "Restitution des bonnes lettres et renaissance", *Mélanges offerts par ses amis et ses élèves à M. Gustave Lanson*, Paris, 1922, p. 128 ff.) while the noun *renaissance* is found, as has been mentioned, in Pierre Belon (see above, p. 17, Note 4). In Germany the verb *renasci* was, significantly, favored by Melanchthon ("Simone I", p. 851) whereas Erasmus preferred other terms such as *repullulascere* or *reviviscere* ("Simone I", p. 856; "Simone III", p. 126).

[4] See especially the contributions of Herbert Weisinger cited above, p. 9, Note 1.

[5] Recently a kind of reaction seems to have set in even among historians of science. George Sarton, for example, who in 1929 considered the Renaissance as "an anticlimax between two peaks" (J. W. Thompson et al., *The Civilization of the Renaissance*,

The student of literature will find it difficult to deny that Petrarch, in addition to "restoring to the waters of Mount Helicon their pristine clarity", set up new standards of verbal expression and aesthetic sensibility as such. It may be a difference in degree when the Christian Neo-Platonism that underlies the entire "Dolce Stil Nuovo" appears more subjective and secular in Petrarch's *Canzoniere* than in Dante's *Vita Nuova* and *Divina Commedia*, the very name of Laura suggesting the glory bestowed by Apollo where Beatrice's suggests the redemption granted by Christ. But it is a difference in kind when Petrarch, in determining the sequence of elements in a sonnet, could base his decision on considerations of euphony ("I thought of changing the order of the first four stanzas so that the first quatrain and the first terzina would have come second and vice versa, but gave it up because then the fuller sound would have been in the middle and the hollower at the beginning and the end") while Dante had analyzed the content of every sonnet or canzone by "parts" and "parts of parts" according to the precepts of scholastic logic.[1] It is quite true that a few bishops and professors climbed mountains long before Petrarch's "epoch-making" ascent of Mont Ventoux; but it is equally true that he was the first to describe his experience in a manner which, depending on whether you like him or not, may be praised as full of sentiment or condemned as sentimental.

Similarly, the art historian, no matter how many details he may find it necessary to revise in the picture sketched out by Filippo Villani and completed by Vasari, will have to accept the basic facts that a first radical break with the mediaeval principles of representing the visible world by means of line and color was made in Italy at the turn of the thirteenth century; that a second fundamental change, starting in architecture and sculpture rather than painting and involving an intense preoccupation with classical antiquity, set in at the beginning of the fifteenth; and that a third, climactic phase of the entire development, finally synchronizing the three arts and temporarily eliminating the dichotomy between the naturalistic and the classicistic points of view, began at the threshold of the sixteenth.[2]

When we compare the Pantheon of *ca.* 125 A.D. with, on the one hand, Our Lady's Church at Trèves of *ca.* 1250 A.D. (one of the very few major central-plan buildings produced by the Gothic age) and, on the other, Palladio's Villa Rotonda of *ca.* 1550 A.D. (Figs. 1–3), we cannot help agreeing with the author of the letter to Leo X who felt that, though the interval of time was longer, the buildings of his age were closer to

Chicago, 1929, p. 75 ff.), stated on the occasion of a Renaissance symposium held in February, 1952 (see above, p. 5, Note 1) that "in the field of science the novelties [introduced by the Renaissance] were gigantic".

[1] T. E. Mommsen, intr., *Petrarch, Sonnets and Songs*, New York, 1946, p. xxvii; cf. E. Panofsky, *Gothic Architecture and Scholasticism*, Latrobe, Pa., 1951, p. 36 f.
[2] See below, p. 202 ff.

those from the time of the Roman emperors than to those from "the times of the Goths":[1] all differences notwithstanding, the Villa Rotonda has more in common with the Pantheon than either of these two structures has in common with Our Lady's at Trèves, and this in spite of the fact that only about three hundred years had passed between Our Lady's at Trèves and the Villa Rotonda, whereas more than eleven hundred had passed between the Pantheon and Our Lady's.

Something rather decisive, then, must have happened between 1250 and 1550. And when we consider two structures erected during this interval in the same decade but on different sides of the Alps—Alberti's Sant'Andrea at Mantua, begun in 1472 (Fig. 4), and the choir of St. Sebaldus at Nuremberg, completed in that very year (Fig. 5)—we strongly suspect that this decisive thing had happened in the fifteenth century and on Italian soil.

We, clever art historians of the twentieth century, may well affirm that Brunelleschi's style was not so sudden a departure from the mediaeval past as it appeared to his contemporaries or near contemporaries. We may point out that San Lorenzo and Santo Spirito are dominated by a general feeling for space more similar to that which prevades some Spanish or South German parish churches than to that which is embodied in the Basilica of Maxentius and that many of Brunelleschi's works reveal the influence of such Romanesque and pre-Romanesque structures as he had seen, from early youth, in his own Tuscany.[2] But the fact remains that Brunelleschian architecture is based on the classical rather than the mediaeval system of proportion (Figs. 6, 7) and conceived in terms of focused rather than what may be called diffused perspective. It is an exaggeration to say that "all influences of classical Rome could be excluded from the early phase of the [Renaissance] style without altering its development",[3] however much the pioneer of this style may have been indebted to the "Tuscan proto-Renaissance". The most recent studies have vindicated the original tradition according to which Brunelleschi's early visit to Rome, disputed or at least postponed by modern critics, took place before he embarked on his career as a practicing architect.[4] And while it may be true that his familiarity with S. Piero Scheraggio, Santi Apostoli, San Miniato, and the Badia of Fiesole prepared him for his experience of the Roman ruins, it may be equally true that his experience of the Roman ruins enabled him—for whom, when he was young, the Gothic of Florence Cathedral and Santa Croce was the living

[1] See above, p. 23, Note 3.

[2] See H. Tietze, "Romanische Kunst und Renaissance", *Vorträge der Bibliothek Warburg*, 1926–1927, p. 43 ff., particularly p. 52 f.

[3] H. Willich, *Die Baukunst der Renaissance in Italien*, as quoted and endorsed by Tietze, *loc. cit.*

[4] P. Sanpaolesi, *La Cupola di Santa Maria del Fiore: Il Progetto, la Costruzione*, Rome, 1941; cf. J. Coolidge's review in *Art Bulletin*, XXXIV, 1952, p. 165 f.

style—to reappreciate the value of San Miniato, S. Piero Scheraggio, Santi Apostoli, and the Badia of Fiesole.

*

WHEN a Venetian forger, operating about 1525–1535, produced what he hoped would pass muster as a Greek relief of the fifth or fourth century B.C., he cleverly combined two figures borrowed from an authentic Attic stele (Greek sculpture being more readily accessible and more highly appreciated in Venice than in Rome or Florence) with superficially disguised variations on two world-famous statues by Michelangelo, the *David* and the *Risen Christ* in S. Maria sopra Minerva (Frontispiece). This is a trivial incident, but one which makes us see, as in a flash, what the Renaissance had accomplished. The works of a great Cinquecento sculptor appeared to his contemporaries as no less classical, if not more classical, than Greek and Roman originals (an analogous role can be shown to have been played, in the North, by the "nude images" of Albrecht Dürer); or, put it the other way, Greek and Roman originals appeared to them as no less modern, if not more modern, than the works of a great Cinquecento sculptor. The Venetian forger relied on the fact that in his age no basic difference was felt between the *buona maniera greca antica* of an Attic relief and Michelangelo's *moderno si glorioso*; and it took four hundred years to separate the ingredients of his compound.[1]

[1] For this relief (first published, but connected only with Michelangelo's *David* and therefore dated somewhat too early, in L. Planiscig, *Venezianische* *Bildhauer der Renaissance*, Vienna, 1921, Fig. 347), see now E. Panofsky, *Meaning in the Visual Arts*, p. 293f., Fig. 88.

CHAPTER II

Renaissance and Renascences

THE FIRST of our preliminary questions may thus be answered in the affirmative: there was a Renaissance "which started in Italy in the first half of the fourteenth century, extended its classicizing tendencies to the visual arts in the fifteenth, and subsequently left its imprint upon all cultural activities in the rest of Europe". There remains the second: can qualitative or structural—as opposed to merely quantitative—differences be shown to distinguish not only this Renaissance from earlier, apparently analogous, revivals but also these earlier revivals from each other? And, if so, is it still justifiable to define the latter as "mediaeval" phenomena?

We all agree that the radical alienation from the Antique that characterizes the high and late phases of what we call the Gothic style—an alienation evident, *exceptis excipiendis*, in every work of art produced north of the Alps after about the middle of the thirteenth and before the end of the fifteenth century and, as will be seen, a prerequisite for the crystallization of the *buona maniera moderna* even in Italy—did not result from a steady decline of classical traditions. Rather it may be said to mark the lowest point on an undulating curve of alternate estrangements and *rapprochements*; and it is precisely because Byzantine art had never reached such a nadir that it would not have achieved a full-scale Renaissance even if Constantinople had not been conquered by the Turks in 1453.[1]

[1] The literature on the revival and survival of classical culture is so extensive that a listing of contributions published in three years (1931–33) fills more than eight hundred pages: *Kulturwissenschaftliche Bibliographie zum Nachleben der Antike, herausgegeben von der Bibliothek Warburg, I, Die Erscheinungen des Jahres 1931,* Leipzig and Berlin, 1934; II (with English title, *A Bibliography of the Survival of the Classics, Edited by the Warburg Institute, The Publications of 1932–1933*), London, 1938; see now F. Heer, "Die 'Renaissance'-Ideologie im frühen Mittelalter", *Mitteilungen des Instituts für Österreichische Geschichtsforschung,* LVII, 1949, p. 23 ff. Even in the comparatively limited field of mediaeval art the flood of publications, beginning with A. Springer's classic "Das Nachleben der Antike im Mittelalter", *Bilder aus der neueren Kunstgeschichte,* 2nd ed., Bonn, 1886, I, p. 1 ff., has swollen to an unmanageable volume; for a useful though naturally incomplete and not too well-organized survey, see the bibliographical section (*Literaturübersicht*) in H. Ladendorf, *Antikenstudium und Antikenkopie, Abhandlungen der sächsischen Akademie der Wissenschaften zu Leipzig,* phil.-hist. Klasse, XLVI, 2, Berlin, 1953, pp. 121–161. I must confine myself to a few hints: C. R. Morey, "The Sources of Mediaeval Style", *Art Bulletin,* VII, 1924, p. 35 ff.;

I

THE first of these *rapprochements* (already "intuited", as will be remembered, by Antonio Manetti) is known as the Carolingian revival or, to use the designation employed in Charlemagne's own circle, the Carolingian *renovatio*.[1] During and after the disruption of the Western Roman Empire, the interrelated and overlapping processes of barbarization, Orientalization and Christianization had led to an almost total eclipse of classical culture in general and classical art in particular. Oases had been left in regions such as Italy, North Africa, Spain and South Gaul, where we can observe the survival of what has nicely been termed a "sub-antique" style; and in at least two centers we even find what amounts to revivals as opposed to survival. Determined efforts to assimilate Latin models were made in England, which produced, for example, the *Codex Amiatinus* and, in sculpture, the Crosses of Ruthwell or Bewcastle, and where the classical tradition was always to remain a force both more persistent and more self-conscious (either in the sense of purism or in the sense of romanticism) than was the case on the Continent. And a kind of Greek or Early Byzantine revival, apparently caused or at least promoted by the influx of artists fleeing from Arabic conquest or iconoclastic persecution, took place in seventh- and eighth-century Rome, whence it spread, to some extent, to other parts of the peninsula.[2] But precisely those regions which were to form the nucleus of

H. Beenken, "Die Mittelstellung der mittelalterlichen Kunst zwischen Antike und Renaissance", *Medieval Studies in Memory of A. Kingsley Porter*, Cambridge (Mass.), 1939, I, p. 47 ff.; D. Miner, "The Survival of Antiquity in the Middle Ages", *The Greek Tradition*, G. Boas, ed., Baltimore, 1939, p. 55 ff.; H. von Einem, "Die Monumentalplastik des Mittelalters und ihr Verhältnis zur Antike", *Antike und Abendland*, III, 1948, p. 120 ff.; H. Schnitzler, *Mittelalter und Antike*, Munich, 1949; W. Paatz, "Renaissance oder Renovatio?", p. 16 ff.; B. Schweitzer, *Die spätantiken Grundlagen der mittelalterlichen Kunst* (Leipziger Universitätsreden, XVI), Leipzig, 1949; *idem*, "Die europäische Bedeutung der römischen Kunst", *Vermächtnis der antiken Kunst, Gastvorträge zur Jahrhundertfeier der archäologischen Sammlungen der Universität Heidelberg*, R. Herbig, ed., Heidelberg, 1950, p. 141 ff.; R. H. L. Hamann MacLean, "Antikenstudium in der Kunst des Mittelalters", *Marburger Jahrbuch für Kunstwissenschaft*, XV, 1949–1950, p. 157 ff. (with good bibliography). In spite of the topographical limitations expressed in its title, the excellent study by J. Adhémar, *Influences antiques dans l'art du moyen âge français; Recherches sur les sources et les thèmes d'inspiration* (Studies of the Warburg Institute, VII), London, 1939, deserves to be counted as a general discussion of the problem. For Byzantine art, see the brilliant summary by K. Weitzmann, "Das klassische Erbe in der Kunst Konstantinopels", *Alte und neue Kunst, Wiener kunstwissenschaftliche Blätter*, III, 1954, p. 41 ff. For special periods and problems, see the following Notes.

[1] See P. E. Schramm, *Kaiser, Rom und Renovatio* (Studien der Bibliothek Warburg, XVII), Leipzig and Berlin, 1929. For the terminology, see also "Simone, II" (particularly the passages from Alcuin), p. 180 f., and Heer, *op. cit.*, *passim*, particularly pp. 31 f., 80. So far as I know, the Carolingians, while using *renovare* and *redintegrare* in a general way, reserved *renasci* for the religious sphere even though earlier writers had referred to the periodical, phoenix-like rejuvenation of Rome itself in such terms as *Roma renascens* or *Troia renascens*. The expressions used by the humanists of the fourteenth, fifteenth and sixteenth centuries do not seem to occur in Carolingian writing.

[2] I borrow the term "sub-antique" from the excellent survey by E. Kitzinger, *Early Mediaeval Art in the British Museum*, London, 1940, p. 8 ff. For the Ashburnham Pentateuch and the *Codex purpureus* in Munich (clm. 23631), see C. R. Morey, *Early Christian Art*, Princeton, 1942, pp. 174 ff., 222 (2nd

43

the Carolingian Empire—the northeast of France and the west of Germany—represented, from the classical point of view, a kind of cultural vacuum.

As happens so often in history (suffice it to remember the formation of the Gothic style in the thus far comparatively unproductive Ile-de-France or that of both the High Renaissance and the Early Baroque in Rome, where none of the great masters was either born or trained), it was in this very vacuum that there occurred a conflux and fusion of forces which resulted in a new synthesis: the first crystallization of a specifically Northwest European tradition. And chief among these forces was a deliberate attempt to reclaim the heritage of Rome, "Rome" meaning Julius Caesar and Augustus as well as Constantine the Great. When Charlemagne set out to reform political and ecclesiastical administration, communications and the calendar, art and literature, and—as a basis for all this—script and language (the documents emanating from his own chancellery during the early years of his regime still tend to be very illiterate), his guiding idea was the *renovatio imperii romani.* He had to invite a Briton, Alcuin, as his chief adviser in cultural matters (just as his grandson Charles the Bald had to enlist the help of an Irishman, John the Scot, to obtain a satisfactory translation of Dionysius the Pseudo-Areopagite's Greek); but all these efforts served, to use the contemporary phrase, to bring about an *aurea Roma iterum renovata.*

The reality and magnitude of this movement cannot be questioned. During the seventh and eighth centuries, when even in England a man as cultured as Aldhelm of Malmesbury (*ca.* 640–709) attacked pagan religion and mythology as furiously as any Tertullian or Arnobius, and when the content of Homer and Virgil, already trivialized by "Dictys" and "Dares" into what has been called "des procès-verbaux", was

ed., Princeton, 1953, pp. 174ff., 228); A. Boinet, *La Miniature Carolingienne,* Paris, 1913, Plate I. For the Cambridge Gospels (probably written in North Italy but transferred to England about 700 at the latest), see the admirable new publication by F. Wormald, *The Miniatures in the Gospels of St. Augustine (Corpus Christi College Ms. 286),* Cambridge, 1954. For the seventh-century copy of an herbal known as "Pseudo-Apuleius", probably written in South France and now preserved in the University Library at Leiden (Cod. Voss. Lat. quart. 9), see K. Weitzmann, *Illustrations in Roll and Codex,* Princeton, 1947 p. 135. For the *Codex Amiatinus,* see E. H. Zimmermann, *Vorkarolingische Minaturen,* Berlin, 1916, Plate 222*, Fig. 24; A. Boeckler, *Abendländische Miniaturen bis zum Ausgang der romanischen Zeit,* Berlin and Leipzig, 1930, p. 19f., Plate 12; E. A. Lowe, *Codices Latini Antiquiores,* Oxford, 1934 ff., III, pp. 8 (No. 299), 43. For pre-Carolingian English art in general, see F. Saxl and R. Wittkower, *British Art and the*

Mediterranean, London, New York and Toronto, 1948, p. 14ff. (for the Ruthwell Cross in particular, see F. Saxl, "The Ruthwell Cross", *Journal of the Warburg and Courtauld Institutes,* VI, 1943, p. 17ff.; M. Schapiro, "The Religious Meaning of the Ruthwell Cross", *Art Bulletin,* XXVI, 1944, p. 232ff.). For pre-Carolingian art on the Continent, see W. Holmqvist, *Kunstprobleme der Merowingerzeit (Kungl. Vitterhets Historie och Antikvitets Akademiens Handlingar,* XLVII), Stockholm, 1939; idem, *Germanic Art in the First Millennium A. D.* (*ibidem,* XC), Stockholm, 1955. Cf. also *Werdendes Abendland an Rhein und Ruhr. Ausstellung in Villa Hügel, Essen, May 18–Sept. 15, 1956,* Essen, 1956. The superb survey of early medieaeval painting by Grabar and Nordenfalk (A. Grabar and C. Nordenfalk, *Early Medieval Painting from the Fourth to the Eleventh Century,* Lausanne, 1957) appeared just in time to be cited but too late to be used for the correction of my errors.

dragged down to an almost infantile level in the anonymous *Excidium Troiae*,[1] few Roman poets and even fewer Roman prose writers were copied: a statistical survey of palimpsests in which the upper as well as the lower script antedates the year 800 has shown that in at least twenty-five of forty-four cases orthodox religious texts were superimposed upon secular Latin texts, whereas—in significant contrast to the practice of subsequent centuries—the opposite occurs only twice.[2] Today we can read the Latin classics in the original largely because of the enthusiasm and industry of Carolingian scribes.

Nor can it be doubted that the employers and advisers of these scribes learned their lesson well. Their often excellent verses in classical meters fill four fat volumes of the *Monumenta Germaniae Historica*, and their ear became astonishingly sensitive to the refinements of Latin prose. Thanks to Charlemagne, writes the greatest representative of Carolingian scholarship, Lupus of Ferrières (a man who collated and corrected classical texts with an acumen akin to that of a modern philologist), to Eginhard, the biographer of the great emperor, studies had raised their heads; now (meaning under Louis the Pious, whose reign struck Lupus as an anticlimax after the fervent beginnings) they are disparaged again so that writers "begin to stray from that dignity of Cicero and the other classics which the best of the Christian authors sought to emulate".[3]

[1] For Aldhelm of Malmesbury, see M. Manitius, *Geschichte der lateinischen Literatur des Mittelalters*, Munich, 1911–1931, I, p. 134; F. J. E. Raby, *A History of Christian-Latin Poetry from the Beginnings to the Close of the Middle Ages*, 2nd ed., Oxford, 1953, p. 142 ff.; E. R. Curtius, *Europäische Literatur und lateinisches Mittelalter*, Bern, 1948 (English translation: *European Literature and the Latin Middle Ages* [Bollingen Series, XXXVI], New York, 1953), pp. 53, 454 f. and *passim*. In a letter to his pupil Wilfrid, who was preparing to go "overseas" (*Patrologia Latina*, LXXXIX, col. 101 f.), Aldhelm enjoins him not to have anything to do with all such horrors as the incest of Persephone, the bigamy of Hermione, the Luperci with their Bacchic rites, etc., but to stick to Christian discipline; and in his *De laudibus virginum* he devotes a whole section to classical mythology, investing every character with a negative connotation (*ibidem*, cols. 261–262). I have not been able to discover a passage said to equate Hercules with Samson (mentioned by Manitius as well as Curtius, p. 224, but without reference); Aldhelm had, in fact, a very low opinion of Hercules and does not mention him when citing Samson in the *De laudibus* (col. 154). For "Dictys" (probably fourth century) and "Dares" (probably sixth century), see Curtius, *op. cit.*, particularly p. 181 f.; Jean Seznec, *The Survival of the Pagan Gods* (Bollingen Series, XXXVIII), New York, 1953, p. 19 f.; E. B. Atwood and V. K. Whitaker, eds., *Excidium Troiae*, Cambridge, Mass., 1944, Introduction. The earliest manuscript of the *Excidium* which has come down to us (unillustrated) is of the late ninth century; but the text must have been composed at a considerably earlier time. For the problem of its illustration, see below, p. 83, Note 1.

[2] See E. Chatelain, "Les Palimpsestes latins", *Annuaire de l'Ecole Pratique des Hautes Etudes, Section des Sciences Historiques et Philologiques*, Paris, 1904, p. 5 ff. The numerical data given in my text are based upon Lowe's *Codices Latini Antiquiores* and have been analyzed by an expert in statistics whose evaluation resulted in the statement that, without bias on the part of the scribes, the probability of the observed distribution's being accidental is extremely low (roughly one chance in 10^{13}).

[3] For Lupus of Ferrières, see C.-H. Beeson, *Lupus of Ferrières as Scribe and Text Critic; A Study of His Autograph Copy of Cicero's "De oratore"*, Cambridge (Mass.), 1930; further, E. Auerbach, "Lateinische Prosa des 9. und 10. Jahrhunderts (*Sermo humilis, II*)", *Romanische Forschungen*, LXVI, 1955, p. 1 ff. The letter referred to in the text was probably written shortly before 836 and is reprinted in *Patrologia Latina*, CXIX, col. 431 ff. The pertinent passages read as

45

In Eginhard's work—epoch-making indeed in that it aimed at a revival of biography as a fine art, taking Suetonius' *Lives of the Emperors* as a model instead of indulging in simple-minded accumulation of alleged facts and no less simple-minded eulogy—Lupus still finds that "elegance of thought, that exquisiteness in the connection of ideas", which he admires in the classical writers (for him *auctores* pure and simple).

In art, the "back-to-Rome" movement had to compete with orientalizing tendencies on the one hand and insular influence on the other; for the same British Isles which had been so important as a refuge of the classical tradition in pre-Carolingian times had simultaneously produced that antinaturalistic, "Celto-Germanic" linearism, either violently expressive or rigidly geometrical, which was to counteract and ultimately to triumph over this classical tradition. On the Carolingian continent, however, these opposing forces stimulated rather than weakened the energies of the *renovatio* movement.

Charlemagne's palace chapel in Aix-la-Chappelle is, in a general way, modeled upon the pattern of Justinian's San Vitale at Ravenna; but it received a west front suggested by Roman city gates, and its exterior was enlivened not by oriental blind arcades as in San Vitale but by Corinthian pilasters of self-consciously classical cast. In the porch at Lorsch (Fig. 8) the polychromatic facing of the walls conforms to pre-Carolingian tradition; but its structural conception—not to mention the capitals of the pilasters, which evince the same classicizing spirit as do those of the palace chapel in Aix—harks back to the Arch of Constantine and, possibly, the Colosseum. The idea of incorporating towers with the basilica, so fundamentally important for the development of high-mediaeval church architecture, originated, it seems, in Asia Minor; but the plan of the basilica itself was revised *romano more*, that is to say, after the fashion of St. Peter's, St. Paul's and St. John in the Lateran. As Richard Krautheimer has shown,[1]

follows: "Amor litterarum ab ipso fere initio pueritiae mihi est innatus, nec earum, ut nunc a plerisque vocantur, superstitiosa otia fastidio sunt. Et nisi intercessisset inopia praeceptorum, et longo situ collapsa priorum studia pene interissent, largiente Domino meae aviditati satisfacere forsitan potuissem. Siquidem vestra memoria per famosissimum imperatorem Carolum, cui litterae eo usque deferre debent ut aeternam ei parent memoriam, coepta revocari, aliquantum quidem extulere caput, satisque constitit veritate subnixum praeclarum dictum: *Honos alit artes, et accenduntur omnes ad studia gloriae.* Nunc oneri sunt qui aliquid discere affectant; ... Sic quoniam a grammatica ad rhetoricam et deinceps ordine ad caeteras liberales disciplinas transire hoc tempore fabula tantum est, cum deinde auctorum voluminibus spatiari aliquantulum coepissem, et dictatus nostra aetate confecti displicerent, propterea

quod ab illa Tulliana caeterorumque gravitate, quam insignes quoque Christianae religionis viri aemulati sunt, oberrarent, venit in manus meas opus vestrum, quo memorati imperatoris clarissima gesta (liceat mihi absque suspicione adulationis dicere) clarissime litteris allegastis. Ibi elegantiam sensuum, ibi raritatem conjunctionum, quam in auctoribus notaveram, ibidemque non longissimis periodis impeditas et implicitas ac modicis absolutas spatiis sententias inveniens, amplexus sum".

[1] R. Krautheimer, "The Carolingian Revival of Early Christian Architecture", *Art Bulletin*, XXIV, 1942, p. 1 ff. For other recent contributions to Carolingian architecture, see the instructive critical bibliography, covering the period from 1928 to 1954, by K. E. Kubach, "Die vorromanische und romanische Baukunst in Mitteleuropa", *Zeitschrift für Kunstgeschichte*, XIII, 1951, p. 124 ff.; XVII, 1954, p. 157 ff. Cf. also

Constantinian edifices were, from the Carolingian architects' point of view, no less but perhaps even more "classical" than the Pantheon or the Theater of Marcellus—just as *Tulliana gravitas* was found and greeted in the Christian Fathers by Lupus of Ferrières.

In the decorative and representational arts the spirit of "aurea Roma iterum renovata" loomed even larger than in architecture. The Oriental component having been all but neutralized by the beginning of the ninth century, the *modus operandi* of painting, carving and goldsmithery was determined by two powerful influences: that of the British Isles and that of contemporary Italy where, as has been mentioned, the seventh and eighth century saw an artistic efflorescence doomed to be eclipsed by the very movement which it helped to produce in the North.[1] Both these influences, however, were vigorously challenged by a third, that of classical antiquity. Drawing from all the sources that were accessible to them both physically and psychologically, the Carolingian masters resorted to Roman as well as Early Christian and "sub-antique" prototypes, book illuminations as well as reliefs in stone and stucco, ivory carvings as well as cameos and coins; for, as in architecture, no fundamental distinction was made between the pagan and the Christian Antique. But the very intensity and universality of their endeavor enabled them to develop, with surprising speed, a sense of discrimination as to the quality of their "material" and a certain ease and freedom in its exploitation.

In ornamental borders or initials classical motifs—the egg-and-dart pattern, the

L. Birchler, E. Pelichet, and A. Schmid, eds., *Frühmittelalterliche Kunst in den Alpenländern* (*Art du Haut Moyen Age dans la Région Alpine; Arte dell'alto Medio Evo nella regione Alpina*), Akten zum III. Internationalen Kongress für Frühmittelalterforschung, Olten and Lausanne, 1954 (Review by R. Krautheimer in *Art Bulletin*, XXXVIII, 1956, p. 130 ff.).

[1] For the Carolingian revival in the representational arts, see (in addition to the general literature referred to above, pp. 5, 9, Notes 4, 1): R. Hinks, *Carolingian Art*, London, 1935. To be added: E. Panofsky, *Die karolingische Renaissance*, Vienna, 1924; S. Singer, "Karolingische Renaissance", *Germanisch-Romanische Wochenschrift*, XIII, 1925, p. 187 ff.; W. Köhler, "An Illustrated Evangelistary of the Ada School and Its Model", *Journal of the Warburg and Courtauld Institutes*, XV, 1952, p. 48 ff.; E. Rosenthal, "Classical Elements in Carolingian Illustration", *Bibliofilia*, LV, 1953, p. 85 ff. For the Italian—or, if you will, Graeco-Italian—prelude to the Carolingian Renaissance in the North, see M. Schapiro's review of K. Weitzmann's *The Fresco Cycle of S. Maria di Castelseprio* in *Art Bulletin*, XXXIV, 1952, p. 147 ff., especially p. 162 f.; cf. also D. Tselos, "A Greco-Italian School of Illuminators and Fresco Painters; Its Relations to the Principal Reims Manuscripts and to the Greek Frescoes in Rome and Castelseprio", *Art Bulletin*, XXXVIII, 1956, p. 1 ff.; E. Rosenbaum, "The Evangelist Portraits of the Ada School and Their Models", *Art Bulletin*, XXXVIII, 1956, p. 81 ff. This initial superiority of Italy may explain why Ingobert, the scribe and, very probably, the illustrator of the Bible of San Paolo fuori Le Mura (A. Boinet, *op. cit.*, Plates CXXI–CXXX; for the date, cf. E. H. Kantorowicz, "The Carolingian King in the Bible of San Paolo fuori Le Mura", *Late-Classical and Mediaeval Studies in Honor of A. M. Friend, Jr.*, Princeton, 1955, p. 287 ff.), takes pride in the fact that his work equals or even surpasses that of the Italians (*Monumenta Germaniae Historica, Poetae Latini Aevi Carolini*, III, p. 259: "Ingobertus eram referens et scriba fidelis / Graphidas Ausonios aequans superansve tenore")—a statement diffïcult to reconcile with the artistic situation of the seventh decade of the ninth century and, therefore, possibly inspired by the lingering memory of a phase preceding the great efflorescense of Northern art under Charlemagne and his successors.

palmette, the vine *rinceau* and the acanthus—began to reassert themselves against the abstract interlaces and schematized animal patterns of insular and "Merovingian" art; and in the illustrative rendering of figures and things a first determined effort was made to recapture that affirmative attitude toward nature which had been characteristic of classical art. The more progressive masters attempted to do justice to the human body as an organism subject to the laws of anatomy and physiology, to space as a three-dimensional medium—in at least one case a Carolingian illuminator anticipated the Dugento and Trecento in appropriating from an Early Christian model a genuine interior with a reasonably well-foreshortened ceiling[1] (Fig. 94)— and to light as that which determines the surface appearance of solid bodies. In short, they sought a kind of verisimilitude which had long been absent from the West European scene.

The Anglo-Saxon schools had been at their best not when attempting to rival the lingering naturalism of Late Mediterranean art but when reducing the figure as well as its environment to a superbly disciplined pattern of planes and lines; only exceptionally did these opposites coincide in such insular manuscripts as a late eighth-century Gospel book in the Vatican Library or, above all, the famed *Codex aureus* at Stockholm.[2] And when the continental illuminators, capable of rivaling the best of goldsmith's work in such marvels of abstract design and glowing color as the frontispiece of the mid-eighth-century *St. Augustine* in the Bibliothèque Nationale (Fig. 9), ventured into the field of descriptive representation the results were as unsatisfactory, not to say ludicrous, as the Evangelists' figures in the exactly contemporary Gundohinus Gospels of 754 (Fig. 10).[3]

[1] Bible of Moutier-Grandval, London, British Museum, MS. Add. 10546, fol. 25 v.; Boinet, *op. cit.*, Plate XLIV; Kitzinger, *op. cit.*, Plate 20; W. Köhler, *Die karolingischen Miniaturen; Die Schule von Tours*, Berlin, 1930–1933, I, pp. 194 ff., 386 ff,, Pl. 51. Cf. G. J. Kern, "Die Anfänge der zentralperspektivischen Konstruktion in der italienischen Malerei des 14. Jahrhunderts", *Mitteilungen des Kunsthistorischen Institutes in Florenz*, II, 1912, p. 39 ff., particularly p. 56 f., Fig. 15; E. Panofsky, "Die Perspektive als symbolische Form", *Vorträge der Bibliothek Warburg*, 1924–1925, p. 258 ff., particularly p. 311, Fig. 15. For the limitations of this, and some other, attempts at reviving linear perspective in Carolingian art, see below, p. 30.

[2] For the Vatican Gospels (MS. Barb. lat. 570), see Lowe, *Codices Latini Antiquiores*, I, pp. 20 (No. 63), 41; illustrations are found in Zimmermann, *op. cit.*, Plates 313–317. For the Stockholm *Codex aureus* (Royal Library, MS. A. 135), see Zimmermann, *ibidem*, Plates 204, 280–286; Boeckler, *Abendländische*

Miniaturen, p. 21, Plate 13; and the recent article by C. Nordenfalk, "A Note on the Stockholm Codex Aureus", *Nordisk Tidskrift för Bok- och Biblioteksväsen*, XXXVIII, 1951, p. 145 ff.

[3] For the Paris *St. Augustine* (Bibliothèque Nationale, MS. lat. 12108), see Lowe, *Codices Latini Antiquiores*, V, pp. 32 (No. 630), 60; Zimmermann, *op. cit.*, Plates 146, 148, 149; Boeckler, *op. cit.*, p. 13. A reproduction in color is found in T. Porcher, ed., *Bibliotheque Nationale, Les Manuscrits à peintures en France du VII^e au XII^e siècle*, Paris, 1954, No. 12, Color Plate A. For the Gundohinus Gospels (Autun, Bibliothèque Municipale, MS. 3), see Lowe, *op. cit.*, VI, Oxford, 1953, pp. 5 (No. 716), 42; Zimmermann, Plates 78–84; Boeckler, pp. 13, 106, Plate 6; and the exhibition catalogue of 1954, No. 7. E. Rosenthal, *op. cit.*, p. 87, points out that the miniatures in the Gundohinus Gospels deserve "not only censure for their ineptness but also thorough research". Since they are almost unique as major attempts at figural representation on the pre-Carolingian Continent,

Compared with these Evangelists, those in the Vienna "Schatzkammer-Evangeliar", the chief product of what is often called the "Palace School" of Charlemagne (Fig. 11), give an impression so deceptively antique that they have been ascribed to artists from Byzantium; so vigorous is the modeling of the bodies beneath their white draperies, so gracefully are they posed in front of what has been called impressionistic landscapes.[1] The mythological characters that represent the planets and constellations in such *Aratea* manuscripts as the *Codex Vossianus Latinus* 79 in the University Library at Leiden (Fig. 12)[2] might have stepped out of a Pompeian mural. And the airy landscapes in the Utrecht Psalter of 820–830, organized in depth by undulating mountain ranges, dotted with buildings *all'antica* and feathery, light-dissolved trees, alive with bucolic or ferocious animals and teeming with classical personifications, are reminiscent of the wall paintings and stucco reliefs in Roman villas and palaces (Figs. 13–16).[3]

this is very true but does not alter the fact that they evince a downright incompetence which modern art historians are reluctant to admit. To call them "expressive" would not have been possible before an extremist interpretation of Riegl's *Kunstwollen*, aided and abetted by psychologists and educators, began to treat the art of children and madmen *pari passu* with modes of expression labeled "primitive" but perfectly adult, sane and even sophisticated. At the Paris exhibition, where the Gundohinus manuscript was exhibited in close proximity to the *St. Augustine*, it became evident that the latter, legitimately measured by its own standards, has style; whereas the former, legitimately measured by any standard, has none. Modern art historians are apt to overlook that, *Kunstwollen* or no, every individual and every period may produce works which are bad *per se*, and not *secundum quid*.

[1] See Boinet, *op. cit.*, Plates LVIII–LIX; Hinks, *op. cit.*, p. 138 ff.; Boeckler, *Abendländische Miniaturen*, p. 27 ff., Plate 18. The Byzantine origin of the illuminators was cautiously endorsed by A. Goldschmidt, *German Illumination*, Florence and New York, 1921, I, p. 9 f., Plates 21, 22. For the contested date and origin of the St. Matthew miniature in Brussels, Bibliothèque Royale, MS. 18723, see H. Swarzenski, "The Xanten Purple Leaf and the Carolingian Renaissance", *Art Bulletin*, XXII, 1940, p. 7 ff.; cf. now Tselos, *op. cit.*, p. 20 ff.

[2] For this famous manuscript (published by Hugo Grotius, with illustrations engraved by Jacob de Gheyn, as early as 1600), its relatives (particularly British Museum, MS. Harley 647, perhaps originally owned by Lupus of Ferrières and in certain respects even more "Pompeian" in style than the *Leidensis*

Vossianus) and its later derivatives, see J. Thiele, *Antike Himmelsbilder*, Berlin, 1898; F. Saxl, *Verzeichnis astrologischer und mythologischer illustrierter Handschriften des lateinischen Mittelalters in römischen Bibliotheken* (*Sitzungsberichte der Heidelberger Akademie der Wissenschaften*, phil.-hist. Klasse, VI, 1915), pp. xvi ff., 4 ff., 103; E. Panofsky and F. Saxl, "Classical Mythology in Mediaeval Art", *Metropolitan Museum Studies*, IV, 2, 1933, pp. 228 ff., F. Saxl and H. Meier (H. Bober, ed.), *Catalogue of Astrological and Mythological Illuminated Manuscripts of the Latin Middle Ages*, I, London, 1953, pp. xiii ff. and *passim*; J. Seznec, *op. cit.*, p. 151 ff.; H. Swarzenski, *Monuments of Romanesque Art, The Art of Church Treasures in Northwestern Europe*, London, 1954, p. 50, Figs. 156–158; Rosenthal, *op. cit.*, Figs. 1 and 2 (interesting juxtaposition of the Twins in the *Leidensis Vossianus* and a Pompeian Apollo).

[3] For the Utrecht Psalter (reproduced *in toto* by E. T. DeWald, *The Illustrations of the Utrecht Psalter*, Princeton, 1932), see the recent pamphlet (unfortunately not considered by Tselos, *op. cit.*) by F. Wormald, *The Utrecht Psalter*, Utrecht, 1953, where the importance of Roman stucco reliefs for the "impressionistic" treatment of the scenery is stressed; for an interesting parallel with other classical reliefs, particularly the *Tabulae Iliacae*, cf. Rosenthal, *op. cit.*, Figs. 12, 13. Yet the main source of inspiration must be sought in late fourth- and early fifth-century book illumination (for a particularly instructive parallel compare the group on fol. 14, identified as an Allegory of the Church in D. Panofsky, "The Textual Basis of the Utrecht Psalter Illustrations", *Art Bulletin*, XXV, 1943, p. 50 ff., Fig. 18, with the Theano group in the Milan *Iliad*, illustrated, e.g., in Morey, *Early*

To mention mythological characters and classical personifications is to hint at what is, from our point of view, perhaps the most important aspect of the Carolingian *renovatio*. Personifications of localities, natural phenomena, human emotions, and abstract concepts as well as such familiar products of classical imagination as Victories, *putti*, Tritons, and Nereids had continued to play their role in Early Christian art up to the beginning of the seventh century. Then, however, they had disappeared from the scene, and it was left to the Carolingian artists not only to reinstate this interrupted tradition but also to make fresh excursions into the realm of Graeco-Roman iconography. Book illuminators reproduced, in addition to the illustrations of Prudentius' *Psychomachia* (where the warfare between the Virtues and the Vices is represented after the fashion of Roman battle scenes and Luxury appears in the guise of Venus accompanied by Jest and Cupid), innumerable pictures of an unadulteratedly secular character: the miniatures found in scientific treatises on botany, zoology, medicine, or the insignia of Roman public offices; in the *Comedies* of Terence and the *Fables* of Aesop; in calendars and encyclopaedias (Figs. 17–19); and, above all, in those astronomical manuscripts, just mentioned, which more than any other single source served to transmit to posterity the genuine effigies of the pagan gods and heroes that had lent their names to the celestial bodies. Ivory carvers, gem cutters and goldsmiths assimilated classical models of all kinds, thus furnishing further material to the illuminators, while, on the other hand, freely appropriating the latter's designs.

Thus Carolingian art acquired a rich and authentic vocabulary of what I shall henceforth refer to as classical "images": figures (or groups of figures) classical not only in form—this, needless to say, applies to numberless motifs handed down by the Antique to Early Christian art and thus held in readiness for the Carolingian revival— but also in significance. And it is characteristic of the Carolingian *renovatio* that these classical "images", including the *dramatis personae* of the pastoral and the divinities of the pagan pantheon, were given liberty to escape from their original context without

Christian Art, Fig. 39). It should be noted, in particular, that a "pictorial" relief composition like the much-debated "Seaport Sarcophagus" in the Vatican (W. Amelung, *Die Sculpturen des Vaticanischen Museums*, Berlin 1903, II, Pl. 5), which in such details as the animated seascope in the foreground and the "Triumphal Arch of Ostia" in the right-hand background amazingly anticipates the Utrecht Psalter (fols. 38v. and 55v.), is hardly imaginable without a painted prototype; that late-antique illumination frequently exhibits an "impressionistic" treatment of accessories, especially the foliage of trees (see, e.g., the Vatican *Virgil* and, above all, the "Quedlinburg *Itala*" in Berlin, H. Degering and A. Boeckler, *Die Quedlinburger Italafragmente*, Berlin 1932); and that the use of pure line drawing as a medium may have been suggested by the Psalter's Early Christian model itself. There is good evidence to show that the *Chronograph of 354* was illustrated in this unambitious technique (see H. Stern, *Le Calendrier de 354; Etudes sur son texte et ses illustrations*, Paris, 1953), specimens of which survive in three examples of the sixth century, the most important being the *Codex Arcerianus* in Wolfenbüttel (Landesbibliothek, MS. 2403, illustrated in Stern, Plate LV, 2, and H. Swarzenski, "The Xanten Purple Leaf", Fig. 7). For the Prudentius manuscripts, see R. Stettiner,

abandoning their original nature. In at least one case—and there may have been many more—a Carolingian *ivoirier* decorated the case and handle of a flabellum (a liturgical fan used to keep the flies away from the priest when saying Mass) with scenes from Virgil's *Eclogues* hardly susceptible to an *interpretatio christiana*. Some of the arches that enframe the Canon Tables and Evangelists' portraits in the Gospel Book of Ada, the putative sister of Charlemagne, are adorned with what may be called fascimiles of Roman cameos unchanged in iconography.[1] And according to the most recent investigations it was in the Carolingian period that classical personifications—such as the Sun on his chariot drawn by four horses, the Moon on her chariot drawn by two oxen, the Ocean represented in the guise of the river-god Eridanus, the Earth nursing two infants or reptiles, Atlas or Seismos shaking "the foundations of the earth"—were permitted not only to proliferate in illustrations of the Octateuch and the Psalter (where they had played a rather modest role in Early Christian art) but also to invade

Die illustrierten Prudentius-Handschriften, Berlin, 1895, 1905; for medical and botanical manuscripts, e.g., C. J. Singer, *Studies in the History and Method of Science*, Oxford, 1917–1921, and K. Sudhoff, ed., *Archiv für Geschichte der Medizin und der Naturwissenschaften*, Leipzig, 1908–1943; for bestiaries, H. Woodruff, "The Physiologus of Bern", *Art Bulletin*, XII, 1930, p. 2 ff.; for the treatise known as *Notitia dignitatum Imperii Romani*, see H. Omont, ed., *Notitia dignitatum Imperii Romani* (*Paris, Bibliothèque Nationale, MS. lat. 9661*), Paris, 1911; *idem*, "Le plus ancien Manuscrit de la Notitia dignitatum", *Mémoires de la Société Nationale des Antiquaires de France*, LI, 1891, p. 225 ff.; P. Schnabel, "Der verlorene Speirer Codex des Itinerarium Antonini, der Notitia Dignitatum und anderer Schriften", *Sitzungsberichte der preussischen Akademie der Wissenschaften*, phil.-historische Klasse, XXIX, 1926, p. 242 ff. (I am grateful to Professor Francis Wormald for kindly informing me that the fragment of the earliest extant copy, described in Omont's article of 1891, produced in 1427, thus antedating the Paris manuscript by some twenty years, and listed as unlocatable since then, is now in his possession); for the *Comedies* of Terence, L. W. Jones and C. R. Morey, *The Minatures of the Manuscripts of Terence*, Princeton, 1930–1931; for Aesop's *Fables*, A. Goldschmidt, *An Early Manuscript of the Aesop Fables of Avianus and Related Manuscripts*, Princeton, 1947; for the *Chronograph of 354* and its Carolingian copy, the *Codex Luxemburgensis* (now lost but still known to Peiresc), Stern, *op. cit.*; for encyclopaedias, A. M. Amelli, *Miniature sacre e profane dell'anno 1023 illustranti l'Enciclopedia medioevale di*

Rabano Mauro, Monte Cassino, 1896 (cf. Panofsky and Saxl, "Classical Mythology in Mediaeval Art", pp. 250, 258, Panofsky, *Studies in Iconology*, p. 76, and Seznec, *op. cit.*, p. 166); for the flabellum of Tournus, L. E. A. Eitner, *The Flabellum of Tournus* (*Art Bulletin Supplement*, I), New York, 1944.

[1] For simulated classical cameos in manuscripts of the so-called Ada group, see, apart from the St. Luke page in the Ada Gospels itself (Trèves, Stadtbibliothek, MS. 22, illustrated, e.g., in Boinet, *op. cit.*, Plate VIII; Hinks, *op. cit.*, Plate 13; Boeckler, *Abendländische Miniaturen*, Plate 15), the instances reproduced in Boinet, Plates XV, XVII, XIX, XXI–XXIII, and Goldschmidt, *German Illumination*, Plates 33, 38, 40, 43. It should be noted, however, that these cameos tend to be gradually Christianized in later manuscripts belonging to, or deriving from, the same tradition. For what may be called a partial Christianization, see, e.g., the St. John page in the Gospels, British Museum, MS. Harley 2788 (Boinet, Plate XIII; Goldschmidt, *German Illumination*, Plate 37), or a canon arch in the Gospels from St.-Médard in Soissons, Paris, Bibliothèque Nationale, MS. lat. 8850 (Goldschmidt, *ibidem*, Plate 31), where the simulated cameo in the apex of the arch seems to show the Annunciation. For complete Christianization, see. e.g., the Gospels of St. Gumbert in the University Library at Erlangen, MS. 141 (Boinet, Plate XXIV; Goldschmidt, *ibidem*, Plate 58) or the so-called *Codex Wittechindeus* in the Berlin Staatsbibliothek, Cod. Theol. Lat. Fol. 1 (Boinet, Plate XXV; Goldschmidt, *ibidem*, Plate 60).

51

the Passion of Christ, where, so far as we know, they had not been tolerated before at all (Fig. 20).[1]

This Carolingian revival, virtually ended with the death of Charles the Bald in 877, was followed by eight or nine decades that have been called "as barren as the seventh century". This judgment, chiefly reflecting the art historian's point of view, has lately been challenged. What may be described as the dark age within the "Dark Ages" has justly been credited not only with a number of important agricultural and technical improvements (mutually interrelated with an enormous and necessary increase in population) but also with noteworthy achievements in music and literature: in music, the acceptance of bowed instruments, a novel system of notation and a mistaken but fruitful theory of modes; in literature, apart from several beautiful hymns, Hrotsvitha of Gandersheim's touching attempts to place Terence in the service of monastic learning and morality, the very personal chronicles and memoirs of Liutprand of Cremona, and the even more personal outpourings of a man like Rather of Lobbes (or Verona).[2]

These achievements, however, must be regarded as positive aspects of a negative or regressive development, as a kind of reaction against the Carolingian *renovatio*

[1] For classical personifications of nature in the Utrecht Psalter, see DeWald, *op. cit.* (Index), and Wormald, *The Utrecht Psalter*, p. 11, correctly emphasizing the fact that some of them, e.g., the river-gods, were borrowed from the *Aratea* manuscripts referred to above, p. 49, Note 2; it is interesting that the Stuttgart Psalter, probably executed at about the same time as the Utrecht Psalter (E. T. DeWald, *The Stuttgart Psalter, Biblia Folio 23, Württembergische Landesbibliothek, Stuttgart*, Princeton, 1930), is less rich in personifications of nature but includes such curious pagan motifs as the Celtic god Cernunnus (fol. 16 v., here used as an equivalent of Hades). For classical personifications in Carolingian Crucifixions, see A. Goldschmidt, *Die Elfenbeinskulpturen aus der Zeit der karolingischen und sächsichen Kaiser*, I, Berlin, 1914, Figs 41, 78, 83, 85, 88, 100, 132a, 163a. Occasionally, as in an ivory illustrated in Goldschmidt, Fig. 71a, or in the Sacramentary of St.-Denis, Paris, Bibliothèque Nationale, MS. lat. 1141, fol. 3 (H. Swarzenski, *Monuments of Romanesque Art*, Fig. 9), the personifications of Earth and/or Ocean are also found in representations of the *Majestas Domini*.

[2] On the tenth century in general, see R. S. López, "Still Another Renaissance", *American Historical Review*, LVI, 1951, p. 1 ff., and the "Symposium on the Tenth Century" in *Mediaevalia et Humanistica*, IX, 1955, p. 3 ff. (with contributions by L. White, L. C. MacKenny, H. Lattin, L. Wallach, and K. J.

Conant). All attempts to "save" the tenth century tend to emphasize the potentialities rather than the actualities of cultural achievement and almost automatically resort to what may be called embryological language. In addition to coining the phrase "period of incubation" (quoted in the text), López says on p. 20: "The renaissance of the tenth century is not an improper term in the intellectual field if we consider embryos as well as hatched young"; and Lynn White, p. 26, concludes his apology with the sentence: "If it [the tenth century] was dark, its darkness was that of the womb".

As a specimen of tenth century hymnology, see, for example, the impressive sequence, prophetic of the *Dies irae*, reprinted by U. Middeldorf, *Art Bulletin*, XXII, 1940, p. 50. An excellent analysis of Rather of Verona's style is found in Auerbach, *op. cit.*, particularly p. 20 ff. (with further literature). It was only near the end of the century, and in a decidedly courtly milieu, that Rather's mannerism as well as Liutprand's waywardness and Hrotsvitha's naïveté were superseded by the elegance of Gerbert of Aurillac, the teacher of Otto III and, as Sylvester II, Pope from 999 to 1003 (Auerbach, p. 52 ff.); his Latin style, most cultured and harking back to the ideals of Lupus of Ferrières, yet charged with intense personal feeling, may be considered a true parallel of the Ottonian Renaissance in art.

which, by ignoring or discarding the results of a somewhat self-conscious effort at living up to "classical" standards, liberated the inventive and expressive powers of outstanding individuals without, however, preventing a decline of culture in general.

As far as art is concerned, it remains true that the years from *ca.* 880 to *ca.* 970 amounted only to a "period of incubation"; it is not until the last third—in England about the middle—of the tenth century that we can observe a general resurgence of artistic competence and discipline—a resurgence so marked that it is often spoken of as the "Ottonian Renaissance" with reference to works produced in Germany, and as the "Anglo-Saxon Renaissance" with reference to works produced in England. In spite of such sobriquets, however, this new flowering does not primarily concern us here. It was a revival in all possible senses except in that of a concerted effort to revive the Antique. Imbued with the religious fervor of the Cluniac Reform, it proclaimed a Christocentric spirit profoundly opposed to the universalistic attitude which at the time of Charlemagne and Charles the Bald had tended to bridge the gulfs that separate the "era under Grace" from the "era under the Law", and the latter from the "era before the Law". The literary portrait of an Ottonian emperor could hardly have been patterned, like Charlemagne's in Eginhard's biography, after the model of a Roman Caesar; nor could he have been addressed as "David" by his intimates.

With only relatively few and well-motivated exceptions, the revival of *ca.* 970–1020[1] drew inspiration only from Early Christian, Carolingian and—very important—

[1] For the "Ottonian" and "Anglo-Saxon" Renaissance in art, see H. Jantzen, *Ottonische Kunst*, Munich, n.d. [1947]; H. Focillon, *L'An Mil*, Paris, 1952; Saxl and Wittkower, *British Art and the Mediterranean*, p. 21 ff.; O. Homburger, *Die Anfänge der Malerschule von Winchester im X. Jahrhundert*, Leipzig, 1912. For the absence of an "antik-heidnische Wiedergeburtsidee", see Heer, *op. cit.*, p. 80.

The conscious revival of Carolingian models after an interruption of nearly two hundred years has been brilliantly demonstrated in one specific case (the "Gerokodex", Darmstadt, Landesbibliothek, MS. 1948) by W. Köhler, "Die Tradition der Adagruppe und die Anfänge des ottonischen Stiles in der Buchmalerei", *Festschrift zum 60. Geburtstag von Paul Clemen*, Düsseldorf, 1926, p. 255 ff.; and in another (here with reference to script and bookmaking), by E. A. Lowe, "The Morgan Golden Gospels, The Date and Origin of the Manuscript", *Studies in Art and Literature for Belle da Costa Greene*, Princeton, 1954, p. 266 ff., exposing the Morgan manuscript M. 23 as an Ottonian imitation of a Carolingian original. For other significant instances in various fields, cf. H. Swarzenski, *Romanesque Monuments*, p. 22 ff. (copies of the Utrecht Psalter, beginning with the early-eleventh-century manuscript, British Museum, MS. Harley 2506, and the slightly later manuscript, British Museum, MS. Cotton Tib. B. V). Similarly, St. Bernward of Hildesheim employed Carolingian models, both works of sculpture and book illuminations, in his silver crucifix as well as in the famous doors originally destined for St. Michael's (see E. Panofsky, *Die deutsche Plastik des elften bis dreizehnten Jahrhunderts*, Munich, 1924, pp. 73–78, Plates 2–5, Text Ills, XI, *a–c*; A. Goldschmidt, *Die deutschen Bronzetüren des Mittelalters*, Marburg, 1926; H. von Einem, "Zur Hildesheimer Bronzetür", *Jahrbuch der preussischen Kunstsammlungen*, LIX, 1938, p. 3 ff.; F. Tschan, *Saint Bernward of Hildesheim*, Notre Dame, Indiana, 1942–1952, especially Vols. II and III; R. Wesenberg, *Bernwardinische Plastik*, Berlin, 1955). His no less famous bronze column, however, unfolding the story of Christ's public life on a continuous spiral, evidently presupposes, in spite of the enormous difference in style and conception (Panofsky, p. 21 f.), the impression of the triumphal columns in Rome and thus constitutes one of the exceptional cases of direct classical influence upon

Byzantine sources. It thus widened and deepened that stream of tradition which carried classical motifs, placed in the service of the Judaeo-Christian faith, from Hellenistic and Roman sources into the sea of mediaeval art; but it did little to add to the volume of this stream by new and direct appropriations from the "pagan" antiquity. As far as classical "images" are concerned, the "Ottonian Renaissance" even tended to de-emphasize their importance and to de-classicize (if I may coin this word) their appearance. By and large the art of *L'An Mil* may be said to have been animated, in form as well as content, by a prophetic vision of the high-mediaeval future rather than by a retrospective enthusiasm for the classical past.[1]

After another hundred years, however, when this high-mediaeval future was about to become a reality, when art approached the High Romanesque stage all over Europe and the Early Gothic stage in the Royal Domain of France, we do find a renascence movement in the sense here under discussion; or, to be more exact, two parallel and, in a sense, complementary renascence movements.[2] Both began in the latter part of the eleventh century; both reached their climax in the twelfth and continued into the thirteenth; and both deliberately reverted to classical sources. They differed, however, from one another in place as well as in the direction of interests.

Ottonian art—another being the imitation of Roman coins in the medallions on the *incipit* page of the Sainte-Chapelle Gospels in Paris, Bibliothèque Nationale, MS. lat. 8851, fol. 16 (see Goldschmidt, *German Illumination*, Plates 9–11; for an interpretation of the medallions which would ascribe the manuscript to Henry II rather than Otto II and thus date it after 1002 rather than between 967 and 983, cf. P. E. Schramm, *Die deutschen Kaiser und Könige in Bildern ihrer Zeit, I Teil bis zur Mitte des 12. Jahrhunderts*, Berlin and Leipzig, 1928, pp. 108f., 197, Fig. 82, with further references).

I believe, however, that such exceptions (a manuscript essay by H. Beseler, "Die Frage einer ottonischen Antikenübernahme", *Schülerfestschrift Hans Jantzen*, Kunsthistorisches Institut München, 1951, was not accessible to me) can be accounted for by special circumstances. In the Gospels of the Sainte-Chapelle, e.g., no matter whether it was produced for Otto II (which seems to be the accepted opinion although Schramm's objections do not seem to have been explicitly refuted) or for Henry II, the "Roman" portraits on the *incipit* page, representing Henry I (twice), Otto I and Otto II (or, alternatively, Henry I, Otto I, Otto II and Henry II), are meant to proclaim the legitimacy of rulers whose right to the Holy Roman Empire was violently challenged of the time; in later productions of the same school,

incidentally, such imitations of Roman coins tend to be Christianized as had been the case in the simulated cameos in Carolingian manuscripts (see above, p. 51, Note 1); the medallions in the Golden Gospels of Henry III in the Escorial, for example A. Boeckler, *Das goldene Evangelienbuch Heinrichs III*, Berlin, 1933, Figs. 75–77), show the busts of youthful martyrs instead of emperors. St. Bernward's column, on the other hand, reflects his personal memories of a visit to Rome in January, 1001—a visit which bore fruit in his own triumph over Archbishop Willigis of Mayence who, exactly six years after St. Bernward's arrival in Rome, was forced to concede to him the long-contested rights to the important convent of Gandersheim. It is, perhaps, not too hazardous to suppose that the unique monument, patterned after the triumphal columns at Rome, commemorates the major success of St. Bernward's administrative career as well as his devotion.

[1] For an important Ottonian artist, possibly active both as a book illuminator and an ivory carver, whose style so clearly heralds the things to come that he has been called "the founder of the Romanesque style", see the excellent article by C. Nordenfalk, "Der Meister des Registrum Gregorii", *Münchner Jahrbuch der bildenden Kunst*, 3rd Ser., I, 1950, p. 61ff.
[2] See below, pp. 68 ff.

II

One of these movements is commonly—though somewhat loosely—referred to as the "proto-Renaissance of the twelfth century".[1] In contrast to both the Carolingian *renovatio* and the Ottonian and Anglo-Saxon revivals of about 1000, it was a Mediterranean phenomenon, arising in Southern France, Italy and Spain. Though it drew strength, it seems, from an admixture of latent "Celto-Germanic" tendencies (so that the initial contribution of Burgundy was more vital than that of Provence, that of Lombardy, Apulia and Sicily more vital than that of Tuscany and even Rome), it originated outside the Carolingian territory: in regions where the classical element was, and in a measure still is, an inherent element of civilization; where the spoken language had remained fairly close to Latin; and where monuments of ancient art were not only plentiful but also, in certain regions at least, of real importance. In further contrast to the two earlier revivals, the "proto-Renaissance of the twelfth

[1] For this "proto-Renaissance", see, in addition to the books and articles referred to above, p. 42, Note 1, and in the following notes: C. H. Haskins, *The Renaissance of the Twelfth Century*; J. Roosval, "Proto-Renaissance at the End of the Twelfth Century", *Essays in Honor of Georg Swarzenski*, Chicago, 1951, p. 39 ff.; Toffanin, *op. cit.*, Vol. I. For the proto-Renaissance in France, see particularly R. Hamann, *Südfranzösische Protorenaissance* (*Deutsche und französische Kunst im Mittelalter*, I), Marburg, 1923; *idem, Die Abteikirche von St. Gilles und ihre künstlerische Nachfolge*, Berlin, 1955 (cf. also W. Horn, *Die Fassade von St.-Gilles, eine Untersuchung zur Frage des Antikeneinflusses in der südfranzösischen Kunst des 12. Jahrhunderts*, Hamburg, doctoral diss., 1937); *idem*, "Altchristliches in der südfranzösischen Protorenaissance des 12. Jahrhunderts", *Die Antike*, X, 1934, p. 264 ff.; M. Schapiro, "The Romanesque Sculpture of Moissac, Part I", *Art Bulletin*, XIII, 1931, pp. 249 ff., 464 ff.; M. Durand-Lefèbvre, *Art gallo-romain et sculpture romane*, Paris, 1937; M. Aubert, *L'Art français à l'époque romane; architecture et sculpture*, Paris, 1929–1950; J. Gantner (in collaboration with M. Pobé, M. Aubert, pref.), *Gallia Romanica; Die hohe Kunst der romanischen Epoche in Frankreich*, Vienna, 1955 (French edition, Paris, 1955). For the proto-Renaissance in Italy, see G. H. Crichton, *Romanesque Sculpture in Italy*, London, 1954; R. Jullian, *L'Eveil de la sculpture en Italie*, Paris, 1945–49; *idem, Les Sculpteurs romans de l'Italie septentrionale*, Paris, 1952; R. Salvini, *Wiligelmo e le origini della scultura romanica*, Milan, 1956. For South Italy, see still E. Bertaux, *L'Art dans l'Italie méridionale*, Paris, 1904; M. Wackernagel, *Die Plastik des 11. und 12. Jahrhunderts in Apulien*, Leipzig, 1911; for more recent literature, see C. A. Willemsen, *Apulien*, Leipzig, 1944; C. D. Sheppard, "A Chronology of Romanesque Sculpture in Campania", *Art Bulletin*, XXXII, 1950, p. 319 ff.; J. Deér, "Die Baseler Löwenkamee und der süditalienische Gemmenschnitt des 12. und 13. Jahrhunderts, Ein Beitrag zur Geschichte der abendländischen Protorenaissance", *Zeitschrift für Schweizerische Archäologie und Kunstgeschichte*, XIV, 1952, p. 129 ff.; H. Wentzel, "Antiken-Imitationen des 12. und 13. Jahrhunderts in Italien", *Zeitschrift für Kunstwissenschaft*, IX, 1955, p. 29 ff. For Venice, where the proto-Renaissance set in at a comparatively late date and was characterized by a particularly marked dependence on Late Antique and Early Christian monuments (at times producing what might be termed real "forgeries") and where sculpture tended to absorb the additional influence of the more developed mosaic, see O. Demus, "A Renascence of Early Christian Art in Thirteenth Century Venice", *Late Classical and Mediaeval Studies in Honor of Albert Mathias Friend, Jr.*, Princeton, 1954, p. 348 ff. For Dalmatia, etc., see O. Kutschera-Woborsky, "Das Giovanninorelief des Spalatiner Vorgebirges", *Jahrbuch des kunsthistorischen Instituts* [deutsch-österreichisches Stattsdenkmalamt], XII, 1918, p. 28 ff. For a still unrivaled wealth of illustrations covering the whole field of European sculpture in the twelfth century, see A. Kingsley Porter, *Romanesque Sculpture of the Pilgrimage Roads*, Cambridge (Mass.), 1923.

century" came into being at a time when—with the beginnings of urbanization on the one hand and the development of organized pilgrimages, not to mention the Crusades, on the other—the importance of local centers of production, mostly monastic, began to be superseded by that of more or less secularized regional schools (it is not until the eleventh century that we speak of the "schools of Auvergne, Normandy or Burgundy" rather than of the "schools of Reims, Tours or the Reichenau", and not until the middle of the twelfth that we encounter the professional lay architect), and when a determined attempt was made to extend the influence of art to the "common man".

A new emphasis was therefore placed on such forms of expression as could exert that mass appeal the preoccupation with which is so touchingly evident in the writings of Abbot Suger of St.-Denis. The crucifixes, the tombs of the saints, the altars—now beginning to be embellished with retables as well as antependia because it became customary for the officiating priest to take his place in front rather than behind the *mensa*, thus leading the community instead of facing it—grew to a size unheard of before. Wall painting emancipated itself from the influence of book illumination so that, where Ottonian murals tend to look like large miniatures, Romanesque miniatures tend to look like small murals (one of the unforgettable impressions of the Paris exhibition of pre-Gothic illuminated manuscripts in 1954). And wall painting in turn was supplemented, and in the Northern countries gradually eclipsed, by two great art forms virtually absent from the pre-Romanesque scene: figural and narrative glass painting and, above all, major sculpture in stone—an art all but extinct up to the second half of the eleventh century,[1] and the ascendancy of which was to transform the House of God into a richly decorated public monument.

Thus confronted, for the first time since the downfall of the Roman Empire, with the problem of monumentality, the Romanesque artists approached the classical past from a point of view quite different from that of their predecessors. Less omnivorous than the Carolingians and almost reversing the principle of selection established by the Ottonians, the champions of the proto-Renaissance tended to focus their attention upon the actual remnants of pre-Christian antiquity, that is to say, on Roman and Gallo-Roman architecture and architectural ornament, stone sculpture, goldsmith's work, gems, and coins.

It was, therefore, almost exclusively in the three-dimensional arts that fresh contacts

[1] For the rather rare examples of West European stone sculpture produced in Carolingian and Ottonian times (for the pre-Carolingian period, cf. above, p. 43 f., Note 2), see A. Kingsley Porter, "The Tomb of Hincmar and Carolingian Sculpture in France", *Burlington Magazine*, L, 1927, p. 75 ff.; H. Focillon, *L'Art des sculptures romanes*, Paris, 1931, especially p. 43 ff.; *idem, L'An Mil, passim*; O. Homburger, "Ein Denkmal ottonischer Plastik in Rom mit dem Bildnis Ottos III", *Jahrbuch der preussischen Kunstsammlungen*, LVII, 1936, p. 130 ff.; and, most particularly, R. Wesenberg, "Die Fragmente monumentaler Skulpturen von St. Pantaleon in Köln", *Zeitschrift für Kunstwissenschaft*, IX, 1955, p. 1 ff.

were made with the Antique—except where the narrative of a painting or book illumination specifically required the presence of a pagan idol, or where a man like Villard de Honnecourt (an architect by profession!) used pen and ink to make a record of some classical object. When the equestrian statue of Marcus Aurelius—generally assumed to represent the first Christian emperor, Constantine, and duplicated in countless Romanesque reliefs and even free-standing monuments—occasionally recurs in a twelfth-century mural, contemporary sculpture can be shown to have served as an intermediary between the painting and the Roman original;[1] it was in the workshop of a great sculptor-goldsmith, Nicolas of Verdun, and not until about 1180, that the rippling and clinging drapery style characteristic of so much classical sculpture from the Parthenon down to Imperial Rome was first transplanted to a two-dimensional medium, enamel; and it was through the influence of the statuary of Paris, Chartres and Reims, and after another thirty or forty years, that it took roots in painting, book illumination and stained glass.[2]

Romanesque architecture not only appropriated a wealth of details hitherto ignored but also produced structures as persuasively classicizing as the façades of St.-Trophîme in Arles (Fig. 21), the Masons' Chapel in St.-Gabriel or the Badia at Fiesole (Fig. 6). The masters of Cluny, Autun and Beaune, in addition to patterning their triforia after the fashion of the Porte d'Arroux (the influence of which can still be felt in the blind arcades of the cathedrals of Lyons and Geneva), resumed the Roman techniques of vaulting large, longitudinal units. And in Romanesque sculpture classical influence was, if anything, even more powerful. As early as the middle of the eleventh century the sarcophagus of Isarn, Abbot of St.-Victor at Marseilles (died 1049), revived, even improved upon, a provincial model which, in a dim recollection of Egyptian and Phoenician anthropomorphic sarcophagi, shows the bust and feet of the deceased emerging from a large commemorative tablet;[3] and during the following century the impact of Roman and Gallo-Roman statuary made itself felt from Salerno, Palermo and Monreale to Modena, Ferrara and Verona, from Provence and Aquitaine to Burgundy and the Ile-de-France, from Spain to Dalmatia and adjacent regions.

It is characteristic of the macroscopic tendencies of this proto-Renaissance sculpture that it was able to liberate, if one may say so, the latent grandeur of models diminutive in size but potentially monumental by virtue of their classical ancestry or provenance. Syrian or Byzantine ivories were thus "monumentalized", for example, in the ambula-

[1] For Romanesque representations of Constantine reflecting the statue of Marcus Aurelius, see Adhémar, op. cit., p. 207ff., Figs. 60–64; for Villard de Honnecourt, ibidem, p. 278ff., Figs. 106–112.

[2] For the role of Nicolas of Verdun, see now H. Swarzenski, Romanesque Monuments, particularly pp. 29ff., 82 (with further references), Figs. 513–520.

[3] For the sarcophagus of Isarn and its Gallo-Roman prototype, see Adhémar, op. cit., p. 236, Figs. 87, 88.

tory reliefs of St.-Sernin in Toulouse and in the much-debated Bari throne of 1098 (Figs. 22, 23),[1] and a no less important role was played by the products of classical glyptography.

In the twelfth century—first, it seems, in Norman-ruled Sicily and probably with the aid of artists called in from Byzantium—the ancient art of the *sculptor* regained the status of a living practice in the Western world; and while the few Carolingian and Ottonian artists interested in classical cameos and their less ambitious relatives, classical coins, had been content to imitate them on their original scale (and preferably, we recall, in book illuminations rather than "in the flesh"), their Romanesque successors employed them as models not only, as is no more than natural, for other cameos and other coins as well as for seals and small metal reliefs,[2] but also, more surprisingly, for large-size sculpture in stone.

It should be noted, however, that such a lapidary magnification of classical gems or coins was much less frequent and persistent on what may be called the home ground of the proto-Renaissance movement (South France and Italy) than in those regions which

[1] For the reliefs in the ambulatory of St.-Sernin in Tolouse, see Kingsley Porter, *op. cit.*, p. 206 ff., Figs. 296-305, 307. For the Bari throne, see *ibidem*, p. 59 ff., Figs. 152-155; A. Grabar, "Trônes episcopaux du XI° et XII° siècle en Italie méridionale", *Wallraf-Richartz-Jahrbuch*, XVI, 1954, p. 7 ff. In my opinion the treatment of the nude in this astonishing monument can be explained only by the influence of Byzantine ivories such as the so-called rosette caskets (see, e.g., A. Goldschmidt and K. Weitzmann, *Die byzantinischen Elfenbeinskulpturen des X.-XIII. Jahrhunderts*, Berlin, 1930-34, I, Figs. 12, 15, 18, 21, 24, 26-33, 35, 38-43, 47-51) and two remarkable plaques, both in the Kaiser Friedrich Museum at Berlin, which show the Entry into Jerusalem (our Fig. 23) and the Death of the Forty Martyrs (*ibidem*, II, Pl. II, Fig. 3; Pl. X, Fig. 10); for two stone reliefs directly copied after Byzantine rosette caskets (one in Ferrara, the other in Como), see K. Weitzmann, "Abendländische Kopien Byzantinischer Rosettenkästen", *Zeitschrift für Kunstgeschichte*, III, 1934, p. 89 ff. It is interesting that the same group of Byzantine ivories continued to interest the South Italian sculptors as late as the thirteenth century, as demonstrated by H. Wentzel, "Die Kamee mit dem ägyptischen Joseph in Leningrad", *Kunstgeschichtliche Studien für Hans Kauffmann*, Berlin, 1956, p. 85 ff.

[2] For the appreciation, use and influence of classical gems and the mediaeval revivals of glyptography,

see Adhémar, *op. cit.*, p. 106 ff.; W. S. Heckscher, "Relics of Pagan Antiquity in Mediaeval Settings", *Journal of the Warburg Institute*, I, 1937-38, p. 204 ff.; Déer, "Die Baseler Löwenkamee"; and a long series of articles by H. Wentzel, to whom our discipline owes a great debt for having called attention to a phenomenon largely neglected by earlier historians of mediaeval art: "Mittelalterliche Gemmen, Versuch einer Grundlegung", *Zeitschrift des deutschen Vereins für Kunstwissenschaft*, VIII, 1941, p. 45 ff.; "Eine Kamee aus Lothringen in Florenz und andere Kunstkammerkameen", *Jahrbuch der preussischen Kunstsammlungen*, LXIV, 1943, p. 1 ff.; "Mittelalterliche Gemmen am Oberrhein und verwandte Arbeiten", *Form und Inhalt, kunstgeschichtliche Studien Otto Schmitt dargebracht*, Stuttgart, 1950, p. 145 ff.; "Mittelalter und Antike im Spiegel kleiner Kunstwerke des 13. Jahrhunderts", *Studier tillägnade Henrik Cornell pd sextiodrsdagen*, Stockholm, 1950, p. 67 ff.; "Portraits 'à l'Antique' on French Mediaeval Gems and Seals", *Journal of the Warburg and Courtauld Institutes*, XVI, 1953, p. 342 ff.; "Die vier Kameen im Aachener Domschatz und die französiche Gemmenschneidekunst des 13. Jahrhunderts", *Zeitschrift für Kunstwissenschaft*, VIII, 1954, p. 1 ff.; "Die grosse Kamee mit Poseidon und Athena in Paris", *Wallraf-Richartz-Jahrbuch*, XVI, 1954, p. 53 ff.; "Die Kamee ... in Leningrad", *op. cit.*; "Mittelalterliche Gemmen in den Sammlungen Italiens", *Mitteilungen des kunsthistorischen Institutes in Florenz*, VII, 1956, p. 239 ff.

were to become the focal territory of the Gothic style: the Royal Domain and Champagne. A beginning was made, probably toward 1180, in a sarcophagus preserved in the Cathedral of Lisieux and probably commissioned by Bishop Arnulf (in office from 1141 to 1181) but executed by an artist from either the Ile-de-France or (in my opinion less probably) from Burgundy rather than by a Norman (Fig. 24).[1] Another case in point is the huge late-twelfth-century lavabo from St.-Denis (now returned to its proper place from the Ecole des Beaux-Arts at Paris) where skillful enlargements of classical gems or coins harmoniously alternate with Early Gothic medallions.[2] And a triumphal climax was reached in the big profile heads that fill the spandrels of the interior west wall in Reims Cathedral (Fig. 25).[3]

These magnificent heads, dating from about the middle of the thirteenth century, bear witness to what I consider a fact of fundamental importance: it was in the very heart of France—that is to say, outside the orbit of the proto-Renaissance proper—and not until the end of the twelfth century—that is to say, not until the Gothic style was passing, as Vasari would say, from infancy to youth and maturity—that mediaeval art acquired the ability to meet the Antique on equal terms.

Within its original geographical limits and during its initial stages, proto-Renaissance sculpture had selected and interpreted its models in a spirit either too emotional and independent or too dispassionate and imitative to absorb the essential qualities of classical art. Some schools, especially the school of Burgundy and its derivatives, subjected classical compositions to a *transposition à la bourguignonne*, as it has nicely been termed, which sacrificed their original character on the altar of expressiveness, all but obscuring it by linearization, elongation and contortion: the figures appear almost dehumanized, their garments, "halfway between toga and contemporary costume, agitated by a violent and arbitrary breeze" (Fig. 26). Other schools—and this applies especially to those of Provence, the ancient *Provincia Romana*—reproduced the Roman and Gallo-Roman originals with so much attention to decorative detail,[4] drapery motifs, facial types and surface texture that the results came, on occasion, dangerously close to unimaginative duplication. Some of the masks and angels' heads on the façade of St.-Gilles might well be mistaken for Gallo-Roman originals (Figs. 27 and 28); and in

[1] For the tomb of Arnulf of Lisieux (for a possible explanation of its iconography, cf. below, p. 90 Note 2), see Adhémar, *op. cit.*, p. 249f., Fig. 83.

[2] For the lavabo from St.-Denis, see Adhémar, *op. cit.*, p. 265f. (with further references), Figs. 99-103. For a possible influence of classical gems on the tomb of St. Edward, see a drawing ascribed to Matthew Paris in M. R. James ed., *La Estoire de*

Seint Aedward le Rei (Cambridge, Library, É E 3, 59), Roxburghe Club, Oxford, 1920, fol. 65.

[3] See Adhémar, *op. cit.*, Fig. 105, and Wentzel, "Mittelalterliche Gemmen am Oberrhein", p. 149, Fig. 4.

[4] For the contrast between the imitation of classical models in Provence and Burgundy ("imitation plus intelligente"), see the pertinent remarks in Adhémar, *op. cit.*, pp. 233 ff. and 241 ff.

at least one case, a sarcophagus in St.-Guilhem-du-Désert, the question "twelfth or fourth century"? is still *sub judice*.[1]

What was not as yet perceived, however, and could not be perceived by Romanesque artists, was what must be considered as the essential principle of classical statuary: the interpretation of the human body as an autonomous, quite literally "self-centered" entity, distinguished from the inanimate world by a mobility controlled from within. As long as the sculptor thought of his work as a piece of inorganic and homogeneous matter bulging out into projections, retreating into cavities, incised with sharply defined contours but never losing its homogeneous density, he was unable to represent the living creature as an organism articulated into structurally different parts. To impart to the human figure that organic balance and freedom which is still best described by the Greek word εὐρυθμία, and to treat drapery in such a way that it appears to be independent from, yet functionally related to, the body was possible only when homogeneous matter ("mass") had been replaced by differentiated structure; and this could happen only when proto-Renaissance sculpture came to be practiced within an architectural system based upon what may be called the "principle of axiality".[2] This principle of axiality, which had prevailed in classical art from the sixth century B.C., had ceased to be respected after the disintegration of the Graeco-Roman world. It had been formally abrogated by the Romanesque style, and it was not reinstated—paradoxically yet understandably—until the advent of that style of architecture which we call Gothic.

In architecture, this style required that the mass of wall and vault be concentrated into tubular shafts and ribs, their centers explicitly indicated by little dots in contemporary architectural drawings (Fig. 29); in sculpture, it required that what I once proposed to term a *"relief en cabochon"*, a form conceived as projecting from a plane surface outside itself (regardless of whether this surface is physically present or only implied by the shape of the figure), be converted into a form conceived as centered around an axis within itself. The jamb figure—originally, if one may say so, an overblown relief (Fig. 30, Text Ills. 1, A, B) even if the "ground" of this relief happens to be, in some exceptional cases, a column (Text Ill. 1, C)—developed into a genuine statue attached to a colonnette, these two components resulting from a process which began by attacking the block diagonally rather than frontally or laterally (Fig. 31, Text Ill. 1, D). This new approach led to the crystallization of both the figure and what

[1] See H. U. von Schoenebeck, "Ein christlicher Sarkophag aus St. Guilhem", *Jahrbuch des deutschen archäologischen Instituts*, XLVII, 1932, p. 97 ff. (brilliantly reconstructing a sarcophagus from a number of fragments and dating it in the fourth century); H. Buchthal, *Bibliography of the Survival of the Classics*, II, London, 1938, p. 204, No. 771 (accepting von Schoenebeck's reconstruction but dating the sarcophagus shortly before 1138).

[2] See Panofsky, *Die deutsche Plastik*, particularly p. 12 ff.

Ill. 1. Schematic Cross Sections Illustrating the development of Gothic Architectural Sculpture.

A and B. Orthogonal or Frontal Romanesque Jamb Figure (e.g., Toulouse, St.-Sernin; St.-Gilles; Arles, St.-Trophime, façade; cf. Fig. 30). C. Romanesque Jamb Figure *Applied* to Colonnette (e.g., Milan, S. Ambrogio). D. Diagonalized Romanesque Jamb Figure (e.g., Toulouse, St.-Etienne; Arles, St.-Trophime, cloister; Ferrara Cathedral; cf. Fig. 31). E. Proto-Gothic Jamb Statue *Attached* to Colonnette (e.g., St.-Denis; Chartres Cathedral, west façade; cf. Fig. 32). F. Early and Classic High Gothic Jamb Statue *Attached* to Colonnette (e.g., Chartres Cathedral, transepts; Reims Cathedral, Amiens Cathedral; cf. Figs. 33, 40). G and H. Terminal High Gothic and Late Gothic Jamb Statue (e.g., Strasbourg Cathedral, west façade). I. High Gothic Archivolt Figure.

may be called the "residual mass" into two basically cylindrical units, the statue and the colonnette (Fig. 32, Text Ill. 1, E); it continued with the gradual attenuation of this colonnette (Fig. 33, Text Ill. 1, F) and ended with the latter's disappearance, the figure becoming completely detached and being either placed within a niche (Text Ill. 1, G) or set out against the flat wall (Text Ill. 1, H) in which case the development has come full circle. An analogous process can be observed in the evolution of the archivolt decoration (Text Ill. 1, I); and figures playing their part in a relief composition

move and act before an imaginary backdrop much like actors on the platform of a small theater stage (Fig. 34).[1]

This architecturally inspired reaffirmation of axiality—possible, I believe, only in France, the one country which borders both on the Mediterranean and the North Sea—was an accomplished fact by the middle of the twelfth century. And when a new wave of Byzantinism (first noticeable, for obvious reasons, in such "minor arts" as book illumination, ivory carving and metal work but soon extending to monumental sculpture in wood and stone) swept all over Europe some twenty-five or thirty years later,[2] it was in what had been the very heart of the Carolingian empire and was to become the very heart of the High Gothic style, Lorraine, the Ile-de-France and Champagne, that art became capable of isolating what was still Hellenic in the Byzantine style.

With Nicolas of Verdun in the van of the development, the schools of Laon, Senlis, Chartres and Paris reimparted to their figures a serene animation as close to Graeco-Roman *humanitas* as mediaeval art could ever come. Posed in resilient, gyratory, *contrapposto* attitudes, their pliant drapery accentuating rather than concealing well-proportioned bodies, the figures began to move in natural yet rhythmical fashion ("das schreitende Stehen, nun wards Wandeln", to quote Wilhelm Vöge's untranslatable phrase) and to establish psychological contact with one another.

It was thus precisely within an Early Gothic atmosphere that "surface classicism", as it may be called, grew into an "intrinsic classicism" which, needless to say, culminated in the school of Reims. Suffice it to mention the Apostles in the portal of the Last Judgment, particularly the two magnificent figures of Saints Peter and Paul, the head of the former bearing an unmistakable likeness to that of Antoninus Pius (Figs. 35

[1] This stylistic difference between Romanesque and Early Gothic sculpture was first formulated by W. Vöge, *Die Anfänge des monumentalen Stiles im Mittelalter; Eine Untersuchung über die erste Blütezeit der französischen Plastik*, Strasbourg, 1894, now more than sixty years old but unsurpassed in fundamental insight. See also *idem*, "Die Bahnbrecher des Naturstudiums um 1200", *Zeitschrift für bildende Kunst*, New Ser., XXV, 1914, p. 193ff.; for further discussion of this problem, E. Panofsky, *Early Netherlandish Painting*, p. 13ff., and W. Paatz, *Von den Gattungen und vom Sinn der gotischen Rundfigur (Sitzungsberichte der Heidelberger Akademie der Wissenschaften*, phil.-hist. Klasse, III, 1951). For an illuminating account of the encounter between the Gothic and the Romanesque principles in a German workshop of

ca. 1230–35, see A. Goldschmidt, *Die Skulpturen in Freiberg und Wechselburg*, Berlin, 1924, p. 9ff. For a special problem in this connection, see C. Seymour, "Thirteenth-Century Sculpture at Noyon and the Development of the Gothic Caryatid", *Gazette des Beaux-Arts*, 6th Ser., XXVI, 1944, p. 163ff.

[2] The first to call attention to this new wave of Byzantinism (with special reference to German art) was, so far as I know, A. Goldschmidt, "Die Stilentwicklung der romanischen Skulptur in Sachsen", *Jahrbuch der königlich preussischen Kunstsammlungen*, XXI, 1900, p. 225ff. As far as France is concerned, the phenomenon was especially stressed by W. Vöge, "Ueber den Bamberger Domskulpturen", *Repertorium für Kunstwissenschaft*, XXII, 1899, p. 94 ff.; XXIV, 1901, pp. 195ff., 255ff.

and 36);[1] the Resurrected in the tympanum of the same portal, some of them patterned after the reclining effigies on Roman sarcophagi, others even rising from urns instead of graves so as to indicate the pagan custom of cremation as opposed to the Christian rites of burial (Fig. 37);[2] two battling monsters on a capital patterned, about 1225, after the wounded huntsman and a lion's paw on a Roman sarcophagus that had been preserved in Reims from time immemorial but had never been noticed, so to speak, until the time had come (Figs. 38, 39);[3] and the famous "Man with the Odysseus Head". The even more famous Visitation group (Fig. 40) is so classical in pose, costume and facial types that it was long assigned to the sixteenth rather than the thirteenth century.

It is, however, significant that just those figures which are the nearest to classical antiquity in spirit—as an example from the minor arts there may be mentioned the admirable little *Mater dolorosa*, probably not much later than 1200, which was one of Vöge's cherished possessions and now honors his memory in the Art Historical Institute of Freiburg University (Fig. 41)[4]—are often the most difficult to derive from any specific model. The most accomplished of these mediaeval sculptors had learned to master the language of classical art to such an extent that they no longer needed to borrow individual phrases or vocables. And we must always envisage the possibility that they were inspired not so much by large-scale stone sculpture as by those graceful Greek and Hellenistic statuettes in bronze or silver, frequently known to us only from their faint echoes in terra-cotta figurines (Figs. 42, 43), which often reflect the products of monumental art and found their way as far as Germany.[5]

[1] For the Master of Saints Peter and Paul, see *idem*, "Die Bahnbrecher des Naturstudiums". I wish to repeat that the similarity between the St. Peter and Antoninus Pius was called to my attention by Professor Karl Lehmann.

[2] See now Adhémar, *op. cit.*, p. 275.

[3] See Panofsky, "Ueber die Reihenfolge der vier Meister von Reims", and Adhémar, *op. cit.*, p. 278.

[4] E. Meyer, "Eine mittelalterliche Bronzestatuette", *Kunstwerke aus dem Besitz der Albert-Ludwig-Universität Freiburg im Breisgau*, Berlin and Freiburg, 1957, p. 17 ff. Cf. also the following Note.

[5] For possible sources of the Reims *Visitation*, see Adhémar, *op. cit.*, p. 276 ff., and, as far as the hairdress and headdress are concerned, G. Swarzenski, *Nicolo Pisano*, Frankfurt-am-Main, 1926, p. 18, Plate 26; Wentzel's tentative attempt to connect it with classical gems ("Mittelalter und Antike", p. 88, Fig. 22) is limited to the facial type of the Virgin and, even so, does not appear convincing. In regard to pose and drapery treatment, however, full-

scale classical statuary has not yielded convincing prototypes either. The closest parallels are found, curiously enough, in certain "Tanagra" statuettes (see, e. g., G. Kleiner, *Tanagrafiguren; Untersuchungen zur hellenistischen Kunst und Geschichte* [*Jahrbuch des deutschen archäologischen Instituts*, Ergänzungsheft, No. 15], Berlin, 1942, Plates 17 c, 21 a, 24 c, 27 b, c; G. M. A. Richter, *The Metropolitan Museum of Art, Handbook of the Classical Collection*, New York, 1917, Fig. 88 d, f, our Fig. 41). It should, however, be borne in mind, first, that, as recently emphasized in a brief but very important article by D. B. Thompson, to whom I am much indebted in regard to the questions here under discussion ("A Bronze Dancer from Alexandria", *American Journal of Archaeology*, LIV, 1950, p. 371 ff., particularly p. 374), small-sized sculpture in clay often reproduces small-sized sculpture in silver or bronze; second, that metal statuettes of high quality—in turn occasionally reflecting "major art"—can be shown, even after the enormous losses caused by theft or recasting, to

In France, then, mediaeval art came closest to the Antique when a proto-Renaissance movement born in the Romanesque South was drawn into the orbit of the Gothic style developed in the Royal Domain and Champagne; and we can understand that in Italy a like stage was not reached until, conversely, the Gothic style developed in the Royal Domain and Champagne had interpenetrated with, and in a sense transformed, the indigenous proto-Renaissance. In Apulia and Sicily, ruled by Normans and thus particularly exposed to French infiltration, this process bore fruit, for example, in the historiated capitals of Monreale (between 1172 and 1189) which, recent statements to the contrary notwithstanding, cannot be explained without the influence of the earlier school of Chartres, that of the Portail Royal. Here a new intimacy with the Antique was achieved not in spite but because of this influence, and while there is nothing in the Portail Royal or its derivatives that would account for the classical vocabulary of the Monreale capitals, including nude *putti*, only the experience of a style that had revived the concept of axiality could have enabled their makers to understand classical syntax.[1] It is, I believe, thanks to the continuance and intensification of this contact

have found their way as far north as France and Germany in ancient times (see, e.g., the *Peasant Woman* found in Carniola [K. A. Neugebauer, *Antike Bronzestatuetten*, Berlin, 1921, Fig. 49], the splendid *Hermaphroditus* found in Mirecourt in Lorraine [*ibidem*, Fig. 45] and the *Jupiter Dolichenus* found in a prehistoric grave near Berlin [*ibidem*, Fig. 63]). It may be mentioned on this occasion that the Freiburg *Mater dolorosa* mentioned in the preceding Note and generally reminiscent of a Demeter type represented by the specimens illustrated in S. Reinach, *Répertoire de la statuaire grecque et romaine*, Paris, 1897–1910, II, p. 241, particularly No. 6, can be explained by a kind of fusion between the motifs transmitted by such bronzes as the Vienna *Juno* (Neugebauer, Fig. 59, our Fig. 40) and the Berlin *Selene* (*ibidem*, Fig. 60)—with the reservation that the diagonal folds of drapery drawn across the chest presuppose a still different model and that the mediaeval artists, although the impression of their works may be as "classical" as that of any Renaissance production, were unfamiliar with the sartorial technicalities of Greek and Roman costume.

[1] For the capitals at Monreale and their relation to Chartres, see C. D. Sheppard, Jr., "Iconography of the Cloister of Monreale", *Art Bulletin*, XXXI, 1949, p. 159 ff.; *idem*, "Monreale et Chartres", *Gazette des Beaux-Arts*, 6th Ser., XXXI, 1949, p. 401 ff.; *idem*, "A Stylistic Analysis of the Cloister at Monreale", *Art Bulletin*, XXXIV, 1952, p. 35 ff. Sheppard's thesis has been rejected by Deér, "Die Baseler Löwenka-

mee", who believes that Sicilian sculpture of the twelfth century developed independently of French models and that its efflorescence preceded that on the South Italian continent; he also assigns many cameos formerly located elsewhere and dated in the thirteenth century to Sicilian glyptographers of the twelfth, a contention contested by Wentzel, "Die vier Kameen im Aachener Domschatz", and "Die grosse Kamee". As far as major sculpture is concerned, I believe that the French affiliations of the Monreale capitals cannot possibly be denied and that Deér would seem to underestimate the importance of the South Italian mainland—as evidenced, for example, by the Bari throne of 1098—in favor of Sicily; he appears to be correct, however, in dating the tombs of the Norman kings in Palermo (p. 137, Note 51, p. 143, Note 97) in the twelfth rather than the thirteenth century (for Sicilian architecture of this period, cf. G. di Stefano, *Monumenti della Sicilia Normanna*, Palermo, 1955). As regards the cameos, I lack the knowledge to pronounce judgment but cannot help feeling that Deér's dates are too early, particularly in the important cases of the charming *Lady Falconer* in the Bargello and the Juritzky *Hercules*, and that his historical and iconographical arguments are not always convincing. When he contends, for example, that the Juritzky *Hercules* must be twelfth rather than thirteenth century because the Christianization of the subject by the addition of the dragon mentioned in Psalm XC (XCI):13 would not be compatible with the period of Frederick II, it may

with France—lately substantiated by a beautiful capital at Troia in Apulia, executed before 1229 and undeniably dependent on the style of the north transept of Chartres Cathedral—that a classicism comparable to that of Reims came into being in Italy. Where this contact was as relatively superficial as, for example, in Dalmatia, a mid-thirteenth-century *Eve* patterned upon the model of a *Venus Pudica* remained a clumsy imitation verging upon caricature.[1]

Whatever role a local Roman[2] tradition may have played in the formation of the schools of sculpture, glyptography and die-cutting called into life by Frederick II, and to whatever extent they may have been dominated by his personal leanings, their French affiliation remains evident throughout. That a monarch who thought of himself as a second Augustus, bestowed upon the cities founded by him such names as Augusta, Caesarea and Aquila, and dedicated the church of his winter encampment before Parma (significantly called Victoria) to St. Victor[3] tended to stress the classical element in his artistic enterprises—except, characteristically, for the comparatively few paintings and book illuminations which were produced on his initiative—is not surprising; and it is probable that, if the occasion demanded it, he personally indicated the models to be followed.[4] But in favoring a classicizing mode of expression in art, just as he favored a classicizing mode of thought in legislation, city planning, etc., he exploited and gave

be objected that Frederick II's indifference to religion was an individual rather than general phenomenon. In fact, another classical Hercules type, in this case a representation of the hero carrying the Eryman-thean boar, was analogously Christianized about 1250 in one of the well-known reliefs on the façade of St. Mark's in Venice (cf. Panofsky and Saxl, "Classical Mythology in Mediaeval Art", p. 231, Figs. 4, 5, and Panofsky, *Studies in Iconology*, Figs. 5, 6).

[1] For the Troia capital, see H. Wentzel, "Ein gotisches Kapitell in Troia", *Zeitschrift für Kunstgeschichte*, XVII, 1954, p. 185 ff. For the portal at Traù (by Magister Radovan), see O. Kutschera-Woborsky, *op. cit.*; F. Saxl, "Die Bibliothek Warburg und ihr Ziel", *Vorträge der Bibliothek Warburg*, 1921–22, p. 1 ff. For other statues of Eve reflecting the *Venus Pudica* type, cf. Adhémar, *op. cit.*, p. 290.

[2] The possibility that Rome had a greater influence on the formation of the proto-Renaissance style than is generally assumed has been suggested by Wentzel, "Antiken-Imitationen", particularly p. 59 ff. It is certainly remarkable that a base in the cloisters of St. John in the Lateran (produced, however, as late as 1222–1230) faithfully imitates a genuine Egyptian sphinx, apparently appropriated through a Roman

intermediary; see Wentzel, *ibidem*, and *Reallexikon zur deutschen Kunstgeschichte*, IV, col. 750 ff., Fig. 1.

[3] For Frederick II's city foundations, especially Victoria, see E. H. Kantorowicz, *Kaiser Friedrich der Zweite*, 3rd ed., Berlin, 1931, I, p. 598 f.; II ("Ergänzungs-band"), p. 242. It is no more than an accident—but an illuminating one—that the "Unanimes Anti-quitatis Amatores" under Sixtus IV made the same St. Victor their patron saint (see above, p. 8, Note 5). The difference would seem to be that Frederick II attempted to press the Antique into the service of his political and cultural aims while "the Sodalitas Litteratorum Sancti Victoris et Sociorum" attempted to place their much-criticized worship of the Antique under the protection of a suitable Catholic saint.

[4] For the artistic activities of Frederick II in general, see, in addition to Kantorowicz, *ibidem*, I, p. 479 ff.; II, p. 209 ff.: Willemsen, *Apulien, passim*; W. Krönig, "Staufische Baukunst in Unteritalien", *Beiträge zur Kunst des Mittelalters* (*Vorträge der ersten deutschen Kunsthistorikertagung auf Schloss Brühl, 1948*), Berlin, 1950, p. 28 ff.; and Wentzel, "Antiken-Imitatio-nen", with further references (a typewritten Mar-burg dissertation of 1922 by E. Holler, *Kaiser Freidrich II und die Antike*, referred to by Wentzel, p. 30, Note 7, was not accessible to me).

fresh impulse to a movement that had been going on for a long time. He promoted the classical style as a matter of imperial policy rather than of "aesthetic" preference, and he never went so far as to exclude other artistic tendencies—indigenous, Byzantine, Saracenic, and, above all, French.[1]

The famous *Augustales*, immortalizing the "Puer Apuliae" in the guise of a Roman Caesar, were not coined until 1231; they were preceded by seals as plainly Romanesque as those of 1212 and 1215 and as undilutedly Early Gothic as those of 1220 and 1225/26.[2] The somewhat later console busts of Castel del Monte mark a transition from the Early to the High Gothic phase while the proto-Renaissance tradition asserts itself in other portions of the sculptural decoration. In the Arch of Capua, erected as late as between 1235 and 1239, and as boldly reviving the triumphal monuments and public statues of the Roman emperors as the *Augustales* had their coins, the Gothic influence not only predominates in the architectural elements (it is well known that Frederick employed a goodly number of Cistercian architects) but even colors the deliberately classicistic style of the statuary, including the still enigmatical "Jupiter's Head".[3] And of those

[1] The classicistic tendency indubitably present—though by no means exclusively prevailing—in "Frederician" sculpture and glyptography (for the latter, see particularly Wentzel, "Die grosse Kamee" and "Die Kamee ... in Leningrad"; for coins, seals and architecture, cf. the following Notes) is absent from the miniatures in Frederick's treatise on falconry (A. Wood and F. M. Fyfe, *The Art of Falconry, Being the "De Arte Venandi Cum Avibus" of Frederick II von. Hohenstaufen*, London, 1943 [2nd ed., Boston, 1955]); nor does it seem to have been evident in the mural which in his palace at Naples (Kantorowicz, *ibidem*, I, p. 215; II, p. 89) once proclaimed the ritual of imperial jurisdiction. This mural is lost, but it would seem that an approximate idea of its style can, after all, be formed on the basis of the *Praeconium Paschale* miniature in the Exultet Roll in the Biblioteca Capitolare at Salerno (Kantorowicz, II, frontispiece; cf. G. B. Ladner, "The 'Portraits' of Emperors in Southern Italian Exultet Rolls", *Speculum*, XVII, 1942, p. 181 ff., particularly p. 186; *Mostra storica nazionale della miniatura*, Palazzo Venezia, Rome, 1953, p. 6of., No. 82).

[2] For Frederick II's *Augustales*, see Kantorowicz, *ibidem*, I, p. 204 ff.; II, p. 255 ff., Plate I, 1, 2; more recently, H. Wentzel, "Der *Augustalis* Friedrichs II", *Zeitschrift für Kunstgeschichte*, XV, 1952, p. 183 ff. (according to Wentzel, "Antiken-Imitationen", p. 35, C. A. Willemsen plans a monograph on the various coinages). For Frederick's seals, see J. R. Dieterich, "Das Porträt Kaiser Friedrichs II von Hohenstau-

fen", *Zeitschrift für bildende Kunst*, New Ser., XIV, 1903, p. 251 ff.

[3] For Frederick's architectural enterprises, see Willemsen, *Apulien*, and L. Bruhns, *Hohenstaufenschlösser*, Königstein im Taunus, 1941; for Castel del Monte in particular, B. Molajoli, *Guida di Castel del Monte*, 2nd ed., Fabriano, 1940, and Wentzel, "Antiken-Imitationen'. The architecture of this castle has been designated, with only slight exaggeration, as "toute entière française" while "la sculpture qui l'accompagne diffère à peine du décor adopté en France, et particulièrement en Champagne, pour les chapiteaux et les clefs de voûtes" (Emile Bertaux, as quoted in Adhémar, *op. cit.*, p. 282). For Cistercian architects employed by Frederick II, see Kantorowicz, *Kaiser Friedrich der Zweite*, I, p. 80; II, p. 36f.

For the triumphal arch of Capua, see Kantorowicz, I, p. 483 ff.; II, p. 210 ff.; E. Langlotz, "Das Porträt Friedrichs II. vom Brückentor in Capua", *Essays in Honor of Georg Swarzenski*, Chicago, 1951, p. 45 ff.; and, above all, C. A. Willemsen, *Kaiser Friedrichs II Triumphtor zu Capua*, Wiesbaden, 1953 (the "Jupiter Head", Plate 69). The colossal head from Lanuvium, preserved in the German Archaeological Institute at Rome (published as a portrait of Frederick II by G. Kaschnitz-Weinberg, "Bildnisse Friedrichs II; I, Der Kolossalkopf aus Lanuvium", *Mitteilungen des deutschen archäologischen Instituts*, röm. Abteilung, LX/LXI, 1953/1954, p. 1 ff.; Wentzel, "Antiken-Imitationen", Fig. 6), appears to be a late-antique original reworked in the thirteenth century. That the head in

deceptively antique cameos now considered as products of the South Italian proto-Renaissance—such, for example, as the Christianized "Hercules" in the Juritzky Collection in Paris (Fig. 44), the "*Wettspiel-Kamee*" in the Vienna Museum, the *Embarkation of Noah* formerly owned by Lorenzo de' Medici and now preserved in the British Museum—none would seem to antedate the classicism of the Ile-de-France and Champagne.[1]

In connection with this *Embarkation of Noah* (Fig. 45) the great name of Nicolo Pisano (ca. 1205–1280) has been pronounced.[2] And he, in fact, exemplifies, on the largest possible scale, the very situation that I have tried to describe. Probably born and brought up in Apulia and certainly familiar, from the outset, with the "Frederician" tradition nourished by classical as well as Gothic sources, he acquired the power of synthesizing these two currents on a new level; but he acquired it only in a new political and spiritual environment.

That he made new contacts with the "Gothick North" is demonstrated, apart from more general factors, by such specific if secondary motifs as capitals and tracery patterns; and it is even more significant that he was the first Italian artist, anticipating Giotto and Duccio by several decades, to accept the Gothic innovation of affixing the crucified Christ to the cross by three nails instead of four—an innovation deemed important enough to be denounced by a contemporary prelate who felt that the French sculptors of the early thirteenth century, in order to strengthen the impression of plastic volume and organic movement (that is to say, for purely artistic reasons), had wantonly defied an iconographic tradition observed for nearly a thousand years.[3] But just these modern tendencies, their effectiveness enhanced by a change of scene which transplanted him from a sphere of imperial authoritarianism into one of republican self-government, enabled Nicolo Pisano to become the greatest—and in a sense the last—of mediaeval classicists.

As major Italian poetry, first flowering in the "Sicilian school" under Frederick II, was brought to perfection by the great Florentines from Guido Guinicelli to Dante and Petrarch,[4] so did the South Italian "proto-Renaissance" culminate in the works

Barletta (*ibidem*, LXII, 1955, p. 1 ff.) is a portrait of Frederick II is even less probable.

On the whole, the art produced under the auspices of Frederick II would seem to reflect his tendencies toward universalism and self-deification rather than an aesthetic bias in favor of classical art. He seems to have resorted to the Antique wherever he found it useful as a means of lending effective, even propagandistic, expression to his imperial aspirations.

[1] As to the dates of these cameos, see the controversy between Wentzel and Deér referred to p. 64, Note 1.

[2] Wentzel, "Die grosse Kamee", p. 70 (assuming that Wentzel meant to refer to Nicolo rather than "Andrea" Pisano).

[3] For literature on the "three-nail type" (Figs. 91, 92), see Panofsky, *Early Netherlandish Painting*, p. 364f. For Giotto's early Crucifix, see Oertel, *Die Frühzeit der italienischen Malerei*, pp. 66 and 219, Notes 120, 122, correctly crediting Nicolo Pisano with the introduction of this Gothic innovation into Italy.

[4] See, for example, W. Mönch, *Das Sonett*, Heidelberg, 1954. In this connection it is interesting to note

produced by Nicolo Pisano after his transmigration to Tuscany. Everyone knows that in his Pisa pulpit of *ca.* 1260 he transformed a Dionysus supported by a satyr into the aged Simeon witnessing the Presentation of Christ (Figs. 46 and 47), a nude Hercules into a personification of Christian fortitude (Fig. 48), a Phaedra into the Virgin Mary;[1] and that some five or six years later, in the *Massacre of the Innocents* seen on the Siena pulpit, he borrowed a gesture of grief from the same Meleager sarcophagus (Fig. 115)— in fact, from the same unforgettable figure—that was to inspire the despairing St. John in Giotto's *Lamentation* (Fig. 93) and one of the mourners in that memorable product of the Verrocchio workshop, the *Death of Francesca Tornabuoni.*[2] It should not be overlooked, however, that Nicolo Pisano, in thus "rediscovering" a collection of Roman monuments always available at Pisa and Florence yet never exploited by any of his predecessors, merely repeated what the masters of Reims had done a generation before.

In short, the acme of mediaeval classicism was reached within the general framework of the Gothic style, much as the acme of seventeenth-century classicism, as represented by Poussin, was reached within the general framework of the Baroque, and that of late eighteenth- and early nineteenth-century classicism, as represented by Flaxman, David or Asmus Carstens, within the general framework of "Romantic sensibility".

III

In contradistinction to the proto-Renaissance discussed in the preceding section, the second of the two renascence movements referred to at the beginning of this discussion may be called "proto-humanism"—provided that the term "humanism" is not considered as synonymous with such general notions as respect for human values, individualism, secularism or even liberalism but more narrowly defined as a specific cultural and educational ideal. This ideal, to quote its greatest mediaeval champion, John of Salisbury (d. 1180), is based on the conviction that "Mercury should not be torn from

what happened in Tuscany to the "Justice picture" first exemplified by Frederick's mural in his palace at Naples (see p. 66, Note 1). This authoritarian and, in a sense, bureaucratic pronouncement, where the populace, kowtowing before the enthroned Emperor, was enjoined to direct its complaints to his chancellor, Petrus de Vinea, rather than to himself, was replaced by affirmations of civic liberty, first, in Giotto's lost fresco in the Arte della Lana at Florence where Brutus was glorified as the paradigm of republican justice (S. Morpurgo, "Brutus, 'il buon giudice', nell' Udienza dell'Arte della Lana", *Miscel-*

lanea di Storia dell'Arte in onore di Igino Benvenuto Supino, Florence, 1933, p. 141 ff.); and, second, in Ambrogio Lorenzetti's famous allegories in the Palazzo Pubblico at Siena.

[1] See G. Swarzenski, *Nicolo Pisano,* Plates 16, 19–21, 26. For later literature on Nicolo Pisano, see W. R. Valentiner, "Studies on Nicola Pisano", *Art Quarterly,* XV, 1952, p. 9 ff.

[2] See A. Bush-Brown, "Giotto: Two Problems in the History of His Style", *Art Bulletin,* XXXIV, 1952, p. 42 ff. (cf., however, Panofsky, *Early Netherlandish Painting,* p. 367, and below, p. 153).

the embraces of Philology": or, in less poetic language, that it is necessary to preserve —or to restore—that union between clear thought and literate expression, reason and eloquence, *ratio* and *oratio*, which had been postulated by the classics from Isocrates to Cicero.[1]

Thus understood, humanism conceives of a liberal education (*liberalia studia*, as John of Salisbury has it, *studia humanitatis*, to use the later academic term which survives in our expression "the humanities")[2] as cultivating the classical tradition from the point of view of the man of letters and the man of taste rather than merely exploiting it for the purposes of the logician, the statesman, the jurist, the doctor, or the scientist. And thus understood, a "proto-humanistic" theme can indeed be isolated from the polyphony of twelfth-century culture, forming a kind of counterpoint to the revival of classical art which we have come to know as proto-Renaissance.

The revival of classical art originated, we recall, in Southern France, Spain and Italy, and the same is true of many other forms of cultural endeavor; but what was virtually absent from this Mediterranean scene was an analogous revival in what may be called (with due caution against the dangers attending the transference of modern terms to the distant past) *les belles-lettres*. "In Paris", says a disgruntled moralist, "the clerics care for the liberal arts; in Orléans, for [classical] literature; in Bologna for law books; in Salerno for pill boxes; and in Toledo for demons; but nowhere for morals".[3] And with a certain number of adjustments—especially the addition of Montpellier and, later, Padua to "Salerno" and "Toledo", and the interpretation of "Orléans" as the symbol of a much wider area—this thumbnail sketch can still be accepted as reasonably true to life.

Within the orbit exemplified by "Bologna, Salerno and Toledo" intellectual interest

[1] See Curtius, *op. cit.*, p. 84f.; for John of Salisbury in general, see H. Liebeschütz, *Mediaeval Humanism in the Life and Writings of John of Salisbury* (Studies of the Warburg Institute, XVII), London, 1950; cf. also the Introduction to D. D. McGarry, tr. and ed., *The Metalogicon of John of Salisbury*, Berkeley and Los Angeles, 1955; W. J. Millor, H. E. Butler, and C. L. N. Brooke, eds., *The Letters of John of Salisbury* (*1153-1161*), I: *The Early Letters*, London, Edinburgh and New York, 1955. For the movement of which John of Salisbury was an outstanding figure, see, in addition to Curtius, *op. cit.*, Haskins, *The Renaissance of the Twelfth Century*, and Renucci, *op. cit.*: H. Liebeschütz, "Das zwölfte Jahrhundert und die Antike", *Archiv für Kulturgeschichte*, XXXV, 1953, p. 247ff.; G. Paré, E. Brunet, and P. Tremblay, *La Renaissance du XII^e siècle: Les écoles et l'enseignement*, Paris, 1933; E. Faral, *Les Arts poétiques du XII^e*

et du XIII^e siècle, Paris, 1924; F. J. E. Raby, *A History of Christian-Latin Poetry; idem, A History of Secular Latin Poetry in the Middle Ages*, Oxford, 1934; M. Hélin, *A History of Mediaeval Latin Literature*, New York, 1949; F. von Bezold, *Das Fortleben der antiken Götter im mittelalterlichen Humanismus*, Bonn, 1922. For recent contributions, see the excellent survey by G. B. Ladner, "Some Recent Publications on the Classical Tradition in the Middle Ages and the Renaissance and on Byzantium", *Traditio*, X, 1954, p. 578ff.

[2] See Kristeller, *The Classics and Renaissance Thought*, p. 8ff. (with further references).

[3] "Ecce quaerunt clerici Parisii artes liberales, Aureliani auctores, Bononiae codices, Salerni pyxides, Toleti daemones, et nusquam mores ..." (quoted in Renucci, *op. cit.*, p. 134).

69

was focused upon precisely those subjects which do not come under the heading of *studia humanitatis*. And it was only in these non-humanistic fields—most branches of philosophy, law, mathematics, medicine, and the natural sciences, which, especially in the South Italian and Spanish centers, included astrology and what we now would call the exploration of the occult—that genuine classical revivals took place.

That all the Greek texts translated (chiefly in Spain) from intermediary Arabic sources were purely scientific or "philosophical" in character goes without saying; but neither can an essayist, orator or poet be found among those authors who, first at the courts of William I and Roger I of Sicily, came to be directly translated from the original Greek.[1] The numerous *Artes poeticae* and *Artes versificatoriae* produced in France and England during the twelfth and early thirteenth centuries do not have any parallel in Italy before Dante's *De vulgari eloquentia*.[2] And Latin-writing poets in Italy almost exclusively limited themselves to historical, political and scientific matters. Their verses—and pretty poor verses they were, by and large, up to Petrarch—deal with the exploits of Robert Guiscard, the virtues of Mathilda of Tuscany, the triumph of the Pisans at Mallorca; or, on the other hand, with such medical subjects as the "four humors" or the Baths of Puteoli. The author of the last-named work, Peter of Eboli, even manages to introduce into his purely political *Liber in honorem Augusti* (a eulogy of Emperor Henry VI) a doctor from Salerno who, expatiating upon the unflattering characterization of Henry's rival, Tancred of Lecce, delivers a lengthy lecture on embryology and the causes of freakish malformation.[3]

No Latin-writing Italian poet of the twelfth century thought of drawing from classical mythology or legend.[4] This field of interest appears to have been pre-empted, as it were, by the practitioners of the *ars dictandi* or *ars dictaminis* (perhaps best rendered as the "art of letter writing"), where mythological and other classical motifs were used

[1] For twelfth-century translations of scientific and philosophical texts, see C. H. Haskins, *Studies in the History of Mediaeval Science*, Cambridge (Mass.), 1924; cf. also Kantorowicz, *Kaiser Friedrich der Zweite*, I, p. 312 ff.; II, p. 149. For the revival of Roman law, see P. Vinogradoff, *Roman Law in Mediaeval Europe*, 2nd ed., Oxford, 1929; E. Calasso, *Lezioni di storia del diritto Italiano; Le fonti del diritto (Sec. V⁰–XV⁰)*, Milan, 1948.

[2] See Faral, *op. cit.* A short list of *Artes poeticae* (all, apparently, descending from a lost work by John of Salisbury) is found in Hélin, *op. cit.*, p. 101. Cf. also Curtius, *op. cit., passim*, and, for Dante's position in particular, p. 354 ff.

[3] See M. Manitius, *op. cit.*, III, Munich, 1931, and Raby, *A History of Secular Latin Poetry, passim.* For the *Gesta Roberti Wiscardi* (by William of Apulia), see

Manitius, p. 660 ff., and Raby, *ibidem*, II, p. 154f. For the poem on Mathilda of Tuscany (by Donizo of Canossa), Manitius, p. 662 ff., and Raby, *ibidem*, II, p. 155f. For the *Liber de bello maioricano* or *Triumphus Pisanorum* (by Henry of Pisa), Manitius, p. 672, and Raby, *ibidem*, p. 156f. For Peter of Eboli's *Liber in honorem Augusti*, see Manitius, p. 703 ff., and Raby, *ibidem*, p. 166 ff. The versification in all these and related poems suffers no comparison with that of contemporary poems in France or England, and it should be noted that the leonine hexameters explaining Frederick II's Justice picture in Naples (see p. 66, Note 1, the hexameters reprinted in Kantorowicz, *Kaiser Friedrich der Zweite*, II, p. 89) are fairly inferior even within the limitations of the species.

[4] See Raby, *ibidem*, II, p. 152f.

by way of erudite allusion, and by the vernacular poets, particularly in the south of Italy, whose works are at times distinguished by an Ovidian flavor largely imparted to them by Provençal influence. When at the end of the following century Guido delle Colonne wished to provide his educated contemporaries ("qui grammaticam legunt") with an up-to-date Latin version of that ever popular theme, the destruction of Troy, he could do so only by paraphrasing a romance composed by a Norman more than one hundred years before. And Petrarch's splendid hexameters describing the statues of classical gods in the third canto of his *Africa* are, to a large extent, still based upon the mythographical treatise of a twelfth-century Englishman.[1]

It was, in fact, in an area remote from the Mediterranean—the northern sections of France, with Burgundy forming a kind of borderline district, West Germany, the Netherlands, and, most particularly, England—that proto-humanism as opposed to the proto-Renaissance came into being.

In this area—Romanized but not really Roman and roughly coextensive with the Carolingian Empire plus the British Isles—the revivalists of the eleventh and twelfth centuries may be said to have begun where men like Alcuin, Eginhard, Theodulf of Orléans or Lupus of Ferrières had left off. Looking upon the Antique as upon a sacred image rather than an ancestor's portrait, they were disinclined to neglect, let alone to abandon, the associative and emotional values of the classical heritage in favor of its practical and intellectual applicability. Only a "Northerner" could have written a letter like that addressed in 1196 by Bishop Conrad of Hildesheim to his old teacher, Herbord—a letter so full of pride because Italy was then in the hands of the Germans yet so full of reverent and credulous admiration for all that which the writer had heard about at school as "through a glass darkly" (Conrad does not mind mixing metaphors in his enthusiasm for both St. Paul and the world of the classics) and now "saw face to face": Cannae, where so many Roman nobles had been killed that their rings

[1] For Guido delle Colonne's *Historia destructionis Troiae* (N. E. Griffin, ed., Cambridge [Mass.], 1936), its retranslation into French (A. Bayat, *La Légende de Troie à la cour de Bourgogne*, Bruges, 1908), and its numerous predecessors and descendants, see the literature referred to in Atwood and Whitaker, *op. cit.*, p. lxxxvii ff., and Renucci, *op. cit.*, pp. 116, 182 (cf. also Curtius, *op. cit.*, p. 34); further, A. Boutémy, "Le Poème 'Pergama flere volo' et ses imitations du XII^e siècle", *Latomus*, V, 1946, p. 233 ff. In spite of all recent research the old dissertation by H. Dunger, *Die Sage vom troianischen Krieg in den Bearbeitungen des Mittelalters und ihre antiken Quellen* (Programm des ... thumschen Gymnasiums), Dresden, 1869, is still very useful. That Petrarch extensively used the "Mythographus III" in the Third Book of his *Africa* (describing the representations of classical gods adorning the palace of King Syphax) was stressed by P. de Nolhac, *Pétrarque et l'humanisme*, 2nd ed., Paris, 1907, I, pp. 103, 118, 158, 205 f.; cf. also H. Liebeschütz, *Fulgentius Metaforalis, Ein Beitrag zur Geschichte der antiken Mythologie im Mittelalter* (Studien der Bibliothek Warburg, IV), Leipzig and Berlin, 1926, *passim*. For the distinctly "modern" stylization to which he subjected his mediaeval sources, see E. Panofsky, *Hercules am Scheidewege und andere antike Bildstoffe in der neueren Kunst* (Studien der Bibliothek Warburg, XVIII), Leipzig and Berlin, 1930, p. 10 ff.; *idem*, *Meaning in the Visual Arts*, p. 155 ff.

filled two bushels; but also a city called Thetis, founded by, and named after, the mother of Achilles; the little town Giovenazzo, the "birthplace of Jupiter"; Mount Parnassus and the Pegasian fountain, dwelling place of the Muses; and all the miraculous devices contrived by that greatest of magicians, Virgil.[1]

Thus, while the Mediterranean revival of Roman law and Greek philosophy and science had a tremendous impact on intellectual life in the North (suffice it to mention, within the twelfth century alone, such men as Ivo of Chartres and Bernold of Constance, the canonists; Abelard and Gilbert de la Porrée, the dialecticians; Bernardus Sylvestris and William of Conches, the moral and natural philosophers; Alanus de Insulis, the metaphysician; Adelhard of Bath, the scientist), this impact promoted rather than impeded the spread of "humanistic" aspirations and activities (even Walter of Châtillon, it should be remembered, began his career as a law student at Bologna). In some individuals, for instance, Alanus de Insulis, the very distinction between philosophy and *belles-lettres* may be said to have ceased to exist; in others, such as John of Salisbury, an instinctive aversion to that dialectical method which, gaining momentum in his own time and environment, was to result in what we know as scholasticism, served only to deepen their devotion to the *liberalia studia*. And nearly everywhere in Northern territory we find a re-emphasis on good Latin both in prose and verse; a reintensification of the interest in classical fable and myth; and, as far as art is concerned, the emergence of what we should not hesitate to call an "aesthetic" attitude[2]—an attitude now tinged with sentiment (let us not forget that English national literature began with a poem elicited by the awesome experience of Roman ruins), now almost antiquarian: instead of arousing the imitative instinct of the architect, the sculptor and the stone carver, the remnants of the classical past appealed to the taste of the collector, the curiosity of the scholar and the imagination of the poet.

Long before Frederick II acquired classical bronzes and marbles for his castles, Henry of Blois, Bishop of Winchester from 1129 to 1170, had imported from Rome, and set up in his palace, a number of "idols" produced by pagan artists "subtili et laborioso magis quam studioso errori". Long before Ristoro d'Arezzo, writing about 1280–1290, praised the specialty of his home town, those lustrous "Aretine" vases which—admirably decorated with "flying *putti*, battle scenes and fruit garlands"— "turned the heads of the *cognoscitori*" and seemed to have been "either produced by gods or descended from heaven", an English visitor to the Eternal City, Magister Gre-

[1] Conrad of Hildesheim's letter to Herbord is found in *Monumenta Germaniae Historica, Scriptores*, XXI, p. 193.

[2] See von Bezold, *op. cit.*, p. 42 ff.; K. Simon, "Diesseitsstimmung in spätromanischer Zeit und Kunst", *Deutsche Vierteljahrschrift für Literaturwissenschaft und Geistesgeschichte*, XII, 1934, p. 49 ff.; and, most particularly, M. Schapiro's brilliant article, "On the Aesthetic Attitude of the Romanesque Age", *Art and Thought*, London, 1948, p. 130 ff.

gorius of Oxford, had spent much of his time in describing and even measuring the classical edifices and had yielded so thoroughly to the "magic spell" (*magica quaedam persuasio*) of a beautiful Venus statue that he felt compelled to visit it time and again in spite of its considerable distance from his lodgings.[1] And Hildebert of Lavardin, Bishop of Le Mans from 1097 to 1125, praised the majesty of Roman ruins and the divine beauty of the Roman gods in distichs so polished in form and so sensitive in feeling that they were long ascribed to a poet of the fifth century and are still quoted in the same breath with du Bellay's *Antiquitez de Rome*, although the good bishop was careful to stress, in a kind of palinode, that the destruction of so much pagan grandeur and loveliness was necessary to bring about the victory of the Cross.[2]

There came into being an entirely new type of antiquarian literature, such as the *Graphia aurea Urbis Romae* and the *Mirabilia Urbis Romae* (composed *ca.* 1150), the content of which tended to merge with that of pseudohistorical expositions such as the *Gesta Romanorum*.[3] And, most important, the world of classical religion, legend and

[1] For Frederick II's acquisition of classical sculpture, see Kantorowicz, *Kaiser Friedrich der Zweite*, I, p. 482 f.; II, p. 210. For the enthusiastic praise of Aretine pottery in Ristoro d'Arezzo's *Libro della compositione del mondo* (with its interesting distinction between connoisseurs who were almost mad with admiration and non-connoisseurs who threw the precious fragments away and the astonishing phrase, "quelli artifici furono divini, o quelle vase descesaro di cielo"), see J. von Schlosser, "Ueber einige Antiken Ghibertis", p. 152 ff.; Ristoro is perhaps not quite sufficiently stressed in the excellent article by H. Wieruszowski, "Arezzo as a Center of Learning and Letters in the Thirteenth Century", *Traditio*, IX, 1953, p. 321 ff. For the acquisition of Roman statues by Bishop Henry of Winchester and the activities of Magister Gregorius of Oxford, see P. Fedele, "Sul Commercio delle antichità in Roma nel XII secolo", *Archivio della R. Società Romana di Storia Patria*, XXXII, 1909, p. 465 ff.; von Bezold, *op. cit.*, pp. 48 ff., 98; J. B. Ross, "A Study of Twelfth-Century Interest in the Antiquities of Rome", *Mediaeval and Historiographical Studies in Honor of J. W. Thompson*, Chicago, 1938, p. 302 ff.; G. McN. Rushforth, "Magister Gregorius de Mirabilibus Urbis Romae", *Journal of Roman Studies*, IX, 1919, p. 44 ff.

The local care for, and trade in, Roman antiquities in the twelfth century (Wentzel, "Antiken-Imitationen", p. 59 ff.) should not be overestimated. The former appears to have been inspired by political rather than artistic considerations (the column of Trajan, for example, was protected "in honor of the Church and the Roman people"); and the latter seems to have been limited to occasional sales to such Northern visitors as Bishop Henry of Winchester (the only case on record), whom the Romans themselves apparently considered as a kind of eccentric (see John of Salisbury's *Historia pontificalis*, XXXIX, the relevant passage referred to by Fedele, von Bezold and Ross, recently reprinted in O. Lehmann-Brockhaus, *Lateinische Schriftquellen zur Kunst in England, Wales und Schottland vom Jahre 901 bis zum Jahre 1307*, Munich, 1956, II, 667, No. 4760). Normally, the "trade in classical antiquities" served not so much the aesthetic instincts of the collector as the practical requirements of the builder who needed entablatures, capitals, facings or—like Suger—columns; it may be compared to the business of the wrecking contractor (latterly called "demolition expert") rather than the art dealer.

[2] For Hildebert of Lavardin, see, for example, Manitius, *op. cit.*, III, particularly pp. 643 ff. and 853 ff.; Raby, *Christian-Latin Poetry*, p. 265 ff.; *idem*, *Secular Latin Poetry*, I, pp. 317 ff.; von Bezold, *op. cit.*, p. 46 ff. For the parallel between his "Par tibi, Roma, nihil", and du Bellay's *Antiquitez de Rome*, see, e.g., Renucci, *op. cit.*, p. 105.

[3] For the presumable date of the *Graphia aurea Urbis Romae* and the *Mirabilia Urbis Romae*, see Schramm, *Kaiser, Rom und Renovatio*, II, pp. 68 ff. and 104 ff. It also seems that the so-called *Heraclius de coloribus Romanorum*, though not quite so late as assumed by Schramm, II, p. 148 ff. (which is excluded by the late-eleventh-century manuscript in Rochester, New

73

mythology began to come to life as it had never come to life before—not only thanks to a growing familiarity with the sources (it is interesting to observe the gradual expansion and, if one may say so, liberalization of the "reading lists" drawn up for the benefit of students)[1] but also, and even more so, thanks to an increasing emphasis on higher learning and literary skill as such. The rise of cathedral schools, universities and free associations not unlike the later academies facilitated the formation of a class of persons who thought of themselves primarily as *litterati* in contradistinction to *illitterati*, addressed each other in much the same vein as their spiritual descendants were to do in the fifteenth and sixteenth centuries[2] and—even though most of them were still clerics and often rose high in the hierarchy—showed a characteristic inclination to withdraw into the bliss of pastoral seclusion. One has to go back to Cicero, Horace and Virgil—and, at the same time, forward to Petrarch, Boccaccio and Marsilio Ficino—to find the old theme "beata solitudo sola beatitudo" treated with so much introspective tenderness as in a poem by Marbod of Rennes, who died in 1123:

> "Rus habet in silva patruus meus; huc mihi saepe
> Mos est abjectis curarum sordibus, et quae
> Excruciant hominem, secedere; ruris amoena
> Herba virens, et silva silens, et spiritus aurae
> Lenis et festivus, et fons in gramine vivus
> Defessam mentem recreant et me mihi reddunt,
> Et faciunt in me consistere ..."[3]

York, published by J. C. Richards, "A New Manuscript of Heraclius", *Speculum*, XV, 1940, p. 255 ff.), is by no means so early as is assumed by many other scholars. Professor Bernhard Bischoff, to whom we owe the conclusive dating of the equally controversial *Schedula diversarum artium* by "Theophilus *qui et* Rugerus" ("Die Ueberlieferung des Theophilus-Rugerus nach den ältesten Handschriften", *Münchner Jahrbuch der bildenden Kunst*, 3rd series, III/IV, 1952/53, p. 1 ff.), was kind enough to inform me that in his opinion the original redaction of the *Heraclius* hardly antedates the middle of the eleventh century (which would make it approximately contemporaneous with the *Schedula*) and was composed in the North (Rhineland?) rather than in Italy. It is to be hoped that Professor Bischoff will discuss the question in greater detail himself.

[1] See Curtius, *op. cit.*, p. 57 ff.

[2] For the use of the terms "litterati" and "illitterati", see, e.g., one of Wibald of Stablo's letters, reprinted in P. Jaffé, *Bibliotheca rerum germanicarum*, I, Berlin, 1864, p. 283, to which my attention was called by Professor William S. Heckscher. For the vaingloriousness of the twelfth-century proto-humanists, see

a remark of Wilhelm Wattenbach, quoted in Raby, *Christian-Latin Poetry*, p. 278, Note 3: "Es erinnert an das Zeitalter der Humanisten, wenn wir sehen, wie hoch diese Dichter und ihre Freunde von sich und ihren Werken denken, wie sie sich als Lieblinge der Musen darstellen und unbedenklich einander Unsterblichkeit und ewigen Ruhm versprechen" (cf., however, the Introduction to E. Panofsky, ed., *Abbot Suger on the Abbey of Saint-Denis and Its Art Treasures*, Princeton, 1946, p. 31 [reprinted in *Meaning in the Visual Arts*, p. 137]). For their cult of friendship, see Raby, *Secular Latin Poetry*, I, p. 333.

[3] For Marbod of Rennes, see Manitius, *op. cit.*, III, p. 719 ff. and *passim*; Raby, *Christian-Latin Poetry*, p. 273 ff.; *idem, Secular Latin Poetry*, I, p. 329 ff. The beautiful poem partly quoted and translated in my text is found in *Patrologia Latina*, CLXXI, col. 1665 ff. (cf. also another poem, *ibidem*, col. 1717, extensively quoted by Raby, *Secular Latin Poetry*, I, p. 336). For the tendency of learned men of the twelfth century to withdraw into monastic or pastoral seclusion, see the life histories of Marbod of Rennes and Baudry of Bourgueil (Raby, *Christian-Latin Poetry*, p. 273 ff., particularly p. 278) and, more especially,

("My uncle has a farm out in the woods, / Where I withdraw, having cast off the squalor / Of all the worries that torment mankind. / Its verdant grass, the silent woods, the gentle / And playful breezes, and the spring, vivacious / Amidst the herbs, refresh the weary mind—/ Restore my self to me and make me rest / Within me ...")

The graceful (*levis*) Ovid, whose influence had been fairly limited in the early Middle Ages, became a "Great Power" in mediaeval culture after *ca.* 1100 and began to be commented upon with an assiduity previously reserved for such more "serious" or more erudite authors as Virgil or Martianus Capella.[1] The knowledge of classical mythology, so necessary for the understanding of all Roman writers, was systematically cultivated and was conclusively summarized in the "*Mythographus III*"—the work of an English scholar traditionally referred to as "Albricus of London" and possibly identical with the renowned scholastic, Alexander Neckham (died 1217)—which was to remain the standard mythological handbook up to Petrus Berchorius' introduction to his *Metamorphosis Ovidiana moraliter explanata* (first version composed about 1340, second version about 1342) and Boccaccio's *Genealogia deorum*—and was to be read, exploited and criticized even later.[2] And the intensity of the enthusiasm with which the Latin authors of the twelfth century immersed themselves in pagan legend, myth and history can be measured by the intensity of the opposition which this enthusiasm aroused among religious as well as philosophical rigorists—an opposition which, paradoxically and characteristically, tends to speak with the very voice which it endeavors to silence.

The idea couched in a merry jingle by an anonymous author of the twelfth century ("Magis credunt Juvenali / Quam doctrinae prophetali / Vel Christi scientiae. / Deum dicunt esse Bacchum, / Et pro Marco legunt Flaccum, / Pro Paulo Virgilium")[3] was

E. H. Kantorowicz, *Die Wiederkehr gelehrter Anachorese im Mittelalter*, Stuttgart, 1937.

[1] For the ascendancy of Ovid after a prolonged eclipse, see P. Lehmann, *Pseudo-antike Literatur des Mittelalters* (Studien der Bibliothek Warburg, XIII), Leipzig and Berlin, 1927, pp. 4ff., 89ff., particularly 92ff. (cf. also the references in H. Fränkel, *Ovid, A Poet between Two Worlds*, Berkeley and Los Angeles, 1945, p. 169, Note 4). For his influence in general, see E. K. Rand, *Ovid and His Influence*, Boston, 1925; for further information, F. Ghisalberti, "Mediaeval Biographies of Ovid", *Journal of the Warburg and Courtauld Institutes*, IX, 1946, p. 10ff. (with reference to his and others' previous studies). For the *Ovide moralisé* in French verse and its aftermath, see below, p. 78, Note 2.

[2] For mediaeval mythography, see von Bezold, *op. cit.*; further, Liebeschütz, *Fulgentius Metaforalis*, Panofsky and Saxl, "Classical Mythology in Mediaeval Art",

passim; Seznec, *op. cit.*, p. 167ff. For the twelfth century, there may be added a versification of Hyginus' *Fabulae* inserted into his poem on Troy by Simon Capra Aurea, an intimate of Abbot Suger (Manitius, *op. cit.*, III, p. 646f.), and Baudry of Bourgueil's long versification of Fulgentius' *Mitologiae* (P. Abrahams, *Les Oeuvres poétiques de Baudri de Bourgueil*, Paris, 1926, CCXVI, p. 273ff.). For the latter, cf. Manitius, *op. cit.*, III, p. 883ff.; P. Lehmann, *op. cit.*, pp. 10f., 81–89 (pseudoepigraphical correspondence between "Ovid" and "Florus" not included in Miss Abrahams' edition); Raby, *Secular Latin Poetry*, I, p. 347ff.

[3] Quoted by Renucci, *op. cit.*, p. 108. For the important developments in the fourteenth century (Petrarch, Berchorius, the so-called "*Libellus de imaginibus deorum*", etc.), see below, p. 78, Note 2.

expressed by Bernard of Cluny ("Bernardus Morlanensis") in verses whose tripping, purely dactylic rhythm and catchy double rhymes (both internal and terminal) almost conceal the fact that they are, technically speaking, carefully constructed hexameters, each line consisting of exactly seventeen syllables:

> "Sed stylus ethnicus atque poeticus abjiciendus;
> Dant sibi turpiter oscula Iupiter et schola Christi;
> Laus perit illius, eminet istius, est honor isti".[1]

("We must forswear the heathen and poetic style; / It is a shame when Jove and followers of Christ embrace; / The former's praise is dead, the latter's lives in glory"). And when Alanus de Insulis inveighs, on philosophical grounds, against the pseudoclassical epics of two famous contemporaries, Joseph of Exeter's *De bello Troiano* and Walter of Châtillon's *Alexandreis*, he manages to outdo his foes in verbal and prosodic sophistication, and the most devastating weapon he can think of is unflattering classical comparison:

> "Sed neque gemmarum radius splendore diescens,
> Nec nitor argenti, nec fulgure gratius aurum
> Excusare potest picturae crimen adultum,
> Quin pictura suo languens pallescat in auro.
> Illic pannoso plebescit carmine noster
> Ennius et Priami fortunas intonat; illic
> Maevius in coelos audens os ponere mutum
> Gesta ducis Macedum tenebrosi carminis umbra
> Pingere dum tentat, in primo limine fessus
> Haeret, et ignavam queritur torpescere musam".[2]

("But neither flash of gems ablaze with light / Nor sheen of silver nor gold's fairer gleam / Will e'er excuse a picture's rooted crime / So that it may not pale in all its gold. / Here rants our Ennius, his shoddy song / Intoning Priam; there our Maevius, / Daring to lift his speechless mouth to heaven / And trying, with the shade of cloudy verse, / To paint the deeds of Alexander, tires, / Stops at the very threshold, and bemoans / The numb inaction of his listless muse").

[1] Bernard of Morlas (Bernardus Morlanensis, Bernardus Morlacensis, Bernardus Morvalensis, or, which is the safest way, Bernard of Cluny), *De contemptu mundi*, III, 318 ff. (H. C. Hoskier, ed., London, 1929, p. 81); the attack on the humanistic point of view begins with verse 295: "Quis modo Coelica sudat ut ethnica scripta doceri"? On the author— who, his objections notwithstanding, was very well versed in classical mythography and history—see Manitius, *op. cit.*, III, p. 780 ff.; Raby, *Christian-Latin Poetry*, p. 315 ff.; Curtius, *op. cit.*, p. 159.

[2] Alanus de Insulis, *Anticlaudianus, Patrologia Latina*, CCX, col. 491 ff., brilliantly interpreted by Curtius, *ibidem*, p. 127. For Alanus in general, see Manitius, *ibidem*, particularly p. 794 ff.; Raby *ibidem*, p. 297.; *idem, Secular Latin Poetry*, II, p. 15 ff.

Alanus' high-minded condemnation, then, bears witness to, rather than detracts from, the vigor of the trend exemplified by its objects.[1] Nor was the fascination of classicizing poetry, least of all of poetry less ponderous than those two mighty epics but captivating by virtue of sentiment, elegance and conciseness, diminished by the protests of the devout. Marbod of Rennes and Hildebert of Lavardin (whose *Lament on His Exile*, composed when he had lost his bishopric, is no less eloquent than his more famous *"Par tibi, Roma, nihil"*)[2] have just been mentioned as masters of the pastoral and the elegy; but two generations after them, in Alanus de Insulis' own lifetime, there could be produced—probably by Matthew of Vendôme, the author of a much-quoted *Ars poetica* and an erudite *Commentary on Ovid* as well as of a witty fabliau named *Milo*—an epigram on Hermaphroditus which kept an honorable place in the *Anthologia Latina* until Ludwig Traube exposed it as a work of the twelfth century.[3]

All this might conceivably be dismissed as "school poetry" (although Walter of Châtillon's *Alexandreis* had not lost its appeal as late as the sixteenth century when a substantial portion of it was translated into blank verse and freely used in Thomas Kyd's *Spanish Tragedy*).[4] Real lifeblood, however, was infused into the characters of pagan myth and fable by the less ambitious but all the more vivacious authors who did not attempt to emulate the solemnity of Virgil, Lucan and Statius or the epigrammatic felicity of Martial or Juvenal but boldly adapted the presentation of classical subjects to the fashion of the day, using rhymed verse rather than classical meters and indulging in topical allusions and witty turns of phrase. This is what still appeals to the modern reader in the songs of the goliards and such lighthearted works as the *Carmen de Leda*, where Leda in person tells her story to the (English) author in order to console him in his own unhappy love for a girl named Albors;[5] in the charming *Danaë*, where at a meeting of the gods in springtime Apollo incites the amorous feelings of his fellow Olympians by singing the loves of famous mortals and finally acts as a Pandarus to

[1] For Joseph of Exeter and Walter of Châtillon (and his followers), see Manitius, *ibidem*, pp. 649 ff., 920 ff.; Raby, *Secular Latin Poetry*, II, pp. 132 ff., 190 ff., 204 ff.

[2] For Hildebert's *Lament on His Exile*, see Manitius, *ibidem*, p. 864; Raby, *Christian-Latin Poetry*, p. 268 f.

[3] *Anthologia Latina*, 786. For Matthew of Vendôme, see Manitius, *ibidem*, pp. 644 ff., 737 ff. (for the *Hermaphroditus* in particular, p. 739); Raby, *Christian-Latin Poetry*, p. 304 ff.; *idem*, *Secular Latin Poetry*, II, p. 30 ff. (for the *Hermaphroditus* in particular, with reference to Faral's doubts as to Matthew's authorship, p. 34).

[4] Before being used by Kyd, the episode in question (the death of Zoroas, *Alexandreis*, III, 1623 ff.) had been translated into blank verse by Nicholas Grimald

for Tottel's *Miscellany* of 1557; see H. Baker, *Introduction to Tragedy*, Baton Rouge (La.), 1939, p. 75 ff. For the use of another, more important passage of Walter's *Alexandreis* (a discussion of Fortune in relation to human decisions), see W. Rüegg, "Entstehung, Quellen und Ziel von Salutatis 'De fato et fortuna'", *Rinascimento*, V, 1954, p. 143 ff. Not many people are aware of the fact that the still proverbial and very authentic-sounding line "Incidit in Scyllam qui vult vitare Charybdin" (*recte* "Incidis in Scyllam cupiens vitare Charybdin") does not come from a classical author but from *Alexandreis*, V, 301.

[5] For the *Carmen de Leda*, see Manitius, *op. cit.*, III, p. 647 ff.; Raby, *Secular Latin Poetry*, II, p. 313.

Jupiter and the daughter of Acrisius; and in the perhaps even more charming *Debate between Helen and Ganymede*, where Helen, assisted by Nature, defends normal love while Ganymede, supported by Grammar (or, as we would say, Philology), praises the other kind almost as Plato had done in the *Phaedrus*:

"Ludus hic quem ludimus
A diis est inventus
Et ab optimatibus
Usque adhuc retentus.

Rustici, qui pecudes
Possunt appellari,
Hi cum mulieribus
Debent inquinari".[1]

("The gods thought up the game we play, / And it is favored to this day / By men of lofty station. / With women uncouth country dolts, / No better than their steers and colts, / May practice fornication").

We can easily conceive that the enthusiasm for the classical world imparted itself to those who could not read Latin at all. It gave rise to countless treatments of classical subject matter in the vernacular languages which made the world of ancient Greece and Rome accessible to fashionable society; suffice it to mention (apart from such ostensibly historical works as the *"Histoire ancienne"* based on Orosius' *Historia antiqua adversus paganos*, *Li Fet des Romains* and the numerous "Chronicles" of either the whole world or certain countries all of which claimed descent from classical antiquity) Benoît de Sainte-More's *Roman de Troie* and *Roman d'Enéas*, the anonymous *Roman de Thèbes* and Lambert Li Tors' *Roman d'Alixandre*.

Shortly after 1300 not only the spurious wisdom of the so-called *Dicta Catonis* but also the authentic stories told in Ovid's *Metamorphoses*—though encumbered with lengthy moralizations—were available in French versions;[2] and very respectable

[1] For the *Dialogue between Helen and Ganymede*, see Manitius, *ibidem*, p. 947f.; Raby, *Secular Latin Poetry*, II, p. 289f. In the Middle Ages Ganymede was so typical a representative of homosexuality that a prelate so inclined could be ridiculed as "ganimedior Ganimede" (von Bezold, *op. cit.*, pp. 58, 101); a particularly forceful passage is found in Bernardus Morlanensis, *De contemptu mundi*, III, 191 ff. (Hoskier, ed., p. 77). For further information on the subject, see Curtius, *op. cit.*, p. 121 ff., and Adhémar, *op. cit.*, pp. 222, 246, Fig. 73. It is significant that the Renaissance glorified the same Ganymede as the classic representative of that ascent of the soul to the absolute by means of beauty which was the

central theme of Neo-Platonism, the very name being derived from γάννυσθαι and μῆδεα, "to enjoy" and "the mind" (cf. Panofsky, *Studies in Iconology*, p. 213ff., Figs. 158, 169).

[2] Between 1316 and 1328 the attempts, beginning as early as the eleventh century, to invest Ovid's *Metamorphoses* with an allegorical and ultimately specifically Christian meaning (see now the handy summary in I. Lavin, "Cephalus and Procris", *Journal of the Warburg and Courtauld Institutes*, XVII, 1954, p. 260ff., particularly p. 262f.) culminated in an enormous French poem formerly attributed to no less illustrious a personage than Philippe de Vitry. This text—hereafter to be referred to as the *"Ovide*

translations of Livy, Valerius Maximus, Seneca, Aristotle, etc., many of them undertaken at the behest of Charles V of France, were made in the further course of the fourteenth century. In the end, the entire mass of mythological, legendary and historical

moralisé in verse" and published *in extenso* by C. de Boer in collaboration with J. T. M. van't Sant in *Verhandelingen der Koninklijke Nederlandse Akademie van Wetenschappen, afd. Letterkunde*, New Ser., XV (1915), XXI (1920), XXX (1931), XXXVI/XXXVII (1936), XLIII (1938)—is divided, like Ovid's *Metamorphoses* itself, into fifteen books and tacitly presupposes the reader's familiarity with the appearance, character and significance of the classical gods. And the same is true of two much-abridged prose versions thereof, one transmitted through Paris, Bibliothèque Nationale, MS. fr. 137, and London, British Museum, MS. Royal 17.E.IV (see Saxl and Meier, *op. cit.*, I, p. 213 ff.); the other, produced in 1466 for King René of Anjou, through Rome, Vatican Library, Cod. Reg. 1680 (recently published by C. de Boer under the title "Ovide moralisé en prose" in *Verhandelingen der Koninklijke Nederlandse Akademie van Wetenschappen, afd. Letterkunde*, New Ser., LXI, 1954).

This need for preliminary mythographical information was met by the *Metamorphosis Ovidiana moraliter explanata* (or, for short, the *Ovidius moralizatus*), a Latin prose work composed, as has already been mentioned, by Petrus Berchorius (Pierre Bersuire) about 1340 and revised about 1342 (see, in addition to the literature referred to above, p. 87, Note 2, F. Ghisalberti, "L'Ovidius moralizatus di Pierre Bersuire", *Studi Romanzi*, XXIII, 1933, p. 5 ff.; J. Engels, *Etudes sur l'Ovide moralisé*, Diss., Groningen, 1945). The earlier version of Berchorius' treatise, originally destined to form the Fifteenth Book of his *Reductorium morale* (as opposed to his better-known *Repertorium morale*), was torn out of context at an early date. It was not only separately copied in numerous manuscripts but also separately printed (with the erroneous attribution to a certain Thomas Valeys, Waley, or de Walleis) from as early as 1509; whereas the first printed edition of the *Reductorium*, comprising only the first fourteen books, did not appear until 1521. Berchorius' *Ovidius moralizatus* supplied precisely what the *Ovide moralisé* in verse had lacked: it is preceded by a strictly mythographical Introduction in which the most prominent members of the pagan pantheon are graphically described as well as heavily moralized and which incorporates, in addition to material culled from the earlier mythographers, a considerable number of "humanistic" motifs. A personal friend of Petrarch's, Berchorius extensively borrowed from the latter's *Africa*—increasing, however, the number of Petrarch's ecphrases from fourteen to seventeen (by the addition of Bacchus, Hercules and Aesculapius) and rearranging their sequence in such a way that the seven planetarian divinities, arranged in astronomical order, are placed at the beginning of the list. This Introduction was to achieve a life of its own. On the one hand, it was translated into French, which French translation served as a preamble for the *Ovide moralisé* in verse in the Copenhagen manuscript Thott 399, 2° (cf. below, p. 87, Note 2) as well as for a French prose version, compounded from both the Latin *Ovidius moralizatus* and the French paraphrases transmitted through Paris, MS. fr. 137, and London, MS. Royal 17.E.IV, which was printed by Colard Mansion at Bruges in 1484 and by Antoine Vérard at Paris in 1493 (cf. M. D. Henkel, *Houtsneden van Mansion's Ovide Moralisé, Bruges 1484*, Amsterdam, 1922, and Lavin, p. 286 f.). On the other hand, it served as a basis for a more "popular" little handbook in Latin, the so-called *Libellus de imaginibus deorum* (reprinted, after Vatican Library, Cod. Reg. 1290, in Liebeschütz, *Fulgentius Metaforalis*, p. 117 ff.). Here the long-winded moralizations were eliminated while the number of items was doubled by the addition of Aeolus, Janus, Vesta, Orpheus, Perseus, and Ceres, and by the substitution of the Twelve Labors of Hercules for his single image.

Rivaled only by Boccaccio's *Genealogia deorum* (and this exclusively in Italy), Berchorius' mythographical Introduction and its derivatives constituted the most important source of information wherever classical divinities had to be depicted or described (for this, see Warburg, *op. cit.*, II, p. 627 f.); recently its influence has been shown to extend even to Chaucer's *House of Fame* and *Knight's Tale* (E. H. Wilkins, "Descriptions of Pagan Divinities from Petrarch to Chaucer", *Speculum*, XXXII, 1957, p. 511 ff.). I doubt, however, that Chaucer used the *Libellus*—which thus would have to be dated before 1380—in preference to, or even to the exclusion of, any other source. If it is argued that Chaucer "agrees with the *Libellus* as against Bersuire" in the specifications that Venus holds her *conca* in her right hand and that her roses are "both white and red", it might be objected that he disagrees with the *Libellus* as well as Bersuire

79

information came to be absorbed, augmented, digested, and distorted in that tremendous stream of *Unterhaltungsliteratur,* half poetic, half didactic, which ran from the *Roman de la Rose* through the *Bestiaire d'Amour* and the *Echecs Amoureux* to, say, Christine de

—and, characteristically, agrees with Petrarch—in describing Mars as standing rather than seated on his chariot (*Africa*, III, 187: "Curribus *insistens*") and that he disagrees with everybody in ascribing to Vulcan a "ful broun" face and in replacing the troublesome *conca* of Venus with a little lyre (*citole*). It thus seems hazardous to tie Chaucer down to the *Libellus*: we must either credit him with the knowledge of other textual or, possibly, visual sources (if one were to assume that the substitution of *cana lamina* for *conca marina* goes back as far as the second half of the fourteenth century, one might even conjecture that he misunderstood a drawing showing Venus with a "slate")—or, perhaps, with a modicum of poetic inventiveness).

As regards the illustrated manuscripts and incunabula of the texts here discussed, the only illustrated manuscript of the *Libellus*, Vatican Library, Cod. Reg. lat. 1290, is published *in extenso* in Liebeschütz (Pls. XVI–XXXII). What seems to be the only illustrated manuscript of Berchorius' *Ovidius moralizatus*, Gotha, Landesbibliothek, Cod. Membr. I, 98, does not contain the "mythographical Introduction", and the other illustrations have not, to my knowledge, been reproduced except for the *Sirens* in Book XIV, for which see E. Panofsky, "Das erste Blatt ...", p. 29, Fig. 25. A series of miniatures inserted into a manuscript in the Bodleian Library at Oxford, MS. Rawlinson B.214, fols. 197v.–200 (Saxl and Meier, *op. cit.*, I, p. 395ff.; II, Figs. 19, 20), corresponds exactly to the Berchorius sequence (see the synoptical table at the end of this Note), except that one leaf, showing Neptune, Pan, Bacchus, and Pluto, is missing between fol. 199 and fol. 200. These miniatures, interspersed with inscriptions, seem, however, to have formed an independent "picture book".

The remaining manuscripts may be roughly divided into the following four groups.

A. Manuscripts of the *Ovide moralisé* in verse uninfluenced by Berchorius, their illustrations endeavoring to translate the Ovidian stories into purely narrative pictures. The most complete and certainly one of the earliest examples of this kind (though in my opinion dating from the third rather than the second quarter of the fourteenth century) is the manuscript in Lyons, Bibliothèque Municipale, MS. 742, which contains fifty-three miniatures and boasts,

among other interesting pictures, a Creation scene where God, characterized as the Christian Deity by a cruciform halo, creates the universe while a Prometheus, dressed in the semi-oriental costume of a sage or prophet, animates man by means of a torch (Fig. 49). The continuance of the tradition exemplified by the Lyons manuscript and its development by elimination on the one hand and elaboration on the other can be observed in Paris, Bibliothèque Nationale, MS. fr. 871 (*ca.* 1400), which now contains only four slightly colored pen drawings (all but the first full page and executed on separate leaves) that serve as frontispieces to Books I, VI, and IX: the *Creation of the World* (still closely akin to Lyons, fol. 4, our Fig. 49) on fol. 1; the charming *Mons Helicon* (to be compared with Lyons, fol. 87, our Fig. 50) on fol. 116 (our Fig. 51); the *Story of Orpheus and Eurydice* on fol. 116; and *Orpheus Charming the Animals* on fol. 116 v. (our Fig. 52).

B. Manuscripts of the French prose redaction transmitted through Paris, Bibliothèque Nationale, MS. fr. 137, and London, British Museum, MS. Royal 17.E.IV, likewise uninfluenced by Berchorius in text as well as illustrations (one miniature of the Paris manuscript, reproduced in Henkel, p. 9, two of the London manuscript in Saxl and Meier, *op. cit.*, Figs. 22, 23).

C. The Manuscripts and incunabula (already mentioned) in which a French translation of Berchorius' Introduction, with its full complement of illustrations precedes either the *Ovide moralisé* in verse (Copenhagen, Royal Library, MS. Thott 399, 2°, one miniature reproduced in Fig. 58) or the French prose version compounded from a translation of Berchorius' *Ovidius moralizatus* and the Paris-London redaction just referred to (the printed editions of 1484 and 1493, for which see Henkel). In both these cases a series of narrative miniatures or woodcuts, belonging to the text proper, thus follows what may be called "the seventeen mythographical images *à la* Berchorius".

D. A closely interrelated family of manuscripts of the *Ovide moralisé* in verse, in which the "mythographical images *à la* Berchorius" (including, as I must add in correction of what I implied in *Meaning in the Visual Arts*, p. 157, the representation of Apollo in the company of that three-headed monster which Petrarch had excavated from Macrobius) have

Pisan's *Epître d'Othéa*; and when the proto-humanism of the transalpine world had played its part in the formation of real humanism in Italy, this stream was further swelled by French, English and German paraphrases and translations of Petrarch and Boccaccio.

crowded out the narrative miniatures altogether, even though they are not referred to or even alluded to in the text. In manuscripts of this kind we find, therefore, the number of images reduced from seventeen to fifteen (by the elimination of Cybele and Aesculapius), and their sequence rearranged so as to establish some kind of connection, however tenuous, with the salient features of the poem; Vulcan, e.g., takes fourth place because the notorious story of his revenge on Mars and Venus is told in *Ovide moralisé*, IV, 1286–1371, while Hercules takes ninth place because he is the hero of *Ovide moralisé*, IX, 1–1029. In the French members of this family (Paris, Bibliothèque Nationale, MS. fr. 373, one miniature reproduced in Fig. 56; Rome, Vatican Library, Cod. Reg. lat. 1480; Geneva, Bibliothèque Publique et Universitaire, MS. fr. 176 [our Fig. 57], all produced about 1380), these mythographical images serve as frontispieces for the fifteen books of the text; whereas in an early fifteenth-century manuscript of English provenance (British Museum, MS. Cott. Julius F. VII, for which see Saxl and Meier, I, p. 215 ff., Fig. 21) they serve to embellish what may be called the table of contents; in this case their sequence is rearranged once more so as to reinstate, in a general way, the system devised by Berchorius, particularly the grouping together of the planetary gods at the beginning.

A synoptic table showing these various sequences may be helpful.

	Petrarch, *Africa* III, 138–264	Berchorius, mythographical Introduction; Copenhagen, MS. Thott 399, 2°(fols. 1–25 v.); Bruges edition of 1484 (fols. 1–35 v.); Oxford, MS. Rawlinson B. 214 (fols. 197 v.–200)	*Libellus de imaginibus deorum* (Rome, Cod. Reg. lat. 1290, fols. 1–8, a fol. 5 a intercalated between fol. 5 and fol. 6)	*Ovide moralisé* in verse (Paris, MS. fr. 373; Rome, Cod. Reg. lat. 1480; Geneva, MS. fr. 176)	*Ovide moralisé* in verse (London, MS. Cotton Julius F.VII)
1	Jupiter	Saturn	Saturn	Saturn	Saturn
2	Saturn	Jupiter	Jupiter	Jupiter	Jupiter
3	Neptune	Mars	Mars	Juno	Mars
4	Apollo (Sol)	Apollo (Sol)	Apollo (Sol)	Vulcan	Apollo (Sol)
5	Mercury (plus Gorgons and Perseus)	Venus	Venus	Pluto	Venus
6	Mars	Mercury	Mercury	Minerva (Pallas)	Mercury
7	Vulcan	Diana (Luna)	Diana (Luna)	Diana (Luna)	Diana (Luna)
8	Pan	Minerva (Pallas)	Minerva (Pallas)	Bacchus	Minerva (Pallas)
9	Juno	Juno	Pan	Hercules	Hercules
10	Minerva (Pallas)	Cybele	Pluto	Venus	Juno
11	Venus	Neptune	Juno	Mercury	Vulcan
12	Diana (Luna)	Pan	Cybele	Mars	Neptune
13	Cybele	Bacchus	Aeolus	Apollo (Sol)	Pan
14	Pluto	Pluto	Janus	Neptune	Bacchus
15		Vulcan	Vulcan	Pan	Pluto
16		Hercules	Neptune		
17		Aesculapius	Vesta		
18			Orpheus		
19			Bacchus		
20			Aesculapius		
21			Perseus		
22–33			Twelve Labors of Hercules		
34			Ceres		

IV

As FAR as the representational arts are concerned, the influence of proto-humanism, diffusing from North to South, interpenetrated with that of the proto-Renaissance which, as has been seen, spread in the opposite direction; and the combined effect of these two complementary movements resulted in what may be called the "reactivation" of classical motifs as well as classical concepts.

Carolingian art, we remember, revived and re-employed scores of "images" in which classical form was happily united with classical content and often not only endowed these images with an expressive power entirely foreign to their prototypes but also, as I have phrased it, "permitted them to escape from their original context without abandoning their original nature". The iconographical significance of these images, however, remained unchanged. The transformation of, say, Orpheus into Christ, Polyhymnia into the Virgin Mary,[1] classical poets into Evangelists, Victories into angels, had been a *fait accompli* in Early Christian art, and the Carolingians do not seem to have taken further steps in this direction. The classical images were either left *in situ*, so to speak, as is the case wherever illuminated manuscripts were copied in their entirety; or they were made to serve a different purpose (and thereby tended to be transposed into a different medium), as is the case with the Virgilian pastorals adorning the flabellum of Tournus, the simulated cameos embellishing the Evangelist pages of the Ada Gospels or—to adduce two instances not as yet mentioned—the circular silver plates produced for Theodulf of Orléans and known to us through his descriptions, one a kind of *Mappa mundi* featuring the personifications of the earth and the ocean, the other a "Tree of the Liberal Arts", each represented with her attributes (Astronomy, for example, with a disk that must have looked like a celestial map from an *Aratea* manuscript);[2] or, finally, they were carried over into Biblical narratives to which they had not been admitted before, as is the case—apart from many of the personifications in which the Utrecht and Stuttgart Psalters abound—with the figures of Sol and Luna, Oceanus and Terra, in numerous Crucifixions (Figs. 16, 20, 63).

[1] See the ivory formerly in the Trivulzio Collection, now in the Museo Archeologico, at Milan, illustrated, e.g., in Morey, *Early Christian Art*, Fig. 82.

[2] For these two descriptions (which must, of course, be read with the same reservations as most poetical ecphrases), see J. von Schlosser, *Schriftquellen zur Geschichte der karolingischen Kunst* (*Quellenschriften für Kunstgeschichte*, New Ser., IV), Vienna, 1892, p. 384f., Nos. 1031–1032, and p. 377, No. 1026. Theodulf's special interest in classical subjects is also attested by his famous ecphrasis on an antique

vase, presumably of silver, showing the Labors of Hercules (Schlosser, p. 427ff., No. 1134; Adhémar, *op. cit.*, pp. 10f., 309f.); it is, however, significant that he apologizes for adopting the pagan nomenclature in his description of the constellations (Schlosser, No. 1026): "Nec tibi displiceant gentilia nomina, lector; / Iste vetustatis mos datur a patribus". Cf. also H. Liebeschütz, "Theodulf of Orléans and the Problem of the Carolingian Renaissance", in D. J. Gordon, ed., *Fritz Saxl, 1890–1948; A. Volume of Memorial Essays*, London, 1957, p. 77ff.

Nowhere in Carolingian art, however, do we seem to encounter an effort to infuse into a given classical image a meaning other than that with which it had been invested from the outset: an Atlas or a river-god in the Utrecht Psalter may immeasurably surpass his model in animation and expressiveness, but he remains an Atlas or a river-god; we are confronted with quotations or paraphrases, however skillful and spirited, rather than with reinterpretations. Conversely—and this is even more important—nowhere in Carolingian art do we seem to encounter an effort to devise a formula that might translate a given classical (or otherwise secular) text into a new picture: where illustrations of such texts were available, they were copied and recopied without cease; where none were available, none were invented.[1]

In both these respects the simultaneous rise of proto-Renaissance and proto-humanism effected an essential change. As we have seen, the sculptors of the eleventh, twelfth and thirteenth centuries repeated on a new level what the Early Christian artists had so extensively done but what their Carolingian heirs had so conspicuously refrained from doing: they subjected classical originals to an *interpretatio Christiana*, the term *Christiana* here meant to include, in addition to that which can be found in Scripture or in hagiology, all kinds of concepts that come under the heading of Christian philosophy. Antoninus Pius, we recall, was transformed into St. Peter, Hercules into Forti-

[1] The *Excidium Troiae* (cf. above, p. 45, Note 1) was, against the opinion of the editors, not illustrated in Carolingian times. The miniatures in the only illustrated manuscript (Florence, Biblioteca Riccardiana, MS. 881, produced in Italy rather than Spain) were, as will be shown in a forthcoming article by Dr. L. D. Ettlinger, freely invented on the basis of the text, and this invention does not antedate the thirteenth century. The main stream of illustrations of the Trojan cycle seems to begin, in the second half of the thirteenth century, in the Benoît de Sainte-More manuscripts (the earliest known example being Paris, Bibliothèque Nationale, MS. 1610, dated 1264) and in the French compilations, partially based on Orosius' *Libri septem historiarum adversus paganos*, which are known as *Le Livre de Orose, Histoire ancienne, Les Livres des histoires du commencement du monde*, etc. (one of the earliest illustrated manuscripts Dijon, Bibliothèque Municipale, MS. 562). Of the French prose versions of the *History of Troy* only one illustrated manuscript is known: Paris, Bibliothèque Nationale, MS. fr. 1612, dating from the end of the thirteenth century. Lately some earlier illustrations, starting about the middle of the eleventh century, have been discovered in manuscripts of the original Latin Orosius text (see D. J. A. Ross, "Illustrated Manuscripts of Orosius", *Scripto-* *rium*, IX, 1955, p. 35 ff.); it is significant, however, that these manuscripts were apparently illustrated by amateurs (according to Ross the scribes themselves) and have no connection with each other, let alone any influence on the later production. The only exception to the rule that no classical or secular text was freshly illustrated in the Carolingian period seems to be the *De universo* by Hrabanus Maurus, an illustrated manuscript of which must have been produced at Fulda in the ninth century (for copies of it, see the references given above, p. 51, Note). It is, however, still possible that these Carolingian miniatures were based on an illustrated copy of Isidore of Seville's *Etymologiae* (although none has come down to us); and even if the originals of the pictures accompanying the Hrabanus text were not all found in one source, the Hrabanus illustrations must have been derived—by groups, as it were—from existing late-antique prototypes. This can be demonstrated by the fact that many such groups can be traced back to common prototypes which served as models for other Carolingian illustrations; see E. Panofsky and F. Saxl, *Dürers "Melencolia I."; Eine quellen- und typengeschichtliche Untersuchung* (Studien der Bibliothek Warburg, II), Leipzig and Berlin, 1923, p. 125 ff.

tude, Phaedra into the Virgin Mary, Dionysus into Simeon; *Venus Pudica* could be changed into Eve, and *Terra* into Luxury.[1]

At the same time, however, classical concepts as well as classical characters (real or imaginary) and classical narratives (historical or mythical) came to be picturalized in a manner entirely independent from classical representational sources. The Four Elements and the Seven Liberal Arts, Socrates and Plato, Aristotle and Seneca, Pythagoras and Euclid, Homer and Alexander the Great, Pyramus and Thisbe, Narcissus and Europa, the heroes of the Trojan war and all the classical gods were depicted either according to the conventions familiar to the artist from the life and art of his day or on the basis of verbal descriptions—which, incidentally, for the most part were furnished by secondary rather than primary sources; in contrast to the great number of postclassical compilations, commentaries and paraphrases provided with illustrations by mediaeval book illuminators, only three scantily illustrated Virgils and hardly any illustrated Ovid have come down to us from the Middle Ages.[2]

All these illustrations bear witness to a curious and, in my opinion, fundamentally important phenomenon which may be described as the "principle of disjunction": wherever in the high and later Middle Ages a work of art borrows its form from a classical model, this form is almost invariably invested with a non-classical, normally Christian, significance; wherever in the high and later Middle Ages a work of art borrows its theme from classical poetry, legend, history or mythology, this theme is quite invariably presented in a non-classical, normally contemporary, form.

To some extent this "principle of disjunction" would seem to operate even in literature. Short poems as convincingly "antique" as Matthew of Vendôme's *Hermaphroditus* are not too frequent, and epics classical in language and meter as well as in content are in a minority as compared to treatments of classical myth and fable in very mediaeval Latin or one of the vernacular languages (whereas didactic poems such as Alanus de Insulis' *Anticlaudianus* or Bernardus Silvestris' *Liber mathematicus* may strike us by nearly impeccable classical versification and a studiedly classical vocabulary). The *De bello Troiano* by Joseph of Exeter, of whom it has been said that "no one understood the rules of the game better since the days of Lucan" and who, in contrast to Walter of Châtillon, scrupulously avoids not only any specific reference to the Christian faith but also—with one exception prompted by patriotism—any other anachronism, has been termed "almost unique".[3]

[1] See above, p. 62 f. and p. 65, Note 1. For the reinterpretation of *Terra* as Luxury, see Adhémar, *op. cit.*, p. 197.

[2] For illustrated manuscripts of the Aeneid, see Panofsky, *Meaning in the Visual Arts*, p. 47, Note 20; for the Naples manuscript specifically (Biblioteca Nazionale, Cod. olim Vienna 58), cf. P. Courcelle, "La Tradition antique dans les miniatures inédites d'un Virgile de Naples", *Mélanges d'Archéologie et d'Histoire*, LVI, 1939, p. 249 ff.

[3] See the references given above, p. 77, Note 1.

In the representational arts of the high and later Middle Ages, however, the "principle of disjunction" applies almost without exception, or only with such exceptions as can be accounted for by special circumstances; from which results the paradox that— quite apart from the now familiar generic difference between sculpture and painting— an intentionally classicizing style is found in the ecclesiastical rather than in the secular sphere, in the decoration of churches, cloisters and liturgical objects rather than in the representations of mythological or other classical subjects which adorned the walls of sumptuous private dwellings and enliven the interesting "Hansa Bowls",[1] not to mention the miniatures in secular manuscripts.

In the pictures accompanying Remigius of Auxerre's *Commentary on Martianus Capella*—which, though composed in the ninth century, did not begin to be illustrated until about 1100—Jupiter is represented in the guise of a ruler enthroned, and the raven which, according to the text, belongs to him as his sacred bird of augury is surrounded by a neat little halo because the illustrator involuntarily assimilated the image of a ruler enthroned and accompanied by a sacred bird to that of Pope Gregory visited by the dove of the Holy Spirit. Apollo—he, too, faithfully represented according to the indications of the text—rides on what looks like a peasant's cart and carries in his hands a kind of nosegay from which emerge the figures of the Three Graces as little busts (Fig. 53).[2] The Greek and Trojan heroes and heroines, referred to as "barons" and "damsels" in the vernacular accounts of the Trojan cycle, invariably move in a mediaeval environment, act according to mediaeval customs and are clad

[1] For these bowls, see J. Weitzmann-Fiedler, "Romanische Bronzeschalen mit mythologischen Darstellungen ...," *Zeitschrift für Kunstwissenschaft*, X, 1956, p. 109 ff. (cf. also *eadem*, "A Pyramus and Thisbe Bowl in the Princeton Museum", *Art Bulletin*, XXXIX, 1957, p. 219 ff.).

[2] Munich, Staatsbibliothek, clm. 14271, fol. 11 v. See Liebeschütz, *Fulgentius Metaforalis*, p. 44 f.; Panofsky and Saxl, "Classical Mythology in Mediaeval Art", p. 253 ff., Fig. 39; and Seznec, *op. cit.*, p. 167 ff., Fig. 67. R. Pfeiffer in his excellent article "The Image of the Delian Apollo and Apolline Ethics", *Journal of the Warburg and Courtauld Institutes*, XV, 1952, p. 20 ff., claims that the representation of Apollo holding the Three Graces in clm. 14271 ultimately derives from a visual model instead of being developed from the text. This, however, is extremely improbable, first, because Apollo holds the Three Graces in his left hand, whereas he should hold them in his right according to all classical sources; second, because the Graces are represented as busts, whereas they appear in full length in all classical representations. It is characteristic that

Agostino di Duccio's relief in the Tempio Malatestiano at Rimini, though still dependent on mediaeval sources in many other ways, reverts to the authentic tradition. For the whole subject, see the recent, brilliant article by E. H. Kantorowicz, "On Transformations of Apolline Ethics", *Charites, Studien zur Altertumswissenschaft* (Festschrift Ernst Langlotz), Bonn, 1957, p. 265 ff.

In contrast to Western art (where, so far as I know, fresh illustrations of classical subjects do not occur until the eleventh century) instances of this kind are found in Byzantine manuscripts as early as the ninth. A perticularly amusing series of instances is found in the *Homilies of Gregory* (Milan, Biblioteca Ambrosiana, Cod. E 49-50 inf.), discussed by K. Weitzmann, *Greek Mythology in Byzantine Art*, Princeton, 1951, p. 88 ff., Figs. 95-99. The Naples Virgil (cf. p. 84, Note 2), produced in South Italy at the end of the tenth century, combines illustrations derived from classical models with others developed from the text and may thus be said to hold an intermediary position between Byzantium and the West.

in mediaeval armor or dress. Achilles and Patroclus as well as Medea and Jason and Dido and Aeneas are shown engaged in playing chess. Laocoön, the "priest", appears tonsured. Thisbe converses with Pyramus through a wall separating two abbreviated Gothic buildings and waits for him on a Gothic tomb slab whose inscription ("Hic situs est Ninus rex") is preceded by the then indispensable cross (Fig. 54).[1] Pygmalion is represented as a practitioner of *la haute couture*, putting the finishing touches to an elaborate mediaeval dress which he has provided for his beautiful statue (Fig. 55).[2] And on occasion the corrupted or ambiguously worded passage in a mythographical text might lead the unsuspecting illustrator—often as late as the fifteenth and sixteenth centuries, when certain mediaeval sources or their derivatives continued to be used even in Italy—into misunderstandings which tend to puzzle as well as to amuse the modern beholder.

It is through errors of this kind that Vulcan, "nutritus ab Sintiis" (meaning the inhabitants of the island of Lemnos, where he alighted after having been precipitated from Mount Olympus), was depicted in the company of either nymphs (Fig. 38) or apes because the *ab Sintiis* in Servius' *Commentary on Virgil*—a *hapax legomenon* in Latin literature—had been misread into *ab ninfis* or *ab simiis*;[3] that the goddess Cybele was shown driving through a landscape incongruously embellished with empty stools and chairs because, owing to the misplacement of an abbreviation sign, the phrase *sedens fingatur* ("she should be depicted seated") had been corrupted into *sedes fingantur* ("seats should be depicted");[4] or that Venus, emerging from the sea, is portrayed holding in her hand a sizable bird rather than a sea shell because of the corruption of one word in Berchorius' *Metamorphosis Ovidiana:* in his description of Venus as "in mari natans et in manu concham marinam continens, quae rosis erat ornata et columbis cirumvolantibus comitata" ("swimming in the sea and holding a sea shell in her right hand, adorned with roses and accompanied by doves fluttering about her") the words *concham* (or *concam*) *marinam* had been misread into *aucam marinam*, a "sea goose" (Fig. 56); and in at least one instance—the fine but little known *Ovide moralisé* in the University Library at Geneva—an illustrator of more than usual intelligence, trying hard to distinguish this "sea goose" from the ordinary land goose, went so far as to provide

[1] Paris, Bibliothèque Nationale, MS. lat. 15158, fol. 47; see Panofsky and Saxl, "Classical Mythology in Mediaeval Art", p. 272; Panofsky, *Meaning in the Visual Arts*, p. 43, Fig. 8.

[2] Oxford, Bodleian Library, MS. Douce 195 (*Roman de la Rose*), fol. 150; see Saxl and Meier, *op. cit.*, p. 356, Plate LIV, Fig. 139.

[3] The nymph motif appears in a picture by Piero di Cosimo, for which see below, p. 180; the ape motif, in a fresco in the Palazzo Schifanoia at Ferrara

(executed by Francesco Cossa and his workshop), for which see A. Warburg, *Gesammelte Schriften*, Leipzig and Berlin, 1932, II, p. 641; Panofsky, *Studies in Iconology*, p. 37 ff.; H. W. Janson, *Apes and Ape Lore in the Middle Ages and the Renaissance* (Studies of the Warburg Institute, XX), London, 1952, pp. 291 ff. and 317, Note 22.

[4] Ferrara, Palazzo Schifanoia. For the motif of the empty stools, see Warburg, *ibidem*, and Fig. 141.

it with a fish tail and scales (Fig. 57).[1] In another group of manuscripts and incunabula an even more elaborate corruption of the same text, with *concam marinam* apparently garbled into *canam laminam* and the punctuation between *continens* and *quae rosis* omitted, resulted in the transformation of the sea shell into a slate (appropriately inscribed with a little love song); and it is this slate, and not the goddess, which appears "adorned with roses and surrounded by doves" (Fig. 58).[2]

While I know no exception to the rule that classical themes transmitted to mediaeval artists by texts were anachronistically modernized, there are certain cases in which the other aspect of the "principle of disjunction"— the rule that classical images known to mediaeval artists by visual experience do not retain their original meaning but are subjected to an *interpretatio Christiana*—was set aside. It is these cases which I had in mind when speaking of exceptions that can be accounted for by special cirumstances, and they can indeed be confined to definite areas of practical purpose or iconographical significance.

First of all, there is—apart, of course, from scientific illustrations and the unique phenomenon of the coins and statues produced at the personal command of Frederick II, where Roman models were subjected to what may be called an *interpretatio imperialis*

[1] Geneva, Bibliothèque Publique et Universitaire, MS. fr. 176, fol. 216. The "Venus with the Sea Goose" is a constant feature in all those cases in which Berchorius' mythographical Introduction to the *Metamorphosis Ovidiana* invaded manuscripts of the *Ovide moralisé* in French verse (see above, p. 78 ff., Note 2, Groups C and D). We find her, therefore, at the beginning of the Tenth Book in Paris, Bibliothèque Nationale, MS. fr. 373, fol. 207 v. (Warburg, *ibidem*, p. 640, Fig. 113, our Fig. 56); in Rome, Vatican Library, Cod. Reg. Lat. 1480, fol. 218 v. In London, British Museum, MS. Cott. Julius F.VII, fol. 8, the representation belongs to the rubric of the Fifth Book; whereas in Copenhagen, MS. Thott 399, 2°, fol. 148 v., it forms the frontispiece of the Fifth Book itself.

[2] Copenhagen, same manuscript, fol. 9 v. (freely repeated in a woodcut in the Bruges edition of 1484, fol. 13 v.), here forming part of a series of classical divinities illustrating a French translation of Berchorius' Introduction (for a reprint of this text, see de Boer's edition of the *Ovide moralisé*, cited above, p. 78 f., Note 2, fifth volume (*Verhande-lingen ...*, XLIII, 1938, p. 387 ff.). The Copenhagen manuscript thus contains two different portrayals of Venus based on two different misreadings of one and the same text. And this text in turn owes its existence to the corruption of a Fulgentius passage originally reading "[Venus] conca marina portari pingitur" but occasionally changed to "[Venus] concam marinam portare pingitur" (see Wilkins, *op. cit.*, p. 531, Note); that only the first of these versions, surviving in the late mediaeval doggerel "... graciis stipata et concha locata" (Liebeschütz, *Fulgentius metaforalis*, p. 116), can be the correct one is evident from classical parallels in art (M. Brickoff, "Afrodite nella conchiglia", *Bollettino d'Arte*, 2nd Ser. IX, 1929–1930, p. 563 ff., Figs. 1–4) as well as literature, the best-known being Tibullus' "Et faveas, concha, Cypria, vecta tua" (*Carmina*, III, 3, 34). The passage accounting for the Venus miniature on fol. 9 v. of the Copenhagen manuscript, literally identical with the corresponding passage in the printed editions, reads as follows: "Venus ... tenant en sa main une lamine dardoise aournée et environnée de roses et de flers"; and I rather cherish the idea (without wanting to be dogmatic about it) that the Latin scribe who corrupted Berchorius' *concam marinam* into *canam laminam* was misled by Petrarch's description (*Africa*, III, 213), which says of Venus: "*concam lasciva gerebat*". It should be noted that the Latin language has no word exactly corresponding to our "slate", which in its mineralogical sense would have to be circumscribed by *lapis sectilis* or the like.

rather than an *interpretatio Christiana*—the special domain of glyptography. Precious and semiprecious stones were always credited with medical and magical properties, and the increasing influence of Arabic pseudoscience lent force to the belief that the effectiveness of these properties could be strengthened by engraving mythological or (which in most cases amounted to the same thing) astrological images upon the appropriate gems—a belief called "not very commendable yet not entirely refutable" by a great naturalist of the thirteenth century, Thomas of Cantimpré. Through lapidaries and encyclopaedias the significance of such images became no less familiar to the Middle Ages than the "virtues" of the stones themselves; and we can easily see that classical cameos showing subjects of this kind were copied—and, perhaps, occasionally forged— with the intent to retain their iconography (and therefore their magic) as well as their design. Albertus Magnus describes a great number of what we still designate, with a word derived from the Arabic, as "talismans". Engraved upon a special kind of stone, the image of Saturn endows the wearer with wealth and power, that of Jupiter with a pleasing personality, that of Mercury with eloquence and business acumen; Pegasus improves the skill of horsemen and the health of their mounts; Hercules killing the Nemean lion gives victory in war; Perseus with the Medusa's head affords protection from thunderstorms.[1]

It should not be forgotten, however, that more often than not such talismans were produced on the basis of verbal descriptions found in the lapidaries rather than by the direct imitation of genuine classical gems. When confronted with such originals, mediaeval patrons and artists were still inclined, unknowingly or on purpose, to misinterpret the subject, as when a winged Victory was inscribed with Malachi's "Ecce mitto angelum meum" or when Poseidon and Athena were rechristened "Adam and Eve". And even where the subject retained its identity, it could still be infused with a less palpable yet no less definitely Christian symbolism. When a cameo portraying the Emperor Augustus was placed in the center of the so-called Cross of Lothair in the Treasury of Aix-la-Chapelle, this was done not in spite but because of the fact that it was recognized as an emperor's portrait.[2]

Second, there is the equally special domain of personifications or divinities intended

[1] See von Bezold, *op. cit.*, p. 39 ff.; C. Meyer, *Der Aberglaube des Mittelalters und der nächstfolgenden Jahrhunderte*, Basel, 1884, p. 57 ff., mostly based on Albertus Magnus' *De rebus metallicis*, II, 3, 5; the passage from Thomas of Cantimpré is quoted on p. 58.

[2] J. Deér, "Das Kaiserbild im Kreuz", *Schweizerische Beiträge zur allgemeinen Geschichte*, XIII, 1955, p. 48 ff. For the deliberate reinterpretations referred to in the text, see von Bezold, *op. cit.*, p. 40f. For the special

case of the Poseidon and Athena cameo, see Wentzel, "Die grosse Kamee"; I believe, however, that the chief object of this excellent study, the Poseidon and Athena cameo in the Cabinet des Médailles at Paris (Wentzel, Figs. 34–37), is not a mediaeval reproduction but a classical original recut and rechristened in the thirteenth century. An analogous problem (except that no recutting would be involved) is posed by the beautiful onyx cameo in Schaffhausen; this is normally considered as a Roman original set in

to indicate a certain region or locality important for the narrative; and, most particularly, that of pagan idols, which tended to be rendered more or less verbatim where the context demanded them. They figure, primarily, in Biblical or hagiological narratives involving their adoration, repudiation or destruction and in such renderings of Idolatry as show her in the act of worshiping a "graven image", the first known instance of this kind being one of the twelve circular reliefs on the central portal of Notre-Dame at Paris (*ca.* 1210) where she adores, instead of the customary "statue on a column", a classical cameo enlarged to the size of a bust portrait; and they figure, secondarily, as indications of an un-Christian environment or as allusions to an undesirable state of mind or body, the classic example of this kind being the *Spinario*. Visible throughout the Middle Ages and placed high upon a column (so that the conspicuous exposure of its genitals caused the observers to interpret it as an image of Priapus), this figure constitutes what has been called "the idol *par excellence*", and it persistently recurs in mediaeval art not only as an idol in the narrower sense of the term but also, e.g., as a personification of sickness, folly, vice in general (the latter transfixed, in one case, by the crosier of a pious bishop), and as a personification of March, which month (for etymological as well as empirical reasons) was associated with the awakening of amorous instincts in the "male animal".[1]

the thirteenth century, whereas Wentzel suggests, with judicious reservations, the possibility that the gem itself is a "Werk staufischer Glyptik".

[1] For the problem of idols in general, see Heckscher, *Sixtus IIII*, where an idol in the strictest sense of the word is defined as "statue plus column"; in this connection it is interesting to note that in such renderings the columns themselves tend to retain a relatively classical shape, that is to say, an organization into base, shaft and capital, even when, as in the Northern Late Gothic style, no such columns existed in actual architecture (see the interesting discussion in E. Forssman, *Säule und Ornament [Acta Universitatis Stockholmiensis]*, Stockholm, 1956, p. 39 ff.). In many cases, of course, idols had to be freely reconstructed from the texts instead of being derived, however indirectly, from an antique original; see, for example, the text-inspired zoomorphic gods in a number of Gregory manuscripts (Weitzmann, *Greek Mythology in Byzantine Art*, Figs. 89–94), significantly contrasting with the beautifully classical Isis in another Gregory manuscript, Paris, Bibliothèque Nationale, MS. Coislin 239, fol. 122 v. (*ibidem*, Fig. 88). In the *Hortus deliciarum* of Herrade of Landsberg, fol. 200 (A. Straub and G. Keller, eds., Herrade de Landsberg, *Hortus Deliciarum*, Strasbourg,

1901, Plate XLIV) Idolatry carries, on an enormous column, a triad of idols which may be said to epitomize the difference here under discussion. Given Herrade's familiarity with Byzantine art, the strange object may well derive from a model such as the "Goat of Mende" in the Jerusalem *Gregory* (MS. Taphou 14, fol. 313, ill. in Weitzel, Fig. 89)— except for the fact that the central figure is replaced by a still fairly "authentic" Mars. For the relief on the central portal of Notre-Dame at Paris, where Idolatry worships a classical cameo enlarged into a life-sized bust portrait, see Wentzel, "Portraits 'A l'Antique' ", p. 342, Plate 48 a.

For the *Spinario* in particular, see W. S. Heckscher, *Reallexikon zur deutschen Kunstgeschichte*, Stuttgart, 1937 ff., IV, p. 290 ff., *s.v.* "Dornauszieher"; cf. also Ladendorf, *op. cit.*, p. 20 ff., and Adhémar, *op. cit.*, p. 189 ff. The connection between the *Spinario* and the month of March has been accounted for by the fact that this month was said to produce "humores variosque dolores". More probably, however, the "Priapean" characteristics of the *Spinario* (*mira magnitudine virilia*) seemed to fit in with a description of March supported by the enormous authority of Isidore of Seville (*Etymologiae*, V, 23) and versified as early as the ninth century: "*Martius* appellatur ...

Of all other mediaeval images directly or indirectly derived from classical models, including the ubiquitous centaurs, sirens and hunting scenes ("diabolus venator est"), the rarer Cupids and such suggestive subjects as The Girl on the Ram[1] we may safely assume that—barring cases of plain incomprehension—a "Christian" significance of one kind or another has been imposed upon them, no matter whether they served to symbolize some moral or doctrinal concept or merely formed part of the *speculum naturae* which had its rightful place in high-mediaeval theology. And where certain cases—such as the tympanum of St.-Ursin at Bourges or the sarcophagus of Bishop Arnulf of Lisieux (Fig. 24), already mentioned—still seem to defy interpretation, the fault is apt to lie with the limitations of our knowledge and ingenuity in applying the "law of disjunction" rather than with the "law of disjunction" as such.[2]

quod eo tempore cuncta animantia agantur ad *marem* et ad concumbendi voluptatem"; and:

"Martius a *Marte* romano auctore vocatus,
Vel tunc quodque animal *mare* coire cupit"

(J. C. Webster, *The Labors of the Months in Antique and Mediaeval Art*, Princeton, 1939, pp. 114, 112).

[1] See R. Hamann, "The Girl and the Ram", *Burlington Magazine*, LX, 1932, p. 91 ff.; F. Nordström, *Virtues and Vices on the 14th Century Corbels in the Choir of Uppsala Cathedral*, Stockholm, 1956, p. 94 ff. It should be noted that it is often difficult to ascertain whether in a given case motifs classical in origin have been copied directly from an antique original or handed down by tradition; I am, for example, inclined to consider the hunting scene on the mid-twelfth-century sarcophagus from Javarzay (now in the Musée du Pilori at Niort), on which see C. Picard, "La Chasse à courre du lièvre", *Studia Antiqua Antonio Salač Septuagenario Oblata*, Prague, 1955, p. 156 ff., Pl. VIII, as a revival rather than a survival. Nor is it always easy to determine whether a motif of this kind has a specific or a more general significance, or even whether it bears a favorable or unfavorable connotation, in a particular case. It is, for example, difficult to decide whether the centaurs ridden by little boys as seen in Vézelay and Chartres (Adhémar, *op. cit.*, p. 267 f., Figs. 95, 97) are in fact intended to portray Chiron instructing the young Achilles or carry the customary, unfavorable implication, on which see J. Bayet, "Le Symbolisme du cerf et du Centaure à la Porte Rouge de Notre-Dame Dame de Paris", *Revue Archéologique*, XLIV, 1954, p. 21 ff. In the Chartres case I find it hard to accept the interpretation as Chiron because the supposed Achilles, perhaps under the influence of the *Boy with a Goose*, carries a sizable

bird in his left hand while the supposed Chiron, who should be a wise and kindly character, threatens a woman with his bow and arrow.

For the symbolism of monsters and animals in general, see the bibliography in T. H. White, *The Book of Beasts, Being a Translation from a Latin Bestiary of the Twelfth Century*, New York, 1954, p. 271 ff. To be added: R. Bernheimer, *Romanische Tierplastik und die Ursprünge ihrer Motive*, Munich, 1931; D. Jalabert, "Recherches sur la faune et la flore romanes", *Bulletin Monumental*, XCIV, 1935, p. 71 ff., XCV, 1936, p. 433 ff., XCVII, 1938, p. 173 ff.; R. Wittkower, "Marvels of the East; A Study in the History of Monsters", *Journal of the Warburg and Courtauld Institutes*, V, 1942, p. 159 ff.; Janson, *op. cit.*; W. S. Heckscher, "Bernini's Elephant and Obelisk", *Art Bulletin*, XXIX, 1947, p. 155 ff.; F. Nordström, "Peterborough, Lincoln and the Science of Robert Grosseteste; A Study in Thirteenth-Century Iconography", *Art Bulletin*, XXXVII, 1955, p. 241 ff. M.-M. Davy's *Essai sur la symbolique romane* (XIIᵉ Siècle), Paris, 1955, is somewhat disappointing in this and other respects.

[2] Even in these two cases a tentative interpretation may be suggested. Of the five medallions adorning the tomb of Arnulf of Lisieux only four, showing the heads of pagan rulers in profile, are inspired by classical coins, whereas the long-bearded head in the center, represented in full face, seems to be freely invented. I believe it possible, therefore, that the four "pagan" heads are meant to represent the Four Monarchies according to Daniel 7, the head in the center thus representing the "Ancient of days" (Daniel 7:22), that is to say, Christ, Whose Second Coming marks the beginning of the Fifth, or Messianic, Kingdom. It was precisely about the middle of

In support of the bold generalizations which open the preceding paragraph I should like to discuss a few specific cases which have been adduced as proof of the contrary: the reliefs on the façade of the church of Schöngrabern; the "pagan" figures on the central portal of Auxerre Cathedral (left embrasure); Master Wiligelmus' "genii" with inverted torches, now arbitrarily set into the façade of Modena Cathedral; the classicizing medallions on the cover of the so-called "Kaiserpokal" preserved in the Treasury of the Cathedral of Osnabrück; and the "Mithras" on one of the capitals in the cloisters of Monreale.

The rather provincial Schöngrabern reliefs (executed about 1230 but still decidedly Romanesque in style) show, in addition to a man fighting a monster and a sea centaur playing the harp while standing on an unidentifiable quadruped, three scenes from classical mythology obviously conceived on the basis of visual experience rather than textual tradition: Sisyphus carrying the stone uphill; Tantalus vainly reaching for the

the twelfth century that the prophecy of Daniel attracted a renewed interest and that the Four Monarchies and their kings (formerly usually identified as Babylonia-Chaldaea ruled by Nebuchadnezzar, Media ruled by Darius, Persia ruled by Cyrus, and the Graeco-Macedonian empire ruled by Alexander) came to be reinterpreted and represented as Babylonia-Chaldea ruled by Nebuchadnezzar, Media and Persia ruled by Cyrus, the Graeco-Macedonian empire ruled by Alexander, and the Roman empire ruled by Caesar or Augustus; see P. Clemen, *Die romanische Monumentalmalerei in den Rheinlanden*, Düsseldorf, 1916, p. 323 f.

The tympanum of St.-Ursin at Bourges is one of the few Romanesque tympana to be divided into registers: it shows, from bottom to top, the Labors of the Months; a hunting scene freely copied from a Roman sarcophagus which contains the remains of St. Lusorius (St. Ludre) and is still preserved in the Abbey of Déols near Bourges (Adhémar, *op. cit.*, Fig. 25); and scenes from the fable centered around the evil deeds of the fox and the wolf, the latter being shown in his well-known encounter with the crane (see Kingsley Porter, *op. cit.*, Fig. 1263; Adhémar, p. 164 ff., Fig. 24; R. Crozet, *L'Art roman en Berry*, Paris, 1932, p. 299 ff.). Since the tomb of St. Lusorius had become the object of an organized pilgrimage in the tenth century, its duplication on the tympanum of St.-Ursin may have been intended to reflect some of St. Lusorius' glory upon St. Ursinus, the first bishop of Bourges, who according to legend was an intimate friend of St. Lusorius: the latter is said to have consecrated St. Ursinus and to have died eight days

thereafter, whereupon St. Ursinus allegedly arranged for St. Lusorius' entombment in the Roman sarcophagus at Déols. As we know from Franz Cumont, the hunting of wild beasts so frequently represented on Roman sarcophagi denoted man's everlasting struggle against evil; see *Recherches sur le symbolisme funéraire des Romains*, Paris, 1942, p. 449 ff., with special reference to the pagan sarcophagus at Déols as well as to Christian sarcophagi in which the hunting motif was retained, at least on the ends, even if the front showed such representations as Christ between the Apostles. It was, therefore, legitimate for the Bourges sculptor to combine a representation of the Labors of the Months, which indicate the processes of nature, with a copy after the hunting sarcophagus of St. Lusorius, which symbolizes man's moral struggle; he was even careful to eliminate from the Roman original the only figure which shows one of the hunters thrown to the ground. The addition of the scenes from the fable would seem to corroborate this moralistic interpretation, for both the fox and the wolf are *typi* of the devil; see, in addition to the bestiaries, Hugh of St. Victor, *De bestiis et aliis rebus*, *Patrologia Latina*, CLXXVII, col. 15 ff. ("istam autem figuram [*scil.*, that of the fox] diabolus possidet") and col. 59 ("eius figuram [*scil.*, that of the wolf] diabolus portat qui semper humano generi iugiter invidet, ac circuit Ecclesias fidelium ut mactet et perdat animas eorum"). The crane, on the other hand, denoted the virtuous, who "in se praecepta scripturae bene vivendi formant" (Hugh of St. Victor, *ibidem*, col. 39 f.).

water; and Ixion on his wheel (Fig. 59).[1] That Ixion has two heads merely expresses, I believe, his rapid rotation on the wheel: "Volvitur Ixion et se sequiturque fugitque" (Ovid, *Metamorphoses*, IV, 461). In fact, the duplication is paralleled in German law books of the thirteenth and fourteenth centuries where persons called upon to perform several actions in quick succession are also represented with two heads and any number of arms (Fig. 60).[2]

All these representations, I submit, do have a moral, even eschatological, significance. While it may be questioned whether the man fighting the monster and the musical sea centaur are meant to indicate the vices of Wrath and *curiositas* (in mediaeval terminology: the indulgence in the pleasures of spectacles and "worldly music"), the commentaries on Ovid and other classical texts leave no doubt as to the fact that Sisyphus, Ixion and Tantalus, tortured in Hades, were understood as paradigmatic examples of three great sins punished in Hell: Sisyphus typifies Pride (because his stone, always rolling to the bottom as soon as it has been carried to the top, symbolizes the fate of the tyrants who, "quant ilz se sont bien hault montez, ilz en trebuchent soubdainement"); Tantalus ("le plus chiche du monde", "the greatest miser in the world") stands for Avarice; Ixion, guilty of an attempt to violate Juno, for Lewdness. And the selection of this specific triad can be accounted for by the fact that as authoritative a source as St. Bonaventure's *Speculum animae* (on the strength of I John 2:16) considers *superbia*, *avaritia* and *luxuria* as the three main branches of the "Tree of Sins", the other vices being only twigs of these branches.[3] The whole series, then, conveys

[1] For the Schöngrabern reliefs, see K. A. Novotny, "Zur Deutung der romanischen Bildwerke Schöngraberns", *Zeitschrift des deutschen Vereins für Kunstwissenschaft*, VII, 1940, p. 64 ff.

[2] For the two-headed and many-armed figures in German law books, see K. von Amira, *Die Dresdner Bilderhandschrift des Sachsenspiegels*, Leipzig, 1902, I, 2, p. 25, with special reference to fol. 68 b (Plate 136, upper picture).

[3] The sinners represented in Schöngrabern were particularly well known to the Middle Ages from Ovid, *Metamorphoses*, IV, 458 ff., and Seneca, *Hercules furens*, V. 750 ff. The interpretation of Sisyphus, Tantalus and Ixion as representatives of Pride, Avarice and Lewdness, respectively, is so typical and constant that it would be tedious to adduce individual sources; for the equation Tantalus = Avarice, see, for example, Bernardus Morlanensis, *De contemptu mundi*, II, 869 ff. (Hoskier, ed., p. 67), where he says of the miser, "Fit sine nomine nominis omine Tantalus ille", "he becomes Tantalus without being thus named, merely by the implications of the name"; or, to jump four

centuries, Andrea Alciati, *Emblemata*, Emblem LXXXIV. The phrases quoted or referred to in the text are taken from the *Ovide moralisé en prose of 1466* (E. de Boer, "Ovide moralisé en prose", pp. 191, 195, 257); it is interesting that the Sisyphus text (p. 257) employs the same verb (*trebucher*) which Villard de Honnecourt, fol. 3 v., applies to Pride (*Orgieus*) itself. For St. Bonaventure's interpretation of Pride, Avarice and Lewdness as the three "main branches" of the Tree of Sins, see M. Bloomfield, *The Seven Deadly Sins, An Introduction to the History of a Religious Concept with Special Reference to Medieval English Literature*, Michigan State College Press, 1952, pp. 89, 371. For the sinful implication of worldly music, see the literature referred to in Nordström, "Peterborough, Lincoln and the Science of Grosseteste", p. 246f. One of the nicest instances is an illumination in a twelfth-century psalter (Cambridge, St. John's College, MS. B. 18, fol. 1, illustrated in H. Swarzenski, *Romanesque Monuments*, Fig. 288), the upper section of which shows David and his musicians making sacred music. The lower

the same admonitory message as do, in non-mythological language, so many other products of Romanesque sculpture; conceivably the Schöngrabern reliefs were placed on the façade of the church in lieu—or perhaps even as part—of a *Last Judgment*.

About fifty years later—a date surprisingly late and explicable only by the presence of a renowned collection of classical silver vessels, the "Trésor de St. Didier", in the local Treasury—we find among the reliefs of Auxerre Cathedral three pagan characters: Hercules with the lion's skin, an enchanting satyr, and Cupid asleep on his torch (Figs. 61, 62, 64). These, as everyone seems to agree, have been "placed in the middle of Biblical scenes only for the sake of their beauty" ("placés au milieu des scènes bibliques sans autre motif que leur beauté").[1] It should be noted, however, that this placement is by no means arbitrary.

The Hercules and the satyr serve as frontispieces, so to speak, for the illustration of Genesis 37:24–28 (Joseph cast into the "pit that is in the wilderness" and sold into Egypt) and Genesis 41:18–24 (the dream of Pharaoh and the attempt of the magicians to interpret it). Both scenes, then, involve the ideas of Egypt and the wilderness, and with these ideas both Hercules and the satyr were closely connected in mediaeval thought. Two writers as well known as Cicero and Pomponius Mela mention a *Hercules Aegyptius* who, according to Cicero, was the son of Nilus; and two mediaeval mythographers lay stress upon the fact—important in connection with the unfraternal behavior of Joseph's brothers in the adjacent relief—that Hercules eliminated the Egyptian king Busiris, who was in the habit of slaughtering his guests. The satyr, on the other hand, was thought of as what may be called the very spirit of the wilderness and, quite particularly, of the Egyptian desert. Visual proof of this is furnished by the illustration of Psalm 77 (78):51–53 in the Stuttgart Psalter which reads: "And [God] smote all the first-born in Egypt ... but made his own people go forth like sheep, and guided them in the wilderness like a flock. And he led them on safely, so that they feared not: but the sea overwhelmed their enemies". In order to visualize the idea of the wilderness and to lend concrete expression to the Psalmist's allusion to the slaying of the first-born and the drowning of Pharaoh the illustrator of the Stuttgart Psalter employed a satyr, explicitly identified by an inscription, as the embodiment or *genius loci* of the Egyptian desert (Fig. 63).[2]

section shows, in contrast, a monstrous being (probably not a bear but an actor dressed up as a wild man and thus impersonating the devil) beating a drum while other figures contribute to this unholy music and still others engage in acrobatic dancing enjoyed by idle spectators.

[1] For the reliefs at Auxerre Cathedral and their probable connection with the "Trésor de St. Didier", see Adhémar, *op. cit.*, p. 283f., Figs. 114 (the sleeping

Cupid) and 116 (satyr and Hercules); for better illustrations, cf. *La Cathédrale d'Auxerre*, Ed. Tel., Paris, n.d., Figs. 7, 10, 15.

[2] The passage of Cicero referred to in the text is found in *De natura deorum*, III, 42 (still referred to in Natale Conti's *Mythologiae,*, VII 1 [Paris edition of 1605, p. 691]); that of Pomponius Mela in *Chorographia*, III, 46 (still referred to by L. G. Gyraldus, *Opera omia*, Leiden, 1696, I, col. 329); that of the two me-

Both the Hercules and the satyr thus would seem to fall under the heading of local or regional personifications. The Cupid asleep on his torch, on the other hand, can be explained as a case of genuine *interpretatio Christiana*. Placed at the very foot of the doorpost the front of which displays the statuettes of the Wise Virgins, he must be taken to represent Carnal Love, viz., the vice of luxury, with which the classical Eros, renamed *Amor carnalis,* had come to be equated in mediaeval iconography while retaining his classical attributes: nudity, wings and either bow or torch. In the Auxerre relief this dangerous foe of virtue is shown reduced to impotence at the feet of the brides of Christ who "went in with him to the marriage".

To the mediaeval mind, thoroughly familiar with such authors as Seneca and Horace, the torch appeared as a symbol of unholy ardor even more telling than the bow and the arrows—so that the illustrators of Prudentius' *Psychomachia*, where only bow and arrows are mentioned as the attributes of Cupid, were prone to supplement them by the torch which in the text belongs to his mistress, Libido (Fig. 65). This should be kept in mind in an attempt to interpret the two intriguing and—except for the fact that right and left are reversed—nearly identical reliefs set into the west façade of Modena Cathedral (Figs. 66, 67).[1] Each of them shows a *putto* with his legs crossed, carrying a wreath in one hand and leaning upon an inverted but burning torch. We take it for granted that such a pair represents Sleep and Death; but we owe this knowledge only to Winckelmann and, above all, to Lessing. Before the eighteenth century even such knowledgeable archaeologists as Giovanni Pietro Bellori and Jan Gruyter considered figures of this description as representations of Cupid. Unquestionably Master Wiligelmus of Modena Cathedral, active about 1170, could hardly have interpreted them otherwise, and that he invested them with the customary unfavorable implication is evident from the fact that one of them is accompanied by a bird which, though often referred to as a pelican, is obviously an ibis. The ibis—owing to his supposedly unappetizing habits, of which his predilection for rotten food and his aversion to entering clean water are the least repulsive—is invariably held up as an example of the *homo carnalis* as opposed to the "Christian reborn from the water and the Holy Spirit". Suffice it to cite the bestiaries and Hugh of St.-Victor's treatise *De bestiis et aliis rebus.*[2] Since the counterpart of this clearly designated *Amor carnalis*—

diaeval mythographers in G. H. Bode, *Scriptores rerum mythicarum latini tres* ..., Celle, 1834, pp. 23, 129. For the miniature in the Stuttgart Psalter, see E. T. DeWald, *The Stuttgart Psalter*, p. 71, fol. 93 v. (cf. Janson, *op. cit.*, p. 18, Plate Ia).

[1] For the Modena relief, see G. Bertoni, *Atlante storico-artistico del Duomo di Modena*, Modena, 1921, Plate 17; Ladendorf, *op. cit.*, p. 86, Note 35, Figs.

6, 7. For the mediaeval reinterpretation of the classical Cupid as *Amor carnalis*, see Panofsky, *Studies in Iconology*, pp. 95, 107, Figs. 84, 85, 88 (Text Ill., p. 95, reproducing the Prudentius illustration referred to in the text).

[2] Hugh of St. Victor, *op. cit.*, col. 55. In Cesare Ripa's *Iconologia* the ibis is still an attribute of *infamia*.

conceivably Jocus, whom Horace (*Carmina*, I, 2, 34) as well as Prudentius (*Psycho-machia*, I, 433) mentions as Cupid's companion, the former in the retinue of Venus, the latter in that of Luxury—has lost his attribute, his significance cannot be estab-lished with equal precision; nor do we know the context for which the two little re-liefs were originally intended. But it is more than probable that, within this context, they played a role defined by moral theology.

The figure of the nude, winged and torch-bearing *Amor carnalis* also provides the key for the interpretation of a monument more puzzling than even the reliefs of Schön-grabern, Auxerre and Modena: the enigmatic Kaiserpokal of Osnabrück, produced shortly before 1300 and well preserved except for the fact that the crowning figure of an emperor was added in the sixteenth century (Fig. 68).[1] Like all chalices, it consists of a *cuppa* and a cover, and both these parts are adorned with twelve circular medallions of the same size; but while the roundels of the *cuppa* are all unique, the cover shows only six different patterns, each roundel forming one of a pair of identical twins with its diametrical opposite. The medallions of the *cuppa* (Figs. 69–71) depict a series of six Vices and Virtues, each Virtue adjacent to the corresponding Vice. According to the scheme established in the decoration of Chartres, Paris and Amiens Cathedrals, the Virtues—always hard to represent because, as a German poet was to formulate it, "Virtue, this theorem is true, / Is a bad thing one does not do"—are depicted as stern ladies enthroned and equipped with appropriate attributes, whereas the Vices are exemplified by actual practice: we have Faith contrasted with Idolatry (a woman adoring a nude idol placed on a column); Charity contrasted with Avarice (a miser gloating over the contents of a treasure chest); Prudence contrasted with Folly (the traditional fool putting one hand to his mouth while brandishing a club with the other); Concord contrasted with Discord or Hardness of Heart (two men fighting); Chastity contrasted with Luxury (a pair of lovers embracing); Humility contrasted with Pride (a proud horseman falling off his mount).

The corresponding medallions on the cover (Fig. 72) differ from those on the *cuppa* not only in the fact, already mentioned, that they show only six subjects but also in that they give a distinctly classicizing impression. Each roundel contains a single figure entirely nude, and one of these nudes (Fig. 73) is faithfully copied after a classical cameo showing a youthful, bearded Hercules Playing the Lyre (*Hercules Musarum*, Fig. 74) while another differs from the same model only in that the lion's skin is omitted and the lyre has been replaced by a bowl filled with grapes.[2]

[1] See C. Dolfen, *Der Kaiserpokal der Stadt Osnabrück*, Osnabrück, 1927; Nordström, *Virtues and Vices*, *passim* (see Index, p. 131), with reference to the medallions on the *cuppa* only.

[2] For the influence of the *Hercules Musarum* cameo on two rather than one of the medallions on the cover of the "Kaiserpokal", see Wentzel, "Mittelalter und Antike", p. 81f., Figs. 9–11; *idem*, "Die grosse Kamee", p. 74, Fig. 51.

In view of this undeniable and direct connection with a classical original, the identity of the *Hercules Musarum* has never been questioned; in fact, all six figures have been thought to represent Hercules in different disguises or incarnations. This interpretation must be dismissed for the simple reason that one of the nude figures (Fig. 75, right) is winged and carries a torch. Both these features, incompatible with Hercules, are characteristic of the now familiar *Amor carnalis*; and, starting from here, we can safely assume that the five remaining nudes also represent Vices in the form of classical divinities. The man equipped with shield and spear (Fig. 76), far from being a "Hercules Hoplites", is clearly identical with Mars, the god of war, and therefore corresponds to the vice of Discord or Hardness of Heart. The man carrying a scepter in his left hand and what seems to be an abbreviation of "triple-throated Cerberus" in his right (Fig. 77, left) is Pluto, who, owing to his erroneous but very ancient identification with Plutus, was considered as the god of riches as well as the ruler of the underworld and, therefore, prefigures the vice of Avarice. The man distinguished by a scepter only (Fig. 75, left) would seem to be Jupiter, the highest of the pagan gods and therefore corresponding to the vice of Pride. The figure with the bowl of grapes (Fig. 77, right) is, needless to say, Bacchus, who, since wine tends to deprive man of his reason, stands for Folly; and the lyre-playing Hercules—probably not correctly identified by the mediaeval observers but, in view of his musical inclinations and his beardlessness, mistaken for Apollo, "a god in the guise of a youth with a harp in his hands"[1]—represents that "unholy" music the practice and enjoyment of which were generally condemned as a manifestation of *curiositas* verging upon the sin of Idolatry. In short, the figures on the cover of the Kaiserpokal typify, in mythological language, the same six Vices which on the *cuppa* are exemplified by their manifestations in everyday life; and this is why each of them appears twice: nude pagan divinities, with the exception of Hercules as reinterpreted by Nicolo Pisano, could be equated only with the Vices (of which no more than six are represented), and not with the Virtues. If this interpretation is accepted, there is no reason to object to the assumption, strongly suggested by the vessel's shape and date, that the Kaiserpokal, though later adapted to secular purposes, was originally intended to be a liturgical chalice.

The "Mithras" unexpectedly appearing on one of the capitals at Monreale (Fig. 78), finally, has been greeted whith actual shouts of triumph by those who believe that

[1] This is how Apollo is described in the Cambridge Lapidary, Gonville and Caius College, MS. 435, a passage all the more apropos as it purports to describe a classical cameo:

"En ceste pire ot un seiel,
un Deu an guise de danzel:

Apollo numez esteit
Et une harpe es meins teneit".

(L. Pannier, *Lapidaires français des XII^e, XIII^e et XIV^e siècles [Bibliothèque de l'Ecole des Hautes Etudes, CII]*, Paris, 1882, p. 147).

mediaeval art could copy pagan images regardless of iconographic significance.[1] Here in one of the great centers of Christian worship we have, it seems, an image representing the hero of the very cult which at the beginning of our era was the most serious rival of Christianity: the Persian sun-god, Mithras, killing the bull. And does not this conclusively show that mediaeval sculptors, when enraptured by the aesthetic values of a classical original, employed it without investing it with a new meaning?

That this capital is rather faithfully copied after a Roman relief showing Mithras killing the bull (Fig. 79) cannot be questioned. What can be questioned is whether it was intended, and understood, to represent Mithras killing the bull. And that this question must be answered in the negative can be demonstrated by the simple fact that even the Renaissance had no idea of the true significance of those Roman reliefs which we have learned to recognize as representations of Mithras. In the *locus classicus* for Mithras, Statius' *Thebaid* (I, 719), he is described as "twisting the horns of the bull" (*torquentem cornua Mithram*) rather than actually killing him. As a result, he was thought of—and depicted—as merely wrestling with the animal, and not, as he does in the reliefs, as piercing its heart with a dagger or sword (Fig. 80).

The high-mediaeval mythographers do not refer to Mithras at all, and even as learned a Renaissance scholar as Giglio Gregorio Giraldi, writing about 1540, not to mention a host of less distinguished authors such as Georgius Pictor, Johannes Herold, Vincenzo Cartari or Natale Conti, describes him—according to the Statius Scholia and the "Mythographus II"—as a "lionheaded man clad in Persian garb and a tiara who with *both hands* clutches the horns of a recalcitrant bull" ("leonis vultu, habitu Persico cum tiara, ambabus manibus reluctantis bovis cornua retentare [fingebatur]"). Conversely, the usually reliable epigraphist Cyriacus of Ancona (*ca.* 1450), confronted with an actual Mithras relief, could make so little sense of it that in his rendering of its inscription (DEO SOLI INVICTO MITRHE) he misread MITRHE into ALTARE. And as late as 1591 the art critic Gregorio Comanini interpreted such a relief as an elaborate allegory of agriculture, considering Mithras with his Phrygian cap as a "young farmer"; the bull, his heart pierced by a dagger, as a personification of the earth pierced by the plow; the snake as representing the intelligent planning necessary for successful farming; the two companions of Mithras, Cautes and Cautopates, as personifications of day and night (which is about right by accident); and the scorpion as a symbol of either the dormant fertility of the soil because the scorpion hibernates, or of the dew because the scorpion likes a humid environment. It was not until 1615 that the excellent Lorenzo Pignoria, caustically ridiculing Comanini's agricultural inter-

[1] For the "Mithras" capital in Monreale, see Sheppard, "The Iconography of the Cloister of Monreale", p. 160, Fig. 1; Wentzel, "Antiken-Imitationen", p. 55f., Fig. 29.

pretation, identified the most famous of all Mithras reliefs, that still preserved on the Capitol, as what it is (Fig. 81).[1]

In the twelfth century, therefore, the subject of a Mithras relief could not possibly have been interpreted correctly, and we have to ask ourselves what, in reality, was the capital's intended significance. This question is answered, I think, by the only, but highly remarkable, change which the sculptor of Monreale made in copying his Roman model: he replaced the Phrygian cap by a kind of turban such as was customarily attributed to pre-Christian characters, particularly to the prophets and high priests of the Old Testament. In other words, the Monreale sculptor conceived of his model as a blood sacrifice pure and simple. Far from recognizing Mithras as Mithras and wishing to portray him as such, he employed his action as an impressive but anonymous example of the ritual slaughter of animals which had been practiced by Jews as well as Gentiles and which Christianity had replaced by the *sacrum sacrificium* of Holy Mass. No fewer than three such renderings of blood sacrifice have been recorded in French twelfth-century sculpture, to which the school of Monreale was very closely linked: one in Vézelay (Fig. 82), one in Besse-en-Chandesse, and one in Charlieu. All of these are meant to affirm the sacramental validity of the Eucharist, a matter of vital interest at a time when Pierre de Bruys had added to his other heresies the claim that "Holy Mass meant nothing at all and should not be celebrated", and when many adhered to this blasphemous opinion even after its originator had been burned in 1132 or 1133. In the case of St.-Fortunat-de-Charlieu—a priory of Cluny, which was the very center of resistance to the Petrobrusian heresy—this polemic intention is particularly evident from the fact that the relief showing the ritual killing of animals is placed directly beneath a representation of the Wedding of Cana so closely resembling a Last Supper (of which Christ's "first miracle" had been a *typus* from Early Christian times and with which it was explicitly compared by Peter the Venerable, the greatest

[1] For the ignorance of the Renaissance as to the true nature of Mithras, see Seznec, *op. cit.*, p. 229, Fig. 94 (from Johannes Herold, *Heydenwelt*, Basel, 1554; cf. also V. Cartari, *Imagini dei Dei degli antichi*, Venice edition of 1571, p. 72, of which the woodcut reproduced in our Fig. 80 is a crude derivative), and, particularly, F. Saxl, *Mithras, Typengeschichtliche Untersuchungen*, Berlin, 1931, p. 110 (also *idem*, "The Origin and Survival of a Pictorial Type [The Mithras Reliefs]", *Proceedings of the Classical Association*, XXXII, 1935, p. 32 ff.); the Gyraldus passage (*Syntagmata*, VII; cf. Bode, *op. cit.*, p. 80, Ch. 19) is found in Gyraldus, *op. cit.*, I, col. 232. For Co-

manini's agricultural interpretation, see E. Panofsky, *Idea, Ein Beitrag zur Begriffsgeschichte der älteren Kunsttheorie* (Studien der Bibliothek Warburg, V), Leipzig and Berlin, 1924, p. 114, Note 238 (Italian translation: *Idea*, Florence, 1952, p. 157, Note 69), where, however, the name of Vincenzo Cartari should be replaced by that of Lorenzo Pignoria, who, so far as we know, first proposed the correct identification of the Mithras reliefs. He had inspected the specimen on the Roman Capitol in 1606 and announced his discovery in his additions to Cartari's *Imagini*, first published at Padua in 1615 (in the Venice edition of 1674, p. 274f.).

theological authority of the Cluniac order) that the subject has occasionally been misinterpreted by art historians.[1]

The "Mithras" capital at Monreale thus corroborates rather than conflicts with the principle of *interpretatio Christiana*. Occurring in the context of a program which, for all its bewildering complexity, is dominated by the antithesis between the Old Testament

[1] For Vézelay, Besse-en-Chandesse and Charlieu, see Adhémar, *op. cit.*, pp. 177 ff., 205, Fig. 78 (Besse), and Fig. 93 (Vézelay); for Besse-en-Chandesse, cf. also the anonymous local monograph, *Eglise de Besse, Monument historique*, p. 16, and F. Deshouillières, "Besse-en-Chandesse", *Congrès Archéologique*, 1924 (Clermont-Ferrand), p. 251 ff. The capital illustrated in Adhémar, Fig. 78, showing the sacrificial slaughter of an ox or bull, is followed by one which shows two men carrying an animal apparently combining the hind part of a ram with the head of a boar, so that the three animals alluded to may have been meant to constitute the components of the Roman *suovetaurilia*. Concerning the subject of the tympanum (as opposed to the lintel) of the portal at Charlieu, there is a certain lack of unanimity. Adhémar identifies this subject as a Last Supper; but E. Mâle, *L'Art religieux du XII^e siècle en France*, Paris, 1922, p. 421 ff. (apparently overlooked by Adhémar, as also by me until I was reminded of it by Mr. W. J. Coe) would seem to be correct in identifying the scene as the Wedding of Cana and in connecting it with Peter the Venerable's treatise *Adversus Petrobrusianos Haereticos, Patrologia Latina*, CLXXXIX, especially cols. 796 (description of the Jewish blood sacrifice, enumerating the same animals as represented in the Charlieu relief) and 802 (parallel between the Last Supper and the Wedding of Cana). The identification of the scene as a Last Supper is understandable because the general arrangement (with an isolated figure in front of the table) corresponds very closely to the traditional renderings of the *Cena Domini*. On the other hand, the number of participants is either too small or too large (depending on whether the heads in the background are counted); only the two figures on either side of Christ are nimbed, and one of them, veiled, would seem to be identical with the Virgin Mary; and two of the remaining figures, obviously the bride and groom, are represented in loving embrace. In connection with the contrast between the Eucharist and pre-Christian blood sacrifice, attention may be called to numerous twelfth-century miniatures where the latter is juxtaposed with the Crucifixion (or the Meeting between Elijah and the Widow of Zare-phath) or appears singly in a context which makes its significance evident *ipso facto*; for three examples, one of them from the famous Bible of Floreffe, which in turn is based upon the Gospels of Averbode, Liège, Bibliothèque de l'Université, MS. lat. 363, fol. 86 v. (see S. Gevaert, "Le Modèle de la Bible de Floreffe", *Revue Belge d'Archéologie et d'Histoire de l'Art*, V, 1935, p. 17 ff., Fig. 8), see C. R. Dodwell, *The Canterbury School of Illumination 1066–1200*, Cambridge, 1954, p. 87 ff. and Plate 58. In H. Swarzenski, *Monuments of Romanesque Art*, Fig. 284, the subject of the miniature in the Dover Bible, Cambridge, Corpus Christi College, MS. 4, fol. 191 v. (Dodwell, Plate 58 a), has been identified as "St. Luke slaughtering his beast". In reality, however, this miniature, though found in the initial of the Gospel of St. Luke, unquestionably represents a priest of the Old Law (possibly Zachariah, the father of John the Baptist, with whose story this Gospel begins), and this interpretation is conclusively confirmed by the fact that, as Professor Francis Wormald kindly informs me, the skin of the animal is painted in red—an obvious allusion to the *vacca rufa* from Numbers 9:2 which, as we learn from Abbot Suger (*De administratione*, XXXIII), seems to have come automatically to the mind of twelfth-century authors when they discussed the contrast between the blood sacrifice of the Old Law and the Eucharist. Another interesting twelfth-century instance is a miniature in Verdun, Bibliothèque de la Ville, MS. 119, fol. 94, where the Synagogue is shown killing an animal (Panofsky, *Studies in Iconology*, Fig. 79). We can easily understand that the contrast between the pre-Christian blood sacrifice and the Eucharist seems to have lost popularity after the end of the twelfth century. One of the rare exceptions that have come to my knowledge is a Dutch panel of ca. 1470 in the Boymans Museum at Rotterdam, which originally formed the counterpart of a *Gathering of the Manna* (one of the many prefigurations of the Eucharist), both panels probably combined with a Crucifixion (see E. Haverkamp Begemann, "Een Noord-Nederlandse Primitief", *Bulletin, Museum Boymans Rotterdam*, II, 1951, p. 51 ff.).

and the New and the idea of the Church's triumph over the Synagogue, it belongs to a series of representations which lend visual expression to the words of St. Paul (Hebrews 10:4): "Impossibile enim est sanguine taurorum et hircorum auferri peccata", "It is not possible that the blood of bulls and goats should take away sins".

From the eleventh and twelfth centuries, then, mediaeval art made classical antiquity assimilable by way of decomposition, as it were. It was for the Italian Renaissance to reintegrate the separated elements. Rendering unto Caesar the things which are Caesar's, Renaissance art not only put an end to the paradoxical mediaeval practice of restricting classical form to non-classical subject matter but also broke the monopoly of architecture and sculpture with regard to classicizing stylization (though painting did not catch up with their "maniera antica" until the second half of the fifteenth century). And we need only to look at Michelangelo's *Bacchus* and *Leda*, Raphael's Farnesina frescoes, Giorgione's *Venus*, Correggio's *Danae*, or Titian's mythological pictures to become aware of the fact that in the Italian High Renaissance the visual language of classical art had regained the status of an idiom in which new poems could be written—just as, conversely, the emotional content of classical mythology, legend and history could come to life in the dramas (non-existent as such throughout the Middle Ages), epics and, finally, operas devoted to such subjects as Orpheus and Eurydice, Cephalus and Procris, Venus and Adonis, Lucrece and Tarquin, Caesar and Brutus, Antony and Cleopatra.

When thirteenth-century Mantua resolved to honor its secular patron saint, Virgil, by public monuments, the poet was portrayed, like the representatives of the liberal arts on the Portail Royal at Chartres, as a mediaeval scholar or canonist seated before his desk and busily engaged in writing (Figs. 84, 85); and it was this image which took the place of the Christ in Majesty when Mantua decided in 1257 to pattern its coins after the Venetian *grosso* (Fig. 86). But when in 1499, at the very threshold of the High Renaissance, Mantegna was asked to design a statue of Virgil—meant to replace another monument said to have been on the Piazza d'Erbe and to have been destroyed by Carlo Malatesta almost exactly one century before—he conceived of Virgil as a truly classical figure, proudly erect, clad in a toga and addressing the beholder with the timeless dignity of a Demosthenes or Sophocles (Fig. 87).[1]

[1] For the history of the various monuments to Virgil in Mantua, see A. Portioli, "Monumenti a Virgilio in Mantova", *Archivio Storico Lombardo*, IV, 1877, p. 536 ff.; E. Müntz, *La Renaissance en Italie et en France*, Paris, 1885, pp. 10, 345; J. Burckhardt, *Die Kultur der Renaissance*, 10th ed., E. Geiger, ed., Leipzig, 1908, I, pp. 158, 339f.; J. Schlosser, "Vom modernen Denkmalkultus", *Vorträge der Bibliothek Warburg*, 1926–27, p. 1 ff.; Jullian, *La Sculpture romane de l'Italie septentrionale*, Plate CXIII; G. de Francovich, *Benedetto Antelami, architetto e scultore, e l'arte del suo tempo*, Milan and Florence, 1952, I, pp. 99, 102, 108, II, Figs. 183, 184; and, most recently and with an excellent discussion of other monuments to famous classical writers, D. Frey, "Apokryphe Liviusbildnisse der Renaissance", *Wallraf-Richartz-Jahrbuch*,

V

THIS reintegration was, however, preceded—and, in my opinion, predicated upon—a general and radical reaction against the classicizing tendencies that had prevailed in proto-Renaissance art and proto-humanistic writing. In Italy the seals and coins postdating the *Augustales* of Frederick II and what I have called the "deceptively antique" cameos produced in the thirteenth century became progressively less rather than more classical in style.[1] Nicolo Pisano's own son, Giovanni, while keenly responding to the expressive value of classical art and even daring to employ a *Venus pudica* type for the representation of Prudence in his Pisa pulpit, repudiated the formal classicism of his father and started what may be called a Gothic counterrevolution which, in spite of certain fluctuations, was to win out in the second half of the fourteenth century; and it was from this Trecento Gothic rather than from the lingering tradition of Nicolo's classicism that the *buona maniera moderna* of Jacopo della Quercia, Ghiberti and Donatello arose.

In France the classicizing style of Reims was—with such rare exceptions as the Auxerre reliefs just mentioned—submerged by an altogether different current exemplified by the *Mary Annunciate* right next to the famous *Visitation* (Fig. 48) and nearly contemporary with it; and next to this *Mary Annunciate* there can be seen the figure of the Angel Gabriel, produced only about ten of fifteen years later, in which classical equilibrium has been abandoned in favor of what is known as the "Gothic sway". How High Gothic ornament was purged of classical motifs, how the acanthus gave

XVII, 1955, p. 132 ff., particularly p. 158f. It is now generally accepted that the beautiful red marble statue in the Palazzo Ducale, datable on stylistic grounds about 1215 (our Fig. 84), antedates the much weaker though better-known white marble portrait, probably executed shortly after 1227, on the Broletto (our Fig. 85; of a third mediaeval monument to Virgil, allegedly destroyed by Carlo Malatesta, we have no visual evidence). Even in the most recent literature, however, the connection of the two statues with the *grosso* of 1257 (our Fig. 86) is not sufficiently appreciated. What is described by Frey as "identical" (*gleich*) with the Christ in Majesty that occupies the same place in the Venetian *grossi*, is in reality a rather crude copy of the red marble statue, except for the fact that the skull cap is omitted. And since the *grosso* is inscribed MANTVE VERGILIVS, the recent doubts as to the intended identity of the two marble portraits turn out to be unfounded. In fact, the red marble statue had a kind of official function even before it served as a model for the coin. Originally placed in the Palazzo della Ragione, "dove tutti i giorni i giudici si recavono a fare giustizia", it presided, as it were, over the legal proceedings much as a crucifix (or an image of the Trinity) did in other mediaeval towns and as the portrait of the Queen of England does in British courts today. To entrust this function to Virgil was logical not only from the point of view of local patriotism but also because he was considered as one in front of whom no untruth could be told (witness, among other things, the legend which credited him with the invention of the famous "Bocca della Verità" in S. M. in Cosmedin).

[1] See the imitations of the *Augustales* illustrated in Kantorowicz, *Kaiser Friedrich der Zweite*, II, Plate I, 3–6, and the collection of seals published by H. Wentzel, "Italienische Siegelstempel und Siegel all'antica im 13. und 14. Jahrhundert", *Mitteilungen des kunsthistorischen Institutes in Florenz*, VII, 1955, p. 73 ff.

way to ivy, oak leaves and water cress and how the Ionic and Corinthian capitals, retained or even revived in Romanesque architecture, were banned is known to all. The series of *Constantines* patterned upon the *Marcus Aurelius* and, we recall, extremely popular throughout the twelfth century, abruptly breaks off in the thirteenth (it was not until the sixteenth century that, under the direct or indirect influence of the Italian Renaissance, equestrian monuments of a similar type were revived in the North).[1] And about 1270–1275 an English workshop, commissioned to produce a retable that was supposed to resemble late-twelfth-century metal work but disinclined to change its pure High Gothic figure style and therefore concentrating its archaistic efforts upon the frame, attempted to stress the "Romanesque" character of this frame by the inclusion of simulated classical cameos:[2] by this time classicizing tendencies were understood to be a thing of the past.

It would not be fair to speak of the classicism of Chartres and Reims as a "frustrated effort". On the contrary, the rise of that "intrinsic" classicism which culminated in the Reims *Visitation* is not only contemporary but, in a sense, coessential with the rise of those naturalistic tendencies which were to supplant it (again we may remember Goethe's dictum about the Antique as part of "natural nature"); and that sway or lilt which determines the High Gothic conception of human movement is nothing but a classical *contrapposto* in disguise. It is, however, precisely this disguise that matters. In a figure posed *all'antica*, the shoulder above the standing leg (the latter's function being comparable to that of a column supporting the load of the entablature), sags; in a figure dominated by the Gothic sway, the shoulder above the standing leg (the latter's function being comparable to that of a pier transmitting energy to the vault-ribs) rises. What had been the result of two natural forces in balance becomes the result of one preternatural force ruling supreme: the classical element is so completely absorbed as to become indiscernible.

Analogous observations can be made in other fields, especially in that of literature. In the course of the thirteenth century the content of classical philosophy, historiography

[1] Adhémar, *op. cit.*, p. 215f.: "... on est étonné de voir qu'à partir du début du XIIIe siècle cette figure disparaît brusquement et absolument". Adhémar accounts for this sudden disappearance of Constantine statues by the fact that the identification of the *Marcus Aurelius* as Constantine began to be questioned in the thirteenth century; but this disappearance fits in so well with the general development of the Gothic style that the doubts as to the identity of the *Marcus Aurelius* may be considered as only a contributory factor. It should be noted that the two well-known equestrian monuments erected in Ger-

many towards the middle of the thirteenth century (the *Reiter* in Bamberg Cathedral and the statue of Otto II on the market square at Magdeburg) have no relation whatever to the Marcus Aurelius-Constantine type and that the revival of the latter in the French Renaissance is largely due to the influence of Dürer's engraving B. 98 which, as far as the movement of the horse is concerned, goes back to Leonardo da Vinci.

[2] See F. Wormald, "Paintings in Westminster Abbey and Contemporary Painting", *Proceedings of the British Academy*, XXXV, 1949, p. 161 ff.

and poetry, though enormously augmented and popularized, came to be as completely absorbed in the high-mediaeval system of thought, imagination and expression as was the classical *contrapposto* in the "Gothic sway", and the linguistic form of Latin writing completely emancipated itself from classical models. Unlike Bernard of Chartres, John of Salisbury, Bernardus Silvestris, or Alanus de Insulis, the great scholastics of the thirteenth and fourteenth centuries no longer modelled their style upon the prose of Cicero or Suetonius, much less upon the verse of Virgil, Horace, Lucan, or Statius. It was, in fact, the very ascendancy of scholasticism, pervading and molding all phases of cultural life, which more than any other single factor contributed to the extinction of "proto-humanistic" aspirations:[1] scholastic thinking demanded and produced a new language—new not only with respect to syntax but also to vocabulary—which could do justice to the principle of *manifestatio* (or, as I once ventured to express it, "clarification for clarification's sake") but would have horrified the classics—as it was to exasperate Petrarch, Lorenzo Valla, Erasmus, and Rabelais.

Thus, after Joseph of Exeter and Walter of Châtillon the days of poetry attempting to rival the classics were numbered, and it is significant that—apart from Albert of Stade's notoriously anachronistic *Troilus*, completed in 1249—the two major classicizing epics of the thirteenth century were devoted to modern rather than Greek or Roman heroes: William of Bretagne's *Philippid* (1214–1224) and, at the very end, Nicolas de Braye's life of St. Louis (*Gesta Ludovici Francorum Regis*).[2] After that, the wish to compete with classical poetry died out altogether. "Look for a [Latin] poet", says Hauréau, "you will not find a single one; the hexameter and the pentameter have gone out of fashion; little rhythmical pieces, now pious, now obscene—that is all". In fact, the very idea of Thomas Aquinas or William of Ockham writing a poem in elegiac couplets is almost ludicrous.

[1] See Curtius, *op. cit.*, p. 84f.: "Johannes [of Salisbury] reproduziert hier die von Cicero (*De officiis* I 50) vorgetragene, auf Poseidonios und Isokrates zurück-gehende Lehre, wonach Vernuft und Rede (*ratio* und *oratio*) zusammen die Grundlage von Gesittung und Gesellschaft bilden ... Die Hochblüte der Scholastik im 13. Jahrhundert machte dieses humanistische Bildungsideal nördlich der Alpen unzeitgemäss. Aber der italienische Humanismus des 14. Jahrhunderts hat ihm neue Entfaltung gewährt. Zwischen der Welt des Johannes von Salisbury und der des Petrarca besteht eine geistige Verwandt-schaft". For Petrarch's non-scholastic as opposed to Dante's scholastic attitude toward poetry, see above, p. 39.

[2] For Albert of Stade (rightly called an "Epigone" in Curtius, *ibidem*, p. 486), see Manitius, *op. cit.*, III, p. 924; Raby, *Secular Latin Poetry*, II, p. 346. Cf. also the literature referred to above, p. 71. Note 1. For William of Bretagne's *Philippid* and Nicholas de Braye's *Gesta Ludovici Francorum Regis*, see Manitius, *op. cit.*, III, p. 923f.; Raby, *Secular Latin Poetry*, II, p. 343.

VI

It may be thought that the peculiar dichotomy that dominated the mediaeval attitude toward the Antique resulted only from the fact that the sculptors, gem cutters and goldsmiths of Monreale, Reims, Pisa, Palermo, or Osnabrück worked from visual models while the illustrators of Remigius' *Commentary on Martianus Capella*, the *Histoire ancienne*, the *Roman de Troie*, or the *Ovide moralisé* had to rely on textual sources.

This difference is, of course, both real and important; yet it does not suffice to explain the phenomenon. It can be shown that a divorce of classical form from classical content took place not only in the absence of a representational tradition but also in spite of a representational tradition still available: even where the Carolingian *renovatio* had rescued classical images from oblivion, these images tended to be abandoned or even rejected in the course of the thirteenth and fourteenth centuries.

The last Prudentius manuscript—the same one which contains the miniature showing Thisbe on a Gothic tombstone—dates from 1289; then the tradition breaks off. The Carolingian *Terences* conscientiously reproducing the settings, gestures, costumes, and masks of the Roman stage were copied and recopied, their classical features gradually diluted but never ceasing to remain recognizable, up to about 1200; after that, there is a gap of more than two hundred years; and when the *Comedies* were illustrated again (first in the *Térence des Ducs* of ca. 1408), the pictures show fifteenth-century personages in fifteenth-century settings.[1] In the illustration of astrononomical texts, finally, the classical tradition revived in the Carolingian copies of the *Aratea* manuscripts and subsequently retained, with changes affecting, as in the case of the Terence pictures, the style but not the structure of the compositions succumbed to a two-pronged offensive by the middle of the thirteenth century.

On the one hand, Western artists began to borrow—or, rather, to reborrow—from Arabic book illuminations in which the familiar classical archetypes had not only been altered so as to conform more closely to the actual position of the stars than to a Hellenic ideal of beauty but had also been subjected to a thorough Orientalization in physiognomical appearance, costume and equipment. In a South Italian manuscript of *ca.* 1250, for example, the Grecian gods and heroes look like characters from the *Arabian Nights* (Fig. 88, as compared to Fig. 12); and owing to a visual misinterpretation of the blood dripping from the neck of the Medusa's head in the representation of Perseus this head (*Caput Medusae*) came to be misunderstood as that of a bearded demon (*Ra'š al Ghul, Caput Algol*) rather than a "Medusa's head"—which, inciden-

[1] A list of fifteenth-century illustrated manuscripts of Terence is found in Jones and Morey, *op. cit.*, p. 225.

tally, is why we still refer to the second-brightest star in the constellation Perseus as "Algol".[1]

As time went on, and as these Orientalizing types spread from South Italy and Spain to regions less closely linked to the Islamic East, they gradually lost their outlandish aspect and thus came to resemble, superficially at least, a second class of neoteric images—images entirely independent of any classical *Bild-Tradition*, however distorted, but freely developed from verbal descriptions. Whether these descriptions were found in texts freshly translated from the Arabic (such as the famous *Introductio in astrologiam* by that Abū Ma'šar who, as "Albumasar", was to attain a status comparable to that of Virgil because he was held to have foretold the birth of Christ) or in the writings of such Western authors, conversant with Arabic sources, as Michael Scot (the court astrologer of Frederick II) and his numerous followers, their illustrators discarded or, rather, ignored the Graeco-Roman types in favor of what looks like ordinary people of different rank and occupation. Venus appears as a young lady smelling a rose; Jupiter as a wealthy gentleman with gloves in hand or even as a monk with cross and chalice; Mercury as a bishop, scholar or musician (Figs. 89, 90).[2] And since a clerical error had crept into one of the texts thus illustrated—in that the word *glauco* in the sentence "caput glauco amictu coopertum" was misread into *galeatum*—it could happen that the tragic Saturn, the god of solitude, silence and deep thought, was shown as an elderly and somewhat gloomy soldier, his head "behelmeted" instead of "veiled with a grayish kerchief" (Fig. 89).[3]

[1] For the change in astronomical and astrological illustrations due to the influence of Arabic book illuminations, see F. Saxl, *Verzeichnis astrologischer und mythologischer illustrierter Handschriften des lateinischen Mittelalters in der National-Bibliothek in Wien* (*Sitzungsberichte der Heidelberger Akademie der Wissenschaften*, phil.-hist. Klasse, 1925/26), published 1927, p. 19 ff.; Panofsky and Saxl, "Classical Mythology in Mediaeval Art", p. 238 ff.; Seznec, *op. cit.*, p. 154 f. For Perseus specifically, see Saxl, *ibidem*, p. 36 ff.; Panofsky and Saxl, *ibidem*, p. 240 ff., Figs. 22–24 (cf., however, E. Panofsky, *Albrecht Dürer*, 3rd ed., Princeton, N. J., 1948, p. 167, No. 1711a).

[2] For the change in astronomical and astrological representations due to the influence of the texts of Abū Ma'š'ar, Michael Scot, etc., see F. Saxl, "Beiträge zu einer Geschichte der Planetendarstellung im Orient und Occident", *Der Islam*, III, 1912, p. 151 ff.; Panofsky and Saxl, "Classical Mythology in Mediaeval Art", p. 242 ff.; Seznec, *op. cit.*, p. 156 ff.; Saxl and Meier, *op. cit.*, I, pp. xxxv, lxi ff. For Mercury as a bishop, see, for example, Munich,

Staatsbibliothek, clm. 10268, fol. 85 (Panofsky and Saxl, *ibidem*, Fig. 27; Panofsky, *Studies in Iconology*, Fig. 14; *idem*, *Meaning in the Visual Arts*, Fig. 14); for Mercury as a scribe (very frequent), British Museum, MS. Add. 16578, fol. 52 v. (Seznec, p. 159, Fig. 62); for Mercury as a musician, New York, Morgan Library, MS. 785, fol. 48 (Panofsky, *Early Netherlandish Painting*, p. 107, Fig. 136, and, for the antecedents and derivatives of this manuscript, Saxl and Meier, I, pp. lxxii ff., 247 ff.). For Jupiter as a bishop, see, for example, Vienna, Nationalbibliothek, MS. 2378, fol. 12 v. (Seznec, *op. cit.*, p. 157, Fig. 61); for Jupiter as a monk (relief on the Campanile at Florence), Seznec, *ibidem*, p. 161, Fig. 63.

[3] For the "behelmeted" Saturn, see, e.g., Munich, Staatsbibliothek, clm. 10268, fol. 85 (cf. preceding Note), Vienna, Nationalibliothek, MS. 2378, fol. 12 v. (Saxl, "Verzeichnis", II, Fig. 22), or, in literal accordance with the reading *caput galeatum amictu coopertum*, Vienna, Nationalbibliothek, MS. 2352, fol. 27 (Saxl, "Beiträge", Fig. 28). The corruption of the authentic *caput glauco amictu coopertum*—based

In short, before the Italian High Renaissance performed its task of reintegration, that undulating curve which, as I said, may serve to describe the fluctuations of classicizing tendencies in postclassical art had reached the zero mark in all genres as well as in all countries. The later phases of the Middle Ages had not only failed to unify what the Antique itself had left to its heirs as a duality—visible monuments on the one hand texts on the other—but even dissolved those representational traditions which the Carolingian *renovatio* had managed to revive and to transmit as a unity.

The "principle of disjunction" thus cannot be accounted for by the accidents of transmission alone. It would seem to express a fundamental tendency or idiosyncrasy of the high-mediaeval mind which we shall re-encounter on several later occasions: an irresistible urge to "compartmentalize" such psychological experiences and cultural activities as were to coalesce or merge in the Renaissance; and, conversely, a basic inability to make what we would call "historical" distinctions. And this leads us back to the question which was posed at the beginning of this chapter: can the three phenomena which we have been considering—the Italian *rinascita*, the Carolingian *renovatio* and the twin movement known as proto-Renaissance and proto-humanism—be shown to differ from each other not only in scale but also in structure? And, if so, is it still possible to distinguish, within this triad of phenomena, between the Renaissance with a capital "*R*" and the two mediaeval revivals which I propose to call "renascences"? This question, too, deserves, I think, an affirmative answer; for, to put it briefly, the two mediaeval renascences were limited and transitory; the Renaissance was total and permanent.

The Carolingian *renovatio* pervaded the whole of the empire and left no sphere of civilization untouched; but it was limited in that it reclaimed lost territory rather than attempting to conquer new lands. It did not transcend a monastic and administrative *Herrenschicht* directly or indirectly connected with the crown; its artistic activities did not include major sculpture in stone; the models selected for imitation were as a rule productions of the minor arts and normally did not antedate the fourth and fifth centuries A.D.; and the classical values—artistic as well as literary—were salvaged but not "reactivated" (as we have seen, no effort was made either to reinterpret classical images or to illustrate classical texts *de novo*).

The classical revival of the eleventh and twelfth centuries, on the other hand, penetrated many strata of society. In art it sought and achieved monumentality, selecting

on *Aeneid*, VIII, 33, and XII, 885, retained by the "Mythographus III", and echoed in Petrarch's "glauco distinctus amictu" (*Africa*, III, 145)—must have taken place during the lifetime of Michael Scot (died 1234) although it is explicitly docu-
mented only more than one hundred years later, viz., in Berchorius' *Metamorphosis Ovidiana* (see Liebeschütz, *Fulgentius Metaforalis*, p. 58, and Panofsky and Saxl, "Classical Mythology in Mediaeval Art", p. 242, Note 20).

ILL. 2. Ninth-Century Text Written in *Capitalis Rustica*, with Thirteenth-Century Transliteration (Leiden, University Library, Cod. lat. Voss. 79. fol, 7).

models of greater antiquity than those normally chosen by the Carolingian masters, and emancipated classical images from what I have called the stage of quotation and paraphrase (it did precisely what the Carolingian *renovatio* had failed to do in that new meanings were infused into classical images and a new visual form was given to classical themes). But it was limited in several other respects: it represented only a special current within the larger stream of contemporary civilization (whereas Carolingian civilization as a whole was coextensive with the *renovatio* movement) and was restricted to particular regions; there was, according to these regions, a basic difference between a recreative and a literary or antiquarian response to the Antique; the proto-Renaissance in the arts was virtually restricted to architecture and sculpture as opposed to painting; and in art as well as literature classical form came to be divorced from classical content. Both these mediaeval renascences, finally, were transitory in that they were followed by a relative or—in the Northern countries—absolute estrangement from the aesthetic traditions, in art as well as literature, of the classical past.

How things were changed by the real, Italian Renaissance can be illustrated by a small but significant incident. The Carolingian *Aratea* manuscript which includes, among so many other classicizing pictures, the Pompeian-looking Gemini reproduced in Fig. 12 had been left untouched for about four hundred years. Then a well-meaning scribe saw fit to repeat the entire text in the script of the thirteenth century (Text Ill. 2) because he evidently thought that the Carolingian "Rustic Capital" would stump his contemporaries, as well as future generations. But the twentieth-century reader finds Carolingian script easier to decipher than Gothic, and this ironic fact tells the whole story.

Our own script and letter press derive from the Italian Renaissance types patterned, in deliberate opposition to the Gothic, upon Carolingian and twelfth-century models which in turn had been evolved on a classical basis. Gothic script, one might say, symbolizes the transitoriness of the mediaeval renascences; our modern letter press, whether "Roman" or "italic", testifies to the enduring quality of the Italian Renaissance. Thereafter, the classical element in our civilization could be opposed (though it should not be forgotten that opposition is only another form of dependence); but it could not entirely disappear again. In the Middle Ages there was in relation to the Antique a cyclical succession of assimilative and non-assimilative stages. Since the Renaissance the Antique has been constantly with us, whether we like it or not. It lives in our mathematics and natural sciences. It has built our theatres and cinemas as opposed to the mediaeval mystery stage. It haunts the speech of our cab driver—not to mention the motor mechanic or radio expert—as opposed to that of the mediaeval peasant. And it is firmly entrenched behind the thin but thus far unbroken glass walls of history, philology and archaeology.

VII

THE formation and, ultimately, formalization of these three disciplines—foreign to the Middle Ages in spite of all the Carolingian and twelfth-century "humanists"[1]—evince a fundamental difference between the mediaeval and the modern attitude towards classical antiquity, a difference which makes us understand the essential strength and the essential weakness of both. In the Italian Renaissance the classical past began to be looked upon from a fixed distance, quite comparable to the "distance between the eye and the object" in that most characteristic invention of this very Renaissance, focused perspective. As in focused perspective, this distance prohibited direct contact—owing to the interposition of an ideal "projection plane"—but permitted a total and rationalized view. Such a distance is absent from both mediaeval renascences. "The Middle Ages", as has recently been said, "never knew that they were mediaeval. The men of the twelfth century had none of that awareness of a Cimmerian night from which—as Rabelais wrote his friend Tiraqueau in 1532—humanity had emerged".[2]

The Carolingian revival had been started because it was felt that a great many things needed overhauling: the administrative system, the liturgy, the language, and the arts. When this was realized, the leading spirits turned to antiquity, both pagan and Christian (and even with a strong initial emphasis on the latter), much as a man

[1] See now F. Gaeta, *Lorenzo Valla: Filologia e storia nell'umanesimo italiano*, Naples, 1955.

[2] W. A. Nitze, "The So-Called Twelfth-Century Re- naissance", *Speculum*, XXIII, 1948, p. 464 ff. (the sentence quoted, p. 466). For Rabelais' letter to Tiraqueau, see above, pp. 17, 22.

whose motor car has broken down might fall back on an automobile inherited from his grandfather which, when reconditioned (and let us not forget that the Carolingians themselves spoke only of *renovare* or *redintegrare* instead of using such words as *reflorescere*, *revivere* or *reviviscere*, let alone *renasci*), will still give excellent service and may even prove more comfortable than the newer model ever was. In other words, the Carolingians approached the Antique with a feeling of legitimate heirs who had neglected or even forgotten their property for a time and now claimed it for precisely those uses for which it had been intended.

In contrast to this untroubled sense of legitimacy, the high-mediaeval attitude toward the Antique is characterized by an ambivalence somewhat analogous to that which marks the high-mediaeval position toward Judaism. Throughout the Christian era the Old Testament has been recognized as the foundation of the New, and in Carolingian art the relation between the Church and the Synagogue still tended to be interpreted in a spirit of hopeful tolerance stressing that which perfect and imperfect revelation have in common instead of that which separates them: an initial in the Drogo Sacramentary produced at Metz between 826 and 855 depicts the Church and the Synagogue in a state of peaceful coexistence rather than as enemies.[1] From the turn of the first millennium, however—witness the Uta Gospels, where the Synagogue, her brow and eyes disappearing behind the frame as the setting sun vanishes beneath the horizon, is opposed to the Church as a power of darkness that "tenet in occasum"[2]— a feeling of hostility towards the living adherents of the Old Dispensation began to outweigh the respect for the dead patriarchs and prophets. And from the twelfth century, when this hostility resulted in discriminatory practices and physical persecution, the Synagogue came to be depicted blindfolded instead of merely turning away from the light and was occasionally shown in the act of killing an animal[3] (although a man as tolerant as Abbot Suger of St.-Denis could still prefer to represent her, in one of his "anagogical" windows, in the role of precursor rather than foe, "unveiled" by God and thus belatedly endowed with sight, where her more fortunate sister receives a

[1] Paris, Bibliothèque Nationale, MS. lat. 9428, fol. 43v. (L. Weber, *Einbanddecken, Elfenbeintafeln, Miniaturen und Schriftproben aus Metzer Handschriften*, Metz, 1912, Plate XXIII, 5). For the ambivalent and changing attitude toward the Synagogue in mediaeval literature, see M. Schlauch, "The Allegory of Church and Syangogue", *Speculum*, XIV, 1939, p. 448ff.; it is to be hoped that an unpublished study by Professor Howard Davis of Columbia University will see the light in the not too distant future.

[2] Munich, Staatsbibliothek, clm. 13601, fol. 94 (cf. Panofsky, *Studies in Iconology*, p. 110f., Fig, 78).

[3] Verdun, Bibliothèque de la Ville, MS. 119 (see

above, p. 99, Note 1). Another early representation of blindfolded Synagogue is found in a stained-glass window in the Musée des Arts Décoratifs in Paris (*Musée des Arts Décoratifs, Vitraux de France du XIᵉ au XIVᵉ siècle*, 2nd ed., Paris, 1953, Plate V). It is interesting that the practice of forcing Jews to wear such discriminatory apparel as the notorious "Jewish hat" was recorded by artists about three quarters of a century before it was written into law under Innocent III (cf. G. Kisch, *Jewry-Law in Mediaeval Germany, Laws and Court Decisions Concerning Jews*, New York, 1949, p. 116).

crown).[1] In the high-mediaeval period, then, we can observe an unresolved tension between the enduring sense of obligation towards the prophetic message of the Old Law and the growing repugnance towards its bloody ritual and its contemporary manifestations. The Apostles could be shown seated or standing on the shoulders of the prophets much as Bernard of Chartres compared his generation's relation to the classics to that of dwarves "who have alighted on the shoulders of giants" and "see more numerous and distant things not by virtue of their own keen vision or their own stature but because they are raised aloft by the giants' magnitude";[2] but in the same iconographical context (in the "Fürstenportal" of Bamberg Cathedral) the Synagogue could be portrayed as a stubborn, benighted enemy of the Church, her statue surmounting the figure of a Jew whose eyes are being put out by a devil.

Similarly there was, on the one hand, a sense of unbroken continuity with classical antiquity that linked the "Holy Roman Empire of the Middle Ages" to Caesar and Augustus, mediaeval music to Pythagoras, mediaeval philosophy to Plato and Aristotle, mediaeval grammar to Donatus—and, on the other, a consciousness of the insurmountable gap that separated the Christian present from the pagan past (so that in the case of Aristotle's writings a sharp distinction was made, or at least attempted, between what was admissible and what should be condemned). The classical world

[1] See Suger's window showing the figure of God, His breast "charged" with seven doves symbolizing the seven gifts of the Holy Spirit, crowning the Church with His right hand while *unveiling* the Synagogue with His left (Panofsky, *Abbot Suger*, p. 194, Fig. 15).

[2] John of Salisbury, *Metalogicon*, III, 4 (*Patrologia Latina*, CXCIX, col. 900; McGarry, ed., p. 167): "Dicebat Bernardus Carnotensis nos esse qusi nanos, gigantium humeris insidentes, ut possimus plura eis et remotiora videre non utique proprii visus acumine, aut eminentia corporis, sed quia in altum subvehimur et extollimur magnitudine gigantica". For this dictum of Bernard of Chartres, one of the most frequently discussed *loci* in mediaeval literature, see R. Klibansky, "Standing on the Shoulders of Giants", *Isis*, XXVI, 1936, p. 147f., and Curtius, *op. cit.*, p. 127. To what extent it may have suggested to artists the idea of representing the Apostles perched on the shoulders of the prophets is a moot question. The main argument in favor of this assumption—the fact that the motif in question occurs, in the north transept windows of the Cathedral, at Chartres itself before its appearance on the Bamberg "Fürstenportal" and in the windows of the west choir of Naumburg Cathedral—is vitiated by two occurrences unquestionably preceding the Chartres windows, viz., the baptismal font in Merseburg Cathedral (H. Beenken, *Romanische Skulptur in Deutschland*, Leipzig, 1924, p. 86 ff., Figs. 43, 44) and, probably, a capital in the church of Payerne about halfway between Berne and Lausanne (J. Gantner, *Kunstgeschichte der Schweiz*, I, Frauenfeld, 1936, p. 226 ff., Fig. 167). On the other hand, it remains true that, barring the very doubtful reconstruction of a mural in San Sebastiano al Palatino in Rome (J. Wilpert, *Die römischen Mosaiken und Malereien der kirchlichen Bauten* ..., Freiburg, i. B., 1916, II, Figs. 513-515, IV, Plate 225, No. 1), all the abovementioned examples postdate not only the lifetime of Bernard of Chartres but also the date of John of Salisbury's *Metalogicon* (largely completed in 1159); and certain it is that, occasional statements to the contrary notwithstanding, the motif is foreign to Byzantine art. Thus an influence of Bernard's simile on the visual arts—conceivably through the intermediary of illustrated manuscripts—still remains within the realm of possibility. De Francovich, *op. cit.*, I, p. 194f., enumerates the examples of Apostles placed on the shoulders of prophets in connection with the prophets holding medallions that enclose the portraits of Apostles (Parma Baptistry) but does not discuss the problem posed by the *aperçu* of Bernard of Chartres.

was not approached historically but pragmatically, as something far-off yet, in a sense, still alive and, therefore, at once potentially useful and potentially dangerous. It is significant that the classical philosophers and poets were frequently represented in the same Oriental costumes as the Jewish prophets, and that the thirteenth century spoke of the Romans, their monuments and their gods as *sarrazin* or *sarazinais*, employing the same word for the pagans of old and the infidels of its own age.[1]

For want of a "perspective distance" classical civilization could not be viewed as a coherent cultural system within which all things belonged together. Even the twelfth century, to quote a competent and unbiased observer, "never considered the whole of classical antiquity, ... it looked upon it as a storehouse of ideas and forms, appropriating therefrom such items as seemed to fit in with the thought and actions of the immediate present".[2] Every phenomenon of the classical past, instead of being seen in context with other phenomena of the classical past, thus had to have one point of contact, and one of divergence, with the mediaeval present: it had to satisfy both the sense of continuity and the feeling of opposition: Hildebert of Lavardin's *Elegy of Rome* is followed, we remember, by a Christian palinode, and Marbod of Rennes' pastoral serves as an introduction for a *Sermo de vitiis et virtutibus*.

Now we can see why the union of classical form and classical content, even if retained in the images revived in Carolingian times, was bound to break apart, and why this process of "disjunction" was so much more radical in the arts—where the very fact that they provided a visual rather than intellectual experience entailed the danger of *curiositas* or even idolatry—than in literature. To the high-mediaeval mind Jason and Medea (even though she tended to perform her tricks of rejuvenation with the aid of the "water of Paradise") were acceptable as long as they were depicted as Gothic aristocrats playing chess in a Gothic chamber. Classical gods and goddesses were acceptable as long as they lent their beautiful presence to Christian saints, to Eve or to the Virgin Mary.[3] But a Thisbe clad in classical costume and waiting for Pyramus by

[1] In addition to Villard de Honnecourt's well-known designation of a "Roman" tomb as *li sepouture d'un sarrazin* (fol. 6, cf. Adhémar, *op. cit.*, p. 279), there may be mentioned a passage in the Cambridge Lapidary (cf. p. 96, Note 1) where the pagan gods are called *des dieux sarazinais* (Pannier, *op. cit.*, p. 147).

[2] Liebeschütz, "Das zwölfte Jahrhundert und die Antike", p. 271 (translation mine).

[3] Von Bezold (*op. cit.*, p. 44) seems to have misinterpreted two lines in Abelard's poem addressed to his (probably imaginary) son, "Astrolabius", when he reads into them an objection to a classicistic representation of Christ or the Virgin Mary in the manner of the Reims *Visitation*. In asking, "Numquid amare potest ut Iuppiter idola Christus / Aut sculpi ut Vesta nostra Maria volet"? Abelard does not object to images adhering to a classicizing manner but to images as such. As the *ut* in the first clause can be construed only with *amare*, and not with *Iuppiter*, so must the *ut* in the second clause be construed with *sculpi*, and not with *Vesta*. We must, therefore, translate not: "Can Our Lady wish to be represented in a sculptured image so as to look like Vesta"? but: "Can Our Lady wish to be represented in a sculptured image as Vesta did"?

a classical mausoleum would have been an archaeological reconstruction incompatible with the sense of continuity; and an image of Mars or Venus classical in form as well as significance was either, as we have seen, an "idol" or talisman or, conversely, served to personify a vice. We can understand that the same Magister Gregorius who studied and measured the Roman buildings with the detachment of an antiquarian was filled with wonder and uneasiness by the "magical attraction" of that too beautiful *Venus*; that Fulcoius of Beauvais (died sometime after 1083) was able to describe a head of Mars discovered by a plowman only in terms of a violent conflict between admiration and terror ("Horrendum caput et tamen hoc horrore decorum, / Lumine terrifico, terror et ipse decet; / Rictibus ore fero, feritate sua speciosum");[1] that there sprang up, as a sinister accompaniment to proto-humanism, those truly terrifying tales (revived by the Romantics from Joseph von Eichendorff and Heinrich Heine to Prosper Mérimée and Gabriele d'Annunzio) about the young man who had put his ring on the finger of a Venus statue and thereby fell prey to the devil; and that, as late as in the second half of the fourteenth century, the Sienese believed the public erection of such a statue, recently excavated and much admired as a "work of Lysippus", to be responsible for their defeat at the hands of the Florentines (they took it down, dismembered it, and surreptitiously buried the fragments in enemy territory).[2]

The "distance" created by the Renaissance deprived antiquity of its realness.[3] The

[1] For these verses of Fulcoius of Beauvais, strangely combining a strong emotional reaction with an attempt at antiquarian analysis, see (in addition to von Bezold, *op. cit.*, pp. 38f., 96, Liebeschütz, *Fulgentius Metaforalis*, p. 14, Manitius, *op. cit.*, III, p. 836ff.) Adhémar, *op. cit.*, pp. 104f., 311f. Another text that deserves to be adduced in this connection is a poem by Baudry de Bourgueil. Describing an obviously authentic dream, this poem, apart from being material for a psychoanalyst's field day, bears witness to the unholy fascination which the Antique exerted upon the mind of a cultured Northerner (Abrahams, *Les Oeuvres poétiques*, XXXVII, p. 19ff.; cf. Manitius, *op. cit.*, III, p. 886). On an unusually grim night and much tormented by physical and moral anxieties, Baudry falls into a fitful slumber and dreams that he is riding over a bridge which, suddenly shaking, precipitates him into a wide and turbulent river. When he tries to get hold of a rock near one of the river's banks, a piece of this rock comes off, remaining in his hands, and turns out to be a "stone skilfully carved by an ancient artist, seeming to exhibit the image of a living lion" (Miss Abrahams certainly errs when she thinks of this stone, explicitly described as *saxum evectum de saxis*,

as a cut gem rather than a big carved rock). In spite of his plight, Baudry cannot help admiring it for a long time ("Admiror lapidem, lapidi studiosus inhoerens; / Admiror formam, mirari quippe licebat / Otia miranti fuerant haec atque natanti") but finally tears himself away and tries to gain the opposite bank, braving the waves and, at the same time, narrowly escaping a hail of falling rocks. At the last moment the current sweeps him against an enormous octagonal column of beautifully polished Parian marble, rising out of the river to the height of "twelve men" and crowned with a sphere; but he miraculously succeeds in overthrowing it "with his left shoulder" so that it vanishes in the waters and no longer obstructs his way to safety.

[2] For this story, admirably told by Lorenzo Ghiberti, see von Schlosser, *Lorenzo Ghibertis Denkwürdigkeiten*, I, p. 63; II, p. 189ff. For the earlier Venus legends, see von Bezold, *op. cit.*, p. 62ff., and G. Huet, "La Légende de la statue de Vénus", *Revue de l'histoire des religions*, LXVIII, 1913, p. 193ff.

[3] This difference between the mediaeval and the Renaissance attitude toward classical antiquity was nicely formulated by E. M. Sanford, "The Study of Ancient History in the Middle Ages", *Journal of the*

classical world ceased to be both a possession and a menace. It became instead the object of a passionate nostalgia which found its symbolic expression in the re-emergence —after fifteen centuries—of that enchanting vision, Arcady.[1] Both mediaeval renascences, regardless of the differences between the Carolingian *renovatio* and the "revival of the twelfth century", were free from this nostalgia. Antiquity, like the old automobile in our homely simile, was still around, so to speak. The Renaissance came to realize that Pan was dead—that the world of ancient Greece and Rome (now, we recall, *sacrosancta vetustas*, "hallowed antiquity") was lost like Milton's Paradise and capable of being regained only in the spirit. The classical past was looked upon, for the first time, as a totality cut off from the present; and, therefore, as an ideal to be longed for instead of a reality to be both utilized and feared.[2]

The Middle Ages had left antiquity unburied and alternately galvanized and exorcised its corpse. The Renaissance stood weeping at its grave and tried to resurrect its soul. And in one fatally auspicious moment it succeeded. This is why the mediaeval concept of the Antique was so concrete and at the same time so incomplete and distorted; whereas the modern one, gradually developed during the last three or four hundred years, is comprehensive and consistent but, if I may say so, abstract. And this is why the mediaeval renascences were transitory; whereas the Renaissance was permanent. Resurrected souls are intangible but have the advantage of immortality and omnipresence. Therefore the role of classical antiquity after the Renaissance is somewhat elusive but, on the other hand, pervasive—and changeable only with a change in our civilization as such.

History of Ideas, V, 1944, p. 21 ff.: "This conviction of unity of history led to disregard of anachronism, and blocked many approaches to historical criticism; but it also saved the ancient world from the aspect of unreality that it has for many modern scholars" (p. 22). See, however, the same author's later article, "The Twelfth Century—Renaissance or Proto-Renaissance"? *Speculum*, XXVI, 1951, p. 635 ff.

[1] See Panofsky, *Meaning in the Visual Arts*, p. 295 ff., particularly p. 302 ff.

[2] Nitze, *op. cit.*, p. 470f.: "The fact remains that the classical element in it [the civilization of the twelfth century] was chiefly background or coloring, given themes that were indigenous in the practical life of the age and not freshly imported from the Ancients... Certainly the Middle Ages and the Renaissance are not mutually exclusive ... But the emphasis each age placed falls on a different aspect of the histoical picture: in the one, on the continuity of the Classics as a preparation for Christian, chivalric ideals; and, in the other, on a break with the immediate past and a return to a Utopian Classical World."

CHAPTER III

I Primi Lumi: Italian Trecento Painting and Its Impact on the Rest of Europe

L<small>IKE THE TERM</small> *buona maniera moderna,* the phrase *i primi lumi* was coined by Giorgio Vasari. The first of his biographies opens as follows: "The tremendous deluge of disasters that had submerged and drowned unfortunate Italy had not only ruined such edifices as truly deserved this name but also, and more important, exterminated all artists when, by the grace of God, there was born in 1240, in the city of Florence, Giovanni Cimabue, destined to give the first lights to the art of painting (*per dar i primi lumi all'arte della pittura*)."[1]

I

T<small>HOROUGHLY</small>—perhaps too thoroughly—committed to the dogma of evolution, the modern art historian is somewhat reluctant to speak or think in terms of "firsts". We have become skeptical of the old tradition according to which Jan van Eyck "invented" oil painting and smile at Pliny when he professes to know precisely which classical sculptor "first accurately depicted sinews, veins and hair" and which classical painter "first expressed the mind and feelings of man, which the Greeks call character, as well as his passions". Yet, no matter whether Jan van Eyck invented or merely immeasurably perfected the process, the fact remains that the use of pigments tempered with oils, thus far resorted to only for special effects or in the interest of durability, did not achieve the status of an artistic method until about 1420, and that the acceptance of this method was symptomatic of a major change in European painting. No matter whether Pythagoras of Rhegion was really the first to represent "nervos et venas capillumque diligentius", a certain anatomical realism did make its appearance in

[1] Vasari, *op. cit.,* I, p. 247. Cimabue's birth date as given by Vasari, though perhaps a trifle too early, would seem to be approximately correct. The date of his death is unknown, but he was still active in 1302.

the first half of the fifth century and did contribute to what we would call an organic rather than mechanical interpretation of the human body. No matter whether Aristides of Thebes (credited with the invention of what was to become a favorite motif of the Baroque, the mortally wounded mother who "seems to fear that her child might suck blood after the living milk has died") was really the first to express "animum et sensus hominis, quae vocant Graeci *ethe*, item perturbationes", the second half of the fourth century did see the rise of that emotional subjectivism and that new emphasis on pathos which was to culminate in the frieze of Pergamon and the Laocoön group.[1]

Similarly, whatever role we may assign to Cimabue as an individual—and after a determined attempt to banish him into the limbo of the *personnages de légende* he now seems to emerge almost exactly as what the tradition established by Dante had made him out to be, the last and most accomplished representative of the *maniera greca* as well as the immediate precursor of Giotto[2]—it is still true that "new lights" went on in central Italy by the turn of the thirteenth century, and that these "lights" illumined a Europe whose culture ("trotz Kaiser und Reich", to quote Wilhelm Vöge once more) had largely been dominated by France for about one hundred and fifty years. And it is equally true that, as far as the visual arts are concerned, this leading role of the Italian Trecento was limited to painting.

The first part of Vasari's *Lives*—covering, we remember, what he calls the *prima età* of the "Renaissance"—comprises, in the second edition of 1568, the biographies of thirty-five artists. Three of these (Giotto, Orcagna and Vasari's townsman, the elusive Margaritone d'Arezzo) are listed as "painters, sculptors and architects" although the biographer is careful to say that Margaritone's efforts as an architect did not amount to much;[3] five (among them the three Pisani, Nicolo, Giovanni and Andrea) as

[1] For Pythagoras of Rhegion, see Pliny, *Naturalis historia*, XXXIV, 59 (J. Overbeck, *Die antiken Schriftquellen zur Geschichte der bildenden Künste bei den Griechen*, Leipzig, 1868, p. 93, No. 499); for Aristides of Thebes, Pliny, XXXIV, 98 (Overbeck, p. 336, No. 1779). In translating the passage referring to the dying mother, I have followed the manuscript tradition: "Intellegiturque sentire mater et timere, ne emortuo lacte sanguinem lambat" (to conjecture an *e* after *emortuo* seems to be superfluous since *emortuo lacte* can easily be construed as an ablative absolute; if the interpolation of a preposition were necessary, *pro* would be more appropriate than *e*). In Baroque painting representations of the gruesome subject abound, and in his *Strage degli Innocenti* Giovan Battista Marino produced about as many variations on the "milk-and-blood-theme" as Beethoven did on Diabelli's little waltz.

[2] The phrase "der unmittelbare Vorläufer" is used by Oertel, *op. cit.*, p. 53. For Cimabue, see further *idem*, pp. 44ff., 47ff., 215; Benkard, *op. cit.*; A. Nicholson, *Cimabue*, Princeton, 1932; R. Salvini, *Cimabue*, Rome 1946; B. Kleinschmidt, *Die Basilika San Francesco in Assisi* (hereafter referred to as "Kleinschmidt, *Die Basilika*"), Berlin, 1915–1928 (vol. II reappeared separately, without change in pagination and numbering, as *Die Wandmalereien der Basilika San Francesco in Assisi*, Berlin, 1930); G. Sinibaldi and G. Brunetti, *Pittura Italiana del Duecento e Trecento; Catalogo della Mostra Giottesca di Firenze del 1937*, Florence, 1943, *passim*, particularly p. 253ff. Reproductions of most of the works touched upon in this chapter are also found in R. van Marle, *The Development of the Italian Schools of Painting*, The Hague, 1923–1938.

[3] Vasari, *op. cit.*, I, p. 366. According to him, Margaritone (*recte* Margarito) worked on the episcopal

"sculptors and architects"; and only one (Arnolfo di Cambio, whom Vasari mistakenly calls Arnolfo di Lapo and had not honored by an individual biography in the first edition of 1550) as an architect pure and simple. All the others, no fewer than twenty-six, are painters; and that Vasari, quite apart from this numerical imbalance, found it difficult to co-ordinate the revival of the three-dimensional arts with that of painting in time and in importance is evident throughout.

In order to show that there was one "through whose talents architecture was improved as greatly as painting was through Cimabue's", Vasari had to claim that the works of Arnolfo di Cambio, the first no-longer-wholly-Gothic architect and the first master of Florence Cathedral, postdated a good many examples of the abominable *maniera tedesca* which had in fact achieved its climax long after Arnolfo's death.[1] And in order to extend the parallel to sculpture (after "having discussed design and painting in the Life of Cimabue and architecture in that of Arnolfo di Lapo"), he had to merge the characters of Nicolo and Giovanni Pisano into what may be called a composite image: Nicolo is treated as a contemporary of Cimabue (who was still alive in 1302) even though his chief activity falls in the third rather than the fourth quarter of the thirteenth century; Giovanni is described as a faithful follower of his father ("seguitò sempre il padre"), except that he "came to surpass him in certain respects", even though he can hardly be called an "assiduous imitator of the Antique"; and both are said to have worked, on several occasions and in several places, in victorious competition with some unnamed *tedeschi*.[2]

In spite of these inaccuracies, Vasari was, as so often, not far from right in principle. Arnolfo di Cambio's project for the façade of Florence Cathedral does seem to anticipate the Renaissance point of view in such important respects as the tendency to create "a balance of verticals and horizontals" and to establish a consistent surface rhythm "based on the very regular proportion of $2:3.5$";[3] Nicolo Pisano's sculpture does seem to anticipate the Renaissance point of view in its attempt to harmonize the mediaeval

palace at Arezzo but "followed the design of Arnolfo di Lapo [viz., di Cambio]"; of the buildings attributed to Margaritone himself Vasari says: "non sono d'importanza".

[1] See Panofsky, "Das erste Blatt ..." (*Meaning in the Visual Arts*, p. 169 ff., particularly p. 221 ff.). In order to make the parallelism between the "no-longer-wholly-Gothic" Arnolfo and the "no-longer-wholly-Byzantine" Cimabue even more convincing, Vasari claims that Arnolfo had been instructed by Cimabue in the "art of design".

[2] Vasari, *op. cit.*, I, pp. 305, 313 f., 312, asserts that Nicolo Pisano worked "in the company" of certain *tedeschi* on the façade of Orvieto (started long after

his death), surpassing not only the works of these *tedeschi* but also his own previous efforts; that Giovanni Pisano produced his pulpit in S. Andrea at Pistoia *per concorrenza* with a pulpit erected in another church (S. Giovanni Evangelista) by "un Tedesco che nè fu molto lodato"; and that a group of *tedeschi* associated themselves with him in Arezzo "for the sake of instruction rather than gain", in consequence of which they became proficient enough to be employed by Boniface VIII at Rome.

[3] See M. Weinberger, "The First Façade of the Cathedral of Florence", *Journal of the Warburg and Courtauld Institutes*, IV, 1940–41, p. 67 ff., particularly p. 78 f.

with the classical one; and it was logical that the sculptural decoration of Arnolfo's façade should have been entrusted to conservative if somewhat provincial followers of Nicolo rather than to the progressive members of a younger generation. In both these cases, however, the anticipation of the post-Gothic future was largely due to the influentiality—by way of conscious revival or unreflecting acceptance of tradition—of the pre-Gothic past and may, therefore, be considered as apparent rather than real.

Having adhered to unequivocally Gothic standards in S. Croce, Arnolfo di Cambio did not intentionally reject the Gothic style in his project for the façade of Florence Cathedral. The greater "classicality" of this design resulted from his successful attempt—perhaps with the Romanesque façade of Lucca Cathedral in mir.d—to harmonize the appearance of the new façade with that of the adjacent Baptistry.[1] The style of Nicolo Pisano is rooted, as we have seen, in the "proto-Renaissance of the twelfth century" as modified by the developments in the Ile-de-France and Champagne. And unlike Cimabue neither Arnolfo nor Nicolo had, if one may say so, his Giotto. The influence of Arnolfo di Cambio—whose plan for the façade of Florence Cathedral was superseded by Francesco Talenti's in 1357—was neutralized by that of such more orthodox Gothicists as Lorenzo Maitani. The influence of Nicolo Pisano was neutralized, as has already been mentioned, by that of his own son, Giovanni, who, while foreshadowing Donatello and Michelangelo in the spirit, was certainly more "Gothic" than his father in the flesh. And, even more important, no architect or sculptor of the Italian Trecento had an appreciable effect upon the course of events outside the peninsula. In these two fields the current of influence continued to flow—with a few rare and easily explicable exceptions[2]—from North to South, and was not to be reversed until the sixteenth century.

An entirely different situation obtained in painting. Here the simultaneous and complementary activities of two great masters who, the merits of their predecessors notwithstanding, must still be recognized as innovators revolutionized the very concept or definition of a picture and reversed what I have called the current of influence for a whole century: in painting—and only in painting—fourteenth-century Italy acquired the same international predominance which thirteenth-century France had acquired,

[1] See Weinberger, *ibidem*; he also shows that the sculpture destined for Arnolfo's façade owes its Pisanesque character to the tradition established by Nicolo in Lucca. For the school of Nicolo Pisano in general, cf. Valentiner, *op. cit.*, and G. Swarzenski, *Nicolo Pisano*, p. 68 ff. (with the judicious conclusion that, as compared to the epoch-making significance of Nicolo's style, "der örtliche Umkreis seiner Wirkung [ist] verhältnismässig klein"). It should be noted only that the beautiful fragment from the high altar of Siena Cathedral (Swarzenski, p. 70, Fig. 126) does not represent the Tetramorph, as do the specimens mentioned *ibidem*, p. 35, and illustrated in Fig. 51, but shows the rather rare subject of the Virgin Mary surrounded by the symbols of the four Evangelists.

[2] For such exceptions, see, e.g., Panofsky, *Early Netherlandish Painting*, p. 365, Note 20[1]; F. Winkler, "Paul de Limbourg in Florence", *Burlington Magazine*, LVI, 1930, p. 94 ff.

and to a large extent retained, in the three-dimensional media; it is not too much of an exaggeration to say that the history of European painting from *ca.* 1320 to *ca.* 1420 can largely be written in terms of Italian influence.

II

THE two great innovators just mentioned are, needless to say, Giotto di Bondone and Duccio di Buoninsegna,[1] and to refer to their activities as complementary is justifiable on several grounds. Duccio, the older of the two by fifteen years or so (he is recorded as early as 1278 and died at the end of 1318 or the beginning of 1319), spent practically all his life in Siena. He was essentially a panel painter rather than a muralist; he had, so far as we know, no active connection with either sculpture or architecture; and he seems to have developed his style—a "maniera greca mescolata assai con la moderna", as Vasari freely quotes from Lorenzo Ghiberti—from purely local sources, continuing, as it were, where his first tangible predecessor, Guido da Siena, had left off.[2] Giotto (probably born in 1266 and alive until 1337) was the pride of Florence, but his activity ranged as far as Rome, Assisi, Padua, Naples, and possibly Rimini; in addition—or, rather, in preference—to panels, he produced mosaics and murals. How closely he approached the ideal of the "universal artist" is attested by the fact that in April, 1334, the Florentines appointed their "expert and famous" (*expertus et famosus*) towns-man as "magister et gubernator laborerii et operis ecclesie Sancte Reparate", in which capacity he, the painter, had all the responsibilities formerly carried by the architects-in-chief of Florence Cathedral and personally provided the designs for the Campanile and its reliefs.[3] His style, finally, fused a specifically Florentine tradition (established

[1] For the extremely voluminous literature on Duccio and Giotto, see Oertel, *op. cit.*, particularly pp. 45 ff., 90, 121–127, 216 (Duccio), and 62–111, 128 ff., 218 f. (Giotto); Sinibaldi and Brunetti, *op. cit.*, pp. 107 ff. (Duccio), and 301 ff. (Giotto). After C. Brandi's excellent *Duccio*, Florence, 1951, there has been published an interesting new reconstruction of the master's principal work: E. T. DeWald, "Observations on Duccio's *Maestà*", *Late-Classical and Mediaeval Studies in Honor of Albert Mathias Friend, Jr.*, Princeton, 1954, p. 362 ff.

[2] Cf. Oertel, *op. cit.*, pp. 41 ff., 214 ff.; Sinibaldi and Brunetti, *op. cit.*, *passim*, particularly pp. 107, 115.

[3] See W. Paatz, "Die Gestalt Giottos im Spiegel einer zeitgenössischen Urkunde", *Eine Gabe der Freunde für Carl Georg Heise zum 28.VI.1950*, Berlin, 1950, p. 85 ff. (cf. also *idem*, "Die Bedeutung des Humanismus für die toskanische Kunst des Trecento", *Kunst-*

chronik, VII, 1954, p. 114 ff.). The significance of the document consists not so much in the fact that one artist, in addition to being called *famosus* and to being eulogized in solemn language, was entrusted with the administrative and financial as well as artistic supervision of a great cathedral as in the fact that this artist was a painter and not an architect. Paatz himself refers to the fact that a title very similar to that conferred upon Giotto was borne, in 1284, by Erwin of Steinbach, the architect-in-chief of Strasbourg Cathedral ("gubernator fabrice ecclesie Argentinensis"). In doing homage to Giotto as an individual his appointment recognized *de facto* the status achieved in fourteenth-century Florence by painting in general. *De jure*, and in principle rather than in an individual case, this status was recognized in 1378 when the painters, still attached to the *arte dei medici e speziali*, were authorized to form an

by such older masters as Coppo di Marcovaldo but already deprovincialized, if one may say so, by Giotto's "teacher", Cimabue) with what had been achieved in Rome during the second half of the thirteenth century, particularly by that great artist who, while described as Giotto's disciple by Vasari, may have an equally valid claim to being called his master as Cimabue: Pietro Cavallini.[1]

In Duccio and Giotto the difference between Siena and Florence, foreshadowed by that between Guido da Siena and Coppo di Marcovaldo, was sharpened to the point of a clear-cut dichotomy which has been described so often and so well that it would be futile to dwell upon it. Duccio's art may be called lyrical: his figures are swayed by emotions which unite them in a communion of almost musical sentiment. Giotto's art may be called either epic or dramatic: his figures are treated as individuals individually reacting to one another; even in scenes including comparatively numerous *dramatis personae* he never attempted to represent a "crowd" (see Fig. 91 as compared to Fig. 92). Duccio—a Sienese *pur sang* and still at heart a Byzantinist—relied on the power of lines and surfaces; but just for this reason he was careful to place the forms defined by these lines and surfaces within an ambient medium that would invest them (as by electrical induction) with a semblance of corporeality. Giotto—a Florentine transformed by a Roman experience which had brought him into contact not only with Cavallini himself but also with Cavallini's late-antique and Early Christian sources and, in a sense, a descendant of Romanesque sculptors rather than Byzantinizing painters[2]—relied on the power of volume; that is to say, he conceived of three-dimensionality not as a quality inherent in an ambient medium and imparted by it to the individual objects but as a quality inherent in the individual objects as such. Giotto, therefore, tended to conquer the third dimension by manipulating the plastic contents of space rather than space itself; even in his latest compositions, such as the *Birth of St. John* and the *Resurrection of Drusiana* in the Peruzzi Chapel in S. Croce, space is generated by the solids instead of pre-existing before them. By introducing figures seen from the back, he invites, even compels the beholder to share the experience of depth by way of empathy (Fig. 93); and he anticipated what is now known as "two-point perspective" by setting buildings slantwise in space (Figs. 107, 113)—an arrangement by virtue of which the stage is deepened in so far, but only in so far, as objects placed obliquely take up more space in depth than if they were placed frontally.

independent branch of this guild and this guild was renamed so as to be known as the *arte de' medici, spetiali, dipintori e merciai* (Meiss, *Painting in Florence and Siena after the Black Death*, New York edition of 1964, p. 63, Note 16).

[1] For Pietro Cavallini (active in 1270 and still alive in 1316) and his connection with earlier Roman developments as exemplified by the frescoes at Grottaferrata, see Oertel, *op. cit.*, pp. 57 ff., 217.

[2] Cf. E. H. Buschbeck, "Ueber eine unbeachtete Wurzel der maniera moderna", *Festschrift für Julius Schlosser zum 60. Geburtstage*, Zurich, Leipzig and Vienna, 1927, p. 88 ff.

However, that Duccio and Giotto attempted to solve their problem by opposite methods cannot obscure, but on the contrary throws a particularly strong light on, the fact that it was the same problem: the problem of creating what we are wont to call a "picture space". And this problem was so new—or, rather, had been so utterly absent from the West European scene for so many centuries—that those who first raised it again still deserve to be called the "fathers of modern painting".

A picture space may be defined as an apparently three-dimensional expanse, composed of bodies (or pseudo-bodies such as clouds) and interstices, that seems to extend indefinitely, though not necessarily infinitely, behind the objectively two-dimensional painting surface; which means that this painting surface has lost that materiality which it had possessed in high-mediaeval art. It has ceased to be an opaque and impervious working surface—either supplied by a wall, a panel, a piece of canvas, a leaf of vellum, a sheet of paper or manufactured by the techniques peculiar to the tapestry weaver or the *peintre-verrier*—and has become a window through which we look out into a section of the visible world. "Painters should know", says Leon Battista Alberti, "that they move on a plane surface with their lines and that, in filling the areas thus defined with colors, the only thing they seek to accomplish is that the forms of the things seen appear upon this plane surface as if it were made of transparent glass"; and, even more explicitly: "I describe a rectangle of whatever size I please, which I imagine to be an open window through which I view whatever is to be depicted there".[1]

Thus to compare a painting to a window is to ascribe to, or to demand of, the artist a direct visual approach to reality: a *notitia intuitiva* (or, more briefly, *intuitus*), to quote the favorite term of those nominalists who—paralleling Duccio's and Giotto's achievement at the same time though in a different field, a different place and a different cultural environment—shook the foundation of high-mediaeval thought by granting "real" existence only to the outward things directly known to us through sensory perception and to the inward states or acts directly known to us through psychological experience. The painter is no longer believed to work "from the ideal image in his soul", as had been stated by Aristotle and maintained by Thomas Aquinas and Meister Eckhart, but from the optical image in his eye.

[1] Alberti, *On Painting*, Janitschek ed., p. 69; Mallè ed., p. 65: "Et sappiano [i pittori] che con sue linee circuiscono la superficie et quando empiono di colori e luoghi descritti niun altra cosa cercarsi non che in questa superficie si presentino le forme delle cose vedute, non altrimenti, che se essa fusse di vetro tralucente". Spencer's translation, p. 51, is not quite accurate not only in the rendering of the verb *circuire* (which is not identical with *circumscrivere* or *descrivere*) but also in that it transforms a description of what the painters are doing ("niun altra cosa cercarsi se non ...") into an injunction as to what they should do ("they should only seek ..."). The other passage, *ibidem*, Janitschek ed., p. 79; Mallè, p. 70; Spencer, p. 56: "Scrivo uno quadrangolo di retti angoli quanto grande io voglio, el quale reputo essere una finestra aperta per donde io miri quello que quivi sarà dipinto."

To judge from a somewhat scanty supply of visual evidence and a considerably larger body of literary information, including the well-known invectives of Plato, a style of painting based upon this sensualistic or illusionistic premise (both these expressions to be taken, of course, without derogatory implications) had come into being by the turn of the fifth century B.C. and was well advanced by the middle of the fourth. And certain it is that it was fully developed in Hellenistic and Roman times. In Rome and Campania we find elaborate interiors, landscapes and city prospects which unquestionably confront us with an "apparently three-dimensional expanse that seems to extend indefinitely behind the objectively two-dimensional painting surface"; and in at least one instance, the famous "Odyssey Landscapes" in the Vatican Library, Alberti's window simile has been anticipated in the concrete in that a continuous stretch of scenery is viewed through a framework of simulated pilasters.

In works like these all the phenomena, quantitative as well as qualitative, which form the subject matter of mathematical optics (as treated by Euclid, Geminus, Damianus, Heliodorus of Larissa, and others) are recognized and exploited. As regards quantities, the principle of "foreshortening" is applied not only to individual objects (wheels and circular shields distorted into ellipses as well as isolated buildings seen obliquely occur as early as the fifth century B.C.) but to the picture space in general: terrain or pavements, walls and ceilings seem to recede into depth, parallel lines not parallel to the picture plane are made to converge, objects seen at a distance shrink in size. And as regards qualities, the Hellenistic and Roman painters may seem to anticipate the effects of nineteenth-century Impressionism: the flattening, blurring and fading of solid form caused by the diffusion and diffraction of light in air; the change of color according to the law of complementarity (particularly evident in the modeling of human flesh by means of greenish or bluish tints); reflections and refractions; and, above all, the colored cast-shadow, that most conspicuous manifestation of the fact that intangible and, of themselves, invisible interstices exist between the tangible and visible "things".

Yet—and this is why we cannot be too careful in making qualifications when transplanting such terms as Impressionism from one historical context to another—the style of the "Odyssey Landscapes" and their kind is fundamentally different from that of Manet, Monet or Signac. Instead of conveying the impression of a stable and coherent world, made to flicker and vibrate by the way it is "seen", they convey the impression of a world unstable and incoherent in itself. Rocks, trees, ships, and tiny figures are freely distributed over vast areas of land and sea; but space and things do not coalesce into a unified whole nor does the space seem to extend beyond our range of vision. The size, volume and color of the objects change according to distance and to the action of light and atmosphere; but these changes cannot be expressed in terms of constant

relations. The "orthogonals" (viz., parallel lines leading straight into depth) "converge"; but they hardly ever converge in one point and often form herringbone pattern rather than what the mathematician calls a "pencil". There are, as has been said, refractions, reflections and cast-shadows but nothing like unified lighting. As a result, the whole has an unreal, almost spectral quality as though extracorporeal space could assert itself only at the expense of the solid bodies and, vampire-like, preyed upon their very substance.[1]

In short, the space presupposed and presented in Hellenistic and Roman painting lacks the two qualities which characterize the space presupposed and presented in "modern" art up to the advent of Picasso: continuity (hence measurability) and infinity. It was conceived as an aggregate or composite of solids and voids, both finite, and not as a homogeneous system within which every point, regardless of whether it happens

[1] For the problem of perspective in classical art, see Kern, "Die Anfänge der zentralperspektivischen Konstruktion"; E. Panofsky, "Die Perspektive als symbolische Form", p. 258 ff., particularly pp. 265 ff., 270 f., 305 ff.; M. Schild Bunim, *Space in Medieval Painting and the Forerunners of Perspective*, New York, 1940, especially pp. 12–37, Figs. 2–9, 74; W. M. Ivins, *Art and Geometry*, Cambridge (Mass.), 1946; Panofsky, *Early Netherlandish Painting*, p. 9 f.; for further literature, cf. *ibidem*, pp. 362, Note 3[2], and 363, Note 12[1]. To be added: E. Bock, "Binokularperspektive als Grundlage einer neuen Bilderscheinung", *Alte und neue Kunst, Wiener kunstwissenschaftliche Blätter*, II, 1953, p. 101 ff.; *idem*, "Perspektive Bilder als Wiedergaben binokularer Gesichtsvorstellungen", *ibidem*, III, 1954, p. 81 ff.; B. Schweitzer, *Vom Sinn der Perspektive*, Tübingen, 1953; P. Williams Lehmann, *Roman Wall Paintings from Boscoreale in the Metropolitan Museum of Art*, Cambridge (Mass.), 1953, p. 147 ff.; Walter J. Ong, "System, Space, and Intellect in Renaissance Symbolism", *Bibliothèque d'Humanisme et Renaissance; Travaux et Documents*, XVIII, 1956, p. 222 ff.; R. Bianchi-Bandinelli, "Oscervazioni storico-artistiche a un passo del 'Sofista' Platonico", *Studi in onore di Ugo Enrico Paoli*, Florence, 1956, p. 81 ff.; P. H. von Blanckenhagen, "Narration in Hellenistic and Roman Art", *American Journal of Archaeology*, LXI, 1957, p. 78 ff. (with special reference to the Odyssey Landscapes); John White, "Developments in Renaissance Perspective", *Journal of the Warburg and Courtauld Institutes*, XII, 1949, p. 58 ff., XIV, 1951, p. 42 ff.; *idem*, *Perspective in Ancient Drawing and Painting* (Society for the Promotion of Hellenic Studies, Supplementary Paper No. 7), London, 1956. The same author's important book, *The Birth and Rebirth of Pictorial Space*, London, 1957, appeared too late to be considered, and D. Gioseffi's *Perspectiva artificialis; Per la storia della prospettiva* (Trieste, Instituto di Storia dell'Arte Antica e Moderna, VII), 1957, is known to me only from an abstract in *Sele Arte*, VI, 1957, July-August, p. 49 ff. Bianchi-Bandinelli, White and Gioseffi (but not Schweitzer) read an exact perspective construction, more or less identical with the Brunelleschian, into the classical authors and monuments. I am admittedly prejudiced; but I am still unable to see that Graeco-Roman painting was familiar with the central projection onto a plane and that the Greek and Roman writers, committed to the angle axiom, interpreted perspective in this way. Quite recently Professor Karl Lehmann kindly called my attention to a passage in Philostratus' *Imagines* (1, 4, 2) which further increases my stubbornness. Describing a throng of soldiers receding in depth, Philostratus says: δεῖ γὰρ κλέπτεσθαι τοὺς ὀφθαλμοὺς τοῖς ἐπιτηδείοις κύκλοις συναπιόντας. In contrast to the arbitrary translation in *The Loeb Classical Library* edition, which renders κύκλοις as "receding *planes*", this sentence can be translated only as follows: "For it is necessary to deceive the eyes which move back in unison with the appropriate *circles*". In other words, the author thinks of the recession in depth in terms of a system of concentric circles (not unlike the rows of seats in an amphitheatre), and not in terms of a system of parallel planes.

to be located in a solid or in a void, is uniquely determined by three co-ordinates per-
pendicular to each other and extending *in infinitum* from a given "point of origin".

In philosophical and mathematical theory this "modern" concept of space as a
quantum continuum was anticipated by Nicolaus Cusanus, to be fully developed and
formalized in Descartes' doctrine of the *substance étendue* which his Netherlandish
follower, Arnold Geulincx, preferred to call the *corpus generaliter sumptum.* In representa-
tional practice, however, it was presupposed and exemplified by what we know as
exact geometrical perspective.

Alberti's window simile defines the picture not only as the record of a direct visual
experience but also, more specifically, as a "perspective" representation. *"Perspectiva"*,
says Dürer, "ist ein lateinsich Wort, bedeutt ein Durchsehung" (*"Perspectiva* is a Latin
word which means a view through something");[1] and it is in order to lead up to what
is the earliest written description of a method by which this *Durchsehung* can be con-
structed on a strictly geometrical basis that Alberti introduces his simile.

In principle, this exact geometrical construction—invented, in all probability, by
Filippo Brunelleschi about 1420 (Text Ill. 3) and transmitted by Alberti with pro-
cedural rather than substantive modifications (Text Ill. 4)[2]—is still founded on two

[1] Lange and Fuhse, *op. cit.,* p. 319, line 11 f.

[2] For Filippo Brunelleschi's construction as illustrated
in Text Ill. 3 (known as *costruzione legittima*), see, e.g.,
Panofsky, "Die Perspektive als symbolische Form",
p. 258 ff.: *idem, The Codex Huygens and Leonardo da
Vinci's Art Theory* (Studies of the Warburg Institute,
XIII), London, 1940, p. 93 ff.; *idem, Albrecht Dürer,*
p. 249 ff. See now the brilliant analysis in R. Kraut-
heimer (in collaboration with T. Krautheimer-Hess),
Lorenzo Ghiberti, Princeton, 1956, p. 229 ff. Proceeding
as an architect accustomed to thinking in terms of
ground plans and elevations, Brunelleschi began with
two preparatory drawings, viz., the ground plan and
the elevation of the whole visual system. In both
drawings the "visual pyramid" is represented by
triangles having their apices in a point standing for
the eye while the picture plane intersecting the
"visual pyramid" is represented by a vertical. In the
ground plan the object or objects naturally appear
in a horizontal diagram, and in the elevation in a
vertical one. When either diagram is connected with
the point representing the eye, the points of intersec-
tion between the connecting lines and the verticals
will determine the sets of values constituting the
perspective image, the ground plan supplying the
transversal and the elevation the vertical quantities.
The perspective image itself is constructed by com-
bining these two sets in a third and final drawing.

In this final drawing, it will be observed, the central
vanishing point does not actually appear; it can be
obtained only *ex post facto* by prolonging the converg-
ing orthogonals.

Alberti's procedure (see now Krautheimer, *Lorenzo
Ghiberti,* p. 244 ff.) started, as it were, where Brunel-
leschi's ended; and since I have recently been accused
of having no clear understanding of this procedure
(Spencer, *op. cit.,* p. 112), I may be forgiven for
boasting that it was I who in an article no longer
cited by *color chi sanno* first interpreted Alberti's
text, which at the time was thought to be either
hopelessly corrupted or unintelligible *per se* (E.
Panofsky, "Das perspektivische Verfahren Leone
Battista Albertis", *Kunstchronik,* New Ser., XXVI,
1914–1915, col. 505 ff.). In an attempt to devise a con-
struction to be used by painters—for whom the *co-
struzione legittima,* perpetuated only by such systemati-
cally-minded theorists as Piero della Francesca and
Dürer, was much too unwieldy—Alberti began, not
with the ground plan and elevation of the object or
objects to appear in the perspective rendering but
with the organization of the perspective rendering
itself. In it figures and things had to be disposed upon
a receding standing plane conceived as a series of
squares, each subdivided, checkerboardwise, into a
number of smaller squares. In order to construct the
first and nearest of such checkerboards (the others can

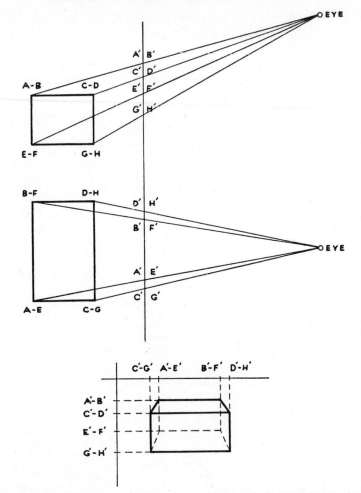

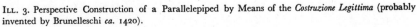

ILL. 3. Perspective Construction of a Parallelepiped by Means of the *Costruzione Legittima* (probably invented by Brunelleschi *ca.* 1420).

premises accepted as axiomatic in classical as well as mediaeval optics: first, that the visual image is produced by straight lines ("visual rays") which connect the eye with

be obtained by simply repeating the process) Alberti began by organizing his *quadrangulo* according to a scheme employed by progressive Italian painters from *ca.* 1340 and by progressive Northerners from *ca.* 1370 (cf. below, p. 126, Note, and p. 159): he divided the base line of the *quadrangulo* into a number

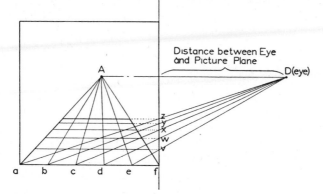

ILL. 4. Perspective Construction of a Checkerboard Floor by Means of the Method First Recorded by L. B. Alberti *ca.* 1435.

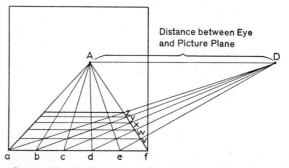

ILL. 5. Perspective Construction of a Checkerboard Floor by Means of the *Distanzpunktverfahren* (first recorded in Giacomo Barozzi da Vignola's *Due regole*, posthumously published in 1583).

the objects seen (no matter whether these rays were thought of as proceeding from the eye, the object or both), the whole configuration thus forming what was called the "visual pyramid" or the "visual cone"; second, that the size and shape of the objects as they appear in the visual image is determined by the relative position of the "visual

of equal parts; he then assumed within the *quadrangulo* a central vanishing point *A* (which determines the "horizon" of the picture and, according to Alberti, should therefore normally be located on the eye level of the human figures to be represented therein); and by connecting this central vanishing point with the terminals and dividing points of the base line (*a, b, c, d, e*) he obtained a "pencil" of converging but apparently equidistant orthogonals extending "quasi persino in infinito". There remained the problem of determining the correct sequence of the transversals with mathematical precision rather than, as had been customary, by way of arbitrary approximation. And in order to solve this

rays". What was fundamentally new was the assumption—foreign, as will be seen, to all pre-Brunelleschian theorists—that all the points constituting this visual image are located on a plane rather than on a curved surface: in other words, that a correct perspective representation can be obtained by projecting the objects onto a plane intersecting the visual pyramid or cone (*intersegazione della piramide visiva,* as Alberti puts it).

This projection—by definition a central one and perfectly analogous to that produced in a photographic camera—can be constructed by elementary geometrical methods (Text Ills. 3–5); and a representation based on this construction—such as, to give what deserves to be called the classic example, Leonardo da Vinci's famous drawing for the *Adoration of the Magi* in the Uffizi—may be defined as an exact projective transformation of a spatial system characterized by precisely those two qualities which distinguish the *quantum continuum* from the *quantum discretum.* Infinity is implied—or, rather, visually symbolized—by the fact that any set of objectively parallel lines, regardless of location and direction, converges towards one single "vanishing point" which thus represents, quite literally, a point where parallels meet, that is to say, a point located in infinity; what is loosely referred to as "*the* vanishing point" of a picture is privileged only in so far as it directly faces the eye and thus forms the focus of only such parallels as are objectively perpendicular to the picture plane, and Alberti himself explicitly states that the convergence of these "orthogonals" indicates the succession and alteration of quantities "quasi persino *in infinito*". Continuity, on the other hand, is implied—or

problem Alberti borrowed from Brunelleschi's *costruzione legittima* the elevation of the visual pyramid (originally to be executed on a separate sheet of paper) which would indicate the loci of the transversals (v, w, x, y, z) upon a vertical coincident with one of the lateral sides of the *quadrangulo* (Text Ill. 4). This method is no less purely geometrical than Brunelleschi's *costruzione legittima,* and there is absolutely no evidence to show that Alberti determined the apparent diminution of quantities with the aid of either a small box with peephole and strings (W. M. Ivins, *On the Rationalization of Sight,* New York, 1938, pp. 14–27) or of the surveying device which he describes in his *Descriptio urbis Romae* (Spencer, p. 113 ff.).

Alberti, then, used Brunelleschi's construction only as a means to correct a workshop practice long in use. And his "abbreviated method" was described—with the slight amendment that the whole construction, prior to being transferred to the panel, was plotted, on a smaller scale, on one piece of paper wide enough to leave room for the elevation—not only by Piero della Francesca and Dürer (who quite correctly refers to it as "der nähere Weg") but also, e.g., by Paolo Uccello, Leonardo da Vinci and Pomponius Gauricus (for the latter's rather difficult text, see "Die Perspektive als symbolische Form", p. 320 ff.); and it was actually employed by all Italian painters up to the time when a still simpler construction, the so-called *Distanzpunktverfahren* (first recorded in Giacomo Barozzi da Vignola's *Le due regole delle prospettiva pratica,* edited and annotated after the author's death by Egnazio Danti, Rome, 1583), found its way into Italy (Text Ill. 5). According to this *Distanzpunktverfahren* a point, located on the horizon and separated from the central vanishing point A by an interval equal to the distance assumed to separate the eye from the picture plane (D), determines, when connected with the dividing points of the base line, the loci of the transversals (v, w, x, y, z) directly on the converging orthogonals instead of on a separate vertical. On a purely empirical basis, the North, presumably the Netherlands, had solved the problem of determining the correct sequence of equidistant transversals as early as the first half of the fifteenth century by the simple device of running a diagonal (*Creutzstrich*) across the converging orthogonals (Text Ill. 6). Such a *Creutzstrich,* cutting the orthogonals so

rather, visually symbolized—by the fact that every point in the perspective image is, as in the Cartesian *corpus generaliter sumptum,* uniquely determined by three co-ordinates; and that, while a series of objectively equal and equidistant magnitudes, if succeeding each other in depth, is transformed into a series of diminishing magnitudes separated by diminishing intervals, this very diminution is a constant one which can be expressed by a recursive formula.[1]

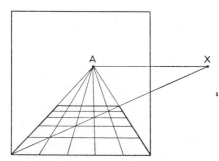

ILL. 6. Perspective Construction of a Checkerboard Floor by Means of the *Creutzstrich* Method (first recorded by Johannes Viator [Jean Pélerin], 1505).

as to form the common diagonal of a row of small equal squares and thus automatically determining the sequence of as many transversals, fulfilled, needless to say, the same practical function as does the line *Da* in Text Ill. 5. It should be noted, however, that this method, first described by Johannes Viator (Jean Pélerin), *De artificiali perspectiva,* first published in 1505 (cf., later on, such other Northern writers as Jean Cousin, Vredeman de Vries and Hieronymus Rodler, whose *Perspectiva* was first published in 1531), was based on workshop experience rather than scientific theory. Those French and German authors knew that the angle of their diagonal affects the rate of perspective diminution; but they determined this angle arbitrarily ("so ferr dich gutdunket", as Rodler puts it) and never realized that the interval between the diagonal's intersection with the horizon and the central vanishing point (AX) equals the distance assumed to separate the eye from the picture plane (for all this, cf. "Die Perspektive als symbolische Form," p. 319f.). A good summary (unfortu-

nately in Polish) is found in J. Bialostocki, *Albrecht Dürer, Jako pisarz i teoretyk sztuki,* Wroclaw (Breslau), 1956, p. xl ff., whereas a lecture by H. Siebenhüner ("Zur Entwicklung der Renaissance-Perspektive", *Kunstchronik,* VII, 1954, p. 129ff.) and the subsequent discussion obscure rather than clarify the issues involved.

[1] I have been deservedly criticized for having expressed the perspective diminution of equal and equidistant quantities located on a horizontal "ground plan" (which, of course, predetermines all other ratios within a given perspective space) in the formula $a/b = b/c = c/d \ldots$ (*Codex Huygens,* pp. 96f., 106; see R. Wittkower, "Brunelleschi and 'Proportion in Perspective'", *Journal of the Warburg and Courtauld Institutes,* XVI, 1953, p. 275ff., particularly p. 280). In reality this diminution (see Text Ill. 7) can be expressed only by a more complicated, recursive formula for which I am indebted to Dr. Raoul Bott:

$$b/c = \frac{3\,a/b - 1}{a/b + 1}, \quad c/d = \frac{3\,b/c - 1}{b/c + 1} \ldots$$

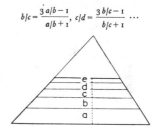

ILL. 7. Sequence of Transversals within a Correctly Foreshortened Square.

As will be seen, however, this formula also expresses a *constant* progression in that, once the ratio a/b is established in accordance with the distance of the eye from the projection plane and its elevation above the horizontal "ground plan", the ratios b/c, c/d, etc., follow automatically from the ratio a/b.

III

THAT Graeco-Roman painting, though striving for and ultimately achieving a perspective mode of representation, never arrived at an exact perspective construction is understandable, not only because this construction expressed, as has been seen, the idea that space is continuous and infinite rather than discontinuous and finite but also because it conflicted with one of the basic tenets of classical optics.

As a central projection onto a plane, the construction invented by Brunelleschi and perfected by his followers implied that magnitudes objectively equal appear inversely proportional to their distances from the eye. If, for example, two equal vertical lines, a and b, are seen at the distances d and $2d$, respectively, b will appear, in the perspective image, precisely half a long as a. According to classical optics, however, the apparent magnitudes are not inversely proportional to the distances but directly proportional to the visual angles, α and β, so that (since β exceeds $\alpha/2$) the apparent magnitude of b will exceed $a/2$ (see Text Ill. 8); the Eighth Theorem of Euclid's *Optica*, explicitly stating that "the apparent difference between equal magnitudes seen from unequal distances is by no means proportional to these distances", was so patently at variance with the rules of Brunelleschian perspective that the Renaissance translators of the Euclid text had no hesitation in amending it in order to eliminate a flagrant contradiction between two equally respected authorities.[1]

Classical optics, then, considered our sphere of vision quite literally as a "sphere"—an assumption, incidentally, which more nearly agrees with physiological and psychological reality than that which underlies Brunelleschi's rectilinear construction. As early as 1624 a German mathematician named Wilhelm Schickardt had the courage to announce, in a friendly disputation with Kepler, that, in contrast with the practice of the painters, our optical experience invariably transforms straight lines and plane surfaces into curved ones, and this view was not only accepted by Kepler himself[2] but also

[1] Cf. Panofsky, "Die Perspektive als symbolische Form", p. 260 ff., 292 ff., particularly p. 301, Note 17.

[2] For Schickardt's controversy with Kepler, see *ibidem*, p. 262 f. and p. 295 f., Notes 10, 11. Kepler had described the trajectory of a meteor observed in South Germany as a curve whereas Schickardt (in a book charmingly entitled *Liechtkugel* and no less charmingly written) maintained that the meteor might in fact have moved in a straight line which appeared as a curve only to the eye. Kepler not only admitted, with characteristic generosity, that Schickardt might be right but also explicitly accounts for his own statement by the admission that he had been thinking of the "rules of graphic representation or perspective" according to which "the projections (*projectiones, vestigia representatoria*) of straight quantities onto a picture plane (*super plano picturae*) remain straight under all conditions", whereas "our vision does not contemplate the picture of the [celestial] hemisphere on a plane tablet but looks at the face of the firmament itself". Recently John White has shown that some Renaissance theorists, empirically anticipated by such keen observers as Conrad Witz, attempted to reconcile the orthodox or rectilinear construction (the shortcomings of which, particularly obvious if the assumed distance between the eye and the picture plane is short, had not failed to attract the attention of

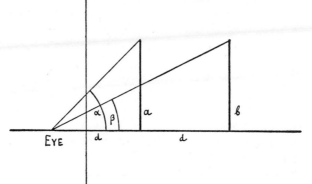

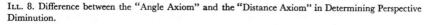

ILL. 8. Difference between the "Angle Axiom" and the "Distance Axiom" in Determining Perspective Diminution.

experimentally confirmed in the nineteenth and twentieth centuries. Since even the simplest curved surface cannot be developed on a plane, no exact perspective construction could be evolved or even envisaged until the urge for such a construction had become stronger than the spell of the "angle axiom" which is the foundation of classical optics. This urge, needless to say, was foreign to both Byzantium and the mediaeval West.

With the disintegration of Graeco-Roman illusionism in late-antique and Early Christian art the "prospect through a window" began to close again; but it was closed, if I may be permitted another self-quotation, with "a light, porous curtain rather than with a solid, impermeable wall". The Byzantine tradition, heir to the late-antique and the Early Christian, thus retained, occasionally attempted to recover and finally transmitted to the practitioners of the *maniera greca* what may be called the residue of Graeco-Roman illusionism. Terrain and vegetation continued to be rendered in pictorial rather than draftsmanlike fashion. The streaks of light and grooves of shade that served for the depiction of drapery tended to be hardened into strips; but these strips were never transformed into purely graphic lines. And, most important, overlapping and foreshortening (including tilted standing planes and slanted walls and ceilings) continued to suggest, however rudimentarily, recession in depth. But if the

painters and theorists alike) with the subjective experience of curvilinearity in what he calls a "synthetic" system of perspective. Mr. White may well be right in thinking that it was Leonardo da Vinci who contemplated a systematic development of this synthetic system, and that the perspective sections of the Codex Huygens (Panofsky, *Codex Huygens*, pp. 62 ff., 98 f., Figs. 53–72) are no less dependent on Leonardo's ideas than are the sections on human proportions, equine proportions and human movement.

Hellenistic and Roman painters themselves had been unable to imagine the systematization of their optical observations into an exact perspective construction, such an idea was even farther from the minds of their Byzantine descendants. The art of the Western Middle Ages, on the other hand, came to abandon perspective ambitions altogether.

True to their general tendencies, the Carolingian *renovatio* and, to a lesser degree, the "Renaissance of about 1000" appropriated some of the perspective devices which had been preserved in late-antique and Early Christian art. We can observe the results of this endeavor in, for example, the baldaquins or canopies, supported by four columns and covered with small segmented domes, which surmount the thrones of kings or emperors; in the broken-front backdrops derived from the classical *scaenae frons*; in the octagonal *tempietti* reminiscent of Roman *macella* which protect the "Fountains of Life"; in the—very rare—interiors delimited by walls and coffered ceiling (Fig. 94).[1]

All these efforts at reviving Graeco-Roman perspective (or, to speak more generally, the Graeco-Roman picture space), including even the enchanting and very nearly "classical" landscapes and buildings in the Utrecht Psalter, are, however, comparable to an attempt to meet the challenge of firearms by making breastplates and chain mail bullet-proof[2] instead of throwing them away and developing entirely different tech-

[1] Bible of Moutier-Grandval, London, British Museum, MS. Add. 10546, fol. 25 v. (see above, p. 48, Note 1). For canopies, see, for example, several miniatures in the Bible of San Paolo fuori le mura (that on fol. 185 illustrated in Kantorowicz, "The Carolingian King in the Bible of San Paolo fuori Le Mura", Fig. 2) and many other instances in Schramm, *Die deutschen Kaiser und Könige in Bildern ihrer Zeit;* for broken-front backdrops (particularly characteristic of the "Ada School"), many Evangelist's portraits produced by this school and, above all, the frontispiece of the Gospels of St.-Médard-de-Soissons, Paris, Bibliothèque Nationale, MS. lat. 8850, fol. 1 v. (Boinet, *op. cit.*, Plate CLXXXII, and Hinks, *op. cit.*, Plate XV); for "Fountains of Life" surmounted by *macellum*-like *tempietti*, the same manuscript, fol. 6 v., or the Codex of St. Emmeram, Munich, Staatsbibliothek, clm. 14000, fol. 11 (Boinet, Plates XVIIIb, CXVII; cf. Panofsky, "Die Perspektive als symbolische Form", p. 310 ff., Figs. 13, 14). The iconological content of the "Fountains of Life" in manuscripts of the Gospels, the special significance of its octagonal shape and its possible connections with baptisteries, particularly the Lateran Baptistry at Rome, has been discussed by P. A. Underwood, "The Fountain of Life in Manuscripts of the Gospels", *Dumbarton Oaks Papers*, IV, 1950, p. 41 ff.

[2] No architectural motif appearing in a Carolingian or Ottonian rendering is free from inconsistencies not only in perspective but also of a structural nature—inconsistencies which show that we are confronted with misunderstood or, as in the superficially plausible buildings in the Utrecht Psalter, half-understood quotations rather than with rational reconstructions. In the "Fountain of Life" miniature in the Gospels of St.-Médard, e.g., four of the columns supporting the *tempietto* connect with the roof while the remaining four connect with the exedra surrounding the whole structure. In the "Fountain of Life" miniature in the Codex of St. Emmeram all columns connect with the roof, but no distinction is made between the columns in front and in back of the basin. In the interior in the Bible of Moutier-Grandval the ceiling is rather convincingly foreshortened (although the orthogonals form a "herringbone" pattern instead of converging towards one point); but the side walls are not foreshortened at all. And one of the most blatant contradictions is found in the title page of the Bible of San Paolo fuori le mura (fol. 1, Kantorowicz, "The Carolingian King ...", Fig. 1), where a circular enclosure, seen in perspective, is surmounted by an open colonnade shown in pure elevation.

niques of tactics and strategy. And such a resolute departure from the Hellenistic interpretation of space was decided upon in the next, or high-mediaeval, phase of Western European art.

Romanesque sculpture, we recall, was conceived in terms of "mass" (inorganic and homogeneous matter) rather than "structure" (matter organized into different parts and parts of parts)[1] so that it could enter into a union with architecture anticipated, if anywhere, in Oriental (Mesopotamian, Sassanian or Armenian) art but entirely foreign to the classical mind: whereas the classical metope, niche statue or caryatid is either an adjunct or an insertion, the Romanesque relief, jamb statue, archivolt figure, or *chapiteau historié* seems to have grown directly out of the very walls, embrasures, arches, or capitals.

This "mass consolidation" in sculpture and architecture is paralleled in painting by what may be called "surface consolidation", and this process can be observed, *in vitro*, so to speak, when we compare the Utrecht Psalter, executed in Hautvillers near Reims between 820 and 830, with a copy—or, rather, the last of three successive transformations—thereof which was produced at the end of the twelfth century.[2] The frameless Carolingian pen drawings, the very looseness of their composition and the very sketchiness of their treatment giving an impression of airy expanse, are transformed into opaquely pigmented miniatures surrounded by a border which strictly delimits the working area. The figures, reduced in number but enlarged in scale, are more substantial in appearance and more composed in behavior. The feathery foliage of the trees is condensed into well-defined shapes not unlike flowers or mushrooms, just as the buildings, no longer aspiring to a classicizing style, seem to have gained in weight and solidity. The impetuous pen strokes and washes have given way to firm, incisive contours. In short, the ground has congealed into a solid, planar working surface while the design has congealed into a system of two-dimensional areas defined by one-dimensional lines; and this "cartographic" tendency of Romanesque book illumination, apparent also in the two new art forms emerging at this time, glass painting and heraldry, is further stressed not only by the gratuitous introduction of numerous scrolls—which, since they bear no inscriptions, serve only to enrich the planimetrical pattern—but also by the transformation of the curves indicating hilly terrain into brightly colored and sharply delineated ribbons which have lost all reference to a three-dimensional

[1] See above, p. 60 f.

[2] Paris, Bibliothèque Nationale, MS. lat. 8846 (edited *in toto* by H. Omont, Paris, n.d.; for the completion of the manuscript by a Spanish hand, see M. Meiss, "Italian Style in Catalonia and a Fourteenth-Century Workshop", *The Journal of the Walters Art* *Gallery*, IV, 1941, p. 45 ff.). For a comparison between this Paris Psalter, the Utrecht Psalter and the intervening manuscripts (British Museum, MS. Harley 603), and the Canterbury Psalter (ed. M. R. James, *The Canterbury Psalter*, London, 1935), see H. Swarzenski, *Monuments of Romanesque Art*, p. 37, Figs. 2–5.

landscape space and operate as mere partitions. Thus for the first time in the history of European art a consubstantiality had been established between the solid objects (figures or things) and their environment. And this consubstantiality persisted even when—as has been briefly touched upon in the preceding chapter—the Gothic style had broken the spell of mass in the three-dimensional arts and the spell of the plane surface in painting.

Gothic sculpture and architecture, it will be remembered, are distinguished from Romanesque in that they are subject to that "principle of axialization" by virtue of which, as I expressed it, jamb and archivolt figures were transformed into statues either attached to colonettes or nestling in half-cylindrical channels, while "figures playing their part in a relief composition developed into actors freely moving and pivoting before an imaginary backdrop as upon the platform of a small theatre stage".[1] But even then the law of consubstantiality remained in force. The Gothic statue, however much emancipated, is expected to consist of the same material as its surroundings[2] and never gives the impression of being detachable; to adorn a façade with bronze figures placed in niches was as repugnant to the Gothic taste as it was pleasing to that of classical antiquity and the Renaissance. The spatial content of the Gothic relief, however much freedom it allows to its components, does not exceed the volume defined by the slab of stone or wood from which it has been carved. The statue cannot exist without a canopy or tabernacle above its head, which, together with the plinth or console beneath at its feeet, provides the figures with *Lebensraum* but still confines it within the precise limits of the structure as a whole. In the relief the scene is, as a rule, overhung by a series of arches or a band of conventionalized clouds which, like a valance, determines the front plane of a three-dimensional rostrum but in so doing limits the ideal depth of this rostrum to the actual distance between the front plane and the ground, that is to say, to the actual thickness of the original slab.

What is true of sculpture is also true of painting and book illumination. Here, too, we often find framing devices analogous to those employed in reliefs,[3] and in the absence of such devices a three-dimensional field of action is secured for the figures by a novel treatment of the ground: it tends to be distinguished from what is "in front" of it, at first by the use of burnished gold to which the Romanesque style had developed a certain aversion (not without reason has the style of thirteenth-century book

[1] See above, p. 61 f.

[2] Where this rule was violated (as when, near the end of the fifteenth century, some of the lacunae in the sculptural decoration of the portal of Ulm Cathedral were filled by wooden statues), this violation was dictated by special reasons (lack of time, suitable material or skilled labor), and the fact that the figures in question consisted of wood rather than stone was carefully concealed from view.

[3] The classic example of this kind is, of course, the Psalter of St. Louis, Paris, Bibliothèque Nationale, MS. lat. 10525 (edited *in toto* by H. Omont, Paris, *n.d.*).

illumination been called the "style à fonds d'or"); and, later on, by the introduction of small over-all patterns (*rinceaux*, diapers, tessellation, and the like) which give the impression of a tapestry spread behind the figures rather than of a solid wall containing them. But here as in the relief the space available to them is limited to what may be called a "slab of volume" defined by a front plane and a background which, though shifted back, remains impenetrable and is still thought of as a material working surface. The action, if any, unfolds in a direction parallel to both the front plane and the background, passing across our field of observation rather than advancing and receding within it; and, even more important, figures and things, their size uninfluenced by distance, continue to be arrayed upon a horizontal standing *line*, which actually traverses the picture from left to right, instead of being distributed over a horizontal standing *plane* which seems to recede into depth.

In short, up to and including its terminal phase (which lasted, depending on the region, from the end of the thirteenth century to the middle of the fourteenth) High Gothic art remained unalterably non-perspective, and even where an architect such as Villard de Honnecourt felt the need to distinguish between convexity and concavity—as, for example, between the exterior and the interior of an apse—he did so by the purely ideographical device of indicating convexity by upward curves and rising "vanishing lines" (if we may call them thus), while indicating concavity by downward curves and descending "vanishing lines", regardless of whether the horizontal members represented by these curves and vanishing lines are above or below eye level (Figs. 95 and 96).[1] The High Gothic style thus never abrogated the complementary principles of "mass consolidation" and "surface consolidation", and we can easily see that "modern", viz., continuous and infinite, space could come into being only when the high-mediaeval sense of solidity and coherence, nurtured by architecture and sculpture, began to fuse with what little had been preserved, throughout the centuries, of the illusionistic tradition established in Graeco-Roman painting.

IV

THIS fusion took place, and could take place only, in the Italy of Cavallini, Duccio and Giotto.

[1] Our illustrations show the interior and the exterior of the ambulatory chapels of Reims Cathedral as represented in Villard de Honnecourt's album, fols. 30 v., 31 (H. R. Hahnloser, *Villard de Honnecourt, Kritische Gesamtausgabe des Bauhüttenbuches, MS. fr. 19093 der Pariser Nationalbibliothek*, Vienna, 1935, p. 162 ff., Pls. 60, 61); it should also be noted that, as a further indication of concavity and convexity, the apices of the lateral windows are shifted towards the center in the representation of the exterior, and away from the center in the representation of the interior—exactly the opposite of what would happen according to the rules of perspective.

Here architecture and sculpture had succumbed to Northern influence to such an extent that the historiographers of the fifteenth and sixteenth century were as justified in speaking of their style as a *modo* inherited from the *tramontani*, or as *la maniera tedesca*,[1] as are their modern descendants in calling it "Italian Gothic". But this—not unconditional—surrender (with very few exceptions Italian Gothic never reached the point of converting the edifice into a "glass house") had not affected the practice of painting in the same way as on the other side of the Alps. Where the North, if not entirely eliminating the wall in favor of windows, tended to conceal it beneath blind tracery, paneling or tapestries, Italy upheld the traditions of the mosaic (considered as "out of fashion" in France as early as 1140)[2] and of the mural, the technique of which, precisely by the turn of the thirteenth century, changed from the thus far customary *al secco* treatment to what is known as *buon fresco*—a change no less important than, more than a hundred years later, that from tempera to oils.[3] Altars were embellished with painted retables (*ancone*) instead of with statuary or goldsmith's work, and panel painting, as good as non-existent in the Gothic North,[4] even invaded carpentry to produce such specifically Italian phenomena as *cassoni, spallieri* and *deschi da parto*.[5]

Towards 1300, then, Italy found herself, for the first time since the downfall of the Roman Empire, in the position of holding the balance of power in the world of art, and it may be said that the very conservatism—or even retrospectiveness— of Italian painting qualified it for leadership at a time when the High Gothic period was drawing to a close.

On the one hand, an Italian painter growing up in the last decades of the thirteenth century could not evade the influence of a Gothic, or at least Gothicized, style whose sculptural and architectural manifestations—not to mention book illumination, "quell' arte che alluminare è chiamata in Parisi"—surrounded him on all sides and with whose practitioners he was often required to collaborate. In the works of Cavallini and Giotto (or, for that matter, Jacopo Torriti, the author of the *Coronation of the Virgin* in the apse of S. Maria Maggiore) Gothic influence—largely transmitted, of course, through Italian sculpture and thus more or less noticeably tinged with the classicism of Nicolo Pisano—is manifest in style as well as iconography.[6] Duccio, more deeply committed

[1] See above, pp. 19–24.

[2] See Suger's well-known reference to a mosaic installed by him *novum contra usum* in the tympanum of the northern portal of the façade of St.-Denis (Panofsky, *Abbot Suger ...*, pp. 46, 161 f.).

[3] See Oertel, *op. cit.*, pp. 70 ff., 219, Note 127.

[4] It is significant that practically all known Northern panel paintings antedating the influence of Italian Trecento painting, such as the two wellknown thirteenth-century retables from Soest in the Kaiser

Friedrich Museum and the above-mentioned altarpiece for Westminster Abbey (p. 102, Note 1), were intended as mere substitutes for goldsmiths' work.

[5] See the instructive remarks in G. Swarzenski, "A Marriage Casket and Its Moral", *Bulletin of the Museum of Fine Arts, Boston*, XLV, 1947, p. 55 ff.

[6] Arnolfo di Cambio, for example, worked side by side not only with Cimabue but also with Cavallini (see Oertel, *op. cit.*, p. 60); Giotto seems to have had personal relations with the architect of the Arena

to the Byzantine tradition than either Giotto or Cavallini and thus, for example, disinclined to accept the slant-eyed type of beauty developed in thirteenth-century France, not only bowed to the Gothic fashion in matters of architectural and decorative detail and in adopting the tell-tale innovation, already mentioned, of fastening the crucified Christ to the cross with three nails rather than four[1] but also learned from the Pisani how to endow his figures with that substantiality and freedom of movement which distinguishes them from the products of the *maniera greca*;[2] it is significant that he restricted the indication of drapery folds by a filigree of gold lines, employed without discrimination in Dugento painting, to the supernatural, viz., the apparition of the Lord transfigured or resurrected.

On the other hand, however, such an Italian painter was heir to a long tradition of panel and wall painting (including the mosaic) which had never lost contact with Early Christian and Byzantine art; these contacts had in fact been renewed or intensified at the very time when the last wave of Byzantinism had spent itself in the North, that is to say, from about the middle of the thirteenth century. And while the Gothic style of the transalpine countries refused, it seems, to blend with the Byzantine (even in those curious schools of book illumination which had been established in the Holy Land by the Crusaders and were exposed to Byzantine influence by the sheer force of circumstance we find mixture rather than fusion),[3] the Byzantinizing or, if one may say so, neo-Early-Christian styles of thirteenth-century Italy did not refuse to blend with the Gothic. Thus the *disjecta membra* of classical perspective, preserved or revived in

Chapel in Padua; and that Torriti's mosaic in S. Maria Maggiore (*ca.* 1290–1295), representing the actual Coronation (as opposed to the "Triumph") of the Virgin Mary, presupposes French influence is evident, no matter where the antecedents of the iconographical formula are sought (cf. G. Zarnecki, "The Coronation of the Virgin from Reading Abbey", *Journal of the Warburg and Courtauld Institutes*, XIII, 1950, p. 1 ff.; Oertel, p. 217, Note 109).

[1] See above, p. 67.

[2] For the influence of thirteenth-century sculpture, especially Nicolo and Giovanni Pisano's Siena pulpit, on Duccio (discernible not only in the somewhat controversial *Flagellation of Christ* in the Frick Collection but also in the *Maestà*), see M. Meiss, "A New Early Duccio", *Art Bulletin*, XXXIII, 1951, p. 95 ff.

[3] A systematic survey of the revival—or revivals—of Early Christian art in the Dugento, particularly a close study of the mosaics in the Baptistry of Florence, would be highly desirable; for Venice, see, for the time being, the excellent study by Otto Demus

(see above, p. 55, Note 1), which gives a foretaste of the author's forthcoming book on the Venetian proto-Renaissance, and the article by M. Muraro referred to below, p. 137, Note 2. The long-neglected schools established in the Holy Land before its reconquest by the infidels are being studied by Dr. Hugo Buchthal; he has been able to prove, for example, that the thus far enigmatic manuscript, Paris, Bibliothèque de l'Arsenal, MS. 5211 (H. Martin and P. Lauer, *Les principaux Manuscrits à peintures de la Bibliothèque de l'Arsenal*, Paris, 1929, p. 17, Plates XI–XIII), where the High Gothic style collides head-on with the Byzantine and strangely transmutes such compositions as the *Inspiration of David* in the famous Paris Psalter (Bibliothèque Nationale, MS. gr. 139), was produced in the Latin Kingdom of Jerusalem. Mr. Buchthal's splendid publication (*Miniature Painting in the Latin Kingdom of Jerusalem* [*With Liturgical and Palaeographical Chapters by Francis Wormald*], Oxford, 1957, appeared too late to be considered in detail.

135

Italian Dugento painting, could be subjected to the unifying discipline of those very principles of mass consolidation and surface consolidation which had eradicated classical perspective in the North. And this was how the "modern" concept of space came into being.

In the *Dream of Pharaoh* in the Baptistry at Florence, for example, the cornice and coffered ceiling of the king's bedchamber are foreshortened according to the "herring-bone scheme" inherited from classical antiquity (Fig. 97). In one of the mosaics at Monreale the Last Supper is staged in a kind of courtyard framed by receding side walls (Fig. 98); and another mosaic in the same cycle, representing the Healing of the Palsied Man, even displays a vigorously foreshortened tiled pavement where the "herringbone scheme" has been discarded in favor of a surprisingly accurate focal convergence. None of these settings, however, is conceived as a unified whole, let alone a rationally constructed interior. The *Dream of Pharaoh* has a foreshortened ceiling but no side walls and no floor; the *Last Supper* has receding side walls but no floor and no ceiling; in the *Healing of the Palsied Man*, finally, the receding pavement comes to a dead stop at the unforeshortened front of a building from whose roof the bed of the patient is lowered by two attendants.

When entering the world of Duccio and Giotto we feel as if we were stepping off a boat and setting foot on firm land. The architectural settings (and what applies to these also applies, *mutatis mutandis*, to the landscapes) give an impression of coherence and stability unmatched in all earlier painting, including the Hellenistic and the Roman. In Duccio's *Maestà* (executed between 1308 and 1311, Figs. 92, 99, 118, 120), in Giotto's frescoes in the Arena Chapel at Padua (*ca.* 1305), and, in a still tentative form, in some of the Old Testament scenes in the Upper Church of Assisi (formerly assigned to a great Anonym, the "Isaac Master", but now tending to be regarded as early works of Giotto himself)[1] we even encounter perfectly consistent, boxlike interiors, their ceilings, pavements and side walls "fitly framed together", as the Apostle would say: interiors measurably extending behind a clearly defined pictorial surface and within which a definite amount of volume is allocated to every solid and every void.

Here, then, we witness the birth of "modern space", a space which may be described as Graeco-Roman space "vu à travers le tempérament gothique": the incongruous and fragmentary material provided by such unsubstantial and inconsistent but, after all, "perspective" representations as the *Dream of Pharaoh* in the Baptistry at Florence and the mosaics of Monreale has been reorganized and disciplined according to the

[1] See F. J. Mather, *The Isaac Master; A Reconstruction of the Work of Gaddo Gaddi*, Princeton, 1932. Cf., however, L. Lochoff, "Gli affreschi dell'Antico e del Nuovo Testamento nella Basilica Superiore di Assisi", *Rivista d'Arte*, XI, 1937, p. 240ff., particularly p. 266ff.; P. Toesca, *Storia dell'arte italiana*, II (Il Trecento), Turin, 1951, p. 446ff.; Oertel, *op. cit.*, p. 66ff.

principles exemplified by such emphatically non-perspective but, within the limitations of their style, perfectly solid and coherent Gothic reliefs as the *Last Supper* in the *jubé* of Naumburg Cathedral of *ca.* 1260 (Fig. 34). And the undeniable influence of late-antique and Early Christian art on Jacopo Torriti, Cavallini and Giotto[1] is, I think, only one aspect, however important, rather than the cause of this process. It is very true that late-antique and Early Christian monuments were and are more plentiful in Rome than in Venice or Tuscany.[2] But that Cavallini and Giotto could, so to speak, "become aware" of these monuments—much as, two generations before, the sculptors of Reims had "become aware" of their Roman sarcophagi—is due to their position on the crest of a wave produced by the conflux of the two mightiest currents in the art of the Middle Ages, the Byzantine and the French Gothic; we should not forget that Duccio, sharing with them the experience of these two currents but not, so far as I can see, that of late-antique and Early Christian art, was nevertheless equally capable of perceiving and solving the problem of "modern" space.

All this was, needless to say, merely a beginning. Measured by the standards established in the fifteenth century, the interiors appearing in the works of the "founding fathers" are not only limited in extension and inaccurate in construction; they are interiors only in a very special and limited sense of the term. The "inside" of the building is not seen from within but from without: the painter, far from introducing us into the structure, only removes its front wall so as to transform it into a kind of oversized doll's house. Yet the impression of stability and coherence prevails. For all their technical shortcomings, the works of Duccio and Giotto confront us with a space no longer discontinuous and finite but (potentially at least) continuous and infinite;

[1] See particularly F. Horb, *Das Innenraumbild des späten Mittelalters; Seine Entstehungsgeschichte,* Zurich and Leipzig, n.d. [1938]; *idem,* "Cavallinis Haus der Madonna", *Göteborgs Kungl. Vetenskaps- och Vitterhets-Samhälles Handlingar,* 7th Ser., ser. A, III, No. 1, 1945 (cf., more recently, A. Rohlfs, "Das Innenraumbild als Kriterium der Bildwelt", *Zeitschrift für Kunstgeschichte,* XVIII, 1955, p. 109ff.); Demus, *op. cit.,* p. 36f.; W. Paeseler, "Der Rückgriff der spätrömischen Dugentomalerei auf die christliche Spätantike", *Beiträge zur Kunst des Mittelalters* (Vorträge der I. deutschen Kunsthistorikertagung, Berlin, 1950, p. 157ff.). It is well known that Cavallini began his career with a restoration and partial reconstruction of the Early Christian murals in San Paolo fuori le mura (which still impressed Michelangelo); and that Giotto studied Early Christian sarcophagi in addition to paintings and mosaics is evident, to mention only one iconographical detail, from the fact that his *Nativity* in the Cappella dell'

Arena is staged in a rustic shed rather than in either a nondescript architectural setting or the Byzantine cave. Duccio, needless to say, retained the "cave type".

[2] Quite recently, however, M. Muraro ("Antichi Affreschi veneziani", *Le Meraviglie del Passato,* Florence, 1954, p. 661ff.) has discovered in S. Zan Degolà at Venice a series of most interesting murals, probably executed in the third quarter of the thirteenth century, which in their broad, pictorial modeling and, most particularly, in the perspective treatment of receding niches, cornices, etc., clearly anticipate the style represented by Pietro Cavallini. The antecedents of the remarkable artist who produced these murals cannot be ascertained, but his works illustrate both the wide range of the Early Christian revival in the thirteenth century and the fact that the final achievement of the great Trecento masters is organically related to that of their predecessors.

and this impression is produced by the fact that the painting surface, while no longer opaque and impervious, has nevertheless retained that planar firmness which it had acquired in the Romanesque and preserved throughout the High Gothic period. The picture is again a "window". But this "window" is no longer what it had been before being "closed". Instead of being a mere aperture cut into the wall or separating two pilasters, it has been fitted with what Alberti was to call a *vetro tralucente*: an imaginary sheet of glass combining the qualities of firmness and planeness with that of transparency and thus able to operate, for the first time in history, as a genuine projection plane.

This "window-pane feeling", if one may say so, created the very condition the absence of which had prevented Graeco-Roman painting from disregarding the "angle axiom" of classical optics. In the Middle Ages there existed—another instance of that "compartmentalization" which, for example, prevented those who objected to Aristotle's theory of free-falling bodies on logical grounds from ever attempting to decide the question by experiment[1]—a curious dichotomy between optic theory and artistic practice. Through such Arabic intermediaries as Alhazen and Al-Khindī (the former often and respectfully quoted by Lorenzo Ghiberti) the Latin West had become thoroughly familiar with classical optics in the twelfth and thirteenth centuries. "High Gothic" authors like Vitellio, Johannes Peckham, Roger Bacon, and, above all, Robert Grosseteste not only perpetuated but also developed the theory, and when they wished to Latinize its Greek name, the best equivalent of ὀπτική they could think of was *perspectiva*. This mediaeval *perspectiva*, however, always remained a mathematical theory of sight, intimately connected with astronomy but entirely divorced from problems of graphic representation.[2] And if Graeco-Roman painters had no reason to revolt against the angle axiom because they did not think of the painting surface as a planar structure clearly at variance with the spherical structure of the field of vision postulated by the theory of sight, Romanesque and Gothic painters—even assuming that they were familiar with scientific optics—had no reason to worry about the angle axiom in the first place because they had learned to think of the painting surface as something

[1] See above, p. 106.

[2] It should be noted that such cases of "optical illusion" as occur in high-mediaeval art—the most spectacular one, significantly, within the personal orbit of Robert Grosseteste—are not a matter of projecting a design upon a painting surface but a matter of directly manipulating the elements that constitute the visual experience of the beholder (see the interesting observations in Nordström, "Peterborough, Lincoln and the Science of Robert Grosseteste"). In most other cases optical illusion is employed, as prescribed by Vitruvius, for purposes of "eurhythmic" correction rather than deception, as

when the objective proportions of statues placed high above the ground (often as much as over a hundred feet) are distorted in such a manner that they look right when seen from below—a procedure facilitated by the fact that mediaeval sculptors placed their statues horizontally rather than vertically while working on them, so that they could reproduce the situation created by the elevation of a statue by the simple device of stepping back from it about as far as it would finally be placed above eye level (see, e.g., G. G. Coulton, *Art and the Reformation*, New York, 1928, p. 177f.).

impervious and opaque which, for this reason, could not be connected with the theory of sight at all.

Only after Duccio and Giotto had imparted to the painting surface the quality of transparency in addition to that of planarity did it become possible to conceive the idea—almost self-evident to us—of interposing this transparent plane between the object and the eye and thus to construct the perspective image as an *intersegazione della piramide visiva,* that is to say, as a central projection. And when Brunelleschi and Alberti found the means of translating this idea into reality, thereby converting perspective as a mathematical theory of sight into a mathematical method of design, it became necessary to make a distinction between the former and the latter: the mathematical method of design (to be called "perspective" pure and simple in modern times) was designated as *perspectiva pingendi* or *perspectiva artificialis* (in Italian often *prospettiva pratica*); the mathematical theory of sight (called *perspectiva* pure and simple during the Middle Ages) came to be qualified by the adjectives *naturalis* or *communis.*

The *perspectiva pingendi* or *perspectiva artificialis* was thus quite literally the child of optical theory and artistic practice—optical theory providing, as it were, the idea of the *piramide visiva,* artistic practice, as it had developed from the end of the thirteenth century, providing the idea of the *intersegazione.* This child was born, we remember, not until *ca.* 1420, about one hundred years after the death of Duccio and more than eighty after the death of Giotto. But during this interval we can observe a preliminary development which took a different shape in different centers.

With Rome practically eliminated from the artistic scene owing to the conditions which forced the Curia to move to Avignon in 1309, the evolution during the first half of the fourteenth century was largely dominated by the schools of Siena and Florence, and its course was determined by the basic difference that, as we have seen, had separated these two schools from the outset. In their frescoes in S. Croce, Giotto's Florentine followers, Maso di Banco and, most particularly, Taddeo Gaddi, intensified their master's tendency to "conquer the third dimension by manipulating the plastic contents of space rather than space itself" and to exploit non-frontal, often very complex, architectural settings as a means of taking depth by storm;[1] a maximum of obliquity and complication was reached in Taddeo's *Rejection of Joachim* and *Presentation of the Virgin* in the Cappella Baroncelli (Fig. 100). In Siena, on the other hand—though not without the aid of Giotto's influence—Ambrogio Lorenzetti and his elder brother Pietro (both of them allegedly victims of the Black Death in 1348) made the most spectacular progress not only in the struggle for an exact perspective construction but also in the representation of space *per se.*[2]

[1] Cf. below, p. 160.

[2] For the Lorenzetti brothers, see E. T. DeWald, "Pietro Lorenzetti", *Art Studies,* VII, 1929, p. 131 ff.; E. Cecchi, *Pietro Lorenzetti,* Milan, 1930; *idem, The*

In Ambrogio Lorenzetti's *Presentation in the Temple* of 1342 (Fig. 101) the organization of what may be called the "picture-immanent" portion of the floor has reached the stage of mathematical accuracy: all non-marginal orthogonals—those orthogonals, that is, which are not cut off by the lateral edges of the picture and thus do not transcend the limits of the painting surface[1]—converge in a precisely defined vanishing point rather than in a less definite vanishing area,[2] and its architectural *mise-en-scène* is, as Vasari would say, a "cosa non bella ma miracolosa". The edifice in which the event takes place is still a "doll's house" in that it exhibits its exterior and its interior at the same time, permitting us to look in on the latter only because the front of the building

Sienese Painters of the Trecento, New York and London, 1931; G. Sinibaldi, *I Lorenzetti,* Siena, 1933; P. Bacci, *Dipinti inediti e sconosciuti di Pietro Lorenzetti ... in Siena e nel contado,* Siena, 1939; Oertel, *op. cit.,* p. 142 ff. Professor George Rowley is preparing a monograph on Ambrogio Lorenzetti.

[1] It should be noted that even the Lorenzetti brothers (their less progressive contemporaries occasionally relapsed into the antiquated "herringbone scheme") failed to impose complete perspective unity upon orthogonal planes when their visual unity was disrupted or obscured. In paintings by Duccio and Giotto—the non-specialist may be permitted to retain the pleasant habit of referring to the newly hypothesized "Master of the Bardi Chapel" (Oertel, *op. cit.,* p. 105 ff.) as Giotto—we can observe that, if a ceiling is divided into sectors separated by console-supported beams, the orthogonals of the lateral sections noticeably deviate from those of the central one; whereas, where no such division exists (as in Duccio's *Annunciation of the Virgin's Death,* our Fig. 120, or Giotto's *Confirmation of the Franciscan Rule*), all the orthogonals converge with reasonable accuracy.

This difference between central and marginal orthogonals persists even in such justly famous examples of perspective competence as Ambrogio Lorenzetti's *Presentation in the Temple* (dated 1342) and *Annunciation* (dated 1344). Here the marginal orthogonals go measurably astray (Figs. 101 and 104), a deviation not noticeable at first glance because they are separated from the central ones by the figures. The abstract mathematical idea of a plane, it seems, was at this stage not powerful enough to prevail against the visual difference between "picture-transcendent" and "picture-immanent" vanishing lines. And no Trecento painter was able to induce orthogonals located in different planes (for example, the floor, the ceiling, and the side walls of a room) to converge in one "general" vanishing point. This was a feat to be achieved in Italy, by the discovery of the *costruzione legittima,* as late as the third decade of the fifteenth century; and in the North, by trial and error, not until after its middle.

[2] Thus any painter could obtain an impeccably correct "pencil" of equidistant non-marginal orthogonals (see Text Ill. 9) by means of the following procedure:

ILL. 9. Trecento Method of Constructing a Checkerboard Floor.

is perforated by a triple arcade (overlapped by the frame) instead of forming a solid wall. But this "doll's house" has been magnified and elaborated into a grand ecclesiastical structure. We face the chevet of a basilica divided by segmented arches into two parts: an anterior section, which may be described as a crossbreed between forechoir and transept (its central nave surmounted by a dodecagonal superstructure vaguely reminiscent of the Baptistry at Florence), and a rear section which corresponds to the choir proper in a Christian church and to the *domus Sancti sanctorum* in the temple of Jerusalem.

The action is, of course, confined to the foreground, which means that the front arcade, though forming an integral part of the basilical structure, had to be scaled so as to serve, at the same time, as a kind of framework closely encompassing the figures. Its columns—technically speaking, in front of the figures—are therefore reduced to a height of less than *ca.* ten feet and so drastically attenuated that their diameter is less than one thirtieth of their height. This, needless to say, creates an unresolved and, "secondo la natura di quei tempi", unresolvable contradiction between the front arcade and the rest of the architecture. But taken by itself, this rest—the background prospect, so to speak—deserves to be called the first convincing ecclesiastical interior, extending deep into space and, within its own limitations, not only drawn to scale but also, in a general way, remaining within the realm of structural possibility.

Ambrogio Lorenzetti does not, of course, confront us with an architectural portrait. His edifice—a Christian church cast in the role of the temple of Solomon or, to put it the other way, the temple of Solomon conceived and ornamented in such a way that its architectural features and even such decorative details as the statues of Moses and Joshua or the mosaic above the "triumphal arch" allude to the omnipresent correlation between the Old Testament and the New—is, on the contrary, an imaginary building exemplifying that principle of "disguised symbolism" which, once the pictorial space had been subjected to the rules that govern empirical space, compelled the artist to

he assumed a point of convergence, *A*, divided the base line of his panel into equal parts and connected the dividing points as well as the terminals (*a, b, c, ... h*) with *A*—an operation most easily performed with the aid of a little nail and a piece of string. This method, used in Italy until the discovery of the Albertian construction (and in the Northern countries even longer) cannot, of course, determine the loci of the marginal orthogonals, and this is a purely technical reason for their unorthodox behavior in even the most progressive specimens of Trecento painting. Since the marginal orthogonals are cut off by the lateral edges of the panel at the points *s, t, ...* (or, respectively, *w. x, ...*), it would have been possible to determine these points, and thereby the correct sequence of equidistant transversals (correct, that is, under the assumption that the distance separating the eye from the projection plane equals either *AB* or *AB*1) only if there had been a device for prolonging the base line of the panel beyond its lateral margins, for dividing this prolongation in the same way as the base line itself and for connecting the dividing points with *A*. Such a device, however, does not seem to have been thought of before Brunelleschi's discovery automatically solved the problem of the marginal orthogonals together with that of the sequence of the transversals.

hide theological or symbolical concepts, openly revealed by his mediaeval predecessor, beneath the cloak of apparent verisimilitude.[1] But in this respect, too, Ambrogio's *Presentation* may rightly be termed a legitimate ancestor of Jan van Eyck's *Madonna in a Church*.[2]

The next step in the development of the ecclesiastical interior was to disconnect the perforated front wall of the building from the building itself, that is to say, to convert this front wall into a mere "diaphragm" which interposes itself between the spectator and the architecture instead of forming an integral part of the latter. This surgical operation eliminated the dimensional inconsistencies left unresolved in Ambrogio's *Presentation;* but it was performed, it seems, in the North rather than in Italy (Fig. 102),[3] and to cut the Gordian knot by the removal of even the "diaphragm" was left, so far as we know, to the genius of Jan van Eyck.

What Ambrogio Lorenzetti did for the ecclesiastical interior—and, lest we forget, for the cityscape and the landscape, his portrait of Siena and his panorama of the fertile, rolling country near-by being the first postclassical vistas essentially derived from visual experience rather than from tradition, memory and imagination—his brother Pietro did for the domestic interior. The house of Joachim and Anna in his *Birth of the Virgin* of 1342 (Fig. 103) is an original, not to say tricky, variation on the theme that may be called "the interior viewed through a triple arcade". First, this triple arcade is no longer painted but has been identified, as it were, with the wood-carved colonnettes, arches and pinnacles of the triptych's frame, which tempts us to believe that the interior extending behind this heavy architectural structure belongs to a real

[1] For the methodical use of "disguised symbolism" by Ambrogio Lorenzetti, see G. Rowley, "Ambrogio Lorenzetti il Pensatore", *La Balzana*, I, 1928, No. 5, and the same author's forthcoming monograph on this master.

[2] Even though there is reason to believe that the basilica in Jan van Eyck's *Madonna in a Church*, like several architectural motifs in other works of his, incorporates concrete reminiscences of an individual building, in this case the Cathedral of Liège (J. Lejeune, *Les Van Eyck, peintres de Liège et de sa cathédrale*, Liège, 1956, particularly p. 35 ff.), the fact remains that all the data are reinterpreted from an aesthetic and iconographic point of view; the painter did not even hesitate to illumine his basilica from the north (see Panofsky, *Early Netherlandish Painting*, p. 146 ff.) even though Liège Cathedral adheres to the normal orientation from west to east; see also the objections put forward by O. Pächt, "Panofsky's 'Early Netherlandish Painting', II", *Burlington Magazine*, XCVIII,

1956, p. 267 ff., p. 274, Note 31. It may be mentioned in this connection that Monsieur Lejeune (whose factual observations are as valuable as the conclusions drawn therefrom are untenable) has misunderstood me in saying, on p. 39 f., that I had considered Notre-Dame-de-Dijon as a possible source of inspiration for Jan van Eyck's *Madonna in a Church*. In reality, the plan derived by me from Jan van Eyck's picture (illustrated in *Early Netherlandish Painting*, p. 434) is quite similar to that of Liège Cathedral and has been juxtaposed with that of Notre-Dame-de-Dijon just in order to show that the latter, while furnishing the model for a Burgundian *Presentation of Christ* in the Louvre (*ibidem*, I, Fig. 64), has nothing to do with Jan van Eyck's *Madonna in a Church*.

[3] Paris, Bibliothèque Nationale, MS. lat. 10538, fol. 78. For the "diaphragm" device, see Panofsky, *Early Netherlandish Painting*, p. 58 f.

rather than a painted house. Second, we view two rooms through three different openings: an anteroom, containing the patiently waiting Joachim and two companions, is confined to the left-hand wing; the birth chamber itself, however, continues throughout the central panel and the right-hand wing so that not only its wall and floor but also the bed of St. Anne and even one of the attendant figures are overlapped by the dividing colonnette. As Ambrogio's *Presentation* set the precedent for Jan van Eyck's *Madonna in a Church,* so did his brother's *Birth of the Virgin* set the precedent for the *Annunciation* in the Ghent altarpiece and, even more conspicuously, for the triptychs of Jan's older contemporary, the Master of Flémalle.[1]

Another landmark in the evolution of the domestic interior is the kitchen which—a daring innovation in itself—a close collaborator of Pietro Lorenzetti found it necessary to include in the *Last Supper* (probably executed some time before 1330) in the Lower Church at Assisi (Fig. 105).[2] In this remarkable kitchen, attached to the pavilion in which the Twelve have gathered much as the anteroom is attached to the bedchamber in the *Birth of the Virgin,* we find, in nuclear form, so to speak, a number of characteristic motifs, indicative of a domestic environment, which were destined to find favor with the great Flemings, their French and Franco-Flemish predecessors and their ubiquitous followers: the little dog licking a platter; the blazing fire (apparently developed from the standard attribute of the personification of February in calendar illustrations but here completely integrated with the architectural setting); the busy servants; and, last but not least, that cupboard or wall shelf, preferably seen from below and laden with all kinds of vessels or utensils, which may be called the *fons et origo* of the "independent" still life.[3]

[1] The Mérode altarpiece by the Master of Flémalle agrees with Pietro Lorenzetti's *Birth of the Virgin* in that the central and right-hand panels form a coherent unit (the house of St. Joseph), whereas the left-hand panel shows the donors placed outside this unit; in a sense, however, it marks a step backward in that the Annunciation chamber, shown in the central panel, is not continuous with the workshop of St. Joseph (shown in the right-hand wing) but separated from it by a solid wall. That this subdivision was retained in the Flémalle Master's last known work, the Werl altarpiece of 1438, is not quite certain, since its central panel is lost, but would seem probable, especially when we accept the reconstruction attempted by P. Pieper, "Zum Werl-Altar des Meisters von Flémalle", *Wallraf-Richartz-Jahrbuch,* XVI, 1954, p. 87 ff.

[2] See B. Kleinschmidt, *Die Basilika,* II, p. 267 f., Fig. 198; Cecchi, *Pietro Lorenzetti,* Plate LXI. As far as

the date of the Assisi cycle is concerned, I agree with Oertel, *op. cit.,* p. 146 ff.; but I believe—with DeWald, "Pietro Lorenzetti", and others—that it was executed by an associate rather than by the master himself.

[3] For little dogs licking a platter or lapping up water from the floor, see, for example, the January picture in the Limbourg brothers' *Très Riches Heures* (cf. p. 159 f.) or Jan van Eyck's *Bathing Scene,* owned by Cardinal Ottaviani, now lost but graphically described by Bartolommeo Fazio (the text reprinted in Panofsky, *Early Netherlandish Painting,* p. 361, Note 27). The custom of representing February as a person or persons warming themselves before a fire predominated in Italy and was nearly invariable in Germany, Spain and France (see the statistics in Webster, *op. cit.,* p. 175 ff.). It is perhaps not accidental that the only exception that has come to my knowledge (apart, of course, from Calendar cycles dispensing

It is, however, not only in its furnishings but also in the construction of the room as such that this remarkable kitchen anticipates the further development of the domestic interior. While even more frankly a "doll's house" than the house of Joachim and St. Anne in the *Birth of the Virgin* (we even see the moon and the stars above the roof), this kitchen makes us realize that the problem of scale, so hard to solve in the rendering of an ecclesiastical structure, presented lesser difficulties in a domestic interior which, by definition, is scaled to the size of ordinary human beings and is normally covered with a flat ceiling rather than vaults. The height of such a ceiling does not necessarily transcend the area of the picture proper, and its receding beams can thus be shown in their entirety. We can foresee that in the domestic interior not only the doll's-house scheme but even the diaphragm device could be abandoned at an earlier date than was the case with an ecclesiastical setting, and this step was taken, as early as the last third of the fourteenth century, by such North Italian masters as Giovanni da Milano, Jacopo Avanzo and Giusto di Menabuoi. The Assisi fresco may thus be said to foreshadow not only the settings of many religious representations which seemed to require, or at least to be compatible with, a domestic environment (the Annunciation, for example) but also the "studies" of such learned saints or scholars as St. Jerome, on the one hand, and Petrarch, on the other.[1]

In spite of all this the neat distinction between Ambrogio and Pietro Lorenzetti as pioneers of the ecclesiastical and the domestic interior needs, like most neat distinctions, a certain amount of qualification. Ambrogio Lorenzetti, too, made an important contribution to the problem of the domestic interior, though not so much by ingenious elaboration as, on the contrary, by the discovery of a no less ingenious shortcut. In his *Annunciation* of 1344 (Fig. 104) we face what I have proposed to call, for want of a better term, the "interior by implication": without any indication of architecture the fact that the scene is laid indoors is made clear by the simple device of placing the figures

with human figures altogether), the February picture in the De Buz Hours in the Harvard College Library (E. Panofsky, "The De Buz Book of Hours; A New Manuscript from the Workshop of the Grandes Heures de Rohan", *Harvard Library Bulletin*, III, 1949, p. 163ff., Plate Ib), shows, instead, the servant cleaning a platter almost exactly as seen—here still before the fireplace—in the Assisi *Last Supper*. That this particular fresco made a profound impression in the North is evident from the fact that two German painters of the fifteenth century, Hans Multscher and the so-called Master of the Regler Altarpiece at Erfurt, employed its hexagonal pavilion as a setting for their representations of Pentecost (see, e.g., C. Glaser, *Die altdeutsche Malerei*, Munich, 1924,

p. 103, Fig. 70; p. 121, Fig. 80). For the motif of the recessed cupboard, see below, p. 145 f.

[1] For Giovanni da Milano, see, for example, the Annunciation in Rome, Palazzo Venezia, of *ca.* 1360 (D. M. Robb, "The Iconography of the Annunciation in the Fourteenth and Fifteenth Centuries", *Art Bulletin*, XVIII, 1936, p. 480ff., Fig. 10). For the Petrarch portraits (Sala dei Giganti at Padua; Darmstadt, State Library, Cod. 101, etc.) and their connection with such works as Giusto di Menabuoi's portrait of a monk in the Abbey Church of Viboldone, see T. E. Mommsen, "Petrarch and the Decoration of the Sala Virorum Illustrium in Padua", *Art Bulletin*, XXXIV, 1952, p. 95ff., particularly p. 99f., Figs. 3–6.

upon a tiled pavement instead of rock or grass, and the very absence of boundaries on top and at the sides gives the illusion—denied to us by both the doll's-house scheme and the diaphragm device—of being actually in the same room with the persons depicted. By adding various kinds of furnishings, this illusion could be intensified into a delightful sense of warmth and intimacy; Ambrogio's *Annunciation* may be said to stand at the beginning of a tradition which, through a long line of French and Franco-Flemish intermediaries, was to culminate in the Flémalle Master's *Salting Madonna*.[1]

<h1 style="text-align:center">VI</h1>

APART from its importance as a harbinger of the future, the Lorenzettian *Last Supper* commands our interest as a product of the past. It brings us, in fact, face to face with our principal problem, namely, the definition of the varying role which classical influence played in various artistic periods. We must ask ourselves whether—and, if so, to what extent—the great Trecento painters found inspiration not only in the reflections of classical painting in Early Christian, late-antique and Byzantine art but also in original Roman murals.

Taddeo Gaddi's decoration of the Baroncelli Chapel in S. Croce includes a painted niche which, like the cupboard in Pietro Lorenzetti's kitchen, is horizontally divided into two compartments. But instead of household utensils it appropriately displays the implements of Holy Mass, and instead of forming part of a painted interior it appears to be recessed, *trompe-l'oeil* fashion, into the wall of the chapel itself. This little mural is thus the earliest known specimen of the "independent" still life in postclassical painting and seems to bear out the contention that this genre came into being by way of substituting "counterfeit presentments" for real objects vital to the purpose of a given room but too precious, too perishable or too dangerous to be exhibited in the flesh: game, fish or fruit in a dining room; sacred vessels in a church; books, boxes and scientific instruments in a study; medicine jars in the office of a doctor or pharmacist.[2] And

[1] For the "interior by implication", see Panofsky, *Early Netherlandish Painting*, p. 19 and *passim*. Some characteristic French and Franco-Flemish examples leading up to the phase represented by the *Salting Madonna* (*ibidem*, Fig. 203) are illustrated in Figs. 23, 26, 40, 55, 61, etc.

[2] For Taddeo Gaddi's still life, see C. de Tolnay, "Les Origines de la nature morte", *Revue des Arts*, I, 1952, p. 151 ff.; cf. C. Sterling, *La Nature morte de l'Antiquité à nos jours*, Paris, 1952, particularly p. 16 ff., Figs. 10, 22–27, Plates 8–11. An independent *trompe-l'oeil* still life probably produced in Austria or South Germany about 1470 which, to judge from the objects

represented, may have served as the door of a medicine cabinet (it is painted on an unusually heavy oak panel and exhibits boxes and bottles) is illustrated in Sterling, *ibidem*, Plate 10. For the *trompe-l'oeil* character of early still lives and their special connection with the science of perspective and the technique of marquetry, cf. E. Winternitz, "Quattrocento Science in the Gubbio Study", *Metropolitan Museum of Art Bulletin*, New Ser., I, 1942, p. 104 ff.; A. Chastel, "Marqueterie et perspective au XVᵉ siècle", *Revue des Arts*, III, 1953, p. 141 ff. (cf. also Sterling, p. 30 ff.).

since examples of this substitutive kind of still life (mostly representing eatables) are not infrequently found in Campanian and Roman wall painting, Taddeo Gaddi has been supposed to have acted under the influence of classical models. This is, of course, not quite impossible; but it is equally possible that he merely bestowed autonomy—and, as it were, an ecclesiastical halo—upon what had been a detail in a domestic interior such as that in Assisi, which seems to antedate Taddeo's niche by a number of years.[1] And then, needless to say, we should be faced with the question as to whether Pietro himself may have borrowed his recessed, bipartite cupboard from a classical source.

That Pietro and his associates knew and exploited Roman wall paintings has been inferred, long before Taddeo Gaddi's ecclesiastical still life attracted attention, from the astonishing hexagonal pavilion in which the scene of the Last Supper itself is laid. Hexagonal structures, it has been argued, existed in Roman murals but not in later representations prior to the Assisi fresco which, therefore, would seem to presuppose a Roman prototype.

The existence of hexagonal *tempietti* in Roman wall painting is, however, something less than certain[2] (whereas octagonal, if not hexagonal, structures of this type do occur, we recall, in Carolingian book illumination); and polygonality as such is characteristic of mediaeval, and particularly Gothic, rather than classical art. Much more can, therefore, be said for the traditional view that the much-debated pavilion, with its tricuspid arches and Gothic columns, depends on Nicolo Pisano's Pisa pulpit (Fig. 106); in fact, its relation to the latter is very much analogous to that between Villard de Honnecourt's rendering of one of the choir chapels of Reims Cathedral (Fig. 96) and its original—except that Pietro's workshop, familiar with the perspective point of view, no longer indiscriminately indicated convexity by curves bending upward (in contrast to the cornice and the capitals, the bases of the columns as well as the benches of the Apostles, being below eye level, are correctly disposed on a descending curve) and had learned to shift the apices of the arches in the foreshortened surfaces outward rather than inward.[3] That the columns were very much attenuated, thereby providing

[1] According to investigations cited by Oertel, *op. cit.,* p. 225, Note 205, the records of payments made between 1332 and 1338 do not refer to the Baroncelli Chapel now extant but to another one, destroyed in 1566. Be that as it may, the style of the frescoes that have come down to us does not permit a dating very different from that suggested by these records. For the chronological position of the Passion cycle in Pietro Lorenzetti's *oeuvre*, see Oertel, pp. 146 ff., 229 f. (Notes 259, 263), who dates it, with good reasons, between 1320 and 1330.

[2] See Horb, *Das Innenraumbild,* p. 63 ff. Oertel, *op. cit.,* p. 229, Note 260, overstates Horb's own claims in saying that the latter had "proved" (*weist nach*) the derivation of Pietro's hexagonal aedicula from classical painting.

[3] See above, p. 133, Note 1. In France, a similar improvement on Villard de Honnecourt was made (under Italian influence) at about the same time; see, for example, the aediculae, housing Apostle figures, in the windows of the Priory at St.-Hymeren-Auge, executed about 1325 (see L. Lefrançois-Pillion and J. Lafond, *L'Art du XIV^e siècle en France,* Paris, 1954, p. 200 ,Plate XLII).

the figures with more "breathing space", is hardly surprising in view of what could be observed in Pietro's own brother's *Presentation of Christ*; and the very fact that these columns are surmounted by statues in the round, supported by the abaci and in turn supporting the cornice, makes the similarity of our pavilion with Nicolo's pulpit all the more striking. Far from deriving from a Roman mural, this pavilion can be presumed, I think, to reflect the impression of an actual structure of fairly recent origin— just as the recessed cupboard in the adjacent kitchen would seem to have its model in real life. Similar *repositigli,* as Boccaccio calls them, can still be seen in many Italian palaces of the thirteenth century, and one of them (lacking, however, a horizontal division) occurs in Giotto's *Annunciation* in the Arena Chapel.

The only major point of difference between the Lorenzettian pavilion and Nicolo Pisano's pulpit is that the latter's corner statues—all Christian Virtues—have been replaced by what has been termed "'Renaissance' *putti*".[1] The *putto*—"a fat, naked child", mostly with "two wings in the fleshy part of his shoulders", to cite the incomparable characterization of Wilkie Collins' Gabriel Betteredge—is, as everyone knows, ubiquitous in Hellenistic and Roman art, and his appearance in a fresco of the third decade of the thirteenth century has, therefore, been adduced as an additional argument in favor of this fresco's direct derivation from a lost classical mural. We should remember, however, that one of Nicolo's Virtues, Fortitude, appears in the guise of a nude Hercules (Fig. 48). The only thing the author of the *Last Supper* had to do, and did, was to transform one chubby adult into a foursome of chubby children, their presence and attributes appropriate to a "large, well-prepared dining hall" (two of the *putti* carry cornucopias, one a rabbit, and one a fish);[2] and in making this transformation he did not require an individual Roman model but followed what, at his time, had become a fairly general custom.

Like other classical motifs, the *putto* was appropriated by the proto-Renaissance of the twelfth century; but, as in the case of other classical motifs, this appearance was limited to sculpture. Setting aside the winged Cupids on the façade of Modena Cathedral (and such examples of uncertain date as those on a sarcophagus in the porch of San Lorenzo fuori Le Mura and on the spiralized columns in S. Trinità dei Monti and San Carlo at Cave), we find them, we recall, on the capitals in the cloister at Monreale; and they continue to occur in decorative sculpture up to the second quarter of the fourteenth century, for instance, in the columns flanking the portal of Siena Cathedral (school of Giovanni Pisano), a marble console from the Baptistry at Florence (now in the Museo Bandini at Fiesole), executed 1313–1314, or, as late as 1337–38,

[1] Horb, *Das Innenraumbild,* p. 65.

[2] Horb, *loc. cit.,* mentions only the cornucopias. For the description of the room in which the Last Supper took place, see Mark 14:15 (*coenaculum grande stratum*) and Luke 22:12 (*coenaculum magnum stratum*).

the capitals of the Baptistry at Pistoia.[1] Apart from such residual survivals, however, a significant change, apparently beginning in Rome, can be observed by the end of the Dugento. The *putto*, to use a hunting expression, "changes his haunts": he migrates from sculpture to painting, and within this migration three stages are apparent.

First, *putti* manifestly derived from such late-antique or Early Christian models as the mosaics in S. Costanza and the sarcophagus of Constantina (originally preserved in this very sanctuary) began to infiltrate, as a *locus minoris resistentiae*, the acanthus borders of mosaics—e.g., Jacopo Torriti's *Coronation of the Virgin* in S. Maria Maggiore —as well as wall paintings; the best-known specimens are those in the *rinceaux* enframing Cimabue's frescoes in the Upper Church at Assisi.[2] Second, the *putto* was admitted to the picture itself, appearing, however, in the guise of a classical—or, rather, would-be classical—work of sculpture incorporated in the *décor* of architectural settings and bearing, needless to say, more or less definite iconographical implications. Thus "petrified", he invaded the St. Francis cycle in the Upper Church at Assisi as well as— here by way of direct borrowing from Roman sarcophagi—Giotto's Arena frescoes (Fig. 107).[3] To this second phase of the development belong the four *putti* in the *Last*

[1] The problem of the *putto* in mediaeval and Renaissance art needs more study than it has received. The most instructive discussion thus far is found in Wentzel, "Antiken-Imitationen", particularly pp. 49 ff. and 66 ff., with illustrations of the *putti* in one of the capitals at Monreale in Fig. 24, in the columns of SS. Trinità and Cave in Figs. 27, 28, in the marble console from the Florentine Baptistry in Fig. 38.

[2] See Wentzel, *ibidem*, p. 67 (two of the *putti* in the borders of the Cimabue frescoes in Assisi illustrated in Figs. 36, 37); for further illustrations, see Kleinschmidt, *Die Basilika*, II, p. 91, Fig. 60; and (in real photographs) P. Toesca, *Affreschi del Vecchio e Nuovo Testamento della Chiesa Superiore del Santuario di Assisi*, Florence, 1948, I, Plates 83–90 (wingless), II, Plates 131–134 (winged). It should be noted, incidentally, that the acanthus itself, never entirely abandoned in Italian sculpture after the proto-Renaissance though always threatened by the competition of Gothic ornament, does not seem to have been appropriated by the two-dimensional media until the end of the thirteenth century.

[3] The most recent discussions of the date of the St. Francis cycle in Assisi (before 1307–08) are J. White, "The Date of 'The Legend of St. Francis' in Assisi", *Burlington Magazine*, XCVIII, 1956, p. 344 ff., and W. Schöne, "Studien zur Oberkirche von Assisi", *Festschrift Kurt Bauch*, Berlin, 1957, p. 50 ff. *Putti*

carrying garlands appear as decorative statues on the roof of the loggia in *St. Francis Presenting Himself to the Sultan* (Kleinschmidt, *Die Basilika*, II, p. 116, Fig. 82; C. H. Weigelt, *Giotto* [Klassiker der Kunst, XXIX], Stuttgart, Berlin and Leipzig, 1925, p. 149); another *putto* is seen in each of the reliefs adorning the upper part of the church in *St. Francis Expelling the Demons from Arezzo* (Kleinschmidt, *Die Basilika*, II, p. 115, Fig. 81; *idem*, *Die Wandmalereien*, p. 115 ff., Fig. 81; Weigelt, *op. cit.*, p. 148). In the first case, the pagan implication of the *putti* (cf., by way of contrast, the *Dream of Pope Innocent III* [Kleinschmidt, *Die Basilika*, II, p. 107, Fig. 73; Weigelt, *op. cit.*, p. 146], where the statues on the roof are angels) is obvious. In the second, their presence may be justified by the fact that the scene takes place, according to the sources, "outside the city gate of Arezzo"—a place where, up to this day, the remains of a Roman amphitheatre and "nymphaeum" can be seen within the very precincts of the church of San Bernardo. In Giotto's Arena cycle identical pairs of *putti* in relief, carrying a conch containing the image of the Lord in half length exactly as in Roman sarcophagi and obviously copied from a classical original, appear in the gable of the house of Joachim both in the *Appearance of the Angel to St. Anne* and in the *Birth of the Virgin* (Weigelt, pp. 8, 13, our Fig. 107). In this case the fact that *putti* rather than angels are entrusted with

Supper at Assisi; three further specimens—less decorous because they embellish the Palace of Pilate—are found in the *Flagellation of Christ,* a fresco which forms part of the same Passion cycle (Fig. 108).[1] The third stage, finally, is reached in Francesco Traini's *Triumph of Death* in the Camposanto at Pisa (*ca.* 1350), where we encounter two pairs of *putti* (Fig. 109) no longer frozen into stony immobility but very much alive and hovering in midair—yet literally copied from a Roman sarcophagus that can still be seen in the Camposanto itself (Fig. 110). One of these pairs displays a scroll, inscribed with hortatory verses, precisely as their classical prototypes display an *imago clipeata;* the other two *putti*—normally described as cupids or *amorini* but invested with a much more sinister meaning by their signaling gesture and the inverted position of their torches—point out to Death ("La Morte") her first victims: an elegant young man and a handsome young lady unsuspectingly absorbed in each other.[2]

After that, however, the *putto* disappeared—or, to be more exact, went underground —for nearly fifty years. Surviving—surreptitiously, as it were—only in the marginal decoration of illuminated manuscripts,[3] he did not re-emerge until the very end of the fourteenth century; but then he re-emerged with a vengeance. Repatriated to sculpture, he greeted the new century in the Porta dei Canonici and, here in the company of two other characters submerged after the Pisani (the nude Hercules and the nude Prudence) as well as other figures directly and understandingly revived from classical sources, in the Porta della Mandorla of Florence Cathedral (Fig. 111).[4] And thanks to Jacopo

the task of carrying the image of the Lord may serve to make it clear that, while Joachim and St. Anne were pious people and the immaculate conception or prenatal sanctification of the Virgin Mary interrupted the transmission of original sin, they still belonged to the Era before Grace. For other figures in Giotto's work revealing the influence of classical sculpture, see p. 152 f.

[1] Kleinschmidt, *Die Basilika,* II, p. 270 ff., Fig. 200; Cecchi, *Pietro Lorenzetti,* Plate LXIV. The three *putti* in the *Flagellation,* perched on capitals supported by lion-shaped consoles, are shown kneeling or crouching rather than standing, one blowing a horn, the two others playing with little animals.

[2] For the voluminous literature (particularly noteworthy, M. Meiss, "The Problem of Francesco Traini", *Art Bulletin,* XV, 1933, p. 97 ff., especially p. 168 ff.), see the recent survey in L. Guerry, *Le Thème du "Triomphe de la Mort" dans la peinture italienne,* Paris, 1950, p. 122 ff., where the numerous inscriptions and their source are reprinted. So far as I know, the dependence of the *putti* on Pisan sarcophagi was first observed by E. Dobbert, "Der Triumph des Todes", *Repertorium für Kunstwissen-*

schaft, IV, 1881, p. 1 ff.; but their sinister meaning in relation to the carefree couple beneath them seems to have gone unmentioned.

[3] For the occurrence of *putti* in the marginal decoration of manuscripts at a time when they had ceased to appear in public, as it were, see, e.g., the *Matricola del Cambio* in the Municipal Library at Perugia, illuminated by Matheolus Ser Cambi in 1377 (P. D'Ancona, *La Miniature italienne du X^e au XVI^e siècle,* Paris and Brussels, 1925, p. 44, Fig. 54). A case of particular interest is the Breviary of Martin II of Aragon, executed in the first years of the fifteenth century (Paris, Bibliothèque Nationale, MS. Rothschild 2529, published by J. Porcher, *Le Bréviaire de Martin d'Aragon,* Paris, n.d. [1953]). Here a Spanish illuminator, Italianate in style but committed to a Paris model produced in the workshop of Jean Pucelle about 1340, replaces most of the little animals inhabiting the borders of the French original with *putti.*

[4] See F. Saxl, "The Classical Inscription in Renaissance Art and Politics", *Journal of the Warburg and Courtauld Institutes,* IV, 1940–41, p. 19 ff., Plate 5c, e; Krautheimer, *Lorenzo Ghiberti,* p. 278 ff. In contrast

della Querćia and Donatello he multiplied to such an extent that the Quattrocento has been called, only half facetiously, the "age of the *putto*". Thereafter he was to haunt all the arts, "fine" as well as "applied", down to the aftermath of the Baroque tradition in the nineteenth century.

This revival of the *putto* in Trecento painting prior to 1350–60—beginning with decorative adaptation, culminating, after an intermediary phase of pseudosculptural reconstruction, in what may be called pictorial animation, and followed by temporary submersion—is a kind of test case which exemplifies, and in a sense epitomizes, what classical antiquity meant and did not mean to the age of the *primi lumi*. It makes us realize that—as might have been predicted from what was said in the first section of this chapter—the end of the Dugento saw a shift of the assimilative impulse from sculpture to painting (which, we recall, had been virtually immune to classical influence throughout the proto-Renaissance); that the force of this impulse was spent

to Krautheimer I believe, however, that the four figures in question—incorporated in a distinctly theological program and alternating with angels—are still subject to an *interpretatio Christiana*. I believe, in fact, that they represent, in humanistic disguise, the tetrad of the Cardinal Virtues, and that a particularly close precedent for their iconography is found in Giovanni Pisano's Pisa pulpit of 1302–1311 (see P. Bacci, *La ricostrizione del Pergamo di Giovanni Pisano nel Duomo di Pisa*, Milan, 1926; H. Keller, *Giovanni Pisano*, Vienna, 1942). The magnificent nude "Hercules" (Krautheimer, Fig. 6) still—or, rather, again—signifies the Virtue of Fortitude. The "Abundantia" equipped with a cornucopia and a bowl overflowing with water (Krautheimer, Fig. 5) represents the Virtue of Temperance, who in Giovanni Pisano's pulpit also carries the cornucopia normally associated with Charity (Keller, Fig. 107); in Giovanni Pisano's figure her other attribute is a compass, but the sculptor of the Porta della Mandorla was fully justified in substituting for this the water vessel which, as a means of diluting wine, is the most frequent attribute of Temperance. The averted nude apparently borrowed from the central figure in the well-known group of the Three Graces and occasionally interpreted as the goddess Hygeia (our Fig. 111) carries the standard attributes of Prudence, the serpent and the mirror; her complete nudity—connected, it would seem, with the idea of *nuda veritas*, so popular in the Middle Ages that the *Horse Tamers* on Monte Cavallo were interpreted as two philosophers to whose minds all things appear "naked and unconcealed"—has again an excellent

precedent in Giovanni Pisano's Pisa pulpit (Keller, Fig. 108); that she is represented from the back would have seemed justifiable on etymological grounds: "Prudens quasi *porro* videns" (Isidore of Seville, *Etymologiae*, ·X, 201). And an Apollo could well be employed as a personification of Justice both as the god of music which, like justice, reduces strife and discord to harmony and as the god of the sun, which Christian thought was wont to associate with the *sol iustitiae* of Malachi 4:2. The profusion of Hercules scenes in the archivolt, finally, can be accounted for by the fact that the Italian Trecento had come to interpret Hercules as a representative not only of the virtue Fortitudo in particular but also of *virtus generalis* or *virtus generaliter sumpta*. This idea, formulated as early as about 1300 by Francesco Barberino, is visually expressed, again, in Giovanni Pisano's Pisa pulpit, where Hercules, emancipated from the tetrad of the Cardinal Virtues and helping to support the entire structure, forms the counterpart of the Archangel Michael, embodying the sum total of the moral virtues while Michael embodies the sum total of the theological ones (Keller, Fig. 116). It should be noted that the *Libellus de imaginibus deorum*, nearly contemporary with the Porta della Mandorla, invariably and almost monotonously interprets all the labors of Hercules as *exempla virtutis* (see Liebeschütz, *Fulgentius Metaforalis*, p. 124 ff., and Panofsky, *Hercules am Scheidewege*, p. 146f.). In this attempt at unraveling the iconography of the Porta della Mandorla, I have been vigorously assisted by Mr. A. R. Turner.

by the middle of the fourteenth century; and that it was not reactivated—then, however, with redoubled intensity—until the beginning of the fifteenth.

That late-antique and Early Christian painting did midwife service when the style of Torriti, Cavallini and Giotto was born has already been mentioned,[1] and no one can deny that it continued to exert a powerful influence upon their successors. This influence was not limited to iconographical vocabulary and compositional syntax but extended (and this was a distinctive novelty in itself) to the handling of light and shade and to the very use of color. It is even possible—though, in my opinion, not overwhelmingly probable—that some of the earlier Trecento masters established contact with Roman painting in the narrower sense of the term: the kind of painting which we associate with the "Second Style" of Pompeii, the "Odyssey Landscapes" and the *Aldobrandini Wedding*.[2] Less questionable and in my opinion more significant, however, is the fact that the Trecento painters of the first two generations, whether or not they absorbed the influence of classical painting, virtually monopolized the influence of classical sculpture: the painters turned for inspiration to the tangible relics of the Antique precisely at a time when the sculptors—either living on the patrimony of their thirteenth-century predecessors, or succumbing to the Gothic style, or attempting to reconcile the one with the other—ceased to do so.

Looking out of his "window", the painter learned to perceive the products of Roman art—buildings and statues, gems and coins, but above all reliefs—as part and parcel of his visible and reproducible environment, as "objects" in the literal sense of the word (*objectum*, "that which is set against me"); it is almost symbolic that, when that fateful Venus statue was excavated in Siena, it was a painter, Ambrogio Lorenzetti, who recorded it in a drawing, whereas we do not know of any reaction on the part of a sculptor.[3]

[1] See above, pp. 135–137.

[2] That the direct dependence of earlier Trecento painting on classical murals can be refuted in the individual case of Pietro Lorenzetti's *Last Supper* does not, of course, invalidate this theory—especially championed by Horb, *opp. citt.*, and now widely accepted—*in toto*; it must be admitted that a figure such as the *Pax* in Ambrogio's *Buon Governo* invites comparison not only with classical sculpture but also with, for example, the personification of Arcady in the well-known *Finding of Telephus* from Herculaneum. On closer inspection, however, the differences, in this as well as all other cases that have come to my attention, would seem to outweigh the similarities, and purely practical considerations are conducive to skepticism. Granting the possibility that examples of "Roman painting in the narrow sense",

now lost, were still preserved and accessible in the fourteenth century, these examples could hardly have existed in Tuscany; and it is precisely in the work of the Lorenzetti brothers (of whom we do not know whether or not they ever visited Rome, not to mention South Italy) that the analogies appear to be the most persuasive.

[3] The story of the finding of the Venus statue in Siena (perhaps in 1334, when the pipes for the Fonte Gaia were laid), its reproduction in a drawing by Ambrogio Lorenzetti, its erection before the Palazzo Pubblico, and its ultimate destruction is told by Ghiberti, *Lorenzo Ghibertis Denkwürdigkeiten*, referred to above, p. 112, Note 2. That the statue represented Venus is not explicitly stated but may be inferred from two facts: first, its destruction was decided upon (in 1357) "cum inhonestum videatur",

Thus the "revival of the *putto* in Trecento painting" has many parallels; but this is not the place to enumerate them. Suffice it to mention that Ambrogio Lorenzetti himself fashioned the figure of *Securitas* in his *Buon Governo* after a Roman *Victory* still preserved in the Accademia delle Belle Arti in Siena; that the *Pax* in the same fresco is clad in a striated and semitranslucent drapery inspired by similar models; that the tympanum mosaic in his *Presentation in the Temple* repeats a sarcophagus of the same kind as those that were exploited by Giotto and Traini; and that the statues of classical gods surmounting the gable of the building in his *Martyrdom of the Franciscans in Morocco* in S. Francesco at Siena (Fig. 112), particularly those of Minerva and Venus (the latter fully clad but accompanied by a little Cupid snuggling up to her as in Marcantonio's famous engraving after Raphael), are unthinkable without the painter's familiarity with classical originals (Fig. 112).[1] In the *Liberation of Piero of Assisi through the Intercession of St. Francis* in the Upper Church at Assisi the Roman locale is visually indicated by a variation on the column of Trajan, and the roof of Herod's banquet hall in one of Giotto's late frescoes in S. Croce (Fig. 113) is decorated with eight statues of pagan divinities, their pedestals connected by garlands, whose iconographic significance in this particular context needs no explanation. These statues show that Giotto had mastered the idiom of classical sculpture to such an extent that he could use it *extempore*, so to speak. When we consider, for example, the charming statuettes perched on the scales of his *Justice* in the Arena Chapel (Fig. 114), one of them threatening the violent in the typical posture of a Jupiter throwing the thunderbolt, the other a diminutive Victory rewarding the peaceful scholar, we find it difficult to decide whether we are faced with figures derived from the Antique or invented *all'antica*.[2] And how Giotto

and it was particularly—in fact, exclusively—on Venus statues that the mediaeval fear of nudity and paganism seems to have been focused; second, the statue is said to have been supported by a dolphin, which is the case in many classical instances, among them the famous Medici *Venus*.

[1] It has long been conjectured that this Marcantonio engraving (B.311, extremely popular and still reflected in the final version of Watteau's *Embarquement pour l'Ile de Cithère*) may be based on a classical model now lost (H. Thode, *Die Antiken in den Stichen Marcantons*, Leipzig, 1881, p. 26); the astonishing anticipation of the Cupid motif in Ambrogio's *Martyrdom of the Franciscans* may lend support to this conjecture. For classical influence on Ambrogio Lorenzetti in general, see Rowley, "Ambrogio Lorenzetti il Pensatore", from whom I borrow most of the instances adduced in the text. There may perhaps be added, e.g., the figure of Charity at the foot of the

Virgin's throne in the altarpiece at Massa Maritima (E. Cecchi, *The Sienese Painters of the Trecento*, Plate CCVII), and the reclining Eve in the fresco at Monte Siepi (G. Rowley, "The Gothic Frescoes at Monte Siepi", *Art Studies*, VII, 1929, p. 107ff., Fig. 1, facing p. 107). Another reclining Eve—this one produced in the workshop of Ambrogio's brother, Pietro, and forming part of the *Coronation of the Virgin* in S. Agostino at Montefalco (Krautheimer, *Lorenzo Ghiberti*, Fig. 86)—recalls the effigies on Etruscan ash urns.

[2] For the works of Giotto referred to in the text, see Kleinschmidt, *Die Basilika*, II, p. 151ff., Figs. 111, 112; and Weigelt, *op. cit.*, pp. 158, 85, 62. To the two statuettes perched on the scales of Justice there may be added the male dancer in the relief on the base of her throne. Posed in a violent *contrapposto* attitude, its left arm and its right leg raised while its right arm is lowered, this figure (except for the fact that it is

could employ a pagan *Pathosformel* (there is no adquate translation for Warburg's indispensable term) to intensify as well as humanize the most sacred of Christian emotions is illustrated by his *Lamentation* (Fig. 93), where, we remember, the gesture of the St. John was inspired by the same Meleager sarcophagus (Fig. 115) which, some forty years before, had been exploited by Nicolo Pisano.[1]

These instances, and quite particularly the last-named, demonstrate the fact that classical marbles—"discovered" by the great painters of the early fourteenth century as they had been "discovered" by the great sculptors of the twelfth and thirteenth— exerted a subtle and pervasive influence upon the formation of the Trecento style, not only in such accidental features as facial types, ornaments and costumes[2] but also in essence: they helped to infuse into Christian painting some of the substantiality and animal vigor peculiar to pagan sculpture (it takes an art historian or archaeologist to single out in Traini's *Triumph of Death* the *putti* copied after Roman originals from the nude children that represent human souls); and, even more important, to familiarize it with psychological experiences transcending the realm of the merely natural yet not incompatible with the functional capacities and limitations of the body.

The principal source of this new expressiveness was, needless to say, the Byzantine tradition which, to repeat Adolph Goldschmidt's immortal simile, passed on the classical heritage—including many of the *Pathosformeln* just mentioned—to posterity "in the form of dehydrated foodstuffs that are inherited from household to household and can be made digestible by the application of moisture and heat". But it is noteworthy

draped) repeats a widespread classical type which, as Saxl has shown, inspired one of Pollaiuolo's dancers in the frescoes at Arcetri (F. Saxl, "*Rinascimento dell' antichità*", *Repertorium für Kunstwissenschaft*, XLIII, 1922, p. 220ff., Fig. 2). It should be noted that Giotto conceives of Justice only as *justitia distributiva*, dispensing due reward and punishment. Ambrogio Lorenzetti, in his *Buon Governo* mural in the Palazzo Pubblico at Siena, adheres to the more elaborate scholastic theory (see, e.g., Thomas Aquinas, *Summa Theologiae*, I, qu. XXI, art. 1) which divides Justice into *justitia distributiva*, on the one hand, and *justitia commutativa* ("as in buying and selling") on the other. In Ambrogio's composition the functions divided in Giotto's fresco between two subsidiary personifications, which might be called "*justitia remunerativa*" and "*justitia punitiva*", are, therefore, entrusted to one, viz., an angel inscribed *Distributiva*, who manages to behead a male delinquent with his right hand while bestowing a crown upon a meritorious woman with his left; whereas a second angel, inscribed *Comutativa*, supervises the peaceful transfer of legal rights. Since God is concerned only with *justitia distributiva*, the angel representing it takes. heraldically speaking, precedence over the personification of *justitia commutativa* in Ambrogio's fresco; and since the Deity prefers the bestowal of rewards to the administration of punishment, the personification of "*justitia remunerativa*" takes precedence over that of "*justitia punitiva*" in Giotto's.

[1] See above, p. 68, Note 2. For the reasons for assuming that Giotto approached the Meleager sarcophagus independently of Nicolo Pisano, see my remarks in *Early Netherlandish Painting*, referred to in that Note.

[2] To mention only one example: Giotto's Hope in the Arena Chapel (Weigelt, *op. cit.*, p. 87), who, clad in a flowing, twice-tucked chiton, may be called the ancestress of innumerable Quattrocento angels and "nymphs", and is in turn the descendant of the equally innumerable heroines and Victories which haunt classical sculpture from at least the end of the fifth century B.C.

that the Trecento painters of the first and second generations felt a need of supplement-
ing this diet by fresh rather than "dehydrated" material.

Not only Giotto's but also Duccio's *Lamentation* (Fig. 118) is derived from the Byzan-
tine *threnos*, where, in contrast to the solemn ritualistic restraint of the High Gothic
Entombment and despite Christian condemnation of the heathen custom of kissing the
dead, the Virgin Mary takes leave of the dead Christ with a last fervent embrace. But
in both Florence and Siena the pathos of the pagan *conclamatio*, surviving in the Byzan-
tine *threnos*, tended to be deepened by direct borrowings from the Antique. In addition
to the Meleager sarcophagus just mentioned, Giotto may well have known and utilized
those Etruscan funeral reliefs where some of the mourners are seen huddling on the
ground as if immobilized by sorrow, and similar Etruscan sources seem to have been
exploited, if not by Duccio himself, at least by his followers (among them Simone
Martini, in whose *Lamentations* the silent grief of these huddled figures is contrasted
with the frenzied despair of others throwing up their arms or tearing their hair).[1]
Here, as in many other scenes (such, for example, as the *Noli me tangere*), the event has
become what it had not been in Gothic interpretations—namely, a drama—and what
it had not been in representations of comparable subjects in classical art—namely, a
drama of purely spiritual significance.

Three important reservations, however, have to be made. First, the direct contact of
Trecento painting with classical sculpture was limited to individual motifs and did not
extend to compositions in their entirety. Second, this contact did not as yet tend to
invalidate the mediaeval "principle of disjunction": the *Lament of Hecuba over Troilus* in
a Neapolitan manuscript of 1350–60 remains virtually indistinguishable from a contem-
porary *Lamentation of Christ*;[2] the classical events described in so humanistic a text as
Petrarch's *De viris illustribus* are enacted by personages clad in fourteenth-century
costumes and are staged in an environment that gives an anachronistic impression
just because some of the settings, even if the hero of the scene happens to be Alexander
the Great, include such landmarks of imperial Rome as the Capitol or S. Nicola in
Carcere (Figs. 116 and 117);[3] and when, conversely, the classical aspect of a figure or

[1] The best-known example is, of course, Simone Mar-
tini's Berlin *Lamentation*; but that similarly emotiona-
lized versions of Duccio's quiet composition (Fig.
118) must have been produced in his own entourage
can be concluded from the reflection of such a ver-
sion in the work of Jean Pucelle (see p. 158 and Fig.
119). For possible Etruscan sources, see Panofsky,
Early Netherlandish Painting, p. 367, Note 24[1].

[2] London, British Museum, MS. 20 DI, fol. 145 v.
(Panofsky and Saxl, "Classical Mythology in
Mediaeval Art", Fig. 50).

[3] Darmstadt, State Library, Cod. 101 (see above, p.
144, Note 1), datable towards 1400 but probably de-
rived from the original decoration of the *Sala Virorum
Illustrium* as executed between 1367 and 1379. The
Roman landmarks—very much schematized so that,
for example, the column of Trajan lacks its band of
reliefs—have been identified and analyzed by
Mommsen, "Petrarch and the Decoration of the
Sala Virorum Illustrium in Padua", p. 110f. It is
remarkable that the—comparatively speaking—most
accurate rendering, that of S. Nicola in Carcere on

group was preserved, this figure or group was still subjected to an *interpretatio Christiana* which could, however, be stretched to the point of casting Hercules in the feminine role of Fortitude—a role that could not have been assigned to him on either the façade of Auxerre Cathedral or in the "Kaiserpokal" at Osnabrück and, for that matter, was soon to be withdrawn from him even in Italy (between Nicolo and Giovanni Pisano's pulpits and the Porta della Mandorla just mentioned, he lent to Fortitude his lion's skin but neither his sex nor his nudity). Third, the influence of classical sculpture on Trecento painting ceased to be effective, so far as can be seen, in the latter half of the century: after the Lorenzetti brothers and Traini no further attempts at direct assimilation seem to have been made for nearly fifty years.

This regression or recession of an active interest in the Antique fits in with the general trend of events in Tuscan painting after about 1350. In the Florence of Orcagna and the Siena of Luca di Tommè—Rome still remaining out of the running, if I may use this colloquial phrase—painting underwent that fundamental "change in style and in taste" which Millard Meiss has taught us to perceive as well as to understand: a change which involved an "opposition between plane and space and between line and mass" (instead of their "harmonious co-ordination"); a "denial of the values of individuality"; and "an intention to magnify the realm of the divine while reducing that of the human".[1]

Of the important North Italian painters active between *ca.* 1350 and *ca.* 1400, on the other hand, the opposite may be asserted. For reasons which still await investigation such masters as Altichiero or Tommaso da Modena developed the style of the founders in a direction which led them as far away from the Tuscan artists of their own generation as from the founders themselves: they decided in favor of either space or mass (or both) against line and plane; in favor of the particular, even in its less beautiful aspects, against the universal (not for nothing do we consider Tommaso da Modena as one of the fathers of independent portraiture); in favor of the "natural" against the "miraculous".[2]

fol. 19 (our Fig. 116), is found in one of the scenes involving Alexander the Great rather than a Roman hero.

[1] See Meiss, *Painting in Florence and Siena after the Black Death*, pp. 18, 31, 38. In the light of Meiss' findings, the fact that the Sienese Venus statue (see p. 112, Note 2, and p. 151, Note 2) generally admired and exposed to public view about 1335, was rejected and dismembered in 1357 assumes a more-than-political and more-than-moral significance. We may also remember, in this connection, that the iconography of the famous Scaligeri tombs in Verona (F. de Maffei, *Le Arche Scaligere di Verona*, Verona, n.d. [1955]) tends to become more exclusively Christian, and less eulogistic, during the second half of the

fourteenth century. On the tomb of Cangrande della Scala (died 1329), we find, in addition to a *Man of Sorrows* and an *Annunciation*, reliefs commemorating his political and military exploits; on the tomb of Mastino II (died 1350), we see the ruler recommended to God, and the rest of the program is limited to Virtues, saints and scenes from the Old Testament; on the tomb of Cansignorio (completed in 1376), finally, statues of Virtues are combined with reliefs exhibiting scenes from the New Testament.

[2] It is no accident that in O. Pächt's excellent study, "Early Italian Nature Studies and the Early Calendar Landscape", *Journal of the Warburg and Courtauld Institutes*, XIII, 1950, p. 13 ff., North Italian rather than Tuscan material occupies the center of the stage.

In one respect, however, the result of these antithetical developments was the same. In Florence and Siena as well as in Verona, Padua and Modena we can observe, in the second half of the fourteenth century, a growing indifference to the Antique: classical art, as we may say in terms admittedly outmoded and inadequate (though hard to replace), was too "naturalistic" to suit the Tuscans and too "idealistic" to suit the North Italians. And in the same measure as Italian painting disavowed its classical heritage, it yielded to the lure of a style which its own influence had called into being on the other side of the Alps.

VII

THAT the early Trecento painters should gain recognition in the rest of Europe was as inevitable as that water seeks its own level once a significant rise has occurred at one point. The emigration of the Curia to Avignon was a contributory factor at best. There was, however, considerable difference in the way the individual countries reacted to the new gospels.

In Germany and England, where the Gothic tradition ruled supreme, the initial impact of Trecento art remained episodic, and individual models were used with the intent of borrowing iconographic innovations and schemes of composition rather than of emulating a style. A southwest German mural of about 1320, preserved in Jung St. Peter's at Strasbourg, reflects Giotto's *Navicella*, while the Klosterneuburg altarpiece, produced in southeast Germany (Austria) probably about 1330, reveals the influence, either direct or transmitted by drawings, of Giotto's frescoes in the Arena Chapel.[1] But in both these cases the artists ignored the new and significant style of their models and appropriated only the *invenzione*. They retranslated their models into the nonperspective language of what may be called the terminal phase of the High Gothic style; and a similar lack of deeper understanding can be observed in the examples of the short-lived "Giottesque episode" in English fourteenth-century painting.[2]

The opposite is true of Spain, particularly Catalonia, where the relatively late arrival and weak development of the Gothic style, combined with the existence of a continuous, if rather provincial, tradition in panel painting, resulted in so unrestrained an assimila-

[1] For the Klosterneuburg altarpiece, see, e.g., Panofsky, *Early Netherlandish Painting*, p. 367, Note 25[1]. The relationship between the Strasbourg painting and Giotto's *Navicella* was discovered by W. Körte, whose article, unobtainable in this country and inaccurately cited in subsequent references, is entitled: "Die früheste Wiederholung nach Giottos Navicella (in Jung-St. Peter in Strassburg)", *Oberrheinische Kunst*, X, 1942, p. 97 ff. I am much indebted to Professors Kurt Bauch and Wolfgang Schöne for helping me to gain access to this interesting essay.

[2] See O. Pächt, "A Giottesque Episode in English Mediaeval Art", *Journal of the Warburg and Courtauld Institutes*, VI, 1943, p. 51 ff.

tion of all available Italian models that we receive the impression of an eclectic Trecento school *in partibus infidelium.*[1]

Apart from the special case of Hungary, there were only two countries—their art and culture closely interrelated in spite of geographical distance—where the Italian influence was neither so marginal and episodic as in Germany and England nor so overwhelming and, in a sense, oppressive as in Spain, and where it operated as a pervasive force stimulating rather than interrupting national growth: Bohemia and France. And it is only in France that we can observe, instead of successive waves of influence, a continuous, methodical and selective assimilation of the Trecento style: continous in that the artists of a given generation never lost contact with their predecessors; methodical in that their interest was always focused on essentials rather than accidents; selective in that the process of appropriation began with what was nearest to the indigenous taste and tradition and gradually progressed to what was farthest.

To the masters of Strasbourg and Klosterneuburg it mattered little whether their models were Florentine or Sienese because they sought, as I have phrased it, to borrow iconographic innovations and schemes of composition, and not to emulate a style. The French, however—or, rather, a succession of masters active in France but mostly hailing from the Netherlands—attempted to do just this. And with unerring instinct they felt that they had to master the idiom of Sienese art, which, like their native language, was "more linear, more mercurial, more lyrical", before they could gain access to the "more massive, more geometric and intellectual" style of the Florentines.[2] They began with Duccio rather than Giotto, and it took them nearly a century to arrive—on a different level—at the point from which the South German masters had prematurely started.

The story of this long journey and its ultimate results has often been told and will soon be retold, with appropriate revisions, by Millard Meiss.[3] Suffice it, therefore, to remind the reader of what may be considered to be its most significant stages.

[1] See Meiss, "Italian Style in Catalonia".

[2] *Idem, Painting in Florence and Siena after the Black Death,* p. 57.

[3] For the time being, I must refer to the pertinent passages in my own *Early Netherlandish Painting,* particularly pp. 24–89, 131–162, 367–397, 411–422, as well as to a number of more recent contributions in part provoked by, and taking issue with, this publication: Pächt's review of *Early Netherlandish Painting,* Pt. II, cited above, p. 142, Note 2, and Pt. I, *Burlington Magazine,* XCVII, 1956, p. 110 ff.; *idem,* "A Forgotten Manuscript from the Library of the Duc de Berry", *ibidem,* p. 146 ff.; *idem,* "Un Tableau de Jacquemart de Hesdin"?, *Revue des Arts,* VI, 1956, p. 149 ff.; J. Held, Review of *Early Netherlandish Painting, Art Bulletin,* XXXVII, 1955, p. 205 ff.; F. Winkler, review of *Early Netherlandish Painting, Kunstchronik,* VIII, 1955, p. 9 ff.; L. M. J. Delaissé, "Enluminure et peinture dans les Pays-Bas; A propos du livre de E. Panofsky 'Early Netherlandish Painting'", *Scriptorium,* XI, 1957, p. 109 ff.; J. Porcher, ed., *Bibliothèque Nationale, Les Manuscrits à peintures en France du XIIIᵉ au XVIᵉ siècle,* Paris, 1955; *idem,* "Les Belles Heures de Jean de Berry et les ateliers parisiens", *Scriptorium,* VII, 1953, p. 121 ff.; C. Nordenfalk, "Französische Buchmalerei 1200–1500", *Kunstchronik,* VII, 1956, p. 179 ff.; M. Meiss, "The Exhibition of French Manuscripts of the

The first decisive step was taken by the great illuminator whom we are still entitled, I believe, to identify with Jean Pucelle, active at Paris from *ca.* 1320.[1] He did precisely what his German and English contemporaries did not: he realized and utilized at once what was both new and important in Trecento painting from a stylistic point of view. It is remarkable enough that the miniatures produced by him and his workshop familiarized the North with such motifs as coffered vaults and ceilings and, in at least one case, with a fairly recognizable portrait of the Palazzo Vecchio in Florence. But it is immeasurably more important that the *Lamentation* (fol. 82 v.) in his "Hours of Jeanne d'Evreux", executed as early as between 1325 and 1328, not only accepted but even deepened that emotional interpretation of human conduct which Duccio and Giotto had revived from Byzantine and classical sources (Fig. 119) and that the *Annunciation* (fol. 16) in the same manuscript is the first coherent perspective interior in Northern art (Fig. 121).

There were, however, three limitations to this first stage in the assimilation of the Trecento style in France. Pucelle's miniatures, encompassed by decorative frames— except for the well-motivated exception of the *Crucifixion* (fol. 68 v.) in the "Hours of Jeanne d'Evreux", which fills the entire available area and has no frame at all— remained adornments of the written page instead of representing a "view through a window pane"; his Italian sources were limited to Duccio and Duccio's closest followers; and his perspective compositions—particularly the *Annunciation*, ceaselessly copied and elaborated for about one hundred years, but also such scenes as *St. Louis Feeding the Leprous Monk* on fol. 123 v.—stand out from the rest of his work as isolated *tours de force* instead of applying a general principle that would extend from specific architectural settings to space in general.

The third of these limitations was overcome in the next phase of the development when masters such as Jean Bondol, the Bruges-born court painter of Charles V (first mentioned in 1368), began to deploy all figures and objects, one behind the other, on an apparently receding standing plane instead of aligning them side by side or above each other on one or more standing lines; they thus succeeded in suggesting real

XIII–XVI Centuries at the Bibliothèque Nationale", *Art Bulletin,* XXXVIII, 1956, p. 187 ff.; C. Sterling, "Oeuvres retrouvées de Jean de Beaumetz, peintre de Philippe le Hardi", *Bulletin, Musées Royaux des Beaux-Arts,* IV, 1955, p. 57 ff.

[1] For Jean Pucelle, see the references in Panofsky, *Early Netherlandish Painting,* p. 369, Note 27[1]. Further: Porcher, ed., *Bibliothèque Nationale, Les Manuscrits à peintures en France du XIII^e au XVI^e siecle,* p. 52 ff.; Nordenfalk, "Französische Buchmalerei 1200–1500",

particularly p. 182; Lefrançois-Pillion and Lafond, *L'Art du XIV^e siècle en France,* pp. 194 ff., 200, 225 ff. (Italian influence on glass painting in Normandy); B. Gagnebin, "Une Bible Historiale de l'atelier de Jean Pucelle", *Genava,* New Ser., IV, 1956, p. 23 ff. A partial facsimile of the "Hours of Jeanne d'Evreux" has been published, with preface by J. J. Rorimer, by the Metropolitan Museum of Art in 1957.

landscapes (Fig. 122) and introduced into the North what I have called the "interior by implication" (Fig. 123).[1]

To overcome the second and first of these limitations two further steps were required. The masters active from *ca.* 1375 up to the end of the century—led by the Master of the Parement de Narbonne, Jacquemart de Hesdin and the great panel painter, Melchior Broederlam—not only made fresh and wider contacts with Italy, extending their field of vision from Duccio and his school to such younger Sienese masters as Simone Martini, Barna da Siena and the Lorenzetti brothers as well as to some Northern representatives of the Trecento style, but also began to duplicate the aesthetic structure of Italian panel painting as such. Their book illuminations, now often circumscribed by a frame that tends to isolate the narrative from its surroundings instead of integrating it therewith into a decorative layout, assumed the character of little panel paintings that have strayed into a manuscript, their backgrounds often no longer elaborated into an abstract decorative pattern but attempting to suggest, however crudely, the natural sky (Fig. 124).[2]

The final steps were taken by the great Franco-Flemish masters of the early fifteenth century, particularly the "Maître des Heures du Maréchal de Boucicaut" (cited for short as the "Boucicaut Master") and his slightly younger contemporaries, the three Limbourg brothers, who, as we now know, all died in 1416, the same year as did their

[1] For this concept, see above, p. 144 f. For the manuscript illustrated in Figs. 122 and 123 (the Bible Historiale of Charles V, The Hague, Museum Meermanno-Westreenianum, MS, 10.B.23), cf. Panofsky, *Early Netherlandish Painting*, p. 35; M. Meiss, "The Exhibition of French Manuscripts"; and, as a dissenting voice, Delaissé, *op. cit.*

[2] Brussels, Bibliothèque Royale, MS. 11060/11061. For the debate concerning the date and authorship of this important manuscript, see the literature referred to above, p. 157, Note 3. I still believe, with Nordenfalk and Meiss (and against Porcher and Pächt), that the Brussels Hours is identical with the manuscript mentioned in the Duc de Berry's inventory of 1402 and there described as having "quarrefors des feuillez en plusieurs lieux faictes des armes et devises de Monseigneur", all the more so as the heraldic argument adduced against a date before 1400 is not so cogent as heraldic arguments always seem to be. While it is true that the shields in the corner quatrefoils of the narrative miniatures in the Brussels manuscript show, within the Duke's *border engrailed,* "France modern" (*azure three fleurs de lys or*), it is equally true that the banners proudly displayed by the little bears in the lateral quatrefoils exhibit "France ancient" (*azure semée of fleurs de lys or*); the good King René of Anjou (d. July 10, 1480) never accepted "France modern" in his entire life. And as regards the first, or double, dedication page of the Brussels Hours (which did not originally belong to the manuscript and antedates the other miniatures), I think that Porcher's proposal to derive it from a manuscript executed for the Duc de Berry in 1406 (Paris, Bibliothèque Nationale MS. fr. 926) is unacceptable because, apart from several other objections, the Brussels miniature is entirely homogeneous in style whereas the Paris miniature shows a distinct stylistic discrepancy between the Madonna and the donatrices. The former shares with the Brussels Madonna the qualities of plastic solidity and linear precision; the latter are rendered in the looser, more pictorial manner characteristic of, e.g., the two well-known Boccaccio manuscripts of 1402, Paris, Bibliothèque Nationale, MSS. fr. 698 and fr. 12420. This combination of donors' portraits conforming to the inscribed date (1406) with a Madonna harking back to a different and considerably earlier style suffices to show that the dedication page of MS. fr. 926 presupposes the first, or double, dedication page of the Brussels Hours, and not vice versa.

beloved patron, the Duc de Berry. In these crucial years Italianism in France reached a point—located, so to speak, perpendicularly above the starting point of Italianism in Germany—at which the North not only gained access to Italian sculpture as well as to Italian painting but also, at long last, established a more than superficial relationship with Giotto and his Florentine followers (cf. Fig. 125 with Fig. 100). At the same time, however, naturalism triumphed, apart from countless observations of particulars, in the interpretation of space as a *locus* of luminary phenomena. We find interiors suffused with a dim chiaroscuro occasionally set off against the brightness of the outdoors (Fig. 126) and—nearly one hundred years before Leonardo da Vinci—landscapes conceived according to the rules of aerial perspective: the blue of the sky fades into a grayish white near the horizon; the distance is lighter and not darker than the foreground; and the intervening air not only diminishes the volume and solidity of far-off objects but also subdues their color to such an extent that the white of walls, the red of roofs and the green of trees appear submerged in a soft cerulescent haze (Fig. 127).

These two developments—one culminating in a maximum of overt Italianization, the other in a maximum of that optical truth to life of which Italian perspective was the *conditio sine qua non*—were complementary, not contradictory. It is no accident that the same manuscript, the famous *Très Riches Heures* in the Musée Condé at Chantilly, which contains adaptations of Taddeo Gaddi's *Presentation of the Virgin* and Giotto's *Stigmatization of St. Francis* also contains the earliest landscapes in which a continuous transition from near to far is achieved by the interposition of a middle plane[1] (whereas the otherwise more "atmospheric" landscapes of the Boucicaut Master still show a cleavage between the foreground, including the figures, and the far distance, which must be appreciated as a separate unit) as well as the earliest genuine snowscape.[2]

An unresolved and, in a sense, unresolvable conflict existed, however, between Italianism and naturalism, on the one hand, and a third tendency, which nevertheless was an integral and increasingly important element in the evolution of Northern painting from *ca.* 1375 to *ca.* 1420–25, on the other. This tendency may be described—of course without derogatory implications—as "Manneristic": a preference for calligraphical and decorative stylization at the expense of pictorial verisimilitude, for the pure profile or the full front view as opposed to foreshortenings, for elongated rather than normal proportions, for a sophisticated, even affected, formalization of pose

[1] This was pointed out, in a Princeton seminar report, by Mr. Robert M. Harris.

[2] Viz., the February picture, fol. 2 v. The February picture in the slightly earlier (*ca.* 1407) cycle of murals in the Torre dell'Aquila at Trent (B. Kurth, "Ein Freskenzyklus im Adlerturm zu Trient", *Jahrbuch des kunsthistorischen Institutes der K. K.* *Zentralkommission für Denkmalpflege*, V, 1911, p. 9 ff.), shows only a few patches of snow distributed over otherwise fairly typical scenery. One may say that the snow is here still used, somewhat like the diminutive towers in pre-Eyckian representations of St. Barbara, as an attribute rather than a *sujet* in its own right.

and gesture, and for "conspicuous waste" in dress and ornaments. From a stylistic point of view this Manneristic tendency may be considered as an overstatement of the sense of elegance and refinement that had always distinguished French, especially Parisian, production from that of other regions; from a sociological point of view, it may be considered as an overstatement of aristocratic ideals in competition with the aspirations of an irrepressibly rising bourgeoisie. It thus entered into the fabric of art much as gold and silver threads are interwoven with wool and silk: it asserted itself primarily in the representation of the nobles, whereas the naturalistic mode of expression, almost amounting to a class distinction, was reserved for the "lower orders", animals and inanimate objects.

But just this conflux of diverse and in part contradictory currents made the style evolved on French soil during the last decades of the fourteenth century acceptable throughout a Europe where architecture, sculpture and goldsmithery were still Gothic, where painting had absorbed, in varying degrees, the innovations of the Italian Trecento, where music was dominated by Netherlandish influence, and where the fashion and manners of the ruling classes were essentially French. Multifarious in origin and structure, this style, created for the benefit of the French aristocracy by artists mostly hailing from the Low Countries or the Rhineland and closely connected with the Italian Schools, became so ubiquitious that art historians refer to it as the "International Style of about 1400". In fact, its products—including those of the so-called "minor" arts which yet exerted a considerable influence on the "major" ones[1]—are, even now, so difficult to locate that they continue to be shifted from Paris to Burgundy, Spain or Bohemia, from Avignon to Bourges, or, like the charming *Adoration of the Magi* illustrated in our Fig. 128 and epitomizing, so to speak, all the characteristics just enumerated, from France to North Italy.[2] The affinity between, say, Stefano da Zevio of Verona or Michelino da Besozzo of Milan and the Upper Rhenish Master of the Garden of Paradise or the Lower Rhenish Master of the Figdor *Nativity,* between any number of North Italian book illuminators and the Boucicaut Master, between the Zavatteri or Gentile da Fabriano (even Pisanello) and the Limbourg brothers strikes us more forcibly than that between all those masters and either their indigenous forerunners or their indigenous successors.

[1] See particularly R. Krautheimer, "Ghiberti and Master Gusmin", *Art Bulletin,* XXIX, 1947, p. 25 ff., and *idem, Lorenzo Ghiberti, passim.*

[2] For a general characterization of the International Style of about 1400, including references to most of the objects adduced in the text, see Panofsky, *Early Netherlandish Painting,* p. 66 ff. (and Notes); Krautheimer, *Lorenzo Ghiberti, passim,* particularly p. 76 ff.

CHAPTER IV

Rinascimento dell'Antichità: The Fifteenth Century

I

By the end of the fourteenth century, then, the art of Italy was nearly as radically estranged from the Antique as was that of the North; and it was only by beginning, as it were, from zero that the real Renaissance could come into being

In contrast to the various mediaeval "renascences" this Renaissance amounted to what the biologists would call a mutational as opposed to an evolutional change: a change both sudden and permanent. And an analogous and simultaneous mutation— viz., the emergence of a new style of painting based on the apparently trivial yet, at the time, essentially novel conviction that, to quote Leonardo, "that picture is the most praiseworthy which most closely resembles the thing to be imitated" and determined by what was to become a Cartesian, or at least Cusanian, interpretation of space—took place on the other side of the Alps. To be specific, it took place in the Netherlands which, after the battle of Agincourt in 1415 and the subsequent transmigration of the Burgundian court from Dijon to Bruges and Lille, had ceased to export its native talent to France and England and from 1420–25 emerged as the second Great Power in European art.

Like nearly all great innovatory movements in the history of art, these two concurrent pheonomena—the *ars nova* or *nouvelle pratique* of Jan van Eyck, the Master of Flémalle and Roger van der Weyden, and the *buona maniera moderna* of Brunelleschi, Donatello and Masaccio—disengaged themselves from the antecedent tradition by way of cross-fertilization, on the one hand, and by way of reversion, on the other: across the boundaries of professional parochialism their pioneers looked for guidance to such sister arts as had achieved remarkable results in a different medium; across the boundaries of time they looked for guidance to the distant past.

The Netherlandish painters evolved their new style in intimate contact with nearly all the other visual arts and, in a manner of speaking, learned to practice them vicari-

ously. From major statuary which, in the works of the mighty Claus Sluter (d. 1406), had broken the spell of the International Style as early as about 1400, they learned to impart to their figures a plastic solidity which makes them look like sculpture turned into flesh; we happen to know that even the greatest painters did not disdain to coat and gild reliefs and statues in stone, wood or brass, thus seeing them in the nude, as it were, and observing the action of light on solid bodies as under laboratory conditions. When they began to adorn the exteriors of their altarpieces with simulated statues in grisaille—"stone-colored figures", as Dürer calls them—they not only showed off their ability to produce a *trompe-l'oeil* effect but also tacitly acknowledged an indebtedness to the sculptors. They repaid this debt, with interest, by providing the sculptors with prototypes, not infrequently even drawings, for their works until, towards the end of the fifteenth century, sculpture became more dependent on painting than painting had been on sculpture at the beginning.

And since the Netherlandish "primitives", deservedly famous for endowing the products of human hands, from "ornate halls and porticoes" to "multicolored garments" and "gold that looked like gold", with the same semblance of reality as the products of nature, often included in their compositions all kinds of buildings and artifacts conforming to the requirements of a given iconographical context (it would not have been easy, for example, to find a throne whose sculptured decoration included, all at once, the Sacrifice of Isaac, the Victory of David over Goliath, the Pelican in her Piety and the Phoenix),[1] they had to construct, without a loss in verisimilitude, what they wished to be seen. They had to become, as it were, their own carpenters, coppersmiths, jewelers, tapestry weavers, sculptors and architects, using the brush instead of hammers, tongs and chisels.

Similarly, Donatello and Masaccio turned to Brunelleschi, either directly or indirectly through Alberti, in matters of perspective and architectural settings. As for the former, we may refer to the Salome relief in Lille and, above all, the bronze reliefs of the altarpiece in S. Antonio at Padua (Fig. 132); as for the latter, to the *Trinity* in

[1] The throne referred to in the text is that of the Madonna in the Dresden triptych by Jan van Eyck. For the principle of "disguised symbolism" practiced by him and his Flemish contemporaries, see C. de Tolnay, *Le Maître de Flémalle et les Frères van Eyck*, Brussels, 1939, *passim*, and Panofsky, *Early Netherlandish Painting*, pp. 131–148. Even when the Master of Flémalle, in his *Betrothal of the Virgin* in the Prado, patterned the unfinished narthex of the Temple of Jerusalem after the south transept of Notre-Dame-du-Sablon in Brussels, which was then in course of erection (R. Maere, "Over het Afbeelden van bestaande gebouwen in het schilderwerk van Vlaamsche Primitieven", *Kunst der Nederlanden*, I, 1930–1931, p. 201 ff.), he had to change the program of its sculptural décor; even when Jan van Eyck, in his *Rolin Madonna*, designed a city prospect on the basis of topographical sketches made at Liège some twenty years before (see Lejeune, *loc. cit.*), he did not hesitate to fuse several distinct vistas into one, to rearrange the individual elements, and to transplant the tower of Utrecht Cathedral (changed only in minor details) to the banks of the Meuse.

S. Maria Novella (Fig. 129),[1] to which we shall shortly revert. Other painters, such as Paolo Uccello, Andrea del Castagno and, later on, Mantegna, drew inspiration from the works of Donatello. And as the pioneers of the Italian Renaissance shared with their Northern contemporaries the "diversionary" propensity for cross-fertilization, so did they share with them the "reversionary" tendency to look for inspiration to their more· or less remote ancestors.

Claus Sluter harked back, in many ways, to the High Gothic tradition of the latter half of the thirteenth century,[2] just as Masaccio did to Giotto. The script and occasionally, as has been observed quite recently, the decorative motifs employed by "humanistic" scribes and book illuminators were patterned after models ranging from the ninth to the twelfth century.[3] And as Brunelleschi's work reveals the influence of such pre-Gothic Tuscan structures as S. Miniato and the Badia of Fiesole,[4] so did the great Flemish painters of his time develop an interest in their indigenous Romanesque—

[1] That the architectural setting of Masaccio's *Trinity* was designed or inspired by Brunelleschi and, at any rate, does not directly depend on a classical structure is demonstrated by the fact—observed by Jacques Mesnil and called to my attention by Mrs. Anne de Egry—that the coffers of the barrel vault are arranged in an even number of rows so that the central axis of the vault is marked by what may be called a Gothic ridge rib in disguise; whereas in classical barrel vaults the number of rows is always odd so that the central axis of the vault is not visibly accentuated (J. Mesnil, *Masaccio et les débuts de la Renaissance*, The Hague, 1927, p. 102). Curiously enough, Mesnil concludes from this astute observation that Brunelleschi, "qui avait été à Rome et connaissait évidemment dans tous leurs détails les arcs de triomphe du Forum", could *not* have been responsible for the design of Masaccio's architecture. It was, however, precisely Brunelleschi who changed the classical disposition of the coffers from odd to even (interior of the Pazzi Chapel) and transmitted this innovation to his contemporaries (see, e.g., Donatello's relief reproduced in our Fig. 132) as well as to the following generations. The unorthodox arrangement can be seen, for example, in Alberti's S. Andrea at Mantua, in Mantegna's *St. James Led to His Martyrdom* in the Eremitani Chapel at Padua (E. Tietze-Conrat, *Andrea Mantegna*, Florence and London, 1955, Pl. 18) and even in Bramante's simulated choir of S. Satiro at Milan. It was "rectified", however, e.g., in the porch of Brunelleschi's own Pazzi Chapel; in several drawings, notably the *Dormition of the Virgin*, by Jacopo Bellini (V. Goloubew, *Les Dessins de Jacopo Bellini au Louvre et au British Museum*, Brussels, 1912, II, Pl. XXVI); in Piero della Francesca's *Madonna of Federigo Montefeltre* in the Brera at Milan; in Ghirlandaio's *Confirmation of the Franciscan Rule* in S.S. Trinità at Florence; and, needless to say, in all Cinquecento art.

[2] I still believe that Sluter's famous Madonna in the portal of the Chartreuse de Champmol was inspired by the *Vierge Dorée* at Amiens and its derivatives rather than by Giovanni Pisano's *Madonna* in the Baptistry at Pisa, as proposed by S. Sulzberger, *La Formation de Claus Sluter* (Communication faite devant les Membres de la Société des Amis du Musée Communal de Bruxelles), Brussels, 1952. Claude Schaefer in his remarkable book *La Sculpture en ronde-bosse au XIV^e siècle dans le duché de Bourgogne*, Paris, 1954, justly refers to Sluter's Madonna in the portal of the Chartreuse de Champmol as dominated by the "diagonale amiénoise", and it should be noted that the very idea of adorning this portal with large-scale jamb figures and a *trumeau* statue represented, about 1400, a kind of reversion to High Gothic custom.

[3] O. Pächt, "Notes and Observations on the Origin of Humanistic Book-Decoration", in D. J. Gordon, ed., *Fritz Saxl, 1890–1948; A Volume of Memorial Essays*, London, 1957, p. 184 ff.; cf. also C. Nordenfalk, "A Traveling Milanese Artist in France at the Beginning of the XI. Century", *Arte del primo millennio* (Atti del Convegno di Pavia [1950] per lo Studio dell'Arte dell'Alto Medio Evo), Turin, 1953, p. 374 ff., particularly Note 10a.

[4] See above, p. 40.

an interest which in Jan van Eyck reached the proportions of a genuine revival, based upon systematic, almost archaeological study and extending from architecture and sculpture to murals, niellos, stained glass, and even epigraphy.[1]

To a considerable extent this "Romanesque revival" was motivated by iconographical considerations. We can observe, specifically, that Romanesque features—taking the place of the vaguely Orientalizing ones employed by the International Style—were introduced as symbols of the Old Testament as opposed to the New or served to conjure up the vision of Jerusalem, the terrestrial as well as the heavenly.[2] This does not, however, preclude but rather presupposes a purely aesthetic relevance of the phenomenon: the fathers of Early Netherlandish painting were evidently attracted by the Romanesque style *qua* style. Contrasting as they did with the filigree-like fragility and intricacy of the contemporary "Flamboyant", the substantial sturdiness and poise of Romanesque structures (dramatically apparent in the use of circular rather than pointed or three-centered arches) were bound to appeal to Jan van Eyck in much the same way as they did to Brunelleschi and helped the former to break away from the Boucicaut Master and the Limbourg brothers much as they did the latter to break away from the *magistri operis* of the cathedrals of Florence, Siena and Orvieto.

II

WHILE the *ars nova* of the North and the Italian Renaissance thus agreed in principle— in the acceptance of verisimilitude as a general and basic postulate, in the interpretation of space as a three-dimensional continuum and in a tendency toward cross-fertilization as well as reversion—they differed (apart from such important technical matters as the emergence of the oil technique in Northern painting and the virtual disappearance of bronze from Northern sculpture) in the distribution and direction of what may be called mutational energy.

The first of these differences consists in the fact that the various arts or media responded to the spirit of innovation that swept over Europe in the first quarter of the fifteenth century in inverse order, so to speak. In the Netherlands, the earliest and most unequivocal departure from the immediate past occurred in painting and music; it was, in fact, in order to glorify two great composers, Guillaume Dufay and Gilles Binchois (both natives of the Hainaut and born about 1400), that the expressions *ars*

[1] For this Romanesque revival, see Panofsky, *Early Netherlandish Painting*, particularly pp. 134–140, 227f. (and Notes). The very idea of representing the Deity in the guise of the Lamb (in the Ghent altarpiece) rather than in that of the triune God or the explicit Trinity—an iconography foreign to "All Saints pictures" after the end of the twelfth century—may be interpreted as a Romanesque revival.

[2] See *ibidem*.

nova and *nouvelle pratique*, which I have appropriated for the new style of painting, were coined. Sculpture, we recall, had had a kind of prenatal headstart over painting, but this situation was reversed once Eyckian and Rogerian painting had been born. And the development of architecture—no less Late Gothic after than before the otherwise crucial years of 1420–25—remained essentially unaltered until it was deflected, like all other arts, by the impact of the transalpine Renaissance.

In Italy, on the other hand, the architects and sculptors broke with the prevailing tradition not only at a slightly earlier date but also, which is more important, with more assistance from the Antique than did the painters. And Italian music, unable to find support in classical prototypes and (therefore?) playing a surprisingly insignificant role in the transition from the Middle Ages to the modern era, did not achieve international importance until the middle of the sixteenth century and did not participate in the mutational process at all.[1]

This brings us to the second difference between the initial stages of the Italian Renaissance and the Northern *ars nova:* the difference in direction or, as the Scholastics would say, *intentio.*

For the Master of Flémalle and the van Eycks the Romanesque style represented the end of their excursion into the past—an excursion which, characteristically, came to a halt as soon as a new generation, dominated by Roger van der Weyden, entered upon the scene. For Brunelleschi the Romanesque style was only a way station, however important, on his road to classical architecture which he and his comrades-in-arms considered as an achievement of their own ancestors. Nor did the epigraphers, calligraphers and, ultimately, typographers of the Quattrocento stop at their Carolingian, Ottonian and twelfth-century models; they proceeded to a revival of what Ghiberti calls *lettere antiche*,[2] that is to say, of that authentic, classical form of lettering (still referred to as "Roman") which, as Millard Meiss has shown, was brought to perfection by Andrea Mantegna and was reduced to geometrical principles—analogous to those obtaining in the theory of human proportions—in a host of "alphabetical treatises".[3] In short, the *intentio* of the Italian Quattrocento was to revert to the sources; but the

[1] See, e.g., E. E. Lowinsky, "Music in the Culture of the Renaissance", *Journal of the History of Ideas*, XV, 1954, p. 509 ff., particularly p. 512: "Flanders was the leading center in Western music and the creative force behind the great development of the art of counterpoint and choral singing in the Renaissance". The papal choir was largely composed of Netherlanders, and it is hard to name any Italian composer contemporary with, and comparable to, one of the illustrious Flemings from Dufay (*ca.* 1400–1474) and

Binchois (*ca.* 1400–1460) through Johannes Okhegem (*ca.* 1430–1495) to Josquin des Prez (1450–1521). It is a memorable fact that some of Michelangelo's poems were set to music by an immigrant from Flanders, Jacob Arcadelt.

[2] See above, p. 33, Note 2.

[3] See M. Meiss, *Andrea Mantegna as Illuminator; An Episode in Renaissance Art, Humanism, and Diplomacy,* New York, 1957, particularly pp. 52–78.

force of this *intentio* varied, within the different arts, according to that "hierarchy of media" which was observed by the Renaissance historiographers themselves.

As was mentioned sometime ago, these Renaissance historiographers, culminating in Vasari, perceptively differentiated between the three inaugurators of the *seconda età*: they credited Brunelleschi, the architect, with the rediscovery and systematic renewal of the classical style in principle; Donatello, the sculptor, with a number of qualities which made him a "great imitator of the ancients" and his productions "more similar to the excellent works of the Greeks and Romans than those of any other man"; and Masaccio, the painter, only with epoch-making achievements in coloring, modeling, foreshortening, "natural postures", and emotional expressiveness. They thereby implied, as I expressed it, that, at the beginning of the new era, "the return to nature had played a maximum role in painting, that the return to classical art had played a maximum role in architecture, and that a balance between these two extremes had been struck by sculpture".[1] *Correctis corrigendis*, this implication still appears acceptable.

The works of Brunelleschi, all Romanesque influences and "latent Gothic" tendencies notwithstanding, reinstated the morphology as well as the proportions of classical architecture and gave rise to a fairly continuous tradition not only in architecture in the narrower sense but also in the allied arts of carpentry, incrustation and cabinet-making. And through such younger masters as Michelozzo, Alberti, Bernardo Rossellino, and Simone Cronaca this essentially classicizing tradition—which shaped the actual environment of people living in the Renaissance—was handed down to the Sangallo brothers, Leonardo da Vinci, Bramante, and Raphael.

In Donatello's imagination the classicizing impulse was always challenged by a fanatical naturalism, at times akin to that of the great Northerners, while a persistent undercurrent of tendencies inherited from the International Style can be observed in the works of his two rivals for immortality, Jacopo della Quercia and, even more noticeably, Lorenzo Ghiberti. And in Masaccio's paintings, where direct borrowings from the Antique are either doubtful or insignificant,[2] the classical element is largely restricted to those features for which, we recall, the painter may be presumed to have

[1] For all this, see above, p. 18 ff.

[2] Apart from the Eve in the *Expulsion from Paradise* in the Carmine Chapel (a figure allegedly inspired by an original *Venus pudica* but more closely akin to such derivations of the latter as Giovanni Pisano's *Prudence*, mentioned above, p. 149 f., and known to Masaccio from his stay at Pisa in 1426), there may be adduced, first, the head of St. John in the *Tribute Money*, also in the Carmine Chapel, which vaguely resembles that of Antinous (K. Steinbart, *Masaccio*, Vienna, 1948, p. 53, Fig. 59; two other classical reminiscences discovered by Steinbart in the same fresco and its "Nebenszene" seem even less convincing to me); and, second (though only tentatively), the Christ child in the *St. Anne* in the Uffizi, Who, as again pointed out to me by Mrs. Anne de Egry, is somewhat reminiscent of the *Boy with the Fox-Goose* (G. Rodenwalt, *Die Kunst der Antike* [*Hellas und Rom*], 2nd ed., Berlin, 1927, p. 489).

relied on the assistance of his friend Brunelleschi: the magnificent setting, just mentioned, of the *Trinity* in S. Maria Novella (Fig. 129) and the throne in the London *Madonna* of 1426 (Fig. 130). Its base is fashioned after a strigilated sarcophagus, and its two-storied superstructure, a kind of *scaenae frons* in miniature, provides what may be called an object lesson in ancient architecture: displaying diminutive examples of three different classical orders (Corinthian, Ionic and Composite) in such a manner that the Corinthian and Composite columns of the wings are shown in front view while the Ionic columns of the back appear in profile, this throne looks like an excerpt from Brunelleschi's Roman notebooks.

With all the reservations appropriate to general statements of this kind, it may be said that, prior to the middle of the Quattrocento, classical motifs entered Italian painting chiefly through the intermediary of either sculpture or architecture or both; and that, taking the intensity of classicizing tendencies to indicate the strength of the "Renaissance" impulse as such, the operation of the mutational process which took place, in Italy as well as in the Netherlands, in the first quarter of the fifteenth century can be expressed by a chiastic pattern:

	ITALY	NETHERLANDS
Maximal change:	Architecture and "Decorative Arts"	Music
	Sculpture	Painting
	Painting	Sculpture
Minimal change:	Music	Architecture and "Decorative Arts"

III

IN PICTURES such as Masaccio's London *Madonna* a curious dichotomy can thus be observed between the classical style of the setting and the non-classical or, at least, less classical style of the figures. And this dichotomy—less noticeable only where, as in Paolo Uccello's fresco in memory of John Hawkwood (Giovanni Acuto) in Florence Cathedral or in Castagno's *Farinata degli Uberti* in S. Apollonia, a painter operated with a work of sculpture in mind[1]—was to inhere in Quattrocento painting for several decades, not only in religious but also, even more conspicuously, in secular representations.

[1] Uccello's fresco, its present form dating from 1436, may be said to fuse the reminiscence of such North Italian funerary monuments as that of Paolo Savelli in the Frari Church at Venice (where Uccello had stayed from 1425 up to at least 1427) with that of classical originals (and we should not forget that he had started his career in the workshop of a sculptor very much interested in antiquity, Lorenzo Ghiberti) into a pictorial anticipation of Donatello's *Gattamelata* (completed in 1453), which monument in turn may have exerted some influence upon the counterpart of Uccello's *John Hawkwood,* Castagno's *Niccolò da Tolentino* of 1456. This is all the more likely as the latter's *Farinata* (probably 1450–1455) is hardly imaginable without the painter's familiarity with Donatello's *David* in the Bargello (probably 1430–1432) while his *Pippo Spano* (in the same series) is reminiscent of Donatello's *St. George* (completed in 1417).

Even Donatello, *grande imitatore degli antichi*, preferred to place classical motifs in the service of Christian iconography. With such exceptions as the *Gattamelata* and the *"Atys-Amorino"*—whom I propose to call *Time as a Playful Child Throwing Dice* (Fig. 131)[1]—he refrained from illustrating subjects from pagan mythology for their own sake (the fairly pedestrian medallions in the courtyard of the Palazzo Medici-Riccardi, most of them literally copied after cameos in Medici possession, have little or nothing to do with his personal style). Much less did he indulge, like his pupil Bertoldo di Giovanni, in free inventions *all'antica*. His most classical nude is not an Apollo but a David. His most classical profiles belong not to pagan goddesses but to the Virgin

[1] For the untenability of all previous interpretations, particularly that as Atys, see H. W. Janson, *The Sculpture of Donatello*, Princeton, 1957, p. 143 ff., Pls. 237-241. My own proposal —suggested by my friend Harold F. Cherniss, who, upon looking at a photograph of Donatello's statue, at once recited the crucial text—is based upon a fragment of Heraclitus, transmitted in St. Hippolytus' *Refutatio omnium haeresium*, IX, 9, 3. In it, Aion, the polymorphous (ποικιλόμορφος, as Nonnus calls him) daemon of time, determining the fate of the world and therefore closely associated with Pan (whose name was always, even in mediaeval times, believed to signify the universe, τὸ πᾶν), is compared to a frivolous child playing a game of chance: "In order to show that the [ruler of the] universe is a child and through time governs all, he [Heraclitus] says what follows '*Time is a playful child throwing dice;* the kingship belongs to a child'", ὅτι δέ ἐστι παῖς τὸ πᾶν καὶ δι' αἰῶνος βασιλεὺς τῶν ὅλων οὕτως λέγει· αἰὼν παῖς ἐστι παίζων, πεσσεύων· παιδὸς ἡ βασιληίη (E. Diels, *Fragmente der Vorsokratiker*, 6th ed., I, Berlin, 1951, Herakleitos, Fragment B 52). And this Heraclitan phrase—alluded to in a poem by Gregory of Nazianzus (*Carmina*, LXXXV, reprinted in *Patrologia Graeca*, XXXVII, col. 1431 f.) and re-emerging, with an inverted sign, in Albert Einstein's famous "God does *not* play dice"—would make a perfect label for Donatello's little figure, whose apparent *joie de vivre* would then acquire, in the sombre light of Heraclitus' pessimism, an unexpectedly profound and, to my mind, very Donatellesque significance. Most of its attributes—the shoulder wings, the foot wings, the friendly snake—are typical of Time throughout. The little tail belongs, of course, to Pan. And the contrast between the genitals conspicuously exposed by the "barbarian" trousers (very appropriate to a divinity of Iranian origin) and the poppies on the belt (time-honored symbols of sleep and death) may serve to

express Time's twofold function as procreator as well as destroyer of all things:

"Do not I, tyme, cause nature to augment,
Do not I, tyme, cause nature to decay,
Do not I, tyme, cause man to be present, ...
Do not I, tyme, cause dethe take his say"?

This very superabundance of attributes is in itself characteristic of "maniform Aion" in such Late Hellenistic renderings as the so-called "*Mithraic Aion*" and the Orphic *Phanes* (for illustrations, see, e.g., Panofsky, *Hercules am Scheidewege*, Text III. 1 and Fig. 8; *idem*, *Studies in Iconology*, Fig. 36). But the most convincing parallels between Donatello's statue and the idea of "Time as a frivolous child playing dice" are, needless to say, the subject's age, his—to quote Janson—"somewhat tipsy gaiety" and, most particularly, his gesture. Who knows whether the "light object" which he apparently once held between the thumb and middle finger of his left hand (Janson, p. 145) was not actually a die or a "backgammon piece" (πεσσός)?

It may be objected that neither Donatello nor his humanistic advisers are likely to have known of Heraclitus' παῖς παίζων, πεσσεύων. But many of the Byzantine scholars and theologians who accompanied Emperor Johannes VIII Palaeologus to Italy and participated in the Council of Florence in 1439 may well have been familiar with Hippolytus' *Refutatio* long before it became generally accessible to the Western world. In fact, the Florence of about 1440 is about the only place where learned conversation may well have turned to a dictum of Heraclitus tucked away in the polemical treatise of an early Greek Father before the days of Diels and Wilamowitz-Möllendorff; and it is not astonishing that Vasari and Giovanni Cinelli, writing in 1568 and 1677, respectively, were no less completely baffled by Donatello's "*Atys-Amorino*" than any modern interpreter.

Mary. The orgiastic *putti* that enliven the *cantoria* of Florence Cathedral and the pulpit projecting from the Cathedral of Prato sound their pipes and timbrels not in honor of Dionysus but of Christ. And when the pedestal of his *Judith* shows similar *putti*, in part directly inspired by classical models, engaged in genuine Bacchanalian rites and activities, these rites and activities serve to accentuate the fact that Judith stands for the virtue of Temperance or Chastity, whereas her victim, Holofernes, personifies the vice of Luxury or Incontinence.[1]

However, no matter whether Donatello's figures were freely invented, portrayed from life or influenced by classical models (and, in the latter case, no matter whether these models were subjected to an *interpretatio Christiana*), they were sufficiently informed with a classical spirit not to conflict with an architectural and decorative setting *all' antica* (Fig. 132). That "balance between a return to the classics and a return to nature" which had been achieved by Tuscan sculpture in the first half of the fifteenth century enabled the characters of Donatello and his contemporary confrères to exist without friction in an environment conforming to the standards of a Brunelleschi or an Alberti while, on the other hand, no intolerable discord resulted from Ghiberti's staging the visit of the Queen of Sheba in front of a temple which, perhaps in order to stress its prefigurative significance, combined Corinthian capitals and aediculated windows *à la* Brunelleschi with pointed arches and Gothic vaults.[2]

Not so with painting. Where Donatello's David looks like an Apollo, where his *Miraculous Healing of the Unfilial Son* resembles a dismemberment of Pentheus,[3] and where the Marys in his Crucifixions and Depositions behave like Maenads, the Aeneases and Didos, Scipios and Alexanders, Venuses and Psyches seen in contemporary (or even later) cassone panels, easel paintings, book illuminations, and even frescoes look "as if Donatello had never lived".[4] Except for such Apollonian nudes as the St. John

[1] See E. Wind, "Donatello's Judith: A Symbol of 'Sanctimonia'", *Journal of the Warburg Institute*, I, 1937, p. 62f.; Janson, *ibidem*, p. 198ff., Pls. 349–377. In the friezes and frames of Donatello's pulpits in S. Lorenzo similar Children's Bacchanals as well as several variations on the *Horse Tamers* of Montecavallo (Janson, p. 209ff., Pls. 378, 401, 421–423, 429, 440f., 455–458, 464f., 471f.) are also used by way of contrast with the content of the reliefs themselves—in much the same way as are, within the reliefs, such elements as pagan idols or the column of Trajan.

[2] See Krautheimer, *Lorenzo Ghiberti*, particularly pp. 258, 265; Pls. 116–119, 120b.

[3] That the main group of Donatello's relief (Padua, S. Antonio, superbly illustrated in Janson, *The Sculpture of Donatello*, Pl. 306), derives from a Pentheus sarcophagus (one specimen still preserved in the Cam-

posanto at Pisa) is mentioned in an article by F. Saxl referred to by Janson, p. 186, Note 16, but was discovered by A. Warburg, who used to cite the case to illustrate what he called *"energetische Inversion"*: the appropriation of a representational type for a purpose diametrically opposed to its original significance. Donatello here reinterpreted the tearing-off a leg from Pentheus (who had offended Dionysus and was dismembered by the Maenads) into the restoration of a leg to a refractory son who had cut it off by way of punishing himself for having mistreated his mother.

[4] I borrow this phrase (intentionally omitting the words "and Masaccio") from the admirable article by E. H. Gombrich, "Apollonio di Giovanni", *Journal of the Warburg and Courtauld Institutes*, XVIII, 1955, p. 16ff.

discarding his robes to assume the "coat of camel's hair" in Domenico Veneziano's Washington predella panel, they either continue to conform to the standards of the International Style (Fig. 133)[1] or, more often than not, resemble the ladies and gentlemen strutting about in contemporary Florence or Siena—ladies and gentlemen whose apparel, all differences of detail notwithstanding, was not essentially dissimilar to that worn by their social equals in Bruges or Ghent; Flemish woolens were as fashionable in Italy as Italian silks, brocades and velvets were in the Netherlands and France. With the fresh influence of the Flemings—as opposed to the lingering tradition of the International Style—the appearance of Paris and Helen became indistinguishable from that of Philip the Good and Isabella of Portugal as portrayed by Roger van der Weyden (Fig. 136).[2] And yet all these non-classical figures—non-classical except for such feeble attempts at suggesting an "authentic" atmosphere as the occasional substitution of little "Medusa's wings" for the ladies' wimples and *hennins* or Greek (that is to say, Byzantine) hats for the gentlemen's *chaperons*[3]—normally move, as did the artists and their patrons themselves, in an architectural environment designed, decorated and furnished *all' antica*.

Since this discrepancy between the style of the figures and that of the setting can be observed in secular as well as in religious painting (where it is less conspicuous only because the costume of the most frequent and most prominent personages, particularly Christ, the Apostles and the Virgin Mary, had hardly ever departed from the essentially classical tradition established in Early Christian art), it cannot be accounted for by a persistence of the mediaeval principle of disjunction; this "law" may serve to explain the relatively long survival of a tendency to place an *interpretatio Christiana*, either by way of contrast or by way of parallel, upon classical motifs, particularly such poignantly "heathenish" themes as pagan idols or rituals;[4] but it does not suffice to explain the

[1] Cassone front, Yale University Art Gallery, convincingly attributed to Apollonio di Giovanni by Gombrich, *ibidem*.

[2] S. Colvin, *A Florentine Picture Chronicle, Being a Series of Ninety-Nine Drawings ... by Maso Finiguerra ... in the British Museum*, London, 1898, Pl. 57 (Warburg, *op. cit.*, I, p. 74, Fig. 19); for the headgear worn by the participants, cf. Roger's portrait, of Philip the Good and Isabella of Portugal reproduced, e.g., in Panofsky, *Early Netherlandish Painting*, Figs. 363 and 376.

[3] For the ladies' "Medusa's wings", see Warburg, *ibidem*, pp. 81 ff., 315, 336 ff. and Fig. 23; for the influence of Byzantine fashions, reputed to reflect the costume of ancient Greece and brought into prominence by the visit of Emperor John VIII

Palaeologus in 1438–39, see *ibidem* (pp. 315, 336 ff.; Figs. 68–70) and Gombrich, "Apollonio di Giovanni". For the would-be classical armor of Piero della Francesca's St. Michael in the National Gallery in London, cf. M. Meiss, "A Documented Altarpiece by Piero della Francesca", *Art Bulletin*, XXIII, 1941, p. 53 ff., particularly p. 63.

[4] For the Bacchic scenes on the pedestal of Donatello's *Judith*, see above, p. 170. For pagan sacrifices represented (mostly as simulated reliefs) in paintings such as Giovanni Bellini's *Redeemer* in the London National Gallery or in Mantegna's *Condemnation of St. James* (our Fig. 136), see F. Saxl, "Pagan Sacrifice in the Italian Renaissance", *Journal of the Warburg Institute*, II, 1939, p. 346 ff.

non-classical figure style obtaining in early Quattrocento painting in general. On the other hand, however, not only cassoni, *deschi da parto* and book illuminations but also major panel and fresco paintings are affected (witness, e.g., Francesco Cossa's murals in the Palazzo Schifanoia at Ferrara[1] or even Piero della Francesca's *Legend of the Holy Cross* in S. Francesco at Arezzo, where only the columnar grandeur of the figures prevents us from realizing that they are, morphologically speaking, "contemporary" whereas their architectural background is classical); we can, therefore, hardly appeal to an "independence of the cassone tradition *vis-à-vis* the achievements of monumental art" which, as the author of this happy phrase judiciously emphasizes, is only "relative".[2] In my opinion the discrepancy here under discussion reflects with particular clarity that general and inherent difference which I believe to distinguish painting from architecture (plus the "decorative arts") and sculpture *qua* media.

IV

THE reconciliation of this difference was perceived as a problem by many prominent Italian painters from the third quarter of the fifteenth century. But the solution of this problem began with a kind of incubation period during which classical figures or groups were avidly recorded and imaginatively developed in the so-called sketchbooks of such art-loving antiquarians as Cyriacus of Ancona,[3] Felice Feliciano or Giovanni Marcanova[4] and such archaeologically-minded artists as Pisanello,[5] Michele di Giovanni da Fiesole,[6] Gentile da Fabriano or Jacopo Bellini.[7] It was but slowly and gradually that these motifs found their way into murals, panel paintings and (later on) prints so as to enter the bloodstream of living art.

This process of extending what Warburg has called the "klassischer Idealstil" from

[1] Even though the Schifanoia murals were completed as late as towards 1470 such purely classical motifs as the Three Graces group in the Venus fresco (correctly stressed by Saxl, *"Rinascimento dell' antichita"*, p. 252, Fig. 20) sneak in by the back door, so to speak, and remain strangers in a generally non-classical company.

[2] Gombrich, "Apollonio di Giovanni", p. 31.

[3] For him, see Saxl, "The Classical Inscription in Renaissance Art and Politics", and, more recently, B. Ashmole, "Cyriac of Ancona and the Temple of Cyzicus", *Journal of the Warburg and Courtauld Institutes*, XIX, 1956, p. 179 ff.

[4] For the illustrations in Marcanova's *Antiquitates*, see E. B. Laurence, "The Illustrations of the Garrett and Modena Manuscripts of Marcanova", *Memoirs of the American Academy at Rome*, VI, 1927, p. 127 ff.

The Garrett manuscript is now in the Princeton University Library, where it bears the signature MS. Garrett 158 (fol. IV, showing the Roman Capitol with the statue of Marcus Aurelius, reproduced in Heckscher, *Sixtus IIII*, Frontispiece).

[5] See, e.g., B. Degenhart, *Antonio Pisanello*, Vienna, 1940, particularly Figs. 30, 31, 33, 146.

[6] Idem, *Italienische Zeichnungen des frühen 15. Jahrhunderts*, Basel, 1949, p. 45 ff.; Figs. 29, 30.

[7] Purely archaeological studies are found on at least two pages of Jacopo Bellini's London sketchbook (Goloubew, *op. cit.*, II, Pls. XLIII, XLIV). For secular compositions based on, or incorporating, the impression of classical monuments, see, e.g., *ibidem*, I, Pls. CIII, CIV, CXXVI, CXXXII; II, Pls. XXXIV XXXV, XXXVIII, XL, XLIV, XLVIII.

the stage sets to the *dramatis personae* did not, however, take its inception in Florence, where major developments had to wait until Lorenzo and Giuliano de' Medici were old enough to assert themselves in matters of taste; much less in Rome which—*pace* Antoniazzo Romano—had so little importance as an artistic center throughout the fifteenth century that no resident of the Eternal City was deemed capable of participating in the decoration of the Sistine Chapel. Rather it was in North Italy—where the universities of Padua, Pavia, Bologna, and Ferrara had been the foci of secular studies for centuries, where most of the great Italian poets, from Dante and Petrarch down to Ariosto and Tasso, had started their careers as students of law, and where the aristocratic and consistently mundane spirit prevailing at the courts of the Scaligeri, the Este, the Visconti, the Gonzaga, and the Malatesta as well as in the oligarchic society of Venice provided a better climate for antiquarian studies than did the bourgeois and less stable atmosphere, often disturbed by social and religious upheavals, that pervaded the city republics of Tuscany—that the initial steps towards an integration of classical environment with classical figures were taken. Here more than anywhere else we can observe the emergence of an antiquarian attitude so pervasive that the archaeologists, the painters and the humanists pure and simple worked and lived, as it were, in unison.

On a fine morning in September 1464 three friends—later on joined by a fourth—set out, "in order to refresh their spirits", for an excursion on the Lago di Garda. They revelled in the beauty of fragrant gardens and enchanted islands but took time out to copy the handsome inscription on a classical marble column; and when they sailed home in their little boat one of the group assumed the role of a Roman emperor, crowned with laurels, singing and playing the lyre, while the two others acted the part of consuls.[1]

Such a piece of classicizing tomfoolery—playful, yet carrying an undertone of genuine sentiment so that it could conclude, characteristically, with a prayer of thanks to the Madonna and her Son for having granted the participants "the wisdom and the will to seek out such delightful places and such venerable ancient monuments"—is not surprising at a time when Marsilio Ficino revived the celebration of Plato's suppositive birthday (November 7) by a solemn reenactment of the Symposium[2] and when the members of the Roman "Academy" disfigured the walls of the Catacombs with inscriptions calling themselves *sacerdotes* and referring to their chairman, Pomponius Laetus, as *pontifex maximus*.[3] What is significant is that the party of visitors to the Lago di Garda was not exclusively composed of philosophers and *littérateurs*. Besides a nearly

[1] See Tietze-Conrat, *Andrea Mantegna*, p. 14; cf. Meiss, *Andrea Mantegna*, particularly pp. 55 ff., 91.

[2] See A. della Torre, *Storia dell'Accademia Platonica di Firenze*, Florence, 1902, p. 813f. The event was deemed worthy of mention by Ficino himself; see the Prologue to his translation of the *Symposium* (*Opera*

omnia, 2nd ed., Basel, 1576, II, p. 1320). It should be noted, however, that the first celebration of Plato's birthday (believed to coincide with the day of his death) postdates the excursion on the Lago di Garda by four years.

[3] See Burckhardt, *Die Kultur der Renaissance*, II, p. 26.

forgotten Mantuan humanist, Samuele da Tradate, who played the "emperor", it included two of the antiquarians just mentioned, *viz.*, Giovanni Marcanova and Felice Feliciano (the narrator, who played one of the "consuls"), and, in addition, the latter's "incomparable friend", the painter Andrea Mantegna (cast in the role of second "consul"). And it is this Mantegna (1431–1506) who, as far as the revival of classical antiquity is concerned, did for Italian painting in the second half of the fifteenth century what Brunelleschi and Donatello had done for Italian sculpture and architecture from *ca.* 1420.

In Florence one of the earliest paintings to show a classical figure transposed into a painted one rather than rendered in a mere drawing is a picture, now generally considered as a late work of Andrea del Castagno (died 1457), where the terrified Pedagogue of the Niobids has lent the pathos of his pose and the agitated movement of his drapery to a victorious David (Fig. 134).[1] This work, however (quite apart from the fact that its author had been in Venice in 1442, possibly up to 1445), is an exception, first, in that it is a ceremonial shield painted on leather rather than a regular panel painting or fresco; second, in that the figure, set out against a landscape background, stands by itself instead of being brought into harmony with an architectural and decorative environment in the classical manner. And this was the very problem which, at exactly the same time (toward 1455), was being resolved in Mantegna's St. James frescoes in the Eremitani Chapel at Padua. In the *Condemnation of St. James* (Fig. 135), for example, the classical setting, dominated by an admirably proportioned triumphal arch which exhibits not only a pagan sacrifice and two medallions showing Roman emperors but also an authentic inscription recorded by Marcanova,[2] is brought into perfect harmony with no less classical figures, in part derived from individually identifiable models.[3]

It is, needless to say, impossible to file Mantegna away under the heading "classicism"; in what is perhaps his most "antiquarian" picture, the Vienna *Martyrdom of St. Sebastian*, teeming with Roman remnants and signed in Greek (ΤΟ·ΕΡΓΟΝ·ΤΟΥ· ΑΝΔΡΕΟΥ), one of the clouds fantastically assumes the shape of a horseman. Nor can it be denied that Mantegna owed much to Jacopo Bellini and even more to Donatello two of whose greatest works, the altar in the Santo and the *Gattamelata*, were still *in statu nascendi* when the young painter arrived at Padua at the age of seventeen.[4] But as little

[1] It is no accident that this picture, which has passed from the Widener Collection to the National Gallery at Washington, was considered as a work of Antonio Pollaiuolo when Warburg (*op. cit.*, II, pp. 449, 625; Figs. 104a, b) discovered its dependence upon the classical statue.

[2] Meiss, *Andrea Mantegna*, p. 92, Note 12.

[3] For this connection, see I. Blum, *Andrea Mantegna und die Antike*, Strasbourg, 1936, Figs. 1, 2; Meiss, *ibidem*, Figs. 11, 17.

[4] In addition, Mantegna's senior partner in the execution of the Eremitani frescoes, Niccolò Pizzolo, had been employed by Donatello for some years before.

as his indebtedness to Jacopo Bellini (his father-in-law since 1454) makes him a Venetian, as little does his indebtedness to Donatello—and, possibly, to such kindred spirits as Castagno and Uccello—make him a Tuscan. And the fact remains that the *klassischer Idealstil* of the Eremitani frescoes has no real parallel in contemporary Florence—jus as "antiqua" letters comparable to his do not appear there until about a decade later.[1]

Here the revision of the figure style according to classical standards did not generally begin until after 1450–1460, and it may well be that just the direct influence of the great Flemings, which can be seen to supersede what I have called the lingering tradition of the International Style precisely at this time,[2] helped to precipitate the development: "omne quod cognoscitur, cognoscitur per suam similitudinem vel per suum oppositum" ("whatever we know, we know either by its analogue or by its opposite"), says Thomas Aquinas. When Paris and Helen, no longer flattened into two-dimensional abstractions but naturalistically presented in three dimensions, had become indistinguishable, as I expressed it, from Philip the Good and Isabella of Portugal, and yet paraded their stiff Burgundian costumes and stiff Burgundian dignity beneath a frieze where Donatellesque *putti*—Christianized in the Florence *cantoria* and the Prato pulpit but re-paganized here—enact a Bacchanalian ritual (Fig. 136), the contradiction between the style of the principal figures and that of their environment had become so flagrant that something had to be done: the painters found themselves confronted with the task of infusing into their characters a vitality as unconstrained as that which animated the productions of contemporary sculpture—particularly when these appeared, in simulated form, in their own paintings or drawings.

Warburg has shown that one of the most effective means of suggesting this animation was a special emphasis, often an over-emphasis, on what he calls "bewegtes Beiwerk": windblown hair, billowing drapery, fluttering ribbons[3]—in short, the motifs characteristic of classical Victories, Horae and, most particularly, Maenads. But it is noteworthy that these alluring motifs—ubiquitously present in classical monuments, lovingly described in classical literature, explicitly recommended to painters by Leone Battista Alberti as early as *ca.* 1435, and producing a kind of obsession in the mind of a sculptor, Agostino di Duccio, only some ten or fifteen years later—did not in fact become a real

[1] See Meiss, *Andrea Mantegna*, p. 39.

[2] For the high esteem in which Netherlandish painting was held in Italy throughout the fifteenth century—so high that we must turn to Italian sources to find more about the great Netherlandish painters than records of payment or civil status—see Warburg, *op. cit.*, particularly pp. 177–239. In H.-W. von Löhneisen, *Die ältere niederländische Malerei, Künstler und Kritiker*, Kassel, 1956, the sources are unfortunately arranged according to a complicated system which makes it difficult to single out the Italian ones. For Eyckian influence in particular, see Meiss, "Jan van Eyck and the Italian Renaissance", *Acts of the XVIIIth International Congress of the History of Art* (in print); *idem*, "A Documented Altarpiece by Piero della Francesca", particularly p. 63 ff.

[3] See Warburg, *op. cit.*, I, p. 5 ff.

vogue in painting until the sixth and seventh decades of the fifteenth century. And in Christian iconography they tended to be reserved, even then, to angels, on the one hand, or to excessively mundane or socially inferior characters, on the other; Fra Filippo's dancing Salome in Prato Cathedral and Ghirlandaio's pretty handmaidens in S.M. Novella are cases in point.

In Quattrocento painting, then, the fashion of "bewegtes Beiwerk" came into being precisely when Flemish influence, in style as well as technique, was approaching its zenith, and this coincidence may well be more than a coincidence in time. We can imagine that the Northern preoccupation with light, color and surface texture made the Italian painters the more acutely aware of plastic form, linear design and organic function; and that the very "piety" and introspectiveness of the early Netherlanders, admired by the *grandes dames* and detested by Michelangelo, served to open—or, at least, to sharpen—the eyes of these Italian painters to the eternally pagan in classical art. In fact, Mantegna, that pioneer of the classicizing style in North Italy, not only yielded to Flemish influence in individual cases but absorbed it to such an extent that his work "from time to time resembles Jan van Eyck's".[1]

The same is true, *mutatis mutandis*, of the master who—Castagno's leather shield and Fra Filippo's latest frescoes notwithstanding—played an analogous role in Florence: Antonio Pollaiuolo. In order to do justice to the naked human form in action, he became the first *pittore anatomista*; he told (apparently from as early as 1460–1465) the story of Hercules in classical rather than mediaeval language, in this respect—conceivably because the Florentine Neo-Platonism produced a climate of universalistic tolerance—slightly ahead of Mantegna, who up to *ca.* 1470–1475 practised his *buona maniera moderna* within the framework of Christian iconography. He rendered Roman kings and generals in heroic nudity, transplanted Bacchic dances to the walls of a villa near Florence and, in doing all this, utilized not only Roman statuary but even Greek vases.[2] He placed so excessive an emphasis on calligraphic contours that a great art historian saw fit to call him a "rococo turner"; yet he arrayed young David, the very character exploited by the sculptors to parade their command of the nude, in a coquettish costume on the fur and velvet of which he lavished all the refinements of the *maniera Fiamminga* and silhouetted his naked figures (which he, in contrast to Mantegna, never incorporated into an architectural context) either against a neutral background or against luminous landscapes unimaginable without a thorough study of the great Netherlanders.

[1] Meiss, *Andrea Mantegna,* p. 27.
[2] See Saxl, "*Rinascimento dell' antichità*"; F. Shapley, "A Student of Ancient Ceramics, Antonio Pollaiuolo", *Art Bulletin,* II, 1919, p. 78 ff. Cf. also Panofsky, *Albrecht Dürer,* II, p. 95 ff.

V

BE THAT as it may, it was not until the sixth decade of the fifteenth century, and in concurrence with the rise of Flemish influence, that the *klassischer Idealstil* began to dominate the style of the figures as well as that of the scenery in Quattrocento painting. And it was this step which coincided with what I have called the re-integration of classical form and classical subject matter, not only in that well-known themes, preferably scenes throbbing with "breathing human passion",[1] were reformulated *all' antica*, but also in that literary sources either unknown or—like Ovid's *Fasti*—neglected during the Middle Ages were illustrated *de novo*; in that classical pictures were "reconstructed" from such descriptions as are found in Lucian and Philostratus;[2] and in that the artists indulged in free inventions, more often than not of a heavily allegorical nature, which could be held up to visiting Northerners as models of *antikische Art*.

It is a well-known fact that not only individual texts but whole authors had lain dormant, as it were, throughout the Middle Ages until they were spectacularly "rediscovered" (the Greek authors in Byzantine, the Latin ones in Carolingian manuscripts) by the early humanists, first by Petrarch and the Petrarchians and later by such sleuthhounds as Guarino Guarini of Verona and Poggio Braccriolini, or even twice in succession. Less well-known, however, is the fact that most of these "rediscoveries", not unlike delayed-action bombs, failed to produce any significant effect on the visual arts, particularly painting, until the last third of the fifteenth century.

Lucian's *Calumny of Apelles* had been translated into Latin as early as 1408, and the subject was explicitly recommended to painters by Alberti as early as *ca.* 1435;[3] but so far as we know his advice went unheeded until Botticelli produced his famous painting (Fig. 149) about fifty years later.

The story of Hercules at the Crossroads was briefly retold by Petrarch and somewhat later, at the turn of the fourteenth century, circumstantially paraphrased by Coluccio Salutati;[4] but it did not appear in a work of art—characteristically still a book illustration rather than a panel painting or mural and, even more characteristically, a *propria manu* production of Felice Feliciano—until 1463.[5] Lucretius' *De rerum natura*, both

[1] For a statistical survey of secular themes in Renaissance art, showing its predilection for "scenes of seduction or rape, of love or drunken revelry", see the literature referred to in Seznec, *op. cit.*, p. 5, Note 6. Cf. also an inconspicuous but instructive pamphlet by F. Saxl, *Classical Antiquity in Renaissance Painting*, London, 1938.

[2] R. Förster, "Die Wiederherstellung antiker Gemälde durch Künstler der Renaissance", *Jahrbuch der preussischen Kunstsammlungen*, XLIII, 1922, p. 126ff.

[3] See the literature referred to above, p. 26, Note 2.

[4] My error in crediting Coluccio Salutati rather than Petrarch with the earliest paraphrase in post-mediaeval literature (Panofsky, *Hercules am Scheidewege*, p. 155) was justly corrected by T. E. Mommsen, "Petrarch and the Story of the Choice of Hercules", *Journal of the Warburg and Courtauld Institutes*, XVI, 1953, p. 178ff.

[5] Rome, Vatican Library, Cod. Reg. lat. 1388, illustrated in Panofsky, *ibidem*, Frontispiece. Apart from

recklessly exploited and furiously attacked by the Fathers of the Church but so completely forgotten in the later Middle Ages that even Dante never alludes to it, was "rediscovered" by Poggio Bracciolini and printed from as early as 1473; but this rediscovery—of fundamental importance for natural philosophy, science and poetry—made no impression on art until the very end of the Quattrocento.[1] The same applies to "Horapollo's" *Hieroglyphica,* that *fons et origo* of what is called emblematism, a manuscript of which had been unearthed on the Island of Andros in 1419 and was brought to Florence a few years later. Its appearance—this time a real discovery—was enthusiastically greeted by the humanists but failed to interest any artist for more than two generations.[2]

Even Vitruvius' *De architectura,* frequently copied from Carolingian times and never forgotten—though only sporadically and peripherally utilized—throughout the Middle Ages, had to be "rediscovered" at the threshold of the Renaissance, and this not only once but twice: first by Boccaccio who, in the virtual absence of fourteenth-century manuscripts, was forced to have the Codex Montecassinensis transcribed at his own expense; and, nearly half a century later, by Poggio Bracciolini in 1414.[3] But it was

a Mantegnesque drawing in Christ Church Library, Oxford (the iconography of which is still in doubt), the next case is again a book illustration found in an Italian MS. containing, *inter alia,* Donatian's *Grammar* (Milan, Biblioteca Trivulziana, MS. 2167) which can be dated, with some accuracy, in 1496. This illustration, a miniature in the narrower sense of the term, was published by E. Tietze-Conrat, "Notes on 'Hercules on the Crossroads'", *Journal of the Warburg and Courtauld Institutes,* XIV, 1951, p. 305, Pl. 52 b; the Christ Church drawing is discussed and reproduced *ibidem,* P. 52 a. It should be noted, however, that the roles of the contestants in the Milan miniature are reversed in Mrs. Tietze-Conrat's description. The left-hand figure—dressed in a dark garment, pointing heavenward and placed in front of a wooded hill surmounted by a castle—obviously personifies Virtue; whereas the right-hand figure—wearing a light-colored dress, pointing downward and standing in front of a barren rock out of which grow two specimens of the proverbial "dry tree"—as obviously personifies Pleasure or Vice. In fact, young Hercules (portrayed in the guise of the first-born son of Lodovico Sforza) turns toward the dark-clad figure in spite of her opponent's persuasive gestures.

[1] See J. Philippe, "Lucrèce dans la théologie Chrétienne du III^e au XIII^e siècle", *Revue de l'Histoire des Religions,* XXXII, 1895, p. 284ff., and XXXIII,

1896, pp. 19ff., 125ff.; E. Bignone, "Per la Fortuna di Lucrezio e dell' Epicureismo nel medio evo", *Rivista di Filologia e di Instruzione Classica,* XLI, 1913, p. 231ff.; A. M. Schmidt, *La Poésie scientifique en France au seizième siècle,* Paris, 1938, *passim.* For Lucretius' influence on Neo-Platonism, see F. F. Gabotto, "L'Epicureismo di Marsilio Ficino", *Rivista di Filosofia Scientifica,* X, 1891, p. 428ff., and for his influence on Fracastoro, A. Castiglioni, "Gerolamo Fracastoro e la dottrina del *contagium vivum",* *Gesnerus,* VIII, 1951, p. 52ff. For his effect on Quattrocento painting, cf. Panofsky, *Studies in Iconology,* particularly pp. 40–65 (see also below, p. 180 ff.) and the literature referred to there, p. 55, Note 60. Characteristically, the preface to Aldo Manuzzi's Lucretius edition of 1500 explicitly dissociates the publisher and the editor from whatever may be contrary to Catholic doctrine in *De rerum natura.*

[2] For the influence of the *Hieroglyphica* (now accessible in a handy English translation by G. Boas, *The Hieroglyphs of Horapollon,* New York, 1950), see the literature cited in Seznec, *op. cit.,* p. 100ff. It should not, however, be forgotten that the tremendous importance of this influence was recognized by Karl Giehlow as early as about 1900; cf. Panofsky and Saxl, *Dürers "Melencolia I.",* pp. IX–XV.

[3] The literature on the survival of Vitruvius in the Middle Ages and its influence on Renaissance architecture and art theory is immense. I limit myself

only another thirty or forty years after this second discovery that—in Alberti's *De architectura*—the Vitruvian doctrines became a living part of architectural theory, and it took them even longer to leave their mark on the representational arts. Boccaccio limited himself to quoting several passages in a purely mythographical context, the longest and most important of these quotations being Vitruvius' account of the origins of human civilization which is adduced in support of the queer notion that Vulcan, the god of fire, was nurtured by apes in his youth.[1] Not until *ca.* 1460 did this Vitruvius passage begin to influence the illustrations of treatises on architecture;[2] and not until the end of the century did it fire the imagination of a painter.

This painter was the delightful and eccentric Piero di Cosimo who, though a "very good and zealous man", refused to admit a priest to his deathbed; who hated doctors and nurses no less intensely than chanting monks but liked to listen to a good downpour; who was "madly in love" with animals and full of admiration for anything produced by nature "either by fancy or accident"; who derived his greatest pleasure from long, lonely walks; and who even refused to have the trees in his garden trimmed because "nature should be allowed to take care of herself".

Though a displaced primitive himself, Piero di Cosimo was far from imagining the primordial condition of man as one of undisturbed bliss—either in the sense of Hesiod's Golden Age or of the Biblical "state of innocence". He considered the age in which he lived as depraved not by a willful departure from primaeval contentment, much less by a Fall from Grace, but only by the over-sophistication of a cultural development that had forgotten where to stop. And in an attempt to show how man, not by divine intervention but by the application of his own innate abilities, had learned to conquer the evils and hardships of what we call the Stone Age while keeping clear of constraint and artificiality, he drew not only from the *Libellus de imaginibus deorum,* from Virgil's *Aeneid* and from Ovid's *Fasti,* but also from those two classical authors in whom he

to the following titles: F. Pellati, "Vitruvio nel medioevo e nel rinascimento", *Bollettino del Reale Instituto di Archeologia e Storia dell' Arte,* V, 1932, p. 111 ff.; *idem, Vitruvio,* Rome, 1938, Wittkower, *Architectural Principles, passim;* G. Lukomski, *I Maestri della Architectura Classica Italiana da Vitruvio allo Scamozzi,* Milan, 1933; H. Koch, *Vom Nachleben des Vitruv* (Deutsche Beiträge zur Altertumswissenschaft), Baden-Baden, 1951. It is, however, significant that the post-Carolingian writers of the Middle Ages mostly limit themselves to repeating Vitruvius' general statements about human proportions, which they tend to interpret in a cosmological rather than aesthetic sense (see, in addition to the instances referred to by Koch, pp. 14–16, an interesting French text quoted

by Wittkower, p. 15, Note 3); and that, contrary to Koch, Cennino Cennini's canon of human proportions has nothing to do with Vitruvius.

[1] Boccaccio, *Genealogia deorum,* XII, 70 (in V. Romano's edition, Bari, 1951, II, p. 624), quotes Vitruvius' *De architectura,* II, 1, for which see above, p. 24. Curiously enough just this long and interesting quotation not only seems to have escaped the notice of Koch, *op. cit.,* but is also absent from Romano's Index of Authors and Sources (II, p. 893).

[2] See p. 24, Note 2. Illustrated editions of the Vitruvius text itself did not begin to appear until 1511; see Lukomski, *op. cit.,* and P. G. Hamberg, *Ur Renässansens illustrerade Vitruviusupplagor,* Uppsala, 1955.

could find the most effective support for what we would designate as an evolutionistic interpretation of history: Lucretius and Vitruvius.

In the late 'eighties of the fifteenth century he adorned the house of a rich but rather unconventional wool merchant, Francesco del Pugliese, with a remarkable series of pictures (five of them preserved) which describe the first steps of human civilization as the transition from an *aera ante Vulcanum* to an *aera sub Vulcano*: they depict the rise of mankind from an age when human beings fought with animals on equal terms, and cohabited with them so as to produce such monsters as human-faced swine, to an early form of civilized life contingent upon the control of fire. The *priscorum hominum vita* before the advent of Vulcan is epitomized in three oblong panels, possibly destined for a kind of anteroom, the last of which represents the escape of men and beasts from a forest fire—that very forest fire which, according to Vitruvius and other classical authors, gave man his chance to outgrow his original bestiality by capturing some of the fleeing animals and by employing the burning logs for a first "hearth". The ensuing events unfold in two large canvases, approximately square in format. The first of these (Fig. 138) shows young Vulcan, precipitated from Mount Olympus onto the Island of Lemnos and still dazed from the fall, as he is helped to his feet by charitable nymphs. The second (Figs. 139, 140) represents him, grown to man's estate, as the first teacher of mankind: at work where others are still asleep and vigorously assisted by the wind god, Aeolus, the fire god produces and demonstrates an inconspicuous but new and very useful metal tool while some of his eager disciples proceed with the erection of such buildings as can be constructed, to use Vitruvius' phrase, "by putting up unsquared trees and interweaving them with branches".[1]

Some ten or twelve years later, probably about 1498 or shortly after, Piero di Cosimo executed for another, less subversive patron, Giovanni Vespucci, at least two pictures which illustrate man's progress to the next—in the painter's personal opinion perhaps the most desirable—phase of his development: the progress from the *aera sub Vulcano* to an *aera sub Baccho*, which added to the means of meeting the necessities of life the simplest and most natural means of enjoying it, wine and honey. Both, needless to say,

[1] For these five pictures—the panels depicting Life in the Stone Age divided between the Metropolitan Museum at New York and the Ashmolean Museum at Oxford, the canvas showing the Descent of Vulcan onto the Island of Lemnos in the Wadsworth Atheneum at Hartford (Conn.), and the canvas representing Vulcan and Aeolus as Teachers of Mankind in the National Gallery at Ottawa—see Panofsky, *Studies in Iconology*, pp. 43–59; R. Langton Douglas, *Piero di Cosimo*, Chicago, 1946, p. 27 ff., Pls. XI–XVI (as to the iconography of the Hartford picture, cf.

also the "correspondence" between these two authors in *Art Bulletin*, XXVIII, 1946, p. 286 ff.; XXIX, 1947, pp. 143 ff., 222 f., 284). It may be added that the interpretation of the peregrine falcon, who looms so large in this exchange of views, as a symbol of magnanimity is found, at Piero's time, not only in manuscript sources but also in a printed book published in Florence in 1491: *The Florentine Fior di Virtù of 1491*, N. Fearson, tr., L. J. Rosenwald, pref., Washington, D. C., 1953, p. 79 f.

are gifts of Bacchus; and one of Piero's pictures (Figs. 141, 142) depicts the Discovery of Honey exactly as described in Ovid's *Fasti*, III, 737–744: "Accompanied by satyrs and votaries, Bacchus proceeds through Thrace; and when his companions sound their cymbals, a young swarm of bees, attracted by the noise, gathers and follows wherever the resounding brass leads them. The god collects the stragglers, imprisons them in a hollow tree and gleans, as a prize, the honey thus discovered".[1]

In these and other mythological—or, if one may say so, pre-mythological—pictures, Piero di Cosimo approaches the sphere of *sacrosancta vetustas* in a spirit which may strike the modern beholder as either mediaeval or ultramodern. When the painter portrays Vulcan as a sturdy blacksmith fashioning a horseshoe and Aeolus as a grizzled journeyman enthusiastically working the bellows, when he shows Bacchus as a broadly grinning country lad and Ariadne as a somewhat simple-minded maiden examining her lover's wreath with a coyly pointed forefinger, when he depicts the satyrs and Bacchantes as a tribe of nomads on the march, burdened with babies and domestic implements and hypnotizing the bees by the noise of kettles, pots and fire-tongs rather than by the sounds of "pipes and timbrels", he either seems to relapse into the naiveté of that Northern book illuminator whose Pygmalion fits the statue with the dress of a Flemish bourgeoise (Fig. 55) or to anticipate the irreverence of a Daumier, if not an Offenbach.

That his renderings of classical subjects—like certain pictures by his Venetian contemporaries[2]—contain an element of parody and humor cannot be questioned. Their comicality, however, is essentially different from what we experience in viewing illustrations of the *Ovide moralisé* or the *Roman de la Rose*, on the one hand, and Daumier's lithographs, on the other. In contrast to his mediaeval forerunners, Piero was not naïve: his humor is intentional and must have been perceptible to his contemporaries as well as to ourselves. In contrast to his nineteenth-century successors, Piero was not a satirist: his humor is entirely without malice. He was fully aware of the difference between the present and the mythical past and could have justified, had he been asked to do so, all his seeming anachronisms by either classical monuments or classical texts. But in the helpful activities of Vulcan and Aeolus, in the *letizia al vivo* of Bacchus and his cortège, in the mute despair of a big dog mourning over the death of his mistress (I am referring, of course, to the dog Laelaps in Piero's *Death of Procris* in the National

[1] For these two pictures (both panels, one in the Worcester Art Museum at Worcester, Mass., the other in the Fogg Art Museum at Cambridge, Mass.), see Panofsky, *Studies in Iconology*, pp. 59–62; Langton Douglas, *op. cit.*, p. 61 ff., Pls. XL–XLV. For the ape in the Worcester panel, cf. Janson, *Apes and Ape Lore*, p. 257, Note 28.

[2] See Giovanni Bellini's *Feast of the Gods* in the National Gallery at Washington, for which cf. E. Wind, *Bellini's Feast of the Gods; A Study in Venetian Humanism*, Cambridge (Mass.), 1948, and John Walker, *Bellini and Titian at Ferrara; A. Study of Styles and Taste*, London, 1956, or Cima da Conigliano's *Procession of Silenus* in the Pennsylvania Museum of Art at Philadelphia (see L. Venturi, *Pitture Italiane in America*, Milan, 1931, Pl. CCCX), where the satyrs show unmistakably negroid features.

Gallery at London), he discovered a set of basic values which make the mythical characters no less accessible to affectionate empathy than are their apparently contemporary re-incarnations; whereas the modern satirist discovers in Mars and Venus, Paris and Helen, Orpheus and Menelaus a set of equally basic shortcomings which make them no less ridiculous than are the elderly middle-class couples doomed by Daumier to impersonate them.

VI

WHILE the re-emergence of Vitruvius' and Lucretius' evolutionism tended to bring the realm of ideas, including the idea of antiquity, down to earth, an altogether different philosophy, also erected on classical foundations, tended to link the terrestrial world, again including antiquity, to Heaven: the Neo-Platonic—or, as it ought to be called in contradistinction to that of Plotinus and his followers, Neo-Neo-Platonic—system evolved by Marsilio Ficino (1433–1499). From his modest villa at Careggi, given to him by Cosimo de'Medici in 1462, the teachings of this gentle "Philosophus Platonicus, Theologus et Medicus", as he liked to style himself, spread in ever-widening circles during the last two decades of his life. When he died, the movement initiated by him had conquered all Europe and, changing in content according to time and place, remained a major force in Western culture for many centuries.[1]

What made this movement so irresistible to all the *beaux esprits* of the Renaissance, from theologians, humanists and natural philosophers to men of fashion and courtesans, is precisely what makes it repugnant to those modern historians of science and philosophy who limit the concept of the latter to an analysis of knowing and the knowable, and that of the former to the mathematical analysis (or prognosis) of experimental observation: it blurred or abolished all those barriers which had kept things apart—but also in order—during the Middle Ages and were to be re-erected, under conditions and with alterations predicated upon their temporary disappearance, by Galileo, Descartes and Newton.

[1] The literature on Florentine Neo-Platonism and its influence on art is so extensive that—in addition to the still indispensable work of A. della Torre, cited above, p. 173, Note 2—only a few titles can be given (cf., however, the references in the following Notes): E. Cassirer, *Individuum und Kosmos in der Philosophie der Renaissance* (Studien der Bibliothek Warburg, X), Leipzig and Berlin, 1927; *idem, Die platonische Renaissance in England* (Studien der Bibliothek Warburg, XXIV), Leipzig and Berlin, 1932; Panofsky, *Studies in Iconology*, Chapters V, VI; P. O. Kristeller, *The Philosophy of Marsilio Ficino*, New York, 1943 (with excellent bibliography up to that year on p. 413 ff.); *idem, Studies in Renaissance Thought and Letters;* E. Garin, *L'Umanesimo italiano; Filosofia e vita civile nel rinascimento*, Bari, 1952; E. H. Gombrich, "*Icones Symbolicae:* The Visual Image in Neo-Platonic Thought", *Journal of the Warburg and Courtauld Institutes*, XI, 1948, p. 163 ff.; D. Redig de Campos, *Raffaello e Michelangelo*, Rome, 1946; F. A. Yates, *The French Academies of the Sixteenth Century* (Studies of the Warburg Institute, XV), London, 1947 (see Index); A. Chastel, "Art et religion dans la Renaissance italienne; Essai sur la méthode", *Bibliothèque d'Humanisme et Renaissance*, VII, 1945, p. 7 ff.; *idem, Marsile Ficin et l'art.*

The Neo-Platonic doctrine—a triumph of "decompartmentalization" and thus, in spite of all connecting links, essentially different from all Scholastic systems, including those of such accepted predecessors as Henry of Ghent or Duns Scotus—endeavored not only to fuse, instead of merely reconciling, the tenets of Platonic and pseudo-Platonic philosophy with Christian dogma (the very title of Ficino's major work, *Theologia Platonica,* would not have been possible in the Middle Ages) but also to prove that all revelation is fundamentally one; and, even more important from the layman's point of view, that the life of the universe as well as that of man is controlled and dominated by a continuous "spiritual circuit" (*circuitus* or *circulus spiritualis*) that leads from God to the world and from the world to God. For Ficino, Plato is both a "Moses talking Attic Greek" and an heir to the wisdom of Orpheus, Hermes Trismegistus, Zoroaster, and the sages of ancient Egypt. The Neo-Platonic universe is a "divine animal", enlivened and unified by a metaphysical force "emanating from God, penetrating the heavens, descending through the elements, and coming to its end in matter".

The microcosm, man, is organized and functions according to the same principles as the macrocosm. He, too, can be described as a hierarchy of four hypostases or "degrees", Mind (*mens*), Soul (*anima*), Nature (*natura*), and Body (*corpus*), that is to say, "Matter extolled by Form"; and both these entities, the universe and man, are so constructed that their less perfect strata are, as it were, the middle terms between the highest and the lowest. While the "ineffable One" (or God) is incorruptible, stable and simple, the first "degree" under Him, Mind, is incorruptible and stable but multiple, comprising as it does the ideas that are the prototypes of all that which exists in the lower zones. The next degree, Soul, is still incorruptible but no longer stable. Moving with a self-induced motion, it is a locus of pure causes rather than pure forms and, anthropologically speaking, dichotomous. The human soul comprises two parts: the "first" or "higher" soul, viz., reason; and the "second" or "lower" soul, viz., inward and outward perception (to wit, imagination and the five senses) as well as the faculties of procreation, nutrition and growth. Man, therefore, shares his "mind" with the Mind divine, and his "lower soul" with the animals; his "higher soul", or reason, however, he shares with nothing in the universe. And while his "mind" is a principle of pure, unconscious thought, providing absolute insights but capable only of contemplation and unable to act, his "reason" is what has been called the "principle of actuosity", incapable of absolute insights but able to "communicate the quality of consciousness not only to the acts of pure thought but also to the empirical functions of life".[1]

[1] Kristeller, *The Philosophy of Marsilio Ficino,* p. 377. The limitation of hypostases to four and their definition as Mind, Soul, Nature, and Body (as presented in the text) is literally taken over from Plotinus and found in a famous passage in Ficino's most popular and influential book, his Commentary on Plato's

In this strange world of Renaissance Neo-Platonism all the frontiers marked out and fortified by the mediaeval mind have disappeared, and this applies particularly to the concepts of love and beauty, the very poles of the axis round which Ficino's doctrine revolves.

The interpretation of love as a metaphysical experience, having its real object in a "supercelestial realm", had survived in the Middle Ages in two entirely different versions: in the idea of Christian *caritas*, it had come to be disassociated from subjective, amatory emotion; in that transcendent eroticism which, utterly foreign to Greek and Roman poetry, was cultivated in the Islamic East and invaded the mediaeval West via Spain and Provence (to culminate in Guido Cavalcanti's and Dante's *dolce stil nuovo*), it had come to be disassociated from the objective forces that are at work in the physical universe.

In similar manner, the Platonic identification of the good with the beautiful and the Plotinian definition of beauty as "splendor of the light divine" and "cause of the harmony and radiance in all things" were known throughout the Middle Ages, chiefly through John the Scot's translation of Dionysius the Pseudo-Areopagite's *De caelesti hierarchia*. But Thomas Aquinas had not only rejected this ontological definition— "[pulchrum] omnium bene compactionis et claritatis causale", "beauty is the ultimate cause of harmony and radiance in all things"—in favor of a purely phenomenal one; he had also made a sharp formal distinction, foreshadowing Kant's *interesseloses Wohlgefallen* ("disinterested pleasure"), between the beautiful and the good and had thus separated the aesthetic experience from its metaphysical mainspring, love. According to him, "beauty requires three things, to wit, first, wholeness (*integritas*), for what is impaired is ugly by this very fact; second, a fitting proportion or harmony (*debita proportio sive consonantia*); third, brightness (*claritas*), for that which has a shining color (*colorem nitidum*) is said to be beautiful". And: "goodness properly appeals to the appetitive faculty, for goodness is what all men strive for ...; beauty, however, appeals to the cognitive faculty, for we call beautiful whatever pleases when seen".[1]

Symposium, called *De amore*, which was completed in 1469 and whose Italian translation, commonly cited as *Convito*, was available in manuscript from 1474 and in print from 1544. Elsewhere, however, Ficino inserts the degree of Sensation between those of soul and Nature. The degree of Nature is particularly difficult to define. Apparently patterned upon the notion of *natura naturans* rather *natura naturata*, it may be described as a universal generative principle which roughly corresponds to the faculties of the "lower" soul in man, containing as it does the "germs" of all material things and operating through a somewhat vaguely defined

vehicle of transmission, the *spiritus mundanus* that functions as a "link" (*vinculum, nodus*) between the incorporeal and the corporeal.

[1] For these two passages (*Summa Theologiae*, I, qu. XXXIX, art. 8, c.; *ibidem*, I, qu. V, 4, c. 1), see E. Panofsky, Review of E. Rosenthal, *Giotto in der mittelalterlichen Geistesentwicklung, Jahrbuch für Kunstwissenschaft*, I, 1924, p. 254ff., particularly p. 257f.; *idem*, "Notes on a Controversial Passage in Suger's *De Consecratione ecclesiae Sancti Dionysii*", *Gazette des Beaux-Arts*, 6th Ser. XXVI, 1944, p. 95ff., particularly p. 112f.

Ficino, defining beauty as "the splendor of the face of God", restored to its "radiance" the metaphysical halo which it had lost at the hands of Thomas Aquinas (to whom *claritas* meant nothing more exalted than a "shining color"); and, not content with reuniting what Thomas Aquinas had been so careful to separate, that is to say, with reinstating the identity of the beautiful with the good, he equated the beautiful not only with love but with beatitude: "The one and self-same circle", he writes of the *circuitus spiritualis* just mentioned, "may be called beauty insofar as it begins in God and attracts to Him; love, insofar as it passes into the world and ravishes it; and beatitude insofar as it reverts to the Creator".

On its way down to earth this "splendor of divine goodness" is broken up into as many rays as there are celestial spheres and terrestrial elements. This accounts for the diversity and imperfection of the sublunary world because, in contrast to "pure forms", corporeal things, polluted by matter, are "crippled, ineffective, subject to countless passions, and impelled to engage in internecine struggles"; but it also accounts for its inherent unity and nobility because the same descent from on high which individualizes, and thereby limits, all earthly things keeps them—through the intermediary of the "cosmic spirit" (*spiritus mundanus*)[1]—in constant touch with God. They have their share, each according to the road by which the divine *influxus* has reached it (and we should not forget that the now trivial expression, "influence", was originally a cosmological term), in a preter-individual and preter-natural power which acts from below to above as well as from above to below.

Since every human being, plant or animal thus operates, if I may say so, as an accumulator of modified supercelestial energy, we can easily see that love—except for a purely physical passion contemptuously called *amor ferinus* and dismissed as a kind of pathological disorder—is always engendered by a beauty which, by its very nature, "calls the soul to God" (Platonists, ancient and modern, liked to derive the Greek word for "beauty", κάλλος, from the verb καλεῖν, "to call"); and that it is a question of degree rather than kind whether this love takes the form of *amor humanus*, satisfied with the production and appreciation of beauty accessible to the senses, or *amor divinus* which rises, and raises, from optical and acoustical perception[2] to an enraptured contemplation of that which transcends not only perception but even reason.[3]

But we can also see that—barring necromancy and demonism—no difference in

[1] See p. 183 f., Note 1.

[2] It should be noted, in this connection, that the Florentine Neo-Platonists, like Ficino himself, give preference to the sense of sight whereas some of their Venetian followers, less orthodox but more musical, reverse this order or at least restore equality; see Panofsky, *Studies in Iconology*, p. 148, Note 69; O. Brendel, "The Interpretation of the Holkham Venus", *Art Bulletin*, XXVIII, 1946, p. 65 ff. (cf. also *ibidem*, XXIX, 1947, p. 65 ff.).

[3] For the theory of *amor divinus*, *amor humanus* and the *geminae Veneres*, see below, p. 198 ff.

principle exists between medicine, magic and astrology. When I pursue any particular activity or conduct myself in any particular way, when I take a walk at any particular hour, when I perform or listen to any particular piece of music, when I eat any particular food, inhale any particular perfume, or take any particular medicine, I do essentially the same as when I wear an amulet fashioned, under appropriate circumstances, of a particular substance and bearing the image or symbol of a particular planet or constellation: in all these cases I expose myself to the influence of the "cosmic spirit" as modified by the spheres and elements through which it has passed. For if the medicine prescribed by a doctor contains, say, peppermint this humble plant has acquired its healing properties by virtue of having stored up "the spirit of the sun combined with that of Jupiter"; while other plants or minerals are poisonous by virtue of having stored up the malignant emanations of Saturn or Mars.[1]

Similarly, and for analogous reasons, Ficino's doctrine does not recognize an essential difference between the authority of Christian and non-Christian sources. Since, as has been mentioned, all revelation is as fundamentally one as is the physical universe, "pagan" myth is not so much a typological or allegorical parallel as a direct manifestation of religious truth. What "equitable Jupiter" has taught Pythagorus and Plato is no less valid than what Jehovah has revealed to any Hebrew prophet.[2] Among the reasons which induced Moses to prescribe the "rest of Holy Sabbath" is the fact— apparently well-known to him—that Saturday (viz., the day of Saturn) is "unsuitable for any action, civil or military, but most appropriate for contemplation".[3] Where the *Ovide moralisé* interprets—"propter aliquam similitudinem", as Thomas Aquinas would say—the story of, for example, Europa abducted by the bull and holding on to one of his horns as "signifying" the redemption of the soul, steadfast in faith, by Christ, Ficino (in an important letter entitled *Prospera in fato fortuna, vera in virtute felicitas*, "good luck is determined by fate, true happiness is founded on virtue") uses the same verb, *significare*, in an attempt to show that "all the heavens are within ourselves": "in us (*in nobis*) the Moon signifies the continuous movement of mind and body; Mars, speed; Saturn, slowness; Mercury, reason; and Venus, humanity". And in an astro-mythological poem by one of his intimates, Lorenzo Buonincontri, the poet, having entered the "third orbit" of the heavens, not only invokes the ruler of this orbit, Venus, in the same breath with the Virgin Mary but greets the "*sancta Dei genitrix*" as a

[1] For this important aspect of Ficino's theory, see Panofsky and Saxl, *Dürer's Melencolia I*, particularly pp. 32 ff., 106 ff.

[2] Marsilio Ficino, *De vita triplici*, II, 45 (*Opera omnia*, I, p. 522). Andrea Riccio did not scruple to represent Moses—traditionally "horned" but never before equipped with rams' horns—in the guise of Jupiter Ammon (statuette in the Musée Jacquemart-André at Paris, illustrated, e.g., in L. Planiscig, *Andrea Riccio*, Vienna, 1927, p. 190, Fig. 211).

[3] *Ibidem*, III, 11, 12 (*Opera omnia*, I, p. 544 ff.).

"goddess of goddesses" (*diva dearum*) whom he, in his previous works, had "often dared address under the fictitious name of Venus" herself.[1]

Small wonder that a philosophy like this, enabling the humanist to come to terms with theology, the scientist with metaphysics, the moralist with the frailty of mankind, and the men and women of the world with the "things of the mind", achieved a success comparable only to that of psychoanalysis in our own day. While it helped to shape the thought of Erasmus of Rotterdam (whose *Praise of Folly* ends on a very serious and essentially Neo-Platonic note), Leone Ebreo, Kepler, Patrizzi, and Giordano Bruno (it even played a role in Michael Servetus' discovery of the pulmonary transit),[2] and while it deeply influenced the outlook of what corresponds to literary criticism, musicology and aesthetics, it could produce—particularly in the more gynocratic milieu of North Italy—an avalanche of *Dialogues on Love* which I have once described, in a flippant moment, as a mixture of Petrarch and Emily Post, couched in the language of Neo-Platonism.[3]

The deepest and most productive effect of the Neo-Platonic *Weltanschauung* can be observed, however, in poetry—from Girolamo Benivieni to Tasso, Joachim du Bellay, Spenser, Donne, Shaftesbury, Goethe, and Keats—and in the visual arts. Never before had Plato's doctrine of "divine frenzy", fused with the Aristotelian notion that all outstanding men are melancholics and with the astrological belief in a special connection between the *humor melancholicus* and the most ill-boding yet highest and most august of the seven Planets, produced the concept of a Saturnian "genius" pursuing his lonely and perilous path on a high ridge above the multitude and set apart from ordinary mortals by his ability to be "creative" under divine inspiration.[4] Not since the days of Suger of St.-Denis, who transferred the light metaphysics of the Pseudo-Areopagite and John the Scot from the world of God-created nature to that of man-made artifacts, had sculptors and painters been credited with the priestlike task of providing that "manual guidance" (*manuductio*) which enables the human mind to ascend "through all things to that Cause of all things Which endows them with place and order, with

[1] Both Ficino's letter (*Opera omnia*, I, p. 805) and the passage from Buonincontri's poem are quoted, in connection with Botticelli's "Primavera" (cf. below, p. 193 ff.), in the excellent article by E. H. Gombrich, "Botticelli's Mythologies; A Study in the Neoplatonic Symbolism of His Circle", *Journal of the Warburg and Courtauld Institutes*, VII, 1945, p. 7 ff. (pp. 15 ff., 41). For references to Venus as "Santa Venere" and "sanctissima dea" in Boccaccio's *Ameto*, see Heckscher, "Aphrodite as a Nun", *The Phoenix*, VII, 1953, p. 105 ff.

[2] See R. H. Bainton, "Michael Servetus and the Pulmonary Transit", *Bulletin of the History of Medicine*, XXV, 1951, p. 1 ff.

[3] Panofsky, *Studies in Iconology*, p. 144 ff.

[4] For evidence for the origin of the modern conception of genius in the Ficinian theory of Saturn as the celestial patron of "intellectuals", see Panofsky and Saxl, *Dürer's Melencolia I*, p. 32 ff.; Panofsky, *Albrecht Dürer*, p. 165 ff. For the heretical application of such words as "to create", "creator", "creation" to human activity (today we have not only courses in "creative writing" for undergraduates but also "creative play periods" for children, "creative" milliners, and even "creative" hairdressers), see below, p. 188, Note 3.

number, species and kind, with goodness and beauty and essence, and with all other grants and gifts".[1] And not even Suger, who naturally thought exclusively in terms of ecclesiastical art, could have imagined a philosophy which, like Ficino's, abolished all borderlines between the sacred and the profane and thus, to borrow Ernst Gombrich's excellent formula, succeeded in "opening up to secular art emotional spheres which had hitherto been the preserve of religious worship".[2]

VII

IN SPITE of his positive attitude towards sculpture and painting, Ficino's personal aesthetic interests were largely limited to music and, next to music, poetry; and the theorists of the visual arts were curiously—yet understandably—slow in embracing his doctrine, even slower in Italy than in the North.[3] Among the artists themselves and their patrons, however, the success of these doctrines was not only ubiquitous but also—given the time lag between Florence, the rest of Italy and the rest of the world—instantaneous.

In many cases the influence of the Neo-Platonic doctrine is so manifest—occasionally

[1] Johannes Eriugena, Commentary on *De caelesti hierarchia, Patrologia Latina,* CXXII, col. 138 C; cf. Panofsky, *Abbot Suger,* pp. 18 ff., 164 f.

[2] Gombrich, "Botticelli's Mythologies", p. 43.

[3] See Panofsky, *Idea,* pp. 52 ff., 68 ff., 122 ff. (Italian translation, pp. 69 ff., 92 ff., 171 ff.); *idem, Albrecht Dürer,* pp. 165 ff., 280 ff.; Lee, *op. cit., passim.* The epithet "divine", now hard to dissociate from Michelangelo, was occasionally applied to artists and their productions from as early as the end of the thirteenth century (first, characteristically, by Ristoro d'Arezzo, quoted above, p. 73, Note 1, with reference to the makers of his beloved Aretine pottery); it occurs, for example, in Tito Vespasiano Strozzi's poem in honor of Pisanello, whom another contemporary, Leonardo Dati (cf. A. Venturi, *Le Vite de' più eccellenti pittori, scultori e architetti,* p. 35), likened to Prometheus:

"Denique, quidquid agis, naturae jura potentis
Aequas divini viribus ingenii"

(for Strozzi's pem see C. Cavattoni, *Tre Carmi latini composti a mezzo il secolo XV in laude di Vittore Pisano,* Verona, 1861, p. 46 f.; for the general use and abuse of the term *divino* in the Renaissance, see C. da Empoli Ciraolo, "La 'Divinità' di Raffaello", *Nuova Antologia,* CDLV, 1952, p. 155 ff.). Not so with the words *creare, creator, creatio,* and their ver-

nacular equivalents. These do not seem to have been applied to artists until the sixteenth century, and in Italy not before *ca.* 1540–1550. While Dürer speaks of the "new creature which the artist creates (*schöpft*) in his heart" as early as about 1525 (Lange and Fuhse, *op. cit.,* p. 227, 12), Leonardo da Vinci, though justly proud of the fact that the painter is "lord and god" of the world which he can arrange according to his own pleasure, studiously avoids the terms *creare* and *creazione* in favor of *generare* and *generazione,* a fact unfortunately neglected in all available translations and paraphrases. In the authoritative manuscript of the *Trattato della pittura,* the Codex Urbinas Latinus 1270, fol. 5, the passage here alluded to has originally the words "signore et dio", and it was only about the middle of the sixteenth century that the famous "Hand 3" substituted *creatore* for *dio* in an interlinear gloss (facsimile now available in A. Philip McMahon, tr., *Leonardo da Vinci, Treatise on Painting,* Princeton, 1956, II, fol. 5; in Vol. I, p. 24, the verb *generare,* occurring twice in this sentence, is rendered as "creating" and "create"!). A statement quoted in Cassirer, *Individuum und Kosmos,* p. 170, as reading "La scienza è una seconda creazione fatta col discorso, la pittura è una seconda creazione fatta colla fantasia" could not be discovered in Leonardo's writings.

even literalized by an inscription or accentuated by what may be called a visual foot-note—that no doubt as to the artist's intention is possible. I shall briefly discuss four instances of this kind which, at the same time, will serve to illustrate the rapid diffusion of the Neo-Platonic movement once it had come into being.

A bust in the Museo Nazionale at Florence, which I, like others, incline to ascribe to an anonymous Florentine master of 1470–1475 rather than to Donatello (Fig. 143), shows the youthful, somewhat androgynous sitter, his fine-boned, full-lipped face expressing an enchanting blend of thoughtfulness and sensuality, adorned with an enormous cameo, almost five inches wide, which so clearly alludes to Plato's immortal comparison of the human soul with "a pair of winged horses" (one docile, the other refractory) "and a charioteer" that it strikes us with the force of an identifying emblem: a romantically-minded observer might feel tempted to imagine that the handsome wearer of this cameo was nicknamed "Fedro" in Ficino's circle.[1]

[1] See A. Chastel, "Le jeune Homme au camée platoni-cien du Bargello", *Proporzioni*, III, 1950, p. 73 ff. A recent attempt to restore the bust—formerly believed, without any reason, to represent Giovanni Antonio da Narni, the son and heir of Gattamelata—to Donatello and to defend a date about 1440 (Janson, *The Sculpture of Donatello*, p. 141 ff., Pls. 232–236) does not appear convincing for purely stylistic and historical reasons. The combination of smoothness and over-particularization, especially evident in the "stippled" hair and the detachable eyebrows, would make me inclined to ascribe the work to a follower of Desiderio da Settignano rather than to the Dona-tello of the *"Atys-Amorino"* even without the "camée platonicien"; and as for the latter, the facts are these. It is generally, and in all probability correctly, sup-posed to be based on a classical original, now lost, which is listed in the inventory of Lorenzo de' Medici drawn up in 1492. There is, however, no evidence for the further assumption (R. Wittkower, "A Sym-bol of Platonic Love in a Portrait Bust by Donatello", *Journal of the Warburg Institute*, I, 1938, p. 260 f.) that this classical cameo had come down to Lorenzo from his grandfather, Cosimo. We have, on the contrary, every reason to believe that the cameo listed in Lorenzo's inventory, and described as showing "una fighura tirata da dua chavagli", is identical with "unus cameus magnus (!)", exhibiting "duos equos cum curru et juvenem super curru", which in 1457 was still in the possession of Car-dinal Pietro Barbò, later Pope Paul II, in Rome (E. Müntz, *Les Arts à la cour des papes pendant le XV^e et le XVI^e siècle*, II, Paris, 1879, p. 225). It may be presumed not to have passed into the hands of the Medici until after Paul's death on July 28, 1471, when the major part of the pontiff's *gemmae et margaritae* was sold—very cheaply, in order to enlist his good will—to Lorenzo the Magnificent (Müntz, p. 154); and this date, needless to say—about five years after the death of Donatello—fits in very nicely with what Chastel and I believe to be that of the Bargello bust.

As can be inferred from the inventory entries as well as later reproductions (Wittkower, Pl. 34, c) the "Barbò-Medici cameo" differed, however, from that seen in the bust in that no disparity existed between the two horses and in that they were driven by an ordinary, *juvenis* rather than by a winged *youth.* In both these respects the sculptor may have drawn additional inspiration from Roman sarcophagi also reflecting the influence of Plato's *Phaedrus* but show-ing, instead of a single charioteer, the turbulent chariot race described in *Phaedrus*, 248 (see Cumont, *op. cit.*, p. 348, Fig. 77; p. 461, Fig. 97). In thus transferring the wings from the horses to the chario-teer (Plato himself speaks of "winged horses" but leaves the charioteer without epithet) the Roman *tumbarii* as well as the author of the Bargello bust would seem to have identified—not without justifi-cation from a Platonic point of view—the "pilot of the soul" with Eros himself, whom "mortals call winged love', whereas the immortals call him 'the Wing-Giver" (Πτέρωτα, to be interpreted as the ac-cusative of πτερωτής) because he forces [man's soul] to grow wings" (*Phaedrus*, 252, B, C).

In Maerten van Heemskerck's *St. Luke Portraying the Virgin*—a subject in which the art of painting may be said to render account of its own methods and aspirations—the Neo-Platonic spirit oddly impinges on both the naturalism of the Netherlandish *ars nova* and the prefigurative symbolism of the Middle Ages (Fig. 144). The Madonna is being painted "from life", placed on a dais in the artist's studio like any ordinary model; but she is, quite literally, "illumined" by an angel holding aloft a torch. St. Luke is rendered as an elderly master craftsman, palette and mahlstick in hand and glasses on his nose; but he is seated on a *cippus*-like marble block adorned with a relief which shows his symbol, the ox, transformed into a fiery animal carrying off its master as the bull does Europa, and the painter himself is inspired by a figure which by its gesture and attribute (arm pointing heavenwards and ivy wreath) is unequivocally characterized as a personification of *Furor poeticus*. Since, we recall, the *Ovide moralisé* interprets Europa as the human soul and the bull as Christ, both these departures from tradition are not so strange as they may seem: as Luke the Evangelist obeys the dictates of the Holy Spirit, so does Luke the painter, like every true artist, obey the dictates of Plato's "divine frenzy".[1]

To juxtapose this Dutch work with a German one, we may adduce a nearly contemporary picture by Lucas Cranach the Elder (Fig. 145) which represents Cupid transforming himself from a personification of "blind", *viz.* ignoble, into an exponent of "seeing", *viz.* Platonic, love: he removes from his eyes the bandage that had been his derogatory attribute throughout the later Middle Ages, and the implications of this self-improving procedure are made explicit by the fact that the little figure is shown standing upon—or, rather, "taking off" from—an enormous tome inscribed PLATONIS OPERA.[2]

Reverting to Florence after an interval of about three-quarters of a century, we may refer to an engraving after Baccio Bandinelli, the often underrated rival of Michelangelo, which illustrates the eternal conflict between Lust and Reason in terms so strictly Ficinian that no less than four Latin distichs were necessary to enlighten an uninstructed observer (Fig. 146). A troop of such mythological representatives of the "lower soul" as Venus, Cupid and Vulcan (the latter acting as armorer) is "shooting it out" with a troop of superior divinities, personifying the "higher soul", viz., Reason,

[1] For Maerten van Heemskerck's picture, now bisected and transferred from the Church of St. Bavo to the Frans Hals Museum at Haarlem, see, in addition to D. Klein, *St. Lukas als Maler der Maria*, Berlin, 1933, pp. 56–57, 83–85, the excellent article by R. K. J. Reznicek, "De Reconstructie van 't'Altaer van S. Lucas' van Maerten van Heemskerck", *Oud Holland*, LXXI, 1956, p. 233 ff. (which, however, intentionally refrains from explaining the "Europa" motif).

It may be added that Evangelists seated upon their symbols (though these behave quite peacefully) are not entirely unknown to mediaeval art; see D. Tselos, "Unique Portraits of the Evangelists in an English Gospel-Book of the Twelfth Century", *Art Bulletin*, XXXIV, 1952, p. 257 ff., particularly p. 272 ff.

[2] For Cranach's picture, preserved in the Pennsylvania Museum of Art at Philadelphia, see Panofsky, *Studies in Iconology*, p. 128 f., Fig. 106.

and led by Jupiter, Minerva, Mercury, and Saturn; but the explanatory distichs inform us that, while Reason is able to engage in active combat, the contemplative Mind (depicted in the guise of a lady holding aloft the flame of divine wisdom) must limit itself to the sublime but somewhat frustrating role of *arbiter* ("umpire").[1]

In countless other and often greater works of art, however, we are confronted with symbolism rather than emblematics or allegory—a symbolism at times so personal and multivalent that it is hard to prove the presence of a Neo-Platonic element and even harder to determine its precise significance. Had not Ficino himself asserted that Platonists, applying the methods of Biblical exegesis to mythology (as Dante had wished to see them applied to his *Divine Comedy*), had at their disposal four modes, variable according to circumstances, of "multiplying the gods and divinities", and had he not explicitly reserved the right to "interpret and distinguish these divinities in different ways as the context requires"?[2]

The intrinsic meaning of Titian's *Sacred and Profane Love* and *Education of Cupid,*[3] of Michelangelo's Sistine Ceiling, Julius Tomb, Medici Chapel, and Cavalieri drawings, of Raphael's frescoes in the "Stanza della Segnatura" and the Villa Farnesina, will, therefore, be debated as long as there are art historians; and the same, it is to be feared, is true of the two famous compositions which, if any, may claim to reflect the attitude of Ficino's most intimate friends and disciples: Botticelli's *Birth of Venus* and *"Primavera"*.

The number of books and essays devoted to the exegesis of these two pictures is

[1] For Bandinelli's composition, see *ibidem*, p. 149 ff.,s Fig. 107; Seznec, *op. cit.*, p. 110 ff., Fig. 38. For the division of the soul alluded to in the explanatory distichs, cf. above, p. 183, Note 1.

[2] Ficino, Commentary on Plato's *Phaedrus* (*Opera omnia*, II, p. 1370), quoted, translated and perceptively interpreted by Gombrich, "Botticelli's Mythologies", p. 37.

[3] For Titian's *Sacred and Profane Love* and *Education of Cupid*, see Panofsky, *Studies in Iconology*, p. 150 ff. (for the former painting, cf. R. Freyhan, "The Evolution of the Caritas Figure in the Thirteenth and Fourteenth Centuries", *Journal of the Warburg and Courtauld Institutes*, XI, 1948, p. 68 ff., particularly p. 85 f., with further references). For Michelangelo's Julius Tomb, Medici Chapel and Cavalieri drawings, see Panofsky, *ibidem*, p. 188 ff.; A. E. Popham and J. Wilde, *The Italian Drawings of the XV and XVI Centuries in the Collection of His Majesty the King at Windsor Castle*, London, 1949, pp. 252 ff., 265 (Cavalieri drawings); C. de Tolnay, *Michelangelo*, IV (*The Tomb of Julius II*), Princeton, 1954, particularly pp. 23 ff., 74 ff.; idem, *Michelangelo*, III (*The Medici Chapel*)

Princeton, 1948, particularly pp. 63 ff. (Medici Chapel), 111 ff., 199 f., 221 f. (Cavalieri drawings). The objections that must be raised to F. Hartt's interpretation ("The Meaning of Michelangelo's Medici Chapel", *Essays in Honor of Georg Swarzenski*, Chicago, 1951, p. 145 ff.) will be discussed elsewhere. That Raphael's version of the myth of Cupid and Psyche was intended to celebrate the ascent and ultimate deification of the human soul ($\psi\upsilon\chi\acute{\eta}$) in addition to telling a beautiful story and to displaying beautiful nudes can be inferred, I think, not only from the exclusion of all events not taking place in the heavens but also from the less well-known fact that the only scene not found in Apuleius—Cupid entreating the Graces to protect Psyche—is invented in a truly Neo-Platonic spirit: the Graces played an enormous role in Ficino's philosophy (see Panofsky, p. 168 f., and, more particularly, Gombrich, "Botticelli's Mythologies", p. 32 ff.) and symbolized, howsoever defined, a triad of qualities, two of them opposites reconciled by a middle term, which make the soul capable of *amor divinus* and thereby worthy of deification.

Legion.[1] But it is significant that—after a judicious application of Ockham's Razor—the more serious interpretations turn out to be complementary rather than mutually exclusive: it is one of the charms of the spirit pervading the Florence of the Magnifici that it "reprend son bien où il le trouve".

After Warburg's fundamental study, first published in 1893,[2] it can hardly be doubted that Venus is the heroine not only of the canvas which depicts her emergence from the sea, but also of the somewhat larger panel—"dimostrando la Primavera", as Vasari expresses it—which represents her gentle rule on earth; that the direct influence of classical sculpture is limited to the figure of Spring in the *"Primavera"*—a figure deriving from a statue in the Uffizi which is now generally conceded to personify this very season[3]—and to the central figure in the *Birth of Venus*, a genuine *Venus Pudica* closely resembling the famous *Medici Venus;*[4] and that what may be called the scenario of both compositions is largely determined by the ecphrases found in Politian's *Giostra*, a poem written in celebration of a famous tournament held by Giuliano de' Medici in 1475, left unfinished when Giuliano was murdered in 1478, and replete with classical reminiscences ranging from the Homeric Hymns to Ovid, Horace, Tibullus, and, above all, Lucretius.

[1] For the literature up to 1944, see Gombrich, *ibidem*, pp. 7–13. To be added (among other contributions): Seznec, *op. cit.*, p. 112 ff.; W. S. Heckscher, "Aphrodite as a Nun"; *idem*, "The *Anadyomene* in the Mediaeval Tradition (Pelagia—Cleopatra— Aphrodite); A Prelude to Botticelli's 'Birth of Venus'", *Nederlands Kunsthistorisch Jaarboek*, VII, 1956, p. 1 ff.; A. B. Ferruolo, "Botticelli's Mythologies, Ficino's *De Amore*, Poliziano's *Stanze per la Giostra*: Their Circle of Love", *Art Bulletin*, XXXVII, 1955, p. 17 ff.; P. Francastel, "La Fête mythologique au Quattrocento; Expression littéraire et visualisation plastique", *Revue d'Esthétique*, V, 1952, p. 377 ff., particularly p. 396 ff.; *idem*, "Un Mito poético social del Quattrocento: La Primavera", *La Torre, Revista General de la Universidad de Puerto Rico*, V, 1957, p. 23 ff.

[2] A. Warburg, *Sandro Botticelli's "Geburt der Venus" und "Frühling"*, reprinted, with additions, in *op. cit.*, I, pp. 5–68, 307–328.

[3] Warburg, *ibidem*, pp. 38, 319, Fig. 15. The identification of the statue (formerly called Flora or Autumn) as the Hora of Spring is assured by a Campana relief in the Louvre, illustrated in Reinach, *Répertoire de reliefs grecs et romains*, Paris, 1909–1912, II, p. 262, 1, and W. H. Roscher, *Ausführliches Lexicon der griechischen und römischen Mythologie*, Leipzig, 1884–1924, II, col. 2735 f.

[4] Since classical and late-antique representations, so far as we know, do not show Venus standing upon her shell but only standing, reclining, seated, or appearing *en buste* within it (see Brickoff, *op. cit.*, Figs. 1–4; Heckscher, "The *Anadyomene*", Figs. 2, 6), it has been concluded that Botticelli based his version upon the mediaeval tradition represented by a miniature in Cod. Pal. lat. 1066, fol. 233 (illustrated in Liebeschütz, *Fulgentius Metaforalis*, Fig. 10), limiting himself to replacing the very unattractive goddess by a figure modeled upon the *Medici Venus* (Warburg, *ibidem*, p. 310). However, in view of Politian's very graphic description "Da' zefiri lascivi spinta a proda/Gir sopra un nicchio" (*Giostra*, I, 99, reprinted by Warburg, p. 8, and probably inspired by Tibullus' "Et faveas concha, Cypria, vecta tua") it is perhaps not necessary to assume that Botticelli had recourse to a mediaeval type which the Middle Ages itself had been inclined to abandon in favor of that other, less authentic image which shows the goddess with a seashell (or some object mistakenly substituted therefor) in her hand instead of placed upon it (see above p. 87, Note 2; Figs. 56–58). The painter may have arrived at his solution simply by employing the *Medici Venus* to visualize Politian's description.

The only difference between Botticelli's *Birth of Venus* and Politian's description is that the number of Horae or Seasons, receiving and clothing the new-born goddess on the shore, has been reduced from three to one: the Season of Spring, "cinctum florente corona".[1] But this one deviation is easily explained by the special affinity which was always felt to exist between the goddess of Love and the season of Spring: "Vere Venus gaudet florentibus aurea sertis" ("in Spring Venus delights in flow'ry wreaths"), as a pedestrian but very popular tetrastich, ascribed to Euphorbius, sums up the impressive beginning of Lucretius' *De rerum natura.*[2] The Hora of Spring has rightfully monopolized a normally collective function.[3]

This brings us to the second of Botticelli's famous compositions, the *"Primavera"* (Fig. 148). It, too, is principally based on Politian. Both in his *Giostra* and in the slightly later pastoral, *Rusticus* (which forms part of his *Sylvae* and was published in 1483), he describes the "realm *(regno)* of Venus". Skillfully developing four lines of Lucretius and two-and-one-half lines of Horace, he enumerates all the elements that play their part in Botticelli's picture: Venus; Cupid; Spring *(la lieta Primavera)*; Flora "granting welcome kisses to her amorous husband", *viz.*, Zephyr; and the dancing Graces.[4] Even the somewhat unusual fact that Cupid's golden arrow is barbed with fire can be explained by the *Giostra:* so forcefully does Cupid draw his bow, Politian says, that "with his left the *fiery gold* he touches, / while with the string he touches his right breast" ("la man sinistra con l'oro focoso, / la destra poppa con la corda tocca").[5] The only figure not accounted for by Politian is that of Mercury; but it is precisely from his presence and behavior that we may infer the presence and import of a "metaliteral" significance in Botticelli's composition.

Mercury belongs, it is true, to the Graces, so much so that he was considered as their "leader" (ἡγεμών) in classical antiquity[6] and appears as such in several re-

[1] Ovid, *Metamorphoses,* II, 27 (with reference to the *Ver novum*). Warburg, *ibidem,* p. 17, convincingly assumes that this *cinctum corona,* combined with the "pictis incinctae vestibus Horae" in *Fasti,* V, 217, may have suggested the belt—and, it may be added, the necklace—of flowers which characterize the personifications of Spring in both the *Birth of Venus* and the *"Primavera".*

[2] Lucretius, *De rerum natura,* I, 1–20. The tetrastich attributed to Euphorbius (still quoted in Ripa's *Iconologia, s.v.* "Stagioni", and alluded to by Cartari, *op. cit.,* p. 52) is found in the *Anthologia Latina,* 570 (A. Riese, ed., II, 1, Leipzig, 1906, p. 77).

[3] It is not only the new-born Venus but also, for example, the new-born Mercury who is clothed by the Horae; see, e.g., Philostratus, *Imagines,* I, 26.

[4] Politian, *Giostra,* I, 68–72; *Rusticus,* 210ff., both

reprinted, together with the Horace passage (*Carmina,* I, 4, 5–7), in Warburg, *op. cit.,* p. 42. For the Lucretius passage and its correct beginning ("It Ver et Veneris [not *Veris*] praenuntius ante/Pennatus graditur"), cf. *ibidem,* pp. 41, 321; the "winged herald" of Venus is, of course, Cupid. The "lieta Primavera", blond and wavy-haired, is explicitly introduced in *Giostra,* I, 72 (reprinted in Ferruolo, *op. cit.,* p. 19).

[5] Politian, *Giostra,* I, 40, quoted—though not connected with the motif of the fire-barbed arrow, for which see below, p. 194 f., Note 3—by Ferruolo, *ibidem,* p. 18.

[6] Cornutus, *De natura deorum,* XVI, C. Lang, ed., Leipzig, 1881, p. 20: Ἡγεμόνα δὲ παραδιδόασιν αὐτῶν τὸν Ἑρμῆν, ἐμφαίνοντες ὅτι εὐλογίστως χαρίζεσθαι δεῖ καὶ μὴ εἰκῇ, ἀλλὰ τοῖς ἀξίοις

liefs.[1] In Botticelli's *"Primavera"*, however, he plays an entirely different role. Far from "leading" the Graces, he turns his back upon them, the elbow of his left arm thrust out against them in a gesture of studied indifference. He almost contemptuously isolates himself from all that they, the goddesses of Love, Spring and Beauty, have to offer: glancing upwards, he raises his right arm and with his caduceus endeavors to dispel the wisps of mist—not real clouds—that cling to the tops of the orange trees.[2]

Considering the almost limitless flexibility of the Neo-Platonic doctrine—though not forgetful of the fact that, in the words of Henry James, "the loyal entertainer" of a "happy thought" is "terribly at the mercy of his own mind"—we may thus accept Politian's *Giostra*, supplemented by his *Sylvae* and the classical sources of both, as the "basic text" of Botticelli's *"Primavera"*[3] and yet admit any number of such metaliteral implications, even of an apparently contradictory nature, as we see fit.

("Hermes is appointed as their [the Graces'] leader in order to show that one must bestow favors reasonably and not arbitrarily, and only upon those who are worthy"). This notion—to be reinstated by Gyraldus, *op. cit.*, col. 419, accepted by Cartari, *op. cit.* (1571 edition, p. 536f.), and underlying Tintoretto's famous painting in the Doges' Palace (Seznec, *op. cit.*, p. 303f., Fig. 108)—did not apparently occur to Seneca who, in *De beneficiis*, I, 3, 2–7 (quoted by Warburg, pp. 28, 40), suggests that Mercury was united with the Graces "not so much because reason or eloquence (*ratio vel oratio*) recommend favors, as because the painter liked it that way" ("quia pictori ita visum est"). Yet Seneca's description may have had some influence upon Botticelli's *"Primavera"*. While nearly all earlier renderings of the Three Graces, including even the mediaeval book illuminations (e.g., our Figs. 56–58), show them entirely nude (a fact stressed and explained by the mythographers from Servius and Fulgentius to the *Ovide moralisé* and the *Libellus de imaginibus deorum*), their appearance in Botticelli's picture agrees with Seneca's amplification of Horace's "solutis Gratiae zonis" (*Carmina*, I, 30, 5): "solutis itaque tunicis utantur, perlucidis autem", "they are clad in loose but transparent gowns".

[1] Pausanias, *Graeciae descriptio*, I, 22, 8 (quoted by Cartari, *op. cit.*, p. 561), describes a relief by Socrates, the son of Sophroniscus, which could be seen at the entrance of the Acropolis at Athens. For an example of this kind, which was actually found on the Acropolis, see *Bulletin de Correspondance Hellénique*, XIII, 1889, Pl. XIV, facing p. 467.

[2] There has been much discussion about what Mercury is doing with his upraised caduceus; but none of the objections against the interpretation here accepted appears convincing, least of all Gombrich's assertion that Mercury, like the personification of truth in Botticelli's *Calumny of Apelles*, "points" to heaven ("Botticelli's Mythologies", p. 28, Pl. 11, a, b): the point, if I may say so, is that Mercury does *not* point, whereas Truth does. On the other hand, there is no literary source for the motif represented in Botticelli's picture. A passage from Virgil's *Aeneid*, IV, 242 ff. (referred to by H. P. Horne, p. 53, and Warburg, *op. cit.*, I, p. 320) describes him only in his traditional role as wind god (see Roscher *Hermes der Windgott*, Leipzig, 1878), but not as a dispeller of clouds: "Turbida nubila tranat" means that he "skims through", not that he "dispels", the turbid clouds.

[3] With all due respect for an author to whose perception we owe so many insights into the philosophical implications of Renaissance art in general, and Botticelli's Mythologies in particular, I cannot see how it is possible to minimize the influence of Politian's *Giostra* and to derive instead the principal motifs of the *"Primavera"* from the description of a kind of musical pantomine, representing the Judgment of Paris, in Apuleius' *Golden Ass*, X, 30–32 (Gombrich, "Botticelli's Mythologies", pp. 22–32). In Botticelli's composition there is no music, so that the "delicate gestures" of his Venus, howsoever interpreted, can hardly be said to "respond to the sweet sound of flutes". Mercury, conspicuously present in the painting, has made a graceful exit from Apuleius' stage as soon as he has delivered the apple to Paris, in fact before the appearance of Juno, the first of the goddesses to enter upon the scene; and even assuming that he had lingered on

Politian was no less responsive to Platonizing ideas than was Ficino to Epicureanism,[1] and in the mind of a cultured contemporary Botticelli's picture may well have evoked all the ideas of May festivals, chivalrous pageants, mythological *tableaux vivants*, and fertility rites which it evoked in that of M. Francastel. But for such a contemporary the notion of a Lucretian "*Vénus Génétrix*"[2] would have been far from incompatible with that of the *Venus-Humanitas* praised in Ficino's letter *Prospera in fato* as a "nymph of heavenly origin, beloved by God on high before all others", and strongly recommended as a bride to the young addressee—none other than Lorenzo de' Pierfrancesco Medici, the very *destinataire* of the "*Primavera*".[3] And that she looks—and conceivably is—pregnant in Botticelli's picture[4] does not invalidate the observation that her posture, gesture and drapery follow a well-established pattern traditionally associated with the Annunciation[5]—a *Typen-Übertragung* which, if the Ficinian equation Venus = *humanitas* were accepted, might even be justified on theological grounds. "The Blessed Virgin", says Thomas Aquinas, "is called the mother of God because she is, in relation to a

for reasons best known to himself, Cupid could hardly have selected him as a target (for this idea, see below, p. 199 f.). While Apuleius' Venus is "surrounded by the gayest crowd of Cupids" who "with burning torches light the path of their mistress as for a marriage feast", Botticelli shows only one Cupid, and that the latter's arrow is barbed with fire can be accounted for, as has been mentioned, by Politian's *oro focoso*; even should Botticelli have committed a kind of conflation between arrow and torch, he would not have needed Apuleius to learn that the torch is no less legitimate a weapon of Cupid than the arrow (see above, p. 94 f., Figs. 64–67, 75, as well as a little collection of instances in Panofsky, *Studies in Iconology*, pp. 96, 98). Finally, while Botticelli's Venus is dressed with almost ostentatious decency, the Venus in Apuleius' pantomime is even more daringly exposed than she appears to be in the genteel translation adopted by Gombrich. Her *tenue pallium bombycinum* is not a "flimsy garment veiling the lovely maiden" but a short, silken skirt or scarf (later on referred to as *lacinia*, "flap" or "lappet") which "obscures" (*inumbrabat*) only her "shapely pudenda" (*spectabilem pubem*) and, when lifted by an "inquisitive breeze", reveals still more. Even if an (undocumented) emendation of the text had suggested a transfer of this description to a figure other than Venus herself, it would not agree with the transparent but ankle-length dress of Botticelli's Flora. The only similarity that may be admitted to exist between the Apuleius text and Botticelli's picture is a symmetrical disposition by which Venus appears between the Graces, on one hand (*hinc*), and the Seasons, on the other (*inde*); but this analogy, not very cogent in itself, is further weakened by the fact that the picture shows the number of Seasons reduced to one, viz., Spring. And since the Graces are companions of Venus from time immemorial (see, e.g., our Figs. 56–58), while Spring, as has been mentioned, already occurs as a single figure in *Giostra*, I, 72, it is, to say the least, unnecessary to assume Botticelli's acquaintance with a text which would have suggested an arrangement similar to that of his "*Primavera*" only after a division by four and disagrees with it in every other respect.

[1] For Politian's Neo-Platonism, see Ferruolo, *op. cit.* (though he would seem to overstate the case somewhat); for Ficino's Epicureanism, Gabotto, *op. cit.*

[2] See Francastel, "La Fête mythologique", p. 397.

[3] See Gombrich, "Botticelli's Mythologies", p. 16; the letter is partially quoted above, p. 186.

[4] Francastel, "La Fête mythologique", p. 396, Note 1, calls her "cette Vénus gravide"; but since so many ladies in fifteenth-century art—from the elegant "damoiselles" in the *Très Riches Heures*, the demonstrably childless Mary of Guelders and Jan van Eyck's newly-wed Jeanne Cenami down to Piero and Antonio Pollaiuolo's *Virtues* and Botticelli's own *Minerva* look hardly less suspicious, I do not dare pronounce upon the gynaecological aspect of the problem.

[5] See Gombrich, "Botticelli's Mythologies", p. 41, Pl. 10, a., b.

Person having both a divine and a human nature, His mother with respect to His humanity".[1]

Nor would I deny that Botticelli's *Birth of Venus*, based though it is on Politian's straightforward paraphrase of the "Homeric Hymn", may have appealed to the men of the Renaissance as both an evocation and a fulfillment of their overwhelming emotion, the longing for "rebirth"[2]; and that the configuration of the group formed by the *Anadyomene* and the Hora of Spring attending upon her bears—morphologically and, by implication, *spiritualiter*—the same relation to the Baptism of Christ as does the Venus in the *"Primavera"* to the Mary Annunciate.[3]

What I should like to emphasize, however, is that latter-day criticism—tending either to separate the *"Primavera"* from the *Birth of Venus* or, conversely, to widen the discussion so as to include such other compositions, in part demonstrably produced for entirely different patrons, as the series of frescoes from Villa Lemmi, the *Mars and Venus* in the National Gallery and the *Minerva and Centaur* in the Uffizi[4]—has somewhat lost sight of the unique relationship which connects the *"Primavera"*, and only the *"Primavera"*, with the *Birth of Venus*, and only the *Birth of Venus*—a relationship which, all thematic and psychological affinities notwithstanding, sets these two pictures apart from Botticelli's other "Mythologies". The London *Mars and Venus* was executed, probably as a marriage picture, for a member of the Vespucci family;[5] the Villa Lemmi belonged to the Tornabuoni; and the original location of the *Minerva and Centaur*—no doubt commissioned by a Medici, but no one knows which—cannot be determined.[6] Of the *"Primavera"* and the *Birth of Venus*, however, we know that they were both executed for that young namesake and second cousin of Lorenzo the Magnificent, Lorenzo di Pierfrancesco de' Medici, just mentioned as the recipient of Ficino's letter *Prospera in fato*;[7] that both of them served to adorn the Villa di Castello (bought for

[1] *Summa Theologiae*, III, qu. XXXV, art. 4, c. Statements to the same effect abound in theological literature.

[2] See Warburg, *op. cit.*, I, p. 310 (with further references); Heckscher, "The *Anadyomene*", *passim*, particularly pp. 3, 7.

[3] See Gombrich, "Botticelli's Mythologies", p. 54 ff., Pl. 15, a., b.

[4] The two articles by Francastel, for example, deal with the *"Primavera"* but not with the *Birth of Venus*, while those by Heckscher deal with the *Birth of Venus* but not with the *"Primavera"*. Gombrich and Ferruolo, on the other hand, treat—quite legitimately from a more general point of view—all of Botticelli's mythological pictures as one coherent group.

[5] This was brilliantly shown by Gombrich, *ibidem*, p. 49.

[6] While earlier writers took it for granted that the *Minerva and Centaur* was commissioned by Lorenzo the Magnificent, Gombrich, *ibidem*, p. 50f., rightly points out that the heraldic device on which this assumption is based was worn by other members of the family as well; but his own opinion that the picture came from "Lorenzo di Pierfrancesco's city palace" is admittedly conjectural.

[7] Lorenzo di Pierfrancesco de' Medici (1463–1503), well known to art historians as an early and enthusiastic patron of Michelangelo, was the grandson of Lorenzo di Giovanni de' Medici, a natural brother of Lorenzo the Magnificent's grandfather, Cosimo. He was identified as the *destinataire* of the *"Primavera"* by Horne, *op. cit.*, p. 50 ff., while the credit for having connected this painting with Ficino's letter belongs to Gombrich.

"Laurentius Minor", as Ficino addresses him, in 1477), where they were still admired by Vasari; and that Vasari's description conveys the impression that they were regarded, if not as pendants in the technical sense of the term, at least as interrelated compositions demanding to be seen and interpreted as a pair.[1]

"At Castello, a villa of Duke Cosimo", Vasari says, "there are two narrative pictures: one showing Venus as she is born and those breezes and winds that bring her ashore, together with the Cupids; and also another Venus whom the Graces adorn with flowers, denoting Spring."[2]

In spite of its inaccuracy—or, rather, just because of its inaccuracy—this brief description is very revealing. We learn from it, first, that Vasari, comparatively indifferent to questions of iconography and hardly ever attempting an interpretation of his own, still knew—or, more probably, was told—that the real heroine of the picture introduced to him as an Allegory of Spring was, like that of its counterpart, Venus; and, second, that the two compositions had merged in his mind to such an extent that he transferred the Cupid from the *"Primavera"* to the *Birth of Venus* (while at the same time pluralizing him) and, on the other hand, transferred the action of adorning the goddess with flowers from the Zephyrs in the *Birth of Venus* to the self-contented Graces in the *"Primavera"*.

Once this external and internal correspondence between the two pictures is realized, we cannot fail to see the importance of another fact so simple and obvious that it has tended to be neglected by the learned interpreters: the fact that the goddess of love,

[1] To refer to the *"Primavera"* and the *Birth of Venus* as pendants (F. Hartt, *Botticelli*, New York, 1953, p. 12) is, at the present state of our knowledge, saying too much. The *"Primavera"*, probably executed about 1478, is painted on wood and measures 2.05 m × 3.16 m (exposed surface 2.03 m × 3.14 m). The *Birth of Venus*, probably completed some years later (according to some experts, about 1480, according to others, as late as about 1485), is painted on canvas and its exposed surface is only 1.70 m × 2.72 m. I learn, however, from Dr. Ugo Procacci, to whom I am very much obliged for his kindness, that its format was originally somewhat wider than it is now. On three sides the "true edges" of the painted surface can be determined: at the top, it exceeds the surface now exposed by 4 cm (of which, however, only 1 cm seems to have been visible); at the bottom, by 2 cm (originally all visible); and on the left, by 2.5 cm (also originally visible). On the right, however, no less than 5 cm are hidden behind the present frame, and these are not limited by a "true edge": here the canvas was cut right

through the paint. And under the assumption that the Venus figure, now slightly off axis, originally formed the center of the composition, we may conjecture that the original width of the painted surface amounted to *ca.* 2.90–2.95 m. Yet neither this difference in size and format (conceivably necessitated by the architecture) nor the difference in support would in itself exclude the possibility of a genuine pendant relationship: the *Birth of Venus* may have been painted on canvas rather than wood either in order to save time—particularly if it was executed about 1480 when Botticelli was on the point of departing for Rome, where he was active in the two following years—or, simply, because it was to be placed above a fireplace, where wood would crack.

[2] Vasari, *op. cit.*, III, p. 312: "A Castello, villa del Duca Cosimo, sono due quadri figurati, l'uno Venere che nasce e quelle aure e venti che la fanno venire in terra con gli amori, e così un' altra Venere che le Grazie la fioriscono, dinotando la Primavera".

occupying the central position in both compositions, is nude in the *Birth of Venus* and decorously draped in the *"Primavera"*. This contrast brings to mind the difference between the two Venus statues by Praxiteles of which the nude one, refused by the inhabitants of the Island of Kos and replaced by a draped one, became the glory of Knidos: the distinction between the "two Venuses, one draped, the other nude" ("doi Veneri, una vestida, laltra nuda") whom Mantegna was asked to include in his *Gates of Comus*; the antithesis between "Eternal Bliss" (*Felicità Eterna*, nude, seated on the starry firmament, and holding a"flame of fire" in her hand) and "Transient Bliss" (*Felicità Breve*, clad in rich garments, resplendent with jewels and equipped with a basin full of gems and coins) in Ripa's *Iconologia*; and the superiority of *Beltà disornata* (Beauty unadorned) over *Beltà ornata* (Beauty adorned) which Scipione Francucci, the earliest interpreter of this world-famous painting, believed to be expressed in Titian's *"Sacred and Profane Love"*—in short, the familiar, and in the Renaissance almost obsessive, preoccupation with the hierarchy that governs the interrelated spheres of Love and Beauty.[1]

For Ficino, as for every good Platonist, *Amor divinus*, divine or transcendent love, was, we recall, incomparably superior to *Amor humanus*, human or natural love; yet he considered both as equally estimable, particularly in comparison with *Amor ferinus*, irrational and, therefore, sub-human passion.[2] And like Plato and Plotinus he, too, accounted for this apparent paradox on genealogical as well as etymological grounds: the two acceptable kinds of love have different mothers who, though referred to as *duae Veneres*, *duplex Venus* or even *geminae Veneres* (the "Twin Venuses"),[3] are of different origin.

Amor divinus is the son of the celestial Venus (*Venus coelestis*) who had miraculously come into being when the genitals of Uranus, the god of heaven, were cast into the sea. She has, therefore, no mother—which means, in view of the supposed connection between the words *mater* and *materia*, that she dwells in the sphere of Mind, utterly remote from that of Matter. The love engendered by her enables our contemplative powers to possess themselves of divine beauty in an act of pure cognition: "ad divinam cogitandam pulchritudinem", to quote Ficino's telling phrase.

Amor humanus, on the contrary, is the son of the "ordinary" or natural Venus (*Venus*

[1] For the two *Venuses* of Praxiteles, Ripa's *Felicità Eterna* and *Felicità Breve* (as well as related personifications) and Mantegna's *doi Veneri*, see Panofsky, *Studies in Iconology*, pp. 150–160. For the *Gates of Comus* (largely executed by Lorenzo Costa), see Wind, *Bellini's Feast of the Gods*, p. 47, Fig. 59; for Titian's *"Sacred and Profane Love"*, the references given above, p. 191, Note 3.

[2] See above p. 185.

[3] For the expression *duplex Venus*, see, e.g., Ficino's *Commentary on the Symposium*, II, 7 (*Opera omnia*, II, p. 1326), the *locus classicus* for the doctrine here summarized; for the expressions *duae Veneres* and *geminae Veneres*, his *Commentary on Plotinus' Enneads*, III, 5 (*ibidem*, p. 1713 ff.).

vulgaris, an epithet here used without derogatory implications), who was the daughter of Zeus and Dione (*viz.*, Jupiter and Juno). She, then, is also of divine origin, but comes from less exalted parentage and was born in natural rather than supernatural fashion. Her home is in a lower sphere of being—that of Soul—and the love engendered by her enables our imaginative and sensory faculties to perceive and produce beauty in the material, perceptible world. Both kinds of love are, consequently, "honorable and praiseworthy, albeit in different degrees"; and each of the two Venuses "impels us to procreate beauty, but each in her own way".[1]

In the light of this doctrine Botticelli's *Birth of Venus*, showing the emergence of the goddess from the sea and thus *ipso facto* proclaiming her as the motherless daughter of Uranus, may be entitled "*The Advent of the Celestial Venus*", whereby we may remember that it was the nude *Venus of Knidos*, and not the draped *Venus of Kos*, in which the Greek mind recognized the image of Ἀφροδίτη Οὐρανία;[2] whereas the "*Primavera*" may be entitled "*The Realm of the Natural Venus*"—which designation leaves room for the identification of the heroine, pregnant or not, with Lucretius' *Venus Genetrix* as well as with Ficino's *Humanitas*.[3]

This formulation also agrees, I believe, with the behavior of those figures which recur in both the *Birth of Venus* and the "*Primavera*": the Hora of Spring and Zephyr. In the *Birth of Venus*—a theophany rather than a festival—Spring is cast in the modest role of a handmaiden deferentially offering a flower-embroidered garment to the *Anadyomene*; and Zephyr, floating in mid-air in the tender embrace of a gentler companion, is entirely absorbed in his task of "conveying the shell to the shore" while scattering flowers. In the "*Primavera*"—a festival rather than a theophany—the Hora of Spring appears in the guise of a dignified and gracious hostess while Zephyr, rushing to earth instead of staying in heaven, appears as the perfervid lover of Flora. And when we interpret the theme of the "*Primavera*" as the realm of the natural in contradistinction to the advent of the celestial Venus, we can understand the presence and conduct of that strange, intrusive character, Mercury.

We do not need Ficino's letter *Prospera in fato* (though its testimony is particularly welcome in our context) to learn that Mercury—the Ἑρμῆς λόγιος of the Greeks—

[1] Ficino, *Commentary on the Symposium*, VI, 4 (*ibidem*, II, p. 1344).

[2] Lucian, *Pro Imaginibus*, XXIII (W. Dindorf, ed., p. 420).

[3] Conversely, the identification of her counterpart with the *Venus coelestis* gives more significance not only to the recurrence (see Ferruolo, *op. cit.*, p. 21; Heckscher, "The *Anadyomene*", p. 6) but also to the alteration of Botticelli's *Venus Pudica* in his *Calumny of Apelles* (Fig. 149). Like the *Venus coelestis*, truth

comes from heaven; but it belongs, according to Ficino, to the *transcendentia*, consisting as it does in the "congruence of natural things with the *rationes* of the Mind Divine" (see Kristeller, *The Philosophy of Marsilio Ficino*, p. 52f.). Botticelli's Truth, therefore, agrees with his Venus in the gesture of her left hand, which expresses the predicates *vergogniosa e pudica* originally belonging to Repentance but transferred to Truth by Alberti, while disagreeing with his Venus in that she points upwards with her right.

signifies Reason.[1] Discursive reason, now, differs from the contemplative mind in that it has no direct access to the sphere of the celestial Venus; but it differs from imagination and sensory perception in that it is not involved in, or is even hostile to, the activities of the natural Venus. Reason is, by definition, both beneath the supra-rational and above the infra-rational. Thus Botticelli's Mercury would seem to symbolize the limitations as well as the possibilities of what human reason—"mere human reason", as a Neo-Platonic would say—can do.[2] Impervious to the fiery arrow of Cupid and turning his back not only upon the dance of the Graces, the fragrant gifts of Spring and the caresses of Zephyr and Flora but even upon Venus herself, he can dispel but not transcend the mist which befogs the "lower faculties" of the soul: he may be said to express the dignity, but also the loneliness of the one psychological power which is excluded from the precincts of *Amor divinus* and excludes itself from those of *Amor humanus.*

VIII

LOOKING back, we may say that the very comprehensiveness with which the Italian Quattrocento absorbed the influence of classical antiquity makes it nearly impossible to characterize this influence in general terms. In all significant masters—at times even in works produced by one and the same master at different periods or for different purposes—we find, to transfer a famous phrase of Paolo Giovio from fifteenth-century humanism to fifteenth-century art, a determined effort to evolve an individual Latinity which, while based on the richest possible erudition, would reveal their "natural genius" and "bear the unmistakable imprint of their own minds".[3]

Mantegna, probably more thoroughly familiar with classical monuments than any of his contemporaries, worked from literary sources as well as from Roman marbles, coins and medals, and in the treatment of classical or would-be classical themes his intentions varied from archaeological reconstruction—archaeological even when he was endeavoring to render a subject such as the Triumph of Caesar *vivis et spirantibus*

[1] See above, p. 183. That the Mercury in the *"Primavera"* stands for Reason has been recognized by Ferruolo, *ibidem*, p. 20f. (with several references, which curiously enough do not include Ficino's letter *Prospera in fato*); his specific role within the context of the picture is, however, interpreted in somewhat different manner.

[2] Those who believe that a similarity exists between the features of Botticelli's Mercury and those of Giuliano de' Medici may be tempted to account for his standoffish behavior by the fact that Politian's *Giostra* describes Giuliano as a kind of new Hippo-

lytus, exclusively devoted to the chase and other healthy pursuits but thoroughly averse to women (see Francastel, "La Fête mythologique", p. 401). There is, however, no evidence for this kind of pictorial reference *ad hominem* at so early a date in Italy. In addition, Botticelli's Mercury bears only a superficial resemblance to Giuliano de' Medici; his face is so nearly identical with that of the St. Sebastian in the but slightly earlier panel (1474) in Berlin that the painter may be presumed to have employed the same model for both figures.

[3] Burckhardt, *op. cit.*, pp. 279, 391.

imaginibus ("in living and breathing figures")[1]—to allegorical moralization and an attempt at reviving both Dionysiac passion and Apollonian serenity. Piero di Cosimo's efforts to lend concrete expression to the evolutionistic theories of Vitruvius and Lucretius and to the festive spirit of Ovid's *Fasti* produced a world fantastic by virtue of the very literalness with which he followed the classical texts. The *sacrosancta vetustas* seen through the eyes of the Venetians appears before us like a fairyland, more joyful but no less remote than the Arcady evoked in Signorelli's *Realm of Pan*. And Botticelli's endeavor to do justice to Neo-Platonic transcendentalism resulted in a voluptuous ethereality or ethereal voluptuousness which was, and is, the delight of the pre-Raphaelite mind; we can easily conceive that he, but not Piero di Cosimo, surrendered to Savonarola.

In nearly all Quattrocento art postdating the middle of the century we can observe, however, a certain strain or uneasiness as far as its relation to the Antique is concerned —an uneasiness produced by the side effects of the very remedy that had relieved the conditions prevailing before. Up to *ca.* 1450–1460, we remember, there existed a stylistic discrepancy between an architectural and decorative environment revised according to classical standards and figures dominated by non-classical traditions and influences. Once an attempt was made to apply the *maniera antica* to the figures as well, another dilemma was bound to arise.

When Mantegna aspired to a comprehensive restoration of the classical world from its visible and tangible remnants, he was exposed to the danger—not always avoided— of converting "living and breathing figures" into statues instead of infusing statues with the breath of life; and we can understand that this rigidity could produce a kind of counterrevolution even in him, not to mention as impassioned a follower as Cosimo Tura.

When, on the other hand, the ambitions of a painter were limited to the appropriation of individual classical models, he was confronted with the problem of preventing such borrowings from giving the impression of extraneous intrusions. A common denominator had to be found between the motifs freshly assimilated from the Antique and the traditional vocabulary; and since, as has been seen, the selection of classical motifs tended to be dictated by a desire for emotional excitement in form and expression rather than for what Winckelmann was to call "noble simplicity and quiet grandeur", this common denominator was found in an over-intensification of linear movement and an over-complication of compositional patterns—including even the architectural and

[1] Tietze-Conrat, *Mantegna*, pp. 21 ff., 183 f., Pls. 108–117. Although the *Triumph of Caesar* (still unfinished in 1492) is executed in natural colors, whereas the *Triumph of Scipio* in the National Gallery at London (Tietze, pp. 27, 184 ff., Pl. 147, datable 1504) is a monochrome deliberately simulating a bas-relief, I cannot see that the spirit of the former is very much less "archaeological" than that of the latter.

decorative elements (our Fig. 149)—which seems to anticipate the "Mannerism" of mid-sixteenth-century art. It is no accident that precisely those masters whom Warburg named as the champions of the *klassischer Idealstil*—such masters as Pollaiuolo, Botticelli and Filippino Lippi—were, at the same time, the chief representatives of what a younger generation of scholars was to refer to, perhaps not altogether accurately, as a "Neo-Gothic" style.[1]

It is characteristic of the High—in Wölfflin's terminology, *klassische*—Renaissance that it succeeded in unifying as well as stabilizing the attitude towards the Antique: the difference between comprehensive restoration and fractional appropriation was resolved into what may be called total absorption. In works that may be said to exemplify this High or *klassische* Renaissance in chemically pure form—so rare in number that even those who do believe in the factuality of the Renaissance as such may feel some little doubt as to the factuality of its climactic phase—the question of whether a given motif is derived from a classical model, depicted from life, suggested by the impression of a contemporary work of art or born in the master's imagination becomes irrelevant.[2] Raphael could produce one of his most beautiful figures, the Muse Euterpe (or Calliope?) reclining next to Apollo in his *Parnassus* (Fig. 153), by blending the *Ariadne* in the Vatican with Michelangelo's *Adam* in such a manner that no one but an art historian would realize the dual ancestry of what appears like a perfectly unified entity.[3] And the exalted humanity of figures such as this—no matter whether they are free inventions, "variations on a theme" or even portraits—is as thoroughly at home in the Bramante-

See, particularly, F. Antal, "Studien zur Gotik im Quattrocento", *Jahrbuch der preussischen Kunstsammlungen*, XLVI, 1925, p. 6ff.; G. Weise, "Die spätgotische Stilströmung in der Kunst der italienischen Renaissance", *Bibliothèque d'Humanisme et Renaissance*, XIV, 1952, p. 99ff.; *idem*, "Spätgotisches Schreiten und andere Motive spätgotischer Ausdrucks- und Bewegungsstilisierung", *Marburger Jahrbuch für Kunstgeschichte*, XIV, 1949, p. 163ff. It should be noted that Antal's views were, to some extent at least, anticipated by R. Hamann, *Die Frührenaissance der italienischen Malerei*, Jena, 1909, who not only coined the term *Neugotik* but even identified this "neo-Gothic" style with the entire Early Renaissance to such an extent that he omitted from his book all Quattrocento painters either active before its emergence or not appreciably affected by it. Such masters as Masaccio, Castagno, Uccello and Piero della Francesca do not belong, in Hamann's opinion, to the *Frührenaissance* but to what he is pleased to call *Vorrenaissance*. As an antidote there

may be recommended a recent article by H. Kauffmann, "Italienische Frührenaissance", *Arbeitsgemeinschaft für Forschung des Landes Nordheim-Westfalen*, *Jahresfeier 1956*, Köln and Opladen, 1956, p. 31ff.
[2] We may, however, take some comfort in the fact that chemistry itself would not be possible were it dominated by statistics. In nature the amount of, say, "pure carbon" is infinitesimally small in comparison with the amount of mixtures, not to mention compounds. Yet, the existence and analysability of mixtures and compounds presupposes the existence and identifiability of "pure" elements.
[3] The derivation of this Muse from the *Ariadne* has often been mentioned; I do not, however, remember a reference to the fact that the upper part of her body, particularly the position of her left arm and shoulders, reveals the influence of Michelangelo's *Adam*—an influence, incidentally, which is not as yet recognizable in the preliminary version of the *Parnassus* as transmitted through Marcantonio's engraving B. 247 (our Fig. 152).

inspired architecture of the *School of Athens* (Fig. 154) as it is amidst the laurels of Mount Parnassus.

Another discrepancy, still noticeable in Quattrocento art, also melted away in the brief burst of flame and light that was the High Renaissance: the discrepancy between motifs derived from verbal and visual tradition. And Raphael's *Parnassus*, to which our discussion has led us, gives us a chance to observe this phenomenon in the small and somewhat esoteric but all the more interesting field of what the Italians call *Archeologia musicale*, the study of musical instruments and their representation in art.

As has been brilliantly shown by Emanuel Winternitz,[1] the Renaissance had to face a self-created problem, unknown to the Middle Ages, which had assumed an almost technological character in theatrical performances and pageants: when themes such as the "Fable of Orpheus" or the "Fable of Cephalus and Procris" were made the subjects of plays, and Roman triumphs were re-enacted in the streets, an attempt had to be made to devise musical instruments the aspect of which would harmonize with costumes and sets *all' antica* even though the sound effects produced by genuine classical lyres and flutes would have been incompatible with the requirements of Renaissance music.

In practice, it seems, this problem was solved (unless the persons in charge were willing to put up with a patent anachronism) by keeping the actual musicians out of sight, whereas the instruments displayed on the stage were dummies more or less imaginatively contrived on the basis of descriptions found in classical literature; and the same method was followed—occasionally perhaps under the direct influence of such "props"—by Quattrocento painters.

To give a particularly telling example: in Filippino Lippi's "*Allegory of Music*" in Berlin (Fig. 150) the leading figure—in fact intended to represent the Muse Erato[2]— is one of the rare instances in which this charming artist made use of a classical model: reversed, changed as to sex and elegantly dressed in billowing garments, his Muse retains the complicated *contrapposto* attitude of Lysippus' *Cupid Stringing His Bow* (Fig. 151);[3] but the primitive lyre from which she contemptuously turns away so as to devote

[1] See E. Winternitz, "Archeologia musicale del rinascimento nel Parnaso di Raffaello", *Rendiconti della Pontificia Accademia Romana di Archeologia*, XXVII, 1952-1954, p. 359 ff.; idem, "Instruments de musique étranges chez Filippino Lippi, Piero di Cosimo et Lorenzo Costa", *Les Fêtes de la Renaissance*, I, Paris, 1956, p. 379 ff.

[2] See A. Scharf, *Filippino Lippi*, Vienna, 1935, p. 111, Fig. 109; K. B. Neilson, *Filippino Lippi*, Cambridge (Mass.), 1938, Fig. 88; Hamann, *Die Frührenaissance der italienischen Malerei*, Fig. 53.

[3] Miss Neilson, *ibidem*, p. 176 f., suggests, to my mind

unconvincingly, a connection with Leonardo's *Leda*; whereas Scharf, *ibidem*, p. 71, goes so far as to assert that "even where Filippino Lippi treated allegorical and mythological subjects borrowings from the Antique cannot be demonstrated". Lysippus' *Cupid Stringing His Bow* was known to the Renaissance through several copies still extant, and its popularity and adaptability are illustrated by Dürer's drawing L. 456 of *ca.* 1495 (reflecting an Italian prototype), which shows the Lysippian figure transformed into an Apollo (see Panofsky, *Albrecht Dürer*, II, p. 93, No. 909, Fig. 57).

her undivided attention to the Apollonian swan looks, as the saying goes, like nothing on earth. Fashioned from a stag's head and, according to the experts, incapable of producing any musical sound whatever,[1] this lyre seems utterly fantastic; but this impression is due, as I said of Piero di Cosimo, only to Filippino's literality. Except for the fact that he, in an attempt to be as unequivocal as possible, showed a complete stag's head instead of a mere skull, he faithfully illustrated Doris' malicious description of the lyre of Polyphemus in Lucian's *Dialogi marini:* "Look at his lyre", says Doris to Galatea, who is inclined to take a more charitable view of her unfortunate lover's musical accomplishments; "it is a stag's head deprived of its flesh, with the antlers for handles, to which he has added a yoke and strings but no pegs, producing only harsh and disharmonious sounds (ἄμουσόν τι καὶ ἀπῳδόν)".[2] In short, Filippino's lyre—its inferior quality further stressed by the fact that one of its strings is broken—is, like the pan-pipe beneath it, a symbol of low-class and uncouth as opposed to refined and "intellectual" music. His composition may be described as a particularly subtle and amusing variation on the age-old theme of that contrast between two kinds of music— the cultured *vs.* the rustic in classical antiquity, the sacred *vs.* the sinful in the Middle Ages[3]—which had found its paradigmatic expression in the Contest between Apollo and Marsyas. But the fact remains that Filippino's impossible-looking instrument can claim the support of an authoritative classical source.[4]

Quite different is the solution arrived at in Raphael's *Parnassus*. In the preliminary version, transmitted through an engraving by Marcantonio (Fig. 152), he provided Apollo as well as three of the Muses with instruments aptly described as *"all' antica* but not genuinely antique"[5]—instruments, that is, which (except for the rustic pan-pipe judiciously omitted from the fresco) do not derive from either classical literature or classical monuments, yet strike the unsuspecting layman as perfectly consistent with a Grecian environment. Prior to executing the fresco itself, however, Raphael had become acquainted with the well-known "Sarcophagus of the Muses" from Casa Mattei, and on the basis of this newly acquired knowledge he replaced what Aristotle would have called "the impossible yet probable" with the authentic, yet—by modern standards—improbable: he equipped the instrument-carrying figures, their number now

[1] Winternitz, "Instruments de musique étranges", p. 391.

[2] Lucian, *Dialogi Marini,* I, 4 (W. Dindorf, ed., p. 73).

[3] For this theme (cf. above p. 92, Note 3), see, e.g., F. W. Sternfeld, "The Dramatic and Allegorical Function of Music in Shakespeare's Tragedies", *Annales Musicologiques,* III, 1955, p. 265 ff., particularly p. 272 f.

[4] When I advised Dr. Winternitz of this little observation he generously reciprocated by informing me

that a sixteenth-century treatise on music gives special credit to Filippino, "quello eccellente pittore", for having depicted even the *plectron* in its authentic classical form. The fantastic instruments in his Parthenice fresco in S. M. Novella (Scharf, *op. cit.,* Fig. 119; better illustration in Hamann, *Die Frührenaissance der italienischen Malerei,* Fig. 52), would also seem to represent a well-meant effort at archaeological reconstruction.

[5] Winternitz, "Archeologia Musicale", p. 373.

increased to four by the inclusion of Sappho, with instruments exactly prefigured in the sarccophagus but in part as outlandish in appearance as the *kithara* of Erato (opposite to the Euterpe-Calliope) and Sappho's *lyra* fashioned from a tortoise shell.[1] Just at the height of this antiquarianism, however, Raphael substituted for Apollo's unorthodox but quite convincing lyre an entirely anachronistic *lira da braccia*, an instrument of which even the most primitive ancestors cannot be traced back beyond the tenth century A.D.

True, several Renaissance musicologists believed that bowed instruments had been familiar to the ancient Greeks; but Raphael must have known that in his day the *lira da braccia* was very much in use whereas the strange objects shown in the "Sarcophagus of the Muses" were not. When he modernized the instrument of the *Musagetes* while, at the same moment, archaizing those of his companions, he expressed the timelessness of a Parnassus that has room for Dante and Petrarch as well as for Homer and Virgil—much as, with an even bolder fusion of the classical past with the present, Leonardo da Vinci, Bramante and Michelangelo were to lend their features to the great Greek philosophers in the *School of Athens*.[2] Like the mediaeval seashell in the hand of Titian's Venus (Fig. 155)[3]—mediaeval only to a professional iconographer—the anachronistic viol in the hands of Raphael's Apollo—anachronistic only to a professional musicologist—may be said to epitomize what I meant when speaking of the "fatally auspicious moment" when the Renaissance succeeded in "resurrecting the soul of antiquity" instead of alternately galvanizing and exorcizing its corpse".

IN SPITE of the "Neo-Gothic" or "anti-classical" currents—which must be considered not only as a potential source of Mannerism but also as an actual and necessary prelude to the *klassische* High Renaissance—the Italian Quattrocento is and remains a *rinascimento dell' antichità*. The number of archaeological records such as the sketches of Francesco di Giorgio, the "*Taccuino Senese*" or the *Codex Escurialensis* increased rather than diminished as the century went on;[4] and at no time did the Quattrocento painters

[1] Winternitz, *ibidem*, p. 375 ff., Figs. 10–18.

[2] Winternitz, *ibidem*, p. 384f.

[3] Gombrich, "Botticelli's Mythologies", p. 30, Note 1, correctly points out that this motif, recurring in "Franciabigio's" *Venus* in the Galleria Borghese, cannot be accounted for by any classical source—except, we recall, for the corrupted reading of a Fulgentius passage referred to above, p. 87, Note 2.

[4] For "archaeological" sketchbooks of the fifteenth century and their significant difference from comparable documents produced in the sixteenth and seventeenth, see the recent and most illuminating survey in P. Pray Bober, *Drawings after the Antique by Amico Aspertini; Sketchbooks in the British Museum* (Studies of the Warburg Institute, XXI), London, 1957, particularly pp. 17 ff., 96 ff. For actual "borrowings" from the Antique in Quattrocento and Cinquecento art, the reader must be referred to the Bibliography in Ladendorf, *op. cit.* The field is too large to lend itself to comprehensive treatment; the very useful book by A. von Salis, *Antike und Renaissance; Ueber Nachleben und Weiterwirken der alten in der neueren Kunst*, Erlenbach-Zurich, 1947, is in reality only a collection of monographs.

—least of all, as has been seen, the champions of the "Neo-Gothic" movement— cease to remain in direct contact with the remnants of classical art.

The *ars nova* of the North, however, may be described as a *nascimento senz' antichità* or even as a *nascimento incontro all' antichità*. With one or two possible exceptions of purely individual relevance and of a purely iconographical character,[1] classical influence did not affect the work of Early Flemish painters; and what applies to painting and to the Netherlands applies, *a fortiori*, to all the other arts and to the North as a whole.

In the age of Thomas Aquinas and Beauvais Cathedral transalpine proto-humanism had succumbed, we remember, to scholasticism, and the transalpine proto-Renaissance to the High Gothic style.[2] In the fourteenth and fifteenth centuries valiant and varied attempts were made, especially in France, the Netherlands and England, at a further assimilation and a domestication of classical subject matter: through a moralization of classical mythology more definitely theological or even Christological than before;[3] through the translation into the vernacular of Greek and Roman classics (Livy, Terence, Valerius Maximus, Flavius Josephus, even Aristotle) and of such recent works particularly rich in classical references as Boccaccio's *De casibus* and *De claris mulieribus*; through popular paraphrases—entertaining, edifying or propagandistic—of mythological, astrological or medical texts. In the end, antiquarian erudition, disseminated by the early products of the printing press, came to be vulgarized and paraded to such an extent that Erasmus of Rotterdam could make fun of preachers who, "if they are to speak of charity begin with the River Nile in Egypt" or, "if they want to explain the mystery of the Cross start out with Baal, the Babylonian snake-god". We can even observe a new development in that the traditional but thus far generic claims to descent from Greece, Troy and Rome began to be exploited for the glorification of an individual dynasty: the Order of the Golden Fleece was founded under the joint auspices of Gideon and Jason, and Philip the Good was not only likened to Alexander, Scipio, Caesar, and Augustus (as Chaucer was to Socrates, Ovid and Seneca) but also considered as a descendant of Hercules who, on

[1] One of these possible exceptions is Jan van Eyck's free imitation of provincial Roman tombstones in his London portrait (probably of Gilles Binchois); cf. Panofsky, *Early Netherlandish Painting*, p. 196f. (and Notes). Another is Roger van der Weyden's transformation of a Deposition into a "Bearing of the Body" (drawing after Roger in the Louvre, illustrated, e.g., in Panofsky, *ibidem*, Fig. 392) under the influence of a Roman sarcophagus; this influence— which does not seem improbable in view of the fact that the subject of Roger's composition had no antecedents in the Northern tradition at his time— was conjectured by S. Sulzberger, "Relations artistiques italo-flamandes autour d'une oeuvre perdue de Roger van der Weyden", *Bulletin de l'Institut Historique Belge de Rome*, XXVI, 1950–1951, p. 251 ff.

[2] See above, p. 101 ff.

[3] See particulary the sources adduced above, p. 78 ff.; cf. Seznec, *op. cit.*, *passim*, particularly pp. 91 ff., 174 ff.

his way to Spain, had taken time out to found the Burgundian dynasty in collaboration with a native damsel named Alise.[1]

All this, however, impeded rather than promoted the appreciation of classical art and literature from a critical and, more important, from an aesthetic point of view. Filled to capacity with information—or misinformation—about classical mythology, religion, history, customs, and science ("never underestimate the Burgundian schoolmaster", as Aby Warburg used to say), the educated Northern mind of the fifteenth century rejoiced in its familiarity with what may be called the topical content of the classical tradition without regretting, or even realizing, its estrangement from classical form. Despite the efforts of such Petrarchians *in partibus* as Nicolas de Clamanges,[2] the revival of a feeling for classical diction had to wait for Erasmus of Rotterdam, Guillaume Budé, Thomas More, and Melanchthon, just as the revival of a feeling for classical proportions and movement had to wait for Dürer, Burgkmair, Holbein, and Gossart. The fabulous collections of art treasures amassed by Louis of Orléans, Philip the Good and, above all, the Duc de Berry, did not as yet include Roman marbles or bronzes, let alone plaster casts of famous classical statues such as were to be ordered by Francis I. The German fifteenth-century copies of the pictures in the *Chronograph of 354* (Fig. 156) or the *De universo* by Hrabanus Maurus (Fig. 157), while bearing witness to the growth of antiquarian interests, evince a profound incomprehension for classical style;[3] and where the fifteenth-century illuminators, painters, tapestry weavers, and printmakers attempted to revive the gods and heroes from textual descriptions alone, their efforts appear to the modern beholder as even more misguided than earlier renderings: a High Gothic Thisbe (Fig. 54) appears to us, if not as "authentic", at least as somehow poetic and romantic; whereas a Galatea clad in a fifteenth-century costume, more comparable to our own fashions in technical construction but just for this reason curiously antiquated and graceless in effect (Fig. 55), strikes us, quite literally, as a "travesty".

Stylistically, then, the reaction of the North to the aesthetic values of classical art may be said to have changed from indifferent to negative—in the terms of our previous simile, from "zero" to "minus"—in the course of the fifteenth century. At the terminal stage of the development—marked by a kind of gentle lassitude (*détente*) in France as well as the Southern Netherlands and by a kind of somber turbulence ("late Gothic

[1] The Erasmus passage referred to is found in *Praise of Folly*, Chapter XXXI. For the mythological pedigrees of individual dynasties, see Seznec, *ibidem*, p. 25 f.

[2] See above, p. 38, Note 3.

[3] For fifteenth-century copies after the Planetary Gods in the *Chronograph of 354* (here used for the illustration of astrological texts), see the closely related manuscripts in Rome, Vatican Library, Cod. Pal. lat. 1370, and Darmstadt, State Library, MS. 266 (cf. Panofsky and Saxl, "Classical Mythology in Mediaeval Art", p. 247f., Fig. 33a; Stern, *op. cit.*, p. 21ff., Pls. XIX [lower pictures], XX). For a fifteenth-century copy after Hrabanus Maurus' *De universo* (Rome, Vatican Library, Cod. Pal. lat. 291), see Panofsky and Saxl, *ibidem*, p. 258, Fig. 41.

Baroque") in the Germanic countries—no direct contact with the Antique was possible. When, at the threshold of the sixteenth century, the time had come for a new *rapprochement* the Northern Renaissance, unlike the mediaeval renascences, was no longer able to "perceive" the remnants of classical art unaided. It could read the original texts only in modern translations. And these translations—translations into an idiom which, though foreign, belonged to the spoken language of the period—were produced in Italy.[1]

Here, in contrast to the North, the decline of classicizing tendencies in the second half of the fourteenth century had not diminished but, on the contrary, helped to enhance the value of classical art in the eyes of a humanistically-minded minority: the very alienation of the later Trecento style from that of the Antique (the visible remains of which continued, after all, to form part of the Italian scene) invited, even challenged, perceptive artists, scholars and "connoisseurs" to compare the contemporary production with that of the classical past, to become conscious of the latter's "superiority", and thus to transfer Petrarch's Rome worship from the realms of literary style and political ideas to that of the visual arts.

When an intimate friend and disciple of Petrarch, Giovanni Dondi—called "Giovanni dell'Orologio" on account of a much-admired astronomical clock which he had constructed for the Castle of Pavia, but no less renowned as a humanist and poet than as a medical man and practical scientist—visited Rome about 1375, he made antiquarian observations and epigraphical transcriptions accurate enough to be included in Mommsen's *Corpus inscriptionum Latinarum*. And sometime later (he lived until 1389), he recorded his and his like-minded friends' experience of classical art in a remarkable letter: "These [viz., the triumphal arches, columns, etc., described in the preceding sentences] verily bear witness to great men; similar monuments, [erected] for similar reasons, are not produced in our own age, and this, indubitably, because of the absence not only of those whose actions would deserve such tributes but also of those who, provided that there were such as had acted accordingly, would be in favor of their being so lavishly honored". And, even more apropos: "Few of the works of art produced by the ancient geniuses have been preserved; but those which have survived somewhere are eagerly looked for and inspected by sensitive persons (*qui in ea re sentiunt*) and command high prices. And if you compare to them what is produced nowadays (*si illis hodierna contuleris*), it will be evident that their authors were superior in natural genius and more knowing in the application of their art. When carefully observing ancient buildings, statues, reliefs, and the like, the artists of our time are amazed. I knew a sculptor in marble famous in his craft among those then living in Italy, particularly

[1] For a more detailed analysis of this phenomenon, see Panofsky, "Dürer's Stellung zur Antike".

as far as figures are concerned; him I have often heard hold forth upon the statues and reliefs which he had seen in Rome with such admiration and reverence that, in merely relating it, he seemed to get beside himself with enthusiasm. Once (so I was told), when in the company of five friends he passed by a place where images of this kind could be seen, he stayed behind and looked at them, enraptured by their artistry; and he kept standing there, forgetful of his companions, until they had proceeded five hundred paces or more. After having talked a good deal about the excellence of those figures and having praised their authors and their authors' genius beyond all measure, he used to conclude, to quote his own words, with the statement that, if those images did not lack the breath of life, they would be superior to living beings—as though he meant to say that nature had not so much been imitated as vanquished by the genius of those great artists".[1]

[1] The text of Dondi's letter (Venice, Biblioteca di San Marco, MS. lat. cl. xiv, 223, fol. 58 v.) is reprinted in Prince d'Essling and E. Müntz, *Pétrarque; Ses études d'art, son influence sur les artistes ...*, Paris, 1902, p. 45, Notes 2, 3 (with reference to another member of Petrarch's circle, Lombardo della Seta, famous for his interest in, and collection of, classical statuary). For Dondi as well as della Seta, cf. Schlosser, "Ueber einige Antiken Ghibertis", particularly p. 157; and, more recently, Mommsen, *Petrarch's Testament*, pp. 27, 33. The passages translated in the text read as follows: "Hec profecto sunt magnorum argumento [should read *argumenta*] virorum. Talibus similia ob similes causas hoc nostro evo non fiunt et quare putas nisi quia desunt tam hi qui illa agant quibus talia premia debeantur, quam hi qui sic agentibus, si forent, faverent quo talia largirentur". And: "De artificiis ingeniorum veterum quamquam pauca supersint, si que tamen manent alicubi, ab his qui ea in re sentiunt cupide queruntur et videntur magnique penduntur. Et si illis hodierna contuleris, non latebit auctores eorum fuisse ex natura ingenio potiores et Artis magisterio doctiores. Edificia dico vetera et statuas sculpturasque cum aliis modi hujus quorum quedam cum diligenter observant hujus temporis artifices obstupescunt. Novi ego marmorarium quemdam famosum illius facultatis artificem inter eos quos tum haberet Ytalia, presertim in artifitio figurarum; hunc pluries audivi statuas atque sculpturas quas Rome prospexerat tanta cum admiratione atque veneratione narantem, ut id referens poni quodamodo extra se ex rei miraculo videretur. Aiebant enim se quinque cum sociis transeuntem inde ubi alique hujusmodi cernerentur ymagines, intuendo fuisse detentum stupore artificii et societatis oblitum substitisse tam diu donec comites per quingentos passus et amplius preterirent; et cum multa de illarum figurarum bonitate narraret et auctores laudaret ultraque modum comendaret ingenia, ad extremum hoc solebat addicere, ut verbo utar suo, nisi illis ymaginibus spiritus vite deesset, meliores illas esse quam vivas, ac si diceret a tantorum artificum ingeniis non modo imitatam fuisse naturam verum etiam superatam". Since the word *sculptura* is consistently used in contradistinction to *statua*, I have rendered it as "relief". Krautheimer's interpretation of Dondi's letter (*Lorenzo Ghiberti*, p. 295ff.), accessible to me only after my own text had been established, places perhaps too great an emphasis on the difference between the artists and connoisseurs, on the one hand, and the humanists, on the other. While it is true that Dondi's reaction to the "aesthetic" values of classical art was less direct and powerful than that of his artist friends, he hardly deserves to be called "purblind". He sympathized with them at least to the extent that he accepted their belief in the superiority of ancient art as well as ancient *virtù*; and when he speaks of the latter as a combination of "justice, fortitude, temperance, and prudence", we should remember that this "quadrivium of medieval virtues" had been established by Plato (see, e.g., *Republic*, 427-428) and was accepted throughout the classical era. As far as Dondi's attitude towards classical monuments is concerned, he may be said to hold an intermediary position between his artist friends and a man like Niccolo da Martoni, a notary from Capua, who visited Athens in 1395 (J. M. Paton, *Chapters on Mediaeval and Renaissance Visitors to Greek Lands*, Princeton, N.J., 1951, p. 30ff.). The latter approaches

Hildebert of Lavardin had spoken of the Roman antiquities, and Ristoro d'Arezzo of Aretine pottery, in a similar vein of rapturous enchantment.[1] But Hildebert had written as a Northerner overwhelmed by the grandeur of the Eternal City; Ristoro had written as a patriot intent on glorifying his "fatherland"; and neither of them—nor, so far as I know, any other writer prior to Dondi—had thought of contrasting the art of the classical past (*artificia ingeniorum veterum*) with that of his own age (*hodierna, hoc nostrum evum*) and of extolling the former at the expense of the latter. In Dondi's words we hear, perhaps for the first time, the echo of that experience—a nostalgic vision born of estrangement as well as a sense of affinity—which is the very essence of the Renaissance.

the monuments of Athens in almost exactly the same spirit as the *Mirabilia Urbis Romae* do the antiquities of Rome; he retells and believes the most incredible stories and admires the Parthenon only because so big a building was erected on top of a hill: "Impossibile videtur menti hominis quomodo ipsa tam magna hedificia construi potuerunt".

[1] See above, p. 72 f.

BIBLIOGRAPHY*

ABRAHAMS, P., *Les Œuvres poétiques de Baudri de Bourgueil*, Paris, 1926.

ACKERMAN, J. S., '*Ars Sine Scientia Nihil Est;* Gothic Theory of Architecture at the Cathedral of Milan,' *Art Bulletin*, XXXI, 1949, p. 84 ff.

ADHÉMAR, J., *Influences antiques dans l'art du moyen âge français; Recherches sur les sources et les thèmes d'inspiration* (Studies of the Warburg Institute, VII), London, 1939.

ALBERTI, LEON BATTISTA, see Janitschek, Mallé, Spencer.

ALTROCCHI, R., 'The Calumny of Apelles in the Literature of the Quattrocento,' *Publications of the Modern Language Association of America*, XXXVI, 1921, p. 454 ff.

AMELLI, A. M., *Miniature sacre e profane dell'anno 1023 illustranti l'Enciclopedia medioevale di Rabano Mauro*, Monte Cassino, 1896.

AMELUNG, W., *Die Sculpturen des Vaticanischen Museums*, Berlin, 1903.

AMIRA, K. von, *Die Dresdner Bilderhandschrift des Sachsenspiegels*, Leipzig, 1902.

ANONIMO FIORENTINO, see Fanfani.

ANTAL, F., 'Studien zur Gotik im Quattrocento,' *Jahrbuch der preussischen Kunstsammlungen*, XLVI, 1925, p. 6 ff.

ASHMOLE, B., 'Cyriac of Ancona and the Temple of Cyzicus,' *Journal of the Warburg and Courtauld Institutes*, XIX, 1956, p. 179 ff.

ATWOOD, E. B., and WHITAKER, V. K., eds., *Excidium Troiae*, Cambridge (Mass.), 1944.

AUBERT, M., *L'Art français à l'epoque romane; architecture et sculpture*, Paris, 1929–1950.

AUERBACH, E., 'Lateinische Prosa des 9. und 10. Jahrhunderts (*Sermo humilis*, II),' *Romanische Forschungen*, LXVI, 1955, p. 1 ff.

BACCI, P., *Dipinti inediti e sconosciuti di Pietro Lorenzetti ... in Siena e nel contado*, Siena, 1939.

—— *La Ricostruzione del pergamo di Giovanni Pisano nel Duomo di Pisa*, Milan, 1926.

BAEYENS, H., *Begrip en probleem van de Renaissance; Bijdrage tot de geschiedenis van hun ontstaan en tot hun kunsthistorische omschrijving*, Louvain, 1952.

BAINTON, R. H., 'Michael Servetus and the Pulmonary Transit,' *Bulletin of the History of Medicine*, XXV, 1951, p. 1 ff.

—— See also *Renaissance*.

BAKER, H., *Introduction to Tragedy*, Baton Rouge (La.), 1939.

BARON, H., *The Crisis of the Early Italian Renaissance*, Princeton, 1955.

—— Review of Baeyens, *Begrip en Probleem van de Renaissance*, in *Historische Zeitschrift*, CLXXXII, 1956, p. 115 ff.

BAUDRY DE BOURGUEIL, see Abrahams.

BAYAT, A., *La Légende de Troie à la cour de Bourgogne*, Bruges, 1908.

BAYET, J., 'Le Symbolisme du cerf et du Centaure à la Porte Rouge de Notre-Dame de Paris,' *Revue Archéologique*, XLIV, 1954, p. 21 ff.

* Only publications postdating 1800 are listed. Modern editions of earlier authors are included only for special reasons.

BEENKEN, H., 'Die Mittelstellung der mittelalterlichen Kunst zwischen Antike und Renaissance,' *Medieval Studies in Memory of A. Kingsley Porter*, Cambridge (Mass.), I, p. 47 ff.

—— *Romanische Skulptur in Deutschland*, Leipzig, 1924.

BEER, E. S. DE, 'Gothic: Origin and Diffusion of the Term; The Idea of Style in Architecture,' *Journal of the Warburg and Courtauld Institutes*, XI, 1948, p. 143 ff.

BEESON, C.-H., *Lupus of Ferrières as Scribe and Text Critic; A Study of His Autograph Copy of Cicero's 'De oratore*,' Cambridge (Mass.), 1930.

BEGEMANN, E. HAVERKAMP, 'Een Noord-Nederlandse Primitief,' *Bulletin Museum Boymans, Rotterdam*, II, 1951, p. 51 ff.

BENEVENUTUS DE RAMBALDIS (Benvenuto da Imola), see Lacaita.

BENKARD, E., *Das literarische Porträt des Giovanni Cimabue*, Munich, 1917.

BERNARDUS MORLANENSIS, see Hoskier.

BERNHEIMER, R., *Romanische Tierplastik und die Ursprünge ihrer Motive*, Munich, 1931.

BERTAUX, E., *L'Art dans l'Italie méridionale*, Paris, 1904.

BERTONI, G., *Atlante storico-artistico del Duomo di Modena*, Modena, 1921.

BESELER, H., 'Die Frage einer ottonischen Antikenübernahme,' *Schülerfestschrift Hans Jantzen*, Kunsthistorisches Institut München (manuscript essays), 1951.

BEZOLD, F. VON, *Das Fortleben der antiken Götter im mittelalterlichen Humanismus*, Bonn, 1922.

BIALOSTOCKI, J., *Albrecht Dürer, Jako pisarz i teoretyk sztuki*, Wroclaw (Breslau), 1956.

BIANCHI-BANDINELLI, R., 'Osservazioni storico-artistiche a un passo del *Sofista* Platonico,' *Studi in onore di Ugo Enrico Paoli*, Florence, 1956, p. 81 ff.

BIGNONE, E., 'Per la Fortuna di Lucrezio e dell' Epicureismo nel medio evo,' *Rivista di Filologia e di Istruzione Classica*, XLI, 1913, p. 231 ff.

BILLI, ANTONIO, see Frey.

BIRCHLER, L., PELICHET, E., and SCHMID, A., eds., *Frühmittelalterliche Kunst in den Alpenländern* (*Art du Haut Moyen Age dans la Région Alpine; Arte dell'alto Medio Evo nella regione Alpina*), Akten zum III. *Internationalen Kongress für Frühmittelalterforschung*, Olten and Lausanne, 1954. See also Krautheimer.

BISCHOFF, B., 'Die Ueberlieferung des Theophilus-Rugerus nach den ältesten Handschriften,' *Münchner Jahrbuch der bildenden Kunst*, 3rd series, III/IV, 1952/53, p. 1 ff.

BLANCKENHAGEN, P. H. VON, 'Narration in Hellenistic and Roman Art,' *American Journal of Archaeology*, LXI, 1957, p. 78 ff.

BLOOMFIELD, M., *The Seven Deadly Sins; An Introduction to the History of a Religious Concept with Special Reference to Medieval English Literature*, Michigan State College Press, 1952.

BLUM, I., *Andrea Mantegna und die Antike*, Strasbourg, 1936.

BOAS, G., *The Hieroglyphs of Horapollon*, New York, 1950.

—— 'Historical Periods,' *Journal of Aesthetics and Art Criticism*, XI, 1953, p. 248 ff.

BOBER, P. PRAY, *Drawings after the Antique by Amico Aspertini; Sketchbooks in the British Museum* (Studies of the Warburg Institute, XXI), London, 1957.

BOCCACCIO, see Corazzini, Romano.

BOCK, E., 'Binokularperspektive als Grundlage einer neuen Bilderscheinung,' *Alte und neue Kunst, Wiener kunstwissenschaftliche Blätter*, II, 1953, p. 101 ff.

—— 'Perspektive Bilder als Wiedergaben binokularer Gesichtsvorstellungen,' *Alte und neue Kunst, Wiener kunstwissenschaftliche Blätter*, III, 1954, p. 81 ff.

BODE, G. H., *Scriptores rerum mythicarum latini tres ...*, Celle, 1834.

BOECKLER, A., *Abendländische Miniaturen bis zum Ausgang der romanischen Zeit* (*Tabulae in usum scholarum*, J. Lietzmann, ed.), Berlin and Leipzig, 1930.

—— *Das goldene Evangelienbuch Heinrichs III*, Berlin, 1933.

—— See also Degering.

BOER, C. DE, 'Ovide moralisé en prose,' *Verhandelingen der K. Nederlandse Akademie van Wetenschappen, afd. Letterkunde*, New Series, LXI, 1954.

—— (in collaboration with J. T. M. van't Sant), 'Ovide moralisé,' *Verhandelingen der Koninklijke Nederlandse Akademie van Wetenschappen, afd. Letterkunde*, New Series, XV (1915), XXI (1920), XXX (1931), XXXVI/XXXVII (1936), XLIII (1938).

BOINET, A., *La Miniature Carolingienne*, Paris, 1913.

BOON, K. G., 'Erwin Panofsky's Early Netherlandish Painting en de sindsdien verschenen litteratur over dit onderwerp,' *Oud-Holland*, LXXII, 1957, p. 169 ff.

BOULENGER, J., 'Le vrai Siècle de la Renaissance,' *Humanisme et Reniassance*, I, 1934, p. 9 ff.

BOUTÉMY, A., 'Le Poème '*Pergama flere volo*' et ses imitations du XIIᵉ siècle,' *Latomus*, V, 1946, p. 233 ff.

BRADNER, L., see also *Rénaissance*.

BRANDI, C., *Duccio*, Florence, 1951.

BRENDEL, O., 'The Interpretation of the Holkham Venus,' *Art Bulletin*, XXVIII, 1946, p. 65 ff.

BRICKOFF, M., 'Afrodite nella conchiglia,' *Bollettino d'Arte*, 2nd Ser., IX, 1929–1930, p. 563 ff.

BRUHNS, L., *Hohenstaufenschlösser*, Königstein im Taunus, 1941.

BRUNETTI, G., see Sinibaldi.

BUCHTHAL, H., *Miniature Painting in the Latin Kingdom of Jerusalem (With Liturgical and Palaeographical Chapter by Francis Wormald)*, Oxford, 1957.

—— Review of Schoenebeck, 'Ein christlicher Sarkophag aus St. Guilhem,' *Bibliography of the Survival of the Classics*, Warburg Institute, ed., II, London, 1938, p. 204.

BUNIM, M. SCHILD, see Schild.

BURCKHARDT, J., *Die Kultur der Renaissance*, 10th ed., E. Geiger, ed., Leipzig, 1908.

BURDACH, KONRAD, 'Sinn und Ursprung der Worte Renaissance und Reformation,' *Sitzungsberichte der Akademie der Wissenschaften in Berlin, phil.-hist. Klasse*, 1910, p. 655 ff.

BUSCHBECK, E. H., 'Ueber eine unbeachtete Wurzel der maniera moderna,' *Festschrift für Julius Schlosser zum 60. Geburtstage*, Zurich, Leipzig and Vienna, 1927, p. 88 ff.

BUSH, D., *The Renaissance and English Humanism*, Toronto, 1939.

BUSH-BROWN, A., 'Giotto: Two Problems in the History of His Style,' *Art Bulletin*, XXXIV, 1952, p. 42 ff.

CALASSO, E., *Lezioni di storia del diritto italiano; Le fonti del diritto* (Sec. Vº–XVº), Milan, 1948.

CASSIRER, E., *Individuum und Kosmos in der Philosophie der Renaissance* (Studien der Bibliothek Warburg, X), Leipzig and Berlin, 1927.

—— *Die platonische Renaissance in England* (Studien der Bibliothek Warburg, XXIV), Leipzig and Berlin, 1932.

CASTIGLIONI, A., 'Gerolamo Fracastoro e la dottrina del *contagium vivum*,' *Gesnerus*, VIII, 1951, p. 52 ff.

CAVATTONI, C., *Tre Carmi latini composti a mezzo il secolo XV in laude di Vittore Pisano*, Verona, 1861.

CECCHI, E., *Pietro Lorenzetti*, Milan, 1930.

—— *The Sienese Painters of the Trecento*, New York and London, 1931.

CENNINI, CENNINO, see Thompson, V. D.

CHASTEL, A., 'Art et religion dans la Renaissance italienne; Essai sur la méthode,' *Bibliothèque d'Humanisme et Renaissance*, VII, 1945, p. 7 ff.

—— 'Le jeune Homme au camée platonicien du Bargello,' *Proporzioni*, III, 1950, p. 73 ff.

—— 'Marqueterie et perspective au XVᵉ siècle,' *Revue des Arts*, III, 1953, p. 141 ff.

—— *Marsile Ficin et l'art*, Geneva and Lille, 1954.

CHATELAIN, E., 'Les Palimpsestes latins,' *Annuaire de l'Ecole Pratique des Hautes Etudes, Section des Sciences Historiques et Philologiques*, Paris, 1904, p. 5 ff.

CHUECA, F., *La Catedral nueva de Salamanca (Acta Salmaticiencie IV)*, Salamanca, 1951.

CLEMEN, P., *Die romanische Monumentalmalerei in den Rheinlanden*, Düsseldorf, 1916.

COLONNE, GUIDO DELLE, see Griffin.

COLVIN, S., *A Florentine Picture Chronicle, Being a Series of Ninety-Nine Drawings ... by Maso Finiguerra ... in the British Museum*, London, 1898.

COOLIDGE, J., Review of P. Sanpaolesi, *La cupola di Santa Maria del Fiore: Il Progetto, la Costruzione* (Rome, 1941), *Art Bulletin*, XXXIV, 1952, p. 165 f.

CORAZZINI, F., ed., *Boccaccio, Lettere edite ed inedite*, Florence, 1877.

Corpus nummorum Italicorum, IV (Lombardia), Rome, 1913.

COULTON, G. G., *Art and the Reformation*, New York, 1928.

COURCELLE, P., 'La Tradition antique dans les miniatures inédites d'un Virgile de Naples,' *Mélanges d'Archéologie et d'Histoire*, LVI, 1939, p. 249 ff.

COVILLE, A., *Contier et Pierre Col et l'humanisme en France au temps de Charles VI*, Paris, 1934.

213

CRICHTON, G. H., *Romanesque Sculpture in Italy*, London, 1954.

CROZET, R., *L'Art roman en Berry*, Paris, 1932.

CUMONT, F., *Recherches sur le symbolisme funéraire des Romains*, Paris, 1942.

CURTIUS, E. R., *Europäische Literatur und lateinisches Mittelalter*, Bern, 1948 (English translation: *European Literature and the Latin Middle Ages* [Bollingen Series, XXXVI], New York, 1953).

D'ANCONA, P., *La Miniature italienne du Xe au XVIe siècle*, Paris and Brussels, 1925.

DAVY, M.-M., *Essai sur la symbolique romane (XIIe Siècle)*, Paris, 1955.

DAWSON, C., *Christianity and the New Age (Essays in Order, No. 3)*, London, 1931.

DEÉR, J., 'Das Kaiserbild im Kreuz,' *Schweizerische Beiträge zur allgemeinen Geschichte*, XIII, 1955, p. 48 ff.

—— 'Die Baseler Löwenkamee und der süditalienische Gemmenschnitt des 12. und 13. Jahrhunderts; Ein Beitrag zur Geschichte der abendländischen Protorenaissance,' *Zeitschrift für Schweizerische Archäologie und Kunstgeschichte*, XIV, 1952, p. 129 ff.

DEGENHART, B., *Antonio Pisanello*, Vienna, 1940.

—— *Italienische Zeichnungen des frühen 15. Jahrhunderts*, Basel, 1949.

DEGERING, H., and BOECKLER, A., *Die Quedlinburger Italafragmente*, Berlin, 1932.

DELAISSÉ, L. M. J., 'Enluminure et peinture dans les Pays-Bas; A propos du livre de E. Panofsky "Early Netherlandish Painting,"' *Scriptorium* XI, 1957, p. 109 ff.

DEMUS, O., 'A Renascence of Early Christian Art in Thirteenth Century Venice,' *Late Classical and Mediaeval Studies in Honor of Albert Mathias Friend, Jr.*, Princeton, 1954, p. 348 ff.

DESHOUILLIÈRES, F., 'Besse-en-Chandesse,' *Congrès Archéologique*, 1924 (Clermont-Ferrand).

DESNEUX, J., 'Nicholas Rolin, authentique donateur de la Vierge d'Autun,' *Revue des Arts*, IV, 1954, p. 195 ff.

—— *Rigueur de Jean van Eyck*, Brussels, 1951.

DEWALD, E. T., *The Illustrations of the Utrecht Psalter*, Princeton, 1932.

—— 'Observations on Duccio's *Maestà*,' *Late-Classical and Mediaeval Studies in Honor of Albert Mathias Friend, Jr.*, Princeton, 1954, p. 362 ff.

—— 'Pietro Lorenzetti,' *Art Studies*, VII, 1929, p. 131 ff.

—— *The Stuttgart Psalter, Biblia Folio 23, Württembergische Landesbibliothek, Stuttgart*, Princeton, 1930.

DIETERICH, J. R., 'Das Porträt Kaiser Friedrichs II von Hohenstaufen,' *Zeitschrift für bildende Kunst*, New Ser., XIV, 1903, p. 251 ff.

DOBBERT, E., 'Der Triumph des Todes,' *Repertorium für Kunstwissenschaft*, IV, 1881, p. 1 ff.

DODWELL, C. R., *The Canterbury School of Illumination 1066–1200*, Cambridge, 1954.

DOLFEN, C., *Der Kaiserpokal der Stadt Osnabrück*, Osnabrück, 1927.

DOREN, A., 'Fortuna im Mittelalter und in der Renaissance,' *Vorträge der Bibliothek Warburg*, I, 1922–1923, p. 71 ff.

DOUGLAS, R. LANGTON, *Piero di Cosimo*, Chicago, 1946.

DÜRER, ALBRECHT, see Lange and Fuhse.

DUNGER, H., *Die Sage vom troianischen Krieg in den Bearbeitungen des Mittelalters und ihre antiken Quellen* (Programm des Vitzthumschen Gymnasiums), Dresden, 1869.

DURAND-LEFÈBVRE, M., *Art gallo-romain et sculpture romane*, Paris, 1937.

EINEM, H. VON, 'Zur Hildesheimer Bronzetür,' *Jahrbuch der preussischen Kunstsammlungen*, LIX, 1938, p. 3 ff.

—— 'Die Monumentalplastik des Mittelalters und ihr Verhältnis zur Antike,' *Antike und Abendland*, III, 1948, p. 120 ff.

EITNER, L. E. A., *The Flabellum of Tournus (Art Bulletin Supplement*, I), New York, 1944.

EMPOLI CIRAOLO, C. DA, 'La "Divinità" di Raffaello,' *Nuova Antologia*, CDLV, 1952, p. 155 ff.

ENGELS, J., *Etudes sur l'Ovide moralisé*, Diss., Groningen, 1945.

ESSLING, PRINCE D', and MÜNTZ, E., *Pétrarque; Ses études d'art, son influence sur les artistes*, Paris, 1902.

Excidium Troiae, see Atwood.

FALCO, G., *La polemica sul Medio Evo*, I, Turin, 1933.

FANFANI, P., ed., *Commento alla Divina Commedia d'Anonimo Fiorentino del secolo XIV*, Bologna, 1868.

FARAL, E., *Les Arts poétiques du XIIe et du XIIIe siècle*, Paris, 1924.

FAVA, D., *Tesori delle Biblioteche d'Italia, Emilia-Romagna*, Milan, 1932.

BIBLIOGRAPHY

FEARSON, N., tr., *The Florentine Fior di Virtù of 1491* (L. J. Rosenwald, pref.), Washington, D. C., 1953.

FEDELE, P., 'Sul Commercio delle antichità in Roma nel XII secolo,' *Archivio della R. Società Romana di Storia Patria*, XXXII, 1909, p. 465 ff.

FERGUSON, W. K., 'Humanist Views of the Renaissance,' *American Historical Review*, XLV, 1939, p. 5 ff.

―― 'The Interpretation of the Renaissance, Suggestions for a Synthesis,' *Journal of the History of Ideas*, XII, 1951, p. 483 ff.

―― *The Renaissance in Historical Thought; Five Centuries of Interpretation*, Cambridge (Mass.), 1948.

―― See also *Renaissance*.

FERRUOLO, A. B., 'Botticelli's Mythologies, Ficino's *De Amore*, Poliziano's *Stanze per la Giostra*: Their Circle of Love,' *Art Bulletin*, XXXVII, 1955, p. 17 ff.

FILARETE, AVERLINO, see Oettingen.

FILIPPIS, M. DE, 'The Renaissance Problem Again,' *Italica*, XX, 1943, p. 65 ff.

FOCILLON, H., *L'An Mil*, Paris, 1952.

―― *L'Art des sculptures romanes*, Paris, 1931.

FÖRSTER, R., 'Die Verleumdung des Apelles in der Renaissance,' *Jahrbuch der königlich preussischen Kunstsammlungen*, VII, 1887, pp. 29 ff., 89 ff.

―― 'Die Wiederherstellung antiker Gemälde durch Künstler der Renaissance,' *Jahrbuch der preussischen Kunstsammlungen*, XLIII, 1922, p. 126 ff.

FORSSMAN, E., *Säule und Ornament* (*Acta Universitatis Stockholmiensis*), Stockholm, 1956.

FRÄNKEL, H., *Ovid, A Poet between Two Worlds*, Berkeley and Los Angeles, 1945.

FRANCASTEL, P., 'La Fête mythologique au Quattrocento: Expression littéraire et visualisation plastique,' *Revue d'Esthétique*, V, 1952, p. 377 ff.

―― 'Un Mito poético social del Quattroento: La Primavera,' *La Torre, Revista General de la Universidad de Puerto Rico*, V, 1957, p. 23 ff.

FRANCOVICH, G. DE, *Benedetto Antelami, architetto e scultore, e l'arte del suo tempo*, Milan and Florence, 1952.

FREY, C., *Il Libro di Antonio Billi*, Berlin, 1892.

―― *Le Vite di Filippo Brunelleschi scultore e architetto fiorentino*, Berlin, 1887.

FREY, D., 'Apokryphe Liviusbildnisse der Renaissance,' *Wallraf-Richartz-Jahrbuch*, XVII, 1955, p. 132 ff.

FREYHAN, R., 'The Evolution of the Caritas Figure in the Thirteenth and Fourteenth Centuries,' *Journal of the Warburg and Courtauld Institutes*, XI, 1948, p. 68 ff.

FYVE, F. M., see Wood.

GABOTTO, F. F., 'L'Epicureismo di Marsilio Ficino,' *Rivista di Filosofia Scientifica*, X, 1891, p. 428 ff.

GAETA, F., *Lorenzo Valla: Filologia e storia nell' umanesimo italiano*, Naples, 1955.

GAGNEBIN, B., 'Une Bible Historiale de l'atelier de Jean Pucelle,' *Genava*, New Ser., IV, 1956, p. 23 ff.

GANTNER, J. (in collaboration with M. Pobé, M. Aubert, pref.), *Gallia Romanica; Die hohe Kunst der romanischen Epoche in Frankreich*, Vienna, 1955 (French edition: Paris, 1955).

―― *Kunstgeschichte der Schweiz*, I, Frauenfeld, 1936.

GARIN, E., *Medioevo e rinascimento*, Bari, 1954.

―― *Il Rinascimento italiano*, Milan, 1941.

―― *L'Umanesimo italiano; Filosofia e vita civile nel rinascimento*, Bari, 1952.

GEVAERT, S., 'Le Modèle de la Bible de Floreffe,' *Revue Belge d'Archéologie et d'Histoire de l'Art*, V, 1935, p. 17 ff.

GHIBERTI, LORENZO, see Morisani, Schlosser.

GHISALBERTI, F., 'Mediaeval Biographies of Ovid,' *Journal of the Warburg and Courtauld Institutes*, IX, 1946, p. 10 ff.

―― 'L'Ovidius moralizatus di Pierre Bersuire,' *Studi Romanzi*, XXIII, 1933, p. 5 ff.

GIGLIOLI, G. A., 'La Calumnia di Apelle,' *Rassegna d'arte*, VII, 1920, p. 173 ff.

GILSON, E., *Les Idées et les lettres*, Paris, 1932.

GIOSEFFI, D., *Perspectiva artificialis; Per la storia della prospettiva* (Trieste, Instituto di Storia dell'Arte Antica e Moderna, VII), Trieste, 1957.

GLASER, C., *Die altdeutsche Malerei*, Munich, 1924.

GOLDSCHMIDT, A., *Die deutschen Bronzetüren des Mittelalters*, Marburg, 1926.

―― *An Early Manuscript of the Aesop Fables of Avianus and Related Manuscripts*, Princeton, 1947.

215

GOLDSCHMIDT, A., *Die Elfenbeinskulpturen aus der Zeit der karolingischen und sächsischen Kaiser*, I, Berlin, 1914.

—— *German Illumination*, Florence and New York, 1921.

—— *Die Skulpturen in Freiberg und Wechselburg*, Berlin, 1924.

—— 'Die Stilentwicklung der romanischen Skulptur in Sachsen,' *Jahrbuch der königlich preussischen Kunstsammlungen*, XXI, 1900, p. 225 ff.

—— and WEITZMANN, K., *Die byzantinischen Elfenbeinskulpturen des X.–XIII. Jahrhunderts*, Berlin, 1930–34.

GOLOUBEW, V., *Les Dessins de Jacopo Bellini au Louvre et au British Museum*, Brussels, 1912.

GOLZIO, V., *Raffaello, nei documenti e nelle testimonianze dei contemporanei e nella letteratura del suo seculo*, Pontificia Accademia Artistica dei Virtuosi al Pantheon, Vatican City, 1936.

GOMBRICH, E. H., 'Apollonio di Giovanni,' *Journal of the Warburg and Courtauld Institutes*, XVIII, 1955, p. 16 ff.

—— 'Botticelli's Mythologies; A Study in the Neoplatonic Symbolism of His Circle,' *Journal of the Warburg and Courtauld Institutes*, VIII, 1945, p. 7 ff.

—— 'Icones Symbolicae: The Visual Image in Neo-Platonic Thought,' *Journal of the Warburg and Courtauld Institutes*, XI, 1948, p. 163 ff.

GORDON, G. S., *Medium Aevum and the Middle Ages* (Society for Pure English, Tract No. XIX), Oxford, 1925.

GRABAR, A., 'Trônes épiscopaux du XIᵉ et XIIᵉ siècle en Italie méridionale,' *Wallraf-Richartz-Jahrbuch*, XVI, 1954, p. 7 ff.

—— and NORDENFALK, C., *Early Medieval Painting from the Fourth to the Eleventh Century*, Lausanne, 1957.

GRAGG, F. A., *Latin Writings of the Italian Humanists*, New York, etc., 1927.

GRIFFIN, N. E., ed., *Guido delle Colonne, Historia destructionis Troiae*, Cambridge (Mass.), 1936.

GRINTEN, E. VAN DEN, *Inquiries into the History of Art-Historical Writing*, Venlo, n.d. [1953].

GUERRY, L., *Le Thème du 'Triomphe de la Mort' dans la peinture italienne*, Paris, 1950.

GUHL, E., *Künstlerbriefe*, 2nd ed., A. Rosenberg, ed., Berlin, 1880.

GUIDO DELLE COLONNE, see Griffin.

HAHNLOSER, H. R., *Villard de Honnecourt, Kritische Gesamtausgabe des Bauhüttenbuches, MS. fr. 19093 der Pariser Nationalbibliothek*, Vienna, 1935.

HAMANN, R., *Die Abteikirche von St. Gilles und ihre künstlerische Nachfolge*, Berlin, 1955.

—— "Altchristliches in der südfranzösischen Protorenaissance des 12. Jahrhunderts,' *Die Antike*, X, 1934, p. 264 ff.

—— *Die Frührenaissance der italienischen Malerei*, Jena, 1909.

—— 'The Girl and the Ram,' *Burlington Magazine*, LX, 1932, p. 91 ff.

—— *Südfranzösische Protorenaissance* (*Deutsche und französische Kunst im Mittelalter*, I), Marburg, 1923.

HAMANN MACLEAN, R. H. L., 'Antikenstudium in der Kunst des Mittelalters,' *Marburger Jahrbuch für Kunstwissenschaft*, XV, 1949–1950, p. 157 ff.

HAMBERG, P. G., *Ur Renässansens illustrerade Vitruviusupplagor*, Uppsala, 1955.

HARTT, F., *Botticelli*, New York, 1953.

—— 'The Meaning of Michelangelo's Medici Chapel,' *Essays in Honor of Georg Swarzenski*, Chicago, 1951, p. 145 ff.

HASELOFF, A., 'Begriff und Wesen der Renaissancekunst,' *Mitteilungen des kunsthistorischen Institutes in Florenz*, II, 1931, p. 373 ff.

HASKINS, C. H., *The Renaissance of the Twelfth Century*, Cambridge (Mass.), 1927.

—— *Studies in the History of Mediaeval Science*, Cambridge (Mass.), 1924.

HECKSCHER, W. S., 'The *Anadyomene* in the Mediaeval Tradition (Pelagia–Cleopatra–Aphrodite); A Prelude to Botticelli's *Birth of Venus*,' *Nederlands Kunsthistorisch Jaarboek*, VII, 1956, p. 1 ff.

—— 'Aphrodite as a Nun,' *The Phoenix*, VII, 1953, p. 105 ff.

—— 'Bernini's Elephant and Obelisk,' *Art Bulletin*, XXIX, 1947, p. 155 ff.

—— 'Dornauszieher,' *Reallexikon zur deutschen Kunstgeschichte*, Stuttgart, 1937 ff., IV, p. 290 ff.

—— 'Relics of Pagan Antiquity in Mediaeval Settings,' *Journal of the Warburg Institute*, I, 1937–38, p. 204 ff.

216

BIBLIOGRAPHY

HECKSCHER, W. S., *Sixtus IIII Aeneas insignes statuas romano populo restituendas censuit* [inaugural address, Utrecht University], The Hague, 1955.

HEER, F., 'Die "Renaissance"-Ideologie im frühen Mittelalter,' *Mitteilungen des Instituts für Österreichische Geschichtsforschung*, LVII, 1949, p. 23 ff.

HELD, J., Review of E. Panofsky, *Early Netherlandish Painting, Art Bulletin*, XXXVII, 1955, p. 205 ff.

HÉLIN, M., *A History of Mediaeval Latin Literature*, New York 1949.

HENKEL, M. D., *Houtsneden van Mansion's Ovide Moralisé, Bruges 1484*, Amsterdam, 1922.

HERRADE OF LANDSBERG, see Straub and Keller.

HERTLINGER, R., 'Zur Frage der ersten, anatomisch richtigen Darstellung des menschlichen Körpers in der Malerei,' *Centaurus*, II, 1951–1953, p. 283 ff.

HINKS, R., *Carolingian Art*, London, 1935.

HOLLER, E., *Kaiser Friedrich II und die Antike*, Diss., Marburg (typescript), 1922.

HOLMQVIST, W., *Germanic Art in the First Millennium A. D. (Kungl. Vitterhets Historie och Antikvitets Akademiens Handlingar*, XC), Stockholm, 1955.

—— *Kunstprobleme der Merowingerzeit (Kungl. Vitterhets Historie och Antikvitets Akademiens Handlingar*, XLVII), Stockholm, 1939.

HOLT, E. G., *A Documentary History of Art*, Garden City, N.Y., 1957–1958.

—— *Literary Sources of Art History*, Princeton, 1947.

HOMBURGER, O., *Die Anfänge der Malerschule von Winchester im X. Jahrhundert*, Leipzig, 1912.

—— 'Ein Denkmal ottonischer Plastik in Rom mit dem Bildnis Ottos III,' *Jahrbuch der preussischen Kunstsammlungen*, LVII, 1936, p. 130 ff.

HORB, F., 'Cavallinis Haus der Madonna,' *Göteborgs Kungl. Vetenskaps- och Vitterhets- Samhälles Handlingar*, 7th Ser., ser. A, III, No. 1, 1945.

—— *Das Innenraumbild des späten Mittelalters; Seine Entstehungsgeschichte*, Zurich and Leipzig, n.d. [1938].

HORN, W., *Die Fassade von St.-Gilles, eine Untersuchung zur Frage des Antikeneinflusses in der südfranzösischen Kunst des 12. Jahrhunderts*, Diss., Hamburg, 1937.

HORNE, H. P., *Alessandro Filipepi Commonly Called Sandro Botticelli*, London, 1908.

HOSKIER, H. C., ed., *Bernardus Morlanensis, De contemptu mundi*, London, 1929.

HUET, G., 'La Légende de la statue de Vénus,' *Revue de l'histoire des religions*, LXVIII, 1913, p. 193 ff.

HUIZINGA, J., *Wege der Kulturgeschichte*, Munich, 1930.

IMOLA, BENVENUTO DA, see Lacaita.

IVINS, W. M., *Art and Geometry*, Cambridge (Mass.), 1946.

—— *On the Rationalization of Sight*, New York, 1938.

JÄGER, W., *Humanism and Theology* (The Aquinas Lecture, 1943), Milwaukee, 1943.

JAFFÉ, P., *Bibliotheca rerum germanicarum*, I, Berlin, 1864.

JALABERT, D., 'Recherches sur la faune et la flore romanes,' *Bulletin Monumental*, XCIV, 1935, p. 71 ff.; XCV, 1936, p. 433 ff.; XCVII, 1938, p. 173 ff.

JAMES, M. R., ed., *The Canterbury Psalter*, London, 1935.

—— *La Estoire de Seint Aedward le Rei (Cambridge, Library, E E 3, 59)*, Roxburghe Club, Oxford, 1920.

JANITSCHEK, H., ed., *Leon Battista Alberti, Kleinere kunsttheoretische Schriften (Quellenschriften für Kunstgeschichte*, XI), Vienna, 1877.

JANSON, H. W., *Apes and Ape Lore in the Middle Ages and the Renaissance* (Studies of the Warburg Institute, XX), London, 1952.

—— *The Sculpture of Donatello*, Princeton, 1957.

JANTZEN, H., *Ottonische Kunst*, Munich, n.d. [1947].

JOHN OF SALISBURY, see McGarry, Millor.

JONES, L. W., and MOREY, C. R., *The Miniatures of the Manuscripts of Terence*, Princeton, 1930–1931.

JULLIAN, R., *L'Eveil de la sculpture en Italie*, Paris, 1945–1949.

—— *Les Sculpteurs romans de l'Italie septentrionale*, Paris, 1952.

KANTOROWICZ, E. H., 'The Carolingian King in the Bible of San Paolo fuori Le Mura,' *Late-Classical and Mediaeval Studies in Honor of A. M. Friend, Jr.*, Princeton, 1955, p. 287 ff.

—— *Kaiser Friedrich der Zweite*, 3rd ed., Berlin, 1931.

KANTOROWICZ, E. H. 'On Transformations of Apolline Ethics,' *Charites, Studien zur Altertumswissenschaft* (Festschrift Ernst Langlotz), Bonn, 1957, p. 265 ff.

—— *Die Wiederkehr gelehrter Anachorese im Mittelalter*, Stuttgart, 1937.

KASCHNITZ-WEINBERG, G., 'Bildnisse Friedrichs II,' *Mitteilungen des deutschen archäologischen Instituts*, röm. Abteilung, LX/LXI, 1953/1954, p. 1 ff.; LXII, 1955, p. 1 ff.

KAUFFMANN, H., 'Italienische Frührenaissance,' *Arbeitsgemeinschaft für Forschung des Landes Nordheim-Westfalen, Jahresfeier 1956*, Köln and Oplanden, 1956, p. 31 ff.

—— 'Ueber 'rinascere,' 'Rinascita,' und einige Stilmerkmale der Quattrocentobaukunst,' *Concordia Decennalis, Deutsche Italienforschungen*, Cologne, 1941, p. 123 ff.

KAUFMANN, R., *Der Renaissancebegriff in der deutschen Kunstgeschichtsschreibung*, Winterthur, 1932.

KELLER, H., *Giovanni Pisano*, Vienna, 1942.

KERN, G. J., 'Die Anfänge der zentralperspektivischen Konstruktion in der italienischen Malerei des 14. Jahrhunderts,' *Mitteilungen des kunsthistorischen Institutes in Florenz*, II, 1912, p. 39 ff.

KISCH, G., *Jewry-Law in Mediaeval Germany, Laws and Court Decisions Concerning Jews*, New York, 1949.

KITZINGER, E., *Early Mediaeval Art in the British Museum*, London, 1940.

KLEIN, D., *St. Lukas als Maler der Maria*, Berlin, 1933.

KLEINER, G., *Tanagrafiguren; Untersuchungen zur hellenistischen Kunst und Geschichte (Jahrbuch des deutschen archäologischen Instituts*, Ergänzungsheft, No. 15), Berlin, 1942.

KLEINSCHMIDT, B., *Die Basilika San Francesco in Assisi*, Berlin, 1915-1928 (vol. II published separately as *Die Wandmalereien der Basilika San Francesco in Assisi*, Berlin, 1930).

KLIBANSKY, R., 'Standing on the Shoulders of Giants,' *Isis*, XXVI, 1936, p. 147 ff.

KOCH, H., *Vom Nachleben des Vitruv* (Deutsche Beiträge zur Altertumswissenschaft), Baden-Baden, 1951.

KÖHLER, W., 'An Illustrated Evangelistary of the Ada School and Its Model,' *Journal of the Warburg and Courtauld Institutes*, XV, 1952, p. 48 ff.

—— *Die karolingischen Miniaturen; Die Schule von Tours*, Berlin, 1930-1933.

—— 'Die Tradition der Adagruppe und die Anfänge des ottonischen Stiles in der Buchmalerei,' *Festschrift zum 60. Geburtstag von Paul Clemen*, Düsseldorf, 1926, p. 255 ff.

KÖRTE, W., 'Die früheste Wiederholung nach Giottos Navicella (in Jung-St. Peter in Strassburg),' *Oberrheinische Kunst*, X, 1942, p. 97 ff.

KRAUTHEIMER, R., 'Die Anfänge der Kunstgeschichtsschreibung in Italien,' *Repertorium für Kunstwissenschaft*, L, 1929, p. 49 ff.

—— 'The Carolingian Revival of Early Christian Architecture,' *Art Bulletin*, XXIV, 1942, p. 1 ff.

—— 'Ghiberti and Master Gusmin,' *Art Bulletin*, XXIX, 1947, p. 25 ff.

—— (in collaboration with T. Krautheimer-Hess), *Lorenzo Ghiberti*, Princeton, 1956.

—— Review of L. Bircher, E. Pelichet, and A. Schmid, eds., *Frühmittelalterliche Kunst in den Alpenländern...*, in *Art Bulletin*, XXXVIII, 1956, p. 130 ff.

KREY, A. C., 'History and the Humanists,' *The Meaning of the Humanities*, T. M. Greene, ed., Princeton, 1940, pp. 43 ff.

KRIS, E., and KURZ, O., *Die Legende vom Künstler*, Vienna, 1934.

KRISTELLER, P. O., *The Classics and Renaissance Thought*, published for Oberlin College by the Harvard University Press, Cambridge (Mass.), 1955.

—— 'The Modern System of the Arts,' *Journal of the History of Ideas*, XII, 1951, p. 496 ff.; XIII, 1952, p. 17 ff.

—— *The Philosophy of Marsilio Ficino*, New York, 1943.

—— *Studies in Renaissance Thought and Letters*, Rome, 1956.

KRÖNIG, W., 'Staufische Baukunst in Unteritalien,' *Beiträge zur Kunst des Mittelalters (Vorträge der ersten deutschen Kunsthistorikertagung auf Schloss Brühl, 1948)*, Berlin, 1950, p. 28 ff.

KUBACH, K. E., 'Die vorromanische und romanische Baukunst in Mitteleuropa,' *Zeitschrift für Kunstgeschichte*, XIII, 1951, p. 124 ff.; XVII, 1954, p. 157 ff.

KUGLER, F., *Handbuch der Kunstgeschichte*, Stuttgart, 1842.

Kulturwissenschaftliche Bibliographie zum Nachleben der Antike ..., see Warburg Institute.

KURTH, B., 'Ein Freskenzyklus im Adlerturm zu Trient,' *Jahrbuch des kunsthistorischen Instituts der K. K. Zentralkommission für Denkmalpflege*, V, 1911, p. 9 ff.

BIBLIOGRAPHY

KUTSCHERA-WOBORSKY, O., 'Das Giovanninorelief des Spalatiner Vorgebirges,' *Jahrbuch des kunst-historischen Instituts* [deutsch-österreichisches Staatsdenkmalamt], XII, 1918, p. 28 ff.

LACAITA, J. P., ed., *Benevenuti de Rambaldis Comentum super Dantis Aldigherij Comoediam*, Florence, 1887.

LADENDORF, H., *Antikenstudium und Antikenkopie, Abhandlungen der sächsischen Akademie der Wissenschaften zu Leipzig*, phil.-hist. Klasse, XLVI, 2, Berlin, 1953.

LADNER, G. B., 'The "Portraits" of Emperors in Southern Italian Exultet Rolls,' *Speculum*, XVII, 1942, p. 181 ff.

—— 'Some Recent Publications on the Classical Tradition in the Middle Ages and the Renaissance and on Byzantium,' *Traditio*, X, 1954, p. 578 ff.

LAFOND, J., see Lefrançois-Pillion.

LANGE, K., and FUHSE, F., *Albrecht Dürers schriftlicher Nachlass*, Halle, 1893.

LANGLOTZ, E., 'Das Porträt Friedrichs II. vom Brückentor in Capua,' *Essays in Honor of Georg Swarzenski*, Chicago, 1951, p. 45 ff.

LAURENCE, E. B., 'The Illustrations of the Garrett and Modena Manuscripts of Marcanova,' *Memoirs of the American Academy at Rome*, VI, 1927, p. 127 ff.

LAVIN, I., 'Cephalus and Procris,' *Journal of the Warburg and Courtauld Institutes*, XVII, 1954, p. 260 ff., 366 ff.

LEE, R. W., '*Ut Pictura Poesis:* The Humanistic Theory of Painting,' *Art Bulletin*, XXII, 1940, p. 197 ff.

LEFRANÇOIS-PILLION, L., and LAFOND, J., *L'Art du XIV^e siècle en France*, Paris, 1954.

LEHMANN, P., 'Mittelalter und Küchenlatein,' *Historische Zeitschrift*, CXXXVII, 1928, p. 197 ff.

—— *Pseudo-antike Literatur des Mittelalters* (Studien der Bibliothek Warburg, XIII), Leipzig and Berlin, 1927.

LEHMANN, P. WILLIAMS, see Williams.

LEHMANN-BROCKHAUS, O., *Lateinische Schriftquellen zur Kunst in England, Wales und Schottland vom Jahre 901 bis zum Jahre 1307*, Munich, 1956.

LEJEUNE, J., *Les Van Eyck, peintres de Liège et de sa cathédrale*, Liège, 1956.

LEMAIRE DE BELGES, JEAN, see Stecher.

LEONARDO DA VINCI, see McMahon.

LIEBESCHÜTZ, H., *Fulgentius Metaforalis, Ein Beitrag zur Geschichte der antiken Mythologie im Mittelalter* (Studien der Bibliothek Warburg, IV), Leipzig and Berlin, 1926.

—— *Mediaeval Humanism in the Life and Writings of John of Salisbury* (Studies of the Warburg Institute, XVII), London, 1950.

—— 'Das zwölfte Jahrhundert und die Antike,' *Archiv für Kulturgeschichte*, XXXV, 1953, p. 247 ff.

—— 'Theodulf of Orléans and the Problem of the Carolingian Renaissance,' in D. J. Gordon, ed., *Fritz Saxl, 1890–1948; A Volume of Memorial Essays*, London, 1951, p. 77 ff.

LOCHOFF, L., 'Gli affreschi dell'Antico e del Nuovo Testamento nella Basilica Superiore di Assisi,' *Rivista d'Arte*, XI, 1937, p. 240 ff.

LOCKWOOD, D. P., 'It is Time to Recognize a New "Modern Age,"' *Journal of the History of Ideas*, IV, 1943, p. 63 ff.

LÖHNEISEN, H.-W. von, *Die ältere niederländische Malerei, Künstler und Kritiker*, Kassel, 1956.

LÓPEZ, R. S., 'Still Another Renaissance,' *American Historical Review*, LVI, 1951, p. 1 ff.

—— See also *Renaissance*.

LOWE, E. A., *Codices Latini Antiquiores*, Oxford, 1934 ff.

—— 'The Morgan Golden Gospels, The Date and Origin of the Manuscript,' *Studies in Art and Literature for Belle da Costa Greene*, Princeton, 1954, p. 266 ff.

LOWINSKY, E. E., 'Music in the Culture of the Renaissance,' *Journal of the History of Ideas*, XV, 1954, p. 509 ff.

LUKOMSKI, G., *I Maestri della Architectura Classica Italiana da Vitruvio allo Scamozzi*, Milan, 1933.

McGARRY, D. D., tr. and ed., *The Metalogicon of John of Salisbury*, Berkeley and Los Angeles, 1955.

McLAUGHLIN, M. M., see Ross, J. B.

McMAHON, A. PHILIP, tr., *Leonardo da Vinci, Treatise on Painting*, Princeton, 1956.

MAERE, R., 'Over het Afbeelden van bestaande gebouwen in het schilderwerk van Vlaamsche Primitieven,' *Kunst der Nederlanden*, I, 1930–1931, p. 201 ff.

BIBLIOGRAPHY

MAFFEI, F. DE, *Le Arche Scaligere di Verona*, Verona, n.d. [1955].

MÂLE, E., *L'Art religieux du XII^e siècle en France*, Paris, 1922.

MALLÉ, L., ed., *Leon Battista Alberti, Della Pittura*, Florence, 1950.

MANETTI, ANTONIO, see Toesca, E.

MANITIUS, M., *Geschichte der lateinischen Literatur des Mittelalters*, Munich, 1911–1931.

MARITAIN, J., *Religion and Culture (Essays in Order, No. 1)*, London, 1931.

—— *True Humanism*, New York, 1938.

MARLE, R. VAN, *The Development of the Italian Schools of Painting*, The Hague, 1923–1938.

MARTIN, H., and LAUER, P., *Les principaux Manuscrits à peintures de la Bibliothèque de l'Arsenal*, Paris, 1929.

MATHER, F. J., *The Isaac Master; A Reconstruction of the Work of Gaddo Gaddi*, Princeton, 1932.

MEIER, H., see Saxl.

MEISS, M., *Andrea Mantegna as Illuminator; An Episode in Renaissance Art, Humanism, and Diplomacy*, New York, 1957.

—— 'A Documented Altarpiece by Piero della Francesca,' *Art Bulletin*, XXIII, 1941, p. 53 ff.

—— 'The Exhibition of French Manuscripts of the XIII–XVI Centuries at the Bibliothèque Nationale,' *Art Bulletin*, XXXVIII, 1956, p. 187 ff.

—— 'Italian Style in Catalonia and a Fourteenth-Century Workshop,' *The Journal of the Walters Art Gallery*, IV, 1941, p. 45 ff.

—— 'Jan van Eyck and the Italian Renaissance,' *Acts of the XVIIIth International Congress of the History of Art* (in print).

—— 'A New Early Duccio,' *Art Bulletin*, XXXIII, 1951, p. 95 ff.

—— *Painting in Florence and Siena after the Black Death*, Princeton, 1951.

—— 'The Problem of Francesco Traini,' *Art Bulletin*, XV, 1933, p. 97 ff.

MESNIL, J., *Masaccio et les débuts de la Renaissance*, The Hague, 1927.

MEYER, C., *Der Aberglaube des Mittelalters und der nächstfolgenden Jahrhunderte*, Basel, 1884.

MEYER, E., 'Eine mittelalterliche Bronzestatuette,' *Kunstwerke aus dem Besitz der Albert-Ludwig-Universität Freiburg im Breisgau*, Berlin and Freiburg, 1957, p. 17 ff.

MIDDELDORF, U., Review of *Kunstgeschichtliches Jahrbuch der Biblioteca Hertziana*, II, in *Art Bulletin*, XXII, 1940, p. 44 ff.

MILANESI, G., ed., *Le Opere di Giorgio Vasari*, Florence, 1878–1906.

MILLOR, W. J., BUTLER, H. E., and BROOKE, C. L. N., eds., *The Letters of John of Salisbury* (1153–1161), I: *The Early Letters*, London, Edinburgh and New York, 1955.

MINER, D., 'The Survival of Antiquity in the Middle Ages,' *The Greek Tradition*, G. Boas, ed., Baltimore, 1939, p. 55 ff.

MÖNCH, W., *Das Sonett*, Heidelberg, 1954.

MOLAJOLI, B., *Guida di Castel del Monte*, 2nd ed., Fabriano, 1940.

MOMMSEN, T. E., intr., *Petrarch, Sonnets and Songs*, New York, 1946.

—— 'Petrarch and the Decoration of the Sala Virorum Illustrium in Padua,' *Art Bulletin*, XXXIV, 1952, p. 95 ff.

—— 'Petrarch and the Story of the Choice of Hercules,' *Journal of the Warburg and Courtauld Institutes*, XVI, 1953, p. 178 ff.

—— 'Petrarch's Concept of the Dark Ages,' *Speculum*, XVII, 1942, p. 226 ff.

—— tr. and ed., *Petrarch's Testament*, Ithaca, N.Y., 1957.

—— 'Rudolph Agricola's Life of Petrarch,' *Traditio*, VIII, 1952, p. 367 ff.

MOREY, C. R., *Early Christian Art*, Princeton, 1942 (2nd ed., Princeton, 1953).

—— 'The Sources of Mediaeval Style,' *Art Bulletin*, VII, 1924, p. 35 ff.

—— See also Jones.

MORISANI, O., 'Art Historians and Art Critics, III; Christoforo Landino,' *Burlington Magazine*, XCV, 1953, p. 267 ff.

—— ed., *Lorenzo Ghiberti, I Commentarii*, Naples, 1947.

MORLAIS, BERNARD OF, see Hoskier.

BIBLIOGRAPHY

MORPURGO, S., 'Brutus, "il buon giudice," nell' Udienza dell'Arte della Lana,' *Miscellanea di Storia dell'Arte in onore di Igino Benvenuto Supino*, Florence, 1933, p. 141 ff.

MÜNTZ, E., *Les Arts à la cour des papes pendant le XV^e et le XVI^e siècle*, II, Paris, 1879.

—— *La Renaissance en Italie et en France*, Paris, 1885.

—— See also Essling.

MURARO, M., 'Antichi Affreschi veneziani,' *Le Meraviglie del Passato*, Florence, 1954, p. 661 ff.

MURRAY, P., 'Art Historians and Art Critics, IV; *XIV Uomini Illustri in Firenze*,' *Burlington Magazine*, XCIX, 1957, p. 330 ff.

NEILSON, K. B., *Filippino Lippi*, Cambridge (Mass.), 1938.

NEUGEBAUER, K. A., *Antike Bronzestatuetten*, Berlin, 1921.

NEUMANN, C., 'Ende des Mittelalters? Die Legende der Ablösung des Mittelalters durch die Renaissance,' *Deutsche Vierteljahrsschrift für Literaturwissenschaft und Geistesgeschichte*, XII, 1934, p. 124 ff.

—— 'Die Wahl des Platzes für Michelangelos David in Florenz im Jahr 1504; Zur Geschichte des Massstabproblems,' *Repertorium für Kunstwissenschaft*, XXXVIII, 1916, p. 1 ff.

NICHOLSON. A., *Cimabue*, Princeton, 1932.

NITZE, W. A., 'The So-Called Twelfth-Century Renaissance,' *Speculum*, XXIII, 1948, p. 464 ff.

NOLHAC, P. DE, *Pétrarque et l'humanisme*, 2nd ed., Paris, 1907.

NORDENFALK, C., 'Französische Buchmalerei 1200–1500,' *Kunstchronik*, VII, 1956, p. 179 ff.

—— 'Der Meister des Registrum Gregorii,' *Münchner Jahrbuch der bildenden Kunst*, 3rd Ser., I, 1950, p. 61 ff.

—— 'A Note on the Stockholm Codex Aureus,' *Nordisk Tidskrift för Bok- och Biblioteksväsen*, XXXVIII, 1951, p. 145 ff.

—— 'A Traveling Milanese Artist in France at the Beginning of the XI. Century,' *Arte del primo millennio* (Atti del Convegno di Pavia [1950] per lo Studio dell' Arte dell'Alto Medio Evo), Turin, 1953, p. 374 ff.

—— See also Grabar.

NORDSTRÖM, F., 'Peterborough, Lincoln and the Science of Robert Grosseteste; A Study in Thirteenth-Century Iconography,' *Art Bulletin*, XXXVII, 1955, p. 241 ff.

—— *Virtues and Vices on the 14th Century Corbels in the Choir of Uppsala Cathedral*, Stockholm, 1956.

NORDSTRÖM, J., *Moyen-Age et Renaissance*, Paris, 1933.

NOVOTNY, K. A., 'Zur Deutung der romanischen Bildwerke Schöngraberns,' *Zeitschrift des deutschen Vereins für Kunstwissenschaft*, VII, 1940, p. 64 ff.

OERTEL, R., *Die Frühzeit der italienischen Malerei*, Stuttgart, 1953.

OETTINGEN, W. VON, ed., *Antonio Averlino Filaretes Traktat über die Baukunst* (*Quellenschriften für Kunstgeschichte*, New Ser., III), Vienna, 1890.

OMONT, H., ed., *Notitia dignitatum Imperii Romani* (Paris, Bibliothèque Nationale, MS. lat. 9661), Paris, 1911.

—— 'Le plus ancien Manuscrit de la Notitia dignitatum,' *Mémoires de la Société Nationale des Antiquaires de France*, LI, 1891, p. 225 ff.

—— ed. [Psalter, Paris, Bibliothèque Nationale, MS. lat 8846], Paris, *n.d.*

—— ed. [Psalter of St. Louis, Paris, Bibliothèque Nationale, MS. lat. 10525], Paris, *n.d.*

ONG, W. J., 'Renaissance Ideas and the American Catholic Mind,' *Thought*, XXIX, 1954, p. 327 ff.

—— 'System, Space, and Intellect in Renaissance Symbolism,' *Bibliothèque d'Humanisme et Renaissance; Travaux et Documents*, XVIII, 1956, p. 222 ff.

OVERBECK, J., *Die antiken Schriftquellen zur Geschichte der bildenden Künste bei den Griechen*, Leipzig, 1868.
Ovide moralisé, see Boer.

PAATZ, W., 'Die Bedeutung des Humanismus für die toskanische Kunst des Trecento,' *Kunstchronik*, VII, 1954, p. 114 ff.

—— 'Die Gestalt Giottos im Spiegel einer zeitgenössischen Urkunde,' *Eine Gabe der Freunde für Carl Georg Heise zum 28.VI.1950*, Berlin, 1950, p. 85 ff.

—— *Die Kunst der Renaissance in Italien*, Stuttgart, 1953.

—— 'Renaissance oder Renovatio,' *Beiträge zur Kunst des Mittelalters* (*Vorträge der ersten deutschen Kunsthistorikertagung auf Schloss Brühl, 1948*), Berlin, 1950, p. 16 ff.

221

PAATZ, W., *Von den Gattungen und vom Sinn der gotischen Rundfigur* (*Sitzungsberichte der Heidelberger Akademie der Wissenschaften*, phil.-hist. Klasse, III, 1951).

PÄCHT, O., 'Early Italian Nature Studies and the Early Calendar Landscape,' *Journal of the Warburg and Courtauld Institutes*, XIII, 1950, p. 13 ff.

—— 'A Forgotten Manuscript from the Library of the Duc de Berry,' *Burlington Magazine*, XCVIII, 1956, p. 146 ff.

—— 'A Giottesque Episode in English Mediaeval Art,' *Journal of the Warburg and Courtauld Institutes*, VI, 1943, p. 51 ff.

—— 'Notes and Observations on the Origin of Humanistic Book-Decoration,' in D. J. Gordon, ed., *Fritz Saxl, 1890–1948; A Volume of Memorial Essays*, London, 1957, p. 184 ff.

—— 'Panofsky's "Early Netherlandish Painting," ' *Burlington Magazine*, XCVIII, 1956, pp. 110 ff., 267 ff.

—— 'Un Tableau de Jacquemart de Hesdin?' *Revue des Arts*, VI, 1956, p. 149 ff.

PAESELER, W., 'Der Rückgriff der spätrömischen Dugentomalerei auf die christliche Spätantike,' *Beiträge zur Kunst des Mittelalters* (Vorträge der I. deutschen Kunsthistorikertagung, Berlin, 1950), p. 157 ff.

PANNIER, L., *Lapidaires français des XIIᵉ, XIIIᵉ et XIVᵉ siècles* (*Bibliothèque de l'Ecole des Hautes Etudes, CII*), Paris, 1882, p. 147.

PANOFSKY, D., 'The Textual Basis of the Utrecht Psalter Illustrations,' *Art Bulletin*, XXV, 1943, p. 50 ff.

PANOFSKY, E., tr. and ed., *Abbot Suger on the Abbey of Saint-Denis and Its Art Treasures*, Princeton, 1946.

—— *Albrecht Dürer*, 3rd ed., Princeton, N.J., 1948.

—— 'Artist, Scientist, Genius: Notes on the "Renaissance-Dämmerung,"' *The Renaissance, A Symposium, The Metropolitan Museum of Art, Feb. 8–10, 1952*, New York, p. 77 ff.

—— *The Codex Huygens and Leonardo da Vinci's Art Theory* (Studies of the Warburg Institute, XIII), London, 1940.

—— 'The De Buz Book of Hours; A New Manuscript from the Workshop of the Grandes Heures de Rohan,' *Harvard Library Bulletin*, III, 1949, p. 163 ff.

—— *Die deutsche Plastik des elften bis dreizehnten Jahrhunderts*, Munich, 1924.

—— 'Dürers Stellung zur Antike,' *Jahrbuch für Kunstgeschichte*, I, 1921/22, p. 43 ff. (English translation in *Meaning in the Visual Arts*, p. 236 ff.).

—— *Early Netherlandish Painting, Its Origins and Character*, Cambridge (Mass.), 1953.

—— 'Die Entwicklung der Proportionslehre als Abbild der Stilentwicklung,' *Monatshefte für Kunstwissenschaft*, XIV, 1921, p. 188 ff. (English translation in *Meaning in the Visual Arts*, New York, 1955, p. 55 ff.).

—— 'Das erste Blatt aus dem 'Libro' Giorgio Vasaris; Eine Studie über die Beurteilung der Gotik in der italienischen Renaissance mit einem Exkurs über zwei Fassadenprojekte Domenico Beccafumis,' *Städel-Jahrbuch*, VI, 1930, p. 25 ff. (English translation in *Meaning in the Visual Arts*, p. 169 ff.).

—— *Gothic Architecture and Scholasticism*, Latrobe, Pa., 1951.

—— *Hercules am Scheidewege und andere antike Bildstoffe in der neueren Kunst* (Studien der Bibliothek Warburg, XVIII), Leipzig and Berlin, 1930.

—— 'The History of Art as a Humanistic Discipline,' *The Meaning of the Humanities*, T. M. Greene, ed., Princeton, 1940, p. 89 ff. (reprinted in *Meaning in the Visual Arts*, p. 1 ff.).

—— *Idea, Ein Beitrag, zur Begiffsgeschichte der älteren Kunsttheorie* (Studien der Bibliothek Warburg, V), Leipzig and Berlin, 1924 (Italian translation: *Idea*, Florence, 1952).

—— *Meaning in the Visual Arts; Papers in and on Art History*, New York, 1955.

—— 'Notes on a Controversial Passage in Suger's *De Consecratione ecclesaie Sancti Dionysii*,' *Gazette des Beaux-Arts*, 6th Ser., XXVI, 1944, p. 95 ff.

—— 'Die Perspektive als symbolische Form,' *Vorträge der Bibliothek Warburg*, 1924–1925, p. 258 ff.

—— 'Das perspektivische Verfahren Leone Battista Albertis,' *Kunstchronik*, New Ser., XXVI, 1914–1915, col. 505 ff.

—— 'Ueber die Reihenfolge der vier Meister von Reims,' *Jahrbuch für Kunstwissenschaft*, II, 1927, p. 77 ff.

—— 'Renaissance and Renascences,' *Kenyon Review*, VI, 1944, p. 201 ff.

—— Review of E. Rosenthal, *Giotto in der mittelalterlichen Geistesentwicklung*, *Jahrbuch für Kunstwissenschaft*, I, 1924, p. 254 ff.

BIBLIOGRAPHY

PANOFSKY, E., *Studies in Iconology*, New York, 1939.
—— and SAXL, F., 'Classical Mythology in Mediaeval Art,' *Metropolitan Museum Studies*, IV, 2, 1933, p. 228 ff.
—— *Dürers 'Melencolia I.';* *Eine quellen- und typengeschichtliche Untersuchung* (Studien der Bibliothek Warburg, II), Leipzig and Berlin, 1923.
PARÉ, G., BRUNET, E., and TREMBLAY, P., *La Renaissance du XII^e siècle: Les écoles et l'enseignement*, Paris, 1933.
Paris, Bibliothèque Nationale, see Omont, Porcher.
Paris, Musée des Arts Décoratifs, Vitraux de France du XI^e au XIV^e Siècle, 2nd ed., Paris, 1953.
PASTOR, L., *The History of the Popes from the Close of the Middle Ages*, IV, F. A. Antrobus, ed., London, 1910; VIII, R. F. Kerr, ed., London, 1908.
PATON, J. M., *Chapters on Mediaeval and Renaissance Visitors to Greek Lands*, Princeton, N. J., 1951.
PATZELT, E., *Die karolingische Renaissance*, Vienna, 1924.
PELLATI, F., *Vitruvio*, Rome, 1938.
—— 'Vitruvio nel medioevo e nel rinascimento,' *Bollettino del Reale Instituto di Archeologia e Storia dell'Arte*, V, 1932, p. 111 ff.
PETRARCH, see Mommsen, Rossi.
PFEIFFER, R., 'The Image of the Delian Apollo and Apolline Ethics,' *Journal of the Warburg and Courtauld Institutes*, XV, 1952, p. 20 ff.
PHILIPPE, J., 'Lucrèce dans la théologie Chrétienne du III^e au XIII^e siècle,' *Revue de l'Histoire des Religions*, XXXII, 1895, p. 284 ff., XXXIII, 1896, pp. 19 ff., 125 ff.
PICARD, C., 'La Chasse à courre du lièvre,' *Studia Antiqua Antonio Salač Septuagenario Oblata*, Prague, 1955, p. 155 ff.
PIEPER, P., 'Zum Werl-Altar des Meisters von Flémalle,' *Wallraf-Richartz-Jahrbuch*, XVI, 1954, p. 87 ff.
PLANISCIG, L., *Venezianische Bildhauer der Renaissance*, Vienna, 1921.
PLATTARD, J., 'Restitution des bonnes lettres et renaissance,' *Mélanges offerts par ses amis et ses élèves à M. Gustave Lanson*, Paris, 1922, p. 128 ff.
POPHAM, A. E., and WILDE, J., *The Italian Drawings of the XV and XVI Centuries in the Collection of His Majesty the King at Windsor Castle*, London, 1949.
PORCHER, J., 'Les Belles Heures de Jean de Berry et les ateliers parisiens,' *Scriptorium*, VII, 1953, p. 121 ff.
—— ed., *Le Bréviaire de Martin d'Aragon*, Paris, n.d. [1953].
—— ed., *Bibliothèque Nationale, Les Manuscrits à peintures en France du VII^e au XII^e sicèle*, Paris, 1954.
—— ed., *Bibliothèque Nationale, Les Manuscrits à peintures en France du XIII^e au XVI^e siècle*, Paris, 1955.
PORTER, A. KINGSLEY, *Romanesque Sculpture of the Pilgrimage Roads*, Cambridge (Mass.), 1923.
—— "The Tomb of Hincmar and Carolingian Sculpture in France,' *Burlington Magazine*, L, 1927, p. 75 ff.
PORTIOLI, A., 'Monumenti a Virgilio in Mantova,' *Archivio Storico Lombardo*, IV, 1877, p. 536 ff.
POT, J. N. J. VAN DER, *De Periodisering der geschiedenis; Een Overzicht der theorieën*, The Hague, 1951.
PROMIS, V., and NEGRONI, C., eds., *La Commedia di Dante Allighieri col commento inedito di Stefano Talice da Ricaldone*, 2nd ed., Milan, 1888.
RABY, F. J. E., *A History of Christian-Latin Poetry from the Beginnings to the Close of the Middle Ages*, 2nd ed., Oxford, 1953.
—— *A History of Secular Latin Poetry in the Middle Ages*, Oxford, 1934.
RAMBALDIS, BENVENUTUS DE, see Lacaita.
RAND, E. K., *Ovid and His Influence*, Boston, 1925.
REDIG DE CAMPOS, D., *Raffaello e Michelangelo*, Rome, 1946.
REINACH, S., *Répertoire de la statuaire grecque et romaine*, Paris, 1897-1910.
—— *Répertoire de reliefs grecs et romains*, Paris, 1909-1912.
Renaissance, The; A Symposium, Feburary 8-10, 1952, The Metropolitan Museum of Art, New York, 1952 (with contributions by R. H. Bainton, L. Bradner, W. K. Ferguson, R. S. López, E. Panofsky, G. Sarton).
RENAUDET, A., 'Autour d'une Définition de l'humanisme,' *Bibliothèque d'Humanisme et Renaissance*, VI, 1945, p. 7 ff.
RENUCCI, P., *L'Aventure de l'humanisme européen au Moyen-Age (IV^e-XIV^e siècle)*, Paris, 1953.

223

REZNICEK, E. K. J., 'De Reconstructie van 't'Altaer van S. Lucas' van Maerten van Heemskerck,' *Oud Holland*, LXXI, 1956, p. 233 ff.

RICALDONE, STEFANO TALICE DA, see Promis.

RICHARDS, J. C., 'A New Manuscript of Heraclius,' *Speculum*, XV, 1940, p. 255 ff.

RICHTER, G. M. A., *The Metropolitan Museum of Art, Handbook of the Classical Collection*, New York, 1917.

ROBB, D. M., 'The Iconography of the Annunciation in the Fourteenth and Fifteenth Centuries,' *Art Bulletin*, XVIII, 1936, p. 480 ff.

RODENWALT, G., *Die Kunst der Antike (Hellas und Rom)*, 2nd ed., Berlin, 1927.

ROHLFS, A., 'Das Innenraumbild als Kriterium der Bildwelt,' *Zeitschrift für Kunstgeschichte*, XVIII, 1955, p. 109 ff.

ROMANO, V., ed., *Boccaccio, Genealogie deorum gentilium libri*, Bari, 1951.

ROME, *Nostra storica nazionale della miniatura, Palazzo Venezia*, Rome, 1953.

ROOSVAL, J., 'Proto-Renaissance at the End of the Twelfth Century,' *Essays in Honor of Georg Swarzenski*, Chicago, 1951, p. 39 ff.

RORIMER, J. J., pref., *Hours of Jeanne d'Evreux, Queen of France, at the Cloisters, The Metropolitan Museum of Art*, New York, 1957.

ROSCHER, W. H., *Ausführliches Lexicon der griechischen und römischen Mythologie*, Leipzig, 1884–1924.

—— *Hermes der Windgott*, Leipzig, 1878.

ROSENBAUM, E., 'The Evangelist Portraits of the Ada School and Their Models,' *Art Bulletin*, XXXVIII, 1956, p. 81 ff.

ROSENTHAL, E., 'Classical Elements in Carolingian Illustration,' *Bibliofilia*, LV, 1953, p. 85 ff.

ROSENWALD, L. G., see Fearson.

ROSS, D. J. A., 'Illustrated Manuscripts of Orosius,' *Scriptorium*, IX, 1955, p. 35 ff.

ROSS, J. B., 'A Study of Twelfth-Century Interest in the Antiquities of Rome,' *Mediaeval and Historiographical Studies in Honor of J. W. Thompson*, Chicago, 1938, p. 302 ff.

—— and McLAUGHLIN, M. M., *Portable Renaissance Reader*, New York, 1953.

ROWLEY, G., 'Ambrogio Lorenzetti il Pensatore,' *La Balzana*, I, 1928, No. 5.

—— 'The Gothic Frescoes at Monte Siepi,' *Art Studies*, VII, 1929, p. 107 ff.

RÜEGG, W., 'Enstehung, Quellen und Ziel von Salutatis "De fato et fortuna,"' *Rinascimento*, V, 1954, p. 143 ff.

RUSHFORTH, G. McN., 'Magister Gregorius de Mirabilibus Urbis Romae,' *Journal of Roman Studies*, IX, 1919, p. 44 ff.

SACHS, C., *The Commonwealth of Art; Style in the Fine Arts, Music, and the Dance*, New York, 1946.

SALIS, A. VON, *Antike und Renaissance; Ueber Nachleben und Weiterwirken der alten in der neueren Kunst*, Erlenbach–Zurich, 1947.

SALISBURY, JOHN OF, see McGarry.

SALVINI, R., *Cimabue*, Rome, 1946.

—— *Wiligelmo e le origini della scultura romanica*, Milan, 1956.

SANFORD, E. M., 'The Study of Ancient History in the Middle Ages,' *Journal of the History of Ideas*, V, 1944, p. 21 ff.

—— 'The Twelfth Century—Renaissance or Proto-Renaissance?' *Speculum*, XXVI, 1951, p. 635 ff.

SANPAOLESI, P., *La Cupola di Santa Maria del Fiore: Il Progetto, la Costruzione*, Rome, 1941. See also Coolidge.

SARTON, G. (article in J. W. Thompson et al., *The Civilization of the Renaissance*, Chicago, 1929), p. 75 ff.

—— article in *The Renaissance, A Symposium, February 8–10, 1952, The Metropolitan Museum of Art*, New York, 1952.

SAXL, F., 'Beiträge zu einer Geschichte der Planetendarstellung im Orient und Occident,' *Der Islam*, III, 1912, p. 151 ff.

—— 'Die Bibliothek Warburg und ihr Ziel,' *Vorträge der Bibliothek Warburg*, 1921–22, p. 1 ff.

—— *Classical Antiquity in Renaissance Painting*, London, 1938.

—— 'The Classical Inscription in Renaissance Art and Politics,' *Journal of the Warburg and Courtauld Institutes*, IV, 1940–41, p. 19 ff.

—— *Mithras, Typengeschichtliche Untersuchungen*, Berlin, 1931.

BIBLIOGRAPHY

SAXL, F., 'The Origin and Survival of a Pictorial Type (The Mithras Reliefs),' *Proceedings of the Classical Association*, XXXII, 1935, p. 32 ff.

—— 'Pagan Sacrifice in the Italian Renaissance,' *Journal of the Warburg Institute*, II, 1939, p. 346 ff.

—— '*Rinascimento dell'antichità*,' *Repertorium für Kunstwissenschaft*, XLIII, 1922, p. 220 ff.

—— 'The Ruthwell Cross,' *Journal of the Warburg and Courtauld Institutes*, VI, 1943, p. 17 ff.

—— *Verzeichnis astrologischer und mythologischer illustrierter Handschriften des lateinischen Mittelalters in der National-Bibliothek in Wien* (*Sitzungsberichte der Heidelberger Akademie der Wissenschaften*, phil.-hist. Klasse, 1925/26), 1927.

—— *Verzeichnis astrologischer und mythologischer illustrierter Handschriften des lateinischen Mittelalters in römischen Bibliotheken* (*Sitzungsberichte der Heidelberger Akademie der Wissenschaften*, phil.-hist. Klasse, VI, 1915).

—— and MEIER, H. (H. Bober, ed.), *Catalogue of Astrological and Mythological Illuminated Manuscripts of the Latin Middle Ages*, London, 1953.

—— and WITTKOWER, R., *British Art and the Mediterranean*, London, New York and Toronto, 1948.

—— See also Panofsky.

SCHAEFER, C., *La Sculpture en ronde-bosse au XIV^e siècle dans le duché de Bourgogne*, Paris, 1954.

SCHAPIRO, M., 'On the Aesthetic Attitude of the Romanesque Age,' *Art and Thought*, London, 1948, p. 130 ff.

—— '*Muscipula Diaboli*, The Symbolism of the Mérode Altarpiece,' *Art Bulletin*, XXVII, 1945, p. 182 ff.

—— 'The Religious Meaning of the Ruthwell Cross,' *Art Bulletin*, XXVI, 1944, p. 232 ff.

—— Review of K. Weitzmann, *The Fresco Cycle of S. Maria di Castelseprio*, *Art Bulletin*, XXXIV, 1952, p. 147 ff.

—— 'The Romanesque Sculpture of Moissac, Part I,' *Art Bulletin*, XIII, 1931, pp. 249 ff., 464 ff.

SCHARF, A., *Filippino Lippi*, Vienna, 1935.

SCHEFFLER, K., *Der Geist der Gotik*, Leipzig, 1925.

SCHILD BUNIM, M., *Space in Medieval Painting and the Forerunners of Perspective*, New York, 1940.

SCHLAUCH, M., 'The Allegory of Church and Synagogue,' *Speculum*, XIV, 1939, p. 448 ff.

SCHLOSSER, J. VON, 'Ueber einige Antiken Ghibertis,' *Jahrbuch der kunsthistorischen Sammlungen des Allerhöchsten Kaiserhauses*, XXIV, 1904, p. 125 ff.

—— 'Zur Geschichte der Kunsthistoriographie; Filippo Villanis Kapitel über die Kunst in Florenz,' *Präludien*, Berlin, 1927, p. 261 ff.

—— 'Zur Geschichte der Kunsthistoriographie; Die florentinische Künstleranekdote,' *Präludien*, Berlin, 1927, p. 248 ff.

—— 'Zur Geschichte der Kunsthistoriographie; Gotik,' *Präludien*, Berlin, 1927, p. 270 ff.

—— *Die Kunstliteratur*, Vienna, 1924 (revised Italian translation: *La Letteratura artistica*, Florence, 1935).

—— *Lorenzo Ghibertis Denkwürdigkeiten*, Berlin, 1912.

—— 'Lorenzo Ghibertis Denkwürdigkeiten, Prolegomena zu einer künftigen Ausgabe,' *Jahrbuch der K. K. Zentralkommission für Kunst- und historische Denkmalpflege*, IV, 1910 (also published in book form, Vienna, 1910).

—— 'Vom modernen Denkmalkultus,' *Vorträge der Bibliothek Warburg*, 1926–27, p. 1 ff.

—— *Schriftquellen zur Geschichte der karolingischen Kunst* (*Quellenschriften für Kunstgeschichte*, New Ser., IV), Vienna, 1892.

—— *Quellenbuch zur Kunstgeschichte des abendländischen Mittelalters* (*Quellenschriften für Kunstgeschichte*, New Ser., VII), Vienna, 1896.

SCHMIDT, A. M., *La Poésie scientifique en France au seizième siècle*, Paris, 1938.

SCHNABEL, P., 'Der verlorene Speirer Codex des Itinerarium Antonini, der Notitia Dignitatum und anderer Schriften,' *Sitzungsberichte der preussischen Akademie der Wissenschaften*, phil.-hist. Klasse, XXIX, 1926, p. 242 ff.

SCHÖNE, W., 'Studien zur Oberkirche von Assisi,' *Festschrift Kurt Bauch*, Berlin, 1957.

SCHNITZLER, H., *Mittelalter und Antike*, Munich, 1949.

SCHOENEBECK, H. U. VON, 'Ein christlicher Sarkophag aus St. Guilhem,' *Jahrbuch des deutschen archäologischen Instituts*, XLVII, 1932, p. 97 ff.

225

SCHRAMM, P. E., *Die deutschen Kaiser und Könige in Bildern ihrer Zeit, I Teil bis zur Mitte des 12. Jahrhunderts*, Berlin and Leipzig, 1928.

—— *Kaiser, Rom und Renovatio* (Studien der Bibliothek Warburg, XVII), Leipzig and Berlin, 1929.

SCHWEITZER, B., 'Die europäische Bedeutung der römischen Kunst,' *Vermächtnis der antiken Kunst, Gastvorträge zur Jahrhundertfeier der archäologischen Sammlungen der Universität Heidelberg*, R. Herbig, ed., Heidelberg, 1950, p. 141 ff.

—— *Die spätantiken Grundlagen der mittelalterlichen Kunst* (Leipziger Universitätsreden, XVI), Leipzig, 1949.

—— *Vom Sinn der Perspektive*, Tübingen, 1953.

SETTON, K. M., 'Some Recent Views of the Italian Renaissance,' *Canadian Historical Association, Report of Annual Meeting*, Toronto, 1947, p. 5 ff.

SEYMOUR, C., 'Thirteenth-Century Sculpture at Noyon and the Development of the Gothic Caryatid,' *Gazette des Beaux-Arts*, 6th Ser., XXVI, 1944, p. 163 ff.

SEZNEC, J., *The Survival of the Pagan Gods* (Bollingen Series, XXXVIII), New York, 1953.

SHAPLEY, F., 'A Student of Ancient Ceramics, Antonio Pollaiuolo,' *Art Bulletin*, II, 1919, p. 78 ff.

SHEPPARD, C. D., JR., 'A Chronology of Romanesque Sculpture in Campania,' *Art Bulletin*, XXXII, 1950, p. 319 ff.

—— 'Iconography of the Cloister of Monreale,' *Art Bulletin*, XXXI, 1949, p. 159 ff.

—— 'Monreale et Chartres,' *Gazette des Beaux-Arts*, 6th Ser., XXXI, 1949, p. 401 ff.

—— 'A Stylistic Analysis of the Cloister at Monreale,' *Art Bulletin*, XXXIV, 1952, p. 35 ff.

SIEBENHÜNER, H., 'Zur Entwicklung der Renaissance-Perspektive,' *Kunstchronik*, VII, 1954, p. 129 ff.

SIMON, K., 'Diesseitsstimmung in spätromanischer Zeit und Kunst,' *Deutsche Vierteljahrschrift für Literaturwissenschaft und Geistesgeschichte*, XII, 1934, p. 49 ff.

SIMONE, F., 'La Coscienza della Rinascita negli humanisti,' *La Rinascita*; II, 1939, p. 838 ff.; III, 1940, p. 163 ff.

—— 'La Coscienza della Rinascita negli scrittori francesi della prima metà del Cinquecento,' *La Rinascita*, VI, 1943, p. 143 ff.

SINGER, C. J., *Studies in the History and Method of Science*, Oxford, 1917–1921.

SINGER, S., 'Karolingische Renaissance,' *Germanisch-Romanische Wochenschrift*, XIII, 1925, p. 187 ff.

SINIBALDI, G., *I Lorenzetti*, Siena, 1933.

—— and BRUNETTI, G., *Pittura Italiana del Duecento e Trecento; Catalogo della Mostra Giottesca di Firenze del 1937*, Florence, 1943.

SMITH, L., ed., *Epistolario di Pier Paolo Vergerio*, Rome, 1934.

SPENCER, J. R., tr., *Leon Battista Alberti, On Painting*, New Haven, 1956.

SPITZER, L., 'The Problem of Latin Renaissance Poetry,' *Studies in the Renaissance* (Publications of the Renaissance Society of America), II, 1955, p. 118 ff.

SPRINGER, A., 'Das Nachleben der Antike im Mittelalter,' *Bilder aus der neueren Kunstgeschichte*, 2nd ed., Bonn, 1886, I, p. 1 ff.

STEFANO, G. DI, *Monumenti della Sicilia Normanna*, Palermo, 1955.

STEINBART, K., *Masaccio*, Vienna, 1948.

STERLING, C., *La Nature morte de l'Antiquité à nos jours*, Paris, 1952.

—— 'Œuvres retrouvées de Jean de Beaumetz, peintre de Philippe le Hardi,' *Bulletin, Musées Royaux des Beaux-Arts*, IV, 1955, p. 57 ff.

—— *La Peinture française; les primitifs*, Paris, 1938.

STERN, H., *Le Calendrier de 354; Etudes sur son texte et ses illustrations*, Paris, 1953.

STERNFELD, F. W., 'The Dramatic and Allegorical Function of Music in Shakespeare's Tragedies,' *Annales Musicologiques*, III, 1955, p. 265 ff.

STETTINER, R., *Die illustrierten Prudentius-Handschriften*, Berlin, 1895, 1905.

STRAUB, A., and KELLER, G., eds., *Herrade de Landsberg, Hortus Deliciarum*, Strasbourg, 1901.

SUDHOFF, K., ed., *Archiv für Geschichte der Medizin und der Naturwissenschaften*, Leipzig, 1908–1943.

SUGER, ABBOT, see Panofsky, E.

SULZBERGER, S., *La Formation de Claus Sluter* (Communication faite devant les Members de la Société des Amis du Musée Communal de Bruxelles), Brussels, 1952.

SULZBERGER, S., 'Relations artistiques italo-flamandes autour d'une oeuvre perdue de Roger van der Weyden.' *Bulletin de l'Institut Historique Belge de Rome*, XXVI, 1950–1951, p. 251 ff.

SWARZENSKI, G., 'A Marriage Casket and Its Moral,' *Bulletin of the Museum of Fine Arts, Boston*, XLV, 1947, p. 55 ff.

—— *Nicolo Pisano*, Frankfurt-am-Main, 1926.

SWARZENSKI, H., *Monuments of Romanesque Art, The Art of Church Treasures in Northwestern Europe*, London, 1954.

—— 'The Xanten Purple Leaf and the Carolingian Renaissance,' *Art Bulletin*, XXII, 1940, p. 7 ff.

'*Symposium on the Tenth Century*,' *Mediaevalia et Humanistica*, IX, 1955, p. 3 ff. (with contributions by L. White, L. C. MacKenny, H. Lattin, L. Wallach, and K. J. Conant).

'*Symposium* "Tradition and Innovation in Fifteenth-Century Italy,"' *Journal of the History of Ideas*, IV, 1943, pp. 1–74 (with contributions by H. Baron, D. B. Durand, E. Cassirer, P. O. Kristeller, L. Thorndike, etc.).

'*Symposium* "Ursprünge und Anfänge der Renaissance,"' *Kunstchronik*, VII, pp. 113–147.

TALICE DA RICALDONE, STEFANO, see Promis.

THIELE, J., *Antike Himmelsbilder*, Berlin, 1898.

THODE, H., *Die Antiken in den Stichen Marcantons*, Leipzig, 1881.

THOMPSON, D. B., 'A Bronze Dancer from Alexandria,' *American Journal of Archaeology*, LIV, 1950, p. 371 ff.

THOMPSON, D. V., Jr., ed., *Cennino d'Andrea Cennini da Colle di Val d'Elsa, Il Libro dell'Arte*, II, New Haven, 1933.

THORNDIKE, L., 'Renaissance or Prenaissance,' *Journal of the History of Ideas*, IV, 1943, p. 65 ff.

TIETZE, H., 'Romanische Kunst und Renaissance,' *Vorträge der Bibliothek Warburg*, 1926–1927, p. 43 ff.

TIETZE-CONRAT, E., *Andrea Mantegna*, Florence and London, 1955.

—— 'Notes on "Hercules on the Crossroads,"' *Journal of the Warburg and Courtauld Institutes*, XIV, 1951, p. 305 ff.

TOESCA, E., ed., *Antonio Manetti, Vita di Ser Brunellesco*, Florence, 1927.

TOESCA, P., *Affreschi del Vecchio e Nuovo Testamento della Chiesa Superiore del Santuario di Assisi*, Florence, 1948.

—— *Storia dell'arte italiana*, II (Il Trecento), Turin, 1951.

TOFFANIN, G., *Storia dell'umanesimo*, Naples, 1952 (English translation: *History of Humanism*, New York, 1955).

TOLNAY, C. DE, *Le Maître de Flémalle et les Frères van Eyck*, Brussels, 1939.

—— *Michelangelo*, III (*The Medici Chapel*), Princeton, 1948; *Michelangelo*, IV (*The Tomb of Julius II*), 1954.

—— 'Les Origines de la nature morte,' *Revue des Arts*, I, 1952, p. 151 ff.

TORRE, A. DELLA, *Storia dell'Accademia Platonica di Firenze*, Florence, 1902.

'Tradition and Innovation in Fifteenth-Century Italy,' see *Symposium*.

TSCHAN, F., *Saint Bernward of Hildesheim*, Notre Dame, Indiana, 1942–1952.

TSELOS, D., 'A Greco-Italian School of Illuminators and Fresco Painters; Its Relations to the Principal Reims Manuscripts and to the Greek Frescoes in Rome and Castelseprio,' *Art Bulletin*, XXXVIII, 1956, p. 1 ff.

—— 'Unique Portraits of the Evangelists in an English Gospel-Book of the Twelfth Century,' *Art Bulletin*, XXXIV, 1952, p. 257 ff.

ULLMAN, B. L., *Studies in the Italian Renaissance*, Rome, 1955.

UNDERWOOD, P. A., 'The Fountain of Life in Manuscripts of the Gospels,' *Dumbarton Oaks Papers*, IV, 1950, p. 41 ff.

VALENTINER, W. R., 'Studies on Nicola Pisano,' *Art Quarterly*, XV, 1952, p. 9 ff.

VARGA, L., *Das Schlagwort vom finsteren Mittelalter*, Vienna and Leipzig, 1932.

VASARI, GIORGIO, see Milanesi and Venturi.

VELLUTELLO, ALESSANDRO, see Landino.

227

VENTURI, A., ed., *Le Vite de' più eccellenti pittori, scultori, e architetti, scritte da M. Giorgio Vasari, I, Gentile da Fabriano e il Pisanello*, Florence, 1896.

VENTURI, L., *Pitture Italiane in America*, Milan, 1931.

VERGERIO, PIER PAOLO, see Smith.

VINOGRADOFF, P., *Roman Law in Mediaeval Europe*, 2nd ed., Oxford, 1929.

VÖGE, W., *Die Anfänge des monumentalen Stiles im Mittelalter; Eine Untersuchung über die erste Blütezeit der französischen Plastik*, Strasbourg, 1894.

—— 'Die Bahnbrecher des Naturstudiums um 1200,' *Zeitschrift für bildende Kunst*, New Ser. XXV, 1914, p. 193 ff.

—— 'Ueber die Bamberger Domskulpturen,' *Repertorium für Kunstwissenschaft*, XXII, 1899, p. 94 ff.; XXIV, 1901, pp. 195 ff., 255 ff.

VOGEL, J., *Bramante und Raffael (Kunstwissenschaftliche Studien, IV)*, Leipzig, 1910.

WACKERNAGEL, M., *Die Plastik des 11. und 12. Jahrhunderts in Apulien*, Leipzig, 1911.

WALKER, J., *Bellini and Titian at Ferrara; A Study of Styles and Taste*, London, 1956.

WARBURG, A., *Gesammelte Schriften*, Leipzig and Berlin, 1932.

WARBURG INSTITUTE, *Kulturwissenschaftliche Bibliographie zum Nachleben der Antike, herausgegeben von der Bibliothek Warburg, I, Die Erscheinungen des Jahres 1931*, Leipzig and Berlin, 1934; II (with English title, *A Bibliography of the Survival of the Classics, Edited by the Warburg Institute, The Publications of 1932-1933*), London, 1938.

WEBER, L., *Einbanddecken, Elfenbeintafeln, Miniaturen und Schriftproben aus Metzer Handschriften*, Metz, 1912.

WEBSTER, J. C., *The Labors of the Months in Antique and Mediaeval Art*, Princeton, 1938.

WEIGELT, C. H., *Giotto (Klassiker der Kunst, XXIX)*, Stuttgart, Berlin and Leipzig, 1925.

WEINBERGER, M., 'The First Façade of the Cathedral of Florence,' *Journal of the Warburg and Courtauld Institutes*, IV, 1940–1941, p. 67 ff.

WEISE, G., 'Die spätgotische Stilströmung in der Kunst der italienischen Renaissance,' *Bibliothèque d'Humanisme et Renaissance*, XIV, 1952, p. 99 ff.

—— 'Spätgotisches Schreiten und andere Motive spätgotischer Ausdrucks-und Bewegungsstilisierung,' *Marburger Jahrbuch für Kunstgeschichte*, XIV, 1949, p. 163 ff.

WEISINGER, H., 'The Attack on the Renaissance in Theology Today,' *Studies in the Renaissance* (Publications of the Renaissance Society of America), II, 1955, p. 176 ff.

—— 'Ideas of History during the Renaissance,' *Journal of the History of Ideas*, VI, 1945, p. 415 ff.

—— 'Renaissance Theories of the Revival of the Fine Arts,' *Italica*, XX, 1943, p. 163 ff.

—— 'The Renaissance Theory of the Reaction Against the Middle Ages as a Cause of the Renaissance,' *Speculum*, XX, 1945, p. 461 ff.

—— 'The Self-Awareness of the Renaissance as a Criterion of the Renaissance,' *Papers of the Michigan Academy of Science, Arts and Literature*, XIX, 1944, p. 661 ff.

WEISZ, E. W., *Jan Gossart gen. Mabuse*, Parchim, 1913.

WEITZMANN, K., 'Abendländische Kopien Byzantinischer Rosettenkästen,' *Zeitschrift für Kunstgeschichte*, III, 1934, p. 89 ff.

—— *Greek Mythology in Byzantine Art*, Princeton, 1951.

—— *Illustrations in Roll and Codex*, Princeton, 1947.

—— 'Das klassische Erbe in der Kunst Konstantinopels,' *Alte und neue Kunst, Wiener kunstwissenschaftliche Blätter*, III, 1954, p. 41 ff.

—— See also Goldschmidt.

WEITZMANN-FIEDLER, J., 'A Pyramus and Thisbe Bowl in the Princeton Museum,' *Art Bulletin*, XXXIX, 1957, p. 219 ff.

—— 'Romanische Bronzeschalen mit mythologischen Darstellungen ...,' *Zeitschrift für Kunstwissenschaft*, X, 1956, p. 109 ff.

WENTZEL, H., 'Antiken-Imitationen des 12. und 13. Jahrhunderts in Italien,' *Zeitschrift für Kunstwissenschaft*, IX, 1955, p. 29 ff.

—— 'Der *Augustalis* Friedrichs II,' *Zeitschrift für Kunstgeschichte*, XV, 1952, p. 183 ff.

—— 'Ein gotisches Kapitell in Troia,' *Zeitschrift für Kunstgeschichte*, XVII, 1954, p. 185 ff.

WENTZEL, H., 'Die grosse Kamee mit Poseidon und Athena in Paris,' *Wallraf-Richartz-Jahrbuch*, XVI, 1954, p. 53 ff.

—— 'Italienische Siegelstempel und Siegel all'antica im 13. und 14. Jahrhundert,' *Mitteilungen des kunsthistorischen Institutes in Florenz*, VII, 1955, p. 73 ff.

—— 'Eine Kamee aus Lothringen in Florenz und andere Kunstkammerkameen,' *Jahrbuch der preussischen Kunstsammlungen*, LXIV, 1943, p. 1 ff.

—— 'Die Kamee mit dem ägyptischen Joseph in Leningrad,' *Kunstgeschichtliche Studien für Hans Kauffmann*, Berlin, 1956, p. 85 ff.

—— 'Mittelalter und Antike im Spiegel kleiner Kunstwerke des 13. Jahrhunderts,' *Studier tillägnade Henrik Cornell på sextioårsdagen*, Stockholm, 1950, p. 67 ff.

—— 'Mittelalterliche Gemmen, Versuch einer Grundlegung,' *Zeitschrift des deutschen Vereins für Kunstwissenschaft*, VIII, 1941, p. 45 ff.

—— 'Mittelalterliche Gemmen am Oberrhein und verwandte Arbeiten,' *Form und Inhalt, kunstgeschichtliche Studien Otto Schmitt dargebracht*, Stuttgart, 1950, p. 145 ff.

—— 'Mittelalterliche Gemmen in den Sammlungen Italiens,' *Mitteilungen des kunsthistorischen Institutes in Florenz*, VII, 1956, p. 239 ff.

—— 'Portraits "à l'Antique" on French Mediaeval Gems and Seals,' *Journal of the Warburg and Courtauld Institutes*, XVI, 1953, p. 342 ff.

—— 'Die vier Kameen im Aachener Domschatz und die französische Gemmenschneidekunst des 13. Jahrhunderts,' *Zeitschrift für Kunstwissenschaft*, VIII, 1954, p. 1 ff.

Werdendes Abendland an Rhein und Ruhr, Ausstellung in Villa Hügel, Essen, May 18–Sept. 15, 1956, Essen, 1956.

WESENBERG, R., *Bernwardinische Plastik*, Berlin, 1955.

—— 'Die Fragmente monumentaler Skulpturen von St. Pantaleon in Köln,' *Zeitschrift für Kunstwissenschaft*, IX, 1955, p. 1 ff.

WHITE, J., *The Birth and Rebirth of Pictorial Space*, London, 1957.

—— 'The Date of 'The Legend of St. Francis' in Assisi,' *Burlington Magazine*, XCVIII, 1956, p. 344 ff.

—— 'Developments in Renaissance Perspective,' *Journal of the Warburg and Courtauld Institutes*, XII, 1949, p. 58 ff., XIV, 1951, p. 42 ff.

—— *Perspective in Ancient Drawing and Painting* (Society for the Promotion of Hellenic Studies, Supplementary Paper No. 7), London, 1956.

WHITE, T. H., *The Book of Beasts, Being a Translation from a Latin Bestiary of the Twelfth Century*, New York, 1954.

WIERUSZOWSKI, H., 'Arezzo as a Center of Learning and Letters in the Thirteenth Century,' *Traditio*, IX, 1953, p. 321 ff.

WILDE, J., see Popham.

WILKINS, E. H., 'Descriptions of Pagan Divinities from Petrarch to Chaucer,' *Speculum*, XXXII, 1957, p. 511 ff.

WILLEMSEN, C. A., *Apulien*, Leipzig, 1944.

—— *Kaiser Friedrichs II Triumphtor zu Capua*, Wiesbaden, 1953.

WILLIAMS LEHMANN, P., *Roman Wall Paintings from Boscoreale in the Metropolitan Museum of Art*, Cambridge (Mass.), 1953.

WILPERT, J., *Die römischen Mosaiken und Malereien der kirchlichen Bauten ...*, Freiburg i. B., 1916.

WIND, E., *Bellini's Feast of the Gods; A Study in Venetian Humanism*, Cambridge (Mass.), 1948.

—— 'Donatello's Judith: A Symbol of *Sanctimonia*,' *Journal of the Warburg Institute*, I, 1937, p. 62 f.

WINKLER, F., 'Paul de Limbourg in Florence,' *Burlington Magazine*, LVI, 1930, p. 94 ff.

—— Review of E. Panofsky, *Early Netherlandish Painting*, *Kunstchronik*, VIII, 1955, p. 9 ff.

WINTERNITZ, E., 'Archeologia musciale del rinascimento nel Parnaso di Raffaello,' *Rendiconti della Pontificia Accademia Romana di Archeologia*, XXVII, 1952–1954, p. 359 ff.

—— 'Instruments de musique étranges chez Filippino Lippi, Piero di Cosimo et Lorenzo Costa,' *Les Fêtes de la Renaissance*, I, Paris, 1956, p. 379 ff.

—— 'Quattrocento Science in the Gubbio Study,' *Metropolitan Museum of Art Bulletin*, New Ser., I, 1942, p. 104 ff.

WITTKOWER, R., *Architectural Principles in the Age of Humanism*, 2nd ed., London, 1952.

229

BIBLIOGRAPHY

WITTKOWER, R., 'Brunelleschi and "Proportion in Perspective,"' *Journal of the Warburg and Courtauld Institutes*, XVI, 1953, p. 275 ff.

—— 'Marvels of the East; A Study in the History of Monsters,' *Journal of the Warburg and Courtauld Institutes*, V, 1942, p. 159 ff.

—— 'A Symbol of Platonic Love in a Portrait Bust by Donatello,' *Journal of the Warburg Institute*, I, 1938, p. 260 f.

—— See also Saxl.

WOOD, A., and FYFE, F. M., *The Art of Falconry, Being the 'De Arte Venandi Cum Avibus' of Frederick II von Hohenstaufen*, London, 1943 (2nd ed., Boston, 1955).

WOODRUFF, H., 'The Physiologus of Bern,' *Art Bulletin*, XII, 1930, p. 2 ff.

WORMALD, F., *The Miniatures in the Gospels of St. Augustine (Corpus Christi College MS. 286)*, Cambridge, 1954.

—— 'Paintings in Westminster Abbey and Contemporary Painting,' *Proceedings of the British Academy*, XXXV, 1949, p. 161 ff.

—— *The Utrecht Psalter*, Utrecht, 1953.

—— See also Buchthal.

WORRINGER, W., *Abstraktion und Einfühlung*, Munich, 1908.

—— *Formprobleme der Gotik*, Munich, 1910.

YATES, F. A., *The French Academies of the Sixteenth Century* (Studies of the Warburg Institute, XV), London, 1947.

ZARNECKI, G., 'The Coronation of the Virgin from Reading Abbey,' *Journal of the Warburg and Courtauld Institutes*, XIII, 1950, p. 1 ff.

ZIMMERMANN, E. H., *Vorkarolingische Miniaturen*, Berlin, 1916.

INDEX

233

235

ILLUSTRATIONS

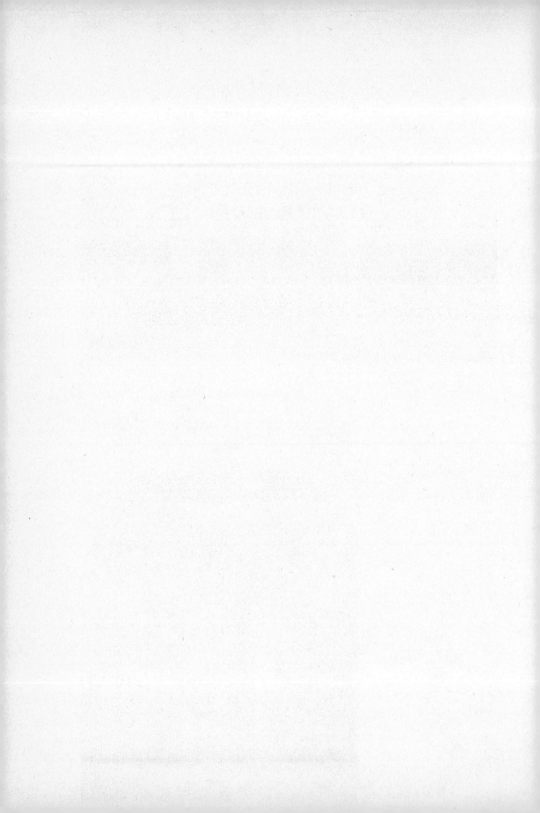

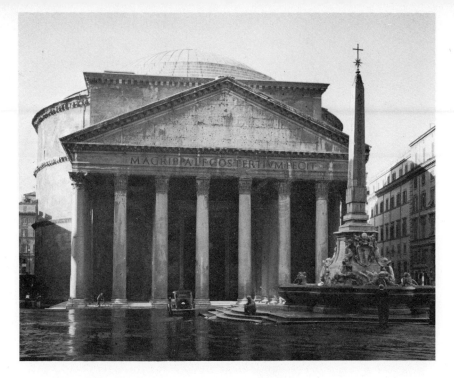

FIG. 1. Rome, The Pantheon.

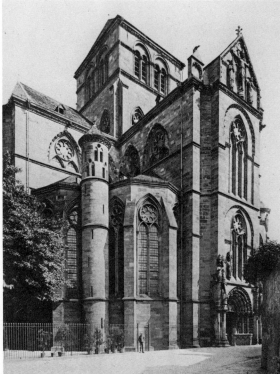

FIG. 2. Trèves, Our Lady's
Church.

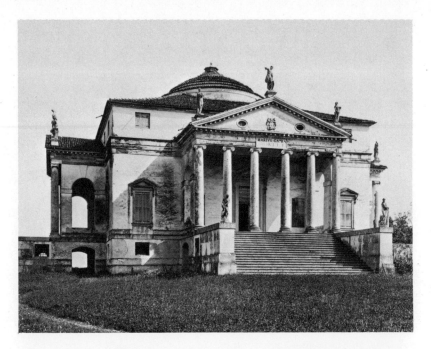

FIG. 3. Palladio, Villa Capra (known as "Villa Rotonda"), near Vicenza.

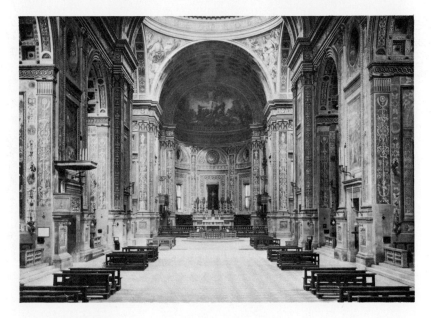

FIG. 4. Leone Battista Alberti, Mantua, S. Andrea, interior.

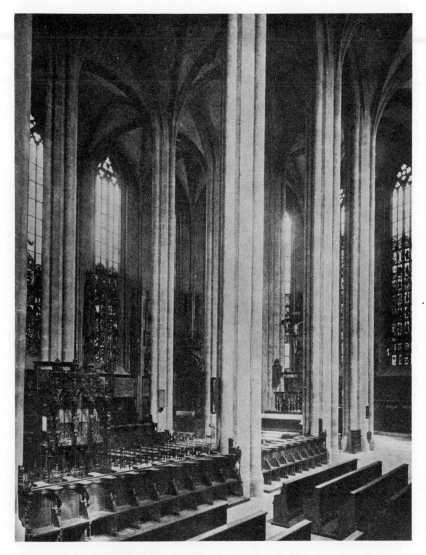

FIG. 5. Nuremberg, S. Sebaldus, interior of the choir.

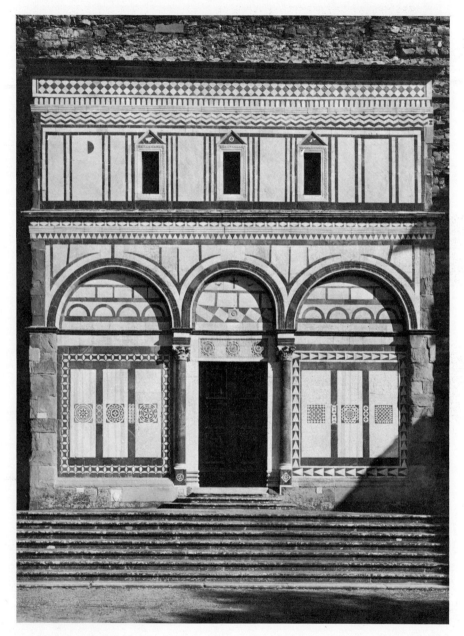

FIG. 6. Fiesole, Badia, façade.

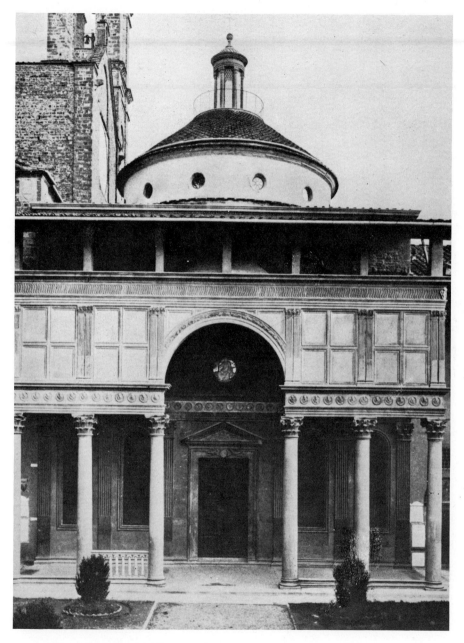

FIG. 7. Filippo Brunelleschi, Florence, Pazzi Chapel, façade.

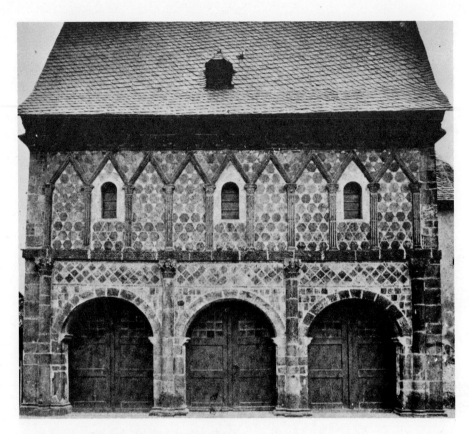

FIG. 8. Lorsch, the Carolingian "Torhalle".

FIG. 9. Paris. Bibliothèque Nationale, MS. lat. 12108 (St. Augustine, *Quaestiones in Heptateuchon*, middle of the eighth century), fol. C v., display page.

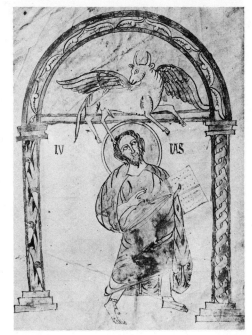

FIG. 10. Autun, Bibliothèque Municipale, MS. 3 (Gundohinus Gospels, completed 754), fol. 187 v., St. Luke.

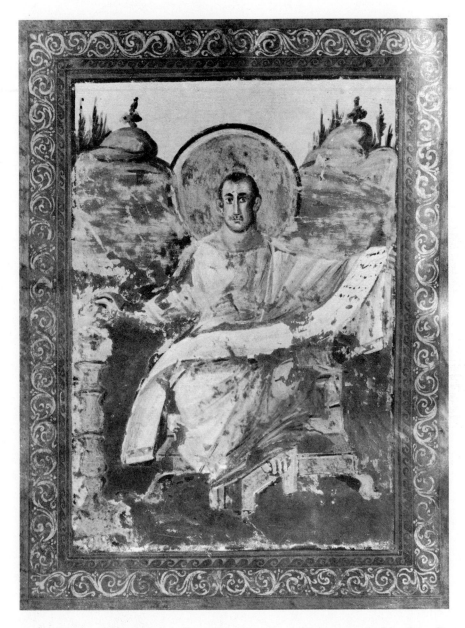

FIG. 11. Vienna, Schatzkammer, So-called "Gospels of Charlemagne", fol. 76 v., St. Mark (somewhat enlarged).

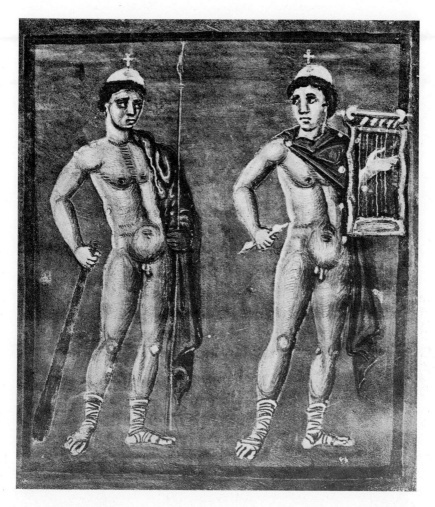

FIG. 12. Leiden, University Library, Cod. Voss. lat. 79 (*Aratea*, first half of ninth century) fol. 16 v., The Twins.

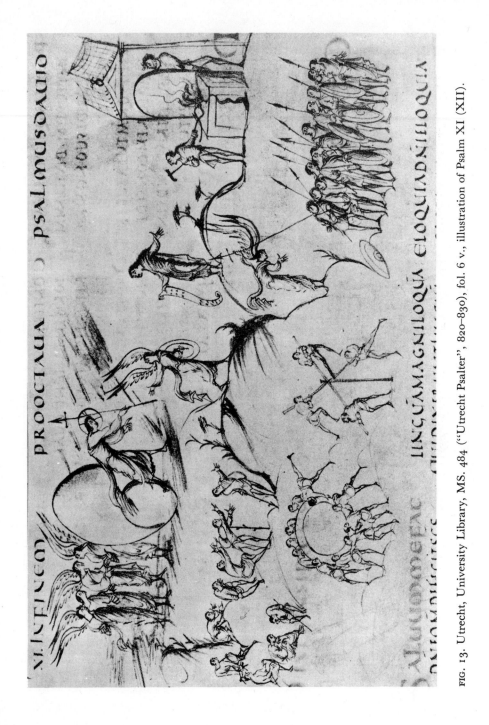

FIG. 13. Utrecht, University Library, MS. 484 ("Utrecht Psalter", 820–830), fol. 6 v., illustration of Psalm XI (XII).

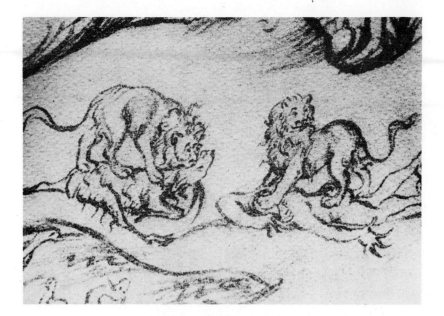

FIG. 14. Utrecht, same manuscript, fol. 59 v., Lions, detail (enlarged) of illustration of Psalm CIII (CIV).

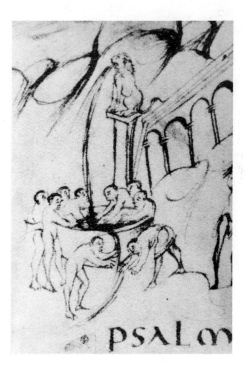

FIG. 15. Utrecht, same manuscript, fol. 14 v., Classical Aqueduct, detail (enlarged) of illustration of Psalm XXV (XXVI).

FIG. 16. Utrecht, same manuscript, fol. 57, Atlas, detail (enlarged) of illustration of Psalm XCVIII (XCIX).

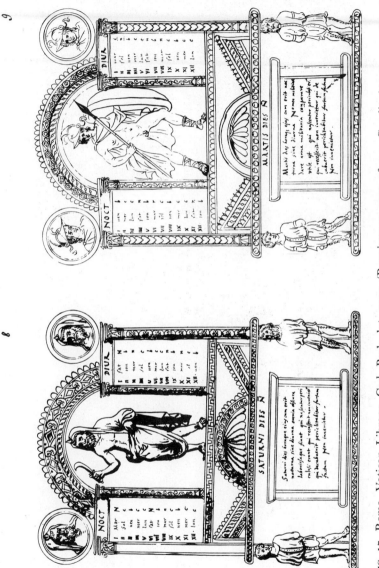

FIG. 17. Rome, Vatican Library, Cod. Barb. lat. 2154 (Renaissance copy after a Carolingian manuscript of the *Chronograph of 354*), fol. 8, Saturn. — FIG. 18. Rome, same manuscript as Fig. 17, fol. 9, Mars.

FIG. 19. Monte Cassino, Library, MS. 132 (Hrabanus Maurus, *De universo*, copy, dated 1023, after a Carolingian manuscript), p. 386, Saturn, Jupiter, Janus, Neptune.

FIG. 20. Munich, Staatsbibliothek, The Crucifixion, Carolingian ivory.

FIG. 21. Arles, St.-Trophîme, façade, middle of the twelfth century.

FIG. 22. Bari, Cathedral, Throne of 1098, detail.

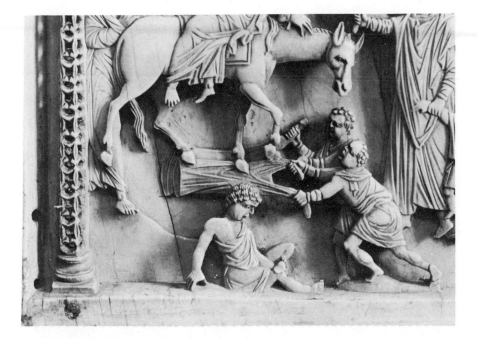

FIG. 23. Berlin, Kaiser-Friedrich-Museum, Entry into Jerusalem, Byzantine ivory of the tenth century, detail (enlarged).

FIG. 24. Lisieux. Cathedral, Sarcophagus, probably of Bishop Arnulf (reigned 1141-1181).

FIG. 25. Reims, Cathedral, Profile Head, interior of west façade, middle of the thirteenth century.

FIG. 26. Lyons, Musée Municipal, Juggler (from Bourges), third quarter of the twelfth century.

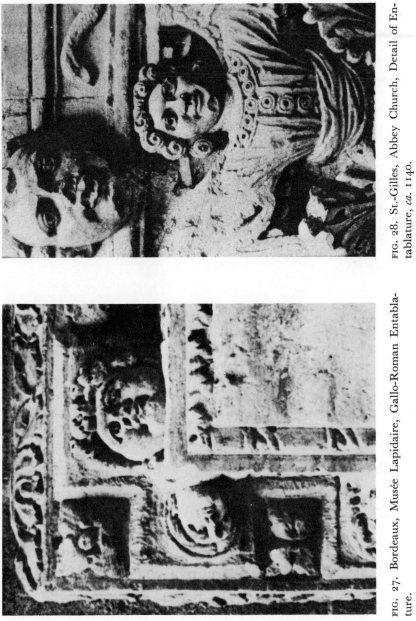

FIG. 28. St.-Gilles, Abbey Church, Detail of Entablature, *ca.* 1140.

FIG. 27. Bordeaux, Musée Lapidaire, Gallo-Roman Entablature.

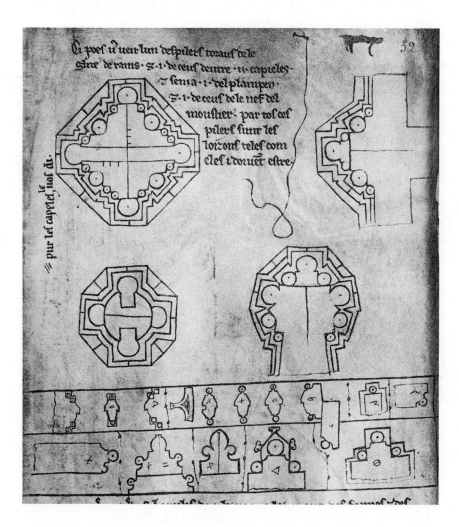

FIG. 29. Villard de Honnecourt, Cross Sections of Piers and Moldings in Reims Cathedral, Paris, Bibliothèque Nationale, MS. fr. 19093 ("Album", *ca.* 1235), fol. 32.

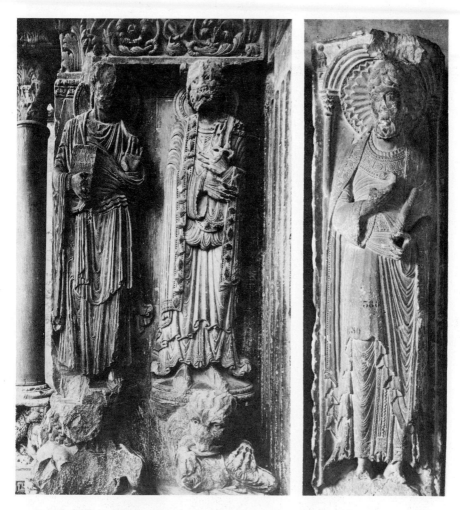

FIG. 30. St.-Gilles, Abbey Church, Sts. John the Evangelist and Peter,
ca. 1140.

FIG. 31. Master Gilabertus, St. Andrew (from St.-Etienne), Toulouse,
Musée Lapidaire, probably towards 1130.

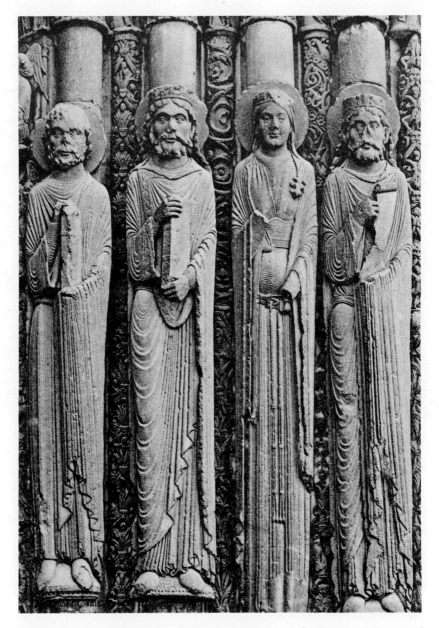

FIG. 32. Chartres, Cathedral, west façade (central portal), Kings and Queens of Israel (and, by implication, France), toward 1145.

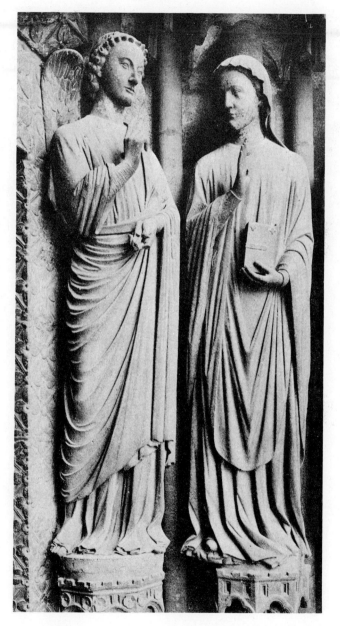

FIG. 33. Chartres, Cathedral, north transept (left portal), The Annunciation, *ca.* 1215.

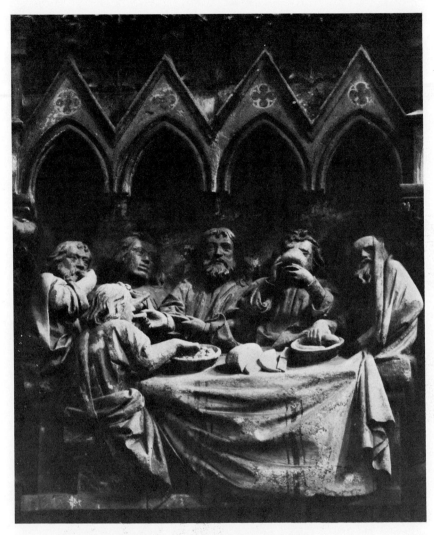

FIG. 34. Naumburg, Cathedral, jubé, Last Supper, *ca.* 1260.

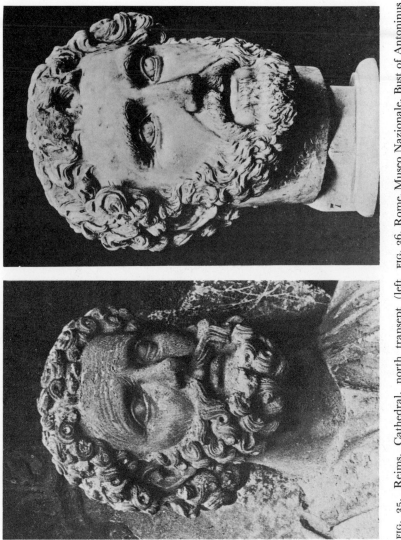

FIG. 35. Reims, Cathedral, north transept (left portal), St. Peter, 1220–1225. FIG. 36. Rome, Museo Nazionale, Bust of Antoninus Pius.

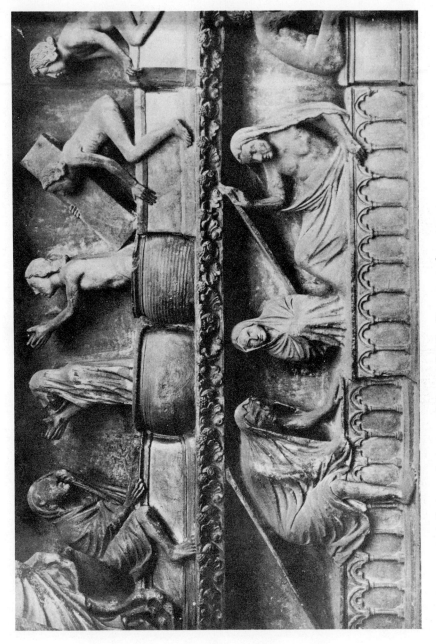

FIG. 37. Reims, Cathedral, north transept (left portal), The Ressurrected, 1220–1225.

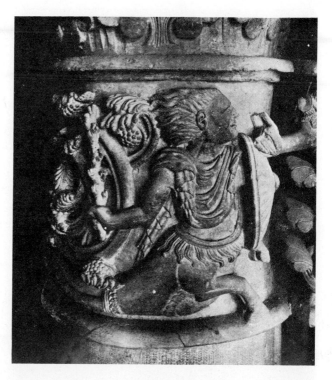

FIG. 38. Reims, Cathedral, Capital, 1220-1225.

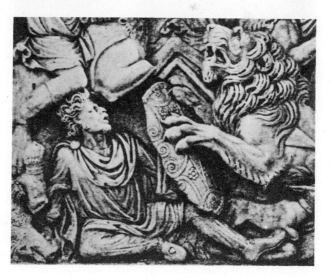

FIG. 39. Reims, Musée Lapidaire, So-called "Sarcophagus of Jovinus", detail.

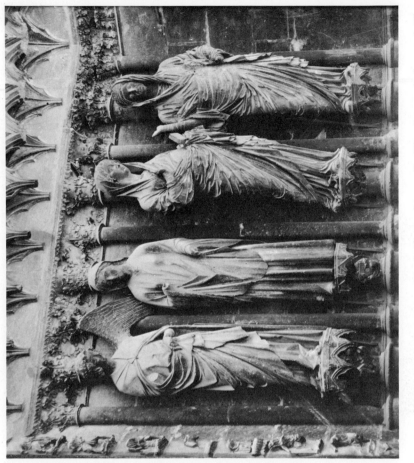

FIG. 40, Reims, Cathedral, west façade (central portal), The Annunciation and The Visitation, *ca.* 1230.

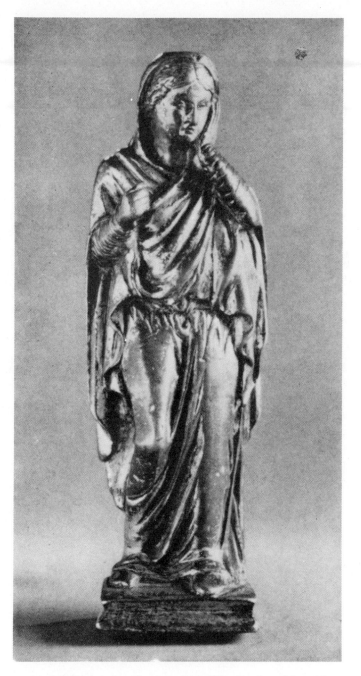

FIG. 41. Freiburg i. Br., Kunstgeschichtliches Institut, *Mater dolorosa*, French bronze statuette, *ca.* 1200.

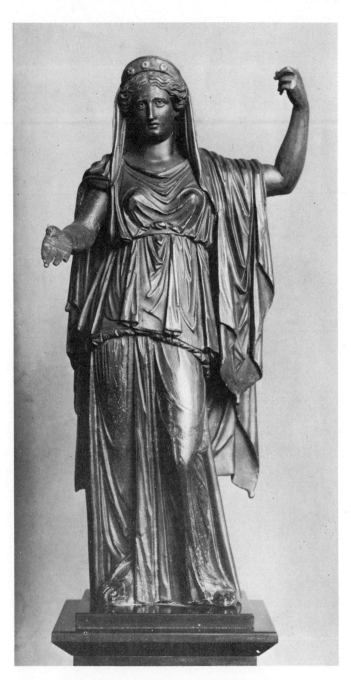

FIG. 42. Vienna, Kunsthistorisches Museum, Juno, Greek bronze statuette.

FIG. 43. New York, Metropolitan Museum, Tanagra figurine
(No. 06.1114).

FIG. 44. Paris, Juritzky Collection, Hercules (prefiguring Christ) Killing the Lion, cameo, probably second quarter of the thirteenth century (plaster cast, enlarged, photograph supplied by Prof. H. Wentzel).

FIG. 45. London, British Museum, Embarkation of Noah, cameo, probably middle of the thirteenth century (plaster cast, enlarged, photograph supplied by Prof. H. Wentzel).

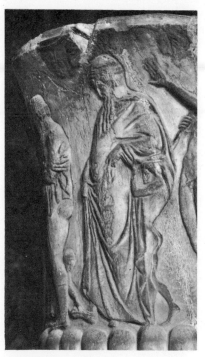

FIG. 46. Nicolo Pisano, Presentation of Christ (detail), Pisa, Pulpit in the Baptistry, *ca.* 1260.

FIG. 47. Pisa, Camposanto, Dionysus Vase, detail.

FIG. 48. Nicolo Pisano, Fortitude in the Guise of Hercules, Pisa, Pulpit in the Baptistry, *ca.* 1260.

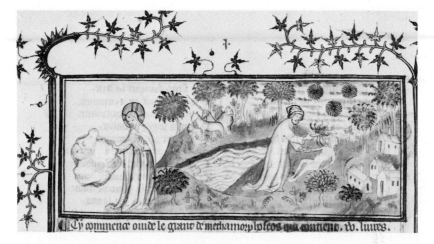

FIG. 49. Lyons, Bibliothèque Municipale, MS. 742 (*Ovide moralisé* in verse, third quarter of the fourteenth century), fol. 4, Creation of the World and Animation of Man by Prometheus.

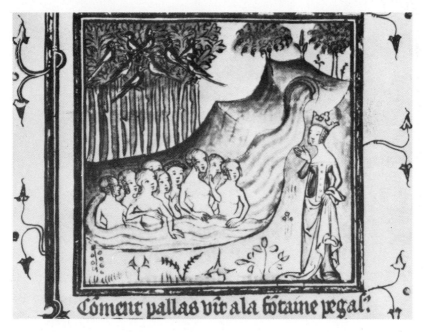

FIG. 50. Lyons, same manuscript as Fig. 49, fol. 87, Minerva, the Muses and the Pierids on Mount Helicon (enlarged).

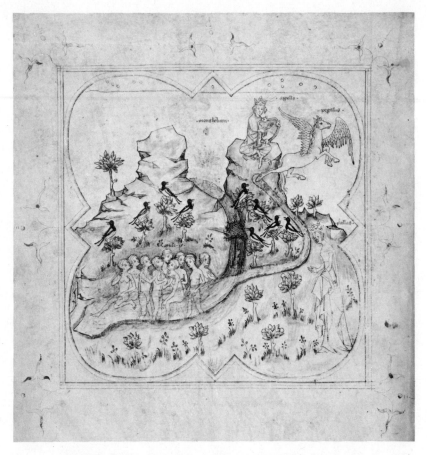

FIG. 51. Paris, Bibliothèque Nationale, MS. fr. 871 (*Ovide moralisé* in verse, *ca.*1400), fol. 116, Apollo, Minerva, Pegasus, the Muses, and the Pierids on Mount Helicon.

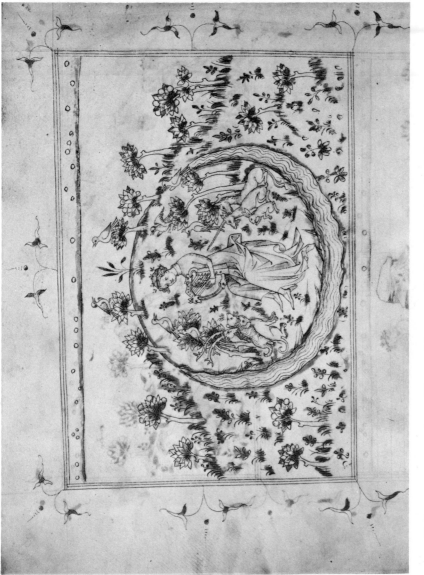

FIG. 52. Paris, same manuscript as Fig. 51, fol. 149 v., Orpheus Charming the Animals.

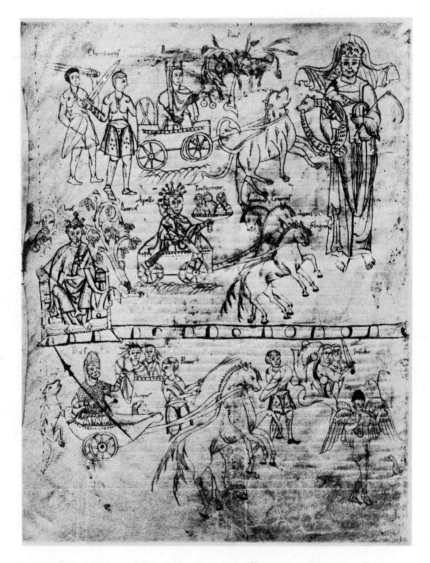

FIG. 53. Munich, Staatsbibliothek, clm. 14271 (Remigius of Auxerre, *Commentary on Martianus Capella, ca.* 1100), fol. 11 v., The Pagan Gods.

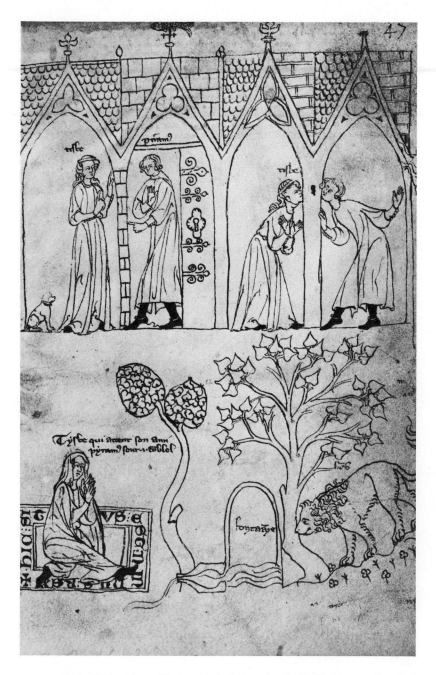

FIG. 54. Paris, Bibliothèque Nationale, MS. lat. 15158 (Ovid, *De remediis amoris*, forming part of a *Psychomachia* manuscript, dated 1289), fol. 47, The Story of Pyramus and Thisbe.

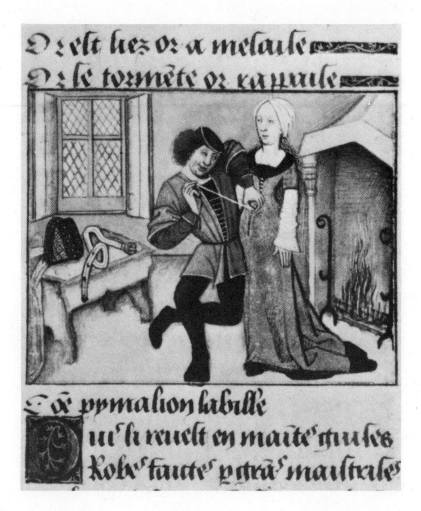

FIG. 55. Oxford, Bodleian Library, MS. Douce 195 (*Roman de la Rose*, *ca.* 1470), fol. 150, Pygmalion Dressing His Statue (enlarged).

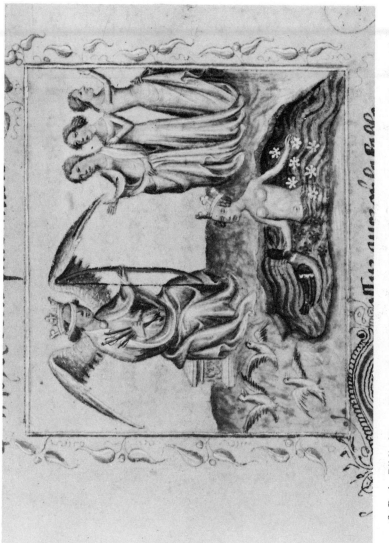

FIG. 56. Paris, Bibliothèque Nationale, MS. fr. 373 (*Ovide moralisé* in verse, towards 1380), fol 207, Venus with the Sea Goose (enlarged).

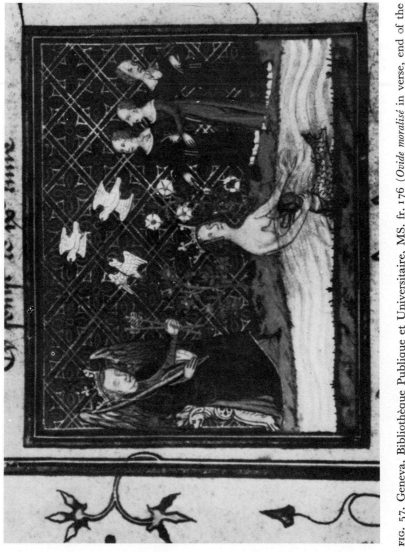

FIG. 57. Geneva, Bibliothèque Publique et Universitaire, MS. fr. 176 (*Ovide moralisé* in verse, end of the fourteenth century), fol. 216, Venus with the Sea Goose, improved version (enlarged).

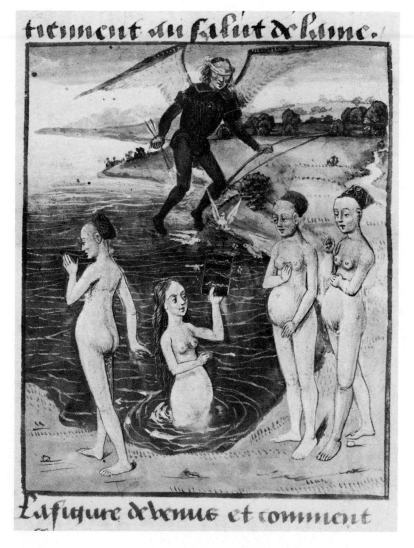

FIG. 58. Copenhagen, Royal Library, MS. Thott 399, 2° (*Ovide moralisé* in verse, preceded by a French translation of the Introduction to Petrus Berchorius' *Ovidius moralizatus*, towards 1480), fol. 9 v., Venus with the Flower-adorned Slate (enlarged).

FIG. 59. Schöngrabern (Austria), Church, Sisyphus, Tantalus and Ixion, *ca.* 1230.

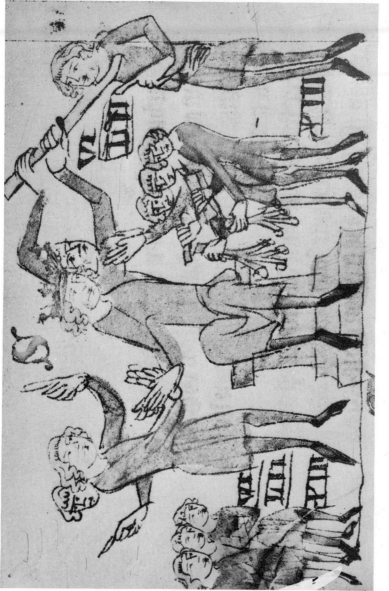

FIG. 60. Dresden, Landesbibliothek, *Sachsenspiegel* (fourteenth century replica of an earlier model), fol. 68 v., Legal Scene.

FIG. 61. Auxerre, Cathedral, west façade, Hercules; Joseph Cast into the Pit (Genesis, XXXVII), *ca.* 1280.

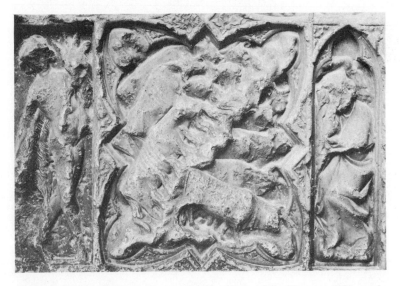

FIG. 62. Auxerre, Cathedral, west façade, Satyr; The Dream of Pharaoh (Genesis, XLI), *ca.* 1280.

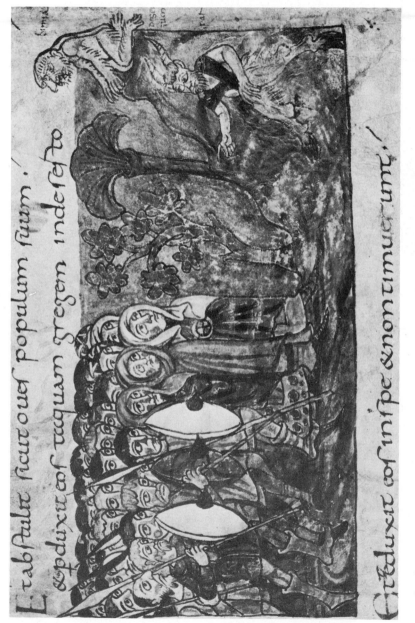

FIG. 63. Stuttgart, Würtembergische Landesbibliothek, MS. Biblia Folio 23 (Stuttgart Psalter, early ninth century), fol. 93 v., Illustrations (slightly enlarged) of Psalm LXXVII (LXXVIII).

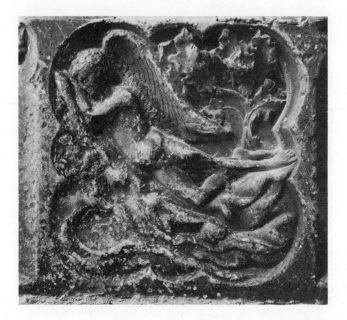

FIG. 64. Auxerre, Cathedral, west façade, *Amor carnalis, ca.* 1280.

C ymbala picunt · bellu̅ · na̅ talib; armis̅
L udebant · resono medrante̅s uulnera sistro
A mor qui ˆcvpido sa̅ · — git̅ · ras̅ vel fare
tracq̅ seuar · cvm̅ relin̅
q̅ens fugit ·

D at tergum fugitiuus amor · lita tela ueneno
E t lapsum exhumeris arcu pharetramq̅; cade̅te̅

FIG. 65. Lyons, Bibliothèque du Palais des Arts, MS. 22 (Prudentius, *Psychomachia,* about 1100), fol. 17 v., Cupid in Flight (slightly enlarged).

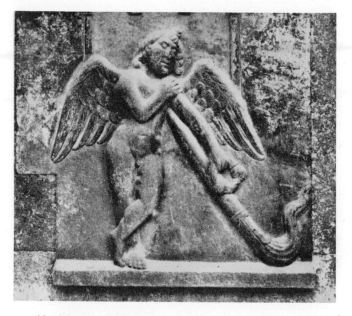

FIG. 66. Master, Wiligelmus, Cupid with Inverted Torch, Modena, Cathedral, west façade, *ca.* 1170.

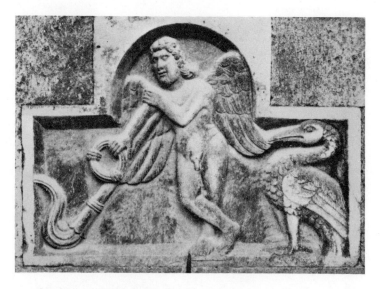

FIG. 67. Master Wiligelmus, Cupid with Inverted Torch and Ibis, Modena, Cathedral, west façade, *ca.* 1170.

FIG. 68. Osnabrück, Town Hall, Chalice known as the *Kaiserpokal*, towards 1300 (photographs reproduced in Figs. 68–77 supplied by Prof. H. Wentzel).

FIGS. 69–71. Osnabrück, same object, details from *cuppa*. Virtues and Vices.

FIG. 69.

Fig. 70.

Fig. 71.

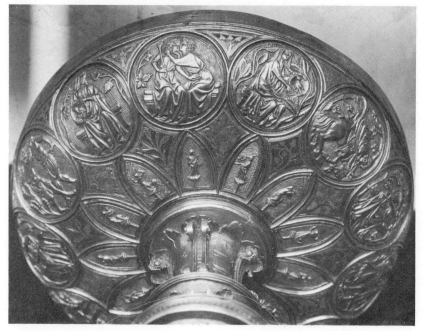

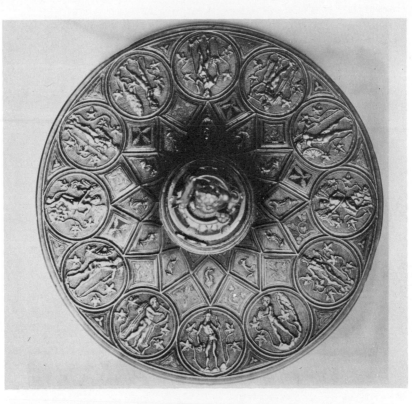

FIG. 72. Osnabrück, same object as Fig. 68, cover.

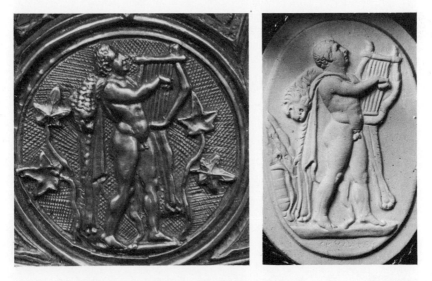

FIG. 73. Osnabrück, same object as Fig. 68, cover, detail. — FIG. 74. Formerly Paris, Roger Collection, *Hercules Musarum*, classical cameo (plaster cast, enlarged).

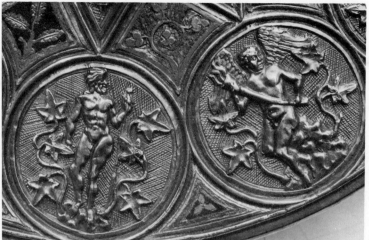

FIG. 75.

FIG. 76.

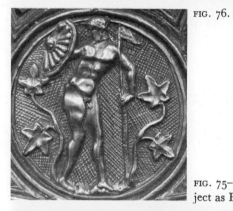

FIG. 75–77. Osnabrück, same object as Fig. 68, cover, details.

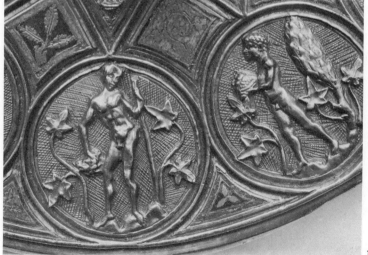

FIG. 77.

FIG. 78. Monreale, Cathedral, Cloister, "Mithras" Capital, between 1172 and 1189.

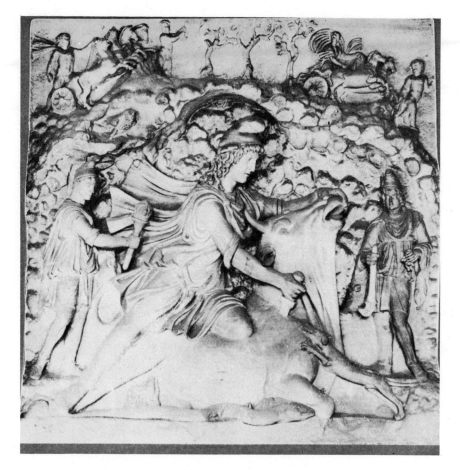

FIG. 79. Mithras Killing the Bull, Rome, Museo Capitolino.

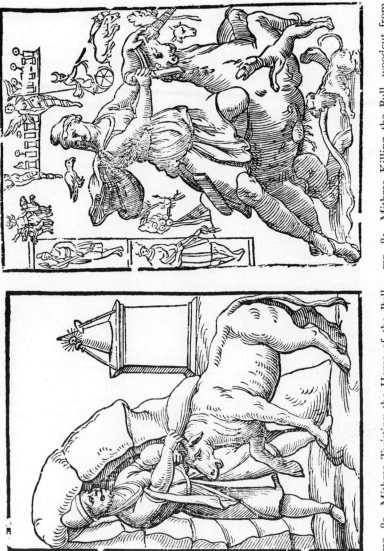

FIG. 80. Mithras Twisting the Horns of the Bull, woodcut from Vincenzo Cartari, *Imagini dei Dei degli antichi*, Venice, 1674, p. 34.

FIG. 81. Mithras Killing the Bull, woodcut from the same publication as Fig. 80, p. 275.

FIG. 82. Vézelay, Ste.-Madeleine (central portal), detail of lintel, Sacrifice of a Bull, between 1120 and 1132.

FIG. 83. Charlieu, St.-Fortunat, small portal, Wedding of Cana and Sacrifice of Animals, middle of the twelfth century.

FIG. 85. Mantua, Broletto, Statue of Virgil, probably about 1227.

FIG. 84. Benedetto Antelami (?), Statue of Virgil, Mantua, Palazzo Ducale, *ca.* 1215.

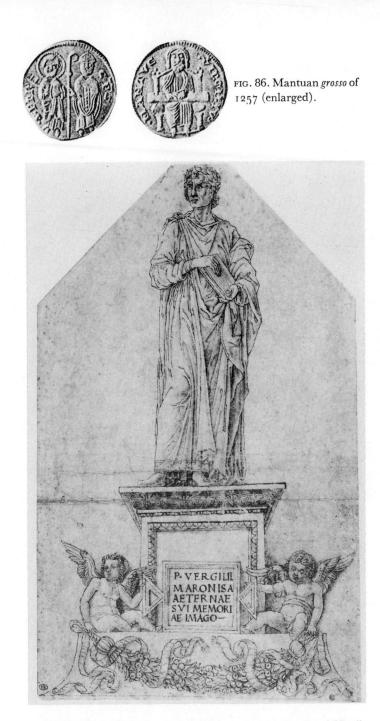

FIG. 86. Mantuan *grosso* of 1257 (enlarged).

P.VERGILII
MARONISA
AETERNAE
SVI MEMORI
AE IMAGO~

FIG. 87. Andrea Mantegna (after), Project for the Statue of Virgil. Planned in 1499, Paris, Louvre.

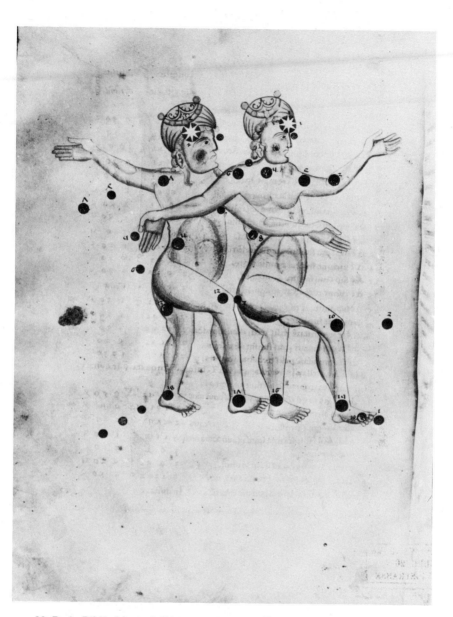

FIG. 88. Paris, Bibliothèque de l'Arsenal, MS. 1036 (Sūfi, *Liber de locis stellarum*, middle of the thirteenth century), fol. 22 v., Gemini.

FIG. 89. Munich, Staatsbibliothek, clm. 10268 (Michael Scotus, *Liber introductorius*, second half of the fourteenth century), fol. 85, Saturn, Jupiter, Mars, Venus, Mercury.

FIG. 90. New York, Pierpont Morgan Library, MS. 785 (Abu Ma'šar, *Liber astrologiae*, fraudulently claimed by Georgius Zothori Zapara Fenduli, towards 1403), fol. 48, Mercury in Exaltation.

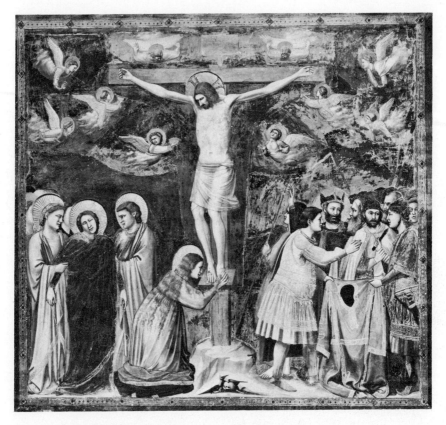

FIG. 91. Giotto, Crucifixion, Padua, Arena Chapel, *ca.* 1305.

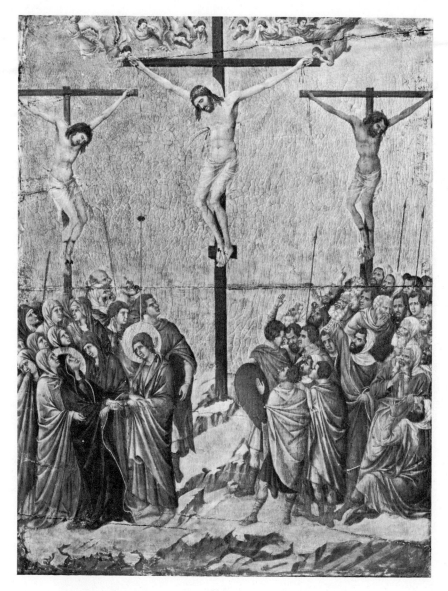

FIG. 92. Duccio di Buoninsegna, Crucifixion, Siena, Opera del Duomo, 1308–1311.

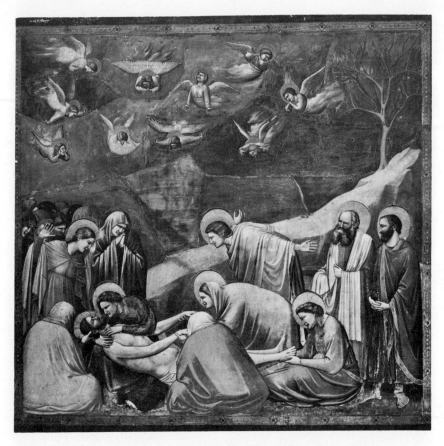

FIG. 93. Giotto, Lamentation of Christ, Padua, Arena Chapel, *ca.* 1305.

FIG. 94. London, British Museum, MS. Add. 10546 (Bible of Moutier-Grandval, second half of the ninth century), fol. 25 *v*, Moses Displaying the Tables of the Law.

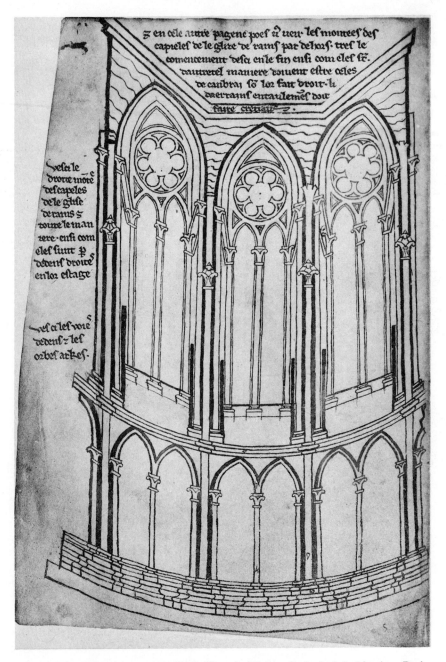

FIG. 95. Villard de Honnecourt, Choir Chapel of Reims Cathedral, inside view, Paris, Bibliothèque Nationale, same manuscript as Fig. 29, fol. 30 v.

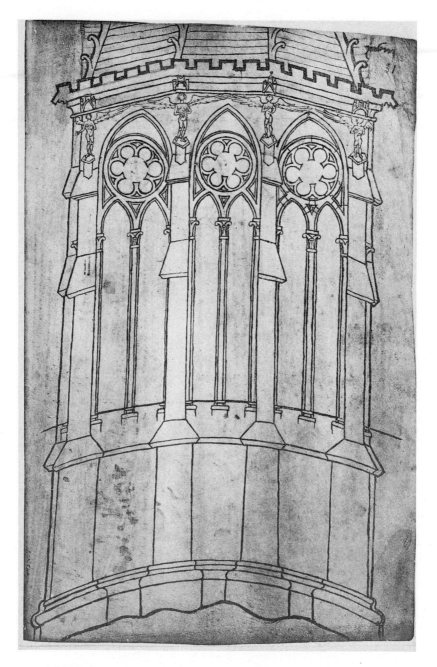

FIG. 96. Villard de Honnecourt, Choir Chapel of Reims Cathedral, outside view, same manuscript as Fig. 29, fol. 31.

FIG. 97. Florence, Baptistry, Dream of Pharaoh, mosaic (much restored), first half of the thirteenth century.

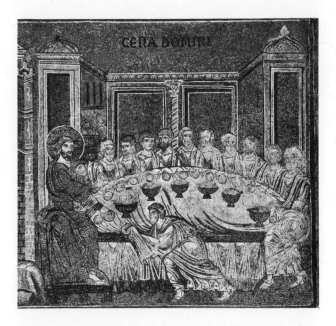

FIG. 98. Monreale, Cathedral, Last Supper, mosaic, late twelfth century.

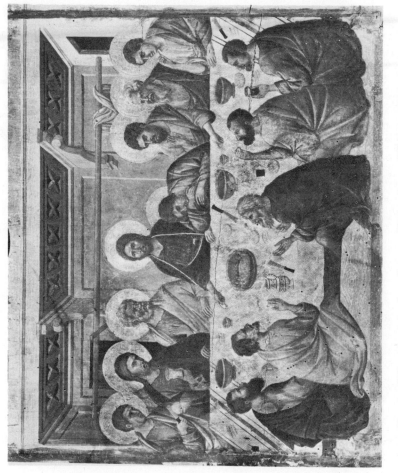

FIG. 99. Duccio di Buoninsegna, Last Supper, Siena, Opera del Duomo, 1308–1311.

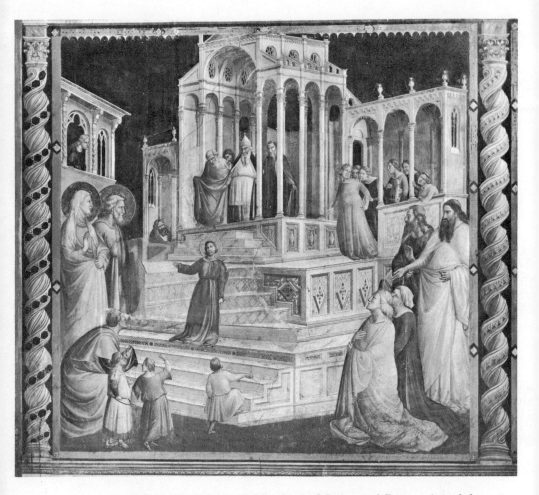

FIG. 100. Taddeo Gaddi, Rejection of Joachim's Offering and Presentation of the Virgin, Florence, S. Croce (Baroncelli Chapel), probably fourth decade of the fourteenth century.

FIG. 101. Ambrogio Lorenzetti, Presentation of Christ, Florence, Uffizi, dated 1342.

FIG. 102. Maitre des Heures du Maréchal de Boucicaut (workshop), Presentation of Christ, Paris, Bibliothèque Nationale, MS. lat. 10538 (Book of Hours, *ca.* 1415), fol. 78.

FIG. 103. Pietro Lorenzetti, Birth of the Virgin, Siena, Opera del Duomo, dated 1342.

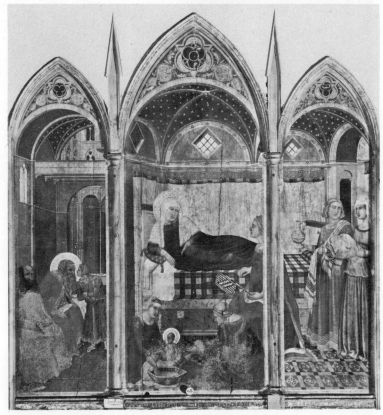

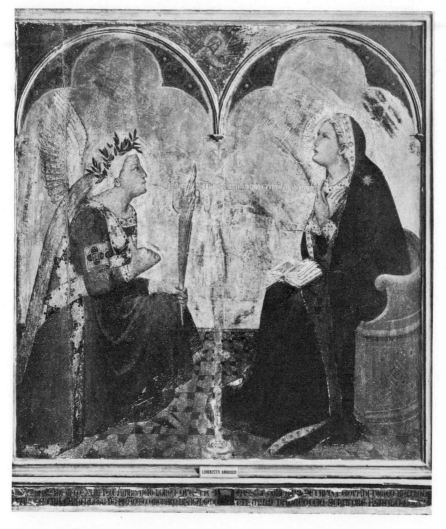

FIG. 104. Ambrogio Lorenzetti, Annunciation, Siena, Accademia, dated 1344.

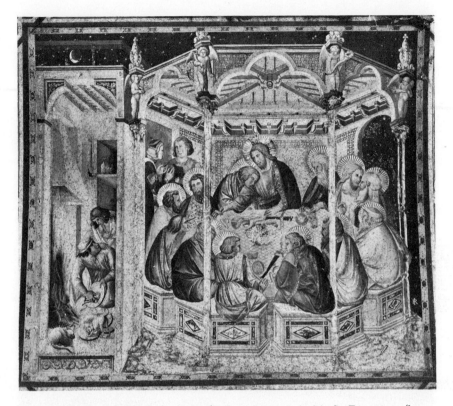

FIG. 105. Pietro Lorenzetti (workshop), Last Supper, Assisi, S. Francesco (lower church), between 1320–1330.

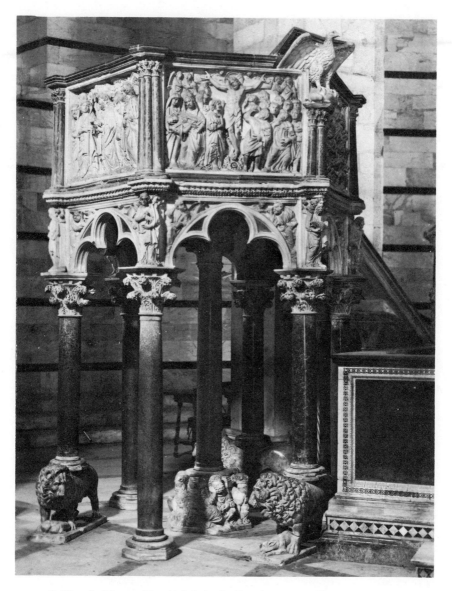

FIG. 106. Niccolo Pisano, Pisa, Pulpit in the Baptistry, *ca.* 1260.

FIG. 107. Giotto, Birth of the Virgin, Padua, Arena Chapel (detail), *ca.* 1305.

FIG. 108. Pietro Lorenzetti (workshop), Flaggellation of Christ (detail), Assisi, S. Francesco (lower church), 1320–1330.

FIG. 109. Francesco Traini, Triumph of Death, Pisa, Camposanto, *ca.* 1350.

FIG. 110. Pisa. Camposanto, Roman Sarcophagus (reused for the burial of Gallo Agnello).

FIG. I I I.
Florence, Cathedral, Porta della
Mandorla, embrasure, Prudence,
1391–1396.

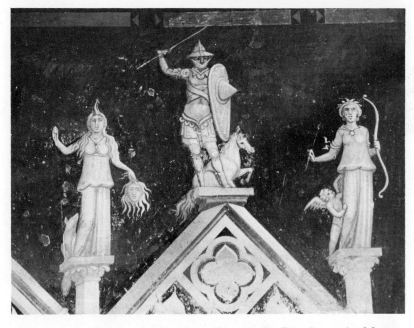

FIG. I I 2. Ambrogio Lorenzetti, Martyrdom of the Franciscans in Morocco
(detail showing Minerva, Mars and Venus), Siena, S. Francesco, *ca.* 1330.

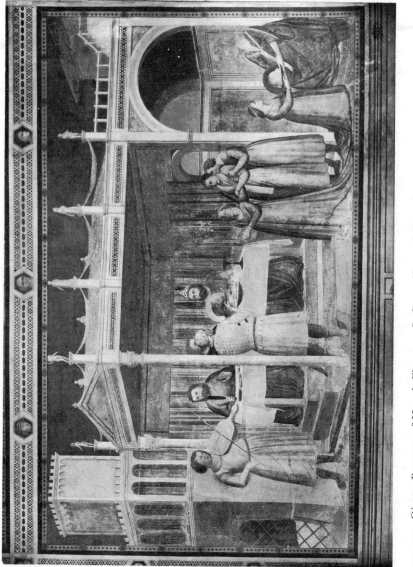

FIG. 113. Giotto, Banquet of Herod, Florence, S. Croce (Peruzzi Chapel), *ca.* 1330.

FIG. 114. Giotto, Allegory of Justice (detail showing *re-muneratio*), Padua, Arena Chapel, *ca.* 1305.

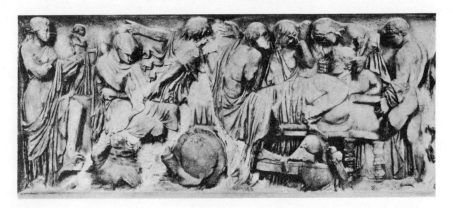

FIG. 115. Formerly Florence, R. di Montalvo Collection, Meleager Sarcophagus, detail.

FIG. 116. Darmstadt, Landesbibliothek, Cod. 101 (Italian translation of Petrarch's *De viris illustribus*, *ca.* 1400), fol. 19, Siege of a City by Alexander the Great.

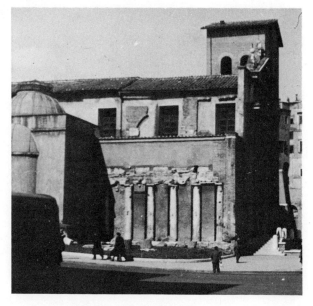

FIG. 117. Rome, S. Nicola in Carcere.

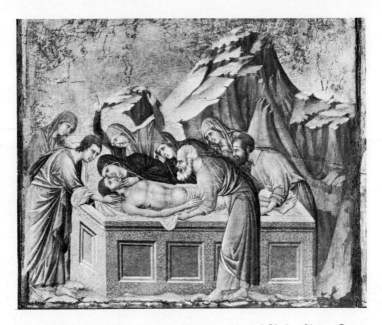

FIG. 118. Duccio di Buoninsegna, Lamentation of Christ, Siena, Opera del Duomo, 1308–1311.

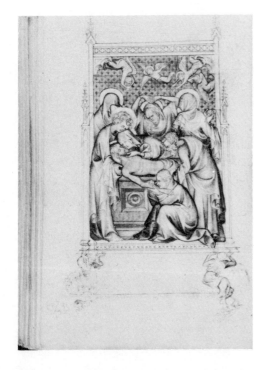

FIG. 119. Jean Pucelle, Lamentation of Christ, New York, Metropolitan Museum (Cloisters), Hours of Jeanne d'Evreux, fol. 82 v., 1325–1328.

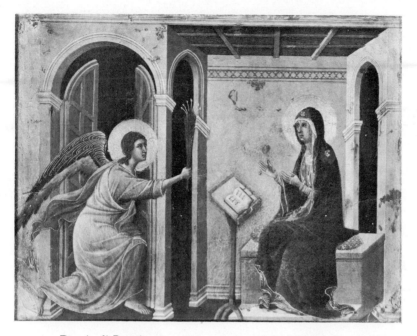

FIG. 120. Duccio di Buoninsegna, Annunciation of the Virgin's Death, Siena, Opera del Duomo, 1308–1311.

FIG. 121. Jean Pucelle, Annunciation, same manuscript as Fig. 119, fol. 16.

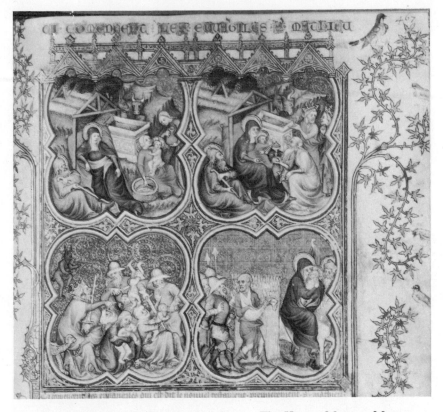

FIG. 122. Jean Bondol (?), Four Infancy Scenes, The Hague, Museum Meermano-Westreenianum, MS. 10.B.23 (Bible Historiale of Charles V, dated 1371), fol. 467.

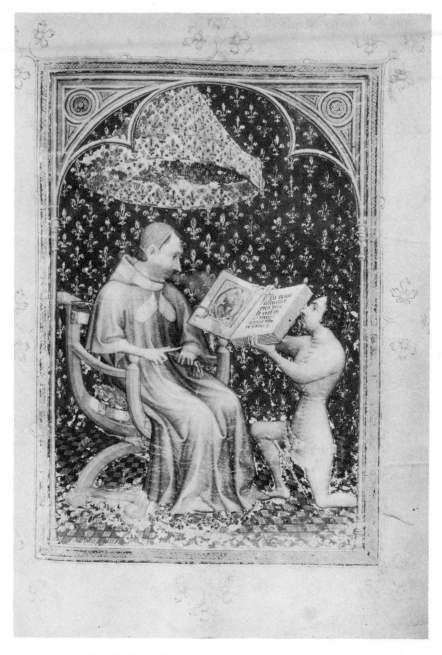

FIG. 123. Jean Bondol, Portrait of Charles V, same manuscript as Fig. 122, fol. 2.

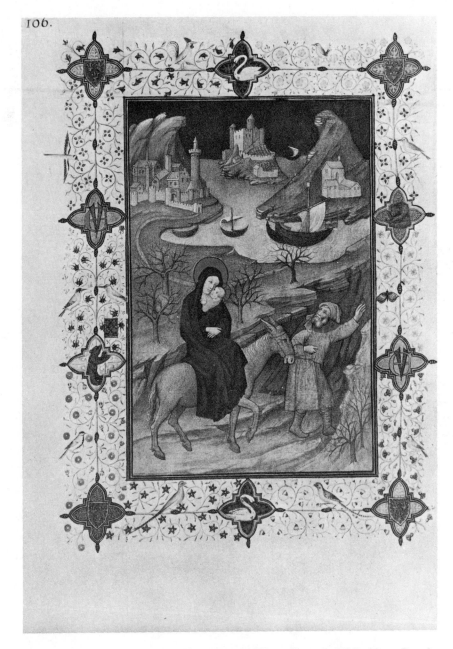

FIG. 124. Jacquemart de Hesdin (?), Flight into Egypt, Brussels, Bibliothèque Royale, MS. 11060/61 (Book of Hours of the Duc de Berry, before 1402), fol. 106.

FIG. 125. The Limbourg Brothers, Presentation of Christ, Chantilly, Musée Condé
(*Très Riches Heures du Duc de Berry*, 1413–1416), fol. *54 v.*

FIG. 126. Maitres des Heures du Maréchal de Boucicaut, King Charles VI in Conversation with Pierre Salmon, Geneva, Bibliothèque Publique et Universitaire, MS. fr. 165 (*Dialogues de Pierre Salmon*, 1411–1412), fol. 4 (slightly enlarged).

FIG. 127. Maitre des Heures du Maréchal de Boucicaut, Annunciation to the Shepherds, Paris, Musée Jacquemart-André (Hours of the Maréchal de Bouci-caut, this page *ca.* 1410), fol. 79 v.

FIG. 128. North Italian Master, Adoration of the Magi, *ca.* 1410, New York, Messrs. Rosenberg & Stiebel.

FIG. 129. Masaccio, The Trinity, Florence, S. M. Novella, probably between 1425 and 1427.

FIG. 130. Masaccio, Madonna, London, National Gallery, 1426 (reproduced by courtesy of the Trustees, the National Gallery, London).

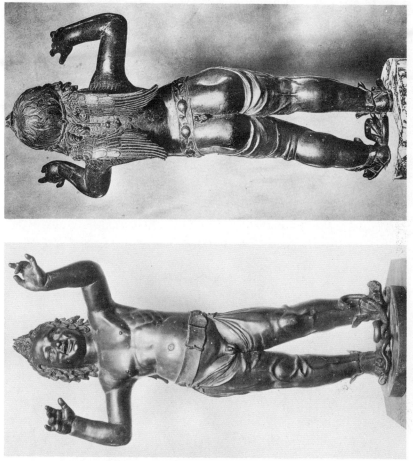

FIG. 131. Donatello, So-called "Atys-Amorino" (more correctly: "Time as a Playful Child Throwing Dice"), Florence, Museo Nazionale, *ca.* 1440. — FIG. 131a. Donatello. So-called "Atys-Amorino", rear view.

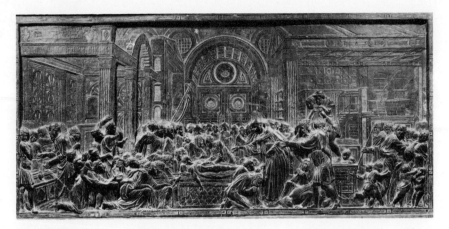

FIG. 132. Donatello, The Heart of the Miser, Padua, S. Antonio, towards 1450.

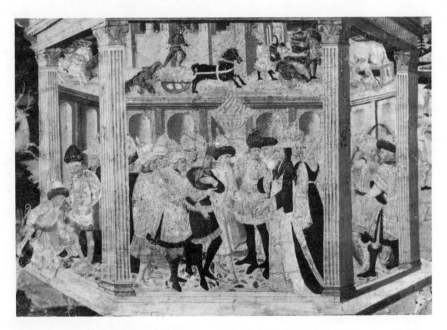

FIG. 133. Apollonio di Giovanni, Scene from the *Aeneid* (cassone front, detail), New Haven (Conn.), Yale University Art Gallery, *ca.* 1460 (reproduced by courtesy of the Yale University Art Gallery).

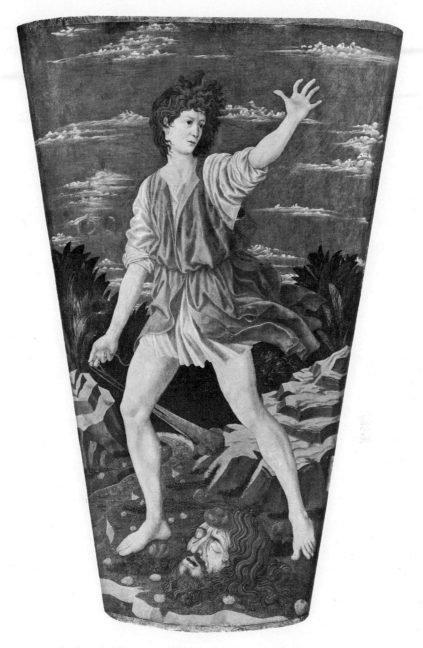

FIG. 134. Andrea del Castagno, David, Washington, D. C., National Gallery of Art, towards 1455 (reproduced by courtesy of the National Gallery of Art, Widener Collection).

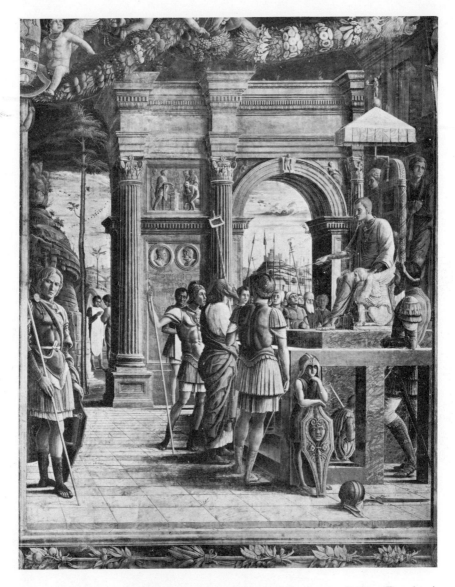

FIG. 135. Andrea Mantegna, The Condemnation of St. James, Padua, Eremitani Church (destroyed), towards 1455.

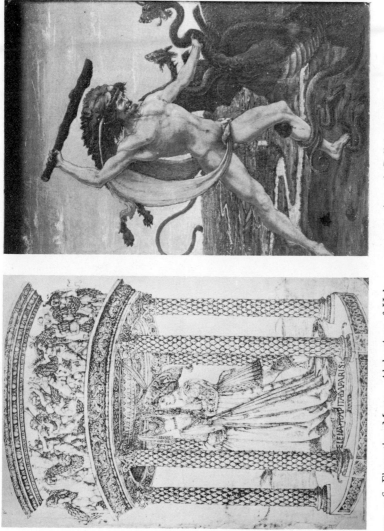

FIG. 136. Florentine Master, Abduction of Helen (pen drawing in the "Florentine Picture Chronicle", *ca.* 1460), London, British Museum.

FIG. 137. Antonio Pollaiuolo, Hercules Fighting the Hydra, Florence, Uffizi, probably 1465–1470.

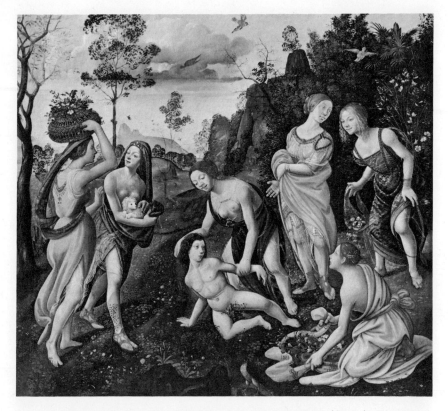

FIG. 138. Piero di Cosimo, The Finding of Vulcan, Hartford (Conn.), Wadsworth Atheneum, *ca.* 1485–1490.

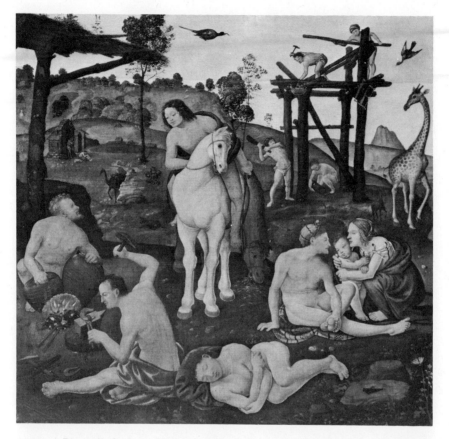

FIG. 139. Piero di Cosimo, Vulcan, Assisted by Aeolus, as Teacher of Mankind, Ottawa, National Gallery, *ca.* 1485–1490 (reproduced by courtesy of the National Gallery, Ottawa).

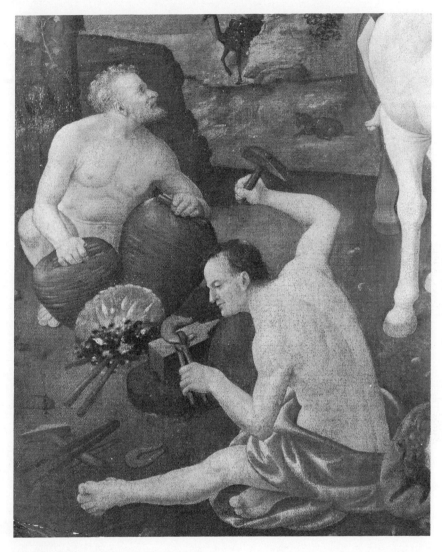

FIG. 140. Piero di Cosimo, detail of Fig. 139.

FIG. 141. Piero di Cosimo, The Discovery of Honey, Worcester (Mass.), Worcester Art Museum, *ca.* 1498.

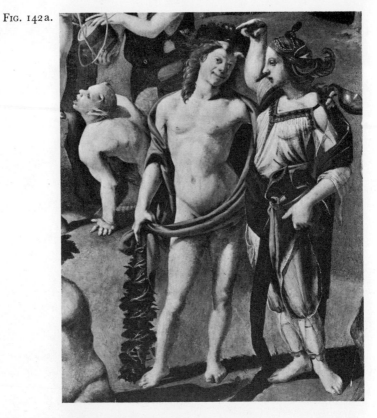

FIG. 142. Piero di Cosimo, details from Fig. 141.

FIG. 142.

FIG. 143. Florentine Master, Bust of a Young Man (ascribed by some to Donatello), Florence, Museo Nazionale, probably 1470–1475.

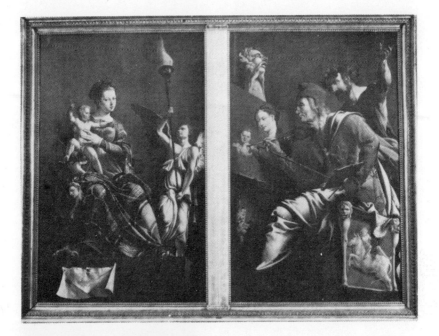

FIG. 144. Maerten van Heemskerck, St. Luke Portraying the Virgin, Haarlem, Frans Hals Museum, dated 1532.

FIG. 145. Lucas Cranach the Elder, Cupid Unblindfolding Himself, Philadelphia, Pennsylvania Museum of Art, *ca.* 1525–1530.

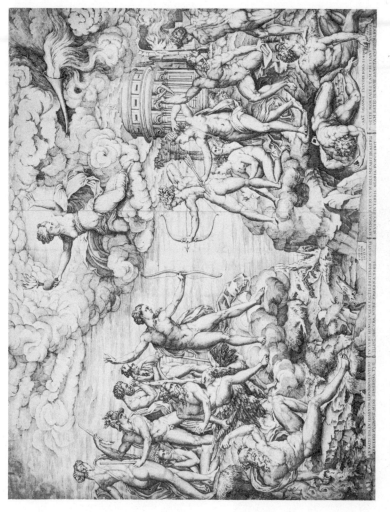

FIG. 146. Nicolas Béatrizet after Baccio Bandinelli, The Combat of Lust and Reason, Engraving B. 44. dated 1545.

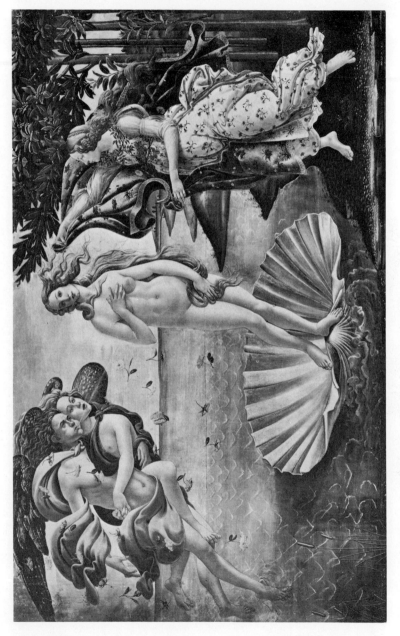

FIG. 147. Sandro Botticelli, The Birth of Venus, Florence, Uffizi, *ca.* 1480.

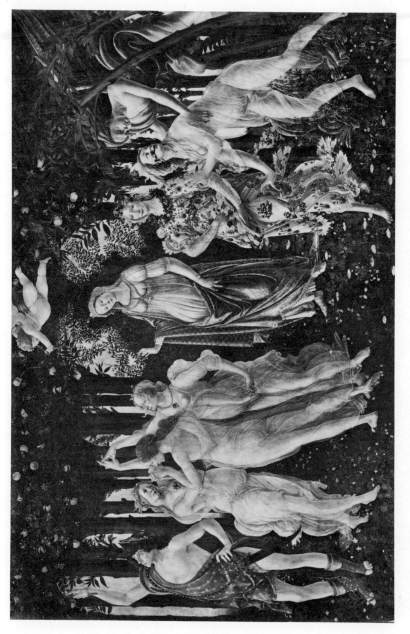

FIG. 148. Sandro Botticelli, The Realm of Venus ("*La Primavera*"), Florence, Uffizi, towards 1478.

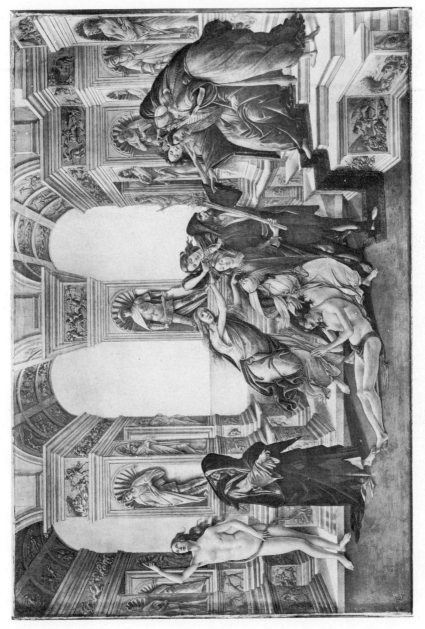

FIG. 149. Sandro Botticelli, The Calumny of Apelles, Florence, Uffizi, *ca.* 1485.

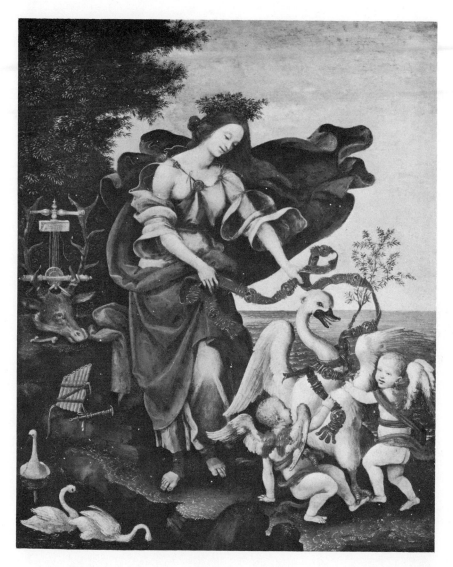

FIG. 150. Filippino Lippi, Erato ("Allegory of Music"), Berlin, Kaiser-Friedrich-Museum, *ca.* 1500.

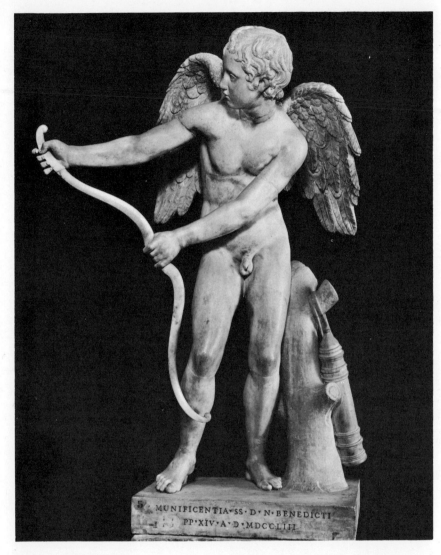

FIG. 151. Lysippus (after), Cupid Stringing His Bow, Rome, Museo Capitolino.

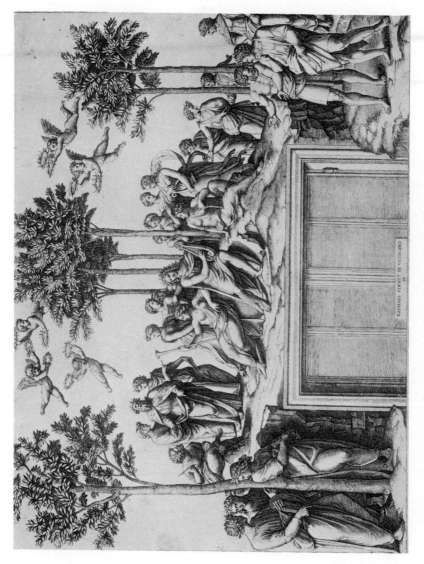

FIG. 152. Marcantonio Raimondi, Parnassus (after Raphael), Engraving B. 247.

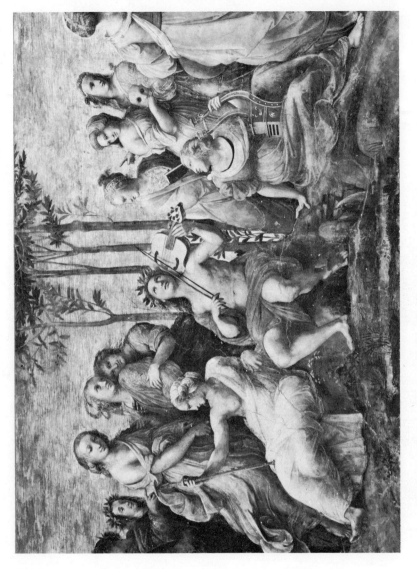

FIG. 153. Raphael, Parnassus (detail), Rome, Vatican, 1509–1511.

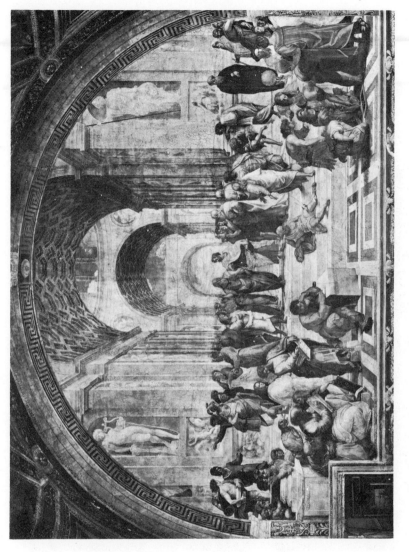

FIG. 154. Raphael, School of Athens, Rome, Vatican 1509–1511.

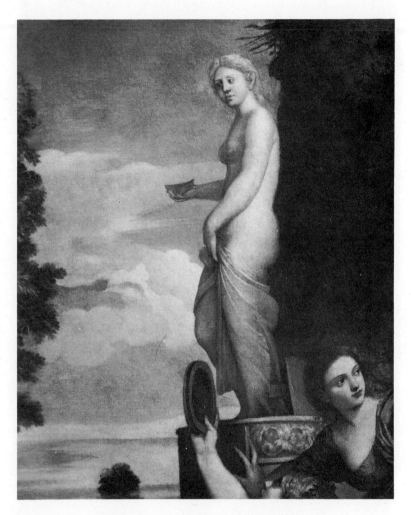

FIG. 155. Titian, Feast of Venus (detail), Madrid, Prado.

FIG. 156. Rome, Biblioteca Vaticana, Cod. Pal. lat.
1370 (miscellaneous astrological treatises written in
Germany about the middle of the fifteenth century),
fol. 97 v., Mars (enlarged).

FIG. 157. Rome, Biblioteca Vaticana, Cod. Pal. lat.
291 (Hrabanus Maurus, *De universo*, German copy,
dated 1425, after a Carolingian manuscript), fol. 190,
Saturn, Jupiter, Janus, Neptune.